ALBERT MOORE

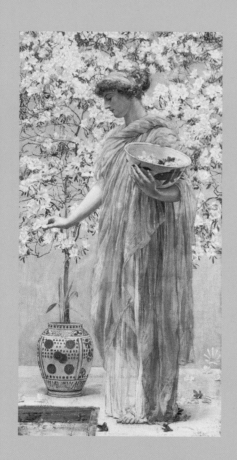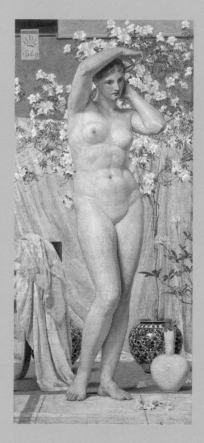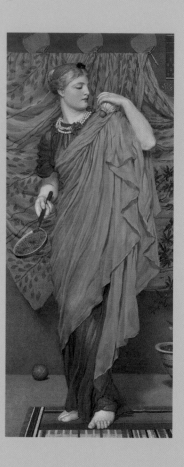

ALBERT MOORE

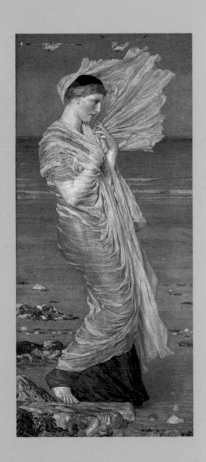
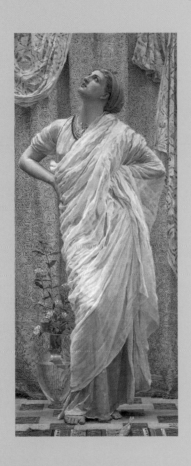
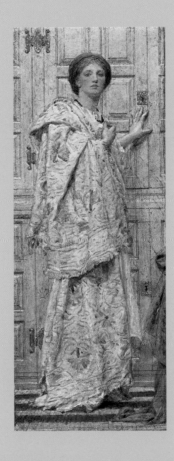
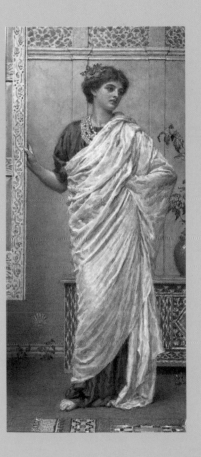

ROBYN ASLESON

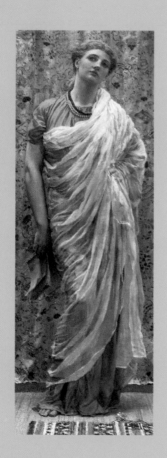
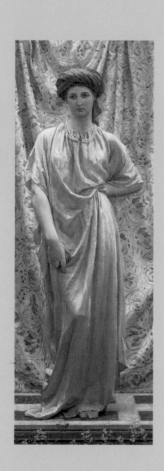
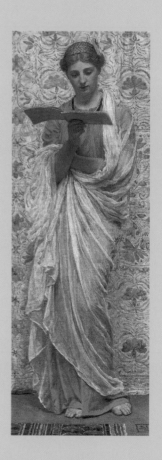
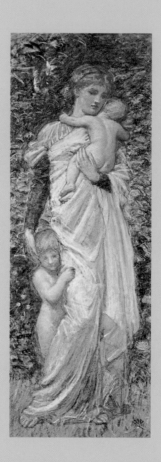

Contents

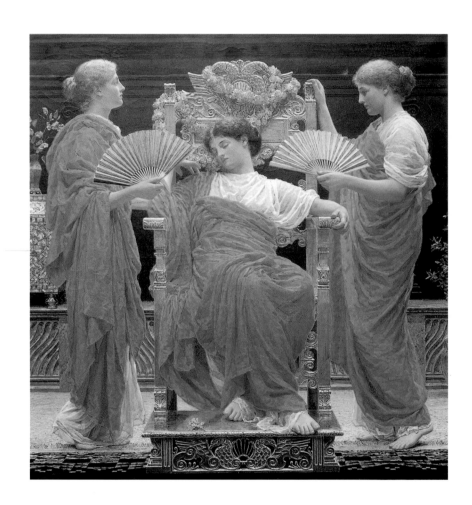

INTRODUCTION

'HE WAS AN ARTIST BORN BEFORE HIS TIME, A PIONEER OF ARTISTIC
PRINCIPLES, WHICH ARE AT PRESENT ONLY DIMLY UNDERSTOOD EVEN
BY THE PEOPLE WHOSE DUTY IT IS TO STUDY AND ANALYSE NEW
MOVEMENTS AND FRESH DEVELOPMENTS. HE WAS INSTINCTIVELY
A PROPHET OF A NEW DISPENSATION, AND WAS TOO SERIOUSLY
CONVINCED OF THE RIGHTNESS OF HIS OWN BELIEFS TO DILUTE THEM
BY MERE OPPORTUNIST CONCESSION TO POPULAR IGNORANCE.'[1]

It is questionable whether Albert Moore would have wished this book
to be written. Relentless in the pursuit of ideal beauty, he rarely
bothered to explain his quest to others. While his colleagues freely
documented their ideas and aspirations in a constant round of lectures,
essays and interviews, Moore remained relatively silent, trusting his art
to serve as his only manifesto and his most eloquent epitaph. The story
of his life, like all other stories, would have struck him as an irrelevant
distraction from the perfected beauty that was the sole subject of his
pictures. Those capable of understanding would do so unaided; those
who could not were of no interest to him.

Independent investigation of the universal laws responsible for
aesthetic pleasure provided the focus of Moore's life's work. Through
systematic analysis of nature and an eclectic array of art, he derived
theoretical principles for ideal combinations of colour, line and form.
His conception of art in purely formal terms was well ahead of its
time and anticipated many of the concerns of twentieth-century
abstraction. During his lifetime, Moore's advanced aesthetic
experiments gained the respect of progressive artists, critics and
patrons, but were lost on the majority of his contemporaries, who saw
in his paintings only an endless parade of classically draped maidens.
As a purveyor of pretty pictures, Moore enjoyed (and continues to
enjoy) considerable popularity, but as a practitioner of innovative
aesthetic theory, he was (and is) virtually unknown. Then as now,
Moore's fundamental concern with abstract principles is masked by
the representational imagery in which he expressed himself.

When Moore died in 1893 still underappreciated by the public and
unhonoured by the Royal Academy, the indignation of his friends and
family was extreme. Galvanized by anger and disappointment, his elder
brother, the sea painter Henry Moore, began to write a biography in
which he expressed his 'firm belief that he, and he alone, could do
justice to his brother's character and art', expressing 'almost a jealousy
of a subject to him so sacred being undertaken by anybody else'.[2]
Having defended his brother throughout his life, Henry Moore felt
compelled to protect him in death, derailing at least one would-be
biographer by denying access to Albert's papers.[3] Nothing came of
Henry Moore's intended biography, but in 1894 Alfred Lys Baldry
completed a full-length book on his former teacher.[4] In this biography
and numerous articles on Moore, Baldry chastised his contemporaries
for failing to appreciate the genius in their midst. 'In times to come',
he wrote, 'one of the most powerful arguments against the use and value
of criticism will be derived from this failure of our contemporaries to
put Albert Moore during his life into the position which was discovered
at his death to have been for many years his by right'.[5]

In the hundred years since the appearance of Baldry's indispensable
biography, Albert Moore's reputation as a taciturn recluse and the
relative poverty of primary documentation have discouraged fresh
examination of the artist's life and career.[6] Only a handful of scholars
have attempted to enlarge, confirm, or correct Baldry's account.
Foremost among them is Richard Green of the York City Art Gallery,
whose conscientious study of Albert Moore over the past three decades
has brought lost works to light and yielded important information.[7]
I am grateful for the assistance and encouragement that he has
graciously afforded me. I am also indebted to members of the Moore
family for their generosity in sharing original documents that have filled
crucial gaps in Albert Moore's history.

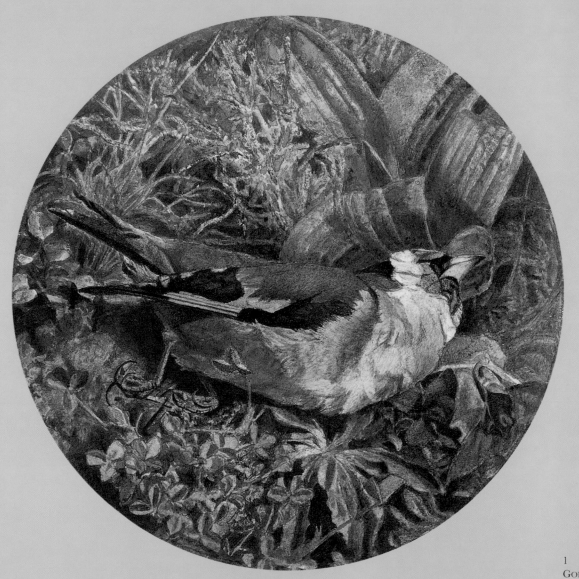

1
GOLDFINCH
1857
*Pencil and watercolour with
surface scratching*
Diameter 14.6 cm *(5¾ in)*
York City Art Gallery

2
Photograph of Albert
Moore
*c.*1855
(from Baldry, *Albert Moore,*
opp. p. 10)

NATURE AND NURTURE

1841-1865

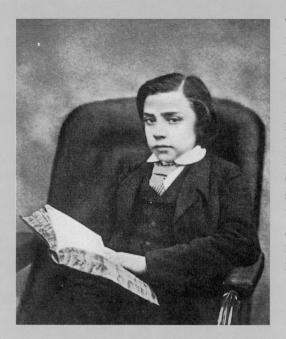

THE MOST FASHIONABLE PLACE TO BE ON A SUNDAY AFTERNOON IN LATE NINETEENTH-CENTURY LONDON WAS HOLLAND PARK ROAD, WHERE THE GLAMOROUS PRESIDENT OF THE ROYAL ACADEMY AND HIS ARTISTIC NEIGHBOURS OPENED THEIR PALATIAL HOMES TO THE PUBLIC FOR A FEW HEADY HOURS. ON THEIR WAY TO CATCH A GLIMPSE OF ENGLAND'S MOST CELEBRATED PAINTERS, VISITORS PASSED AN OBSCURE LANE BOUNDED INAUSPICIOUSLY BY A DAIRY, A STABLE AND A PUB. FEW WOULD HAVE REALIZED THAT THE SOLITARY RED-BRICK HOUSE MIDWAY DOWN THE LANE WAS HOME TO ANOTHER PROMINENT PAINTER (SEE BELOW, PLS. 142, 143). HIS ADDRESS WAS UNLISTED IN THE STREET DIRECTORIES AND HIS NAME APPEARED ONLY RARELY IN THE 'EXCLUSIVE' REPORTS THAT ADVERTISED PAINTINGS IN PROGRESS IN ARTISTS' STUDIOS. ADMISSION TO THE INNER SANCTUM OF THE RED-BRICK HOUSE WAS SOLELY BY INVITATION, AND THAT INVITATION WAS EXTENDED TO VERY FEW.

Situated near the very epicentre of the contemporary art world yet undeniably beyond its pale, Albert Moore's studio provides a fitting metaphor for his career. While his paintings made prominent appearances at the annual exhibitions of the Royal Academy and other institutions, the man himself remained an enigma, a shadowy figure on the periphery of a profession illuminated by the limelight of publicity. The comparative obscurity in which Moore increasingly chose to live has established his image as an isolated eccentric, leading a hermit's life while pursuing a single-minded quest for ideal beauty. Although this image reflects the circumstances of Moore's last years with some accuracy, it neglects the earlier personal and professional experiences that shaped his development as an artist. Investigation of the complex social and artistic networks in which Moore operated does not alter the fact that his work followed a highly independent course. But the direction of that course is made intelligible only through an understanding of the formative influences that guided his precocious early efforts and structured his mature vision.

In a family known for artistic ability, Albert Moore was regarded as a wonder. By the age of four, they claimed, he 'had settled down into a systematic and intelligent course of working from natural objects' which enabled him to 'copy the leaves of any plant he saw, and repeat

3
William Moore Sr
UNKNOWN MAN AND
HIS DOG
n.d.
Oil on copper
60.9 x 44.4 cm
(24 x 17½ in)
York City Art Gallery

4
WILLIAM MOORE
*c.*1851
Crayon
Whereabouts unknown
(from Baldry, *Albert Moore*,
opp. p. 10)

the copies till he could draw them from memory'.[1] The adult artist's diligence and perfectionism are prefigured in the child's habit of countering praise with a vow to do better in his next attempt.[2] Albert's father, William Moore (1790-1861), was well qualified to nurture the artistic gifts with which nature had endowed his son. Having designed japanned goods for a Birmingham manufacturing firm prior to devoting himself to portraiture (Pl. 3), the elder Moore rooted his art in painstaking design and draughtsmanship. He transferred this legacy to his children, reputedly administering lessons in accurate drawing to each of them in turn (Pl. 4).[3] Following the death of his first wife, Martha Jackson, William Moore married Sarah Collingham (1799-1863), an amateur draughtswoman with numerous artistic relations.[4] Around 1830 the Moores settled in York, where they added a 'second family' of six sons to the eight children from William Moore's previous marriage. By the time Albert was born on 4 September 1841, his father was over fifty years of age and several of his siblings were old enough to be his parents.

The modest market for portraiture in the northern provinces provided meagrely for the extensive Moore family. Most of the children left school in their early teens in order to earn their own livings. Albert's eldest half-brother, Edwin (1813-93), in addition to painting landscapes and topographical views (Pl. 6), taught drawing, perspective and painting at the Quaker school in York while also offering private drawing classes at his home.[5] The *Elementary Drawing Book* which he published in 1840 provides a systematic course in the rules of perspective, illustrated with sketches and geometric diagrams (Pl. 5). The same rigorous approach to drawing characterized a younger brother, William Moore Jr. (1817-1909), also a landscape painter and art instructor who served as his father's assistant for a time and taught many of his siblings.[6] Other sons of the 'first family' included: Joseph Wright Moore (1816-40), who worked as a carver and gilder; Charles (1819-36), a cabinet-maker; Frank (1821-65), a decorative painter and picture dealer; and George (1825-1906), a coach-builder.[7]

The same combination of art and craftsmanship characterized the sons of William Moore's 'second family', several of whom supplemented home education with study at the York School of Design. The eldest, John Collingham Moore (1829-80), was among the first students to enrol when the School opened in 1842 as a provincial branch of the Government School of Design at Somerset House, London. He was followed by his younger brothers, Robert Collingham (1836-1909), Henry (1831-95) and Albert, and even their father registered at the age of 52.[8] The other brothers apparently went directly to work: Frederick Collingham (b. 1833) was an optician and clockmaker and Benjamin James (1838-75) worked as a lithographer before becoming a designer of stained glass.

During the 1840s Edwin, William and John Moore established a private class for studying the nude model. Study of the human figure was the centrepiece of established academic training in art, but the Moores showed a daring disregard for convention in instituting such a class in the climate of prudery that then existed at York. The genitalia

of plaster casts at the York School of Design so disturbed a female student around this time that the master was requested to remove the offending anatomy and cover the area with sculpted fig leaves.[9] The casts survived more or less intact, but the Moore brothers' life class proved less fortunate, reputedly disbanded under pressure from the city's Calvinist community.[10] Nevertheless, their willingness to defy the sensibilities of their neighbours while fulfilling the requirements of art anticipates Albert's notorious indifference to convention, and provides evidence that he acquired from his family the self-confidence necessary to pursue his unorthodox convictions. John Ward Knowles, a contemporary chronicler of York history, believed this to be the case, reporting that while drawing from plaster casts at the York School of Design, William Moore Sr. 'used to assume a patronizing air to the other students' and 'apparently transmitted a little of the Moore pomposity to his sons'.[11] The 'Moore pomposity' took firm and early root in Albert, and to a great extent determined the shape of his life and art. His pupil and biographer,

Alfred Lys Baldry, asserted that even as a child, he 'was by no means ready to accept without question the experience of others', but would 'fight hard for his own views, and pit his own beliefs against those of the older members of his family'.[12]

The artistic Moore brothers were not the sort of students that the Board of Trade had in mind when it established the National Schools of Design. The sole purpose of the Schools was to improve the quality of English manufacture by providing artisans with rigorous training in draughtsmanship and design. Official policy stipulated that 'no person making [fine] Art his profession should be eligible for admission as a student'.[13] The provincial branch at York never fitted the mould prescribed for it, however.[14] The curriculum bore the personal impress of the figure painter and Royal Academician William Etty (1787-1849), a native of the city who continued to promote its artistic and architectural interests while pursuing his career in London.[15] It is likely that shared

5
Edwin Moore
INCLINED PLANES
Engraving published in
Moore's *Elementary Drawing
Book* (1840)

6
Edwin Moore
FOUNTAINS ABBEY
1865
Watercolour
50.7 x 36.5 cm
(20 x 14¼ in)
York City Art Gallery

11

sympathies engendered a degree of intimacy between Etty and members of the Moore family. While visiting York in 1839 and 1840, the painter humbly enrolled as a student in perspective classes given by young Edwin Moore.[16] He shared the family's strong commitment to study of the nude model, which he considered nature's supreme achievement in design and form (Pl. 7). Etty faithfully attended the Royal Academy's life classes throughout his London residence, and on retiring to York in 1848 (despite fears that 'he could not have a Model without scandal, —a mob perhaps'), he continued to work from male and female models in his studio. Despite opposition, he also instituted a class for studying the male nude at the School of Design.[17] Prior to this, the only life class available in York was that operated briefly by the Moore brothers.

Etty ensured that teaching at York was grounded in the study of nature in general, as well as the human figure in particular. In an address delivered at the School's opening in 1842, he exhorted students 'to study ... the varied forms and colour which nature presents; the beauty of plumage in birds, the colours and shapes of shells, flowers and plants, both wild and cultivated, to try to express these with a pure, accurate and clear *outline*, the first essential'.[18] Etty's identification of feathers, shells, flowers and plants as evocative sources of abstract formal values anticipated the strategies that Albert Moore later adopted in deriving pictorial inspiration from nature. Etty's emphasis on the value of 'pure, accurate, and clear *outline*' would also have a place in Moore's mature art.

Etty died in 1849 when Moore was only eight years old, but the painter's legacy lived on at the York School of Design. The monthly committee reports of Thomas Cotchett, principal of the School from September 1851, catalogue a wide range of natural specimens brought in for visual analysis.[19] Cotchett also sustained Etty's commitment to the study of the human figure, initiating a 'Rustic figure and Draped Model' class to complement the life class.[20] Casts of classical sculpture were also available; indeed, during the 1850s, 'the students at the York School had to make the Elgin marbles their principal objects'.[21] Studied in tandem with the living model, these sculptures assisted students in accommodating nature to the ideals of art.

On 9 October 1851, William Moore Sr., who had suffered from a disease of the brain for at least two years, died of fever, leaving his widow, Sarah, in charge of their five younger sons.[22] Henry had been working for a picture dealer while also assisting his disabled father in carrying out his commissions. He now enrolled at the York School of Design along with his ten-year-old brother, Albert, who was simultaneously earning prizes for his academic studies at St. Peter's School.[23] Despite the ten years and three brothers between them, Albert and Henry Moore enjoyed a particularly close relationship.[24] Both soon distinguished themselves at the York School of Design, where Albert's performances reportedly aroused 'stir and comment'. It was later recalled that he was 'constantly making sketch notes' and achieved 'excellent progress especially in Anatomy'.[25] In February 1852 he won a five-shilling prize for his unshaded chalk drawing of an

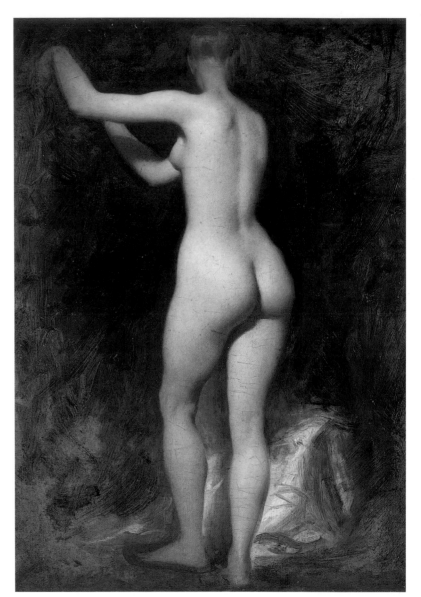

7
William Etty
STANDING FEMALE NUDE
(BACK VIEW)
*c.*1825-30
Oil on millboard laid on panel
68.5 x 43.1 cm
(27 x 17 in)
Private collection

8
John Collingham Moore
ON THE TIBER NEAR
AQUACERTOSA
Watercolour
27.0 x 45.3 cm
(10⅝ x 17⅞ in)
Victoria and Albert
Museum, London

ornament from the flat. In May 1853 another drawing earned him a medal from the Department of Science and Art at Marlborough House, London.[26]

The emphasis on life drawing at the York School of Design paved the way for students to pursue careers in fine art, a profession with the potential to confer higher social status and greater remuneration than designing for manufacture. The most ambitious fled York and enrolled at the Royal Academy Schools, England's most prestigious art institution. John Collingham Moore had done just that in 1849. Accepted as a student on 20 December 1850, he advanced to the life school on 24 December 1851.[27] He was soon followed by Henry Moore, who became a probationer on 10 July 1852, and was admitted as a student that Christmas Eve. Thomas Cotchett reported that Henry's admission to the Academy Schools 'may be considered gratifying as tending to prove that the course and direction of the studies in this school are sound and effective'.[28]

Toward the end of 1855 the two Moore brothers were joined unexpectedly by their mother and youngest brother, Albert, who had received a sudden opportunity to pursue his education in London. The architect David Moore (1802-79), one of the proprietors of the Kensington Grammar School and almost certainly a relation, had been forced to withdraw his own 12-year-old son owing to ill health. He offered the vacated place to the family prodigy, 14-year-old Albert, who was admitted in January 1856.[29] The arrangement enabled Albert to advance his education to a level unprecedented within his immediate family. This momentous occasion was documented by a photograph of the young scholar in suit and tie, looking up from his hefty tome with a serious and rather sad stare (Pl. 2). The move to London also enabled Sarah Moore to provide a proper home for her as yet unmarried sons, 26-year-old John and 24-year-old Henry. By the end of 1855 all three sons were living with their mother at 25 Lower Phillimore Place, a Georgian terrace off Kensington High Street. Proximity to the Kensington Grammar School and to the David Moore family, both located just across the High Street near Kensington Square, probably recommended Lower Phillimore Place as a residence.[30]

In addition to rare artistic ability, Albert evidently possessed exceptional intelligence. Contrary to his subsequent misrepresentation as an uncultured bumpkin, he was actually 'pronounced to be one of the cleverest and most intellectual of the scholars' at the Kensington Grammar School, and his performance recommended his continuing for a second year.[31] Academic education was evidently intended to prepare Albert for a career other than art. Indeed, the school's primary function was to prepare students for the universities and military colleges through instruction in 'the Hebrew, Greek, Latin, French, and English Languages; History, Geography, Mathematics, [and] Arithmetic'. In addition to these courses, Moore elected to study German for two terms in a fee-paying class in which he ranked first, and his letters demonstrate knowledge of Italian, French, and Latin. He excelled from the start in mathematics, generally achieving the highest place in his class.[32] At the same time, Moore was reportedly

working as an architectural draughtsman, presumably under David Moore, and it was later stated that his family had expected him to become an architect.[33] The linear clarity and geometric discipline required of architectural drawings had a formative effect on Moore's style and informed his subsequent designs for architectural ornament. Moreover, his advanced training in maths, building on the instruction in geometry and perspective that he had received at home, laid the groundwork for the methodical approach to design that characterized his mature career.

While a student at the Kensington Grammar School, Moore devoted his holidays to nature studies in the countryside.[34] One or more of his brothers generally accompanied him on these excursions, for as landscape painters, Edwin, William, John and Henry were constantly in search of promising scenery. Shared devotion to nature provided the Moore brothers with a common bond, but their artistic responses to the natural world differed radically. While the eldest, Edwin and William, still worked in the early-nineteenth-century topographical and picturesque traditions, John developed a greater sensitivity to

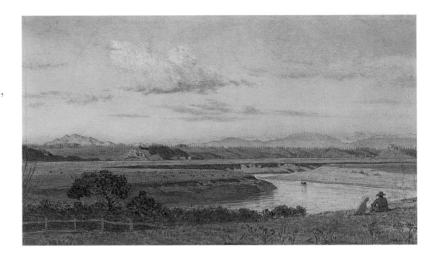

atmospheric effects and abstract formal properties (Pl. 8). Henry, who later achieved fame as a sea painter, devoted his youth to closely observed landscape, animal and flower paintings, and Albert was reportedly his constant companion during 'long rambles across pastoral country in search of subjects' (Pl. 9).[35]

When he was about fifteen, Albert executed the watercolour drawings *A Woodcock* (unlocated) and *Goldfinch* (Pl. 1), based on specimens provided by a co-operative gamekeeper. Henry may have worked from the same examples, for he was then carrying out an encyclopedic series of oil studies of birds.[36] In *Goldfinch* Albert meticulously reproduced subtle variations in the colour and texture of the plumage, but he also devoted attention to a wide variety of plant life on the ground. His precise delineation of a humble patch of earth exemplifies the sort of nature studies that Etty encouraged at the York School of Design.[37] But it may also reflect the influence of John Ruskin (1819-1900), the empassioned aesthetic moralist who in 1843 had rallied English artists with the call to 'go to Nature in all singleness of heart, and walk with her laboriously and trustingly,

having no other thoughts but how best to penetrate her meaning, ... rejecting nothing, selecting nothing, and scorning nothing'.[38] In the early 1850s Ruskin was championing the exacting naturalism of the Pre-Raphaelite Brotherhood, a group of young artists who had united in 1848 with the aim of eschewing artistic convention in order to pursue original expression and direct study of nature. Setting up makeshift studios out of doors so that they could paint with their subjects immediately before them, the Pre-Raphaelites submitted themselves to a painstaking apprenticeship which yielded a style characterized by a profusion of infinitesimal detail.

The doctrine of truth to nature exasperated the art establishment of the Royal Academy as much as it inspired idealistic young artists.

Devon, the previous summer, it represented a forest glade with meticulously rendered trees, ferns and other foliage. Half a century later, one of Moore's schoolmates at the Royal Academy could still recall the depiction of stripped wood, 'bleached a silvery-grey, showing in parts almost prismatic tints'. Henry was the clear favourite of the Academy students, and their disgust was audible when the prize was awarded to another picture—the sole entry that had not been studied from nature. According to the artist Henry Holiday, the decision was motivated 'by the innate dislike of nature then prevalent among the [council] members', who were 'determined to crush the pernicious heresy of studying from nature'.[42]

At the same time that Henry Moore was exciting comment, Albert

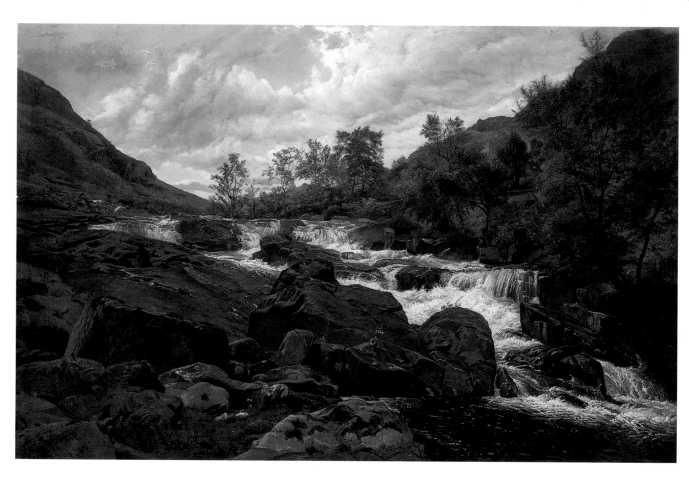

9
Henry Moore
A MOUNTAIN TORRENT
1859
Oil on canvas
60.9 x 91.3 cm
(24 x 36 in)
Private collection

Henry Moore became ensnared in the controversy, and the experience provided his brother Albert with a vicarious foretaste of the hazards of aesthetic politics. In 1856 one of the pictures that Henry exhibited at the Royal Academy attracted the attention of John Everett Millais (1829-96), a founding member of the Pre-Raphaelite Brotherhood and a distant relation.[39] The following year Henry's painting *A Swiss Meadow in June* elicited a rhapsodic review from Ruskin himself,[40] and William Michael Rossetti (another member of the Pre-Raphaelites) invited him to contribute to an exhibition of British pictures in New York.[41] *A Coast Woodland*, the masterful work that Henry entered in the first Turner Gold Medal competition in 1857, seemed certain to confirm his status as a rising star in the movement to reform landscape painting through greater fidelity to nature. Executed at Clovelly,

quietly exhibited two of his own nature studies, the watercolours *Goldfinch* and *A Woodcock*, at the Royal Academy in 1857. The acceptance of these pictures by an artist still shy of his sixteenth birthday provided strong incentive for Moore to pursue a career in art, and the term that he completed in August at the Kensington Grammar School proved to be his last. Savouring his freedom during the hiatus 'between school time and real work', Moore embarked on a sketching trip to Dockray, near Ullswater, an area of the Lake District popular with his brothers and other artists. During this visit and on his return the following year, Moore made watercolour and pencil sketches intended principally to further his artistic education. His method is suggested by a sepia drawing of 1860, *A Gate* (now unlocated), the background of which, according to Baldry, was studied

outdoors at Borrowdale (Pl. 10).[43] Far from an unmediated
transcription of nature, the drawing indicates that Moore deliberately
accommodated the terrain to an abstract geometric pattern. The
curve he delineated at the top of the picture evidently determined the
rising contours of the mountain, and when the curve is completed
to form a circle, it proves to have dictated the position of several
elements in the lower section of the drawing as well, such as the dog's
raised paw and the largest stones in the road. Although this method
may seem artificial, Baldry claimed that Moore actually derived it
from nature: 'from the unconscious line agreement of natural forms
came the method of composition which he followed; from effects
observed out of doors came ideas for pictorial arrangements.'[44]
Moore's reliance on drawing as a means of penetrating the underlying
formal logic of nature was inculcated by his father and brothers.
Henry Moore would later declare, 'Drawing is the beginning of
everything. It is almost like the discovery of a new sense, and from the
time we begin to draw objects we begin to discover their beauties'.[45]

Moore's finished watercolours of this period clearly reveal his
engagement in the underlying patterns of nature. In *A Waterfall in the
Lake District* he delineated the complex structure of a craggy hillside,
mapping patches of moss and lichen, and the internal veins, crevices
and discolourations of each stone (Pl. 11). It is tempting to propose a
connection with Ruskin, who in 1856 had published his compelling
essay 'Of Mountain Beauty' as the fourth volume of *Modern Painters*.
Through close geological observation, Ruskin urged artists to decode
the living language of nature, which he assured them was rich with
moral and anthropomorphic intimations.[46] It is difficult to discern this
sort of content in Moore's watercolour, however, for he seems more
interested in expressing linear and colouristic patterns such as the
serpentine lines weaving through the composition—than in conveying
a sense of nature's ethical meaning. Indeed, the artist's engagement in
two-dimensional design overwhelms even the naturalistic qualities of
his watercolour, resulting in a flatness that distorts spatial relationships
and confuses the topography.

A similar absorption in organic pattern and rhythm informs Moore's
watercolour *Study of an Ash Trunk* (Pl. 12). It was exhibited at the
Royal Academy in 1858 along with the pencil drawing *Wayside Weeds*
(unlocated), which Baldry described as 'a tangle of leaves and flowers
growing on a bank'.[47] Moore composed *Study of an Ash Trunk*, like his
other nature studies, with careful attention to formal patterns. The
sloping plane of the tree trunk divides the composition approximately
into thirds. Though placed off-centre, this warm brown band balances
the cool green triangles at either side, and its strong left-to-right
diagonal thrust is counterbalanced by the vines and ivy that form
sweeping diagonal curves in an opposing direction. The dense
tangle of the foreground seems to obscure the middle distance and
background, but Moore has actually used grey and green washes to
summarily screen off areas of potential recession. Placed shallowly
within the pictorial space before a flat wall of colour, Moore's three-
dimensional botanical specimens dissolve into two-dimensional
surface pattern.[48]

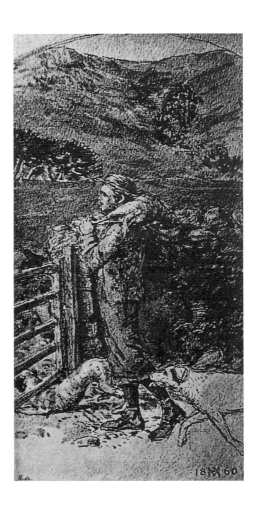

10
A GATE
1860
Pencil and sepia
Whereabouts unknown
(from Baldry, *Albert Moore*,
opp. p. 12)

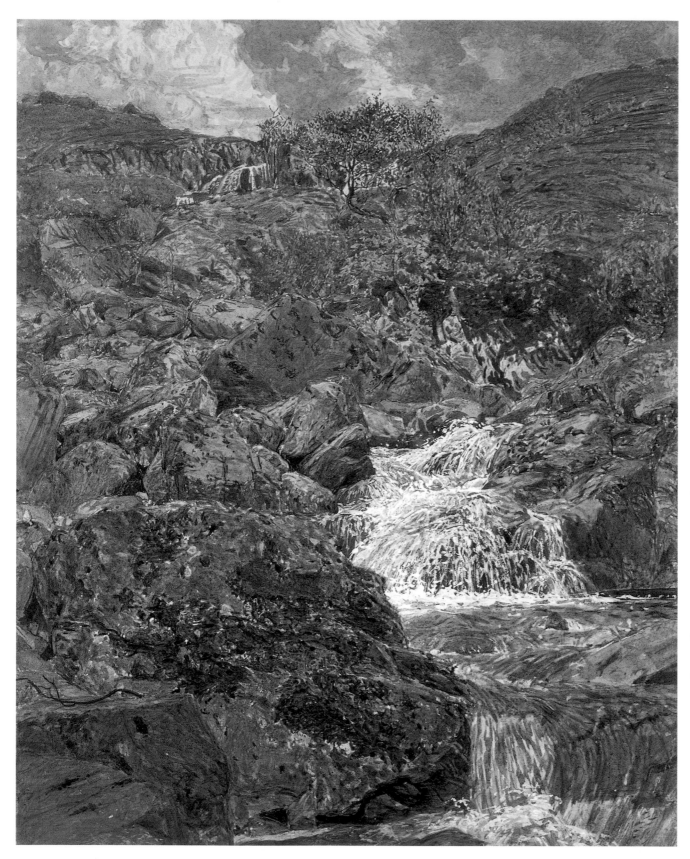

11
WATERFALL IN THE LAKE
DISTRICT
*c.*1857-8
Watercolour and gouache
over pencil
30.8 x 24.3 cm
(12⅜ x 9⅝ in)
Ashmolean Museum,
Oxford

12
STUDY OF AN ASH TRUNK
1857
Watercolour and gouache with
gum arabic
30.4 x 22.8 cm
(12 x 9 in)
Ashmolean Museum,
Oxford

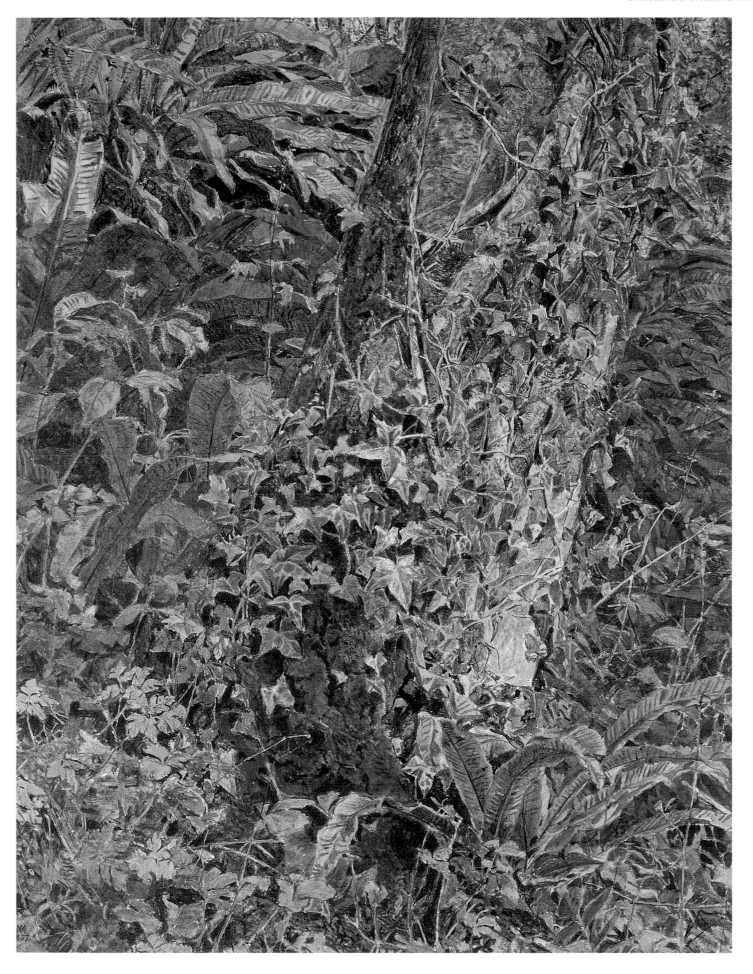

These studies are early instances of the sensitivity to two-dimensional design that enabled Moore throughout his career to translate natural objects into flat patterns of line and colour. At no stage did he ever demonstrate concern or facility for spatial illusionism. The persistence of this tendency throughout his artistic life raises the possibility that impaired depth perception played a role in his affinity for two-dimensional surface patterning. An unspecified sight defect hampered the career of his elder brother William,[49] but Albert may have turned a similar condition to his advantage, as an aid to that conscious compression of space that gave his paintings their idiosyncratic appearance.

Having uprooted to Kensington in order to facilitate Albert's academic education, his mother and elder brothers continued to plot their movements with a view to fostering the abilities of the family's youngest member. Around the time of his Lake District sketching tour, he had applied for admission to the Royal Academy Schools, submitting, as required, a large chalk drawing of an undraped antique statue. His acceptance as a probationer in the painting school on 9 January 1858 prompted the family's move to 8 Berners Street, Fitzroy Square, a location more convenient to the Academy's premises in Trafalgar Square. His brothers Henry and John were returning to the neighbourhood in which they had lived prior to joining their mother and brother at Lower Phillimore Place.[50] London's answer to the Quartier Latin of Paris, the streets neighbouring Fitzroy Square had been a haven for artists and craftsmen since the eighteenth century. By the mid-nineteenth century, many of the flats contained purpose-built artists' studios with oversized windows providing constant northern light.[51] The additional advantages of affordable rents and proximity to the British Museum ensured that the area remained popular with artists, especially those in the early stages of their careers whose pleasure in the bohemian sociability of the neighbourhood enabled them to overlook the shabbiness of once elegant interiors.

Moore's enrolment at the Royal Academy Schools proved more valuable for its social and professional contacts than for any instruction received. Two students accepted along with him as probationers would become good friends and influential artists in their own rights. William Blake Richmond (1842-1921) had an even more daunting artistic heritage to contend with than Moore did. His father, the portrait painter and watercolourist George Richmond, RA (1809-96), had named his son after his mentor, the visionary poet and artist William Blake. The elder Richmond's circle included most of the prominent artists and critics of his day, including John Ruskin and the leaders of the Pre-Raphaelite Brotherhood.[52] The younger Richmond's memoirs contain an evocative pen portrait of Albert Moore as a 'reticent but attractive lad of sixteen':

> There sat near me during the days of my probationership a striking-looking boy, some twelve months older than I. He had strange luminous blue eyes and a shock of clustering curly hair, he was short, thick-set, and slightly bandy-legged. He spoke to no one, was evidently taciturn or shy, but extremely industrious, and drew curiously, in a style unlike

that of any of us, very sensitive and searching, but more delicate than strong. When he did speak, his accent at once betrayed his county.[53]

Moore's other friend at the Academy Schools was Frederick Walker (1840-75). Like Moore, Walker was the talented but reserved younger son of an extensive family, living with his widowed mother while searching desultorily for a career. Having cast aside an architectural traineeship in order to attend the Academy, Walker would soon abandon the Academy for an apprenticeship in wood engraving, but it was the sculpturesque figure style that he later developed in painting that secured his fame and demonstrated his affinity with Moore (Pl. 13).[54]

Moore was recommended for admission to the Royal Academy Schools by Richard Burchett (1815-75), Head Master of the Central Training School for Art at South Kensington. Known for his expertise in the scientific principles of drawing, Burchett had published a number of books based on lectures and exercises that he had devised as part of the official course of instruction.[55] He placed great emphasis on geometry as the basis of drawing and design. Indeed, like his colleagues Henry Cole and Richard Redgrave, Burchett sought 'to reduce art to a systematized body of knowledge governed by strict rules'.[56] Responsible for introducing elementary drawing instruction to the nation's schools, Burchett may have come across Albert Moore at the Kensington Grammar School. Alternatively, Moore may have pursued training at South Kensington for a time. In any case, once the meeting was effected, Burchett would have found much to commend in Moore's gift for mathematics and his knowledge of perspective and geometry.

According to the Academy's rules, Moore and his fellow probationers had three months in which to prepare a set of drawings, to be accompanied by 'Outline Drawings of an Anatomical figure and Skeleton, not less than two feet high, with references, on each Drawing, to the several muscles, tendons, and bones contained therein'. His specimens approved, Moore was admitted a student on 31 March 1858. The ivory ticket bearing his name conferred the privilege of attending classes and lectures at the Academy for the next seven years.[57] However, he soon grew dissatisfied with the system, and bore with it only briefly. Though considered the first essential step on the path to artistic success, the Academy Schools were none the less notorious for low standards, slack administration and inept teaching. Diatribes against the inadequacies of the Schools had long been, and would long continue to be, the subject of heated debates in the journals and in official testimony before government committees.[58]

Preceded at the Royal Academy by three of his elder brothers, Moore had advance warning of the poor instruction there, and it is somewhat surprising that he felt obliged to pass through the Academy's hoops at all. Perhaps he merely used the Schools to gain access to plaster casts and other specimens, as his father had done at the York School of Design. More likely still, the Academy was pressed upon him by his mother and elder brothers, who were evidently concerned by the

'habits of procrastination and indolence' that they perceived following his departure from the Kensington Grammar School. Family worries over Frederick Walker's listless drifting had likewise resulted in his enrolment at the Academy.[59] Affiliation with the Schools provided the boys' elders with some assurance that they were following a regulated course of instruction. From Moore's own point of view, however, the experience can only have intensified the painful sense of subjection to authority figures that plagued his personal life. His brothers' biographers allude to the paternalistic stance they adopted towards Albert, and this proliferation of father figures—though well-intended—proved highly irritating to him.[60]

Just prior to his tour of the Lake District, Albert's favourite brother Henry had confronted him with the family's concerns about his idleness. Although Albert initially judged this 'altogether kind and just', he was less pleased some months later when Henry rehearsed the same admonitions in a sternly worded letter. His reply expressed obvious irritation in the most deferential terms. 'I respect you more than any of my relations', he wrote, 'and I shall therefore be very sorry if you take anything that I am going to say for impertinence. I confess I was a little hurt by your opening sentence tho' I do not doubt for a moment that your motives are kind.' Chafing under the close scrutiny of his dozen elder brothers, Moore's respectful assurances do little to soften his tone of self-righteous resentment:

> I begin to think with some dismay, that my few idle months between school time and real work will always be had in remembrance tho' I was absurd enough to expect that they would be passed over, on account of its being not at all unusual for people, at that period of their lives, to sin in a similar manner ... I hope you will not conclude from my thus defending myself that I am unconscious of or ungrateful for your great kindness and generosity—I only think you are a little hard upon me.[61]

Moore's sense of injustice is clear, and in light of the extreme diligence for which he was later known, the family's concern seems unwarranted.

But it was not only Albert's work habits that fell under the scrutiny of the elder Moore brothers, who also reproached his negligent grooming and spending habits. He was financially dependent on John and Henry, and his surviving letters to them are punctuated with accounts of his expenditures on clothing and other personal items. The following report to John attests to the minute details of his private life that he was compelled to divulge to his brothers:

> I have got a pair of trousers & a waistcoat from Miles's, the former are black with a little red—price 16s and the waistcoat 12s 6d. I have also got and paid for the collars; they were—I am sorry to say—9s. Since I have been in London I have expended about £1.7.7. I [am] glad you told me of Lindsay's [a shop] I like it better than any other place I have been to.[62]

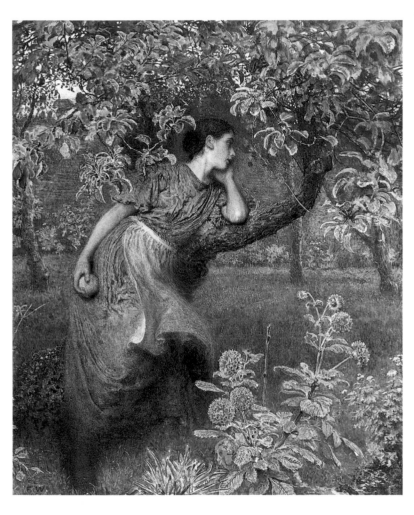

13
Frederick Walker
AUTUMN
1865
Watercolour and gouache
62.2 x 50.1 cm
(24½ x 19¾ in)
Victoria and Albert
Museum, London

Albert's polite and matter-of-fact letters to John are occasionally relieved by flashes of humour or witty drawings, such as the pair of pugilists fighting over the 'CHAMPIONS BELT' hanging on the wall, which Moore inscribed 'Price £100' (Pl. 14). But it was to Henry that he revealed the exasperation that accompanied his humiliating sense of dependence and lack of privacy. In the same letter in which he replied to Henry's 'letter of advice', Albert replied sardonically to the family's complaints against his luxurious 'mop' of hair:

I never had my hair cut decently except at a place in Kensington, where I have always gone for the last three years. I was rather shy of the York barbers. I had a secret dread that if I came under their scissors the M's. [Moores] might suspect that I had visited a famous town south west of the city of York in my way to Walsham. I don't expect by

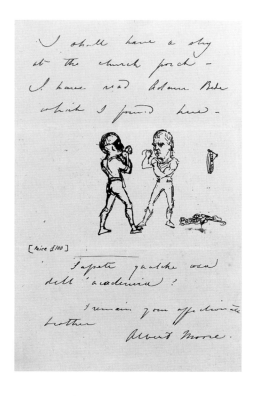

this excuse which I know is very weak—to justify myself, but I say this, that it was not from indolence. The 'mop' too was not nearly so well grown as you seem to imagine and was far from being as extensive as the one I had the pleasure of owning last Xmas.

He went on to account for the shabbiness of his clothing, which had caused consternation on his last visit home.[63] In closing, Albert assured his brother that he had indeed visited his favourite barber in Kensington the previous Thursday, and had begun drawing a figure at the Royal Academy the following evening. In other words, he was well on his way to respectability.

The next step in that course was to advance from the Antique to the Life School at the Academy, where at last he would gain access to the

living model. But before making this transition, Academy regulations required attendance at a perspective course and two series of lectures, as well as the completion of numerous drawings, including 'at least six accurately finished Drawings of Groups or figures from the Antique' and 'Drawings as large as nature of a Hand and Foot'.[64] Moore evidently made some effort to comply with these rules. During the winter of 1858 he informed his brother John, 'I am getting on tolerably well with my drawings at the R.A.' Several of these, approved and signed by Charles Landseer, Keeper of the Schools, survived in his brother Henry's collection after Moore's death.[65] However, he evidently lost patience early on, and later claimed that he remained a student of the Academy only a few months, 'convinced that he could make more definite progress away from its cramping restrictions'.[66] Similar convictions led Frederick Walker to abandon the Academy Schools with equal speed, but their friend William Richmond persevered for a few years more.[67]

Brought up to believe in the importance of study from the living model, Moore was understandably eager to advance to that stage, but his options were limited. 'I cannot send in for the "life" until March', he complained to his brother John during the winter of 1858. 'There is no life class at Leigh's or Cary's in the morning. I should like to go to Ruskins School s'il peut être accompli.'[68] All of the private art schools to which Moore referred—Leigh's, Cary's, and Ruskin's—were located within a short walk of his family's flat in Berners Street, but only Leigh's provided the immediate access to the life model that Moore desired.[69] James Mathews Leigh (1808-60) bore the unique distinction of having been William Etty's only pupil, and he had reinforced his early indoctrination in life drawing through residence in Paris, where he had been impressed by the French atelier system.[70] The General Practical School of Art that he operated in Newman Street admitted students on a casual basis and at a reasonable fee, and served as a congenial base for many of the young artists in Moore's circle. They enjoyed considerable autonomy in pursuing independent directions, reined in only occasionally by the stinging but insightful criticisms delivered by the perambulating principal, who would dash corrections across students' canvases and lecture them on the compositional elements of 'surface', 'regions' and 'masses'.[71]

Apart from advocating cleanliness—urging that palettes be kept as immaculate as the breakfast table—Leigh apparently left the students to teach themselves the technical aspects of painting.[72] The human figure was the focus of the school, and students had the opportunity to study casts of ancient sculpture, living models and even cadavers dissected by Leigh himself (Pl. 15).[73] At Leigh's, Moore would have learned the traditional academic method of figure composition, which required meticulous study of individual parts of the human figure, prior to re-consolidation of these fragments into a perfected whole. Moore adapted this technique to his own requirements in the painstaking preparatory method that he followed throughout his career.

Leigh's emphasis on scrupulous design and cleanliness reinforced Moore's own predilections, and did nothing to engender more

14
SKETCH OF PUGILISTS
Detail from a MS. letter to
John Collingham Moore
c.1860
Pen and ink
Pierpont Morgan Library,
New York

15
Photograph of the Antique
School of Heatherley's
(formerly Leigh's) School
of Art, by Clarke and Hyde
c.1900

spontaneous expression. However, to offset the deadening effect of extensive preparatory study prior to final execution, Leigh instituted a sketching club that allowed students the pleasure of making spontaneous drawings of a set subject over a two-hour period. Another sketching society was initiated in the late 1850s by a triumvirate of dissatisfied Royal Academy students who had taken refuge at Leigh's: Simeon Solomon (1841-1905), Henry Holiday (1839-1927) and Marcus Stone (1840-1921). Moore (and possibly Richmond and Walker) later completed this group and became firm friends of the other members.[74] The society held weekly meetings at each member's home on a rotating basis, with the host responsible for setting the theme and collecting the sketches at the end of the two-hour session. Few of the resulting sketches have survived, but Baldry speculated that Moore's sepia drawing, *A Rest*, was executed during a meeting held in 1860 (Pl. 16).[75] The theme was one to which Moore would return often, but his masculine, modern-day interpretation of 'rest' in 1860 was swiftly superseded by the feminine, otherworldly embodiments of repose that preoccupied him in years to come.

With Richmond, Moore gained admission as a student of the Print Room of the British Museum on 1 November 1859.[76] The Print Room had become a crucial resource for progressive artists, architects and designers seeking authentic examples of medieval style and subject-matter. Members of the Pre-Raphaelite Brotherhood developed their idiosyncratic drawings and paintings in direct response to the woodcuts and illuminated manuscripts they studied there. Gothic Revivalists relied on the same materials as models for stained glass, sculpture and other ecclesiastical decorations. Moore probably made similar use of the Print Room's historic materials in connection with the Tennyson illustrations and Old Testament subjects that he was then pursuing. It was also probably at this time that he executed a pen-and-ink drawing after Albrecht Dürer, an important model for Pre-Raphaelite style.[77]

It is surprising that neither Moore nor Richmond applied for permission to copy the ancient sculptures and plaster casts at the British Museum, as their Royal Academy schoolmate Frederick Walker had done in 1855.[78] Home to the Parthenon sculptures and many other important works of art, the Museum served as an unofficial drawing school, frequented by young students eager to hone their manual skills. Moore's paintings of the next few years demonstrate a steadily maturing appreciation of sculptural form and a particular familiarity with the Parthenon sculptures. He may have learned their secrets through intense visual analysis during the Museum's public hours, and he certainly worked at home with the cast collection his brothers had assembled.[79]

Moore studied paintings at the National Gallery in the same manner. In a letter of April 1860 he informed his brother John that the Gallery had just hung 'a Titian equal to any I ever saw—a portrait of Ariosto. It is perfectly delightful and does one good to see'.[80] Moore's admiration for this suave, early work by Titian—evidently one of a number with which he was familiar—attests to the catholicity of his taste during the period in which his own personal style was evolving

16
A REST
1860
Pencil and sepia
Whereabouts unknown
(from Baldry, *Albert Moore*,
opp. p. 12)

(Pl. 17). During these impressionable years, Baldry claimed, in addition to making his own studies from nature and the human form, Moore 'added serious consideration of the various ways in which they have been represented by artists of different times and countries'.[81] Moore's statements in subsequent years reflect a broadly based knowledge of art history, encompassing Tintoretto, Turner and contemporary French painting. He was also well versed in the writings of John Ruskin, the most influential British art critic of the late-nineteenth century.[82]

Significantly, Moore's interest in Titian coincides with his first experiments in oil painting, which he initiated around 1859. Eighteen was a rather advanced age for a first foray in the medium, especially in view of his many prior years of art practice, which included more esoteric media, such as photography and etching.[83] Baldry mentions two unexhibited and now unlocated genre subjects in oil, *Home Pets* and *A Garden Scene*, both dated 1859.[84] In the same year, Moore exhibited an oil study of the head of a Nubian woman at the Royal Academy, and a letter of 1860 alludes to a number of other oil portraits that he was executing, including one of a baby in Pinner. The same letter further notes that a couple of his oil heads had been admired, 'tho' one or two have objected that they are too thinly painted'.[85] This criticism, together with the artist's belated introduction to the oil medium, suggests that the lack of sensuous appeal in his mature handling of oil resulted from natural inclination rather than conscious adherence to aesthetic principle. Indifferent to the potential richness of the medium, Moore employed it merely as a vehicle for the expression of design.

Shared antagonism towards mainstream art teaching fuelled the excitement Moore and his friends felt for the Pre-Raphaelite Brotherhood. 'We liked the anarchy of it', William Blake Richmond later recalled, 'we liked the old dodderers to be vexed; and what a contempt we had for the sleepy old conventional school, so British in its narrow ways, so respectable in its entire absence of virile enthusiasm!'[86] As a visible token of youthful rebellion, the vivid and detailed style associated with Pre-Raphaelitism held tremendous glamour for the generation of artists who followed in its wake. Richmond later remembered, 'At this time Moore was not Classical at all, he was disposed to be Romantic, perhaps, and Epic. The Pre-Raphaelite mantle was upon his shoulders; his designs and some small landscapes in water-colour were highly idealistic'.[87]

The paucity of surviving examples makes it impossible to assess the full impact of Pre-Raphaelitism on Albert Moore's early work. However, he evidently made a trip to East Denham during the spring of 1860 with the intention of working in the Pre-Raphaelite mode. He reported to his brother John:

> I have done nothing out of doors yet—it's too cold. I have
> painted a few flowers & a girl's head partly—I have got a
> jewel of a model—tolerable face—firstrate colour & neat
> hands & feet & figure and sits well. I am trying mixing the
> colours and putting them on the full strength at once, as I

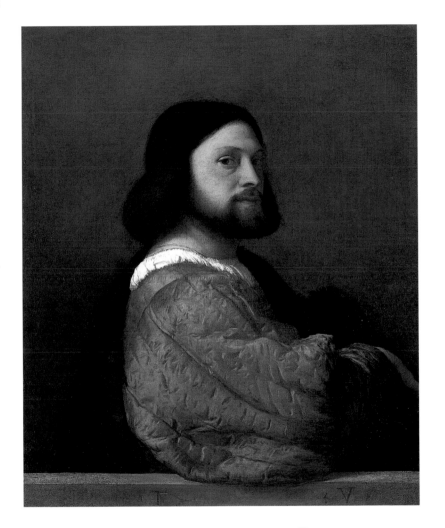

17
Titian
PORTRAIT OF A MAN
*c.*1512
Oil on canvas
81.2 x 66.3 cm
(36 x 32 in)
National Gallery, London

had to do with the oil, and working them into consistency, where necessary, afterwards.[88]

At the spring exhibition held by the Society of British Artists that year, Moore showed two watercolours: a genre subject, *Girl Gathering Nuts*, and a landscape study made at Dockray, entitled *Down in the Ghyll*.[89] Neither drawing has been located or reproduced, but the *Athenaeum* reported 'some spirited rendering of foliage' in Moore's landscape, and noted that his picture of 'a girl plucking hazels, is strangely clever, and yet perverse in the faintness of colour and weakness of tone that are united with thoughtful drawing, truth of character and intensely careful execution'.[90] This notice implies that while emulating the Pre-Raphaelites' predilection for detail, Moore did not necessarily adopt their customary vivid colours. Already in 1860, he was experimenting with the pale, tertiary hues that became hallmarks of Aestheticism later in the decade.

Henry Moore continued to work in a Pre-Raphaelite vein during the late 1850s and early 1860s and he no doubt reinforced the same tendencies in Albert's art. He and his friend the genre painter and watercolourist Frederick Smallfield (1829-1915) invited Albert along on sketching trips, and in April 1860 urged him to return to his abandoned set of drawings after Tennyson. Albert had probably commenced these drawings in emulation of the edition of the poet's works published by Edward Moxon in 1857 with numerous illustrations by Millais and his Pre-Raphaelite brethren, Dante Gabriel Rossetti (1828-82) and William Holman Hunt (1827-1910).[91] In 1862 Moore experimented with the Pre-Raphaelite method of painting in transparent colour on a wet white ground in *A Song of Praise* (unlocated), a small study of a woman singing.[92]

The Pre-Raphaelites had petered out as a coherent group by the time Moore arrived in London, but the individual artists who had formed the original core—Millais, Rossetti and Hunt—continued to attract attention. Vigorously anti-establishment in their solitary pursuit of personal visions, Hunt and Rossetti would seem the most appropriate role models for Moore, but it was in fact the dashing (if increasingly conventional) Millais who fascinated the younger generation.[93] The appearance of Millais's *The Black Brunswicker* (Pl. 18) at the Royal Academy exhibition of 1860 was the subject of an enthusiastic letter from Albert to his brother John:

> I went to see Millais' picture the day of sending in, and was much pleased. The subject is happily chosen, —A Black Brunswicker departing for Waterloo, and a young lady trying to hold the door against him. The heads are very good in expression and well painted, especially the man's: the whole picture is very carefully & some parts wonderfully painted— the white satin dress par exemple. I heard Millais say that Landseer's picture was one of his finest. The exhibition is expected to be very good.[94]

There is marked irony in Moore's youthful enthusiasm for the very sort of sentimental narrative art that he ultimately sought to

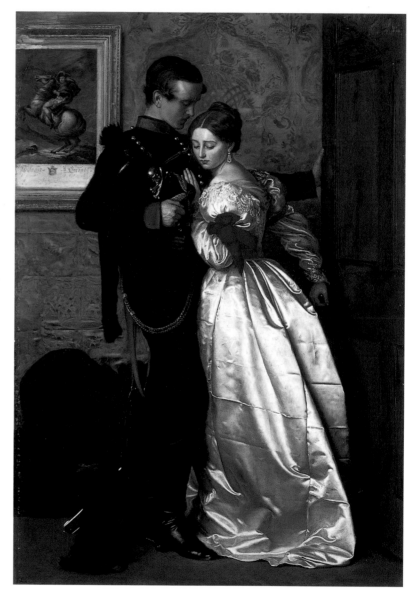

18
John Everett Millais
THE BLACK BRUNSWICKER
1859-60
Oil on canvas
98.9 x 66 cm
(39 x 26 in)
Lady Lever Art Gallery,
Port Sunlight

undermine. Having failed to attract buyers with more abstract 'mood-pictures', Millais had deliberately returned to the mawkish theme of ill-fated love that had secured earlier triumphs.[95] In a setting which recalls the fetishistic materialism of a seventeenth-century Dutch painting, he depicted the emotional crisis of young lovers at crossed purposes: a soldier dutifully returning to the perils of war while his sweetheart protests in vain. Moore faithfully reproduced this composition in his letter to John (Pl. 19). His admiration for Millais's polished white satin and expressive heads is consistent with his regard for the highly finished painting by Titian, and just as surprising—a striking contrast to his subsequent rejection of illusionism in painting. Indeed, Moore's high regard for *The Black Brunswicker* in 1860 provides a useful benchmark for charting his rapid aesthetic maturation over the next decade.

During the five years that they lived under the same roof, the three Moore brothers functioned as a symbiotic unit. While Henry and John were away on sketching trips, Albert served as their London agent, forwarding messages, accommodating patrons, delivering paintings and seeing to financial matters. In turn, his elder brothers provided him with professional advice and useful contacts. Although invariably described as possessing dour dispositions, the Moores inspired great loyalty and affection, and through his brothers' friends and his own acquaintances, Albert found himself part of an extensive social circle during the late 1850s and early 1860s. Casual asides in his letters bear testimony to a daily routine punctuated with social calls. In a letter of 1858 he reported to John:

19
SKETCH AFTER MILLAIS'S 'BLACK BRUNSWICKER'
Detail from a MS. letter to John Collingham Moore
1860
Pen and ink
Private collection

> I dined with the Andrew's [sic] last Sunday & found them all well. Yesterday Thornton & Flossie came to tea & drew a little from some casts. In the evening I went to Mr. E. Richardson's —out—& to J's—whom I found just arrived from Scotland, having travelled all night. He said that this had been the worst season for sketching that he had experienced 'in the whole course of his life'. He talked to me very enthusiastically about Scotland & thereby placed it in amicis meis futuris D.V. [among my future friends, God willing].[96]

As this passage indicates, the family's social networks were based in the art world, and through them Moore was introduced to a range of aesthetic theories and styles.

As in many other Victorian households, social gatherings hosted by the Moore family featured music as the principal entertainment. William Richmond, who considered Albert Moore among his closest friends during this period and who also became an intimate of John and Henry, recalled in his memoirs the wholesome and congenial ambience of their home, proof of Sarah Moore's effectiveness in keeping bohemian dissipation at bay:

> Many were the pleasant evenings we spent together in his brothers' rooms in 8, Berners Street, where much Handel and Bach went on, at which I assisted. The three brothers

all sang and played, and these gatherings, homely and snug, were presided over by the old widowed mother, Mrs. Moore, a quiet North country old lady, proud of her three distinguished sons, John, Henry, and Albert.[97]

John was a particularly accomplished musician and played three instruments. His wife, according to Richmond, 'plays better than any amateur I ever heard, Bach, Beethoven, Schumann, etc.' Henry had considered a career as a violinist before turning to art, and lent his powerful baritone voice to Henry Leslie's choir and the Moray Minstrels.[98] Albert, in addition to singing and playing at home with his brothers, very likely attended the large musical soirées held at the home of his friend Simeon Solomon during the early 1860s.[99] Shared enthusiasm for music proved an important social bond among these artists, and fostered their interest in the analogies of musical and painterly expression.

Moore's friends Solomon, Richmond, Henry Holiday and Marcus Stone were among the first to join the Artists' Rifles Corps, formed in 1859 as part of the Volunteer Movement.[100] Moore signed on, too, although submission to authority and to corporate structure cannot have come easily. His military experience was evidently brief, probably for physical as well as temperamental reasons. His health often failed and his frame was rather slight; a friend later recalled his 'odd awkward little body that seemed to have no connection with [his head]'.[101] The Artists' Rifles proved to be a dress rehearsal for the English art establishment of the last quarter of the nineteenth century, with the country's most prominent artists ranged beneath the command of Frederic Leighton (1830-96), future President of the Royal Academy. Moore's marginal relationship to the corps, a participant in name only, proved equally prophetic. Through sheer neglect, he remained on the lists until 1871, when the painter Val Prinsep removed his name, 'as you are not likely ever to come to drill'.[102]

Nevertheless, through the Artists' Rifles or some other connection, Moore was steadily acquiring influential friends. Foremost among them was Frederic Leighton himself. Ever assiduous in promoting deserving young artists, he became a conspicious supporter of Moore in the late 1860s. For the next 25 years, their art developed along similar lines, often demonstrating an uncanny affinity. However, the intense admiration that Leighton felt for Moore's work did not extend to his personality, which he clearly recognized as a professional liability.[103] Blunt in speech and negligent in dress and manner, Moore was temperamentally antithetical to the impeccably suave and diplomatic Leighton. Moreover, his fierce independence precluded the kind of close, paternal relationship that Leighton developed with other young protégés. As the following chapters will show, Leighton remained Moore's loyal champion to the end of his life. But he expressed no sense of personal loss when his colleague died, stating only, 'Poor Albert Moore's death deprives us of a most interesting and gifted artist'.[104]

In addition to an extensive network of artists, Moore established numerous contacts in architectural circles. Around 1858 he developed a particularly close friendship with William Eden Nesfield (1835-88), an older, Eton-educated architect who had studied drawing under his father's friend, James Duffield Harding, Ruskin's former drawing instructor.[105] Retaining his interest in fine art even after establishing his architectural practice in 1860, Nesfield made his offices a social hub for kindred spirits from a range of disciplines. His assistant John McKean Brydon later recalled the interdisciplinary and collaborative spirit of Nesfield's social circle:

> Here o' nights would come his artistic friends—the Painter, the Sculptor, the Poet—and with inspiriting intercourse stimulate each other to higher and nobler efforts. The warm hearted geniality of his nature was infectious; his kindly counsel, and the brilliant example of his conscientious work, both as a designer and a draughtsman, were the highest encouragement to all who came under his influence.[106]

Simeon Solomon offered a less reverent portrait in a letter of 1863 to the poet Algernon Charles Swinburne, describing Nesfield as 'one of our very best architects, a man of great knowledge, invention, and consummate amiability ... A fat, jolly, hearty fellow, genuinely good natured, very fond of smoking and, I deeply grieve to say, of women'.[107] William Richmond, also a friend of Nesfield, captured the architect's robust humour as well as his expansive girth in a pencil and chalk portrait executed in April of 1859 (Pl. 20).

Shortly after Nesfield sat to Richmond, he provided Albert Moore (who was still only 17) with his first opportunity for travel on the continent, inviting him on a sketching tour of Gothic cathedrals in northern France. Nesfield was returning to familiar ground in order to complete additional drawings for a book on medieval architecture that he had begun two years earlier. He and Moore arrived in St Malo, Normandy, on 28 May 1859 and Nesfield's last drawings are dated 9 September.[108] These drawings indicate that it was not the buildings

alone that claimed their attention, but the stylized flowers and plants, carved in stone or fashioned of metal, which provided elegant variations on the botanically based ornament that Moore had studied at the York School of Design. It is tempting to see in the young artist who appears in some of Nesfield's drawings, portfolio in hand, a reminiscence of his travelling companion, Albert Moore (Pl. 21).[109] The trip provided Moore with a valuable education in accommodating decorative schemes to architecture—and at a crucial time, when he was still fresh from his training in architectural draughtsmanship and not yet very far advanced in his artistic career.

It is uncertain how long Moore remained abroad, or how far afield he travelled.[110] His statement some years later that he had 'studied my profession all over Europe' and 'seen most of the picture galleries abroad' suggests that his travels on the continent were possibly more extensive than hitherto imagined.[111] In any case, on his return to England, Moore began a series of Old Testament subjects which clearly indicate his decision not to follow his father and brothers into the prosaic but profitable fields of portrait and landscape painting, but to aim for the prestigious if risky calling of imaginative figure painting. He was very likely nudged in that direction by Simeon Solomon, a prodigy like Moore, who shared his impatience with artistic and social conventions, as well as his frustration as the youngest of several daunting brothers, all living at home with their widowed mother.[112] Inspired by the arcane subject-matter and style of Rossetti, Solomon pursued a highly individual exploration of archaic ritual and mysticism, claiming to have illustrated the Bible by the age of sixteen.[113] He freely displayed collections of his drawings to friends and acquaintances, and Moore probably saw the same series of designs in sepia wash and pen and ink which his friend William Richmond described as 'wholly inspired by the Hebrew Bible, ... indescribably ancient-looking and strangely imbued with the semi-barbaric life it tells of in the Book of Kings and the Psalter of David'.[114]

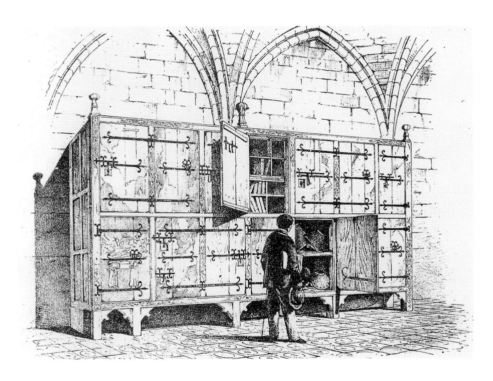

20
William Blake Richmond
PORTRAIT OF WILLIAM
EDEN NESFIELD
1859
Pencil and chalk
44.4 x 31.7 cm
(17½ x 12½ in)
National Portrait Gallery,
London

21
William Eden Nesfield
BAYEUX CATHEDRAL.
ARMOIRE IN UPPER
SANCTUARY
Engraving published as
Pl. 8 of Nesfield's *Specimens
of Medieval Architecture* (1862)

These drawings seem to have influenced Moore's illustration of a passage from I Kings 8, *Elijah Running to Jezreel before Ahab's Chariot*, exhibited at the Royal Academy in 1861 (Pl. 22).[115] In style, the drawing recalls the awkward, angular poses and hard-edged linearity that Pre-Raphaelite artists had adopted in their earliest drawings and prints. Suppressing his knowledge of the mechanics of foreshortening and perspective (the focus of his brother Edwin's teaching), Moore deliberately cultivated a style that would appear, like Solomon's, 'indescribably ancient-looking and strangely imbued with semi-barbaric life'. The research underlying such imagery is suggested by a letter that Richmond wrote to his brother on 16 October 1862:

> I have just finished reading one of the most interesting books ... 'Wilkinsons Ancient Egypt' and have I hope got some good out of it. They must indeed have been extraordinary people, full of genius and taste. The British

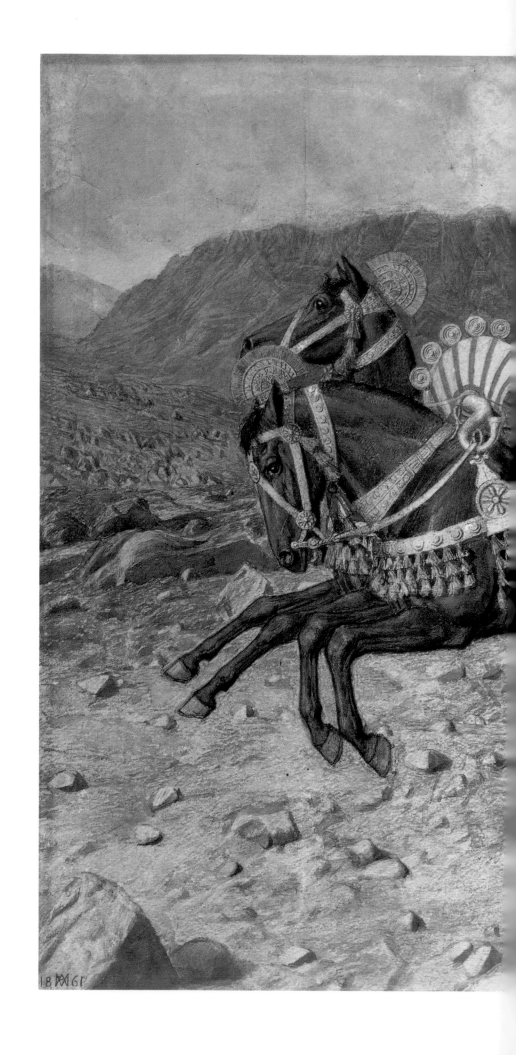

22
Elijah Running to
Jezreel before Ahab's
Chariot
1861
Sepia and pencil heightened with
scratching out
43.8 x 64.7 cm
(17¼ x 25½ in)
Private collection

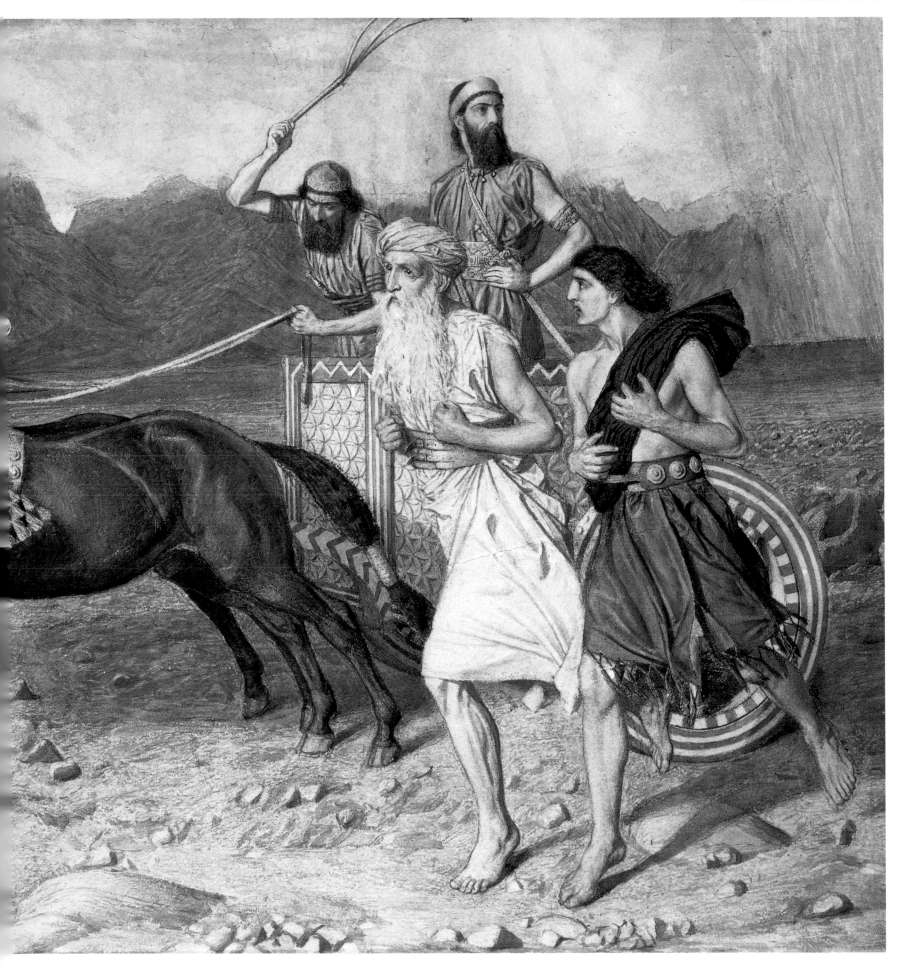

Museum has been a source of much pleasure to me, I have been making drawings from some of the Assyrian Sculptures and learning something about the costumes etc.[116]

Unearthed by Sir Austen Henry Layard at Nineveh during the late 1840s, the relief sculptures to which Richmond alludes had been installed amid considerable publicity in their own basement gallery at the British Museum in 1860.[117] Heralded as 'scriptural antiquities' offering a direct, physical link to biblical times, the reliefs were among a plethora of new archaeological materials that promised to liberate contemporary artists from the hackneyed formulas of past generations.[118]

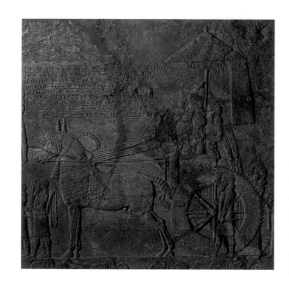

The influence of the reliefs on *Elijah Running to Jezreel* is evident in the construction and ornamentation of Ahab's chariot, the details of the horses' equipage, and the distinctive headgear and costumes of Moore's figures (Pl. 23).[119] But in addition to adapting specific objects from the Nineveh reliefs, Moore also tried to imitate the style in which they were executed. Working in low relief, Assyrian artists defined their imagery through linear outline, rather than three-dimensional modelling. Similarly, Moore emphasized the tense, angular silhouettes of his figures and the internal lines of drapery and musculature. He set his scene before a flat landscape backdrop which minimizes the illusion of recession into space. The exaggerated flatness of Moore's drawing confuses the physical relationship of the overlapping figures so that, as in many Assyrian examples, his chariot appears to be drawn not by a pair of horses, but by a twin-headed, eight-legged chimaera.[120]

The self-conscious archaism of such passages belies the naturalistic study that underlay Moore's conception. For the whipping gesture of the charioteer, Baldry recorded, 'the correct rise and fall of the man's arm, and the eager craning forward of his neck and shoulders, were secured by giving the model a cushion to flog, and by noticing the recurrence of the particular details of movement which produced the impression of strong action'.[121] Similarly, Moore's pencil study for the head of Elijah reveals the assured draughtsmanship that he deliberately masked with static, angular poses and a naïve style of execution (Pl. 24). Moore's vigorous delineation of the rugged facial features, and his sensitive rendering of the old man's poignant gaze, suggest a grasp of human physiognomy and an insight into psychology that are underappreciated in his art.[122] The same qualities distinguish his slightly earlier pencil drawing of his brother, *William Moore Jr.*, executed around 1858, which attests to Moore's ability, if not his desire, for a career in portraiture (Pl. 25).

In a second biblical subject exhibited at the Royal Academy in 1861, Moore eschewed the archaism of *Elijah* and produced a naturalistic painting of touching immediacy. This small oil, entitled *The Mother of Sisera Looked out at a Window*, illustrates a passage from the book of Judges in which a woman bewails her son's absence, unaware that he has been slain (Pl. 26).[123] Whereas *Elijah Running to Jezreel* depicted action, *The Mother of Sisera* conveys emotion: the pathos of maternal anxiety. Moore probably worked from the same model Simeon

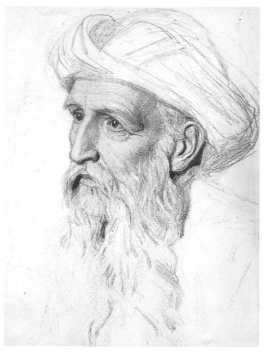

23
ASSURBANIPAL IN HIS WAR
CHARIOT
c.668–627 BC
Stone relief
Detail of sculpture from
the Palace of Assurbanipal
at Nineveh
British Museum, London

24
STUDY FOR THE HEAD OF
ELIJAH FOR 'ELIJAH
RUNNING TO JEZREEL'
c.1861
Pencil
26.6 x 20.3 cm
(10½ x 8 in)
Birmingham Museum and
Art Gallery

25
PORTRAIT OF WILLIAM
MOORE JR.
*c.*1858
Pencil
22.8 15.2 cm
(9 x 6 in)
York City Art Gallery

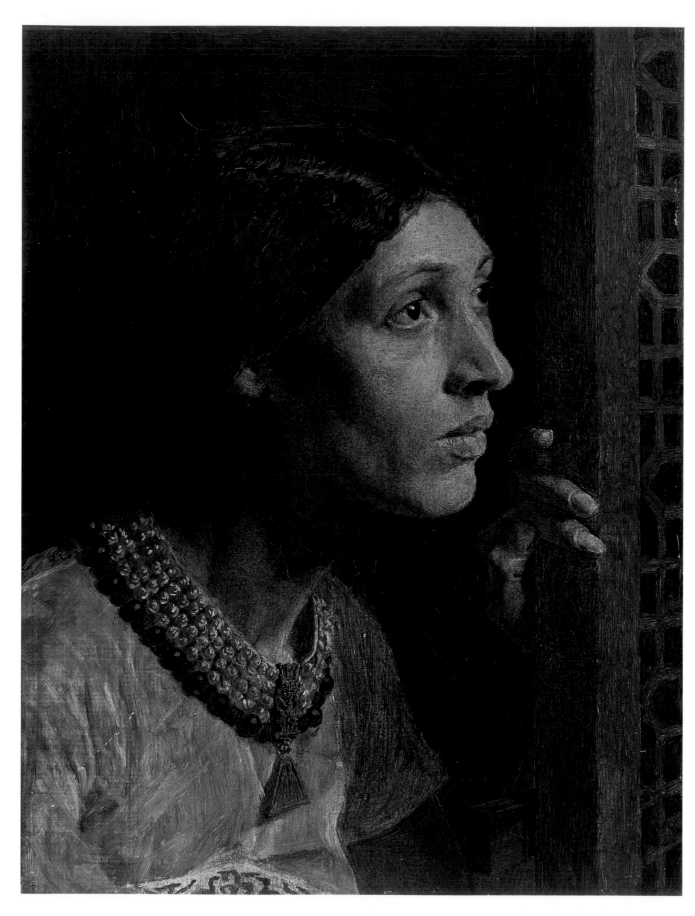

26
'THE MOTHER OF SISERA
LOOKED OUT AT A
WINDOW'
1861
Oil on canvas
30.4 x 23.5 cm
(12 x 9¼ in)
Tullie House Museum and
Art Gallery, Carlisle

Solomon employed for his painting *The Mother of Moses*, exhibited at the Royal Academy the previous year, and criticized for representing figures of 'the exaggerated Jewish type'.[124] Like Solomon, Moore worked in a low and restricted colour key and included authentic details of costume and accessory (such as the wooden lattice screen and the elaborate beaded necklace) which locate the woman in an ancient Middle Eastern context. Yet these details are entirely eclipsed by the psychological power of the portrait. The timorous faith expressed by the woman's features—her mouth slightly agape, cheek hollowed by care, eyes uplifted in uncertain hope—is universally recognizable and renders irrelevant all differences of time and place.[125] An early charcoal study indicates that Moore initially intended to represent the woman not in profile but nearly straight-on, peering over a wall separating her from the viewer (Pl. 27). By altering the viewpoint, Moore also changed our psychological relationship with the woman, enhancing the sense of intimate connection with her.

In 1862 Moore exhibited a third biblical subject at the Royal Academy, *'And Jonathan Stripped Himself of the Robe That Was upon Him, and Gave It to David'* (unlocated), based on a passage from I Samuel 18: 4.[126] The subject of David's relationship with Jonathan was popular among artists in Moore's circle,[127] but his painting was evidently not the anatomical tour de force that many of them were and that his title suggests. Baldry describes it as representing 'the white-robed David, with a brown and white sash and draped with a scarlet cloak, with Jonathan in his dark green tunic, yellow sash, and yellow and white bead necklace, against a dark brown background, and on a tessellated pavement of brown and black squares'.[128] The colours cited indicate that Moore was still working in a subdued palette of sombre earth tones.

It is striking to note how many of Moore's early pictures deal with the male figure, a subject virtually absent from his mature work. In addition to *'Jonathan Stripped Himself of the Robe'*, the 1862 Royal Academy exhibition included *'The Thoughts of Youth are Long, Long Thoughts'* (unlocated), a painting inspired by Longfellow's poem, 'My Lost Youth' (1858). According to Baldry the painting represented 'a young man in a contemplative attitude with his hands clasped behind his head'.[129] It was probably also around this time that Moore made a sepia drawing of the Old Testament subject *The Death of Jacob* (unlocated). Moore was not unique in beginning his career with a preponderance of masculine themes which he steadily replaced with feminine imagery. A similar transition from male to female figures occurred during the 1860s in the work of Frederic Leighton, Edward Poynter and other painters who were reinterpreting classical sculpture through the filter of contemporary notions about beauty and the purpose of art.[130]

In the winter of 1862, shortly after his 21st birthday, Moore journeyed to Rome, apparently remaining in Italy with his brother John (now semi-resident in the city) until the spring of 1863. Little is known of Moore's activities during this visit, but he probably followed an itinerary similar to the one that William Richmond adopted in 1866 in consultation with John Moore. Richmond's programme included

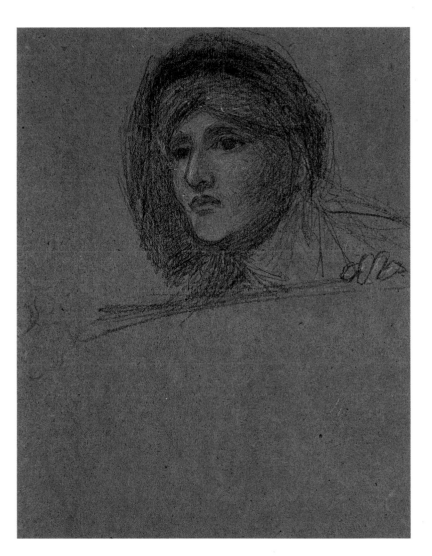

27
STUDY OF A WOMAN'S
HEAD FOR 'THE MOTHER
OF SISERA LOOKED OUT
AT A WINDOW'
*c.*1861
*Black and white chalks on
brown paper*
29 x 23.1 cm
(11⅜ x 9⅛ in)
Victoria and Albert
Museum, London

Overleaf
28
ELIJAH'S SACRIFICE
1863
Oil on canvas
99 x 175.1 cm
(39 x 69 in)
Bury City Art Gallery

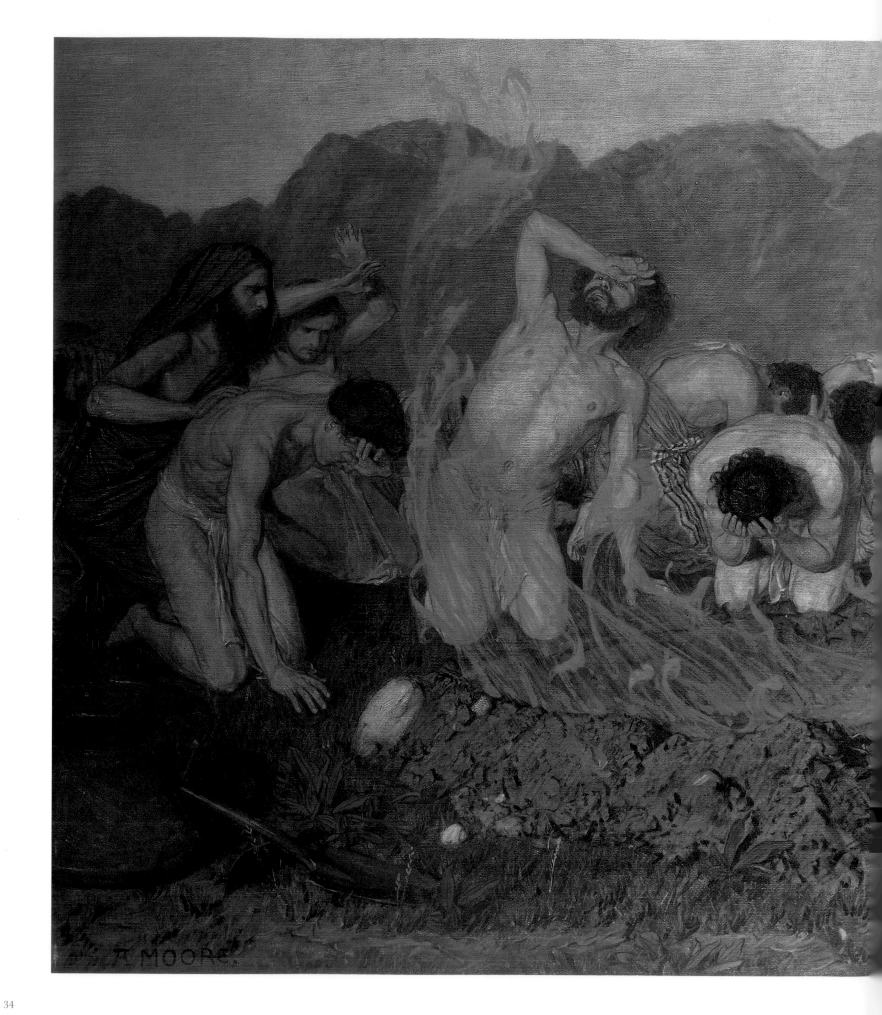

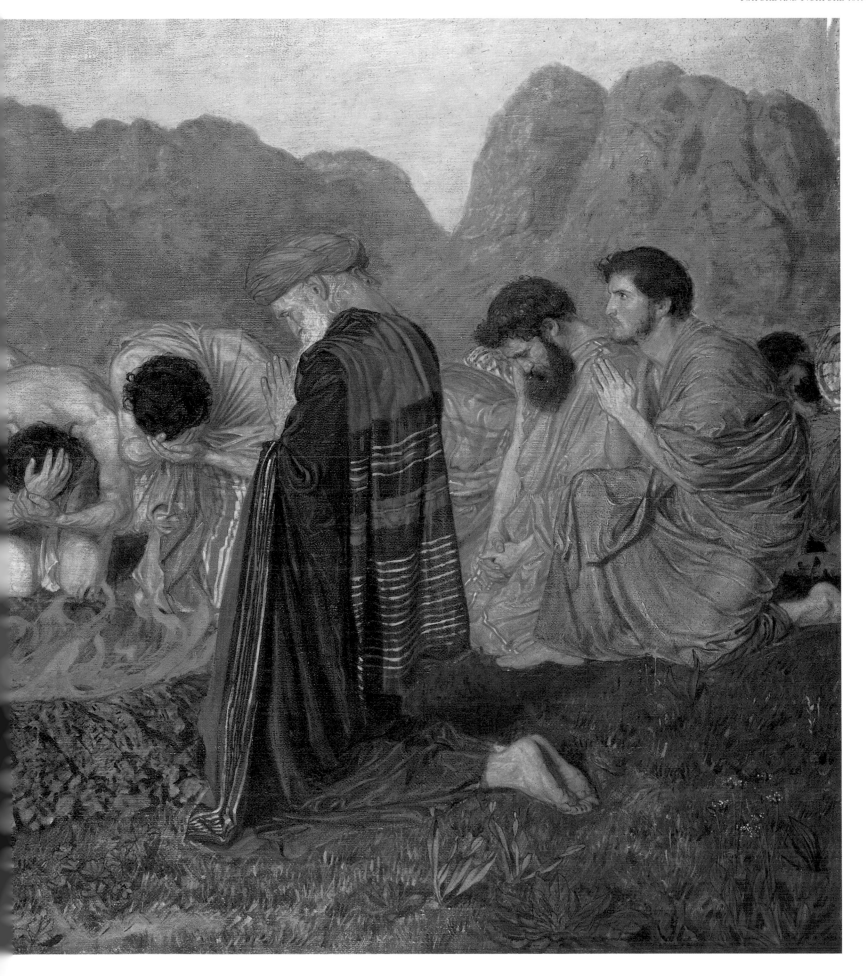

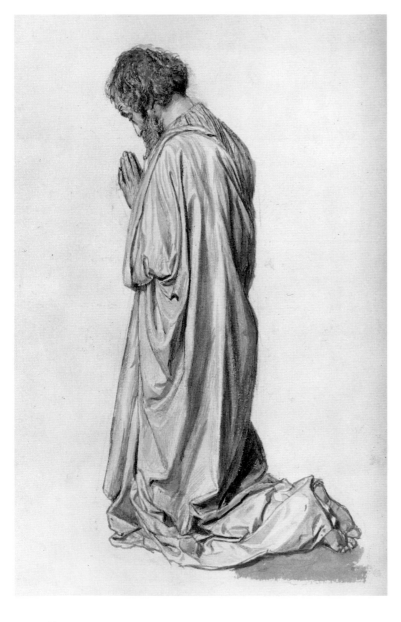

mornings at the Vatican copying classical statuary and Renaissance paintings, evenings working from the nude model at the British Academy of Arts, and afternoons sketching 'all the beautiful material I can find'. He also sketched with John Moore in the Roman Campagna, and made longer journeys to Naples and Pompeii.[131]

First-hand exposure to the city's magnificent artistic heritage invariably inflamed the ambitions of young English artists. It was in a Roman studio that Leighton painted *Cimabue's Madonna*, the monumental tableau that launched his English career in 1855, and a decade later William Richmond struggled with his enormous *Procession of Bacchus at the Time of the Vintage* in the same studio. *Elijah's Sacrifice*, the painting Moore executed at Rome, is in size and scope by far the most ambitious work that he had yet attempted (Pl. 28).[132] With over a dozen male figures, many of them nude and contorted into difficult positions, the painting advertises the skill in rendering anatomy that Moore had achieved through hard study in life classes. Long-standing deficiencies in English figure painting made such a demonstration of ability all the more impressive in one so young, and Moore undoubtedly considered the picture a strategic manoeuvre for gaining recognition at an early stage in his career. *The Wrestlers* (1863), an unlocated watercolour that Moore executed around the time of his Roman sojourn, probably also contained a preponderance of male nudes.[133]

Elijah's Sacrifice represents the passage in I Kings 18: 38-9 describing the miraculous fire called forth by the prophet on Mount Carmel: 'Then the fire of the Lord fell, and consumed the burnt sacrifice and the wood, and the stones, and the dust, and licked up the water that was in the trench. And when all the people saw it, they fell on their faces: and they said, The Lord, he is the God.' The symmetrical composition enabled Moore to communicate the narrative through counterbalanced groups of contrasting figures. The prophet Elijah, whose eyecatching red turban and robustly patterned robe differentiate him from the other figures, kneels in solemn prayer at the right side of the blaze. On the left side, a naked priest of Baal recoils violently from the leaping flames, echoing while simultaneously distorting Elijah's reverential pose. The agitated figures beside him present heathen counterparts to the contemplative believers beside Elijah at the opposite end of the canvas. The two extremes are linked by the central group of bowed figures whose poses express mingled emotions of terror and shame.

According to Baldry, Moore based the landscape backdrop of *Elijah's Sacrifice* on sketches made at 'a desolate spot between Rome and Tivoli'.[134] Despite the perils of fleas, charging buffalo, and thieving bandits, the sombre, dignified simplicity of the Campagna's topography had a profound effect on many of Moore's contemporaries, most notably his brother John, who was inspired to reject the quasi-scientific documentation of natural detail in favour of greater breadth and simplicity of form and a poetic evocation of sentiment and atmosphere.[135] Albert had undoubtedly been introduced to these ideas in London, not only through John but also through his friend George Heming Mason (1818-72), who shared John's London

studio with Albert and Henry during their brother's absence in Rome during the winter of 1859.[136] But the experience of the Campagna itself induced Albert to adopt greater breadth of scope and handling in *Elijah's Sacrifice* than he had in any of his previous paintings. Still clinging to the fastidious outlining and veining of foreground foliage in emulation of Pre-Raphaelite style, he indicated the mountains of the background in far more summary fashion. Seeking unity of colour, he imposed severe limitations on his palette of subdued earth tones. Ruddy highlights in the grey-blue mountains reflect the warm afterglow of the sky and the flames of the sacred fire, while the green drapery of Elijah and other figures repeats the colours of the foreground foliage. A dark brown ground further unifies these various tints.

Yet while adopting something of the breadth and unity that characterized paintings by his brother John and his colleagues, Moore eschewed their rigorous treatment of depth. Rather than chart a measured recession from foreground to horizon, he compressed spatial relationships within the painting, treating the figures and scenery as a series of flat, overlapping silhouettes. Though more naturalistically rendered than those in *Elijah Running to Jezreel*, the figures in *Elijah's Sacrifice* are still defined through linear rather than sculptural means, their silhouettes outlined with brown paint and emphasis placed on the internal lines of anatomy and drapery. The emphatic delineation of musculature mimics the general effect of Michelangelo's Mannerist style, although Moore's reliance on line to define form differs entirely from Michelangelo's sculptural modelling through light and shade. The contorted poses of several of Moore's figures seem to derive from prototypes in the Sistine Chapel, particularly *The Last Judgement*. Even the organization of Moore's picture, which contrasts images of righteousness on one side with damnation on the other, mimics the structure of Michelangelo's famous fresco.[137] Significantly, the Sistine Chapel provided one of the revelations of William Richmond's 1866 Roman sojourn, convincing him that Michelangelo was 'so much more like the antique than I ever thought, so much more simple'.[138]

Moore's idealized treatment of the male nude also owed something to his study of classical sculpture in Rome and its environs. The collections of the Vatican, Capitoline and Conservatori Museums abounded with iconic statues and reliefs, as did the National Museum of Naples further south. These sculptures were studied in conjunction with living Italian models, whose excellent physiques and ease with nudity were much valued by English artists. Moore could have hired his pick from those congregating daily on the Spanish Steps. Figure studies for *Elijah's Sacrifice* suggest that he employed a variety of male models and freely synthesized their physiognomies in his final painting (Pls. 29, 30). Like the preparatory study for *Elijah Running to Jezreel*, these drawings reveal the sophistication of Moore's skills in draughtsmanship, as well as his sensitivity to the structural and psychological aspects of the human face.

Elijah's Sacrifice is the first of several pictures in which Moore emulated the appearance of fresco. The painting's dry execution and textured

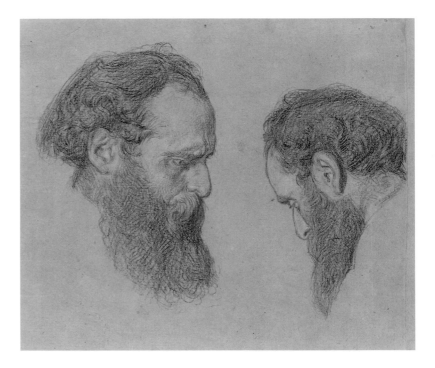

30
STUDY OF HEADS FOR
'ELIJAH'S SACRIFICE'
1863
Pencil
20.9 x 25.4 cm
(8¼ x 10 in)
Tate Gallery, London

ground (with the warp and weft of the coarsely woven canvas conspicuous beneath the thin skin of paint) deliberately recall the matte finish and rough surface of fresco. Carried out directly on a wet plaster wall, fresco requires tremendous speed and certainty of execution, typically resulting in greater breadth of handling and simplicity of design than characterizes conventional oil paintings. With his evident aversion to the sensuous and illusionistic properties of oil and his greater affinity with the austerity of two-dimensional linear design, Moore found much to admire in the fresco medium.[139] Moreover, having already carried out ceiling and wall decorations in connection with some of Nesfield's architectural commissions (a subject addressed in the following chapter), he had practical reasons for absorbing lessons from the celebrated ancient and Renaissance frescoes in the vicinity of Rome. Under their influence, he painted his own fresco *The Four Seasons*, which he exhibited in London on his return (Pl. 31).

That event was precipitated by the sudden death of Moore's mother on 28 January 1863. He left Italy that spring—earlier than planned, but apparently too late to complete *Elijah's Sacrifice* for the Royal Academy exhibition in May.[140] Moore's brothers had already moved to Kensington, leaving him independent of family for the first time in his life. Searching for a flat of his own in the familiar area near Berners Street, he settled on a studio at 12 Newman Street.[141] There, in February 1864, Moore held a one-man show in which he exhibited *Elijah's Sacrifice*, *The Four Seasons*, and two new paintings. The exhibition attracted the notice of Frederic George Stephens (1828-1907), an original member of the Pre-Raphaelite Brotherhood who had subsequently turned art critic. Stephens enthusiastically endorsed Moore's efforts, introducing his review in the *Athenaeum* with the remark that 'a critic's pleasantest office is to call attention to works which, from their nature, do not catch the eye of everyone'.[142]

Moore's decision to open his studio to the public probably owed as much to financial necessity as it did to his new-found sense of independence. Unrepresented in any exhibition during the previous eighteen months, he urgently needed to promote his work and attract buyers. The Royal Academy exhibition was a mere three months away, but he had reason not to rely exclusively on the chance of exhibiting there. The decisions of the Academy's selection committee had proven especially exasperating in recent years, leading critics and artists alike to complain that an overabundance of rather mediocre paintings by Academicians crowded out superior works by non-members. The scandalous number of undeserved exclusions led struggling young artists in Moore's circle to create their own exhibition opportunities.[143] In April 1864 Moore experienced first-hand the Academy's devastating capriciousness when *Elijah's Sacrifice* was rejected. Channelling his disappointment toward a positive end, he joined with his brother, Henry, and various friends (including Solomon, Millais and Edward Poynter) in organizing a new exhibition venue, the Dudley Gallery, intended to provide opportunities for public display by unaffiliated artists working in media other than oil.[144]

Moore may have made alterations to *Elijah's Sacrifice* prior to resubmitting it to the Royal Academy selection committee in the spring of 1865. The picture was accepted on that occasion, along with a more recent work, *The Marble Seat* (Pl. 73). For the first time, many of the leading journals devoted extensive commentary to Moore's pictures and linked him with a coterie of promising artists who were breaking new ground in modern British painting by treating the human figure on a monumental scale. National inadequacies in this area had long been a subject of embarrassment and concern in progressive art circles. While mainstream artists and critics continued to take pride in the homely themes and modest scale that characterized British art, less insular commentators charged that lacklustre taste, stunted aspirations and deficient skills underlay the national predilection for small, anecdotal genre paintings. The proliferation of international exhibitions only increased awareness that the prosaic little pictures of Britain made a poor showing beside the grand figural tableaux produced in France and elsewhere on the Continent. In a review for the important French journal *Gazette des Beaux Arts*, the critic Philippe Burty seized on the poverty of figure painting at the Royal Academy exhibition of 1865, asserting that deficient training in the human form had left England with an art that was merely 'skin-deep'.[145] Only a few artists seemed inclined to more serious painting, among them Moore, whose *Elijah's Sacrifice* Burty described as 'a little dry in execution, but very knowledgeable and very original'.[146]

The qualities that pleased the Frenchman bewildered many of Moore's compatriots, who were impressed by his ambitious conception but unnerved by the manner of its execution. All agreed that *Elijah's Sacrifice* represented a highly original *tour de force* and a radical departure from the conventions established by Old Master paintings of biblical scenes. Yet they found the figure of Elijah insufficiently idealized for a holy prophet, appearing 'too little above the common Arab type'. The landscape, on the other hand, struck many as artificial: 'rather an attempt in the modern French style than as a true piece of that species of gradation which the French artists have reduced to a system'. The 'dry and fresco-like manner', it was feared, 'will not catch the popular eye', despite the merits of poetic spirit and grave conception.[147]

The most hostile review appeared in the *Art Journal*, where *Elijah's Sacrifice* was described as 'a marvellous, we had almost said an outrageous, though clever picture', whose merit 'is surpassed by its eccentricity'. After praising the representation of the figures and the setting, the critic added:

> Nevertheless, there is no use disguising the fact that the picture is bizarre and all but ridiculous. This unfortunate termination to a great labour results from the contempt shown for beauty, from the deliberate choice of grotesque forms and attitudes, and from the preponderance of a bricky and obnoxious colour. We shall look forward with interest to see whether the independent power wherewith Mr. Moore is gifted will enable him to throw off a mannerism which, if persisted in, cannot but prove fatal.[148]

Even Moore's champions shared this critic's sense of the picture's 'strangeness', and echoed his tentative warning about the future direction Moore's art might take. Francis Turner Palgrave observed 'a singular impress of the supernatural about the scene, and this is precisely the central idea, and the idea which it is most difficult to secure. To have reached this shows that the author has a real gift; what remains is to realise it in art'.[149] Despite these reservations, Moore's painting occasioned stiff competition among collectors. It sold immediately for 150 guineas to John Hamilton Trist (1811-91), a wine merchant from Brighton who frequented artists' studios in London.[150]

Ironically, Moore's art had already advanced significantly beyond *Elijah's Sacrifice* by the time of the picture's belated appearance at the Royal Academy exhibition of 1865. The three paintings that Moore exhibited alongside it at his one-man show in February 1864 demonstrated a dramatic shift from the works executed prior to his Roman sojourn. *A Girl Dancing* (unlocated) represented a female figure

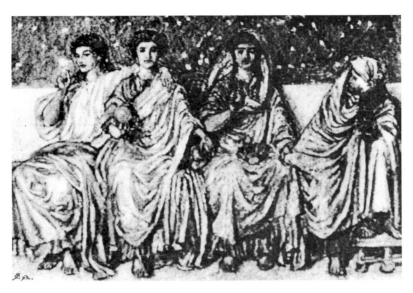

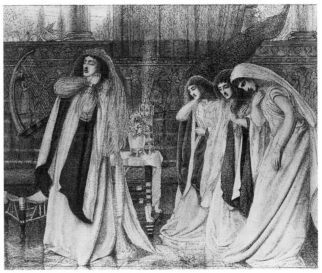

in transparent white gauze drapery and a red scarf, standing on a floor inlaid with tiles of white, red and black marble. The background of the picture consisted of green drapery and brown wooden panels ornamented with sculpted reliefs of peacocks.[151] A related picture in the 1864 exhibition, *Dancing Girl Resting*, set a similarly draped figure against a marble wall hung with a lyre and a woven mat (Pl. 33).

The prevalence of warm earth tones and decorative patterning links the two paintings with Moore's previous works *'Jonathan Stripped Himself of the Robe'* and *Elijah's Sacrifice*. However, the emphasis on masculine figures and literary content has gone. Operating independently of specific literary, historical, or even geographic associations, the pictures offered self-contained visual experiences grounded in the creation of mood, rather than the depiction of discrete actions or narratives. *A Girl Dancing* represented the vitality of a figure in motion; *Dancing Girl Resting* shows the repose following exertion, with the figure (as described by F.G. Stephens) 'panting through parted lips, with

31
THE FOUR SEASONS
1863-4
Fresco
Whereabouts unknown
(from Baldry, *Albert Moore*,
p. 29)

32
Simeon Solomon
QUEEN ESTHER HEARING
THE NEWS OF THE
INTENDED MASSACRE OF
THE JEWS UNDER
ARTAXERXES
1860
Pen and ink
28.5 x 35 cm
(11¼ x 13¼ in)
Private collection

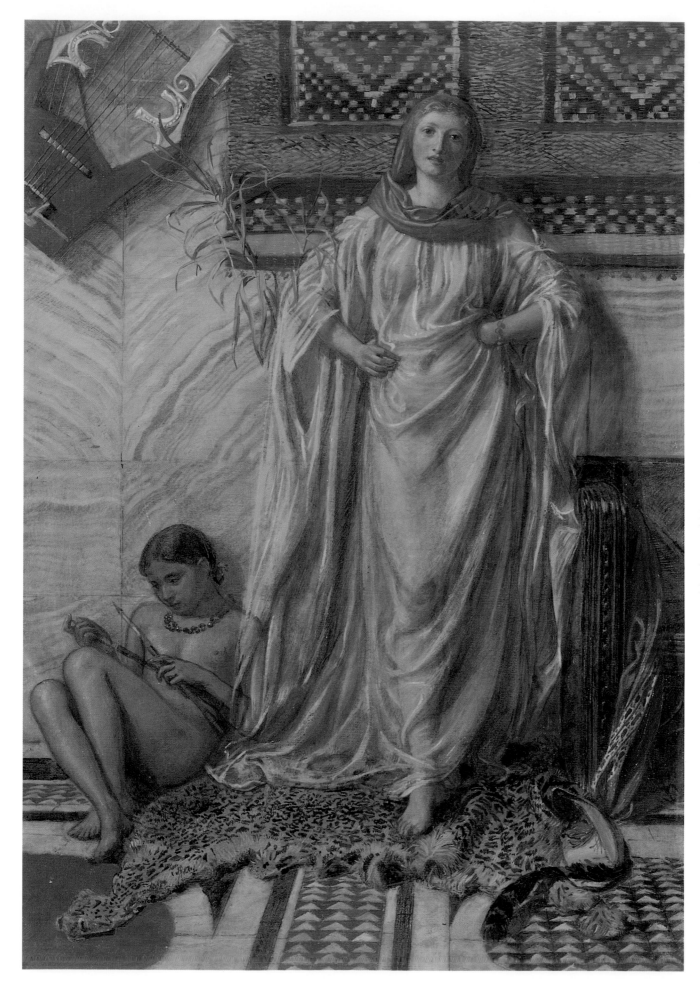

33
DANCING GIRL RESTING
1863-4
Oil on canvas
57.1 x 40.6 cm
(22½ x 16 in)
Private collection

heaving bust, her arms gracefully a-kimbo, and hands upon her hips'.[152] Although the figure is, as Stephens conscientiously specified, 'wholly-robed', the contours of her naked body are clearly revealed beneath the thin drapery whose agitated swags and streaming folds invest the dancer, though at rest, with a sense of shimmering movement. Naked but for a strand of beads, the dark-skinned girl reclining at the dancer's feet embodies a more profound state of repose. Her limp posture and abstracted gaze convey utter lassitude and, together with the panting exhaustion of the dancer herself, establish the languorous mood of passion spent that is the picture's essential subject.

The luxurious setting of striated marble, leopard skin, mosaic tiles and woven textiles embellish the picture and enhance its air of decadent exoticism. In this respect, Moore was again influenced by his friend Simeon Solomon, whose paintings and drawings of this period show a similar preoccupation with the sensuous, exotic elements of ancient music-making (Pl. 32).[153] The use of such props by Moore and Solomon reflects the growing interest in non-Western textiles and furniture that arose in the wake of the International Exhibition of 1862. Reviewing that exhibition, the architect William Burges called attention to the excellent cloth of gold, brocade-silks and carpets that could only be obtained from India, China, Turkey or Japan. 'In fact', he observed, 'the eastern nations are just as much in advance of us in artistic textile fabrics and enamels, as we are of them in railways and machinery. No one denies the latter to be very excellent things, but the fact of being proficient in them should not prevent us having beautiful things around us in our daily life'.[154] Burges's words attest to the idealization of the East as a land in which beauty had been allowed to flourish unimpeded by the ostensibly antagonistic requirements of industrialization. Like many of his contemporaries, Moore would use his paintings to envision ideal worlds in which beauty constitutes a daily necessity. In *Dancing Girl Resting*, the atmosphere of perfect repose and hedonistic sensualism combines with the element of beauty to provide a pointed contrast between the ideals of art and the realities of modern life.

The fourth picture in Moore's studio exhibition of February 1864 further developed the theme of beautifully draped female figures in placid states of repose. *The Four Seasons*, as mentioned earlier, was carried out in fresco on a small plaster slab in imitation of the mural paintings the artist had seen in Rome. The actual experience of painting rapidly on a wet plaster surface with little possibility of correction or embellishment forced Moore to adopt simpler imagery and broader handling than in his previous paintings. In his review of the picture, F.G. Stephens noted: 'Artists rarely produce frescoes in this country, and for a young one to do so with the success that has attended Mr. Moore's effort is especially deserving of record'. Brushing aside 'some evidently temporary shortcomings' attendant upon Moore's youth, Stephens asserted that 'in dealing with the exceptional process of fresco, the artist has imparted to his work the freedom no less than the gravity of high Art'.

The austere composition represents four seasonal personifications seated together on a bench before the shallow backdrop of a blue sky dotted with constellations. The stark frontal presentation of the figures, the lack of spatial recession, and the broad, dry handling were calculated to affront eyes accustomed to illusionistic paintings packed with narrative detail. Most of the picture's visual interest derives from the bold linear patterning of the drapery but, perhaps as a concession to his audience, Moore also employed a conventional symbolic vocabulary that allowed the picture to be read almost like a book. The device provided critics with a set text, and Stephens was among those who took the bait, penning a lengthy interpretation of Moore's symbolism and projecting psychological and narrative meanings onto the static figures.[155]

It is unknown how many people attended Moore's 1864 studio exhibition and saw *The Four Seasons*, but at the Royal Academy three months later it created 'a decided sensation' among progressive art critics.[156] The picture was heralded as a 'remarkable specimen-piece of a new painter' by William Michael Rossetti (1829-1919), a critic who, like Stephens, had been an original member of the Pre-Raphaelite Brotherhood. Emphasizing Moore's achievement of the true spirit and manner of ancient art, Rossetti noted:

> Its great merit was that it represented with true feeling for style the special aptitudes of fresco-painting, and that it entered into the antique quality with singular spontaneity and thoroughness. Without saying that a connoisseur could ever be deceived into supposing this to be really an antique work, we do affirm that the putting it forward as such would be less outrageous than in the case of any other modern painting we call to mind: and this amounts to high praise.

Unlike Stephens, Rossetti resisted the temptation of projecting emotion and narrative onto the painting, emphasizing instead the static, inexpressive quality of the 'stately seated women, calm in perennial authority, to which smiles and tears are equally strangers ... Silent as the zenith they sit, touching in unbroken sequence'.[157] Writing in 1870, Sidney Colvin described *The Four Seasons* as 'the work by which Mr. Moore first drew notice upon himself', recalling that it had been 'detected by the eyes of the curious amid the nether shades of the Academy Sculpture-room and revealed the presence of an artist of a class not common among us—an artist applying himself altogether to the visible, decorative, form-and-colour department'.[158]

By placing Moore's fresco so obscurely in the Academy's Sculpture Room, rather than in the more prestigious locations occupied by paintings, the Hanging Committee may have intended to ostracize a work they considered a curiosity notable for its medium alone. More charitably, they may have deemed Moore's minimalist colour scheme and frieze-like composition more advantageously placed amid monochrome sculpture than glossy, illusionistic oil paintings. In any case, the placement accurately reflects the artist's alienated position in relation to mainstream English painting as well as his greater debt to the medium of sculpture than that of oil. Indeed, the rapid advances in his easel paintings of the 1860s resulted directly from design work he was simultaneously carrying out for architectural sculpture and mural painting, a seminal aspect of Moore's early career which forms the subject of the following chapter.

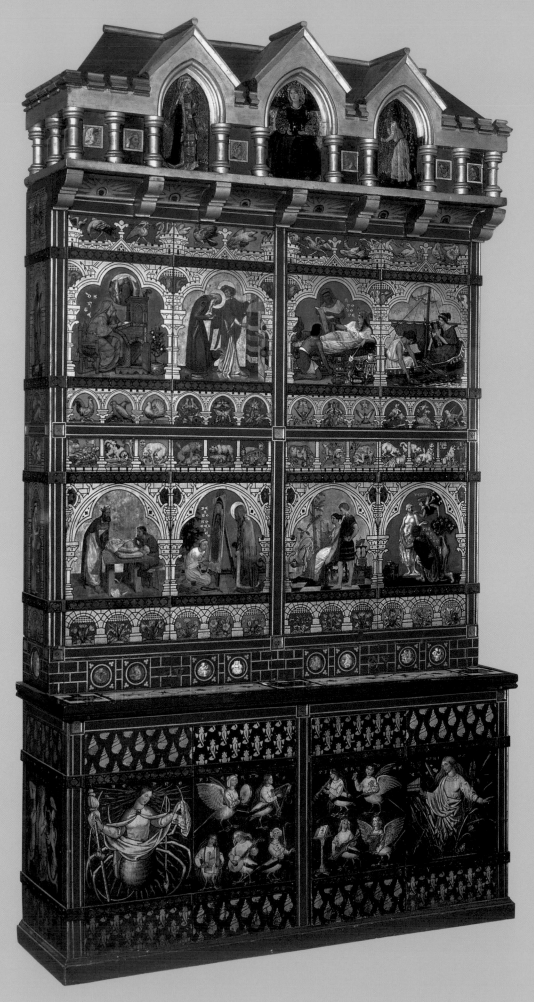

34
William Burges *et al.*
BOOKCASE
1859-62
Carved, painted and gilt wood
317.1 x 173.8 x 49.5 cm
(125 x 68½ x 19½ in)
Ashmolean Museum,
Oxford

35
CHRIST AS SALVATOR
MUNDI
*c.*1865
Sepia cartoon for stained glass
119.2 x 47 cm
(47 x 18½ in)
Birmingham Museum and
Art Gallery

CHAPTER TWO **COLLABORATION AND INDEPENDENCE**

1860-1869

DURING THE LATE NINETEENTH CENTURY, ARTISTS AND CRITICS
FREQUENTLY REMARKED ON THE PROMINENCE OF ARCHITECTURAL
DECORATION AMONG THE CANON OF ART HISTORY'S MASTER WORKS.
FROM PHIDIAS'S SCULPTURES FOR THE PARTHENON, TO GIOTTO'S
FRESCOES IN THE ARENA CHAPEL, TO RAPHAEL'S AND
MICHELANGELO'S PROGRAMMES AT THE VATICAN, THE HARMONIOUS
INTEGRATION OF FIGURAL IMAGERY WITH ARCHITECTURAL STRUCTURE
SEEMED TO HAVE SPURRED ARTISTS TO THEIR GREATEST
ACHIEVEMENTS. THE COMPARATIVE TRIVIALITY OF MORE RECENT
PRODUCTIONS, IT WAS ALLEGED, RESULTED FROM THE STERILE CLIMATE
OF ISOLATION IN WHICH ARTISTS AND ARCHITECTS NOW WORKED.
MANY COMMENTATORS URGED A RETURN TO THE FRUITFUL CROSS-
POLLINATION THAT HAD DISTINGUISHED PAST AGES. 'UNTIL WE HAVE
ARCHITECTS, PAINTERS, AND SCULPTORS WORKING SIDE BY SIDE',
EDWARD WILLIAM GODWIN WROTE IN 1867, 'NO GREAT ADVANCE IS
POSSIBLE TO EITHER ART.'[1]

The Gothic Revival generated numerous opportunities for such
collaboration. But while possessing the will, few Victorian painters
could boast the formidable range of skills that these projects required.
Most merely carried out on an enlarged scale the same pictorial
imagery that they were accustomed to place within a gilt frame. They
overlooked the fact that the closely detailed, three-dimensional
illusionism pursued in contemporary easel painting was diametrically
opposed to the requirements of mural painting. The aim of the latter
was to reinforce and embellish the wall surface, rather than dissolve it
through an impression of spatial recession.[2] Moreover, architecture's
geometric rigour imposed a degree of abstraction and mathematical
precision on painting that was quite foreign to most Victorian artists,
who viewed painting in the light of visual story-telling, rather than
analytical design.[3] Indeed, the qualities that harmonized most
effectively with architecture—two-dimensional linearity, diffuse
lighting, breadth of handling and matt finish—laid bare the
weaknesses in draughtsmanship and anatomical knowledge that British
painters notoriously cloaked in veils of varnish and chiaroscuro.
Monumental scale proved equally unforgiving of their deficiencies.

A confident draughtsman with a thorough understanding of anatomy,
mathematics and architecture, as well as painting, Albert Moore was

ideally equipped for the collaborative ventures sought by architects. His 1859 tour of French cathedrals with Nesfield set the seal on his qualifications by enabling him to study exemplary models of architectural decoration through an architect's eyes.[4] Shortly after his return, Moore came to the attention of William Burges (1827-81), one of England's most ardent and imaginative proponents of medieval culture and a vigorous advocate of closer relations between artists and architects. Burges invited Moore to paint one of the panels of a bookcase that he had designed for his own use based on the examples of thirteenth-century furniture that Moore and Nesfield had studied in France (Pl. 34; cf. Pl. 21).[5] Over a dozen other painters decorated portions of the bookcase, most of them, like Moore, still in their twenties and not much advanced beyond student status.[6]

Burges met many of these young painters at Leigh's art school in Newman Street, where the architect (pursuing the ideal of artistic unity) regularly drew from the life model, as well as casts from antique sculpture and specimens of medieval ornament. The painter Henry Stacy Marks (1829-98), who met Burges at Leigh's, recalled that the walls of his house were decorated 'either by Burges or by any friend who happened to look in', and that at the centre of one room stood the 'Great Bookcase':

> The panels were arranged to have a figure composition in each, by young painters, adherents to the Gothic revival movement, of subjects from Pagan and Christian history. Burne Jones, Albert Moore, Poynter, Smallfield, and others had already contributed their work. The rectangular base had merely the ground laid for the decorations; these I painted under Burges's superintendence and from his suggestion.[7]

Marks makes clear that the painters did not work together as a team but on a one-to-one basis with Burges. He also indicates that the architect dictated the nature of the decorations rather than allowing the painters a free hand.[8] This close supervision ensured unity of appearance, as did the technique of painting directly on the cabinet, rather than on detached pieces of canvas executed in isolation. Though palpably the work of several hands, the decoration of the Great Bookcase attests to the unified results that could be achieved by a team of artists working in submission to a single overseer.

To indicate the contents of the bookcase, Burges had devised a scheme of twelve panels symbolic of the various arts in Christian and pagan contexts. Moore and Simeon Solomon each represented sculpture; Solomon painted the ancient Greek legend of Pygmalion and Galatea, and Moore depicted the London goldsmith William Torel, whose bronze effigy of Queen Eleanor, wife of Edward I, was the first large-scale English figure to be cast in metal (Pl. 36). At this time, Moore was at the height of his fervour for the Pre-Raphaelites and his painting for Burges exhibits the same stiffness and angularity (softened somewhat by the naturalistic fall of drapery and the sensitively rendered faces) that distinguish his 1861 drawing *Elijah Running to Jezreel* (Pl. 22). Painted against the flat gold ground

36
EDWARD I AND WILLIAM
TOREL (DETAIL OF PL. 34)
*c.*1860
Oil on wood

37
Interior of the dairy at
Croxteth, Lancashire,
designed by William Eden
Nesfield
1860-1, formerly with
painted ceiling and
fountain designed by
Albert Moore

prescribed by Burges and adhering closely to the architect's specifications, Moore's painting cannot be considered entirely his own, but until his lost works of 1859 and 1860 are located, the panel for Burges will remain significant as his earliest extant composition in oil.

Several of the painters who contributed to Burges's Great Bookcase went on to assist him with other projects. Moore did not, but he clearly learned much from Burges and his art developed rapidly in a direction consistent with the architect's own ideas. Indeed, it was most likely Burges who provided the crucial impetus for Moore's transition from medievalism to a more eclectic, classically based style during the early 1860s. The combination of pagan and Christian themes in the bookcase exemplifies the architect's faith in the profound sympathies between Greek and Gothic art. Delving more deeply than most Gothic Revivalists, Burges tapped into the abstract design principles

which he believed artists of the Middle Ages had derived from classical remains, and which the ancient Greeks, in turn, had derived from nature.[9] In his own work, Burges harmonized medievalism with a wide array of seemingly unrelated stylistic influences.[10]

Burges's eclecticism was much imitated by younger architects, among them Nesfield.[11] In tandem with Moore, Nesfield swiftly abandoned strict medievalism in favour of a more eclectic style. Indeed, the two came very close to realizing the unified collaboration that was the ideal of many progressive artists and architects. From his very earliest commissions, Nesfield made a point of working side by side with Moore and he undoubtedly advised him on the qualities that architects sought in decorative painting. Nesfield's letters to his patrons and collaborators teemed with rough sketches for paintings, sculpture and furnishings. 'He spared no pains to obtain what he wanted', the

sculptor James Forsyth recalled, 'and [he] expected those associated with him to catch his ideas.'[12] For his part, Moore appears to have scouted out details of buildings that might interest Nesfield while travelling on sketching trips.[13]

In 1860 Nesfield enlisted Moore's assistance in decorating an octagonal red-brick dairy which formed part of the model farm that he was creating (as his first architectural commission) at Shipley Hall, near Ilkeston, Derbyshire.[14] Nesfield's patron was a fellow Etonian, Alfred Miller Mundy (1809-77), the scion of an ancient Derbyshire family whose modern fortune was in coal.[15] Nesfield based the Shipley dairy on a medieval baptistery with a font in the centre of the building. The decoration featured blue and white Minton ceramic tiles bearing Mundy's monogram, stone carvings ornamented with Japanese circular motifs, and four quatrefoil, stained-glass panels depicting the four seasons by the well-known ecclesiological designer Nat Hubert John Westlake (1833-1921), a collaborator on Burges's bookcase. Around the eight sides of the ceiling, Moore painted a band of circular motifs depicting the twelve signs of the zodiac and twelve stylized floral motifs, alternating in groups of three.[16] Moore worked directly on canvas sections that were subsequently applied to the walls. Derbyshire's damp, cold climate made true fresco painting in the Italian manner impractical, and Moore was not yet sufficiently experienced to attempt one of the alternative methods with which other painters were then experimenting.

In 1861 Moore undertook the interior ornamentation of a second red-brick dairy designed by Nesfield, this one for William Philip Molyneux (1835-97), a contemporary at Eton who had recently succeeded as 4th Earl Sefton (Pl. 37). The dairy was part of the home farm at Sefton's country seat Croxteth Hall, near Liverpool, and it supplied the needs of residents and tenants while also providing the family and their guests with an attractive fantasy of pastoral life.[17] Immaculately attired workers oversaw pedigree herds of unusual livestock against the backdrop of Nesfield's nostalgically medievalized 'Old English' architecture. Like other buildings on the farm, the model dairy utilized the latest innovations in farming and, thanks to Nesfield, incorporated advanced ideas concerning the alliance of beauty and usefulness. Practical concerns for the appropriate levels of hygiene, humidity and temperature were met by the aesthetically pleasing décor of blue and white ceramic tiles, slate benches and a central fountain whose incised marble panels were designed by Moore.[18]

Moore also designed the painted ceiling of the dairy, which featured twelve panels inserted between the tiled beams. These were presumably painted in London and sent north for installation. They have since been removed and are presumed destroyed.[19] They remained in situ as late as 1903, however, when the *Liverpool Daily Post* described the dairy as 'charmingly decorated, its painted ceiling representing the twelve months, December with the Christmas ox being led to the butcher, being decidedly appropriate'.[20] This description relates the Croxteth ceiling to a series of twelve watercolour drawings in which Moore personified the months of the year as human figures engaged in appropriate agricultural activities

38
FIGURES EMBLEMATICAL OF
THE MONTHS OF THE YEAR
*c.*1861
Watercolour and gouache
12 squares, each measuring
15.5 x 15.5 cm
(6⅛ x 6⅛ in)
Victoria and Albert
Museum, London

(Pl. 38).[21] 'December' is represented by two classically draped labourers, one shouldering a pickaxe and leading an ox. In style, the drawing recalls the simple naturalism and linear fluidity of designs executed on fifth-century Greek white-ground pottery, but the vignette of the Christmas ox also recalls sculptural motifs in the north and south frieze of the Parthenon, in which draped male figures lead bulls to sacrifice (Pl. 39). Moore had studied casts of the Parthenon sculptures at the York School of Design and had ample opportunity for seeing the marbles while living just a few streets from the British Museum. Celebrated as the finest extant specimens of classical Greek sculpture, the marbles had a profound impact on artists of Moore's generation.

The other scenes in Moore's series of the months of the year are less obviously classical in inspiration. Certain passages are as reminiscent of medieval woodcuts as Greek vase painting. In particular, they reflect the style of a widely admired fourteenth-century Psalter in the British Museum, engraved by N.H.J. Westlake and published in instalments from 1859 to 1865 (Pl. 40).[22] The accompanying text by the architect A. William Purdue emphasizes the acute naturalism of the medieval artist, and there can be little doubt that Moore, in the same spirit, based his allegorical figures on close observation of nature. Adopting a deliberately archaic style, he translated these everyday realities into a quaint, otherworldly context. 'February', for example, merely restyles Moore's drawing of 1860, *A Gate* (Pl. 10), which he had based on observations made during a sketching tour of Borrowdale. The simplified forms and nervous, wiry lines of his designs for Croxteth mingle archaism with naïve charm, a combination wholly in keeping with the pastoral conceit of model farms such as Lord Sefton's.[23]

The six-foot-high stone fountain that Nesfield designed for the Croxteth dairy was by all accounts a spectacular object. Based on the severe style of thirteenth-century French architecture, it consisted of a circular basin supported by a central shaft ringed by eight short detached red marble columns with square foliated capitals. From the centre of the basin rose a short column of green marble surmounted by a squared alabaster capital. Water flowed through metallic dolphin heads protruding from the capital, which was crowned by a sculpture of a mother and child. Moore designed the panels that ornamented the sides of the basin, and these were executed in black incised work by the sculptor Thomas Earp of Kennington Road, London. The carvings showed groups of figures personifying the four seasons, alternating with inlaid mosaic panels representing a peacock, the Milky Way, and other devices in rich combinations of marble.[24] A hint of the appearance of these lost mosaic panels is perhaps provided by the seated female personifications set against starry constellations in Moore's fresco *The Four Seasons* of 1864 (Pl. 31). Significantly, one critic described that fresco as a 'scheme for mosaic treatment'.[25]

The Croxteth fountain was displayed at the International Exhibition

39
YOUTHS BRINGING CATTLE
TO THE SACRIFICE
c.440 BC
Marble relief
Slab XXXVIII from the
south frieze of the
Parthenon
Height 100 cm *(39⅜ in)*
British Museum, London

of 1862 as part of the medieval court that William Burges and the architect William Slater organized on behalf of the Ecclesiological Society.[26] In addition to the fountain, Moore was represented by his panel in Burges's Great Bookcase, which was also on view. The pronounced classicism of Moore's mosaic panels struck some critics as perverse ornamentation for a fountain of essentially medieval style. One declared, 'There is a trifle of affectation in the subject panels, which might, moreover, we think, have been more appropriately filled'.[27] Burges, not surprisingly, put a positive spin on the combination of Greek and Gothic. Reviewing the International Exhibition for the *Gentleman's Magazine* in June, he singled out the collaboration of Nesfield and Moore as presaging positive growth in English design. Directing his readers to the Croxteth fountain, he noted:

> This fountain deserves especial notice, on account of the incised figures, which are Greek, and like those we see on the vases. Now the fountain itself is severe thirteenth-century architecture, such as we find at Chartres, yet the fountain and the figures agree perfectly well together, and furnish another proof how much Greek (not Roman, and still less revival) art has in common with severe thirteenth century.

Six months later, in an article in the *Ecclesiologist*, Burges again called attention to the Croxteth fountain as evidence of 'how well Greek sculpture and drawing adapts itself to what I hope may eventually turn out to be the basis of our future architecture'. Distinguishing Moore's insight into the true principles of Greek art from the sham classicism that had typified modern 'revivals' of antiquity, Burges urged 'the rising school' of English architects to emulate the painter in absorbing all they could through direct engagement with authentic examples of Greek sculpture, painting and architecture.[28]

With Burges publicizing the theoretical rationale behind their work, Nesfield and Moore continued to raise eyebrows through unapologetic and provocative combinations of medieval and classical elements. In 1862, the year of the international exhibition that occasioned Burges's high praise, Nesfield at last published the complete bound volume of *Specimens of Medieval Architecture, chiefly selected from Examples of the 12th and 13th Centuries in France and Italy*.[29] The underlying purpose of the work, he explained in the preface, was 'to stimulate the growing appreciation of the noble buildings of the Middle Ages, and of those grand principles which actuated their authors'. Ironically, the volume documenting the architect's expertise in and enthusiasm for twelfth- and thirteenth-century architecture coincided with the straying of his attention in other directions. His designs from this date evince the eclecticism that became a hallmark of his style, combining early English, Italian Renaissance and medieval French motifs with Japanese and other non-European influences.

Specimens of Medieval Architecture also marks a turning point in the work of Albert Moore. He had accompanied Nesfield to northern France as an impressionable follower of fashion, keen to imitate the medieval tendencies of his idols the Pre-Raphaelites. Three years later he was

40
CAIN AND ABEL
c.1860
Engraving published in
Nathaniel Hubert John
Westlake, *The Illustrations of
Old Testament History in Queen
Mary's Psalter* (1859-65)

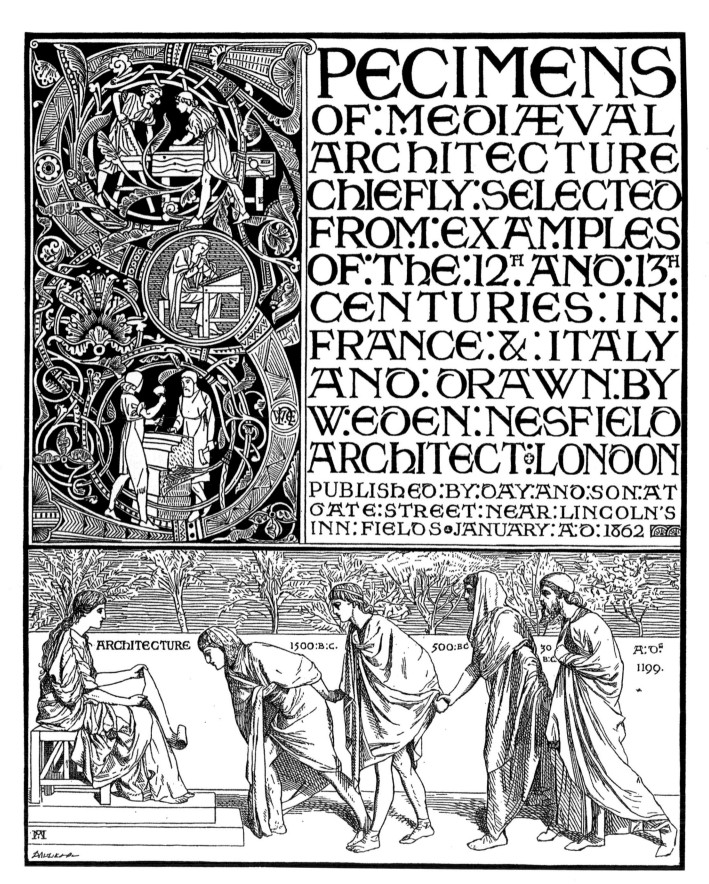

41
Albert Moore and William
Eden Nesfield
'SPECIMENS OF MEDIEVAL
ARCHITECTURE',
WITH INSET REPRESENTING
'THE PROGRESS OF
ARCHITECTURE'
1862
India-proof for engraving
by Dalziel Brothers
Published as title-piece in
Nesfield's *Specimens of
Medieval Architecture* (1862)
42 x 29.7 cm
(16½ x 11¾ in)
British Museum, London

an independent and innovative artist, forging his own style through a fresh interpretation of classical art. The change is clear in the allegorical representation of *The Progress of Architecture* that Moore drew for the title-page of Nesfield's volume (Pl. 41).[30] Here again, the artist and architect merged medieval and classical style, with Nesfield's embellished title in the upper register clearly based on Gothic and Celtic prototypes, while Moore's frieze below draws on the flowing lines and rounded forms of Greek sculpture.

Nesfield dedicated *Specimens of Medieval Architecture* to William, 2nd Earl Craven (1809-66), another patron with extensive Etonian connections. Between 1860 and 1861, Nesfield had remodelled the kitchen and dairy at Craven's house, Combe Abbey, near Coventry, Warwickshire.[31] In the summer and autumn of 1863, while the architect was adding a new east wing to the house in the early French Gothic style, Moore painted decorative panels for the new kitchen and dairy, reportedly working in oil directly on the plaster walls, rather than on canvas as he had done at Shipley and Croxteth.[32] Moore's exposure to fresco painting in Rome in 1862-3 and his recent experimentation with a free-standing fresco (*The Four Seasons*) account for the change in technique. Intense admiration for Italian mural painting led to many such experiments in nineteenth-century England and to an extensive literature on methods suited to Britain's damp climate.[33] But an unforeseen problem with mural painting was the changing taste of successive house owners. When Combe Abbey changed hands in the early 1920s, its purchaser levelled Nesfield's alterations, destroying Moore's decorations in the process.[34]

Nevertheless, a notion of Moore's decoration scheme for the kitchen at Combe Abbey is documented in a sketch reproduced by Baldry, which shows a procession of classically draped male and female figures carrying animal carcasses, jugs of liquid and baskets of fruit (Pl. 43). At the far end of the frieze, confronting the procession, stands the recipient of the offerings: a stout man dressed in fancifully classicized versions of a cook's apron and cap, resting his chin quizzically in his hand.[35] This domestic parade, terminating in the comical figure of the cook, seems a witty play on the solemn religious procession represented in the frieze of the Parthenon, where male and female figures carry offerings for the goddess Athena (Pl. 42). Moore enhanced the painting's resemblance to relief sculpture by executing the figures in pale tones, so that they appeared to project out beyond the darker yellow-brown background. As an irreverent send-up of an icon of classical art, Moore's design for Combe Abbey's kitchen instances the wry sense of humour that friends noted in his personality, but that rarely surfaces in his art.

It seems likely that Moore also contributed to the decoration of the Great Hall at Combe Abbey, which included a figural frieze reminiscent of the painter's allegorical representations of the months and seasons at Croxteth. Nesfield's plan, displayed at the international exhibition of 1862, showed 'at the end of the hall a painted (or tapestried) representation of the months by female figures, in breezy garments, bearing products of the various seasons, and whose names are inscribed over their heads'.[36] This description fits another set of

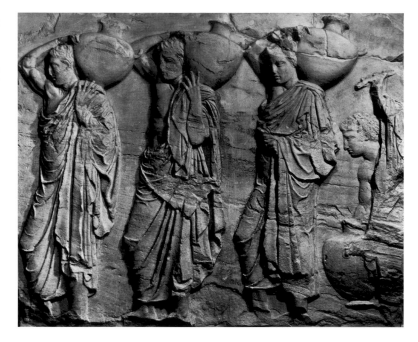

42
WATER-JAR CARRIERS
*c.*440 BC
Marble relief
Slab VI from the north
frieze of the Parthenon
Height 100 cm *(39⅜ in)*
Acropolis Museum, Athens

43
DESIGN FOR KITCHEN
FRIEZE AT COMBE ABBEY
1863
Fresco
Destroyed (from Baldry,
Albert Moore, p. 27)

watercolour drawings at the Victoria and Albert Museum, in which Moore employed female figures to represent each of the twelve months of the year (Pl. 44). Like the Croxteth months, most of the figures in this set engage in appropriate agricultural activities, while others show the effects of the weather. They are executed in the same quaint linear style—with no attempt at spatial illusion—that Moore adopted for the kitchen frieze. Arranged in threesomes, the figures are drawn on four separate sheets corresponding to the four seasons. This arrangement was abandoned in a series of ceramic tiles for which the drawings evidently provided models, as indicated by a surviving example combining 'September' and 'October' (Pl. 45). Mannered as they are, Moore's designs for the months of the year evidently derived from the same sort of naturalistic study of the live model that underpinned his equally mannered drawing of *Elijah Running to Jezreel*. Baldry noted that in his preparatory studies for Combe Abbey, Moore devoted 'scrupulous attention to the posing of the figures, [and] to the appropriateness of their gestures and action'.[37]

These classically draped female figures foreshadow the future concerns of Moore's art, and preparatory drawings for them very

the dormered, red-brick façade, he recycled Moore's designs for the months of the year at Combe Abbey and these were executed in low-relief stone carvings, nearly two-thirds the size of life, by the well-known sculptor James Forsyth of London. Standing within the gables, their effect was, according to Charles Lock Eastlake, 'very striking'.[40]

Nesfield's measured drawings for the new wing (demolished in the 1950s) indicate that in addition to the exterior of the house, Moore contributed designs to the interior. The drawing for the medieval-revival Great Hall features a fireplace wall rising fifteen feet, ornamented with circular bosses—the so-called 'pies' that Nesfield based on Japanese prototypes—and classically draped figures reminiscent of Moore's free-standing paintings (Pl. 47).[41] Three figures in individual frames appear in the upper part of the wall, and below them is a frieze of thirteen figures apparently enacting a drama. As at Croxteth and Combe Abbey, the figures at Cloverley were two-dimensional in conception; their anatomy and drapery merely provided vehicles for the expression of linear patterns. The stiff angularity that Moore affected previously has disappeared, however, replaced by mellifluous curves suggestive of classical statuary. A grid

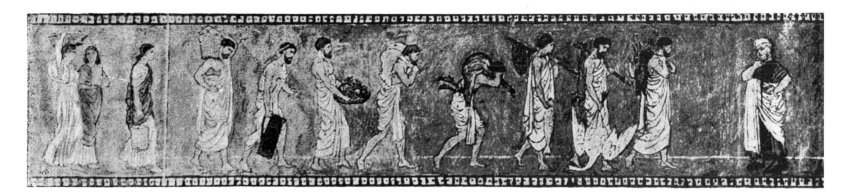

likely provided the inspiration for motifs employed in his later paintings.[38] Moore made the transition from this architectural context to easel painting through a small group of anomalous works, seemingly designed for architecture, but never executed as such. In addition to *The Four Seasons* noted earlier, he exhibited *The Elements* at the Dudley Gallery in 1866 (Pl. 46). In this small gouache drawing, Moore stripped away the psychological and narrative qualities implicit in *The Four Seasons* and reduced the symbolism to the physical attributes borne by each of the four female personifications: a Japanese fan for wind; a flaming pot for fire; a flowing jug for water; and a branch for earth. By eradicating most of the picture's extra-aesthetic interest, Moore forced the viewer to concentrate on the undulating lines of the drapery and the clear and fluent outlining of the underlying anatomy.

Moore furthered this new level of abstraction while working on a decoration scheme at Cloverley Hall near Whitchurch, Shropshire, a sixteenth-century house recently purchased by the prominent Liverpool banker John Pemberton Heywood (1803-77).[39] Nesfield carried out alterations and new building at Cloverley between 1865 and 1870. For

of vertical and horizontal lines underpins the design of the frieze, and this severe linear system is overlaid by two concentric arcs whose rising curves (echoing those of the arches on the opposite side of the wall) determine the configuration of the figure group. Similar use of a curve has already been noted in Moore's drawing *A Gate* of 1860, where it helped the artist determine the silhouette of the mountainous backdrop (Pl. 10). In Moore's future work, curves and circles would continue to exert a fundamental influence.

As Eastlake pointed out in his important 1872 study of the Gothic Revival, Cloverley constituted a grand experiment in the integration of Greek sculpture and Gothic architecture that Burges was simultaneously advocating.[42] A number of ecclesiastical commissions provided Moore with equally challenging opportunities for merging 'pagan' figure painting with 'Christian' architecture. In 1862 he came to the notice of the glass-making firm James Powell & Sons. Powell's regularly commissioned artists to provide designs on a freelance basis. Moore's name and address (23 Berners Street) appear on a flyleaf of the firm's window glass order book for 1860-9, along with some of his friends and neighbours, including Edward Poynter, William

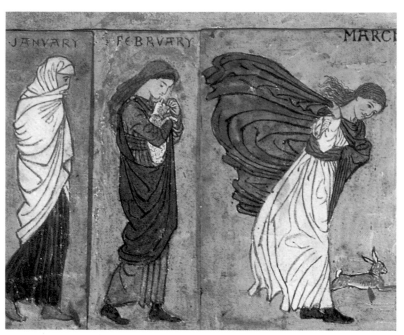

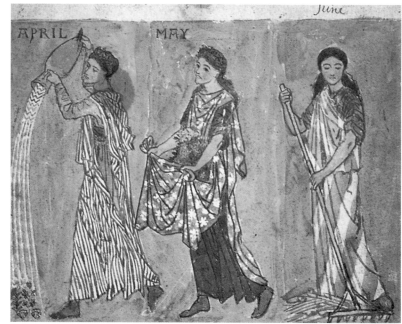

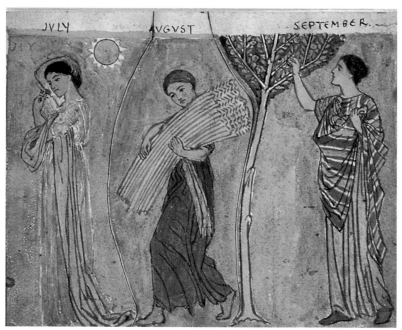

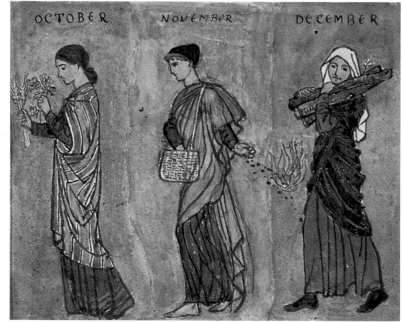

44
FIGURES EMBLEMATICAL OF
THE MONTHS OF THE YEAR
*c.*1862-3
Watercolour and gouache
4 squares, each measuring
15.2 x 18.4 cm *(6 x 7¼ in)*
Victoria and Albert
Museum, London

De Morgan, Edward Burne-Jones and Arthur Lankester (the latter recommended by Poynter).[43]

Moore was hired to provide cartoons for the eastern window of a church at Thursford, Norfolk, where the young architect William Lightly (d. 1865) was carrying out extensive rebuilding. The project had been commissioned by Joseph Stonehewer Scott Chad (1829-1907) of Thursford Hall, who had recently inherited a fortune from his great uncle. The church remains intact, featuring a High Victorian chancel with naturalistic capitals and columns. It is dominated by Moore's splendid window, which is divided into three sections depicting *Scenes from the Life of Christ* and *The Twelve Apostles* (Pl. 48).[44] Completed in December 1862, the window was fairly inexpensive, costing a little less than £100.[45]

Moore had learned the principles of designing for stained glass under Thomas Cotchett at the York School of Design, and he had ample opportunity for studying exceptional specimens in the Minster and parish churches of York and the cathedrals of northern France.[46] However, his window at Thursford is wholly original and astonishingly innovative. Rejecting the convention of imitating the effects of oil painting, Moore tailored his design to the unique properties of glass: simplicity, linearity and transparency.[47] Nikolaus Pevsner described the window as 'one of the most beautiful of its time in England, or indeed Europe, as good as the early Morris glass, which is saying much. It is more reminiscent of progressive work of the 1920s than of anything in the nineteenth century.'[48] As Pevsner suggests, Moore's window exemplifies the flat, linear style and clean delineation that would much later become hallmarks of progressive glass design. The fluid definition of the figures provides a particularly striking contrast to the cramped, angular style affected by Moore's contemporaries. The carefully observed swags and folds of the mourner standing at the foot of the cross in the central light attest to the artist's facility in employing drapery to express the body beneath it. For this quality alone, his window would have attracted favourable notice, for the naturalistic treatment of human figures was one area in which modern glassmakers were exhorted to improve upon medieval models.[49]

Moore enhanced the legibility of his window through distinct colour transitions. Although the sonorous ruby glass seems alien to his taste, delicate tertiary hues, such as sea foam green and powder blue, reflect the paler colours with which he was already beginning to experiment.[50] Moore's strong sense of design minimized the need for painted shadows and internal detail, thus maximizing the brilliance of the window. While his contemporaries treated the leads merely as structural devices for securing the various pieces of coloured glass, Moore made potent use of the strong black lines to unify the composition and crystallize the forms of the figures.[51] The same emphasis on pure outline emerges in his easel paintings of this period, as does his placement of flat figures against a shallow backdrop of all-over abstract pattern. These distinctive features of Moore's paintings undoubtedly owed much to his early study of effective glass design.

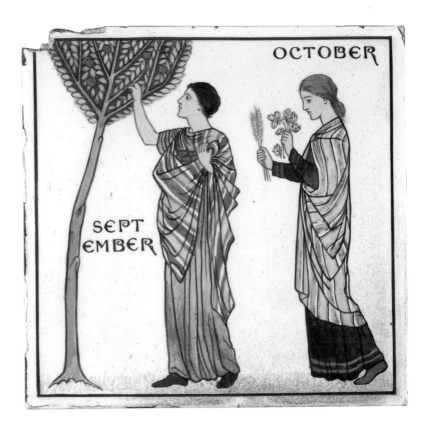

45
After Albert Moore
SEPTEMBER AND OCTOBER
n.d.
Ceramic tile
15.2 x 15.2 cm
(6 x 6 in)
York City Art Gallery

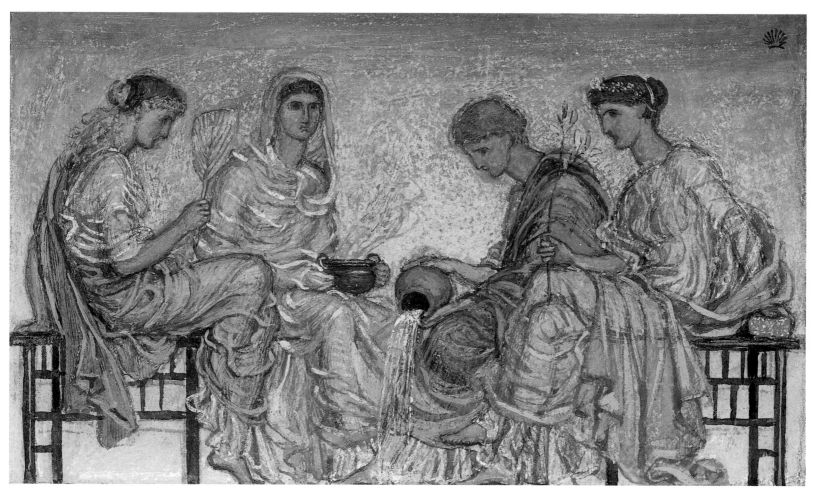

46
THE ELEMENTS
1866
Crayon and gouache
10.8 x 18.4 cm
(4¼ x 7¼ in)
Private collection

In 1864 Moore was asked to provide a cartoon of Christ as Salvator Mundi for a memorial window to be produced by the recently incorporated design firm of Morris, Marshall, Faulkner & Co.[52] Moore's figure ultimately appeared at the centre of the south-east window in the chancel of the parish church of St Peter's, Bradford (Pl. 49). The original drawing survives, showing the nude figure of Christ in black chalk, with the drapery folds superimposed in wash (Pl. 35). Compared with the assured draughtsmanship of which Moore was capable, the study is surprisingly crude, marred by uncertain, fussy lines. Some of this may represent the work of William Morris himself, for he generally reworked such drawings, completing the compositions with appropriate backgrounds and ornamental detail, and ultimately selecting the coloured glass and supervising its painting.[53] The awkwardness of the drawing is absent in the finished window, which possesses all the elegant simplicity of Moore's developing classical style.

The windows for Bradford and Thursford apparently constitute the sum total of Moore's work in stained glass.[54] Powell's had hoped for more, and in December 1862, when Edward Burne-Jones ceased designing for the firm in order to work exclusively for Morris & Co, they offered the position to Moore, who declined. It was around this time that Moore made Burne-Jones's acquaintance, most likely through their mutual friends Simeon Solomon and Henry Holiday. Moore recommended the latter for Burne-Jones's former position, and Holiday thus began a 60-year career as a designer of stained glass.[55] Moore may have considered the medium uncongenial or the work too distracting from his painting practice. Nevertheless, his innovations were perpetuated by other designers such as Holiday and his pupils, who followed Moore in replacing Gothic motifs with classical sensibilities.[56]

Toward the end of 1862, while completing the church of St Mary, Thursford, William Lightly and his mentor Edward I'Anson Jr (1812-88) were consulted about the viability of a fourteenth-century church that had suffered fire damage in November.[57] The Dutch Church in Austin Friars, near Old Broad Street, was one of the most ancient and significant of the original medieval churches in the City of London, and consequently the subject of intense interest in architectural circles. At a meeting of the Ecclesiological Society held on 26 March 1863, Lightly displayed Albert Moore's full-sized cartoons for St Mary's, Thursford, and in the course of further discussions announced the decision to completely demolish and rebuild the church in Austin Friars.[58] Lightly's announcement sparked a full-scale protest led by the architect George Gilbert Scott and supported by the Ecclesiological Society and both Houses of Parliament.[59] The public outcry sent Lightly back to his drawing board to devise plans for the restoration of the church. The new arrangements included a fresco on the east wall, to be executed by Albert Moore.

Despite the impressive medieval pedigree of the Dutch Church, Moore did not hesitate to adopt the frankly modern interpretation of classical style that he had previously employed in decorating Nesfield's country houses. Indeed, one of Moore's drawings for the project

47
William Eden Nesfield
DETAIL OF PANELLING FOR
GREAT HALL, CLOVERLEY
c.1865
*Detail of pen and wash
drawing*
Victoria and Albert
Museum, London

Overleaf
48
After Albert Moore
SCENES FROM THE LIFE
OF CHRIST, WITH THE
TWELVE APOSTLES
1862
Height of central window
342 cm *(135 in)*
East window, Church of
St Mary, Thursford,
Norfolk

49
After Albert Moore
CHRIST AS SALVATOR
MUNDI
1864
Height 260 cm *(102 in)*
Originally the south
window of St Peter's
Church, Bradford, now
installed in the north
ambulatory wall, Bradford
Cathedral

(Pl. 50) demonstrates eclecticism worthy of Nesfield himself, with tables and benches evidently modelled on furniture Moore had seen in the Japanese Court of the International Exhibition in 1862. These anticipate similar articles produced several years later by the architect and designer Edward William Godwin (1833-86). Moore's design further indicates his intention of adhering to an austerity appropriate to the Calvinist setting, while expressing the full decorative potential of line and form. In the upper register, the symmetrically arranged figures of *The Last Supper* rise and fall in melodious curves offset by the emphatic horizontal bands of wall, table, bench and floor. In contrast to the lyrical flow of the upper section, the uniformly vertical figures of *The Passover* present a more solemn, static appearance.[60] These abstract linear patterns enhance the internal unity of the various sections while differentiating each from the others.

Before Moore could carry out his ingenious design on the walls at Austin Friars, it was determined that no fresco would be painted at all. Edward I'Anson later recalled that the Church authorities had

determined Moore's fresco to be 'inconsistent with the service', and doctrinal concerns also resulted in the elimination of the stained glass.[61] Additional pressure was probably exerted by the architectural preservationists who had saved the church from demolition in the first place, and who urged that this unique example of medieval architecture ought to be preserved intact with minimal modern additions and alterations. Moore's work was not thrown away, however. The seated poses designed for *The Last Supper* recurred in several subsequent paintings, such as *The Elements* of 1866 (Pl. 46), in which the classically draped male figures have become female, seated on Japanese benches reminiscent of those in the Austin Friars drawing.

Also dating from 1866, Moore's design for the unexecuted picture *Somnus Presiding over Sleep and Dreams* (Pl. 51) emulates the tiered organization intended for Austin Friars, as well as the use of geometric patterned bands to frame the component sections.[62] The format suggests that the design was not for a free-standing painting but an architectural mural. Moore's exhibition of five related drapery studies

at the Dudley Gallery in 1868 indicates that he pursued the project for a number of years before abandoning it for unknown reasons.[63] The studies of seated and recumbent figures that he produced for the scheme nevertheless provided influential models for the paintings he produced over the next 25 years. *Sommus* also influenced Frederic Leighton, who ultimately acquired the drawing and evidently used its figures as points of departure for his own paintings, most notably his enthroned women of the 1890s such as *Fatidica* (Lady Lever Art Gallery) and the *Tragic Poetess* (private collection, Japan).

In 1864 Moore drew on his abortive work for Austin Friars in preparing a far more ambitious decorative programme for St Alban's Church in the Pinfold area of Rochdale, near Manchester. The church had been erected in 1856 by the architect Joseph Clarke (1818-88), a Gothic Revivalist responsible for several new buildings and restorations in the neighbourhood.[64] The painted decorations (along with many other improvements) were financed by Jonathan Nield (1824-87), a wealthy local banker who took great interest in contemporary art and architecture, and who also commissioned Clarke to build him an ambitious High Victorian Gothic villa and the Boys' School in the grounds of St Alban's.[65] With money apparently no object, Clarke devised lavish appointments for the interior which the *Builder* described as 'of a very costly character; and when completed they will probably attract much attention'.[66]

Clarke handpicked the team of artisans employed to carry out his designs at Rochdale, and it was most likely he who selected Albert Moore to design and execute the mural scheme, for which he was paid £700.[67] The painter was by then fairly well known in architectural circles, and Clarke had seen his stained-glass cartoons for Thursford in March 1863, at the same meeting of the Ecclesiological Society at which he presented his initial plans for Rochdale.[68] He must have approached Moore soon thereafter, for at a meeting of the Ecclesiological Society held on 25 May 1864 Clarke reported that the artist was already executing 'a series of flat fresco decorations' at St Alban's.[69] In July William Michael Rossetti identified Moore as one of only 'ten British painters more or less qualified to undertake monumental work'. Even among these ten, Rossetti noted, only Moore had actually proved his capacity by exhibiting a fresco (*The Four Seasons*), in imitation of Roman examples.[70]

The Rochdale project was of a wholly different order of magnitude, however. As Moore's most extensive and important mural programme it is worth examining in some detail, even though the frescoes themselves no longer survive. An idea of their appearance may be gleaned from Moore's studies, together with photographs of the church prior to demolition. The artist first completed *The Last Supper* in the arcaded reredos above the altar of the chancel (Pl. 52). He allowed the architectural framework of the arcade to suggest his design, reiterating the curves of the Gothic arches in the lines of the figural groups, and echoing the rhythmic fall of the vertical columns in his placement of these groups. Harmony with the existing architecture was a more vexed issue in the paintings Moore completed the following year (1865), *The Twenty-four Elders of Revelation* on either

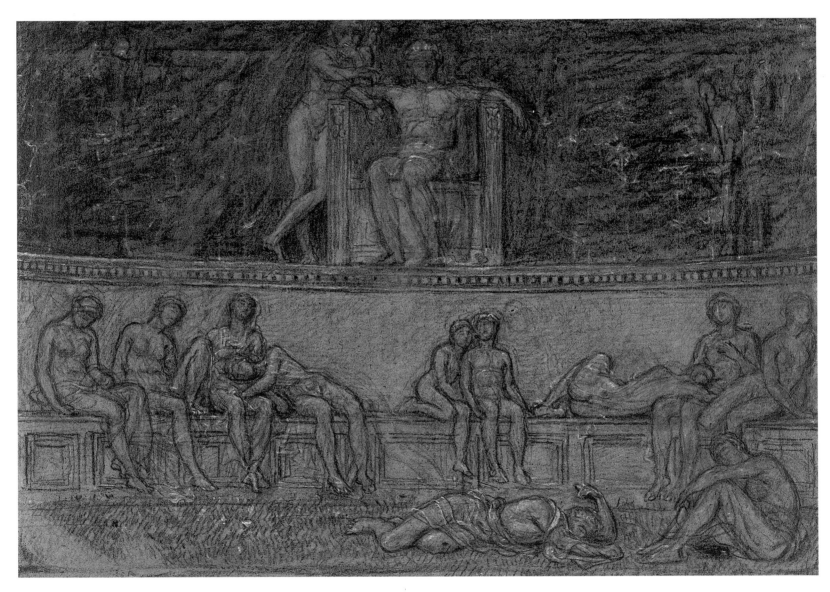

50
COMPOSITIONAL STUDY
FOR THE FRESCO 'THE
LAST SUPPER' AND 'THE
PASSOVER', INTENDED FOR
THE DUTCH CHURCH,
AUSTIN FRIARS
1862
Photograph of lost original
Royal Institute of British
Architects, London

51
SOMNUS PRESIDING OVER
SLEEP AND DREAMS
1866
*Black and white chalks on
brown paper*
23.8 x 33 cm
(9⅜ x 13 in)
Victoria and Albert
Museum, London

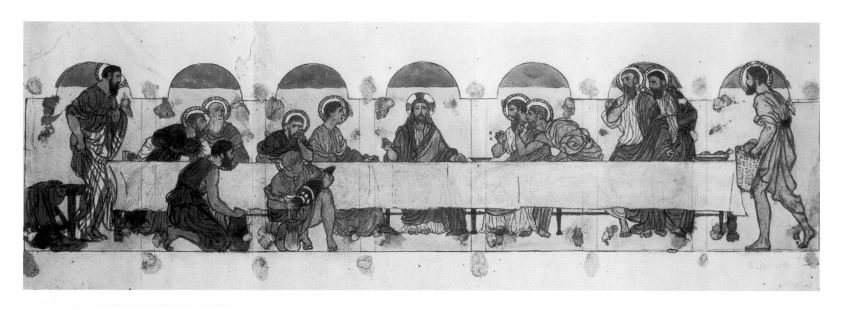

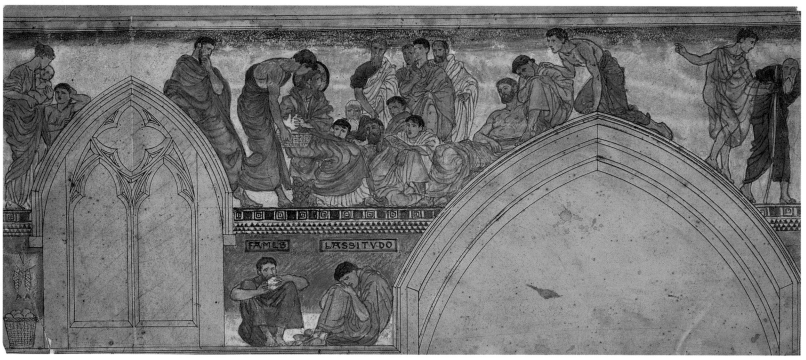

52
STUDY FOR 'THE LAST
SUPPER' FOR THE CHURCH
OF ST ALBAN, ROCHDALE
1864
Watercolour
24.1 x 59.6 cm
(9½ x 23½ in)
Private collection

53
STUDY FOR 'THE FEEDING
OF THE FIVE THOUSAND',
'HUNGER' AND
'WEARINESS'
1864-5
Coloured chalks
25.4 x 58.4 cm
(10 x 23 in)
Private collection

side of the east window (above the reredos), and *The Feeding of the Five Thousand*, *Hunger* and *Weariness* on the chancel's south wall (Pl. 53).[71] Although the choice of these subjects had been carefully premeditated, Clarke had evidently devoted little forethought to the means by which Moore would carry them out. Arches and windows broke up the wall in awkward configurations which proved a severe trial to Moore's ingenuity. The situation was by no means unusual, for despite widespread endorsement of the notion of greater unity of architecture and painting, buildings were generally designed without much feasible space for mural painting.[72]

Moore's recognition of the complementary function of mural painting in relation to architecture constrained him to work around the building's limitations. In response to the strong ruddy colours employed in the church, he intensified his usually subtle palette. Godwin assured those who saw Moore's design in the Architectural Exhibition in May 1867 that despite the 'fiery' appearance of the drawing when seen out of context, the actual fresco on the wall of St Alban's 'does, in fact, look exceedingly luminous and tender, possessing only red enough sufficiently to unite the lower part of the wall with the roof'.[73] The awkward wall shapes presented additional challenges. Rather than gloss over these obstructions, Moore very deliberately incorporated them into his designs, so that the figures in *The Feeding of the Five Thousand* are shown leaning against the moulding of a real window, and walking and crawling over an arch. The severely constricted vertical space on either side of the east window forced Moore to stack the figures in the *Twenty-four Elders of Revelation* on top of one another, as revealed by his nude cartoons for the fresco.[74]

Notwithstanding the careful analysis and meticulous drawing that went into the designs for Rochdale, there is a hint of irreverent whimsy in Moore's unconventional compositions. Godwin suspected him of executing the designs in bad faith for a building he did not admire. In the review cited above, he noted that the figures in Moore's painting were out of scale with the architecture, adding, 'It is quite possible that the building is ill-designed, and that the painter looked upon the architect as anything but a brother artist. If such were the case, we think the painter would have done wisely to decline the work; if such were not the case, then Mr. Moore has entirely missed the great purpose of his art.' Contrasting Moore's work at Rochdale with his design for the Dutch Church of Austin Friars, also on display in the Architectural Exhibition, Godwin observed that in the latter instance, 'There are no architectural forms to rouse the ire of the artist; and working, therefore, in a better spirit, he has produced a better work.'[75]

In preparing the designs for St Alban's, Moore made careful studies from nude and draped models in his studio, arranging boxes and cushions to simulate the surrounding architecture of the church (Pls. 55, 56).[76] These small-scale studies were later enlarged to their actual size and pinpricked for chalk transfer to the walls. When complete, the drawings and other necessary materials were transported to Rochdale, where Moore executed the paintings directly on the walls. Baldry recounts a slapstick episode during Moore's short journey from his

54
Photograph of the demolished chancel of the Church of St Alban, Rochdale
*c.*1971
Rochdale Local Studies Library

studio in Russell Place to Euston Station, when the floor of his overloaded cab fell out in mid-journey and Moore and his brother Henry 'had to run along inside for some distance, until the attention of the driver could be called to the mishap'.[77]

According to the 1863 *Builder* article quoted above, Clarke had originally intended the chancel wall-paintings at St Alban's to be carried out using 'the new water-glass process' of fresco, which required the elaborate preparation of the walls with multiple layers of lime and sand mortar, ferro-silicic acid and potassium. Despite mixed results, this laborious technique enjoyed a brief vogue around mid-century and was employed at the Houses of Parliament as a suitable English alternative to traditional methods of fresco.[78] Moore apparently decided against the water-glass technique and adopted the method he had used three years earlier at Combe Abbey, painting in oil directly on the plaster walls. In 1878 Clarke was still able to state that the paintings at Rochdale were 'as perfect now, with the exception of dust, as when finished'.[79] But the passing years rapidly took their toll. By 1894 Baldry found that the colours had 'unfortunately suffered not a little from atmospheric influences', and ten years later, during St Alban's jubilee in 1906, a curate reported that 'the problem of dealing with the frescoes by Albert Moore, R.A. [sic], which have suffered from decay and discolouration, confronts our Wardens and Church Council.'[80] The final blow came in the 1970s when St Alban's itself was levelled (Pl. 54).

Shortly after completing the Rochdale frescoes, Moore received a second commission for mural work in the vicinity of Manchester from the banker and philanthropist Oliver Heywood (1825-92), a relation of John Pemberton Heywood of Cloverley and of several of John Collingham Moore's earliest patrons.[81] Following the death of his father in August 1865, Heywood and his family had transferred to Claremont, a Georgian house near Salford which had been his father's home for forty years.[82] Refurbishments began immediately, and by 1866, Moore was carrying out decorative frescoes on the coved ceiling and three over-door panels of the octagonal hall, reportedly adopting the sort of pale colour scheme that he had begun to employ in his easel paintings. The scale of the work was evidently enormous. From Rome, where he was beginning his own tentative experiments in fresco, William Richmond informed his parents during the spring of 1866, 'Albert Moore is at work on a picture 24 feet by 18 I hear and greatly engrossed over it.'[83]

Unfortunately, the fresco method fared no better at Claremont than elsewhere, and Baldry found the decorations badly deteriorated in 1894. They were entirely destroyed in 1955 when the house was pulled down to make way for a housing estate. Claremont is the least documented of Moore's architectural programmes, but its frescoes are possibly documented by a series of idyllic vignettes of everyday life in antiquity which Moore executed around this time.[84] For a scene of women drawing water at a well, Moore initially contemplated an elaborate composition set within an extensive mountainous landscape, with sheep in the foreground and a group of shepherds watching a wrestling match (Pl. 58). He subsequently minimized the diffuse,

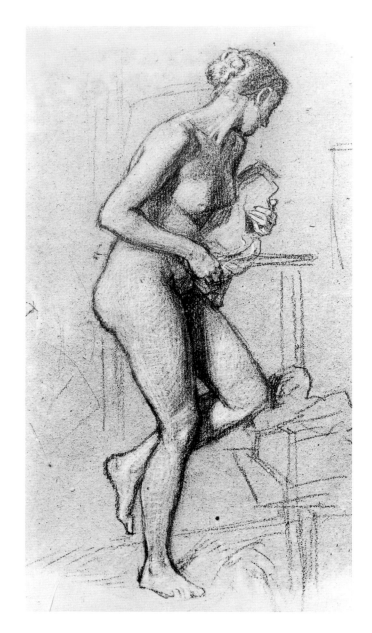

55
STUDY OF A NUDE FEMALE FIGURE FOR 'THE FEEDING OF THE FIVE THOUSAND' FOR THE CHURCH OF ST ALBAN, ROCHDALE
1864-5
Black and white chalks on brown paper
33.5 x 18.6 cm
(13¼ x 7⅜ in)
Victoria and Albert Museum, London

narrative quality of the composition and, homing in on the central fountain scene, produced a simple, symmetrical design admirably suited to its architectural context (Pl. 59). Greek vase paintings of women bearing water jars at fountains ornamented with lions' heads (Pl. 57)[85] provided the thematic springboard for Moore's own invention, which he developed through exhaustive studies of nude and draped models (Pls. 60, 61).[86] These studies informed the easel paintings that he was carrying out simultaneously, and many years later he returned to the motif of water-drawing in a small and apparently unexhibited painting (Pl. 62).

Moore's meticulous methods and diverse activities had become a strain by this date. On moving to a new studio at 17 Fitzroy Street in 1866, he immediately sought assistance in order to prevent his expanding fresco practice from interfering with his easel paintings. On 14 November 1866, he wrote to Charles Augustus Howell, an art dealer and close associate of Dante Gabriel Rossetti:

> I have been informed that you have a young protegé, named Murray, who is following the art business, and as I am thinking of taking on a kind of pupil, it is possible that he may be just the person I want. My pupil, whoever he may be, will have to help me in fresco work &c. at some fixed salary, and I shall feel bound of course, to facilitate his progress in art as much as possible.[87]

It is unknown whether 17-year-old Charles Fairfax Murray actually became Moore's pupil. He was certainly well-suited for the job, having already distinguished himself as a draughtsman while serving in an engineer's office, and he subsequently did work for the decorating firm Collinson and Lock. However, in the same month that Moore wrote to Howell, Edward Burne-Jones hired Murray as his first studio assistant, deputing him to carry out the fourteen decorative figure panels that he had designed for the Dining Room of the South Kensington Museum. Murray also worked for Rossetti, Ruskin, William Morris and George Frederic Watts, and he was probably too busy to provide the kind of assistance that Moore required.[88] Nevertheless, Moore must have hired someone to aid him during the late 1860s, for it was a period of remarkable productivity and artistic growth.

Moore's work as a decorative painter continued to intrigue Godwin, who had long lamented the estrangement of artists and architects, 'neither having any sympathy for the other or any thought in common'. In November 1866, as part of a series of articles on painted decorations, Godwin complained of the national incapacity for monumental work that each year's painting exhibitions too plainly revealed. He demanded, 'Will not some of our younger artists who can draw the figure make an effort to rise out of this miserably small life of easel pictures to the noble work for which, sooner or later, they will be so much wanted?' Only one artist offered Godwin a glimmer of hope. Albert Moore's *Lilies* (Pl. 84), exhibited that winter at the French Gallery, was 'the nearest approach to the spirit of the true wall-painter, but its exceeding delicacy of colour makes it indeed but "the ghost of a promise".' Godwin implored Moore to assume

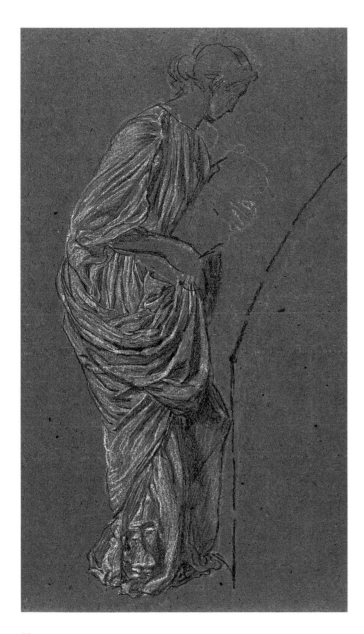

56
STUDY OF A DRAPED
FEMALE FIGURE FOR
'THE FEEDING OF THE FIVE
THOUSAND' FOR THE
CHURCH OF ST ALBAN,
ROCHDALE
1864-5
Black and white chalks on
brown paper
26.5 x 14.8 cm
(10½ x 5⅞ in)
Victoria and Albert
Museum, London

a leadership role in guiding English art to a higher plane. 'Even *one* energetic, business-like, good-tempered man would be enough to gather round him a school for the exercise of painting as a monumental art. Will Mr. Moore be good enough to try?'[89] On 19 July Godwin reiterated his belief that 'with the exception of Mr. Fred. Walker and Mr. Albert Moore, there is no one who gives any evidence of those powers which are absolutely necessary to a wall painter.' But he warned that the abilities of even these two would remain untapped until 'one or the other may have the opportunity of working with some architect who knows something of art'.[90] In light of Moore's extensive collaboration with Nesfield and his well-known association with the architect's 'clique', Godwin's remark is rather curious.[91]

At the same time as he was speculating on Moore's capacity for monumental art, Godwin was apparently scouting for an architect with whom the painter could work harmoniously. Such an opportunity seemed to present itself when St Martin's Hall, an important venue for choral singing and the site of Charles Dickens's famous public readings, closed its doors in May 1867 to be gutted, rebuilt and reopened five months later as the New Queen's Theatre, one of the largest performance halls in London.[92] Financed by Lionel Lawson, proprietor of the *Daily Telegraph*, the Queen's Theatre was designed by the architect Charles John Phipps (1835-97), who was just beginning a long and illustrious career in theatre design. Following his relocation from Bath to London in 1864, Phipps had fallen in with architects on the cutting edge of new developments in mural painting, and in 1866 Godwin, along with his partner William Burges and George Gilbert Scott, had proposed Phipps as a fellow of the Royal Institute of British Architects. The following year, Godwin encouraged Phipps to employ Albert Moore to paint an enormous frieze, measuring 30 by 7 feet, above the proscenium of the Queen's Theatre. The architect's consent generated great excitement in artistic circles. 'When I first heard that Mr. Albert Moore had been commissioned', Godwin later wrote, 'I, in common with many others, rejoiced that such an opportunity had at last occurred to one who seemed so eminently qualified for the task, and I looked forward to the opening of this theatre full of hopeful expectancy that here, at last, we should see a fair result of the union of architecture and painting.'[93]

Undeterred by the imminent opening date of the theatre and the paltry fee of £200, Moore accepted the commission.[94] The resulting painting, *A Greek Play*, is now in a severely compromised condition, but the artist's preparatory studies, together with a contemporary engraving of the work in situ (Pl. 63), convey a vivid impression of its original appearance.[95] The long expanse of the frieze evidently suggested spatial analogies with the auditorium itself and inspired Moore to design a radically simplified and classicized version of the activities that would occur there. He represented an audience of thirteen seated and standing figures observing a drama enacted by three performers. A preliminary colour study (Pl. 64) indicates a limited palette of salmon, violet-grey, and flesh colour for the figures, and horizontal bands of violet-grey and white in the background. Descriptions of the painting in situ suggest that these colours were intensified in the final version. The artist J. M. Swan later recalled,

57
KALLIRRHOË FOUNTAIN
*c.*510 BC
Attic black-figure hydria
British Museum, London

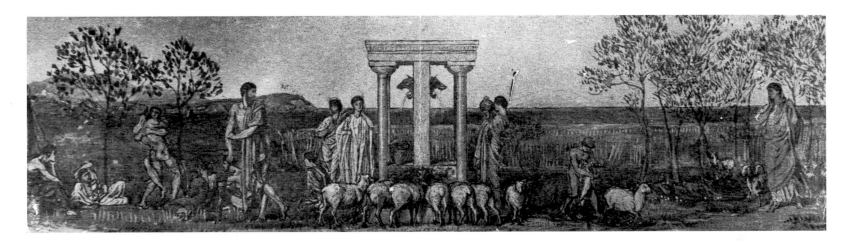

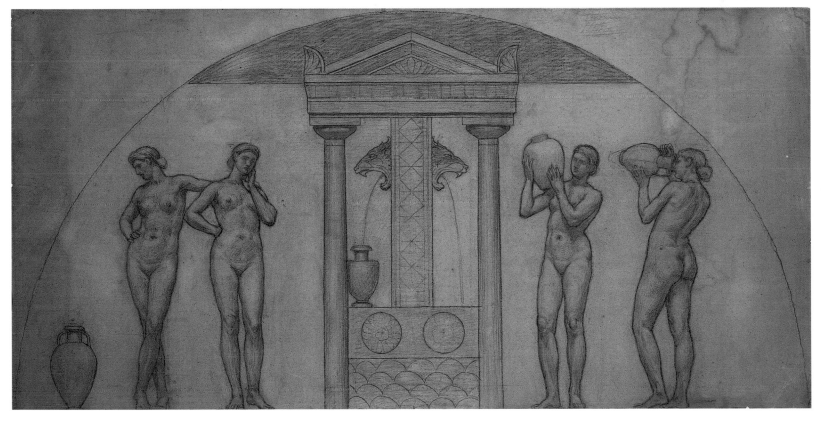

58
PASTORAL SCENE OF
SHEPHERDS AND MAIDENS
AT A WELL
c.1866
Charcoal on brown paper
Whereabouts unknown

59
COMPOSITIONAL STUDY OF
WOMEN DRAWING WATER
AT A WELL
c.1866
Charcoal on brown paper
78.3 x 154 cm
(30⅞ x 60¾ in)
Victoria and Albert
Museum, London

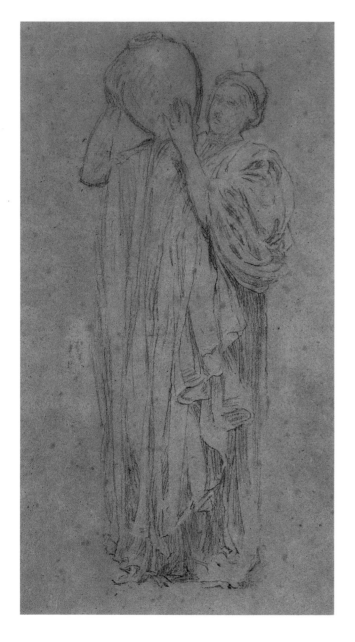

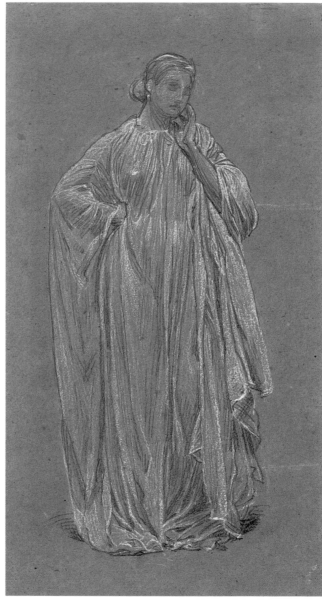

60
STUDY OF A DRAPED
FEMALE FIGURE, HOLDING
A PITCHER ON HER RIGHT
SHOULDER, FOR 'WOMEN
DRAWING WATER AT A
WELL'
*c.*1866
Black and white chalks on
brown paper
36.5 x 22.8 cm
(14⅜ x 9 in)
Private collection

61
STUDY OF A DRAPED
FEMALE FIGURE FOR
'WOMEN DRAWING WATER
AT A WELL'
*c.*1866
Black and white chalks on
brown paper
36.8 x 20.3 cm
(14½ x 8 in)
Metropolitan Museum
of Art, New York

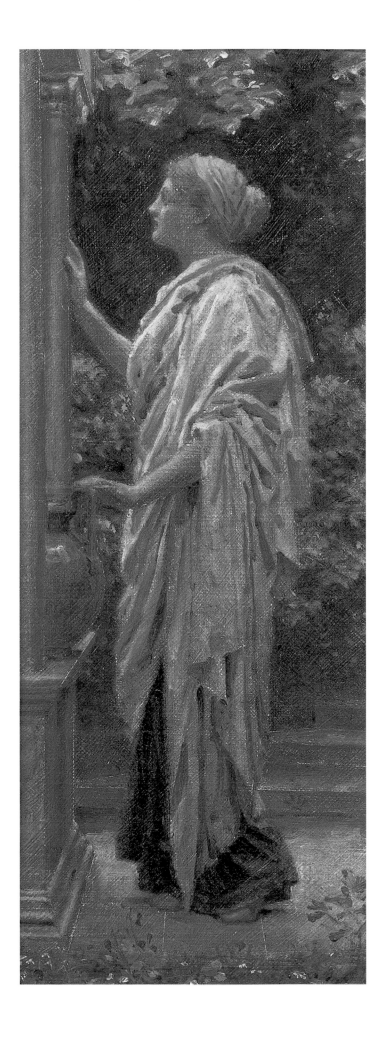

62
THE FOUNTAIN
*c.*1880
Oil on canvas
29.2 x 10.8 cm
(11½ x 4¼ in)
Private collection

63
THE QUEEN'S THEATRE
WITH ALBERT MOORE'S
'A GREEK PLAY' OVER THE
PROSCENIUM
Engraving published in
the *Illustrated London News*
(26 October 1867)

64
STUDY FOR 'A GREEK PLAY'
1867
*Watercolour and gouache over
black chalk*
12.7 x 53 cm
(5 x 20⅞ in)
Victoria and Albert
Museum, London

'It was splendid. I used to rave about it; it was beautiful in reds and blacks; I have not seen the equal of it in England.'[96]

A thumbnail sketch in the margin of one of Moore's preparatory drawings shows that he conceived of the picture as a geometric diagram, a rectangle superimposed by the arcs of two concentric circles, punctuated by diagonal and vertical lines (Pl. 67). It will be recalled that he employed a similar construction, with the arcs inverted, in his design for the figural frieze in the Great Hall at Cloverley. In fleshing out his abstract diagram for the Queen's Theatre, Moore made chalk studies of nude and draped models posed in his studio (Pls. 68, 69). He then elaborated full-scale nude cartoons of each of the figures which he transferred directly to the coarsely woven canvas.[97] This was so large that Moore's studio could not accommodate it, and the artist Thomas Armstrong (1835-1911), who frequently visited his friend while the picture was in progress, later recalled that Moore had to hire an additional studio a few doors down from his usual one.[98] The painting was executed in egg tempera which dried to the desired dull, matt finish.[99] Fresco was not an option at the Queen's Theatre because the speed with which the building was

addition, the four women seated near the centre of Moore's painting emulate the physical intimacy of the paired goddesses in the east pediment of the Parthenon. The goddesses on the right side of the pediment, one reclining in the lap of another (Pl. 66), recall the left-hand group in Moore's painting, while those on the pediment's left side (Pl. 74), one figure sitting behind the other and casually resting her arm on her companion's back, are reminiscent of Moore's right-hand group.

Phidias's sculptures from the Parthenon may have inspired the poses of *A Greek Play*, but the style employed by Moore (here, and in his small crayon and gouache drawing *The Elements* of 1866; Pl. 46) owes more to classical painting. Indeed, at this time Moore seems to have been experimenting with a painterly style appropriate to his fifth-century sculptural models. The fine, fluid grace of his line, the clarity with which he outlined the body and its drapery, and his integration of foreshortened figures with the flat silhouettes of furniture all derive from fifth-century Greek vase painting. Such vases, in turn, were believed to reflect the ideal style of the fifth-century Greek painter Polygnotos, whose pre-eminence in decorative wall-painting coincided

erected left no time for plaster to dry. Speed of execution was also a factor in Moore's contract, and Armstrong later recollected the twelve- and sixteen-hour days that the artist (assisted by his brother Henry) devoted to completing the enormous painting before the theatre's opening in October. According to Armstrong, 'Moore's health was much impaired by the continuous labour he had to expend on the frieze to finish it according to the terms of the contract.'[100]

Moore's small colour study for the painting includes inscriptions identifying the three figures at far left as the 'Chorus', 'Antigone' and 'Oedipus', indicating the subject as Sophocles's tragedy *Oedipus at Colonus*. Such a specific literary reference is unusual for Moore, and it is significant that he excised the inscriptions from his final painting, thereby enabling a more generalized reading.[101] But his equally unusual allusions to specific artistic models persisted into the final work. Several passages are clearly intended to invoke comparison with England's most important archaeological treasure, the sculptures of the Parthenon. The audience portion of Moore's painting recalls sections of the east frieze, which includes an audience of seated gods and goddesses, a cluster of heroes and magistrates standing in relaxed contrapposto, and a line of beautifully draped maidens (Pl. 65).[102] In

with Phidias's in decorative sculpture. Victorian commentators regarded contemporaneously executed vase paintings as the closest visual equivalents to Polygnotos's work (none of which survives) and they supplemented this evidence with the testimony of ancient authors, who attributed the singular effectiveness of his paintings to their emphatically two-dimensional treatment of space, clear delineation of the anatomy underlying folds of drapery, and avoidance of dramatic action and emotion in favour of dignified restraint.[103] All of these features are discernible in Moore's art, suggesting his inculcation of the lessons of Polygnotos along with those of Phidias.

Encouraged by Godwin, Phipps evidently asked Moore to devise a decoration scheme for the rest of the Queen's Theatre, explaining that otherwise the matter would be left to a commercial decorator. Foreseeing the crushing impact of crimson and gold on the delicate lines and hues of his proscenium painting, Moore agreed to make additional drawings without a formal commission or remuneration of any kind. In the seats of the dress circle and upper boxes, Moore repeated the flesh colours of *A Greek Play* and he recommended delicate shades of grey for the boxes themselves. A large-scale rendering of the overall decoration scheme garnered the support of

architects and painters to whom it was shown, and Phipps and the theatre's proprietor, Henry Labouchere, approved the execution of the designs.

Before work was very far along, however, Labouchere put a stop to it, evidently taking exception to the unaccustomed appearance of Moore's progressive style when expressed on a grand scale. The artist's intemperate response to the criticism abruptly terminated his association with the Queen's Theatre and he was not informed when Phipps instructed a watercolourist called Hart to make substantial alterations to the original drawings. The revised scheme was carried out by the decorators Messrs Green and King of Baker Street, Portman Square. Standard devices such as arabesques, medallions and musical instruments were substituted for the innovative ceiling ornament devised by Moore. The tender tones of grey that the artist had intended for the boxes were intensified to purple, and the fragile flesh colour of the seats made an intense red. The effect on Moore's proscenium painting was devastating. As Godwin himself expressed it, the 'offensive over-*prononcé* patterns swamp, with their barbarism, the exquisite Greek refinement of the only work of art our theatres possess'.[104]

When the Queen's Theatre opened in October 1867, the disjunction between its traditional décor and the progressive painting over the proscenium elicited grumbling. A disappointed Godwin reported that this 'attempt to reconcile the painter and the architect, in the persons of Mr. Albert Moore and Mr. C. J. Phipps ... has unfortunately been in vain.' Godwin faulted Moore for failing to ascertain the compatibility of the decoration scheme as a whole prior to accepting the commission to paint its principal feature. 'Mr. Moore's sin was a sin of omission', Godwin observed, 'of forgetfulness of the maxim that self-preservation is the first law of nature.' But the villain of the piece, according to Godwin, was the philistine Labouchere, whom he considered entirely out of his depth, unqualified to appreciate or understand Moore's advanced ideas. As a result of his meddling, Godwin alleged, Moore's scheme now appeared 'both pale and weak' in comparison with its gaudy surroundings. 'Had the painter's scheme been adhered to by the architect ... the Queen's Theatre would have been a success.' Indeed, Godwin concluded, the scheme of decoration 'would eventually have done good service to the art progress of the nineteenth century, by refining some of that lump called the English mind.'[105]

Intrigued by the controversy, members of the Institute of British Architects urged Phipps to lend the designs for the Queen's Theatre to their Conduit Street exhibition in May 1868. By complying, Phipps unwittingly launched a verbal battle that would fill the pages of

the *Building News* for weeks to come. The campaign began with an anonymous letter pondering how the garish colours shown in Moore's drawing could possibly have been selected by 'the painter of "Azaleas"' (Pl. 90), known for 'his harmonies of colour, and the Greek refinement which he always manages to infuse into his work'.[106] The question left Moore little choice but to defend his reputation. In the next issue of the *Building News*, he asserted that his drawings had been so completely altered since they left his hands the previous autumn that 'they cannot now be correctly described as mine or as suggested by me'. Indeed, until he stumbled upon the drawings at the exhibition, he had no idea that the unsanctioned alterations had been made.[107] The watercolourist Hart also entered the fray, bemoaning 'that impertinent interference' with which architects too often treated artists, and decrying the destruction of Moore's colour scheme and of the drawings themselves, which had been 'rent and patched by some clumsy hand'.[108]

Phipps countered these complaints with the reminder that artists must 'work *with* the architect' and adopt his concern for the scheme as a whole. 'Had more of this spirit been shown at the Queen's Theatre', he added, 'I should not now have to deplore the utter want of harmony between the mural decoration and the frieze which Mr. Moore painted.'[109] These unflattering charges elicited a lengthy letter from Moore in which he methodically refuted each of Phipps's statements, and complained that despite his own generosity in working without pay 'for the sake of having the decoration carried out in keeping with my proscenium ... Mr. Phipps has never even gone through the form of thanking me, but freely allowed himself the expression of such insinuations as the one contained in his letter, that I took no interest in the general harmony of the decorations.'[110] Phipps had the last word, squeezing in a final letter before the editor of the *Building News* called a halt. Apologizing for prolonging a correspondence that had 'degenerated into a personal squabble between Mr. Moore and myself', he cast further aspersions on Moore's designs and alleged that 'had Mr. Moore acted with good temper, or even common politeness, his scheme or a modification of it might have been accepted.' Phipps had altered the 'delicate flesh tint' and the 'unmitigated ugliness of the [ceiling] detail' solely because these were 'the very points which made the scheme ridiculous in the eyes of those for whom the theatre was built'. He added, 'I had the greatest difficulty in preventing, not only his decoration, but also the [proscenium] picture, from being cast aside altogether.'[111] Caught between an avant-garde artist in single-minded pursuit of his vision and a pragmatic businessman concerned with mass appeal, Phipps was obviously in an awkward position. Even whose who appreciated Moore's designs (as Phipps clearly did not) acknowledged that his

sensibilities were too far in advance of public taste for general consumption.[112]

It is easy to imagine Moore's distaste for this public airing of a 'personal squabble'. Nevertheless, undeterred by his clash with the commercially minded Phipps and Labouchere, he next ventured into the still riskier terrain of public works. His attention was first claimed by the decoration scheme proposed for the Albert Memorial Hall (then under construction), which included a seven-foot-high, 800-foot-long mosaic frieze encircling the upper part of the exterior wall. The building and decoration of the Hall were supervised by Henry Cole (1808-82), secretary of the Science and Art Department at South Kensington. On Friday 31 January 1868, Cole recorded in his diary, 'Saw Moore Artist who wanted £2000 to do the frieze of the Hall and wished to do it all himself.'[113] Cole's entry suggests scepticism at the ambitious price and scope of work proposed by Moore, yet he reportedly gave the artist an opportunity to prove himself. According to Baldry, Cole explained his ideas for the decoration, and Moore drew them up on a small scale. Sections were then enlarged to full size and elevated on scaffolding to test their legibility from the ground. Having progressed this far, Moore encountered immovable resistance on the matter of his fee. Convinced that the amount on offer would not compensate the lost income from other sources, Moore refused to budge and lost the commission altogether.[114] The frieze ultimately required the efforts of a small army of workers. Female students at the South Kensington School of Design enlarged drawings made by a team of seven professional artists, each of whom had responsibility for one or more fifty-foot segments of the frieze. For their efforts, the seven were paid a total of £782.[115]

65
MAIDENS
c.440 BC
Marble relief
Slab VII from the east
frieze of the Parthenon
Height 96 cm *(37¼ in)*
Louvre, Paris

66
THREE GODDESSES
c.435 BC
Marble
Sculptures from the east
pediment of the Parthenon
Length c.3.5 m *(138 in)*
British Museum, London

A second opportunity for contributing to a public building presented itself in 1869, when amid considerable parliamentary protest, the aborted decoration programme for the new Palace of Westminster was re-initiated by Austen Henry Layard (1817-94), former excavator of Nineveh, now First Commissioner of the Board of Works. Having recently championed Giuseppe Salviati's revival of ancient mosaic techniques by establishing the Venice and Murano Glass and Mosaic Company, Layard proposed that the mural decorations for the gloomy Central Hall be carried out in the light-catching medium of mosaic, which offered greater permanence and brilliance than fresco. The mosaics would be produced by the Salviati firm in Venice from designs made by young English artists whose work Layard knew and admired.[116] The first week of January 1869 Layard's office wrote to Moore offering him £100 for a cartoon of a single figure. When executed, the figure would measure about eight feet in height and appear against a gold ground framed by a mosaic border. The letter closed with the fateful clause that the cartoon was 'to become the property of the Board who are to be under no further obligation to you in respect of it'.[117]

Chastened by recent disappointments, Moore hesitated a week before

finally accepting the commission. He was then informed that there would in fact be four mosaics in the Central Hall, to be carried out by himself, Edward Poynter, Frederic Leighton and Val Prinsep. The choice of figure was left to each artist and no stylistic guidelines were stipulated.[118] The lack of continuity worried Poynter, who on sending in his cartoon of Saint David on 7 May, wrote: 'I have not seen any of the other designs so I do not know how far it will agree with them, but when all the designs are made we (the artists) might have a meeting.'[119] Some sort of meeting was indeed held on 14 June, but it is unclear whether the artists were present. Three days later, the Office of Works and Buildings modified the original agreement with Moore. Leighton and Prinsep were to be dropped and 'It is now proposed that you and Mr. Poynter should each of you prepare two cartoons, each cartoon representing subjects emblematical of one of the Four divisions of the United Kingdom.' Although Layard had 'no wish to suggest any particular treatment of the subjects ... he hopes that by your working together the design may be so far brought into harmony with each other as to form parts of one consistent scheme.'[120] Moreover, 'having reconsidered the circumstances of the case', Layard 'now proposed

that the sum to be paid for each such Cartoon shall be £150 instead of £100, as was originally intended'. Once again, Moore hesitated. On 22 June he met with Poynter and the architect Edward M. Barry to review their preliminary sketches and discuss the mosaics. Later in the day, Barry sent Layard's office word that 'everything is now arranged with Messrs. Poynter and Moore and they will at once proceed with their designs'. The following day Moore posted a terse acceptance of the commission.[121]

The arched shape of the mosaic panels provided Moore with a framework similar to that of the east window at St Mary, Thursford. Consequently, his cartoons for Saint Andrew and Saint Patrick utilize some of the same pictorial solutions that he had developed for stained glass (Pl. 70). As at Thursford, he divided up the vertical format in horizontal bands of contrasting colour and pattern. He also counterbalanced the verticality of the uppermost group of figures with horizontally disposed figures below. A palpable sense of stasis results from this balanced composition. Bolstering the mosaic's capacity to lighten the gloomy hall, Moore worked in a limited palette of pale green, orange, grey and yellow (which should be read as gold).

Moore completed his cartoons around the third week of July.[122] On 10 August he received a letter from the Office of Works and Buildings stating that 'while fully appreciating the extreme beauty and elegance of your designs, he [Layard] has arrived at the conclusion, although

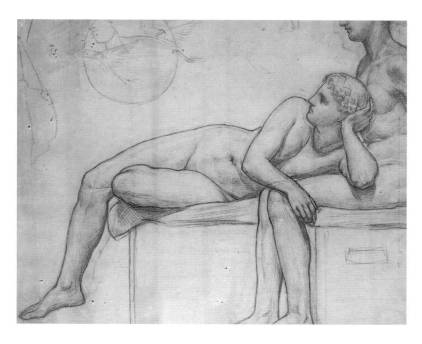

67
DETAIL OF PL. 68

68
STUDY OF A NUDE FEMALE FIGURE RECLINING ON A SEAT AND RESTING ON THE LAP OF A SEATED FIGURE, FOR 'A GREEK PLAY'
1867
Charcoal on brown paper
117 x 161.8 cm
(46⅛ x 63¾ in)
Victoria and Albert Museum, London

most reluctantly, that it will be impossible ... to assimilate them to those of Mr. Poynter'. It was Layard's opinion, the letter continued, 'that the designs of Mr. Poynter are more appropriate to the material in which they are to be executed, and he can therefore only express to you his regret that he is unable to avail himself of those proposed by yourself, which he so much admires.' As revealed in internal correspondence, Layard specifically objected to the monochromatic scheme and unsuitable style of Moore's drawings.[123] But political pressure as well as aesthetic judgement certainly motivated his extraordinary decision to renege on the agreement. Many in Parliament disliked spending public money on lavish decoration schemes, and Moore's progressive designs were unlikely to reassure them.

Oblivious to the situation in Parliament, Moore was utterly unprepared for Layard's bombshell. The extraordinary length and frank content of his response of 14 August articulate his enormous sense of personal injury in having been humiliated so publicly and unexpectedly at a crucial moment in his career. Side-stepping the impersonal middlemen who had been writing to him, Moore addressed Layard directly. 'When artists are applied to regarding important works such as those in question', he wrote, 'the point as to their fitness for the undertaking must have been already decided. Such being the case, I had no idea that in accepting the commission I was becoming the subject of an experiment.' The long germination and high profile of the commission made the failure of the 'experiment' disastrous from Moore's point of view. 'I have been publicly named as being engaged on this work', he reminded Layard; 'you must be aware that the rejection of my designs amounts to a very grave injury.'[124] Moreover, as 'no stipulation was made with me to take Mr. Poynter's designs as my model ... I cannot see by what reasoning I am to be considered solely responsible for any incongruity that may be thought to exist'. He had already made 'considerable changes' in his original design aimed at harmonizing with Poynter's work, and the remaining distinctions 'would necessarily disappear in execution, on account of the use of the same materials'. He stated that both he and Poynter were agreed on this issue, 'having some experience in such matters', adding sardonically, 'I should have expected that some weight would have been attached by you to Mr. Poynter's opinions, at any rate.'[125]

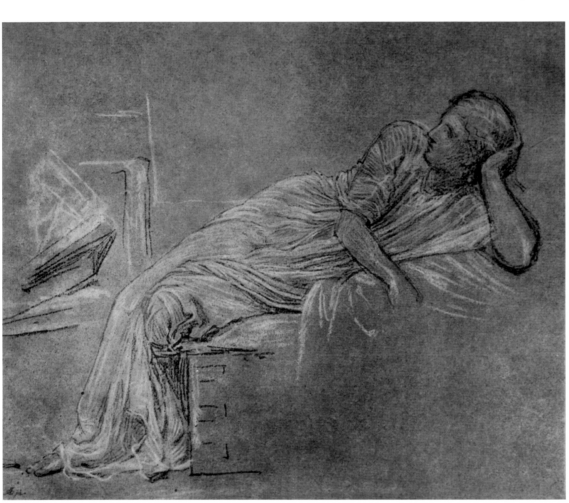

69
STUDY OF A DRAPED
FEMALE FIGURE RECLINING
ON A SEAT, FOR 'A GREEK
PLAY'
1867
*Black and white chalks on
brown paper*
Whereabouts unknown
(from Baldry, *Albert Moore*,
opp. p. 76)

Layard, then travelling on the Continent, was informed of Moore's letter by an assistant who warned him 'not to pitch Moore altogether', for fear of the trouble the outspoken artist might stir. 'He will no doubt get up a row among his brother artists, and perhaps in the House; and as he is certainly a man of talent, many, who won't take the trouble to read the papers, or could not reason logically upon them if they did, will sympathise with him as an artist.'[126] In reply, Layard urged his colleagues to handle Moore delicately, for 'I have not committed myself to Poynter with regard to the four mosaics and I should still be very glad to come to an arrangement with Moore, whose talents I much admire.' On the other hand, he considered the artist unrealistic in his ideas of public decoration:

> Moore seems to forget that the decoration of a great hall is [a] very different thing from the mere painting of a picture in which the artist could of course be left entirely to himself. But in decorating a great building for the public the architecture must be consulted and the critics and the public taste—and in this respect it is I not Mr. Moore, who would be responsible to the public.

Layard asked that 'a civil letter' be written to Moore stating 'that as soon as I return I will see him, and that it would give me great pleasure if we could come to some arrangement. At the same time not pledging me to anything.'[127] Before the issue could be resolved, a ministerial reshuffle resulted in Layard's replacement by Acton Smee Ayrton, a man 'with a lukewarm zeal for art, but with very strong instincts for economy and a very decided distrust of the artistic race'.[128] Lacking Layard's esteem for Moore, Ayrton was presumably less indulgent of his wounded pride. Consequently, a meeting in November 1869 concluded with Moore's announcement that 'he cannot further adapt his style to that of Mr. Poynter, and that, rather than attempt it, he would prefer that the agreement should be

cancelled, he being paid for the services he has already rendered'. Moore's request for £126 triggered a spate of official quibbling, but on 29 December he received 100 guineas, along with the written assurance that the commission 'is only rescinded in consequence of the necessity for preserving unity of style', and that the Board of Works, 'entertaining as they do a high opinion of your talent, regret that under the circumstances of the case, they cannot avail themselves of your valuable services on the present occasion.'[129] Moore had been treated poorly, but his resolution to make 'no concession whatever' was also largely to blame. 'I wish he was less impracticable,' sighed Frederic Leighton in a letter of October 1869 to his friend Layard. Thanking the former Commissioner for his efforts on behalf of the talented but headstrong artist whom they both admired, Leighton acknowledged, 'He belongs to the "irritabile genus".'[130]

The frustration and disappointment occasioned by Moore's abortive labour at Austin Friars, the Queen's Theatre, the Albert Memorial Hall and the Houses of Parliament seem to have discouraged him from actively seeking further architectural work. These episodes can only have reinforced his impatience with authority and his commitment to the solitary pursuit of his own private vision. That vision had nevertheless been changed forever by the experience of designing for architecture. During the rest of his career, Moore would rely on the same abstract geometric principles in designing his easel pictures. Moreover, these pictures were invariably characterized by the qualities required of mural paintings: two-dimensional linearity; breadth of handling; a dry, matt surface; and shallow space. The experience of fresco painting, which required a rapid or, literally, 'fresh' manner of execution, also left an indelible mark on the artist's mature technique. Though he rarely designed pictures for a specific architectural setting, Moore never lost sight of the fact that his paintings were integral elements in a larger architectural ensemble.

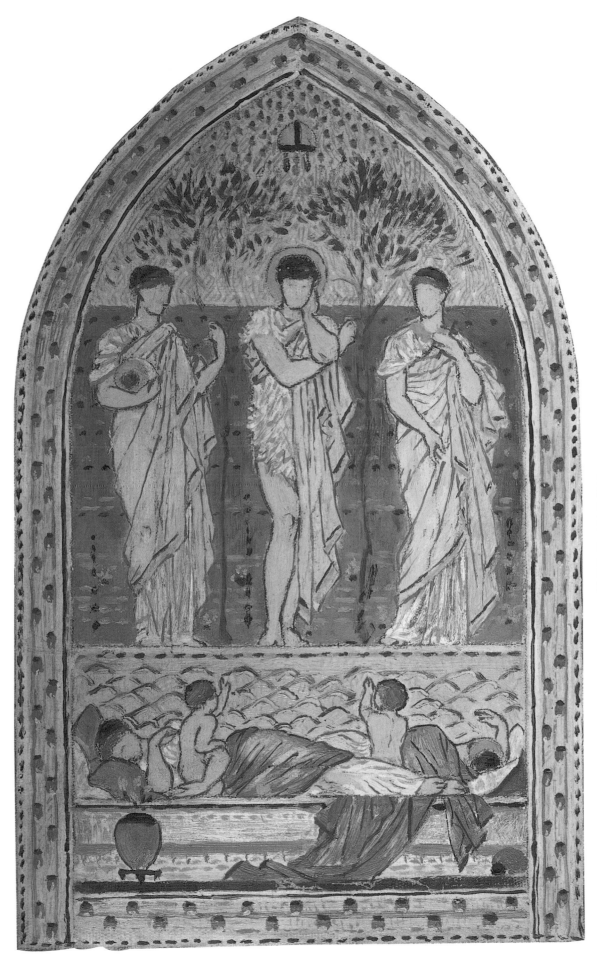

70
DESIGN FOR MOSAIC
PANEL, 'ST PATRICK'
1869
Watercolour
35.5 x 21.6 cm
(14 x 8½ in)
Public Record Office,
Kew, London

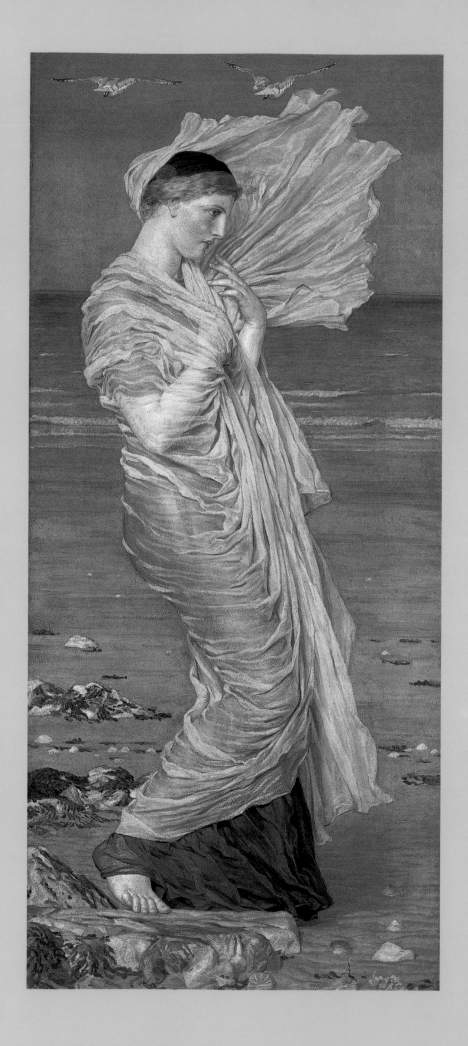

71
SEA-GULLS
1870-1
Oil on canvas
68.5 x 154.8 cm
(27 x 61 in)
Williamson Art Gallery &
Museum, Birkenhead

72
STUDY OF TWO NUDE
WOMEN FOR 'NYMPHS
DANCING'
*c.*1870-2
Black chalk heightened with
white on brown paper
33.0 x 44.4 cm
(13 x 7½ in)
Private collection

THE ANALYSIS OF BEAUTY

1865-74

MOORE'S DESIGN WORK FOR ARCHITECTURE TRANSLATED DIRECTLY INTO HIS FREE-STANDING PAINTINGS. CONVINCED THAT THE DISTINCTION BETWEEN MURAL AND EASEL PAINTING WAS FALLACIOUS, AND THAT THE FOREMOST OBLIGATION OF ALL ART WAS TO BE 'DECORATIVE', HE MOVED STEADILY TOWARDS AN IMAGERY THAT FUNCTIONED PURELY VISUALLY, WITHOUT REFERENCE TO EXTRANEOUS SUBJECT-MATTER. HIS EVOLVING CONCEPTION OF PAINTING IN ABSTRACT TERMS, AS A PROBLEM OF LINEAR AND CHROMATIC ARRANGEMENT, WAS RADICAL IN ITS TIME, REVERSING THE PREVAILING VIEW THAT DESCRIPTIVE STORYTELLING CONSTITUTED THE CHIEF FUNCTION OF ART. WITH INCREASING CLARITY, MOORE ASSERTED THE REVOLUTIONARY IDEA THAT THE ARTIST'S CHOICE OF SUBJECT WAS ACTUALLY IMMATERIAL—'MERELY A MECHANISM FOR GETTING BEAUTIFUL PEOPLE INTO BEAUTIFUL SITUATIONS'[1]—AND THAT LINE, COLOUR AND FORM HAD THEIR OWN INDEPENDENT STORY TO TELL. HIS APPROACH PUT INTO RIGOROUS PRACTICE THE ARTISTIC THEORIES THAT WOULD SOON CRYSTALLIZE AS THE AESTHETIC MOVEMENT. BUT ALTHOUGH OTHER ARTISTS WOULD JOIN HIM IN ELIMINATING NARRATIVE CONTENT FROM THEIR PAINTINGS, NO BRITISH ARTIST OF THE NINETEENTH CENTURY MATCHED ALBERT MOORE'S COMMITMENT TO ADAPTING AESTHETIC THEORY TO WORKS OF ART.

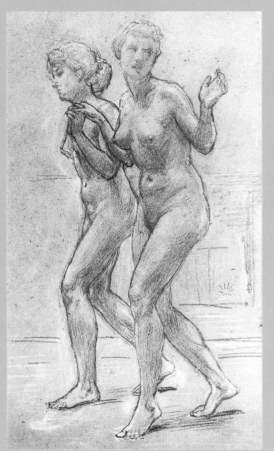

The Royal Academy exhibition of 1865 marked the turning point in Moore's approach to subject-matter and style. He contributed two distinctly dissimilar paintings which critics interpreted as evidence of 'his wealthy invention and scope of artistic power'.[2] In truth, however, the paintings were less indicative of the artist's range than of his transition from the conventional subjects of his youth to the original ideas that occupied his mature career. Incomplete at the time of the 1863 Academy exhibition and rejected in 1864, *Elijah's Sacrifice* (Pl. 28) was already a relic of the past, a vestige of the artist's brief enthusiasm for the biblical subject-matter popular among 'cutting-edge' painters of his student days. *The Marble Seat* (Pl. 73), by contrast, drew inspiration from the classical vocabulary and lack of narrative in Moore's recent architectural design work, pointing the way forward to a new direction in British art.[3] As most critics recognized, the composition was inspired by a sculpture group from the east pediment of the Parthenon (Pl. 74), a prestigious model that would resurface frequently in paintings by Moore's contemporaries.[4] But *The Marble Seat* also revisits the intimately grouped, classically draped women of *The Four Seasons* (Pl. 31), the fresco Moore had exhibited at the previous year's Academy. The level of abstraction in that work was excused by its monumental medium. *The Marble Seat*, by contrast, was a free-standing oil painting, and in it, verisimilitude was expected to outweigh decorative concerns.

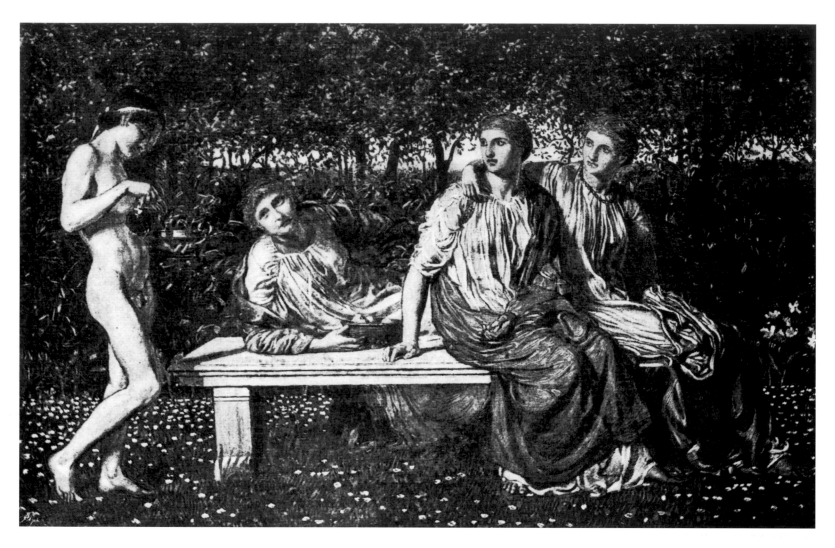

73
THE MARBLE SEAT
1865
Oil on canvas
73.6 x 47 cm
(29 x 18½ in)
Whereabouts unknown
(from Baldry, *Albert Moore*,
opp. p. 28)

As a result, critics scarcely knew what to make of the picture. Everything about it, from the seemingly irrelevant title to the lack of telling gestures and facial expressions, seemed (and indeed was) calculated as a foil to narrative interpretation, undermining the psychological element on which Victorian viewers relied in responding to works of art. The suppression of emotion, while aiding Moore's overall project of eliminating meaning, also demonstrated conscious imitation of classical art, in which the eradication of strong passions and momentary emotions had long been recognized as a defining quality.[5] In this respect, *The Marble Seat* presented a marked contrast to *Elijah's Sacrifice* and to the evocations of antiquity that other young artists of Moore's circle contributed to the 1865 exhibition. In *Habet!*, for example, Simeon Solomon traced the various emotions experienced by Roman women at a gladiatorial contest (Pl. 75). Moore's painting, in the view of William Michael Rossetti, 'represents classic social life from a different point of view—no longer the dramatic and passionate, but with that conception of ideal repose and silent remoteness which predominates when the mind yields itself up to the contemplation of antiquity'. As such, Rossetti asserted, the painting 'reaches back much further than Mr. Solomon's to the roots of the typical classic feeling'.[6]

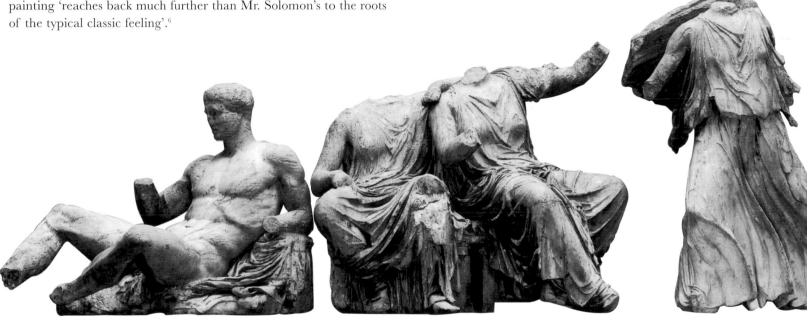

74
THREE GODDESSES WITH
DIONYSUS
c.435 BC
Marble
Sculptures from the east
pediment of the Parthenon
Height of tallest figure
173 cm *(68¼ in)*
British Museum, London

Solomon's *Habet!* furnishes a vivid reminder of the fact that Moore pursued his interest in the autonomy of art not in a vacuum, but in an atmosphere permeated by the French philosophy of *l'art pour l'art* (art for art's sake). The notion of art as a law unto itself, functioning independently of moral or social obligations, had existed in France and England for some time, but in the writings of Charles Baudelaire (1821-67) and Théophile Gautier (1811-72) the philosophy crystallized as an invitation to savour the pleasurable sensations of taboo experiences and ideas. Solomon's seductive coalescence of cruelty and beauty in *Habet!* exemplifies this aspect of art for art's sake, no doubt inculcated by his friend the poet Algernon Swinburne, who had published a review of Baudelaire's *Les Fleurs du mal* in 1862. Like Gautier and Baudelaire, Solomon and Swinburne delighted in affronting the conventional mores of 'philistine' society through their pursuit of an amoral cult of beauty. After meeting Swinburne at one of Solomon's 'bachelor parties' in 1864, the artist George du Maurier

declared 'he has an utterly perverted moral sense, and ranks Lucrezia Borgia with Jesus Christ.'[7] Solomon's questionable morality also aroused concern; John Addington Symonds described his art as 'the product of a distempered and radically vicious soul gifted with a sense of beauty—une fleur maldive'.[8]

This licentious aspect of the art-for-art's-sake philosophy had no apparent impact on Moore. Although he and Solomon worked closely in the 1860s and shared many of the same sources, they interpreted their materials in entirely different ways. Around the time that Moore was painting *The Marble Seat*, Solomon, under Swinburne's influence, executed a watercolour that re-formulated the seated goddesses of the Parthenon pediment as a lesbian romance, a provocative theme previously adopted by both Baudelaire and Gautier (Pl. 76). Significantly, it is only Solomon's subject-matter that challenges the status quo: artistically, it is a conventional Victorian image, an amalgamation of clues necessary for 'reading' a particular story. Moore compiles no such clues in *The Marble Seat*, nor does he insinuate a salacious undercurrent. On the contrary, he interprets beauty's independence from conventional morality in terms of purity rather than license. Undisturbed by passion, the female figures in his painting gaze sedately at the youth pouring wine into a kylix, seemingly oblivious to his nakedness.

The women's equanimity would not have been shared by Moore's contemporaries. Unaccustomed to male nudity in recent art, most would have considered this encounter between a naked ephebe and two fully clothed, mature women indecent and bizarre. Moore probably derived his transgressive imagery from classical Greek sculpture and painting, in which nude males and draped females are the rule (see, for example, Pls. 74, 108, 175). His recent sojourn in Rome would also have been a factor, encouraging a more relaxed attitude towards the body than that which prevailed in his own country.[9] Indeed, the very blandness with which Moore's figures encounter one another constitutes a daring challenge to the prevalent Victorian view of artistic nudity as an incitement to lust. While this pioneering assertion may have shocked the average Royal Academy visitor, it encouraged several of Moore's friends and colleagues (among them, Frederic Leighton, Frederic Walker and William Richmond) to exhibit their own tributes to youthful male nudity at the Academy.[10]

Socially as well as artistically, Moore seems to have been oblivious (or at least impervious) to the dabbling in taboo experience that Solomon, Swinburne and others in his circle pursued in imitative pursuit of Baudelarian amorality. When in 1863 Solomon showed off a salacious pamphlet on flagellation, a topic that he and Swinburne relished, Moore was entirely nonplussed. Solomon informed the poet, 'when he [Moore] read it he asked me with open mouth and eyes what it meant; he was entirely ignorant of [the] whole subject, and I sighed to think how I was in his happy, innocent condition ... but, I warrant you, I quickly enlightened him.' Solomon's explanation failed to entice Moore, nor did the risqué picture accompanying the text. His only comment was that the illustrator was evidently 'accustomed to draw

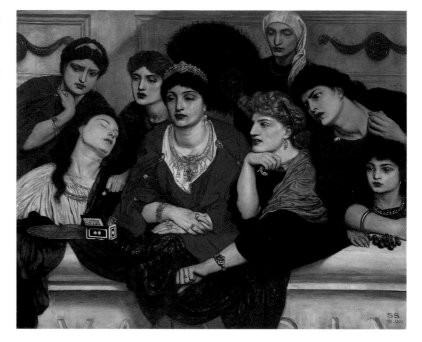

75
Simeon Solomon
HABET!
1865
Oil on canvas
121.8 x 101.2 cm
(48 x 39⅞ in)
Private collection (on loan to Bradford Art Galleries and Museums)

patterns of books, for the books as you will see are eminently superior to the rest of the drawing'.[11] It is small wonder that some members of this outré circle repudiated Moore as 'dull'.[12]

The Academy exhibition of 1865 established 23-year-old Moore as a prominent figure within London's avant-garde. Thereafter, his works attracted prominent critical notice—despite the vertiginous heights and obscure corners to which the Academy's hanging committee generally consigned them. Although several critics had encouraged him to pursue the human drama of *Elijah's Sacrifice* rather than the rarefied atmosphere of *The Marble Seat*, Moore was already well advanced on an ambitious painting which, despite its Old Testament theme, constituted a further development of his abstract, classical and decorative interests. Begun around 1864, *The Shulamite* (Pl. 77) rivals the size of some of Moore's designs for architecture, measuring nearly seven by three feet. Eschewing the drama and emotion of his earlier Old Testament scenes, Moore adapted a passage from the Song of Solomon in which the lovesick bride catalogues the attributes of her absent loved one.[13] Sumptuous in imagery and amorous in tone, these verses enjoyed considerable vogue in the 1860s among artists like Moore who were increasingly engaged by beauty and mood at the expense of action and emotion.[14] Instead of representing the bride's voluptuous vision, Moore suggested the impact of her words on a listening audience, a strategy later repeated by Simeon Solomon.[15] As the bride speaks, her spellbound maidens unconsciously embrace and hold hands. Their instinctive response to beauty is physical intimacy and affection. The resulting figural groups convey a mood of pleasurable, passive repose.

An early watercolour study for *The Shulamite*[16] shows a slightly more compressed figural composition and a lavish mosaic floor reminiscent of that in *Dancing Girl Resting* (Pl. 33). Measured order and classical restraint prevail in the final design, which reflects Moore's recent experience in relating the human figure to an architectural framework. In both composition and subject-matter, the painting resembles the figural group he was simultaneously designing for the Great Hall at Cloverley, in which an audience of classically draped figures listens to a seated speaker (Pl. 47). As at Cloverley, Moore unified the composition by means of an implied central arc which skims the heads of the bride and the central group of figures. A series of horizontal bands punctuated by vertical elements imposes order on the expansive scene, a compositional strategy also adopted at Cloverley and later repeated in *A Greek Play* (Pl. 64), another architectural representation of a classically draped audience. Conceiving of *The Shulamite* in the spirit of mural painting—as an integral part of a larger decorative ensemble—Moore devised a frame for the picture in which the simple, geometric lines recall the architectural mouldings surrounding his mural design for Cloverley.

When *The Shulamite* finally appeared at the Royal Academy in 1866, its 'eccentricies' struck viewers forcibly.[17] It was among a number of audacious pictures that the conservative hanging committee (Charles West Cope, John Callcott Horsley and Thomas Faed) felt obliged to punish through ambivalent placement: within the prestigious North

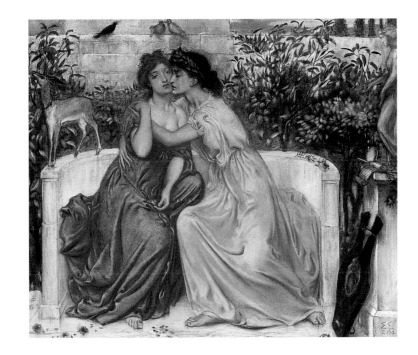

76
Simeon Solomon
SAPPHO AND ERINNA IN
A GARDEN AT MYTILENE
1864
Watercolour
33 x 38.1 cm
(13 x 15 in)
Tate Gallery, London

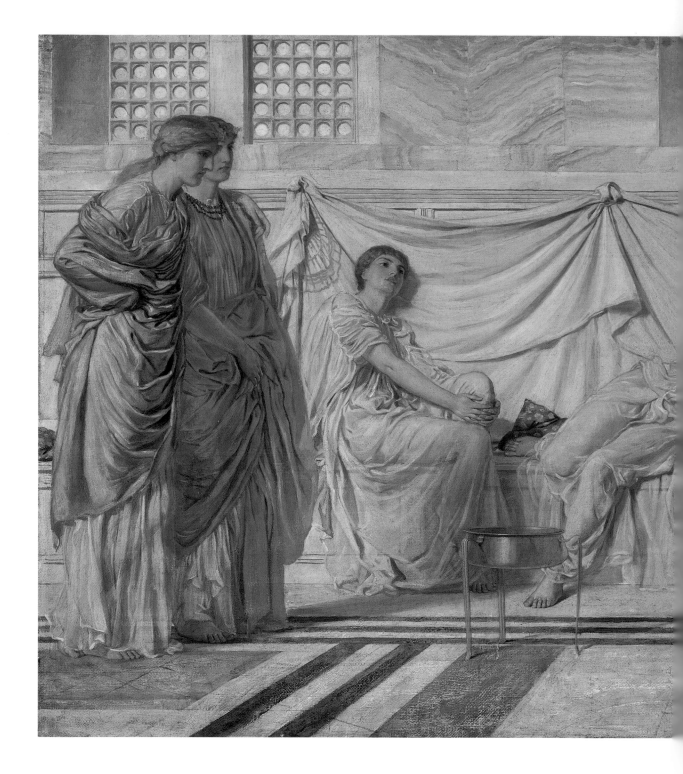

77
THE SHULAMITE
1864-6
Oil on canvas
210.6 x 96.4 cm
(83 x 38 in)
Walker Art Gallery,
Liverpool

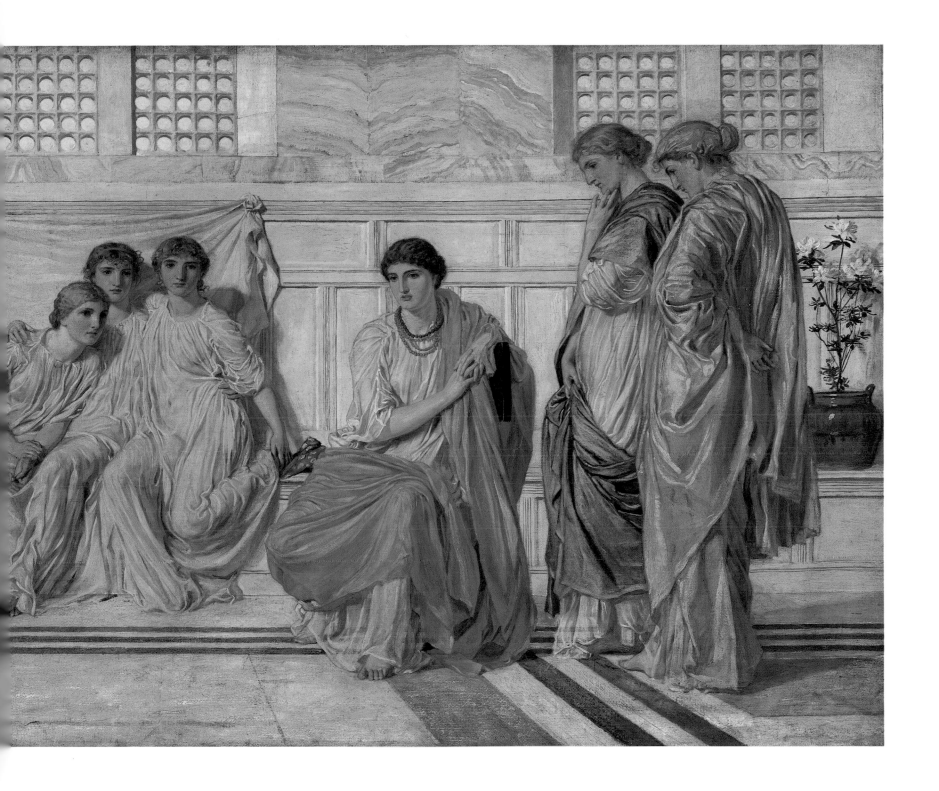

Room but at an outlandish height over one of the doors. Sympathizers noted that Moore's picture 'suffers most from its elevation, for its merits are of a more delicate and subtle kind' and 'its exquisite draperies, clothing exquisite form, [are] wholly out of sight'.[18] The artist's evident reliance on antique prototypes elicited both praise and blame. J. Beavington Atkinson complained that Moore had based his drapery style not on classical Greek sculpture 'but after the manner of the corrupt Roman', and that his handling adopted 'the mannerism rather than the merit' of Pompeian wall-painting.[19] The most

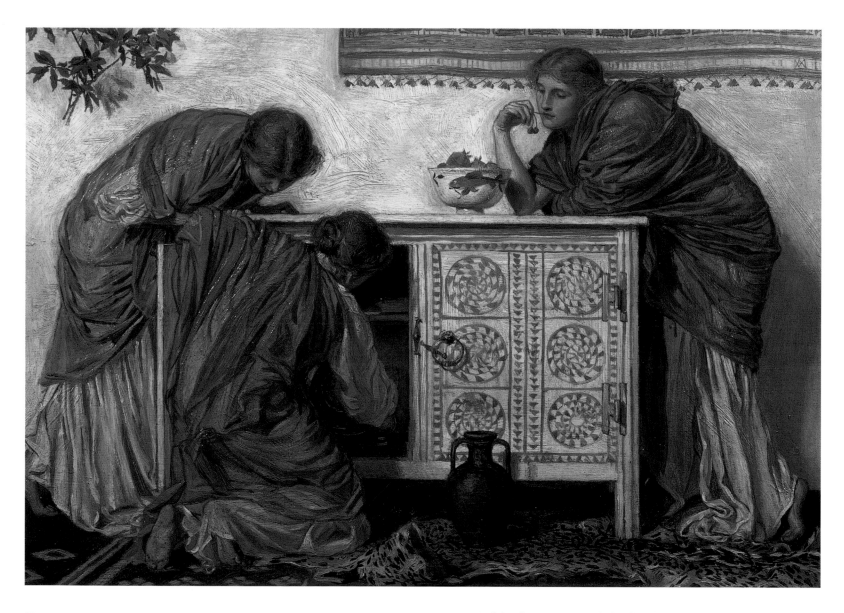

78
POMEGRANATES
1865-6
Oil on canvas
25.4 x 35.5 cm
(10 x 14 in)
Guildhall Art Gallery,
London

strenuous objections concerned the flaccid organization of colour and form, and the repetitive quality of the heads and drapery. It is true that the panoramic scope of *The Shulamite* resulted in a diffuse composition and that the disparate figural groups lack cohesion. However, Moore probably cultivated the repetitive quality deliberately, as an early instance of his treatment of facial features and drapery folds as elements of a pattern, deployed with an eye to rhythmic sequencing and harmonic balance. Preparatory studies from the nude and draped model demonstrate far closer attention to the nuances of each figure than his critics credited him with.[20]

While conservative commentators recoiled from Moore's 'eccentricities', the cachet of 'advanced' art immediately lured a special breed of collectors who prided themselves on appreciating recondite artistic genius.[21] Stylistic boundaries mattered little to these enthusiasts. Thus, while critics characterized Moore's art as a violent reaction against Pre-Raphaelitism, his collectors recognized no such opposition. John Hamilton Trist hung *Elijah's Sacrifice* and a subsequent painting, *Pomegranates* (Pl. 78), alongside works by Dante Gabriel Rossetti, Arthur Hughes and Ford Madox Brown.[22] A similar mixture characterized the collection of the wealthy Liverpool insurance underwriter Philip Rathbone (1828-95), purchaser of *The Marble Seat* and *The Shulamite*.[23] Rathbone, like Trist, frequented artists' studios and absorbed their progressive ideas. He later broadcast these concepts in lectures and articles, several of which contain generous praise for Moore as well as statements that seem to paraphrase the artist's own opinions. Paying homage to Moore's gift for monumental painting, Rathbone on one occasion decried the taste for easel pictures that had 'cramped into domestic decoration a genius whose grace of line remains upon private canvases instead of upon public walls, but whose nobility of idea and conception has had absolutely no field for expansion'.[24] Rathbone also championed paintings of chaste nudity such as *The Marble Seat*, declaring, 'It is necessary for the future of English art, and of English morality, that the right of the nude to a place in our galleries should be boldly asserted.'[25]

The long germination of *The Shulamite* made it almost as much a relic of the past in 1866 as *Elijah's Sacrifice* had been in 1865. These large canvases impeded the rapid evolution of Moore's ideas, and a more accurate assessment of the state of his art in 1866 is provided by the smaller pictures he exhibited at the Academy that year, *Pomegranates* and *Apricots* (Pl. 80). Of the two, *Pomegranates* marks the most dramatic advance over the diffuse organization of *The Shulamite* and provides the clearest evidence of the systematic investigation of formal principles that Moore carried out during this period. The orange discs ornamenting the cabinet supply the key to the entire composition, which is built upon round forms and concentric curves. The most important of these are the curved backs of the two standing women, which generate a unifying, circular motion that enhances the picture's cohesion.[26]

The transitional nature of *Pomegranates* is confirmed by the combination of familiar props (such as the mosaic floor, leopard skin and wall hanging employed previously in *Dancing Girl Resting*) with allusions to Japanese art, which according to Baldry ranked alongside Greek art as a seminal influence on Moore's evolving formal system. Not only is the scene reminiscent of an *ukiyo-e* print (Pl. 79), but the carp bowl, the radically truncated wall hanging, the suspended spray of foliage and the ornamentation of the cabinet all imitate Japanese artefacts and pictorial conventions.[27] Moore also emulated the precise mapping of shapes and colours by Japanese artists, ensuring that areas of whiteness balance darker areas, and that the various pigments fall into harmonious relationships. The unmodulated contrast between the vibrant orange and pink drapery and the stark white backdrop

79
Kitao Masanobu (Santo Kyoden)
THE COURTESANS SEGAWA AND MATSUBITO
1783-4
Coloured print
36.7 x 50.8 cm
(14½ x 20 in)
British Museum, London

emphasizes the silhouettes of the figures, which read as two-dimensional shapes. The artist's instinctive minimalization of spatial depth and chiaroscuro attain greater clarity here from the example of Japanese art.[28]

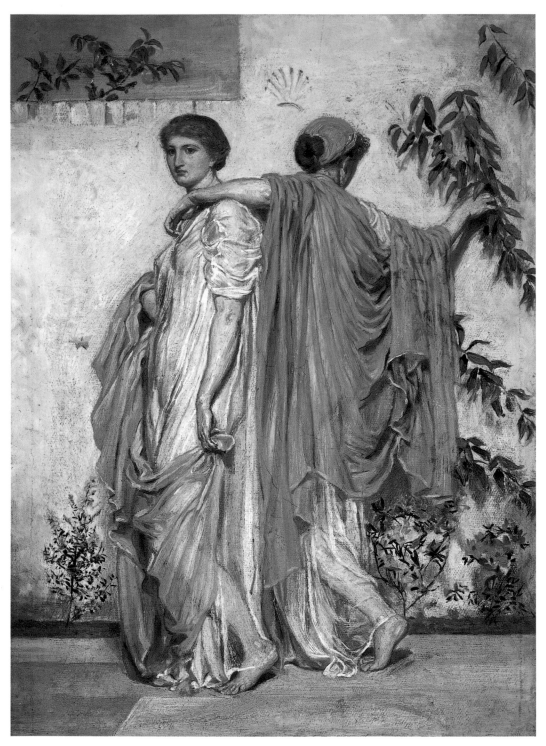

Pomegranates provides an early instance of the anachronism that Moore deliberately embraced as an integral feature of his art. Merging Japanese artefacts and pictorial conventions with Greek drapery, and rendering them in the dry manner of Roman wall-painting,[29] the picture marks Moore's conscious rejection of temporal and geographical coherence in favour of the alternative logic of beauty. Shortly after completing *Pomegranates*, he devised a signature emblematic of the universal aesthetic principles that he sought in diverse cultures. From the fanning lines of the superimposed initials 'AM' with which he signed *Pomegranates* and earlier paintings,[30] Moore fashioned a stylized anthemion—an ornament occurring in a wide range of cultures but noted in his day as peculiarly prevalent in Greece and Japan.[31] The first publicly exhibited painting to bear the anthemion is *Apricots*, in which the device masquerades as a faded graffito reminiscent of the kind found on the walls of Pompeii.[32] This splash of colour near the centre of the canvas helps anchor the asymmetrical composition, but the unusually prominent placement lends the signature a provocative quality. Like the cryptic 'PRB' on early paintings by the Pre-Raphaelite Brotherhood, the anthemion served as an advertisement of party loyalty intended to mystify outsiders. In 1860 Simeon Solomon had begun to sign his drawings with a monogram crowned by an anthemion, a device he also used in engraved stationery from 1865. When the American expatriate artist James McNeill Whistler (1834-1903) first exhibited a painting bearing his emblematic butterfly, its kinship with Moore's signature was recognized immediately.[33]

Although eclecticism is less overt in *Apricots*, it remains a fundamental influence. Japanese prints inspired the more audacious aspects of the composition, such as the rectangular view of sky and foliage, inserted like a cartouche into the upper left of the canvas, and the parallel rows of branches at right, which emulate the emphatic diagonals favoured by Japanese artists.[34] Whereas in *The Shulamite*, Moore took pains to chart the illusion of

three-dimensional space through the lines of the architecture, in *Apricots* he deliberately blocked spatial recession by means of a shallowly placed wall. His omission of foreground and background and of linear perspective imitates the aspects of Japanese art that struck British observers most forcibly.[35] However, the same features recall aspects of Roman wall-painting, as does the dry, chalky appearance that Moore cultivated by mixing his pigments with only a small quantity of oil.[36] Indeed, the figures themselves call to mind two of the most famous paintings taken from the walls of Pompeii and Stabiae (Pls. 81, 99).

Apricots also demonstrates Moore's continuing interest in the representation of movement. The complicated pose of the figure at right (moving forward while simultaneously gesturing back with her head and arm) is calculated to suggest spontaneity. Any awkwardness is dispelled by the broad, rhythmic waves of cloth descending from her shoulders, which visually unify her seemingly disconnected limbs.[37] The flexed calf of her left leg, plainly visible beneath the transparent drapery, echoes the position of her partner's leg—a repetition that contributes to the sense of sequential movement. Still feeling his way with the use of drapery, Moore overburdened these figures with far too much fabric. The great bundles of cloth carried over the akimbo arm of the figure at left and the extra loop doubled over her companion's right arm seem to interfere with the freedom of their limbs. Moreover, the action of the drapery bears no relationship to the form and movement of the bodies beneath. In *Pomegranates*, by contrast, the swags and folds of drapery help to articulate the body by following its contours, encircling the curves of the kneeling woman's thighs and the back and hips of the figure to her right.

With *Pomegranates* and *Apricots*, Moore initiated his practice of employing titles that refer to natural objects within the painting. In truth, he disliked using titles at all, and informed one appalled patron that the picture he had commissioned had no name and he could call it whatever he liked.[38] On another occasion, when the conventional labels *A Greek Slave* and *A Roman Lady* were arbitrarily appended to two of his paintings at McLean's Gallery, Moore was sufficiently incensed to disavow the titles in a public letter.[39] Nevertheless, Moore seems to have used his peculiar titles, as Whistler did, to 'point out something of what I mean in my theory of painting' and to 'indicate seriously the kind of work I am about'.[40] The titles dissociate Moore's works from any nuance of sentimental or historical meaning, indicating that his paintings are no more 'about' the women on whom we instinctively focus than the flowers and fruit we might otherwise have overlooked. Through his titles Moore may also have wished to invoke analogies with still-life painting, a non-narrative art form that lends itself to evaluation in purely visual terms.[41] The implied objectification of the human figure reflects Moore's habitual response to the world in visual rather than personal terms. One of his closest associates noted, 'Albert Moore would come in from a walk full of almost inarticulate delight at the memory of ... a flower-girl's basket of primroses seen through grey mist on a rainy morning. Burne-Jones would have woven a romance or told an amusing tale about the flower girl, but would not have noticed her primroses.'[42] The comparison reveals as much about

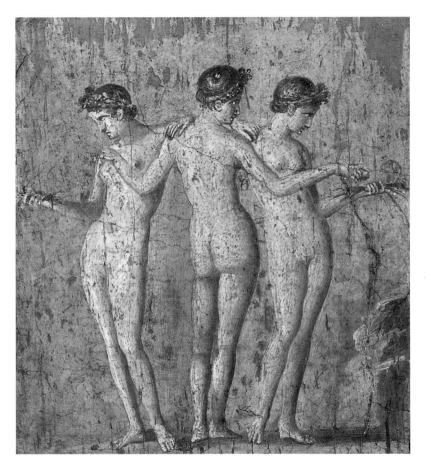

80
APRICOTS
1866
Oil on canvas
42.5 x 28.5 cm
(16¾ x 11¼ in)
Fulham Public Library,
London Borough of
Hammersmith

81
THREE GRACES
*c.*79 AD
Wall painting from Pompeii
Museo Nazionale, Naples

Moore's life as it does his art, helping to explain his air of detachment in social situations and his ultimate immersion in art to the virtual exclusion of companionship.

Yet during the 1860s and early 1870s Moore participated actively in a convivial network of rising young artists, architects and writers based in the bohemian neighbourhood bordering Fitzroy Square, where he had once shared a flat with his mother and brothers. Moore had clung to this familiar artistic centre on returning from Rome in 1863, settling first at 12 Newman Street, before relocating in 1865 to Russell Place (redesignated Fitzroy Street later in the year).[43] The neighbourhood was notoriously shabby and the studio-flats spartan indeed, but it was there that Moore began to spin his dreams of ideal beauty and to solidify his reputation within the artistic avant-garde.[44] The shared necessity of finding fresh air and proper cooking did much to fuel the rapid development and dissemination of new ideas among the young turks of Fitzroy Square.[45] Moore's neighbour Simeon Solomon was constantly in and out of his studio, occasionally bringing new friends along.[46] The painter Thomas Armstrong did the same, later describing himself as 'a constant visitor' to Moore's studio. In addition to observing the artist at work, Armstrong acquired preparatory drawings for a few of Moore's paintings, and his indoctrination is manifest in the often-noted resemblance of his work to Moore's.[47] William De Morgan, another admirer of Moore's art and a former colleague at the Royal Academy Schools, recalled a gang of artists collecting Armstrong from his flat in Charlotte Street so that they could all go 'like sheep' to observe Moore at work.[48] Nesfield's architectural offices in Argyll Street were a few blocks away, and Moore reportedly spent much time there, along with Armstrong, Whistler and the illustrator Randolph Caldecott. Around the corner from Nesfield was Greliche's restaurant, a favourite gathering spot for Moore, Armstrong, Caldecott, the painter Thomas Reynolds Lamont, the architect Joseph Wallis and the illustrator Henry Blackburn.[49] Rome itself could not rival Fitzroy Square's mix of creativity and companionship. Marooned in that city in 1867, Simeon Solomon confessed to his patron Frederic Leyland, 'One of my principal reasons for desiring to be again in England is to be again among all those painters who are to me so much better than any others, I mean [Burne-]Jones, Rossetti, Whistler and Moore.'[50]

'Gentle, earnest Albert Moore' seems an unlikely member of this boisterous, bohemian crowd (Pl. 82). But his extroverted and often outrageous friends admired him for his strong convictions and forthright nature, and he, in turn, enjoyed the respite they provided from his own pensive, perfectionistic nature. A friend of later years remarked, 'He was a sad man, and loved to laugh.'[51] Contemporary accounts attest to the great affection that Moore inspired among his associates. He was decidedly 'not a man who wore his heart on his sleeve', it was noted, 'but to those with whom he chose to be intimate he was a most delightful and social companion, looking at the world and its ways with his own eyes, forming his own judgments, and expressing them in a very happy and original manner, quite unbiassed by convention.'[52]

82
Photograph of
Albert Moore
n.d.
(from Baldry, *Albert Moore*,
p. 1)

Moore's instinctive gravitation towards fellow iconoclasts fostered the development of his art in unconventional directions while alienating the artist from the more conservative friends of his youth. In 1867 William Blake Richmond returned from an eighteen-month sojourn in Italy to find that Moore had 'joined the Whistler clique, which was not to my liking'. Apart from his objections to Whistler himself, who 'made himself sometimes into a god, sometimes into a buffoon', Richmond believed that his influence 'destroyed almost completely the imaginative faculty which was evinced in Moore's early work'. It is not known exactly when Moore met Whistler, who ultimately became his 'most intimate friend and keenest sympathizer'.[53] Years later Moore indicated that their friendship began in 1864, when he was 23 years old and Whistler 30.[54] That was the year of Moore's one-man show at his studio in Newman Street, at which he first exhibited *The Four Seasons* and *Elijah's Sacrifice*. It was also in 1864 that Moore joined the Arts Club, founded in March of the previous year as 'a place of meeting for the large element of art society in London'.[55] Whistler was among the founding members, as were several friends, acquaintances and sympathizers of Moore.[56] Located in Hanover Square, a short walk from Moore's studio, the club offered artists a comfortable place to smoke, drink and chat, far from the smell of turpentine and linseed oil. Moore almost invariably addressed his correspondence on Arts Club stationery, and he continued to make visits until the year of his death. If not at the Arts Club, Moore and Whistler might easily have met through their mutual friend Simeon Solomon, who delighted in orchestrating introductions and brought several new friends to both artists' studios.

Certainly by August 1865, Whistler and Moore were sufficiently intimate for the former to fire off a letter to the artist Henri Fantin-Latour in Paris, proposing that Moore become the third member of their idealistic triumvirate, the Société des Trois. In that position Moore would substitute for the French painter Alphonse Legros, with whom Whistler had quarrelled recently. Whistler wished to paint the three of them in a portrait intended (like the society it commemorated) as 'an apotheosis of everything that can scandalise the Academicians'. Moore had not only replaced Legros in Whistler's life, but also Dante Gabriel Rossetti, whom Whistler had eighteen months earlier proposed to include in another group-portrait-as-manifesto, Fantin's *Hommage à Eugène Delacroix* (1864).[57] Whistler had reportedly endeavoured to orchestrate a friendship between his friends Moore and Rossetti, believing that the former 'would have delighted in the poet's unexpected turns of humour'.[58] Indeed, Moore chuckled heartily at their very first dinner together, when Rossetti impulsively checked the mark on the bottom of his soup dish while the vessel was still full to the brim. 'The ensuing flood seemed to come upon him as a complete surprise, and Albert Moore laughed whenever he remembered the incident for the rest of his life.'[59] Rossetti was not amused, however. Indeed, he considered Moore so uninteresting that he cut him on their next meeting. 'Whether he noticed or not I don't know', Rossetti wrote to Ford Madox Brown, 'but dull dogs are best avoided.'[60] He had as little sympathy for Moore's work as for the man himself. 'There can be no doubt that he possesses certain gifts of drawing and of design (in its artistic relation) in an admirable degree',

Rossetti wrote to a mutual patron. But in more intimate company, he summarized Moore's pictures as 'pretty enough, but sublimated café-painting and nothing more'.[61]

Rossetti's contemptuous assessment is the sort of thing one would expect to hear from the notoriously intolerant and egotistical Whistler. Yet Whistler's extraordinary personal and professional regard for Moore caused him to break all his usual rules of conduct. 'Whistler was always at his best and gentlest with Albert Moore,' Graham Robertson recalled. 'He understood the rather slow working of his brain and knew that his thoughts were worth waiting for.'[62] Moore's propensity for protracted rumination no doubt gained emphasis from his great love of smoking; a friend recalled that he 'rarely had his pipe out of his mouth'.[63] His long, thoughtful silences must have provided a welcome respite from the aggressive verbal sparring in which Whistler engaged his other friends. Indeed, Whistler's letters evince affection for the idiosyncratic phrases and monosyllabic responses on which Moore relied.[64] The relationship was clearly symbiotic, for Graham Robertson recalled that 'Moore on his side adored Whistler, whose quick wit stimulated him.'[65]

Whistler's admiration for Moore's art was a defining factor in their friendship. During the early 1860s, he had grown deeply dissatisfied with the dextrous flourishes and Courbet-inspired realism that had lent his painting a fashionable élan. Seeking a firmer foundation than the 'trickery' on which he had hitherto relied, he turned to the art of Japan for inspiration. Yet his attempts to graft superficial elements of Japanese décor and design to his existing painting style only entrenched Whistler's sense of his own inadequacies as a draughtsman and designer. In Moore's meticulous approach to painting, Whistler saw the antidote to all that he rejected in his own work. His letter of August 1865 to Fantin provides clear evidence of Moore's impact on his ideas. Whistler described a painting he had recently begun (Pl. 83) as 'the purest' thing he had ever painted, for 'I now pay most attention to the composition.' Sweeping away the bric-à-brac of porcelain, painted screens and pseudo-Asian angularity that he had imported into recent paintings, Whistler substituted a severe composition consisting of long horizontal bands intersected by the curves of two elegantly draped figures.

The underlying design logic is pure Moore, one that he had been developing for the last few years in architectual murals such as *The Last Supper* (Pl. 50) and in free-standing paintings such as *The Shulamite*. Around this time he also began *Lilies* (exhibited at the French Gallery in 1866), a painting of a female figure draped in white reclining on a white sofa (Pl. 84).[66] The woman's position marks a further development of the reclining figure in *The Marble Seat*, and both paintings inform the pose of the left-hand figure in Whistler's painting. In recognition of this fact, Whistler may initially have contemplated titling his painting in a manner reminiscent of Moore's, for it is first referred to as 'the Sofa'—an upholstered variation on Moore's *Marble Seat*. Both artists played with a colour scheme dominated by white with peach and blue-grey accents. They employed a similar assortment of props: exotic objects of Japanese manufacture, displays of flowers

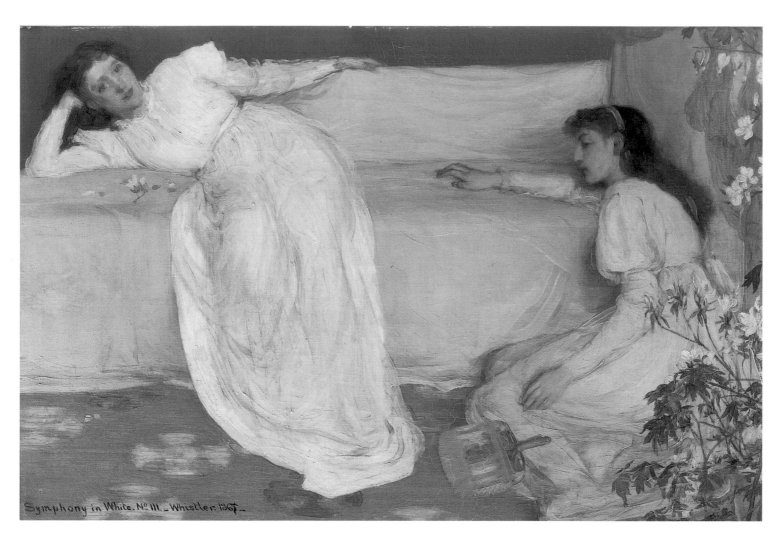

Symphony in White. Nº III. _ Whistler. 1867 _

83
James McNeill Whistler
Symphony in White
No. III
1865-7
Oil on canvas
51.1 x 76.8 cm
(21⅛ x 30¼ in)
Barber Institute of Fine
Arts, University of
Birmingham

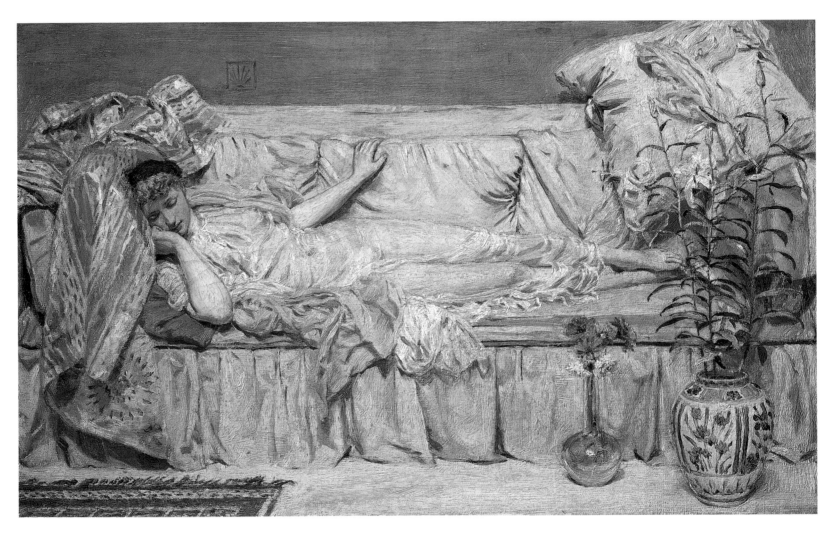

84
LILIES
1866
Oil on canvas
29.8 x 47.6 cm
(11¾ x 18¾ in)
Sterling and Francine Clark
Art Institute, Williamstown,
Massachusetts

suggestive of the East and boldly patterned rugs. More importantly, Whistler and Moore handled their materials in an analogous fashion, demonstrating the same acute attention to design.

Moore was certainly among the coterie of artists who congregated at Whistler's house to study his collection of Far Eastern ceramics and prints, and Whistler's enthusiasm for these artefacts undoubtedly encouraged Moore's rapid assimilation of Japanese influences into the style he had already founded on nature and classical Greek art.[67] But it was Moore who led Whistler in extracting the principles of Japanese composition and adapting them to his own paintings.[68] In doing so, Moore was emulating another friend—Nesfield—who had anticipated him in integrating Japanese elements within a profoundly eclectic, modern style. As noted in the previous chapter, Nesfield had begun to experiment with Japanese motifs in his very first architectural commission at Shipley in 1860. He went on to assemble a collection of Japanese art following the International Exhibition of 1862, which had featured Europe's first comprehensive display of art and artefacts from the recently opened empire.[69] With little previous exposure to the culture of Japan, Western enthusiasts such as Nesfield experienced these objects with innocent eyes. Unable to determine what they 'meant', they focused exceptional attention on what William Michael Rossetti termed the 'character and beauty in the abstract properties of form and colour'.[70] In particular, Nesfield's collection aided his pioneering study of Japanese geometric patterns, ornamental foliage and landscape conventions. A colleague later recalled, 'at that time the Japanese craze had not broken out into an epidemic ... but Nesfield knew all about the movement; he could estimate Japanese Art at its true value, and its place in the grammar of ornament.'[71] In the absence of important institutional collections, private hoards such as Nesfield's provided the sole means of studying Japanese art, and for Moore (who was reportedly too ascetic to own furniture let alone collect bibelots), access to such collections proved crucial.[72]

Nesfield also provided Moore with a model of stylistic eclecticism. Writing to Swinburne in 1863, Simeon Solomon mentioned Nesfield's 'very jolly collection of Persian, Indian, Greek and Japanese things that I should really like you to see'.[73] John McKean Brydon, who joined Nesfield's firm as an assistant in 1867, later described his wide-ranging collection in greater detail:

> His room in Argyle Street was a sight in those days, containing as it did a valuable collection of blue and white Nankin china and Persian plates, Japanese curios, brass sconces and other metal work, nick-nacks of various descriptions, and a well stocked library, in a case designed by himself ... How proud he was of his Persian plates, and how enthusiastic over the flush of the blue in his hawthorne jars, or the drawing of the 'Long Elizas' on his six mark dishes, only those know who were privileged to hear him discourse thereon.

Nesfield translated his eclectic collection of exotic artefacts into an

equally eclectic architectural style, which mingled Japanese-inspired ornament (most notably the so-called 'pies' that he derived from *mon* devices) with disparate but stylistically harmonious elements from other cultures.[74] As Charles Eastlake observed in his *History of the Gothic Revival*, Nesfield's rare instinct for the 'elements in decorative design common to good art of all ages' enabled him to create aesthetic unity from a seemingly discordant array of styles.[75] Obeying a purely aesthetic logic which dismissed all historical and geographical considerations as irrelevant, Nesfield provided valuable lessons for Moore. The anachronisms that he built into his architecture furnished models for the beautiful, if eccentric, combinations that Moore introduced into *Pomegranates*, *Lilies* and subsequent paintings.

It was an eclectic work of this kind that attracted the notice of the Newcastle lead manufacturer James Leathart (1820-95) when he visited Moore's studio in the latter part of 1865. Simeon Solomon had received a number of commissions from Leathart over the previous two years and he may have arranged for his patron to meet Moore.

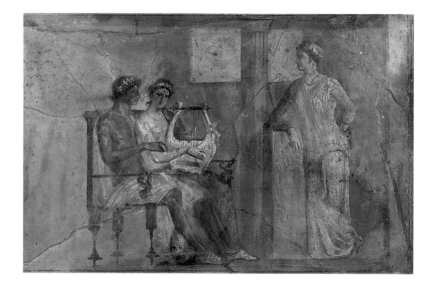

Following the visit, Solomon congratulated Leathart on his decision to purchase a small, unfinished painting he had admired in Moore's studio. 'I am very glad you have decided upon Moore's little picture,' he wrote; 'I think you are certain to like it very much when done.'[76] The picture in question was almost certainly *A Musician* (Pl. 86), a work which again combines aspects of ancient Roman wall-painting, Greek sculpture and Japanese prints. A wall-painting from Herculaneum on display at the British Museum seems to have sparked Moore's ideas (Pl. 85). He retained the bipolar construction of the ancient work, distinctly separating the performance on one side of the canvas from the audience on the other. He reinforced the division through gender, so that, as in *The Marble Seat*, an active male figure on the left performs for a pair of passive females on the right. Moore also emulated the rough surface quality of the Roman painting and based his unusual, tertiary hues on its faded pigments. These colours are deployed after the manner of Japanese prints, with one laid in clear contrast alongside another. A white dado inserted between the figures and the grey wall allows the colours to sing out brightly. The frets,

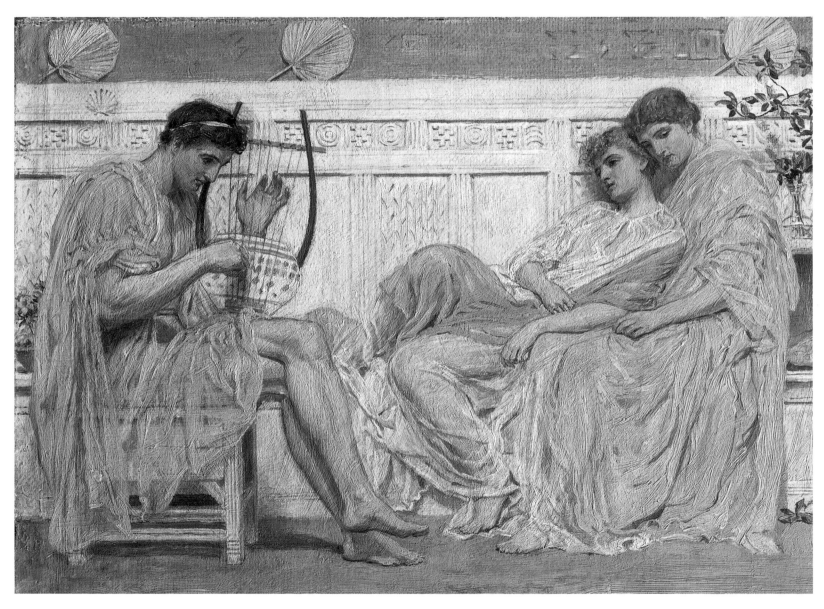

85
THE MUSIC LESSON
*c.*100 AD
Wall painting from
Herculaneum
*c.*61 x 91 cm
(24 x 36 in)
British Museum, London

86
A MUSICIAN
1865-6
Oil on canvas
26.0 x 30.7 cm
(10¼ x 15¼ in)
Yale Center for British Art,
New Haven

concentric circles and other markings of the dado exemplify the sort of pan-cultural ornaments that attracted interest in the 1860s for their occurrence in Japan, Greece and other disparate parts of the globe.

In Moore's hands, the pedagogical Roman *Music Lesson* became an ode to musical pleasure, a revisitation of *The Shulamite*'s theme of an audience listening to a performer. Again, Moore employed the comfortable intimacy of women as the vehicle for his message of tranquil, sensuous absorption, and he again drew inspiration from the Parthenon's east pediment, arranging his models in a pose that emulates the pair of nestling goddesses. The undisciplined behaviour of the drapery, which falls in random folds bearing no relation either to the underlying anatomy or to an overall linear pattern, reveals that as yet Moore had absorbed little of the formal logic of Greek drapery systems. Even so, the undulating curves created by the interior lines of the drapery and the silhouettes of the figures provide a lyrical contrast to the measured, linear grid of the dado backdrop. Moore clarified this contrast in a line drawing showing three variations on the composition, produced as a decorative panel representing the nine Muses and published in 1868 in an illustrated edition of John Milton's 'Ode on the Nativity' (Pl. 87).[77] The success of these designs led to commissions for other illustration projects.[78]

The compositional strategy of *A Musician* had already been employed in earlier works such as the Austin Friars *Last Supper* and *The Shulamite*, but its significance emerges more clearly in this concentrated format and in connection with the musical theme. The arrangement of lines and colours provides a pictorial equivalent to the unheard music of the seated lyre player, allowing the eyes to experience what the ears cannot hear. The architectural background—regularly punctuated by the geometric divisions of the white dado—provides the underlying rhythm, and the curves of the figures trace the lilting melody. Even the Japanese fans, strategically positioned at intervals along the wall, suggest the percussive emphasis necessary to complete Moore's musical phrase. It is 'a sort of pictorial music, drawn as from a lyre of but few strings', the critic F.G. Stephens would later remark. 'Indeed, it is very like antique music, which was soft, of narrow compass, apt to be monotonous, and best fitted for the lyre and flute'.[79]

As noted above (pp. 25–6), music played a vital role in Moore's family and among his friends, who devoted evenings to singing and playing Handel and Bach, and to attending musical soirées and concerts. At the same time, the theoretical relationship of music and painting was very much in the air. Analogies established between the two arts by ancient and Renaissance theorists had gained fresh emphasis in Immanuel Kant's *Critique of Judgement* (1790), in which music and decorative art were likened as 'free beauties' which had no intrinsic meaning and therefore enabled a uniquely pure aesthetic experience.[80] More recently, in his essay *De la couleur* (1846), Baudelaire had posited sensuous correspondences among the arts, drawing links between music, colours, sounds and perfumes. In England, these ideas were explored in paintings such as Rossetti's *The Blue Bower* (1865) and Leighton's *Lieder ohne Wörte* (1860-1) in which the artist sought 'to translate to the eye of the spectator something of the pleasure which

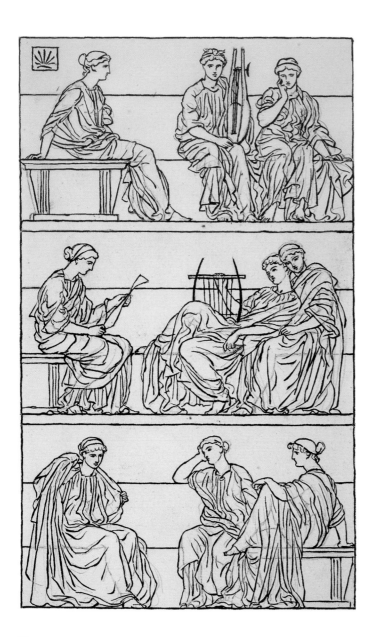

87
THE MUSES: 'AND WITH
YOUR NINEFOLD
HARMONY/ MAKE UP FULL
CONSORT TO THE
ANGELICK SYMPHONY'
c.1867
Brush and Indian-ink outline
over red chalk and pencil
31.7 x 18.1 cm
(12½ x 7⅛ in)
British Museum, London

the child receives through her ears' (Pl. 88).[81] Synaesthesia—the capacity of one of the senses to evoke the sensation of another—also became a factor in English art criticism, with the effects of line and colour in painting compared to rhythm and harmony in music.[82] Walter Pater would ultimately gloss the synaesthetic tendency with his famous statement, 'All art constantly aspires toward the condition of music'—that is, towards a sensuous abstraction in which content is subsumed by form.[83]

These imaginative assertions of the relationship between music and the visual arts coincided with scientific investigations drawing on recent theories of optics, acoustics and other fields. The texts and artefacts of ancient Greece and Rome were also scrutinized in this far-reaching search for antiquity's lost canons of proportion, legendary mathematical equations believed to hold the key to ideal beauty in nature and the arts. Admired in his day as 'the modern Pythagoras', the Scottish decorator David Ramsay Hay (1798-1866) was among the most prolific and influential of the theorists, publishing numerous treatises which hypothesized mathematical analogies between music, colour and line. Likening the vibrations of the optical nerve (productive of sight) to the vibrations of a musical string (productive of sound), Hay developed a theory of proportions that enabled him to refer harmony of colour to the numerical ratios of various notes in the diatonic scale, and beauty of line to the angles corresponding to the harmonic ratios of musical chords. Hay's texts, together with the alternative theories they inspired, formed part of the curriculum at the York School of Design and the School of Art at South Kensington, and Moore certainly knew of them.[84] His knowledge of music, mathematics and architecture provided the expertise necessary to test the various systems proposed, and the increasing role of geometry and proportion in his preparatory studies suggests that these theories had an impact on his art.

Whistler did not share Moore's knowledge of music and mathematics, but the poetic analogy of the sister arts intrigued him. In 1867, the year Moore finally showed *A Musician* at the Royal Academy,[85] Whistler exhibited the picture once referred to as 'the Sofa' under the experimental title *Symphony in White, No. 3*. Most critics considered this merely the latest in a long series of exasperating Whistlerian affectations, but a few thanked him for at last providing the clue necessary for understanding that the true purpose of his art was 'to attain abstract art, as exclusively addressed to the eye as a symphony independent of words is addressed to the ear'.[86] Critics overlooked the same intentions in Moore's *A Musician*. Blind to the analytical reasoning that underpinned it, at least one interpreted the painting as a Roman genre scene in the manner of Gérôme, Ingres and Alma-Tadema.[87]

Only Sidney Colvin (1845-1927), a recent Cambridge graduate who had studied under the eminent classical scholars Richard Claverhouse Jebb and Henry Butcher, recognized Moore's purely formal links to ancient art. Describing Moore as 'essentially Greek in taste', Colvin observed that his preference for low colour keys and subdued emotion demonstrated 'an aesthetic turn radically akin to that of the Greeks'.

88
Frederic Leighton
LIEDER OHNE WORTE
c.1860-1
Oil on canvas
101.7 x 63 cm
(40¼ x 24⅞ in)
Tate Gallery, London

Moreover, 'In these small and slightly tinted works he achieves a perfection of design, a delicacy of decorative colour, a large grace and harmonious repose, that have hardly a parallel in modern art.'[88] Colvin proved a crucial early advocate of Moore, about whom he believed 'more mistaken opinion—... more utter nonsense—has been spoken and written, than any other painter'.[89] In 1870 Colvin published the first article ever devoted to the artist, in which he reiterated his belief that Moore was 'nearer in spirit to the Greeks than any other artist among us', praising in particular 'his power of arranging and combining the lines of the human form into a visible rhythm and symmetry not less delightful than the audible rhythm and symmetry of music'.[90]

Although few critics possessed Colvin's understanding of Moore's art, many shared his admiration for its beauty, and *A Musician* attracted considerable praise for its 'harmonies of line and subtleties of contour'.[91] Whistler, by contrast, although closely associated with Moore, was often taken to task for lacking these very qualities.[92] The critical barbs hit their mark and in the months following the 1867 exhibition, Whistler redoubled his admiration for Moore, along with his determination to emulate his friend's fastidious command of design and draughtsmanship. The preparatory drawings and correspondence of both artists, together with eyewitness accounts of their studios, indicate that by this date Moore had crystallized (and Whistler was doggedly imitating) a systematic investigation of the formal logic of beauty. According to Baldry, Moore 'set himself to contrive a system which should be in accord with Nature, and yet should embody the experience of the most thoughtful and observant artists'. Through comparative analysis of nature and 'the finest examples of Greek art'—a fusion of realism and idealism—Moore 'finally learned the lessons in observation, and gathered the hints about expression, which he needed to perfect his own taste and judgment'.[93] These insights enabled him to master 'the great facts of Nature'—that is, the underlying geometrical constants responsible for ideal beauty.

Rejecting the misguided neo-classicism of artists such as Ingres (who were, in Whistler's words, 'not at all Greek, as is maintained, but very viciously French'), Moore and Whistler sought to rediscover for themselves the formal qualities responsible for the beauty that the Greeks had elicited from nature and the human body. According to one eyewitness, it was Whistler's 'habit to pose his model beside a skeleton, with a bust of the Venus de Milo at hand', a technique aimed at capturing 'the Greek ideal, and not a mere copying of his model'.[94] Moore is the most likely source of this method, and it helps to account for the reminiscence of the Venus de Milo that commentators often discerned in the faces and bodies of his figures.[95] Accustomed to the anatomical distortions engendered by tightly laced corsets and boots, many of them balked at the fuller waists and larger feet of Moore's figures, but these, too, derived from his emulation of Greek statuary.

By the beginning of January 1868, Whistler had taken up temporary use of a studio directly opposite the British Museum and a stone's

89
STUDY OF A NUDE FEMALE
FIGURE, HOLDING A BOWL,
FOR 'AZALEAS'
*c.*1867
*Charcoal and white chalk on
brown paper*
180.5 x 92.7 cm
(71⅛ x 36½ in)
Victoria and Albert
Museum, London

90
AZALEAS
1867-8
*Oil on canvas, with original
frame designed by the artist*
197.9 x 100.2 cm
(78 x 39½ in)
Hugh Lane Municipal
Gallery of Modern Art,
Dublin

throw from Moore's Fitzroy Street flat.[96] From this date both artists demonstrate a sophisticated understanding of drapery systems which suggests close analysis of the techniques employed in ancient sculpture. Although neither of them appears to have applied for the permission necessary to make drawings in the museum's antiquities department or sculpture galleries, they may have learned what they needed to know through visual analysis and discussion, with rapidly sketched notations to record salient details.[97] Such a method is consistent with the technique of memory drawing that Whistler had learned in France and that Moore had practised for some years.[98] Returning to their studios, the artists presumably experimented with sheets of muslin, coaxing it to fall naturally into the beautiful patterns they had observed in sculpture. It was a laborious process, and Whistler complained of spending 'the whole day drawing from models!!'[99] It was not that the fabric possessed importance in and of itself, but that its infinite flexibility provided the greatest scope for abstract expression. Each element of the composition was broken down and analysed in a similar fashion.[100] A visitor to Whistler's studio noted 'an immense number of drawings of the various figures in black and white and pastel on brown paper, some in the nude, some with drapery added'. The same eyewitness believed that Whistler 'probably learned from Moore the use he then made of pastel ... The coloured chalks were very sparingly used, over a carefully drawn black outline on brown paper, and I have been told that Moore's studio was full of such work, pinned to the walls, just as Whistler's used to be.'[101]

Whistler's letters attest to the crusading spirit in which he and Moore laboured, convinced that together they would resuscitate 'the true traditions of painting in the nineteenth century'. Initially, Whistler seemed delighted with the progress of the campaign. To Fantin he wrote, 'I am now much more exacting and hard to please than when I threw everything slap-dash on the canvas, knowing that instinct and beautiful color would pull me through.'[102] But ultimately, Whistler's intense admiration for Moore undermined his artistic personality, and his geometrically ordered arrangements of classically draped women struck observers as somewhat too 'distinctly influenced by Albert Moore'.[103] Moore himself would later tell his students, 'You will not want to paint as I do when you are doing work of your own, ... but what I am teaching you will help you to find out [how you want to paint].'[104] Whistler ultimately dispensed with the laborious preparatory work for which he had so little patience,[105] but the radical geometry of Moore's design schemes governed the whole of his future art production. The two men never lost their sense of partnership in a joint crusade, and it was evidently with his friend's blessing that Whistler publicly appropriated much of Moore's artistic theory as his own. Privately, he conceded the debt. 'Whistler, of course, owed much to Albert Moore and always acknowledged it,' Graham Robertson recalled; 'Moore was the only painter in England whom he considered "great".' This bold statement is corroborated by numerous witnesses.[106]

Moore followed up his tiny painting *A Musician* at the Academy exhibition of 1867 with the over life-size *Azaleas* the following year (Pl. 90). Nearly the size of *The Shulamite, Azaleas* demonstrates Moore's ability to represent the human figure on a grand scale, an accomplishment then rare among English artists and especially impressive in a 26-year-old. Moore's previous experience in architectural design work provided the abstract methodology as well as the executive techniques he required. Although his preparatory process bears a generic resemblance to the academic methods inculcated on the Continent and adopted by English artists such as Leighton and Poynter, Moore made ingenious modifications to the standard procedure in accordance with his idiosyncratic interest in ideal geometry. After making numerous studies of the draped and nude figure, he executed a full-scale nude cartoon (Pl. 89). At this stage, as in his architectural schemes, Moore sought to accommodate the human body to an abstract, geometric armature, now generated internally by the composition itself, rather than imposed externally by surrounding architectural elements. He devised this 'system of line arrangement' by determining 'the directions of the more prominent lines of the composition' and charting 'a series of parallels to them throughout the drawing'. According to Baldry this system derived from Moore's study of landscape, which had led to his conclusion that 'Nature's chief rules' were parallelism and optical (rather than actual) balance.[107] Baldry further claimed that this abstract linear armature determined every element of Moore's compositions, not only the positioning of the figures, but the placement of accessories, the shape and size of the canvas, and the distribution of the drapery folds, wall hangings and architectural elements.[108] Vestiges of the system are visible in the nude cartoon for *Azaleas*, indicated by a series of horizontal and diagonal lines through the mid-section of the figure and near her feet. Moore meticulously oriented the figure in relation to these lines. He tried the profile of the head in half a dozen alternative placements (one of which was prematurely transferred to the canvas) before at last hitting on the final orientation. The artist also struggled with the extended hand and raised heel, ultimately concealing the latter beneath a cascade of opaque drapery. Above the hand Moore jotted down what appears to be his model's schedule: 'Monday Tuesday Thursday'.[109]

Once perfected, the nude cartoon was transferred to the final canvas by the pouncing technique Moore used for his architectural murals. The resulting outline was fleshed out in oil colours and then a full-size drapery cartoon was made and transferred on top of it. By painting the drapery over the fully rendered nude figure, Moore enhanced the appearance of transparency, for the ghostly outline of the body continued to show through the fabric. This unusual effect[110] provides further evidence of Moore's emulation of fifth-century Greek vase paintings and the lost art of Polygnotos. Within the next few years, however, he would ally this pictorial approach to drapery with the plastic techniques of fifth-century Greek sculpture.

Moore camouflaged his painstaking preparations for *Azaleas* with a remarkably fresh and spontaneous manner of painting. Emanating from the twisted roll of fabric along the figure's left shoulder, the drapery folds are traced by long, fluent strokes which present an elegant counterpoint to the energetic brushwork of the azalea. Aiming for the impromptu appearance of 'a happily contrived and expressive sketch', Moore endeavoured to make each stroke perfect and to avoid

two passes of the brush where one would suffice. He would later advise his students, 'Spend an hour if necessary in thinking over a touch, but put it on in an instant as soon as you have made up your mind about it.'[111] This brisk but deliberate technique adapted oil painting to the literally 'fresh' manner of fresco, with which Moore had experimented a few years earlier. In further emulation of fresco, he painted only on a moist surface, removing any passages that could not be finished by the end of the day.[112]

The careful mental preparation and rapid material execution that characterized Moore's approach suggest the influence of Chinese and Japanese painting, a model particularly apparent in the 'broken ink' style of brushwork employed for the azalea bush. Other aspects of the picture reveal further Eastern influences. These include the carp bowl held in the woman's arm (an actual studio prop that also appears in *Pomegranates* and subsequent works)[113] and the geometric pattern of the azalea pot, which provides a succinct visual treatise on the principles of asymmetry and optical balance that Moore discerned in Japanese (as well as Greek) art. Strokes of colour necessary for integrating the predominantly yellow figure with the predominantly white background are provided by the yellow butterflies flitting about the azalea bush, another element derived from Japanese art.[114] The russet blossoms in the woman's hair, in her bowl and scattered across the floor provide further assistance in unifying the monumental composition.

Moore's systematic limitations on his colour scheme probably owed something to Japanese prints, which characteristically employ a limited number of secondary and tertiary hues. But his exact distribution of colour was presumably determined by the system of line arrangement which, according to Baldry, guided him in the placement of each pigment and in the overall balance of the chromatic ensemble.[115] One critic who saw *Azaleas* at the Royal Academy in 1868 (consigned, with customary ambivalence, to the upper reaches of a wall in the prestigious North Room), remarked that 'at the great altitude at which it is hung, [the painting] looks more like a piece of framed tapestry than a picture in oils'.[116] The observation reflects *Azaleas*'s chromatically interspersed surface patterning, and anticipates Whistler's comment later in the year that 'colour ought to be, as it were, embroidered on the canvas, ... the same colour ought to appear here and there, in the same way a thread appears in an embroidery.' Whistler attributed the practice to Japanese artists, claiming, 'they never look for contrast, on the contrary, they're after repetition.'[117] It seems likely that Moore was the intermediary for this insight, as he had already absorbed it into his own practice.

Not surprisingly, the systematic repetitions and geometric armature of *Azaleas* gained particular notice among architectural critics. The *Building News* declared it the 'only decorative painting' at the 1868 exhibition, and added that it 'ought to have been hung with the architectural drawings'.[118] Perhaps the same critic singled out *Azaleas* as 'one of the few pictures in the Academy that has a frame that fits the picture', one that was 'purely Greek in conception'.[119] Art critics were less enthusiastic, but even they grudgingly admitted the beauty of Moore's picture. Obliged to view the painting 'through a strong opera

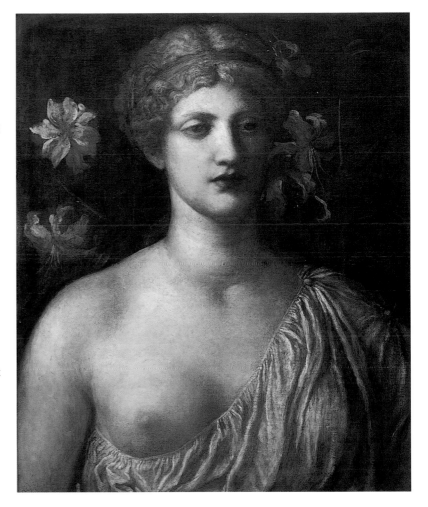

91
George Frederic Watts
THE WIFE OF PYGMALION
1868
Oil on canvas
67.3 x 53.3 cm
(26½ x 21 in)
Faringdon Collection Trust,
Buscot Park, Oxfordshire

glass', one described it as 'a very curious work indeed, brimful of undeniable talent—of genius almost—but daringly eccentric in design and execution'.[120] Another characterized Moore's idealistic tendency as a rare 'luxury of the imagination', observing that in the colour scheme ('delicate, faint, and quiescent') 'no force of black nor intrusion of positive pigments is permitted to break the spell of dreamy reverie'.[121]

The most perceptive reviews were penned by William Michael Rossetti and Algernon Swinburne, who knew much of Moore through their mutual friends Whistler and Solomon.[122] Proclaiming *Azaleas* one of the key pictures of the year, Rossetti scoffed at those who tried to evaluate its merits as a historical reconstruction of classical antiquity. 'Whether or not azaleas were known to Grecian ladies, whether or not they came from America, are questions not difficult of solution, but of sublime indifference to Mr. Moore,' he wrote. The artist's exclusive concern was to capture 'a sense of beauty in disposition of form, and double-distilled refinement in colour'.[123] Both Rossetti and Swinburne drew parallels between Moore's painting and another work in the exhibition, *The Wife of Pygmalion, A Translation from the Greek*, in which George Frederic Watts sought to create a painterly equivalent of classical sculpture (Pl. 91). Swinburne invoked similar analogies between *Azaleas* and the arts of music and poetry. 'His painting is to artists what the verse of Théophile Gautier is to poets; the faultless and secure expression of an exclusive worship of things formally beautiful'. Blazoning *Azaleas* as an instance of pure art-for-art's-sake, Swinburne concluded, 'The melody of colour, the symphony of form is complete: one more beautiful thing is achieved, one more delight is born into the world; and its meaning is beauty; and its reason for being is to be.'[124]

Moore's interest in the abstract affinities of the sister arts has already been shown in the painting he exhibited in 1867, *A Musician*. Around the same time, he began work on a free-standing painting, *A Quartet, A Painter's Tribute to the Art of Music, AD 1868* (Pl. 93). The title—verbose by most artists' standards, but especially so by Moore's—signals the picture's manifesto-like thrust. It recalls not only the musical titles that Moore and Whistler had employed previously, but also the idea of correspondences invoked by Watts's *The Wife of Pygmalion*. Baldry described *A Quartet* as a decoration symbolic of ideal music and therefore unlimited by restrictions of time or place. To this end, Moore dispensed with the arcane lyre that had sounded a misleadingly archaeological note in *A Musician*, and grounded his painting in actual sensory experience. His representation of violins, a cello and a bass viol reflect contemporary enthusiasm for stringed instruments, considered 'of the whole range ... those most capable of producing the finest qualities of sound and the greatest charm of expression'.[125] Moore studied the characteristic poses used in fingering and bowing from an 'experienced violinist', possibly his brother Henry, who once considered playing the instrument professionally.[126] Moore's imagery thus demonstrates his commitment to grounding idealism in actual observation and solid materials.

A Quartet also demonstrates Moore's habit of reworking with greater sophistication previously essayed themes, in this case the pleasant state

of absorption experienced by a female audience. As in *A Musician*, the women listen passively to male performers, but by turning their backs to the viewer and opening a space between them, Moore invites us to join in the contemplation of music. The critic F.G. Stephens saw the figures themselves as embodiments of music, associating the women's graceful forms and flowing lines with 'the suave, long-sustained and fluttering harmonies of the lighter order in music', while 'the graver, more sedate and powerful poses of the men offer ... apt suggestions of the more serious elements of melody.'[127] The pair of women at far left repeat the gesture of casual embrace that Moore had employed in *Apricots* and *The Shulamite*, but here it becomes a knot of interwoven limbs and drapery. This complex position gains clarity from the artist's full realization of the nude figure beneath the transparent cloth.

The composition itself restates in more elaborate form the structural system employed in *A Musician*, contrasting the austere horizontal bands of the architecture with the irregular curves of the human body. To this basic arrangement, Moore added a series of strong diagonals created principally by the bows and necks of the string instruments and the arms and legs of the figures. By extending these diagonals to their full length, Moore generated the linear armature described by Baldry, and analysis confirms that the lines and their points of intersection do indeed determine the positions and orientation of virtually every object in the composition. A glimpse of the artist's technique is provided by his preliminary drawing of the two female figures at left, in which the shadow cast on the back of one figure by the draped arm of the other provides a cardinal point of intersection (Pl. 92). Moore's smudged chalk markings show how he experimented with the extended left-hand leg of this shadowy right angle in determining the placement of the woman's head. A pentimento in the final painting reveals that his indecision persisted right up to the last stages of execution and that he initially tried the woman's head in a higher position. Moore's rigorous structure inspired one of his contemporaries to describe the painting (with acute insight) as 'abstract art crystallized into a decoration with music as its theme', adding that it was 'almost architectural in its simplicity'.[128]

When exhibited at the Royal Academy in 1869, *A Quartet* sparked a sensation. To the end of the century, it remained famous as the painting 'which fired so many young brains with enthusiasm, which inspired so many sonnets, and furnished so many aesthetic drawing-rooms'.[129] This extreme response is rather difficult to understand today. We are too diverted by the incongruity of Moore's ensemble—four earnest men, naked but for filmy peach drapery and a strategically draped animal skin—to take the picture very seriously. The humour was certainly not intended, but the shock value was. *A Quartet* constitutes Moore's boldest statement of his 'astonishing dictum' that 'anachronism is the soul of art'.[130] Through this defiant repudiation of archaeological pedantry, he thumbed his nose at those who quibbled over such 'errors' as his combination of American azaleas, Japanese fans and Greek drapery. Like Dante Gabriel Rossetti, Moore may have derived perverse delight from 'puzzling fools' and jolting dim-sighted judges from their aesthetic stupor.[131]

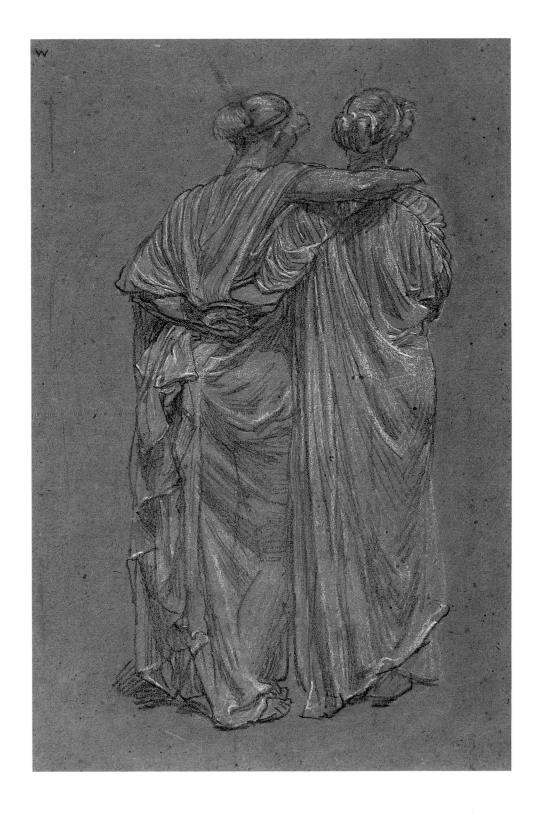

92
STUDY OF TWO
CLASSICALLY DRAPED
FEMALE FIGURES FOR
'A QUARTET'
c.1867-8
Black and white chalks on
brown paper
31.4 x 20.3 cm
(12⅜ x 8 in)
British Museum, London

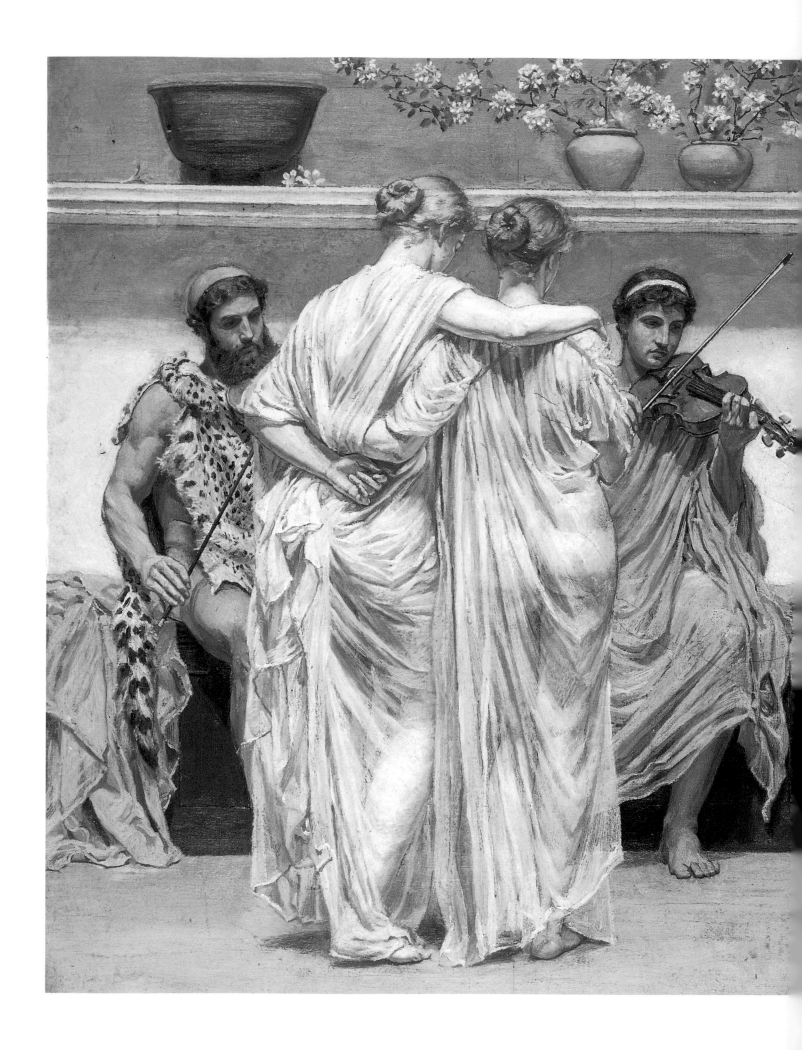

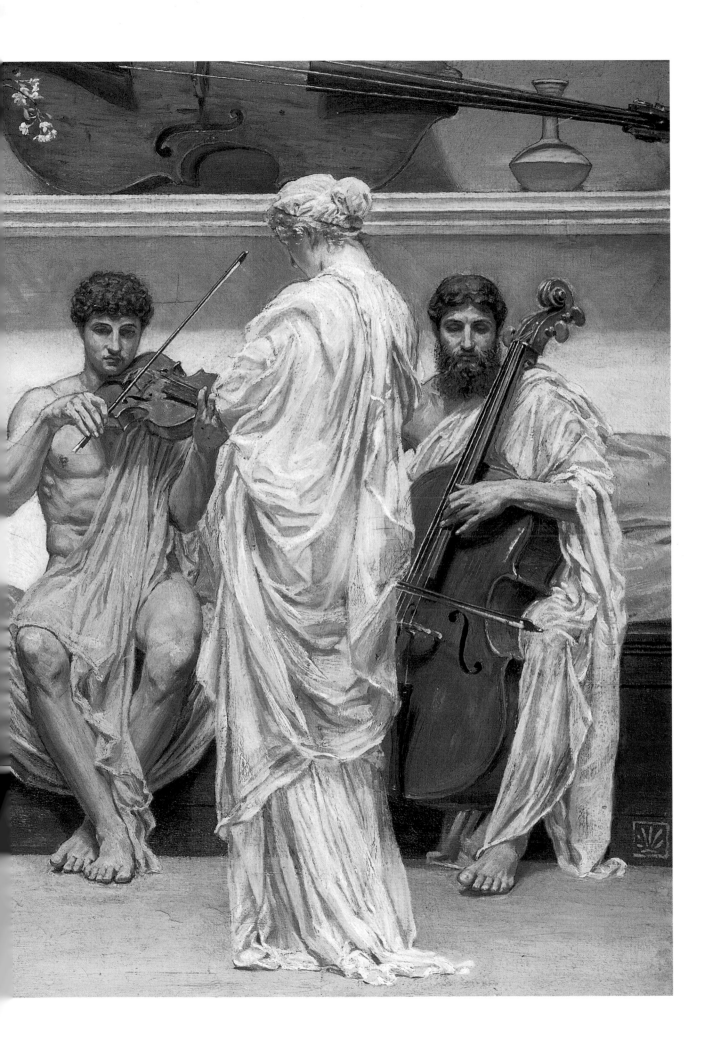

93
A QUARTET, A PAINTER'S
TRIBUTE TO THE ART OF
MUSIC, AD 1868
1868
Oil on canvas
59.6 x 87.5 cm
(23½ x 34½ in)
Private collection

Yet surprisingly few of Moore's contemporaries remarked upon the jarring effect that the picture's anachronisms produce today. The rather opaque critic William Davies was virtually unique in complaining that 'the mental perplexity' arising from the violins and 'other discordant accessories' was 'extremely irritating and provoking'.[132] Admirers, by contrast, saw only 'the suggestion of the most delightful music which we know interwoven with the representation of our best ideals of beauty'. The Rev. Richard St John Tyrwhitt declared the picture 'most beautiful, fiddles or no fiddles', while Sidney Colvin proclaimed, 'If authority were needed, Raphael has drawn Apollo playing the violin.'[133] One suspects an element of radical chic behind this refusal to acknowledge anything discordant in the picture. Tom Taylor confirmed as much with his comment that 'even outsiders, to whom Mr A. Moore is usually a puzzle, will recognize the charm.'[134] Taylor's use of the term 'outsider' attests to the existence by this date of a recognizable avant-garde—an alternative 'inside' crowd to that identified with the Royal Academy. The tension between the two groups helps account for the hostility of some of Moore's notices, such as that in the *Saturday Review*, which lambasted his 'perverse' and 'strange' painting as an 'ultra sign of the times', adding ominously, 'The classic mania which has set in has not yet reached its height; more alarming examples may be looked for.'[135]

By the time Moore completed *A Quartet*, his health and finances had been exhausted by abortive and poorly remunerated architectural projects.[136] With lack of money weighing heavily on his mind, he snatched at the casual offer of a commission made by the wealthy Liverpool shipping magnate and art collector Frederic Leyland (1831-92), a patron of both Whistler and Solomon. They had convinced their friend of Leyland's earnestness in encouraging Moore to paint a life-size nude 'Venus' for his collection. Leyland had already purchased nudes by Watts and Leighton, which startled Royal Academy visitors when exhibited in 1866 and 1867. These daring examples may have inspired Moore to paint *A Wardrobe* (Pl. 94), a nude of about half the size of life that evolved from the figure studies he was simultaneously carrying out for the Queen's Theatre. The geometrically ornamented cabinet, leopard skin and piles of superfluous drapery associate the painting with Moore's two small works of 1866, *Pomegranates* and *Apricots*, but the monumental treatment of the solitary, standing figure points the way forward to *Azaleas* and demonstrates the profound impact of classical sculpture on Moore's treatment of the female body, as comparison with *Dancing Girl Resting* indicates clearly (Pl. 33).[137] Unlike Watts and Leighton, Moore did not use classical mythology to justify the nudity of his figure; indeed, the lack of literary reference in his title 'A Wardrobe' makes his representation of an unclothed woman all the more astonishing for its time. The unease engendered by the implication of looking at a real woman, rather than a mythical goddess, is evidenced by the fact that subsequent purchasers insisted on calling the picture 'Venus at the Bath'.[138]

Leyland probably glimpsed *A Wardrobe* on his visit to Moore's studio and expressed interest in a larger variation on the theme.[139] Moore followed up their conversation with several weeks' labour on preliminary chalk drawings and an oil sketch (Pl. 95) which combined

the action of dressing (or undressing) from *A Wardrobe* with an updated setting employing the Japanese-inspired ceramics and floral backdrop of *Azaleas*.[140] The composition caused tremendous difficulty and Moore made five potential designs before enlarging one to a full-scale cartoon, only to abandon it as well. His trepidation arose from consciousness of the painting's importance to his career. From time immemorial, the nude had constituted the supreme test of artistic ability—a test that British artists were notoriously liable to fail owing to insufficient facility in anatomy, draughtsmanship, flesh painting and canons of proportion. For an artist of Moore's youth to attempt a life-size nude constituted an act of tremendous bravado. As he later explained to Leyland, 'I always consider the beginning of a picture the most important part of it, but in the present case, I have taken more than usual time and pains in this respect, —for my own sake as an artist.'[141]

By 12 December 1868 Moore had honed his design considerably, and with three or four months of solid work still to go, he asked his patron for an advance of £100. 'I find my balance so low', he confessed, 'that I am full of apprehension on this point.' Uncertain whether Leyland would be visiting London soon, Moore included a sketch of the picture (Pl. 96), along with a verbal description:

> She is winding a ribbon over her head and I think the movement—as I have seen it and wish to represent it—is very graceful. The left hand holds the end of the ribbon at the back of the head and the right hand takes it round twice and then the two ends are tied together. The head moves over from one side to the other so as always to have that side uppermost which the ribbon is crossing. I am afraid my description is rather involved and I trust the picture will have the effect of being simpler.[142]

The action described by Moore replicates a standard pose in Greek sculpture, the *diadumenos*, or fillet-binder. His letter makes clear, however, that he had not merely copied a static prototype, but experienced for himself the graceful movement that originally inspired ancient sculptors.[143]

Moore had gone this far without receiving a formal commission from Leyland, and his letter evidently took his patron by surprise. On his next visit to London, Leyland proposed, they would discuss the possibility of a smaller canvas with a proportionately reduced price tag. This message panicked Moore, who had lost, by his own estimate, more than £800 in refused commissions while working on Leyland's picture. In reply, he explained the predicament in which Leyland's request for a life-size nude had placed him, for 'on account of the unfortunate prejudice which exists against this kind of picture, it would hardly be possible, or at any rate prudent, to proceed with it except as a commission.' Eager to accommodate Leyland's concerns, he suggested scaling back the canvas a few inches in each direction ('the cartoon not being yet made'), but urged his would-be patron to state his preferences immediately, as 'I am at a loss to know how to proceed during the time that may elapse before I may have the

pleasure of seeing you.'[144] When three weeks passed without his hearing from Leyland, Moore reiterated the point more forcefully:

> The time I am losing with respect to getting a picture done by the end of March, —i.e. in time for the exhibition—, is a matter of consequence to me, and this year more so than usual—. I never find it convenient to carry on more than one picture of any moment at the same time, and it will, no doubt, be evident to you that it is desirable that the size of the Venus picture should be fixed as soon as possible, as I am, meantime, quite unable to proceed with it.

By 22 January 1869, Moore and Leyland had agreed on the size of the figure and the price of 225 guineas.[145] Moore referred to the work as 'a Venus', indicating that it represented a type of ideal beauty, rather than the mythological Roman goddess.

Notations in the margins of Moore's full-size cartoon (Pl. 97) indicate that he based the composition on an orthogonal grid overlaid by intersecting diagonal lines. Vestiges of this armature survive in the painting's numerous rectilinear devices, such as the cartouche, which provides the unit of measurement employed throughout the painting, and in the limbs of the figure, which literally flesh out the intersecting diagonals. As in the cartoon for *Azaleas*, numerous readjustments and marginal sketches (such as the small study of a head at upper right) reveal how many difficulties remained unresolved at this late stage in Moore's composition process.

By 8 April 1869 Moore had completed *A Venus* and sent it to the Royal Academy, where Leyland saw it for the first time (Pl. 98).[146] Solomon and Whistler had already described the work to him in generous terms,[147] and their enthusiasm was echoed by Sidney Colvin, who emphasized Moore's originality in applying to a free-standing painting the kind of abstract formal principles that were generally reserved for mural decoration. *A Venus* was not an imitation of natural appearances, Colvin explained, but an experimental arrangement of chromatic tones based on a theoretical system.[148] Indeed, Moore extrapolated the colour scheme almost entirely from the cherished blue and white pots in his painting, and the pink blossoms in the white vase. Warm brown and yellow accents anchor the composition at strategic points. But the subtle, quasi-scientific balance of Moore's system was destroyed by the garish colours surrounding it at the Academy. Colvin complained that proper appreciation required that 'a mental abstraction be made of all the pictures about it'. If that were done, he believed, 'The look of flatness, as well as the coldness and the rippling shadows, would ... give place to relief and suffusion'.[149]

In addition to its noisy neighbours, Moore's picture suffered from the strong light in which it hung at the Academy. Bright illumination exaggerated the painting's deliberately rough surface texture, plainly revealing the warp and weft of the coarsely woven canvas and emphasizing the chalkiness of the artist's under-saturated medium.[150] Several commentators recognized his emulation of the rough, dry surfaces of Roman wall-painting, and took offence at the

application of this ostensibly 'masculine' mode to a quintessentially feminine subject. Moore's draughtsmanly articulation of the figure's anatomy only heightened their distaste, for although the technique was regularly employed to delineate the musculature of male nudes, artists invariably mystified the female body through smoothly polished surfaces and forms that melted imperceptibly into one another.

The androgynous quality of Moore's *A Venus* helps account for the virulent response it elicited. Characterizing the picture as 'repellent', one critic observed, 'Such nudities are quite unobjectionable, because

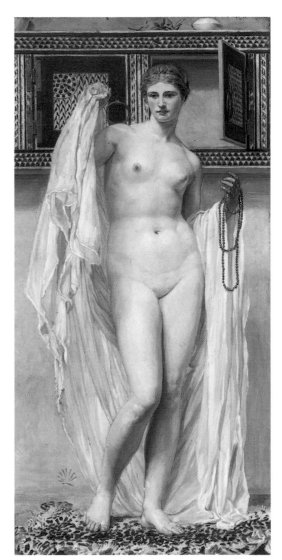

91
A WARDROBE
1867
Oil on canvas
100.2 x 48.2 cm
(39½ x 19 in)
Johannesburg Art Gallery

absolutely disagreeable. The figure is neither marble, paint, nor flesh, but stucco.' Another wrote in similar terms, 'Other Venuses may have erred on the side of being over alluring; this, on the contrary ... is only somewhat too repulsive.'[151] Only the Rev. Richard St John Tyrwhitt (vicar of St Mary Magdalen, Oxford, and a champion of 'chaste nudities') seems to have appreciated Moore's motives: 'We hazard the conjecture that he painted it on such coarse canvas on purpose that the nude figure may look like the *picture* of a woman, rather than like a woman, however perfectly drawn and coloured' [my emphasis].[152] The critical response attests to the delicate line toed

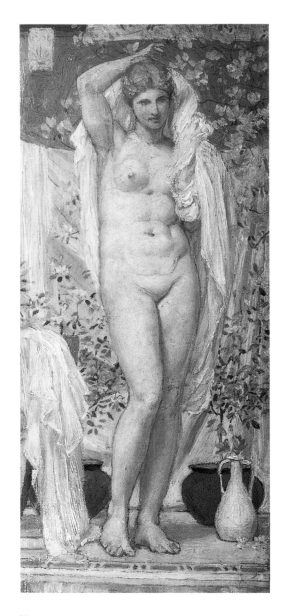

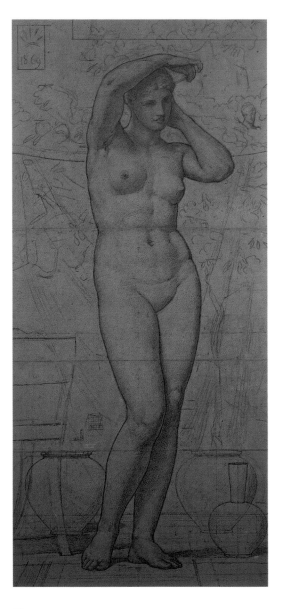

95
COMPOSITIONAL STUDY
FOR 'A VENUS'
1868
Oil on canvas
44.4 x 19 cm
(17 ½ x 7 ½ in)
Private collection

96
SKETCH OF 'A VENUS'
Detail from a MS. letter
of 12 December 1868
to Frederic Leyland
Pen and ink
Pennell-Whistler Collection,
Library of Congress,
Washington DC

97
CARTOON FOR 'A VENUS'
1869
Black chalk on brown paper
33.5 x 18.6 cm
(13¼ x 7⅜ in)
Victoria and Albert
Museum, London

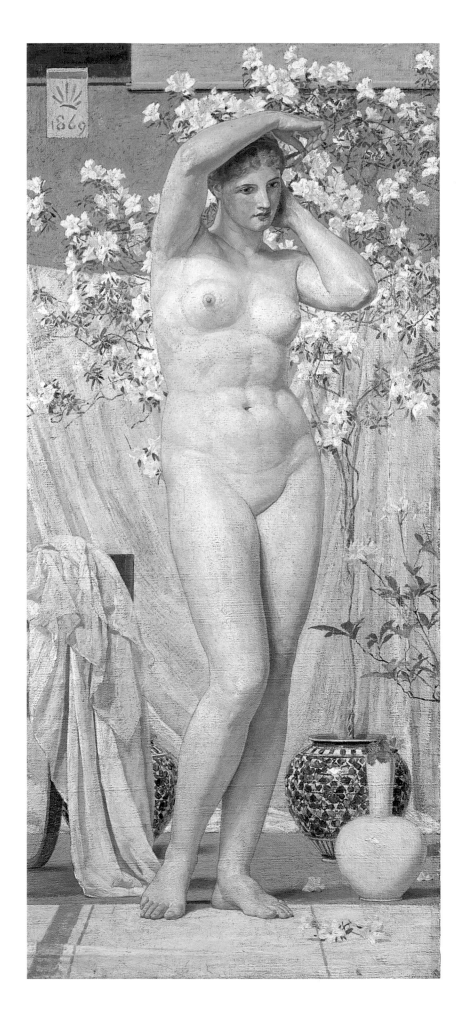

98
A VENUS
1869
Oil on canvas
159.8 x 76.1 cm
(63 x 30 in)
York City Art Gallery

by a small group of artists—principally, Leighton, Watts, Poynter, and Moore—who were responsible for reviving the exhibition of ambitious female nudes during the late 1860s.[153] Pictures that triggered desire were condemned as immoral, but those calculated to extinguish a carnal response were denigrated as inartistic and 'repellent'. The issue of nudity distracted so much attention from Moore's formal intentions that it is no wonder he waited sixteen years before exhibiting another large-scale nude at the Academy. As we shall see, that picture, too, yielded disastrous results.

The exhibition at which Moore showed *A Quartet* and *A Venus* definitively launched classicism as the first progressive English art movement since Pre-Raphaelitism.[154] The centenary of the Royal Academy's founding, 1869, was also the year in which the institution transferred to more commodious accommodations at Burlington House, arousing expectations of nobler themes, executed on a grander scale. Two freshly elected Academicians, Leighton and Watts, oversaw the hanging of the summer exhibition. They boldly exploited the opportunity to promote non-Academicians who shared their admiration for antiquity as an antidote to all that was ugly, weak and slovenly in present-day life and art. Previous hanging committees had relegated such 'eccentrics' to obscure corners and lofty heights, but in 1869 many of them held pride of place. The results were startling and profound, seemingly transforming the face of British art overnight.[155]

This new wave of neo-classicists eschewed artistic convention and worked directly from ancient Greek and Roman artefacts. Through fresh analysis of these authentic sources, they endeavoured to tap into the lost 'secrets' of the classical ideal. Their fresh approach infused antiquity with a new sense of vitality and relevance, and it became the vehicle for a revolution in British aesthetics. Albert Moore's quest for ideal beauty was more radical than the classical revivalism of his contemporaries, and indeed he was unique in focusing exclusively on formal values without any particular interest in classical culture as such. Nevertheless, his analysis of Greek and Roman antiquities dovetailed with the preoccupations of the group. Linkage with Watts and Leighton, two of the most prestigious and influential artists of the day, undoubtedly boosted Moore's career. Leighton in particular proved a valuable ally, and in 1869 he reportedly threatened to withdraw all of his own pictures if Moore's *A Venus* were not exhibited.[156] He ultimately hung the painting as a pendant to his own classical tableau, *Electra at the Tomb of Agamemnon*. Several months later, on 24 January 1870, Moore received his first (futile) endorsement for a vacant Associate's position at the Royal Academy—a solitary vote that could only have come from Leighton.

Further evidence of Leighton's intervention appeared at the following year's exhibition when Moore's painting *A Garden* (Pl. 103) hung prominently among other full-length, life-size figures by non-Academicians in the most prestigious room.[157] In theme, *A Garden* recalls the images of women plucking flowers and fruit in *Apricots* and *Azaleas*. Like those paintings, it unnerved critics as 'an anomaly, and perhaps an anachronism', whose style 'has no precise place in time or space'. Confusion resulted once again from Moore's imitation of

99
SPRING
*c.*79 AD
*Detail of a wall painting
from Stabiae*
Museo Nazionale, Naples

100
STUDY FOR 'A GARDEN'
*c.*1869
*Black and white chalks on
brown paper*
30 x 17.8 cm
(11⅞ x 7 in)
Hunterian Art Gallery,
University of Glasgow

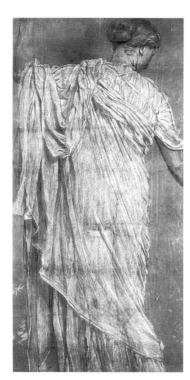

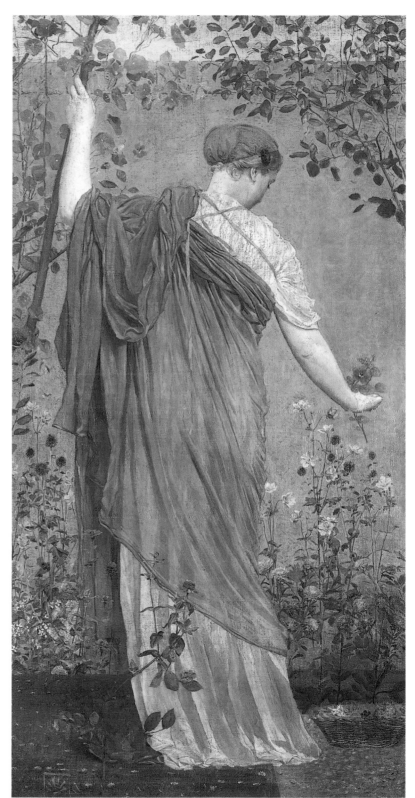

101
NUDE CARTOON FOR
'A GARDEN'
c.1868
Black and white chalks on
brown paper
119.5 x 60.7 cm
(47 x 24 cm)
Victoria and Albert
Museum, London

102
CARTOON OF A DRAPED
FEMALE FIGURE FOR 'A
GARDEN'
c.1869
Charcoal on brown paper
157.3 x 86.3 cm
(62 x 34 in)
Victoria and Albert
Museum, London

103
A GARDEN
1869
Oil on canvas
174.4 x 87.8 cm
(68¾ x 34⅜ in)
Tate Gallery, London

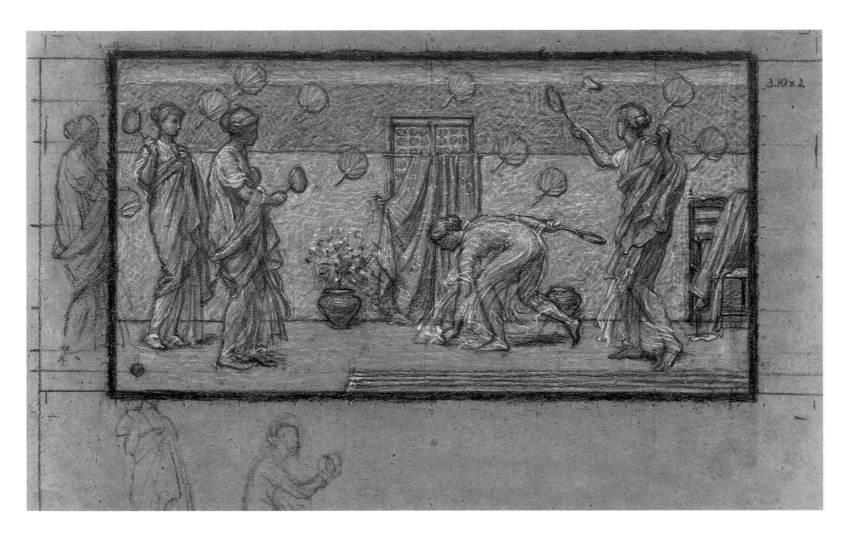

104
STUDY FOR 'BATTLEDORE
AND SHUTTLECOCK'
*c.*1868-70
Black and white chalks on
brown paper
23.5 x 36.8 cm
(9¼ x 14½ in)
Yale Center for British Art,
New Haven

Roman wall-painting in an easel picture, and from his 'unaccountable liking for washed-out greens and feeble, faded tones generally'.[158] Both of these qualities may be traced to a particular fresco (Pl. 99) which seems to have inspired the theme and treatment of *A Garden*, as well as Moore's earlier painting *Apricots*.

As he often did, Moore plotted the basic conception of *A Garden* in a small sketch on brown paper (Pl. 100).[159] Despite numerous subsequent alterations, this draft prefigures fairly accurately the distribution of line in the final arrangement. He had already solidified the disposition of the figure by executing numerous small black-and-white drawings (no more than a foot in height) from the nude model. His object in these studies, according to Baldry, was to make an exact record of the actual proportions and physical characteristics of the figure he was working from. Only after enlarging his design to the full-scale nude cartoon did Moore allow himself to make the improvements suggested by 'his knowledge of what was best in both nature and art'.[160] Moore's nude cartoon for *A Garden* documents the refinements through which he sought to bring the figure into closer agreement with his abstract geometric ideal (Pl. 101). Diagrams sketched into the margins provide the logic behind such changes as the reorientation of the raised arm from the acute angle of its initial position to a nearly perfect right angle. The placement of the buttocks was similarly accommodated to an annotated system of right angles, linking arcs and diagonal lines.

Once perfected, the nude cartoon was transferred to a number of canvases to provide the basis for oil studies in which Moore 'settled the exact placing of the [drapery] folds, the relations of the various masses one to the other, and their conformity with the general composition of the picture'.[161] Moore's drapery cartoon for *A Garden* (Pl. 102) demonstrates the sensitive manner in which he related the folds and swags of fabric to the body beneath it, a relationship that is masked in the final painting.

In November 1869, shortly after completing *A Garden*, Moore relocated his studio to 3 Red Lion Square, Holborn, while retaining his residence at Fitzroy Street.[162] The maintenance of a separate studio strained the artist's modest finances as it had done two years previously, and he was forced once again to ask a patron for a £100 advance, as he was 'at this moment much pressed for ready money'.[163] Moore rationalized his move on the grounds of needing a studio with better light, but his abandonment of the familiar neighbourhood may also reflect his desire for isolation. While joining with relish in the area's bohemian social life, Moore was displeased by interruptions when at work.[164] While his studio lay along a well-beaten path, the unexpected calls of friends, patrons and admirers must have been a constant annoyance.

During one such impromptu visit to Moore's Fitzroy Street studio around 1869, Thomas Armstrong and the ceramicist William De Morgan were startled to find their friend busily 'painting young ladies dressed in white and lilac *nocturnes* [sic], and I think playing battledore and shuttlecock'.[165] An impression of this remarkable scene is

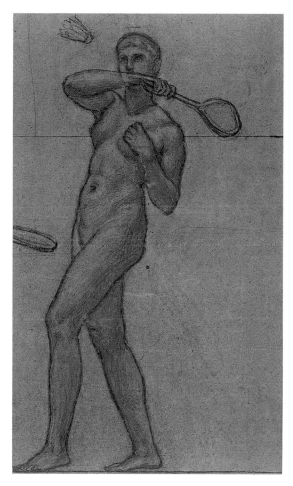

105
STUDY OF A NUDE FIGURE
FOR 'BATTLEDORE AND
SHUTTLECOCK'
*c.*1868-70
*Black and white chalks on
brown paper*
51.3 x 30.1 cm
(20¼ x 11⅞ in)
Victoria and Albert
Museum, London

conveyed by chalk drawings in which Moore documented his models'
spontaneous actions (Pls. 104-7). They reveal that the young ladies
were not always clad in white and lilac, but also played the game in
the nude. Baldry later confirmed that Moore 'set his models for some
hours to play the game of battledore and shuttlecock, watching them
and sketching each attitude that struck him as presenting pictorial
possibilities.'[166] Like Whistler, he seems to have found that 'as he
watched their movements, they would take the pose he wanted, or
suggest a group, an arrangement.'[167] The contemporary French
theorist Horace Lecoq de Boisbaudran advocated studying 'living
drapery' in this way, for 'there spring into view unsuspected motives,
often of great beauty, as the model walks, runs or rests'.[168]

Throughout his career, Moore returned to the problem of conveying
movement without sacrificing the ideal quality of repose. In *A Girl
Dancing* and *Dancing Girl Resting* (Pl. 33), he had paired a moment of
active physical exertion with the repose that followed it. In his studies
of battledore and shuttlecock players, he sought to capture the
'moments of quiescence' between periods of strong action: 'vigorous
leaps and bounds arrested suddenly, and changing constantly in
direction and velocity' (Pl. 105).[169] Although studies from the nude
provided crucial information about the positions assumed by the
limbs, Moore's drapery studies illustrate his prevailing interest in
the impression of fluid movement created by sweeping curves and
clustered pleats of fabric (Pl. 106). According to Baldry, Moore
analysed a series of related actions in order to isolate only those
elements that were essential to an underlying pattern. His synthetic
approach differed from later experiments with freeze-frame
photography carried out by artists such as Thomas Eakins and
Eadweard Muybridge.[170] Moore, by contrast, compressed non-
synchronic moments of action into a single image intended to convey
change over time, a concern that would later absorb Italian Futurists
such as Giacomo Balla.

Moore evidently abandoned plans to carry out *Battledore and Shuttlecock*
on a large scale, executing instead a small painting whose exact date
and present whereabouts remain mysterious.[171] His compositional
sketch for the picture (Pl. 104) shows strong stylistic links to the
1867-9 period. Like the bows in the recently completed *A Quartet*, the
rackets provide vigorous diagonal counterpoints to Moore's customary
juxtaposition of fluid figural curves and rigid orthogonal architecture.
The Japanese fans positioned strategically on the wall (a device
borrowed from *A Musician*) mimic the shape of the battledores, so
that the eye reads them as a barrage of rackets tossed from the
players on one side of the room to those on the other. This whimsical
presentation is compounded by the surprise of seeing lively movement
in figures modelled on classical statuary.[172] Moore's design prefigures
later attempts to invest classically draped figures with a vital sense of
motion,[173] but his extraordinary decision to represent them engaged in
a modern game is unique. Indeed, not until Surrealism would artists
again take such liberties.

As it often did, Moore's focus ultimately narrowed to a radically
simplified interpretation of his theme, which he pursued as a pair

106
STUDY OF A DRAPED
FIGURE FOR 'BATTLEDORE
AND SHUTTLECOCK'
*c.*1869-70
Whereabouts unknown
(from *The Studio*, 31 May
1904)

of paintings for James Leathart. After purchasing *A Musician* in 1865, Leathart had gone on to buy *Elijah's Sacrifice* in March 1867. Still interested in Moore, he consulted Dante Gabriel Rossetti about him in April of that year. No great admirer, Rossetti tactfully replied that he had 'not seen anything of his done lately'.[174] On the strength of a small oil sketch, Leathart nevertheless commissioned Moore to produce a pair of classically draped figures, each bearing a racket and shuttlecock. Leathart's sanction of this bizarre subject attests to his exceptional liberality. To Moore, of course, the subject was immaterial.[175] He initiated the pictures as contrasts in linear patterning, expressed principally through layered systems of drapery. The broadly sweeping curves in *Shuttlecock* (Pl. 111) reinforce the static quality of the figure's expression and gesture, whereas in *Battledore* (Pl. 112) intersecting diagonal swags and zigzagging folds compound the gestural suggestion of abrupt, transitory motion. Moore's preparatory drawings from models buried in volumes of drapery reveal his incremental development of the precise arrangement of fabric (Pl. 109). In his final paintings, he deliberately compressed the volumes of drapery in order to create a flat, linear appearance reminiscent of classical relief sculpture (Pl. 108).

Moore wrote to Leathart on 10 November 1868 to report that he was 'now fairly at work on your two pictures, and propose to go on with them continuously till they are finished'.[176] By 15 February 1869 he had transferred the nude cartoons to the final canvases and was ready to paint the draperies. At that point Moore informed Leathart that he had 'hit upon combinations of colour darker in character than the little sketch you saw some time ago'. Impatient to pursue his rapidly evolving ideas but constrained by the deference due his patron, Moore wrote awkwardly:

> I think it best to learn your views on the subject. That is to say, if you have any particular desire that the pictures should be kept light in character—as for instance, for the sake of their effect in your room—I shall of course be ready to recur to something like the original scheme: at the same time I have reason to believe that the later combination would succeed—having tried them in small sketches [Pl. 110]—and I may say I should not hesitate to carry them out, were I the only person concerned.[177]

Moore's letter attests once more to the conflict between his commitment to devising paintings in relation to a larger decorative ensemble, and his desire to explore independently the aesthetic questions that interested him.[178]

In addition, Moore's message shows that despite his eagerness to gain his patron's sanction, he had no interest in cultivating his understanding. By characterizing his new colour arrangements as a simple substitution of 'dark' for 'light', he glossed over the complex reasoning behind them. It was actually Moore's intention to develop contrasts in colour harmony analogous to the linear contrasts expressed through the drapery folds. Having obtained Leathart's

107
TWO DRAPED FIGURES,
STUDIES FOR 'BATTLEDORE
AND SHUTTLECOCK'
*c.*1868-70
Black and white chalks on
brown paper
35.6 x 23.4 cm
(14 x 9¼ in)
Ashmolean Museum,
Oxford

consent to the change, Moore developed each picture as a separate experiment in the science of colour. He had received rigorous training in this subject at the School of Design at York (and possibly at South Kensington), where the teaching was deeply influenced by Michel Eugène Chevreul's *The Principles of Harmony and Contrast of Colours* (1839), a treatise inspired by study of the coloured threads in Gobelin tapestries.[179] In *Shuttlecock* Moore allied the complementary colours blue and orange that Chevreul had theorized as a 'harmony of contrasts'. Like black and white, these chromatic opposites combine to produce grey, the exact tonality depending on the proportion of each pigment in the mix. The terms of Moore's chromatic equation are laid out geometrically in the mat at the figure's feet, which is woven with alternating bands of chromatic complements—blue and orange, black and white—together with grey, the by-product of each of the two chromatic pairs. A contemporary of Moore, the poet and art critic Cosmo Monkhouse, later observed that each of the artist's 'subtle' and 'scientific' pictures 'is a little problem of colour inimitably worked out in lovely forms. The problems are plain enough, as each picture generally contains some little strip of matting or carpet which is at once the proposition and the Q.E.D.'[180]

The chromatic arrangement in *Shuttlecock* exploits the tendency of colours to imprint upon the eye an impression of their complements. Framed by passages of deep blue, the grey-blue drapery gains warmth from the resulting suggestion of orange pigmentation. Conversely, by placing orange and blue in vibrant opposition near the face, hands, and feet of the figure, Moore enhanced the harmonious blending of those pigments within the flesh tones. Moore puzzled out a different chromatic riddle in *Battledore*. Juxtaposing pale blue with green, he created 'harmony of analogy' (green being a mixture of blue and yellow), which he strengthened through highlights of complementary orange dotted throughout the painting.

The science of colour excited great fascination in nineteenth-century England, but almost exclusively within the context of architectural decoration and manufacture. The rigorous application of colour theory to pictorial art was deemed antithetical to the naturalism demanded of painters, and with *Battledore* and *Shuttlecock*, Moore evidently pushed abstract interests to a level his contemporaries could not accept. When the two paintings appeared together at the Royal Academy in 1871, many praised the nobility of the artist's figurative conceptions, while balking at his obvious engagement in scientific theories. Charging Moore with squandering his obvious 'power of drawing and sense of beauty' by pursuing pictures that were 'more and more purely decorative, and singularly trivial in motive or meaning', William Bell Scott complained that 'there is absolutely no reality in his figures, and, lovely in design as they are, no enjoyment to be found in looking at them.'[181] Similarly, F.G. Stephens dismissed them as mere 'exercises in harmonies of tints'.[182] The low status of applied design in relation to 'high art' prejudiced critics against Moore's attempts to merge the two, and accounts for the note

108
COLUMN DRUM FROM THE
TEMPLE AT EPHESUS
330-310 BC
Marble relief
height 182 cm *(71¾ in)*
British Museum, London

109
STUDY OF A DRAPED
FIGURE FOR
'SHUTTLECOCK'
*c.*1868-9
*Black and white chalks on
brown paper*
32.3 x 14.3 cm
(12¾ x 5⅝ in)
Private collection

110
COLOUR SKETCH OF
'SHUTTLECOCK'
*c.*1869
Oil on canvas
37.1 x 15.9 cm
(14⅝ x 6¼ in)
Sheffield City Art Galleries

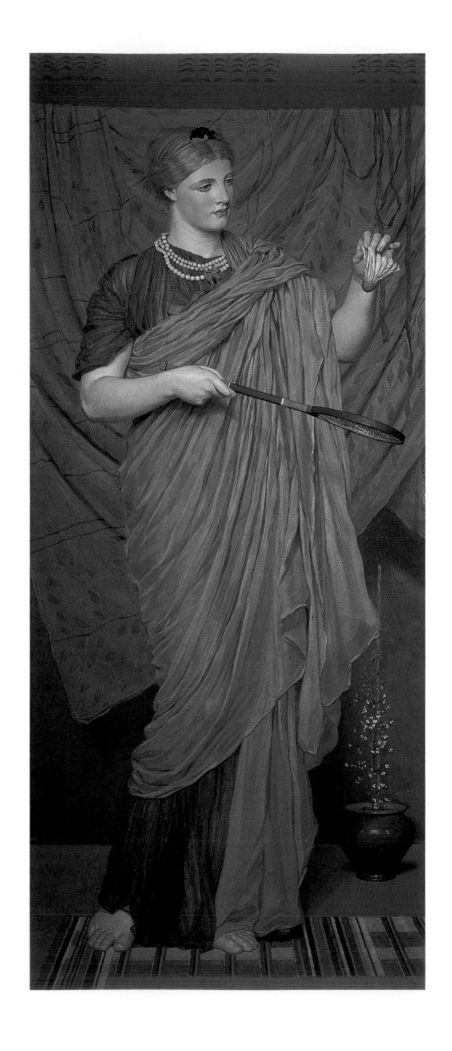

111
SHUTTLECOCK
1868-70
Oil on canvas
106.6 x 44.4 cm
(42 x 17½ in)
Private collection

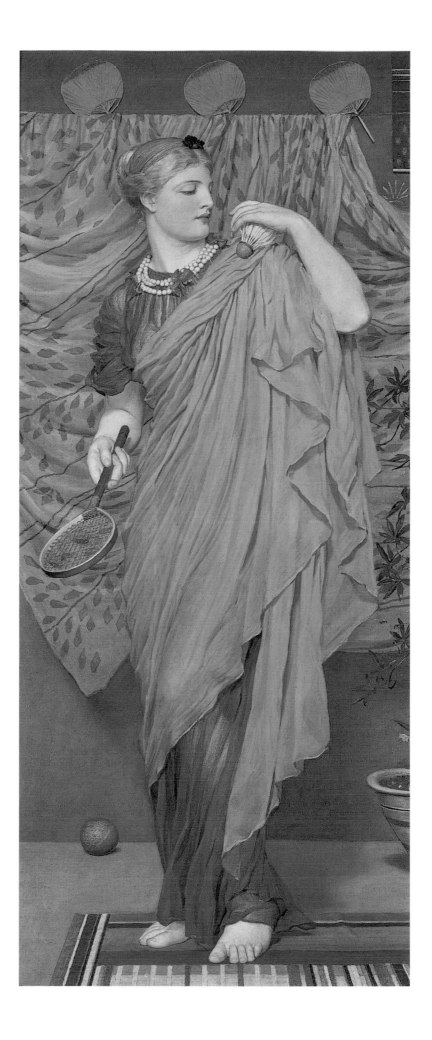

112
BATTLEDORE
1868-70
Oil on canvas
106.6 x 44.4 cm
(42 x 17½ in)
Private collection

of snobbery in the comment that his 'chromatic concord holds relationship with Japanese screens which sell at threepence apiece'.[183] Even Sidney Colvin, who had congratulated Moore on the theoretical colour system of *A Venus*, now asserted that the artist was misguided in employing pigments 'not to imitate life, but to produce an agreeable pattern', for this 'thin and abstract system of colour' had already been achieved perfectly in 'a thousand [Japanese] fans, screens, and printed hangings'.[184] Only one critic appreciated Moore's abstraction as 'a timely protest against the vulgar naturalism, the common realism, which is applauded by the uneducated multitudes who throng our London exhibitions'.[185]

Such criticisms may have dampened the enthusiasm of Moore's patron James Leathart, but it was the artist himself who finished the

job. Having sent *Shuttlecock* and *Battledore* to Leathart in July and September 1870, Moore wrote on 23 November asking for an advance on a third, as yet unfinished painting that Leathart had offered to buy that March. Leathart had wanted the picture by Christmas, but Moore doubted his ability to comply. 'The weather is so uncertain that I don't like to fix any precise date,' he wrote, alluding to the overcast skies that so often impeded artists' work.[186] But in reality, Moore was absorbed in painting *Sea-gulls* (Pl. 71), a major work for Frederic Leyland which occupied him right up to the Royal Academy exhibition that spring. Moore intended to show *Shuttlecock* and *Battledore* in the same exhibition, and he designed a pair of simple but elegant frames of carved wood, which he deemed 'unusually successful, and certainly the best with which I have had anything to do' (Pl. 113).[187]

Unfortunately, he had neglected to consult with Leathart who was outraged to receive the framer's bill for £20.[188] In his defence, Moore composed a polite but firm statement, indicating that he merely followed 'the general custom, which is, that when pictures are bought in their frames, the latter are included in the purchase—but in case of commissions the price named only refers to the picture, and the frame ... is paid for by its possessor'.[189] In a subsequent letter, he reminded Leathart that he had gratuitously donated his own time and effort in designing the frames, which were 'as much an advantage to his client as to himself'.[190]

Leathart's response indicates that despite his interest in the work of 'advanced' artists, he did not share their holistic conception of the frame as integral to the work of art. On the contrary, expending 10 per cent of the picture's value on the frame struck him as 'extravagant'.[191] But Leathart also disliked the autonomy that Moore had assumed for himself, considering it 'wrong in principle and liable to abuse in practise' and 'different from that I have been accustomed to during an experience of many years'. He agreed to keep and pay for the frames on condition that Moore give him 'a sketch or sketches of the value of £10-£20'.[192] The matter might have ended there, but Moore stubbornly persisted. He wrote again on 24 August, citing letters from Watts, Leighton, and 'a distinguished architect' (probably Nesfield) vindicating the course of action he had taken and the fairness of the framer's price.[193] To settle the matter, he proposed paying the £5 difference between his frames and the standard plaster type, but he denied Leathart's interpretation of this offer as an admission of guilt, declaring on 6 September:

> The compromise I proposed was not, therefore, because I considered myself in any way called upon to pay the cost of the frames, but because I did not think it right that I should be the means of your incurring any undue expense in the matter—as by this arrangement ... you will possess at least full value for money expended, while I am a definite loser, I trust that I shall not be held, on reflection, to have been inconsiderate in adhering to it, though your assent is given somewhat reluctantly.[194]

Leathart responded with a generous letter praising *Battledore* and *Shuttlecock*, but the damage had been done and the matter of an additional commission was dropped.

The third painting Moore exhibited at the Royal Academy in 1871, *Sea-gulls*, had also occasioned conflict—not this time with a patron, but with Whistler. During a visit to Moore's studio in the spring of 1870, Leyland had admired his preliminary oil sketch of a figure draped in pale yellow, which was then claimed by another patron. That commission apparently fell through just as Moore was finishing the second of Leathart's paintings.[195] Having already designed a second figure as a companion to the first, Moore put both sketches in a box and sent them off for Leyland's inspection on 29 August 1870. With his patron's consent, Moore proposed to 'commence the two pictures at once, and to go straight on with them'. He set his price for the pair

at 450 guineas and requested an advance on account.[196] Evidently delighted, Leyland sent a cheque for £150 by return of post.[197]

Before turning his attention to Leyland's commission, Moore took a brief holiday to Hastings in mid-September 1870, probably hoping to make studies of the ocean and seashore.[198] On his return to London, he found a disturbing letter from Whistler, evidently composed while visiting Leyland.[199] The rambling opening sentences indicate unprecedented trepidation in a man who delighted in throwing down gauntlets and pursuing quarrels as sport.[200] Whistler recalled a previous occasion on which Moore had expressed concern that 'a certain bathing subject' he wished to paint might too closely resemble a sketch of Whistler's, as 'it would annoy you greatly to find yourself at work upon anything that might be in the same strain as that of another'. Having now seen the 'two beautiful sketches' that Moore had sent to Leyland as potential commissions, he was inclined to agree with Moore:

> While admiring them as you know I must do everything of yours—more than the productions of any living man—it struck me dimly— perhaps—and with great hesitation that one of my sketches of girls on the sea shore, was in motive not unlike your yellow one—of course I don't mean in scheme of color but in general sentiment of movement and in the place of the sea—sky and shore, etc.

Whistler had commenced half a dozen or more pictures that borrowed explicitly from his friend, and he now seized on the one instance in which his own conception (windswept figures by the seashore) might arguably have influenced Moore (Pl. 114).[201] In fact, the resemblance between their respective sketches was so slight that Whistler felt obliged to append a detailed description of his own.[202] Whistler's anxiety was no doubt exaggerated by the fact that with *Sea-gulls*, Moore would fulfil his second commission for Leyland, while Whistler (who originally brought them together) had yet to complete his first picture for Leyland, commissioned in 1867.

Worse still, Whistler feared that by prior exhibition Moore's painting would cast his own in the light of an imitation—a mortifying prospect for one who prided himself on originality. He asked Moore to consider whether 'we may each paint our picture without harming each other in the opinion of those who do not understand us and might be our

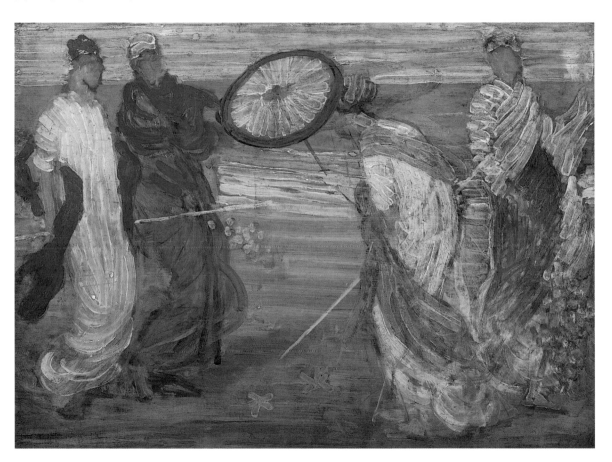

113
Photograph of James Leathart's drawing room at Bracken Dene, Gateshead, showing the painting *Shuttlecock* in the frame designed by Moore
c.1895

114
James McNeill Whistler
SYMPHONY IN BLUE AND PINK
c.1868
Oil on canvas
47.7 x 61.9 cm
(18¾ x 24¾ in)
Freer Gallery of Art, Washington DC

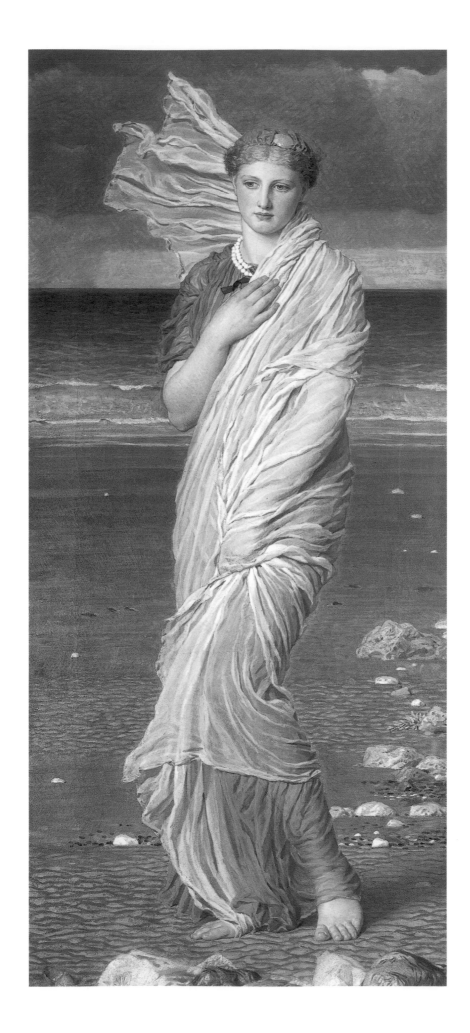

115
SHELLS
1874
Oil on canvas
156.0 x 68.5 cm
(61½ x 27 in)
Walker Art Gallery,
Liverpool

natural enemies. Or more clearly if after you have painted yours I may still paint mine without suffering.' He proposed that Moore accompany Nesfield to his studio in Chelsea to inspect the sketch, all the while protesting his doubts that 'any incomplete little note of mine could even unconsciously have remained upon the impression of a man of such boundless imagination and endless power of arrangement as yourself'.

On 19 September 1870 Nesfield and Moore duly made the examination requested by Whistler, and later that day Nesfield filed his report:

> I strongly feel that you have seen and felt Moore's spécialité in his female figures, method of clothing them and use of colored muslin also his hard study of Greek work. Then Moore has thoroughly appreciated and felt your mastery of painting in a light key ... In answer to your question 'could each paint the two pictures without harming each in the opinion of those who do not understand both' I am quite certain you both may. The effect and treatment are so very wide apart, that there can be no danger from the vulgar fact of there being, shore, sea, and sky and a young woman walking on the foreground.[203]

In this tactful response, Nesfield took care to distribute credit evenhandedly, for he must have realized that restoring Whistler's confidence was essential to maintaining peaceful coexistence. His further remarks attest to the close relationship of the three men, and to his anxiety about their continued intimacy: 'As you and Albert have asked me to be arbitrator in this matter I of course take it for granted that my decision is valuable and to be accepted, also that we are all "in the family"... I have such a sincere admiration for you both that this slight awkwardness has considerably worried me, so much so that I have not done a stroke of worth to day.'

In the end, the crisis was averted. Moore and Whistler continued to see each other often, occasionally rowing together on the Thames. Scenes glimpsed along the river had undoubtedly inspired each of their paintings of windswept figures at the water's edge. Indeed, *Sea-gulls* lends credence to Baldry's assertion that Moore extrapolated his pictorial compositions from phenomena observed in nature: 'From the unconscious line agreement of natural forms came the method of composition which he followed; from effects observed out of doors came ideas for pictorial arrangements and for the choice of appropriate accessories.'[204] In *Sea-gulls* Moore introduced obvious analogies between the liquid patterns of the sea and the rippling and splashing motion of the figure's hair and drapery. As in *Battledore* and *Shuttlecock*, he had gone to unusual lengths to analyse these effects. According to Baldry, he 'used a special machine, a revolving fan which, working at high velocity, produced a very strong air current, so as to enable him to give to the draperies the effect of being blown by a brisk breeze'. Once again, Moore's intention was to discern the patterns inherent in nature: 'the constantly repeating ripple, the recurrent clinging and falling apart, which, like the advance

and recession of a wave, are susceptible of analysis and record'.[205]

Baldry's choice of words bears out the analogy with water noted above, and hints at the artist's use of the principle of parallelism (which he considered one of 'Nature's chief rules') to systematize these instances of 'unconscious line agreement'. Thus, the long horizontal waves of the ocean gradually coalesce into the ridges and valleys they have imprinted in the sand, and these lines are echoed in the figure's clinging drapery, which the wind has shaped into another succession of parallel crests and hollows. The analogous patterning of fabric and water relates Moore's painting to the marine subjects through which his brother Henry explored 'the sequence and rhythm of wave movement' with 'the analytical knowledge of a scientist'. Henry's biographer likened the liquid patterns of these sea paintings to 'a fabric of flowing lines' and a 'piece of pure decoration'.[206] The drapery treatment in *Sea-gulls* also calls to mind the reclining goddess of the Parthenon's east pediment, whose hips, thighs and calves are moulded in the same way by encircling coils of drapery (Pl. 66). Moore also emulated classical relief sculpture, emphasizing the contrast between the static horizontals of the background and the zigzagging diagonals of the figure's limbs and drapery.[207]

On 9 January Moore informed Leyland that another client had expressed a desire for a full-scale repetition of the pale yellow 'figure in a wind', adding: 'I have agreed, subject to your approval, to paint it for him when yours is finished. I should not, of course, entertain the idea if I thought it would in any way prejudice the picture I am painting for you, but I hope you will not hesitate to inform me if you find the arrangement objectionable.'[208] By return of post, Leyland refused Moore's request, and in his reply of 14 January, the artist assured him that 'as I am ... to design something else for my client, I am not myself affected by the way the point has been decided.'[209] This diplomatic assertion was far from the truth, for the gruelling preparatory work required by each new design sapped the artist's time and energy. During the mid-1870s he increasingly sought opportunities for repeating and reinterpreting existing designs, a strategy that required care in order to avoid irritating patrons.

With less than a month remaining before the Royal Academy deadline, Moore reported on 9 March that he was still 'not yet quite finished' with *Sea-gulls*, and he remained unsatisfied even after sending the picture off.[210] He regretted that Leyland had seen the painting for the first time at the Academy, where 'the glare upon it puts it out so much', but he added, 'I think I see my way to improving it when it comes away'.[211] Moore's efforts to redress the surface of the picture following its exhibition may account for the unusually thick paint layers now present in *Sea-gulls*. He had been experimenting for some time with the surface quality of his paintings, which consistently drew complaints.[212] By the time he turned his attention to the companion picture, *Shells* (Pl. 115), an obligation delayed two years by ill health and pressing commitments,[213] Moore had developed a new procedure aimed at attaining a more appealing surface. After transferring the nude cartoon to his canvas and filling in the outline with colour, he used a fine-bristled brush to lay a coat of white lead over the entire

picture. When dry, he made another transfer of the nude cartoon, adding more detail. This, too, he covered with white lead, applied in an opposing direction. Moore repeated this procedure after transferring the drapery cartoon, and with all subsequent stages of the painting. The resulting cross-hatched texture created a finely dappled surface reminiscent of stippling, so that the graduated tones of *Shells* merge with greater nuance than those of *Sea-gulls*.[214]

In both pictures, the background consists of a series of horizontal bands of subtly modulated colour, each based on grey but differentiated by tints of blue, green, purple or brown. Moore's treatment of the transparent over-drapery provides further evidence of his mastery of delicately graduated tints; the drapery yields a range of tonal effects as it doubles back on itself, skims the pale flesh, or

alone in the power of finding out for himself and in common nature the sources of this ideal loveliness and of thus forging a new and stronger link between art and truth.'[217] The *Art Journal*, too, lauded Moore's singular discernment of ideal beauty in the world around him as a crucial counterbalance to mundane realism. 'The artist is pursuing no unreal or intangible ideal,' the critic asserted; 'his art has as close a contact with nature as can be got, and the beauty he seeks to present to us, the grace that he contrives to secure, is genuinely derived from the actual and simple movements of living men and women.'[218] Yet others disparaged Moore's combination of idealism and realism as 'hybrid Greek fancies ... of a very pseudo-classic order'. His attempt 'to introduce a pure Greek sentiment into nineteenth-century England', according to William Davies, 'has pretty much the same effect as a modern bonnet would have had on the head of Aspasia.'[219]

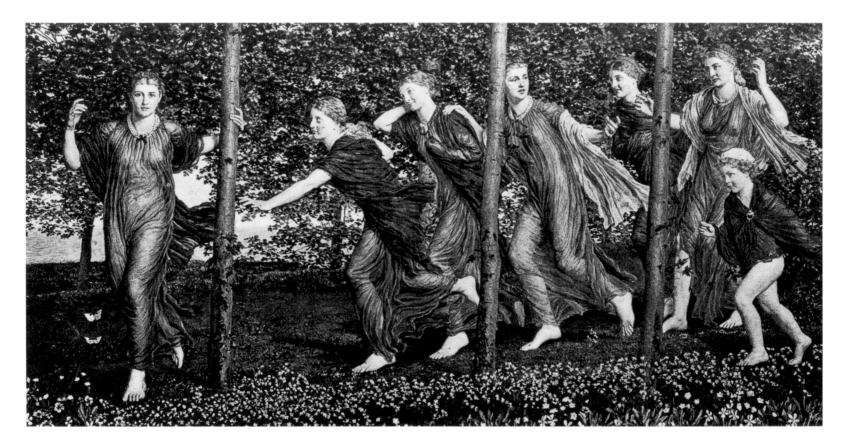

clings to the darker undergarment. Moore's fastidious painting habits ensured that each tint retained its individual clarity, for 'more than an hour daily was spent by him in washing his brushes, of which he used about two hundred.'[215]

When *Shells* appeared at the Royal Academy in 1874, critics stressed the artist's emulation of disparate aspects of classical art—chiefly the spontaneous handling and chalky colour of fresco, and the form-revealing patterns of sculptural drapery.[216] Sidney Colvin again emphasized that Moore's analysis of the natural phenomena responsible for Greek idealism distinguished his art from the more imitative neo-classicism of his contemporaries. 'Other painters', he wrote, 'carry the recollection of great achievements in art easily and successfully into their own drawing; but Mr Moore stands almost

Ironically, the very combination of mundane realism and classical idealism of which this critic complained distinguished a new class of antiquities that was well on its way towards creating an international sensation. Graves looted in and around Tanagra, Boeotia, in 1870-3 had yielded a cache of small terracotta figurines dating from about 330-200 BC. Elaborate drapery systems, sprightly gestures and individualized expressions differentiated these figurines from the classical Athenian statues on which they were modelled. Their beguiling naturalism was further enhanced by layers of pastel paint still clinging to the clay.[220] In contrast to full-scale statuary—imbued with the daunting majesty of mythological goddesses—these humble statuettes provided lifelike evocations of the charm and elegance of actual women. Their uncanny similarity to pictures executed by Moore and Whistler prior to the Boeotian excavations has led to much

speculation about the artists' early access to such antiquities.[221] Rather than exerting a formative influence, however, it seems more likely that the figurines latterly entrenched tendencies already initiated by Moore and imitated by Whistler—such as the linear complexity of the drapery folds and the candour of the figures themselves. Indeed, it can be said that Moore's figure type (which his contemporaries perceived as a singular innovation) helped to generate a taste for the graceful charm of Tanagra, as much as the figurines lent authority to his own idiosyncratic blend of realism and idealism.[222]

The major effort required to complete *Sea-gulls* by early April 1871 had shattered Moore's health and necessitated his abandoning work for some months. Although Leyland had paid him £86 5s. in March and advanced another £120 towards *Shells* the following April, Moore's suspended labour and his travel in search of 'change of air' rapidly exhausted his funds. On 17 June he was obliged to ask his patron for an additional £50, explaining that 'at present I have always to sail rather close to the wind' and therefore the 'forced delay and expence have proved rather inconvenient in a pecuniary sense.'[223]

An added strain on the artist's finances was the more elaborate household that he had begun to operate. Around 1870, presumably wishing to be nearer his studio in Red Lion Square and in a slightly more secluded locale, he had left Fitzroy Street and moved to a small house at 37 Great Ormond Street, around the corner from Queen's Square.[224] Also living with Moore was his 14-year-old servant Alice Elizabeth Bayall and Elizabeth Moore, listed in the 1871 census as the artist's 25-year-old wife from Southampton.[225] An exhaustive search has yielded no record of Moore's marriage—either official or anecdotal.[226] Vestigial evidence of the relationship survives only in the sly hints that cropped up years later in Moore's obituaries, where it was 'darkly hinted' that 'other causes quite apart from his merit as an artist' accounted for the artist's life-long exclusion from membership in the Royal Academy.[227] Fearing that 'by saying too little or suggesting too much', these hints were 'likely to be seriously misunderstood', a writer for the *Magazine of Art* finally vowed to 'frankly explain' the reason for Moore's exclusion:

> It was simply because his views of the marriage laws were unconventional, and he had the courage of his convictions ... The basis on which that body founded its objection, it is said, was the Article I of the Instrument, which enacts that members of the Academy shall be 'men of fair moral characters'.[228]

In late nineteenth-century London, it was hardly unusual for men to consort with prostitutes or keep mistresses. The practice was especially prevalent among artists, and particularly the artists of Moore's circle. As long as such philandering adhered to an unwritten code of discretion, members of the Academy were prepared to look the other way. Indeed, as the writer for the *Magazine of Art* went on to point out, 'The Academy has more than once ignored, and therefore condoned acts which no one dreams of coupling with [Moore].'

116
FOLLOW MY LEADER
*c.*1873
Oil on canvas
182.7 x 91.3 cm
(72 x 36 in)
Private collection

117
STUDY FOR THE THIRD
FIGURE IN 'FOLLOW MY
LEADER'
*c.*1871
*Black and white chalks on
brown paper*
30.4 x 17.1 cm
(12 x 6¾ in)
York City Art Gallery

But although discreet hypocrisy was widespread and acceptable, openly flouting the law by cohabitation with a 'spouse' to whom one was not legally married constituted a gross moral outrage. This was the crime of which Moore was evidently guilty. A clandestine double life would have ill-suited him, and his candour made it impossible for Academicians to sustain the pretence of ignorance. From the 'clear and honest, but woefully inconsistent' point of view of these members, they had no choice but to keep Moore out. In concluding his notice, the writer for the *Magazine of Art* combined a paean to moral relativism with an assertion of the proper separation of public and private life:

> In the eyes of a certain proportion of the members, as well as in those of most people outside, it is no bar to the appreciation of a man's talent that he should entertain views

shorter duration than George Eliot's, for in 1881 no 'wife' is listed at his address. No reference to her emerges in contemporary letters, diaries, or reminiscences, nor is anything known of any other liaisons on Moore's part. This silence would be surprising, were it not for the fact that Moore himself so rarely surfaces in writings of the period. Nevertheless, the characterization of the relationship as 'a matter of common knowledge' suggests that it was discussed if not written of, presumably by those hostile to Moore. A malicious whispering campaign helps to explain why Elizabeth Moore (and perhaps other 'wives' unrecorded by the census) remained so long in the minds of many Academicians. Baldry claimed that Moore's opponents were unable 'to forget unreasonable prejudices and to sink unworthy personal feelings', adding, 'the reason why Albert Moore never succeeded in entering Burlington House was purely personal, and not at all dependent on anything inherent to his work. His pictures, year

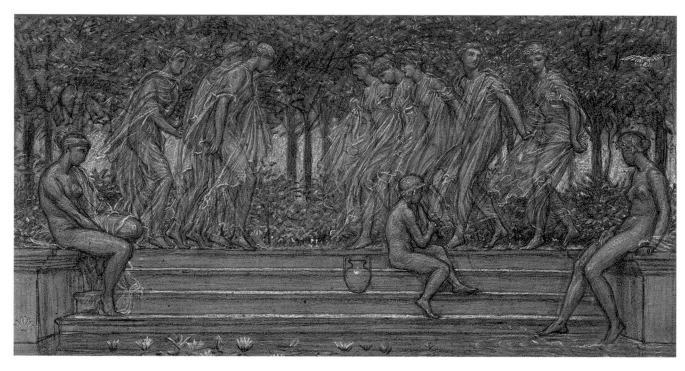

118
NYMPHS DANCING:
DESIGN FOR A PICTURE
*c.*1870-2
Black and white chalks on brown paper
20.3 x 38.1 cm
(8 x 15 in)
Victoria and Albert Museum, London

shared by George Henry Lewes, George Eliot, and a vast number of our greatest men and women—views which have reference alone to his private life, into which no prying should be tolerated, even in principle. To take notice of gossip, even though it be a matter of common knowledge, is less injurious to the man who is to be ostracised, than to the ultimate reputation of the Academy and of English art itself.[229]

The reference to the common-law marriage of George Henry Lewes and Mary Anne Evans ('George Eliot') is intriguing, as Moore had read *Adam Bede* soon after its publication in 1859, and might easily have met the author herself through their mutual friends Thomas Armstrong and Barbara Bodichon.[230]

If the census is to be relied on, however, Moore's marriage proved of

by year, were treated with no disfavour; ... it was the artist himself that was left out.'[231] Elsewhere, however, Baldry blamed Moore's exclusion from the Academy on aesthetic differences.[232] It seems most likely that Moore's 'immorality' provided a convenient rationale for excluding a man whose barbed insults and challenging mode of art had incurred the insuperable resentment of many within the Academy.

Prior to completing *Shells*, Moore had carried out a far more ambitious painting for the wealthy Newcastle industrialist and inventor Sir William Armstrong (1810-1900). In 1870 Armstrong had engaged Richard Norman Shaw (Nesfield's former partner and current office-mate) to rebuild and enlarge his house, Cragside, in the Elizabethan style. On the recommendation of either Shaw or Nesfield, Moore was engaged in 1871 to paint a large, multiple-figure, free-standing composition for Armstrong, for the princely fee of 900 guineas (Pl. 116).[233] *Follow My Leader* is a logical development of Moore's previous

work on the battledore and shuttlecock theme, translating a simple child's game into a sophisticated study of figures in motion. Having previously set his models to work with rackets and shuttlecocks, Moore now asked them to run up and down the length of his studio while he diligently recorded the effects of motion on their drapery.[234] Marginal notations in Moore's chalk studies indicate his particular fascination with ribbon-like silhouettes and reiterated curves (Pl. 117). The drawings also suggest that he exaggerated the effect of air currents by employing the revolving fans that were simultaneously in use for *Sea-gulls* and *Shells*; these enabled him to approximate the masterful treatment of running and flying figures in classical Greek sculpture. Moore enhanced the sense of motion by accommodating his figures to a system of intersecting diagonal lines expressive of dynamic movement.[235]

The impression of motion in *Follow My Leader* is further enhanced by a colonnade of slender young trees in the foreground. Although the eye reads the trees as vertical, they actually incline to the right, counterbalancing the emphatic leftward diagonal thrust of the figure group. As such, the trees exemplify the principle of 'optical rather than actual balance' that Baldry claimed Moore had derived from natural observation. These partitions also create an effect analogous to that of freeze-frame photography, seeming to encapsulate successive moments of continuous action and, by doing so, to chart change over time. By expanding and compressing the space through which the figures move, the erratic placement of the trees accentuates the impression of varied momentum. Moreover, like the Italian Renaissance model from which the device is likely to derive, the arrangement has a musical quality, with the emphatic vertical elements providing a rhythmic overlay to the melodic rise and fall of the figures.

These musical associations were overtly expressed in Moore's design for an unexecuted picture of dancing figures (Pl. 118). Like *Follow My Leader*, it represents a group of women moving in sequence across a horizontal space punctuated by trees.[236] The swirling folds of the dancers' drapery convey a melodic quality, while the repetitive positioning of their legs and feet establishes a steady rhythm. Moore arrived at the poses by sketching nude models traipsing across his studio (Pl. 72).[237] In order to reinforce the picture's musical quality, he inserted details intended to evoke the sensation of sound, such as the piping boy, fluttering bird, and splashing feet of the woman seated at right. Like his design for the unrealised *Somnus* (Pl. 51), this drawing for an unexecuted work once belonged to Frederic Leighton, and it seems to have informed his painting *The Daphnephoria* of 1876 (Lady Lever Art Gallery).

Moore succumbed to an unknown illness while at work on *Follow My Leader* and by August 1872 he was ensconced at Armstrong's house in Newcastle, 'trying to recruit my health which has not been brilliant lately'.[238] He failed to exhibit anything at the Academy that year, but his name was brought before the public by Charles Lock Eastlake's *History of the Gothic Revival*, which praised his work at Cloverley and issued a plea for more projects of the same kind. 'For the price of a single easel-

picture', Eastlake informed his readers, 'many a wealthy man might secure the services of a Marks, a Holiday, or an Albert Moore to enliven every room in his house with pictured allegory or old-world lore'. Indeed, 'a band of figure subjects round many a drawing-room wall' could be carried out for 'less than half the money lavished on fashionable upholstery, gilded cornices, and rococo furniture'.[239]

It was perhaps to Eastlake that Moore owed a commission that year (1872) to produce a decoration scheme for the residence of Augustus Frederick Lehmann at 15 Berkeley Square, London. He had not collaborated on such a project in several years, and he may have accepted the commission out of regard for the architect and

119
DESIGN FOR A DECORATIVE PANEL
*c.*1875
Black chalk on brown paper
58.4 x 25.4 cm
(23 x 10 in)
Private collection

decorator, George Aitchison, to whom he and his brothers had been introduced a decade earlier by George Mason. Moore was asked to design a frieze measuring 25 feet in length for the upper wall of Lehmann's front drawing room. Although the frieze no longer survives, it is documented by Aitchison's drawing (Pl. 121) and by a dozen or so studies by Moore.[240] Many of the rooms in Lehmann's house were decorated with bird imagery; Moore chose to represent a parade of peacocks, strutting and preening in a variety of carefully observed poses. He had previously adopted the peacock motif in the panels of the Croxteth fountain (1861) and in the carved reliefs represented in his painting *A Girl Dancing* (1863-4). His frieze for Lehmann's house is among the earliest architectural treatments of

a motif that would come to dominate Aesthetic décor, ultimately bearing fruit in Whistler's notorious *Peacock Room* (1876-7) for F. R. Leyland, and in Arthur Silver's *Peacock Feather* fabric (1884) for Liberty's.[241] In contrast to these rather artificial stylizations of the bird, Moore's drawings exhibit a naturalism worthy of an ornithologist, yet they also reveal the same underlying geometric armatures that characterized his adaptations of the human figure. Geometric configurations in the internal patterning and collective arrangement of the feathers, and in the natural angularity of the peacocks' stances, provided additional interest for the artist (Pl. 120).

Along with the frieze, Moore designed five plaques to be inlaid in ivory on the top of a serving table (no longer extant) that Aitchison made for Lehmann's dining room (Pl. 122).[242] Moore designed a central roundel, with a man and woman sitting at a table and a dog at their feet. The four panels surrounding them show figures gathering food and drink: two fishermen; a hunter with a dog and stag; two harvesters; and two grape-pickers. These designs brought Moore full

circle to the agricultural representations of the seasons with which his career in decorative painting had begun in the early 1860s. But the radical advances he had made over the previous decade are evident in the greater clarity of form attained in these vignettes, despite the use of poses requiring complicated foreshortening.

Moore also appears to have assisted in some way with Aitchison's interior design scheme for 52 Princes' Gate, the London residence of the Tynemouth shipbuilder Thomas Eustace Smith. During the summer of 1875, Aitchison served as intermediary for Moore and Smith's wife, Eustacia, the moving force behind the decoration scheme. She was also responsible for much of the family's fine art collection, and was likely instrumental in their purchase of Moore's *A Garden*, exhibited at the Royal Academy in 1870.[243] On 28 July 1875 Aitchison informed Moore that Mrs Smith hoped to see him prior to leaving London the following week.[244] The meeting very likely concerned plans for the friezes to decorate her boudoir, which were ultimately designed by Moore's friends Armstrong, Leighton and

120
CARTOON OF A PORTION OF THE PEACOCK FRIEZE FOR 15 BERKELEY SQUARE, LONDON
*c.*1872-3
Charcoal and white chalks on brown paper
46 x 154.9 cm
(18¼ x 61 in)
Victoria and Albert Museum, London

121
George Aitchison
DESIGN FOR DECORATION OF THE FRONT DRAWING ROOM, 15 BERKELEY SQUARE, LONDON, WITH ALBERT MOORE'S PEACOCK FRIEZE
1872-3
Watercolour
52 x 72.3 cm
(20½ x 28½ in)
Royal Institute of British Architects, London

Crane.[245] The possibility of Moore's involvement is suggested by
his design for the left half of a decorative panel that was evidently
intended to serve as an artisan's template (Pl. 119). The drawing
cannot be associated with any of Moore's paintings, but it is similar
in feeling to an ivory and ebony inlaid panel for Eustacia Smith's
boudoir.[246] Whatever the actual circumstances of this drawing may
be, the fluent and well-balanced design provides clear evidence of
Moore's facility in devising the kind of decorative pattern which
would become an increasingly important element of his paintings over
the next two decades.

This chapter has highlighted some of the patterns of repetition that
characterized Moore's lifelong investigation of a limited constellation
of aesthetic issues. His dogged pursuit of perfection during the crucial
1865-74 period led him to return time and again to motifs and
compositions that he had explored on previous occasions without

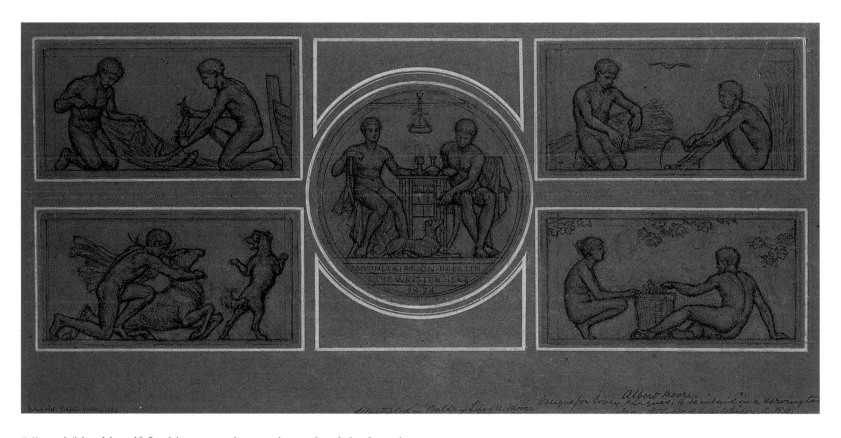

fully satisfying himself. In this respect, he merely emulated the formal
repetitions that he discerned in wide-ranging sources of aesthetic
pleasure: music, landscape, botanical specimens, drapery, architecture.
Through analysis of the ordering patterns underlying such phenomena,
he devised the artful repetitions of line, colour and form that underpin
his compositions. Moore's cyclical work pattern continued for the rest of
his life, confining him to a limited range of subject-matter, but freeing
him from the obligation of inventing new thematic vehicles for the
purely visual effects that most interested him. Never a rapid worker, his
especially slow rate of production during the early 1870s reflects the
deep ruminations and patient experiments which were to yield the core
theories and methodologies of his mature career.

122
DESIGNS FOR IVORY
PLAQUES
1874
Black chalk on brown paper
24.8 x 49.6 cm
(9¾ x 19½ in)
Ashmolean Museum,
Oxford

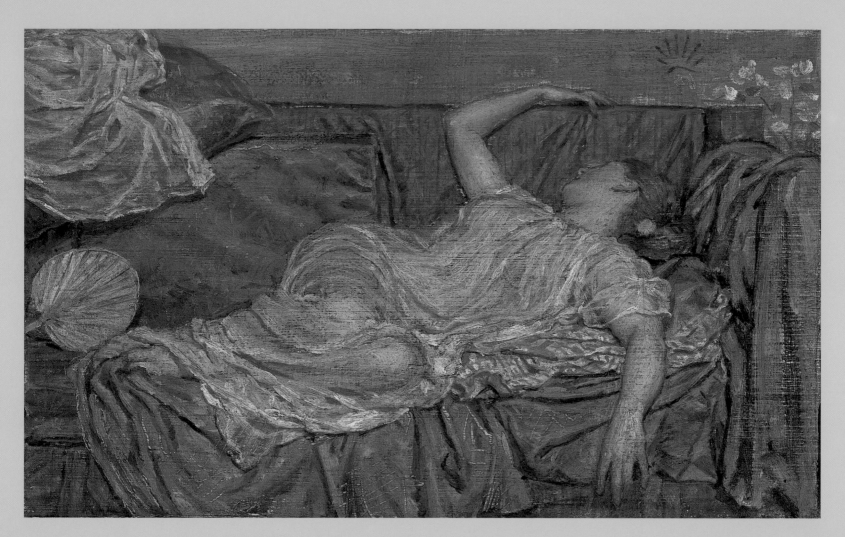

123
A Palm Fan
1875
Oil on canvas
16.5 x 26.6 cm
(6½ x 10½ in)
Private collection

124
White Hydrangea
1885
Oil on canvas
114.2 x 44.4 cm
(45 x 17½ in)
Unlocated

POLITICS AND PATRONAGE

1875-1885

THE NOTION THAT ALBERT MOORE 'LIVED ONLY FOR HIS ART', A
TRUISM OFTEN INVOKED BY HIS CONTEMPORARIES, GLOSSES OVER THE
PRACTICAL REALITIES OF AESTHETIC POLITICS AND ART PATRONAGE
THAT NO ARTIST COULD ESCAPE. THE NECESSITY OF EXHIBITING AND
SELLING PICTURES WITH BANKABLE REGULARITY INEVITABLY SHAPED
THE COURSE OF HIS CAREER AND INFLUENCED THE KINDS OF IMAGERY
HE PRODUCED. FOR ALL MOORE'S EFFORTS AT INDEPENDENCE, HIS
ART IS BEST UNDERSTOOD AS A COMPROMISE BETWEEN HIS PERSONAL
VISION AND THE PRAGMATIC CIRCUMSTANCES OF HIS PROFESSION AS
A WHOLE. POTENTIAL CONSTRAINTS ON HIS FREEDOM WERE LIMITED,
HOWEVER, BY THE ESSENTIAL BEAUTY OF THE PAINTINGS THEMSELVES.
THEY EXERTED THEIR APPEAL DIRECTLY, REQUIRING NO PANDERING
FROM THE ARTIST HIMSELF, AND THEY SPOKE TO SEVERAL DIFFERENT
ART PUBLICS.[1] SOPHISTICATED AUDIENCES MIGHT APPRECIATE THE
UNDERLYING THEORETICAL PRINCIPLES BEHIND THEM, BUT A MUCH
LARGER SEGMENT OF THE ART WORLD RESPONDED TO MOORE'S
SINGULAR CONCEPTION OF FEMININE LOVELINESS—BASED ON
PRESTIGIOUS GREEK MODELS AND COUCHED IN FASHIONABLE ANGLO-
JAPANESE DÉCOR. FOR STILL ANOTHER AUDIENCE, MOORE WAS MERELY
'A PAINTER OF PRETTY PRURIENCIES ANGLING FOR THE PATRONAGE
OF THE MAN OF THE WORLD WITH THE BAIT OF HALF-DRAPED
FEMININITY'.[2]

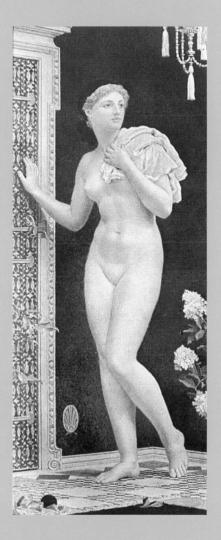

Throughout his mature career, Moore revisited the theme of feminine
repose that he had first essayed in *Somnus Presiding over Sleep and Dreams*
(Pl. 51) and other pictures of the late 1860s. His small painting *A
Palm Fan* (Pl. 123), exhibited at the Royal Academy in 1875, owes
an obvious debt to *Lilies* (Pl. 84) but the greater sophistication
in draughtsmanship and colour arrangement demonstrates the
refinement of Moore's aesthetic system over the intervening decade.
Here, the woman's body melts into the overall pattern of line, form
and colour. Her averted face reinforces the artist's depersonalized
treatment of her body as a convenient studio prop—a malleable
armature of pleasing volumes and hollows. The picture indicates
Moore's decisive move towards objectification of the female form.
As one contemporary critic expressed it, 'Humanity ceased to interest
him except as a pattern, as a superlatively composed arrangement
of lines and masses; and was useful to him simply on account of
its decorative appropriateness.'[3] Indeed, the splayed fingers of the
woman's dangling left hand echo the radiating lines found elsewhere
in the composition: in Moore's anthemion signature, the Japanese
fan and the drapery folds, some of which the artist scratched
vigorously into the paint with the handle of his brush. The muted
browns and creams that define the woman's body recur throughout
the composition, unifying figure and setting, and bleeding through the

contrasting blue drapery which cuts a bold swath through the centre of the picture.

Moore painted *A Palm Fan* while developing a more elaborate composition treating the theme of sleeping women. Reverting to an oil sketch apparently made a decade earlier,[4] he undertook fresh preparatory studies and meticulously orchestrated the arrangement of figures, drapery and decorative accessories.[5] Once perfected, this composition served as the vehicle for more abstract concerns, enabling Moore to pursue subtle experimentation in colour arrangement. The three paintings resulting from these experiments are virtually identical in all respects except colour scheme. Elaborated

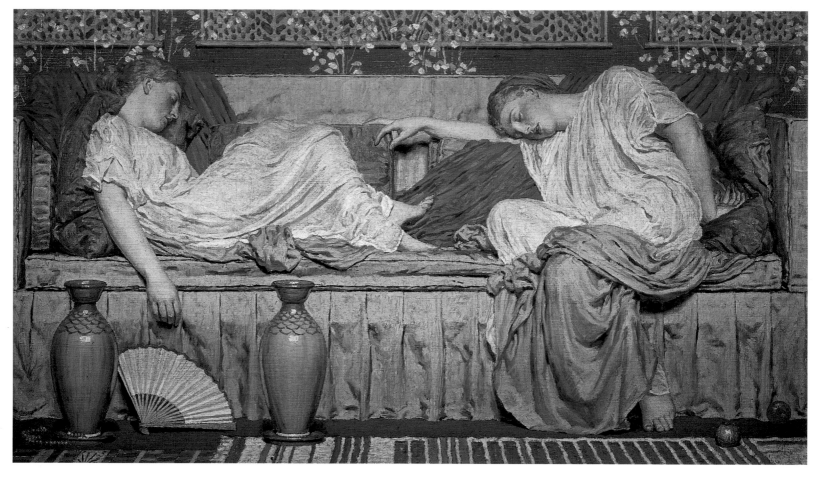

125
APPLES
1875
Oil on canvas
29.2 x 50.7 cm
(11½ x 20 in)
Private collection

from the same cartoons, they enabled Moore to advance his analysis of chromatic harmony while producing saleable works of art. In *Beads* (Pl. 126), exhibited at the Royal Academy in 1876, Moore rehearsed *A Palm Fan*'s combination of brown and cream tonalities enlivened by a contrasting blue. In *A Sofa* (Pl. 127) he adopted a monochromatic scheme of subtly modulated creams and browns warming to orange and yellow. A still more adventurous combination of mottled greens and blues, with butterscotch, brown, white and charcoal accents, appears in *Apples* (Pl. 125).

These paintings dramatize the irrelevance of 'subject' in Moore's pursuit of purely aesthetic questions. The cartoons that he reworked on these occasions were merely convenient templates for new

chromatic combinations. In this respect, the figures in Moore's paintings have been likened 'to the squares of Josef Albers or the recurrent shapes of Mark Rothko'.[6] The comparison is useful not only for the similarities but also for the differences it suggests between the artists. All three adopted thematically mundane but aesthetically perfect linear arrangements as the basis for experiments in colour. But whereas Albers and Rothko grounded their experiments in a radically simplified geometry, Moore's use of line was as analytically complex as his use of colour. He would doubtless have considered the paintings of Albers and Rothko in the light of the diagrams in contemporary treatises on chromatics: as skeletal theories that needed to be fleshed out—quite literally—in beautiful human forms.

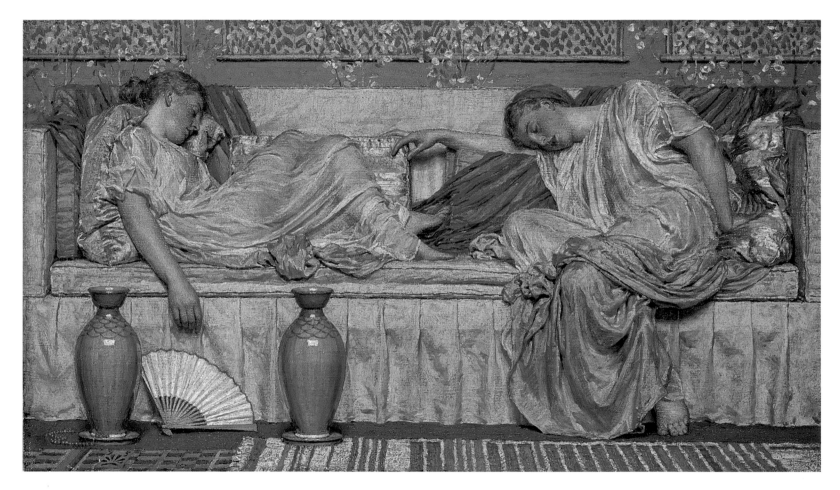

126
BEADS
1875
Oil on canvas
28.9 x 50.1 cm
(11¼ x 19¾ in)
National Gallery of
Scotland, Edinburgh

In late nineteenth-century England, this meant the aestheticized female form. The enduring cultural conception of women as cyphers—blank slates onto which a wide range of meanings could be projected—has made them the customary vehicles for allegorical imagery, to include Moore's seasonal cycles for architecture.[7] But this cypher-like quality also made women the most obvious vehicles for subjectless easel paintings. Stereotypically associated with a pacific, private sphere in which harmony and beauty reigned, they 'naturally' lent themselves to the value system that Aesthetic artists were advancing in reaction against the competitive commercial world.[8]

However, by choosing to express abstract, analytical principles in the representational, figurative language of his own day, Moore caused

127
A SOFA
1875
Oil on canvas, with original
frame designed by the artist
28.9 x 50.1 cm
(11⅜ x 19¾ in)
Private collection

132

himself to be misunderstood, now and in his lifetime. Attention has always been distracted from the true intentions of his art by the beguiling feminine forms in which he expressed them. Moreover, the devalued status of 'feminine' attributes (to include beauty) has led even critics cognizant of Moore's fundamentally decorative purpose to question whether it consitutes an adequate aim for art. In reviewing Moore's *Beads* in conjunction with Leighton's *Weaving the Wreath* at the Royal Academy exhibition of 1876, Henry Heathcote Statham, editor of *The Builder*, declared that such pictures, 'graceful and beautiful as they are, do not address our highest perceptions: they are *objets de luxe*; they touch no feeling, as they express none, for like Mr. Morris's poems (which have the same range in literature as these in painting), they spring from the aesthetic sense only of the painter.'[9] The comment underscores the controversial nature of Moore's direct appeal to the eye and to the unique emotion of aesthetic pleasure. Indeed, through his pioneering quest for aesthetic purism he anticipated some of the principal artistic debates of the twentieth century.

Yet for all their engagement in abstract, aesthetic concerns, Moore's sofa pictures also figure among his most sensuous evocations of the female form. *A Palm Fan* is a particularly voluptuous image of repose, in which the complex disposition of the woman's limbs is made more alluring by the liquid flow of drapery over and around the contours of her body. Similarly, in *A Sofa*, *Beads* and *Apples*, the snaking movement of the drapery exaggerates the curves of the anatomy, which is clearly legible beneath the transparent gauze fabric. Flushed cheeks and parted lips add a sultry quality to the women's unconscious repose, while their delicately poised fingertips heighten our sense of the fragility of this moment of suspended animation. The eroticism of the women's unconscious, voluptuous abandonment seems obvious today, but it was entirely suppressed from contemporary reviews of *Beads* and related pictures. One critic found the 'languid heaviness' of Moore's painting *Dreamers* of 1882 (Pl. 149) 'suggestive of overfeeding', while another worried that the awkward positions assumed by 'the dreaming damsels' ensured 'that their sensations on awakening are likely to be terrible'.[10] The bemused and mocking tone adopted in such criticism indicates the novelty of Moore's somnolent imagery, and its contrariness to mainstream expectations.

Sensuous and poignant, the delicate touches of nature in paintings such as *A Palm Fan* and *A Sofa* clearly indicate that Moore's response to the female body was visceral as well as intellectual.[11] His studio methods provide further confirmation that his aim was not to obliterate humanity from his art, but to strike a delicate balance between nature and abstraction. He insisted always on working from the living model, refusing to rely on his own mental image or the canons of sculpture and theory. At the same time, he valued models who conformed to a predetermined ideal. Early in his career he had worked with Milly Jones, an experienced professional who also sat to Whistler, Rossetti and Burne-Jones. Later on, according to his friend Merton Russell-Cotes, his models 'were mostly Yorkshire girls, two or three in particular, all of the same type, tall, well formed, with charming oval faces, beautiful hair and blue eyes—perfect types of English womanhood'.[12] The artist's preparatory drawings confirm Russell-

128
STUDY OF A DRAPED
FIGURE
*c.*1874
Oil on canvas
21.6 x 14 cm
(8½ x 5½ in)
Private collection

Cotes's claim; half a dozen or so likenesses recur in them, and though palpably representative of actual women, they bear a strong resemblance to the ideal types of Moore's paintings. Just as he might seek the finest lily in the garden and, in painting it, make subtle alterations to enhance its natural beauty, so, too, with models Moore presumably sought the loveliest available, but made them more so. Although he painted directly from his perfected figure cartoons, Moore constantly referred to impromptu sketches and photographs which captured the vital details of unidealized nature (Pl. 128).[13] Through this system of checks and balances, he ensured that the warm, sensuous appeal of his models survived the chilling effect of ideal geometry.

Moore's practice of making exhaustive figure studies provided innumerable occasions for observing his weary models at rest. He was not alone in adapting such studio vignettes to artistic purposes: the chance sight of a sleeping model inspired Frederic Leighton's painting *Flaming June* (Pl. 129), and similar episodes may lie behind the lounging and unconscious women in the works of other artists who adhered to laborious academic techniques.[14] The impromptu studies of resting models that gave rise to Moore's series of sofa pictures also inspired *Pansies* (Pl. 130), exhibited at the Royal Academy in 1875. The painting proved crucial in establishing Moore's reputation in mainstream art circles, for it brought him to the attention of John Ruskin, who singled it out in his review of the Academy as a 'consummately artistic and scientific work'. Discerning the acute analysis underlying Moore's linear and chromatic arrangement, Ruskin called attention to the perfectly balanced interrelationship of each element. He suggested that 'by way of a lesson in composition', his readers should 'hide in this picture the little honeysuckle ornament above the head, and the riband hanging over the basket, and see what becomes of everything!' Moore had indeed devoted special attention to the placement of the anthemion (Ruskin's 'little honeysuckle ornament'). A pentimento bleeding through the overpaint reveals its original position a fraction of an inch to the right. Ruskin also praised Moore's close observation of natural effects of light and shadow, underscoring 'the general modes of unaffected relief by which the extended left arm in "Pansies" detaches itself from the background'. After studying Moore's painting, he claimed, 'you ought afterwards, if you have an eye for colour, never more to mistake a tinted drawing for a painting.' Also singled out for praise in Ruskin's review was Moore's small painting *A Flower Walk* (Pl. 131). 'Try the effect of concealing the yellow flower in the hair', he wrote, 'And for comparison with the elementary method of Mr. Tadema, look at the blue reflection on the chin in this figure; at the reflection of the warm brick wall on its right arm.'[15]

Ruskin couched his admiration for Moore's composition in terms of the painting's careful workmanship, lauding the artist's meticulous touch above the famously eye-deceiving realism of Lawrence Alma-Tadema, whose *Sculpture Gallery* was in the same exhibition. Taking a leaf from Alma-Tadema, who encouraged the use of a magnifying glass in scrutinizing his paintings, Ruskin instructed Academy visitors to make a close, patient examination of the sofa and basket in *Pansies*

129
Frederic Leighton
FLAMING JUNE
1895
Oil on canvas
120.5 x 120.5 cm
(47½ x 47½ in)
Museo de Arte de Ponce,
Puerto Rico

130
PANSIES
1875
Oil on canvas
26 x 19.7 cm
(10¼ x 7¾ in)
Private collection

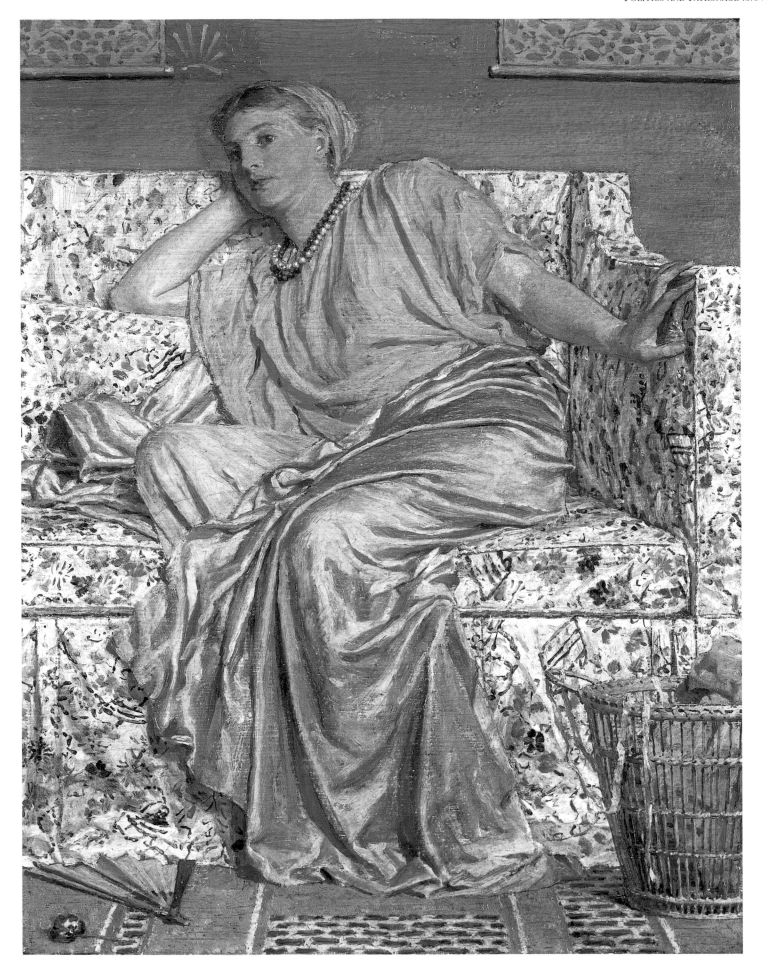

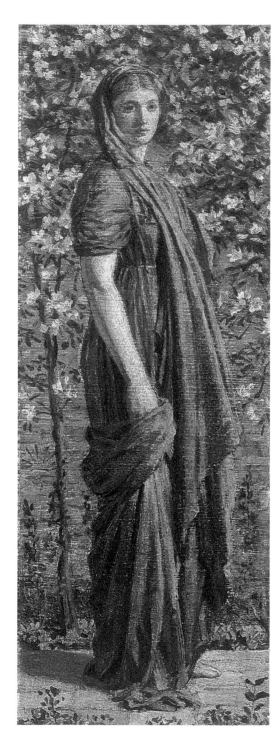

131
A Flower Walk
1875
Oil on canvas
27.3 x 11.4 cm
(10¾ x 4½ in)
Princeton University Art
Museum

using 'a lens of moderate power'. Ruskin's insistence not only on the 'scientific' nature of Moore's conception but also on his painstaking execution is significant, setting the stage for their next, more acrimonious encounter three years later.

Ruskin was correct in seizing on the highly wrought finish of *Pansies*, which differs markedly from the deliberately anti-illusionistic handling of previous works. With unusual specificity, Moore contrasted the semi-transparent gauze of the woman's apricot-coloured shift with the shimmering, pale taupe satin encircling her waist and lower limbs. According to Baldry, Moore 'made study after study so that he could be sure of giving to each one [of his fabrics] its specific characteristics of form and fold and the anatomical structure—as it might be called—of the material from which the drapery was made'.[16] In *Pansies*, the fluid motion of the drapery also bears eloquent testimony to Moore's mastery of the 'secrets' of fifth-century Greek sculpture. As in the goddesses of the Parthenon's east pediment, Moore's drapery defines the body of the seated figure while also contributing an independent linear interest to the composition as a whole. This quality is particularly notable in the satin mantle which sweeps fluently over the curved hip and thigh, collects in eddies on either side of the left knee and tumbles in cascading ripples to the floor.

Pansies figures among several paintings of the late 1870s in which Moore's sensuous delight in luxurious fabrics almost provides the picture's *raison d'être*. The first paintings to presage this keynote of his mature style were *Shuttlecock* and *Battledore* of 1871 (Pls. 111, 112), which derive their visual interest as much from the contrasting patterns of wallpaper, hanging fabrics and rugs as from the artist's masterful handling of drapery folds. Moore's growing fascination with the artistic possibilities not only of the draped figure but also of textile and needlework design was symptomatic of the revival of those handicrafts during the late nineteenth-century Arts and Crafts movement, to which Moore had already contributed stained-glass designs, mural paintings and furniture ornamentation. The reaction against inferior, machine-made products generated a grassroots movement of women dedicated to 'restoring Ornamental Needlework to the high place it once held among the decorative arts'.[17] Their ideas for patterned fabrics and wallpapers developed in concert with those of progressive artists and architects. Henry Moore designed patterns for crewel work under the influence of Barbara Bodichon and Gertrude Jekyll,[18] and William Morris, George Aitchison and Walter Crane were among those who contributed designs and advice to the Royal School of Art-Needlework, founded in 1872 by a group of women keen to revive 'the principles which have guided Eastern and Western embroideries at their best periods'.[19]

During the early 1870s Moore conferred with at least one of the women involved in the School of Art-Needlework. Gertrude Jekyll, who would subsequently transform the theory and practice of English garden design, was first known among artists as a polymathic craftswoman with a particular expertise in designing for fabric.[20] In 1870, at the London International Exhibition Society in New Bond Street, Jekyll exhibited some embroideries on linen and serge whose

'remarkable merit in point of colour and arrangement' deeply impressed Frederic Leighton. He hired Jekyll to design a table cloth 'of some good design and rich tone', and commissions for quilts and other items soon followed. From 1870 to 1877, Jekyll and other needlewomen met at Thomas Armstrong's studio to discuss the design and disposition of embroideries, curtains and decorative hangings in his paintings.[21] She recorded in her diary of 1870-3 frequent meetings with additional artists, including Albert Moore, Simeon Solomon, Edward Poynter, William De Morgan and George Frederic Watts. Jekyll's note of a dinner with Moore and Frederick Walker attests to the continuing friendship of those artists more than a decade after their Royal Academy Schools days.[22]

Jekyll's derivation of design principles from an eclectic range of influences—including floriculture, Greek art and recent colour theory[23]—would certainly have resonated with Moore, and her conception of needlework in terms of plant form and colour ('Pomegranate ornament on blue chair', for example) parallels his approach to painting.[24] Their similar taste in fabric at this time is suggested by the botanical pattern employed in the background of *Shuttlecock* and *Battledore*, which Jekyll employed in the dining room she began decorating for Jacques and Léonie Blumenthal in 1871—the year that Moore's pictures appeared at the Royal Academy.[25] In other paintings, Moore deliberately called attention to his translation of natural specimens into decorative patterns, drawing implicit analogies between his own work and that of designers such as Jekyll, Morris and Christopher Dresser who, like him, deduced design principles from the formal logic of flowers, fruit and foliage. In the lower left corner of *Pansies*, for example, he inserted a plucked flower in testimony to the natural origins not only of the pansy-studded fabric covering the sofa, but of the picture as a whole. The colour scheme derives from a variegated bouquet of purple, yellow and apricot pansies, and this botanically based palette is reconstituted as a geometric pattern, woven into the rug at the bottom of the canvas.[26]

Like Armstrong and Leighton, Moore evidently formed his own working collection of fabrics and needlework. The embroidery represented in *Pansies*, for example, was undoubtedly an actual studio prop, for it was repeated in five other paintings over the next thirteen years.[27] In addition to pieces of modern English manufacture such as this, Moore acquired imported and historic textiles. His use of Chinese silks for draping his models was noted by colleagues, and in 1883 he sold an eighteenth-century Spanish embroidered silk coverlet (then believed to be Persian) to the South Kensington Museum for £30.[28] Taking liberties with the colour scheme, Moore employed the coverlet as a wall treatment in *Topaz* and *Dreamers* (Pls. 147, 149).

The most likely source for such exotic materials was Arthur Lasenby Liberty, a textile merchant whom Moore reportedly met during the 1860s while Liberty was managing the 'Oriental Warehouse' in Regent Street. An exotic offshoot of the firm Farmer & Rogers, the shop was initially stocked with goods from the phenomenally popular Japanese Court of the 1862 International Exhibition. Moore's early transactions with Liberty are perhaps documented by the unusual

textiles in paintings such as *Dancing Girl Resting* (Pl. 33) and *Pomegranates* (Pl. 78). Their long friendship is indicated by the merchant's possession of at least four of the artist's late pastels.[29] In the spring of 1875 Liberty opened his own shop in Regent Street, crediting Moore and several other 'prominent artists and students of the East' (including Nesfield, Whistler, Godwin, Burges, Leighton, Rossetti and Burne-Jones) with initiating his 'course of education in artistic taste'. In addition to imported goods—'the silks and brocades of China and Japan, the soft woollen fabrics of Kashmir, the filmy gauzes of India, the light cottons familiar in the Tropics'[30]—Liberty commissioned high-quality British products designed 'artistically' with an eye to matching the beauty of imported goods. Within eighteen months, he was providing artists with one-stop shopping for home décor and studio accessories. Godwin wrote in December of 1876, 'an artist might almost decorate and furnish his rooms from this one shop. There are matting and mats, carpets and rugs for the floor; Japanese papers for the walls, curtain stuffs for windows and doors; folding screens, chairs, stools, and so forth.'[31]

The vast array of luxurious textiles imported by Liberty had an immediate impact on Moore's art. In 1877 he exhibited *The End of the Story*, *A Reader*, *Marigolds* and *Sapphires*, in each of which a beautifully draped woman stands before the graceful arabesques of a printed or embroidered hanging (Pls. 132, 135-7). The patterns of Liberty's imported fabrics provided only one facet of their interest to Moore and his colleagues, however. Accustomed to making 'prolonged visits' to artists' studios, Liberty noted that 'The soft, delicate coloured fabrics of the East particularly attracted these artists because they could get nothing of European make that would drape properly and which was of sufficiently well-balanced colouring to satisfy the eye.' The superior handling and subtle colours of the cloth proved crucial to Moore's evolving interest in the language of drapery. According to Liberty, 'Albert Moore found them so helpful that he gave me a beautiful drawing of a group of classical figures holding up some of these draperies.'[32] Liberty's claims about the prominence of imported fabrics in Moore's studio practice were repeated by Harold Frederic, an American writer to whom Moore occasionally spoke about his art. Frederic asserted that Moore employed robes of Chinese silk in order to obtain 'that strangely beautiful drapery in which he perpetuates the flowing lines of the Greek ideal'.[33]

Moore may also have experimented with Indian fabrics similar to Dacca muslin, an extremely fine cloth said to bear closer resemblance to a web of dew than to the work of human hands. Ten square yards of this 'exquisite tissue' reportedly weighed just three ounces.[34] Several layers would not have encumbered the free movement of Moore's models. Since the mid-1860s he had employed very thin and often transparent fabrics that enabled him to reveal the fully rendered naked form beneath. With *Sea-gulls* and *Shells* (Pls. 71, 115) in the early 1870s he began a different sort of experiment, combining transparent and opaque fabrics in order to create unusual layering effects. In *The End of the Story* of 1877 (the background of which repeats the pansy-patterned fabric discussed above), Moore layered a transparent white fabric over opaque green drapery (Pl. 132). As the folds of white fabric

expand and contract, they create subtly varied tints and an overall impression of shimmering iridescence. In this way, Moore made drapery a vehicle for chromatic as well as linear experimentation.

According to Harold Frederic, Moore achieved his drapery arrangements by 'never touching a fold with his hands, but having the model move again and again till he catches the desired effect'. The process was obviously time-consuming; Frederic noted that 'Oftentimes the drapery of a single figure ... represents the toil of months.'[35] Although he was undoubtedly working towards preconceived notions of good design, Moore was clearly attracted by the arbitrary patterns into which the drapery 'naturally' fell. Like the splatter paintings of Jackson Pollock, his experimentation with drapery afforded a stimulating combination of design and chance. A second version of *The End of the Story* attests to Moore's scrupulous attention to the language of drapery (Pl. 133). Rather than copy the original painting, he used the nude cartoon as the underlying framework for fresh experimentation with cloth patterns. An added twist over one shoulder resulted in a new pattern of drapery folds, with an emphatic, diagonal sweep along the left and graceful ripples down the right. The artist also studied the patterned backdrop anew and redesigned the rug at the figure's feet. Whereas, in his series of sofa pictures, repetition had allowed Moore to explore new colour schemes, successive versions of *The End of the Story* enabled him to investigate new linear combinations while his palette remained more or less constant.

In view of Moore's careful scrutiny of every aspect of his picture-patterns, it is not surprising that he eventually began making his own fabric designs based on imported and modern examples. The sheer number of patterns represented in his paintings, with only a few recurring in more than one work, suggests that he designed these fabrics as theoretical rather than actual pieces.[36] A few of Moore's drawings for these fabrics survive, evincing his commitment to ensuring that every element of his pictures functioned as part of a unified design.[37]

Moore contributed *The End of the Story*, along with *Sapphires* and *Marigolds*, to the inaugural exhibition of the Grosvenor Gallery in the summer of 1877. Founded as an alternative exhibition space to the Royal Academy, the Bond Street venue was instantly perceived as a haven for avant-garde artists, particularly those associated with the notion of art for art's sake. Indeed, in promoting the new gallery, the proprietor Sir Coutts Lindsay capitalized on his exhibitors' outré chic. Describing the Grosvenor as the only option available for 'outsider' artists beyond the Academy's pale, Lindsay stated: 'There are several thoughtful men in London whose ideas and method of embodying them are strange to us; but as I do not think strangeness, or even eccentricity of method, sufficient excuse for ignoring the works of men otherwise notable, I have built the Grosvenor Gallery that their pictures ... may be fairly and honestly judged.'[38] An amateur artist with some experience in mural and ceramic design, Sir Coutts Lindsay was a particular supporter of decorative painting.[39] Consequently, style tended to eclipse subject-matter in the art on display, with the result

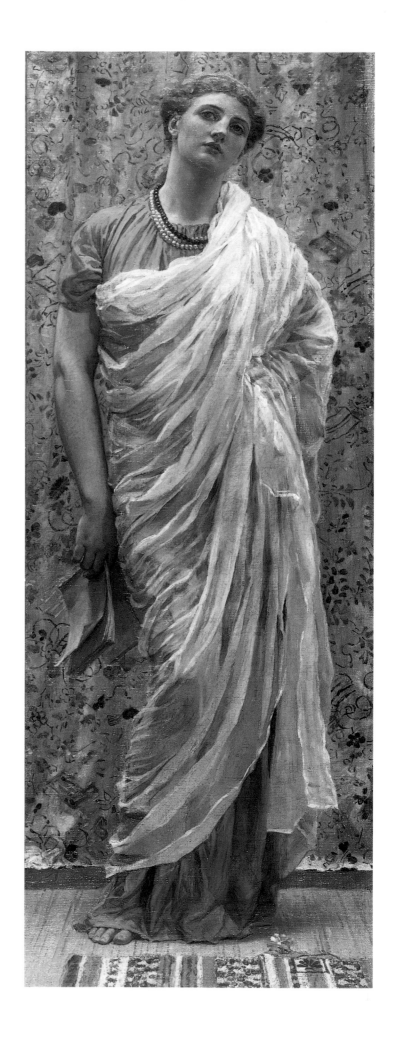

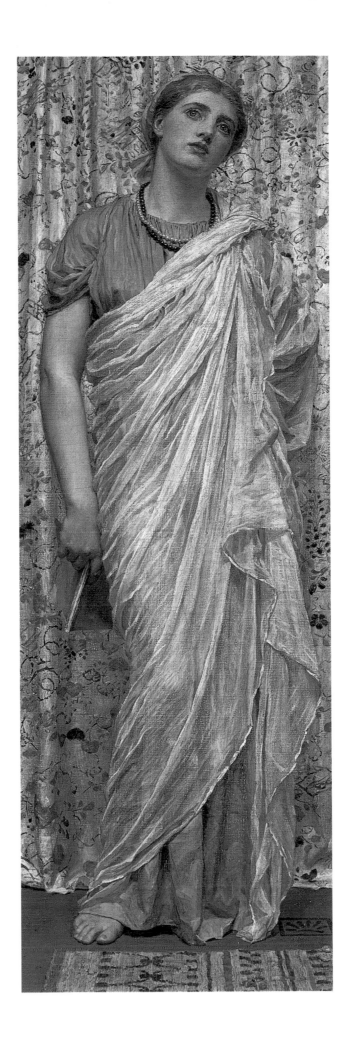

132
THE END OF THE STORY
1877
Oil on canvas
87.5 x 33 cm
(34½ x 13 in)
Private collection

133
THE END OF THE STORY
*c.*1877
Oil on canvas laid down on board
86.3 x 30.4 cm
(34 x 12 in)
Private collection

that the comforting, sentimental themes familiar to Academy visitors were nowhere in evidence. The contrast startled eyes accustomed to a preponderance of domestic idylls.

Moore's subjectless pictures were entirely at home in this context, and it is not surprising that he was among the first group of 64 artists invited to exhibit at the Grosvenor. The prominent display of his works forced thoughtful critics to confront once again the issue of meaning in art. In his review of the exhibition, Sidney Colvin associated Moore and Whistler for their shared tendency to treat the human body 'simply as the principal element in a pattern'. For them, he wrote, 'the subject has no weight at all; their pictures do not invite the mind to consider the thing represented but only the representation. They only select just so much fact as will serve to sustain and give the occasion to some preconceived scheme of lines and colours.'[40] Like many critics who drew parallels between the two, Colvin gave preference to Moore for the 'more classical spirit' of his design, which 'has the large dignity of the Greeks and is carried out to perfect finish'. Refusing to search Moore's art for narrative content, Colvin characterized his major work, the life-sized *Sapphires* (Pl. 137), as 'a lovely vision of shimmering sea blue relieved among delicate patterns and flowers of more positive blue and white, and thrown up by two touches of orange headgear and orange butterfly'. In *Marigolds* (Pl. 136), executed in the same year, Moore furthered his experiments with the complementary pairing of blue and orange using an entirely different compositional framework. He subsequently reinterpreted the design of *Sapphires* as an arrangement of red and white called *Poppies* (unlocated).[41]

Colvin's abstract response to Moore's art was encouraged by the pre-eminence of visual concerns in the hanging practices of the Grosvenor (Pl. 134). In order to foster appreciation of individual style, Lindsay adopted the unique strategy of grouping the works of each artist in a unified display and hanging the walls sparingly in order to prevent pictures from clashing with one another.[42] This sympathetic presentation was particularly congenial to Moore's subtle and sophisticated systems of pale, tertiary hues. For the past decade and more, critics had noted that his paintings suffered egregiously at the Academy, where pictures hung frame-to-frame in a chock-a-block jumble.[43] Many Academy exhibitors deliberately pitched their colour schemes to a brilliant level capable of standing out from the crowd. Some heightened the tonalities on the spot after seeing the effect of works hung in juxtaposition with their own.

Moore's scientifically reasoned chromatic harmonies could not be adulterated in this way, and it is not surprising that he immediately embraced the Grosvenor as his preferred exhibition venue. In 1877, while sending three works to the new gallery, he contributed only one modest-sized painting, *A Reader*, to the Royal Academy (Pl. 135). The following year, the Grosvenor received his chief work, the life-size standing figure *Birds* (Pl. 138), while the Academy displayed a much smaller work, *Garnets*.[44] His name swiftly became synonymous with the 'advanced' style of art featured at the Grosvenor. Distinguishing between old guard and avant-garde in an article of 1882, Charles

134
THE GROSVENOR GALLERY OF FINE ART, NEW BOND STREET
Wood engraving published in the *Illustrated London News* (5 May 1877)

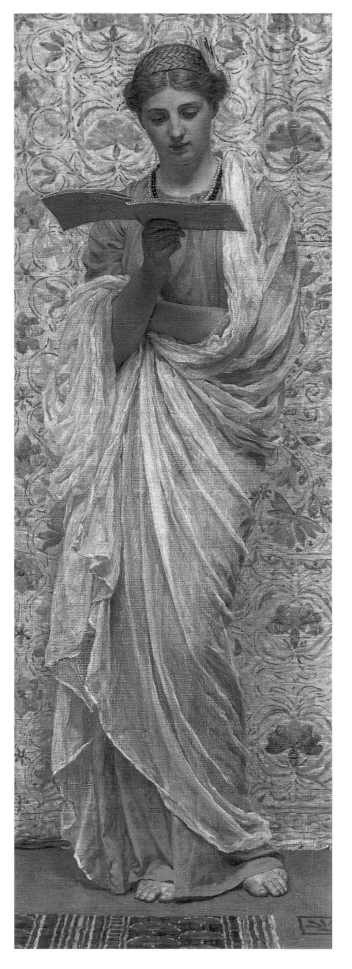

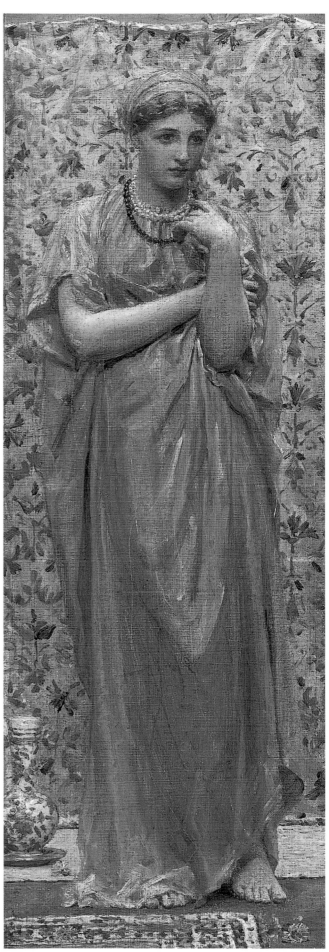

135
A READER
1877
Oil on canvas mounted on board
86.3 x 30.4 cm
(34 x 12 in)
Private collection

136
MARIGOLDS
1877
Oil on canvas
36.8 x 15.2 cm
(14½ x 6 in)
Private collection

137
SAPPHIRES
1877
Oil on canvas
154.8 x 54.5 cm
(61 x 21½ in)
Birmingham Museum and
Art Gallery

138
BIRDS
1878
Oil on canvas
155.4 x 65.3 cm
(61¼ x 25¾ in)
Birmingham Museum and
Art Gallery

Dempsey explained that 'the exhibitions of the Royal Academy are illustrative of what I shall call *Received Art*, and that the works of some of the painters prominent in the Grosvenor Gallery displays may be taken as exemplars of what I mean by *Advanced Art*. Amongst the exponents of the latter, Messrs. Burne-Jones, Albert Moore, and Whistler are conspicuous.'[45] In the same year, while promoting a new 'English Renaissance' of beauty, Oscar Wilde set the seal on Moore's cutting-edge fashionability by latching on to the painter as 'the ultimate expression of our artistic movement'. Together with Whistler, Wilde claimed, Moore exemplified 'the younger school' which repudiated Ruskin's moralistic approach to art and placed absolute value in exquisite workmanship. Echoing the theories of Walter Pater, Wilde asserted that by 'rejecting all literary reminiscence and all metaphysical idea', Moore and Whistler emulated the condition of music 'in which form and matter are always one'.[46]

In the winter of 1880, Lindsay further signalled the Grosvenor's sophisticated tastes through an exhibition of artists' working sketches. Moore contributed preparatory studies of hands, heads, drapery, plants and flowers, as well as a cartoon for *Sea-gulls*.[47] The utilitarian works on display—dismissed by one critic as mere 'portfolio scraps'—were a far cry from the well-polished bijoux featured at the Academy. They were distinctly caviar to the general, requiring engagement in the creative process itself, which Lindsay made it his business to showcase and glamorize. Whereas the Academy attracted audiences expecting to be entertained, the Grosvenor sought disciples in search of aesthetic enlightenment. Lindsay and his wife Blanche, Lady Lindsay, consciously cultivated an atmosphere of aristocratic luxury in the fittings of their gallery in order to enhance their visitors' sense of partaking in an élite experience. Indeed, one critic declared, 'This is no public picture exhibition, but rather a patrician's private gallery shown by courtesy of its owner.'[48] Encouraging a reverential attitude towards the Grosvenor's band of progressive, misunderstood geniuses, the Lindsays abetted a value system grounded in the intangibles of originality, beauty and finesse, rendering irrelevant more objective criteria such as size, materials and labour. This new system was indispensable to artists whose pursuit of perfection necessarily reduced their level of productivity. In accordance with the law of supply and demand—as well as the snob appeal of exclusivity—their works became more valuable as soon as they were perceived as 'rare'.[49]

The emerging reverence towards the rare in contemporary art had obvious ramifications for the financial side of Moore's career. Having evidently determined not to repeat the cash-flow problems of the late 1860s (when life-size figures for Leyland and Leathart had entirely monopolized his time), Moore thereafter produced only one life-size figure every several years while earning his bread and butter through smaller canvases. The effect on his prices is clear. In 1869 and 1870 Moore charged Leyland 225 guineas for each of three life-size paintings. Just seven years later, at the first Grosvenor exhibition, he was able to ask 600 guineas for *Sapphires*, one of his increasingly rare life-size paintings. The price of *The End of the Story*, a work just over half life-size, was 300 guineas, and the much smaller *Marigolds* was offered for 100 guineas. These were good, but not outstanding prices;

139
Edward Burne-Jones
LAUS VENERIS
1873-8
Oil with gold paint on canvas
121.8 x 182.7 cm
(48 x 72 in)
Laing Art Gallery,
Newcastle-upon-Tyne

other Grosvenor contributors charged a great deal more.[50] Yet Moore's strategy evidently succeeded in securing him steady sales among a small but faithful clientele. Harold Frederic claimed, 'His pictures are sold on the easel, while they are still unfinished,' and Baldry confirmed, 'He had believers who competed one with the other for his pictures, so that he escaped the sordid struggle for life which has been the lot of so many other great workers in art.'[51]

Ruskin's assessment of Moore as a solid workman and careful designer reverberated in the reviews of other critics. Positive assessments of the soundness of Moore's draughtsmanship and materials dovetailed with praise for the 'healthiness' of his figurative imagery. In this respect, Moore was advanced as a corrective to the 'degenerate' style of artists such as Dante Gabriel Rossetti and Edward Burne-Jones. In a controversial review of 1871, the poet Robert Buchanan had condemned Rossetti's paintings as exemplifying the taint of his 'fleshly school of poetry', both manifesting 'the same morbid deviation from healthy forms of life, the same sense of weary, wasting, yet exquisite sensuality; nothing virile, nothing tender, nothing completely sane'.[52] Simultaneously, critics complained of the sickliness of the physical types and emotional states represented in Burne-Jones's paintings.[53] In 1878, while Moore's *Birds* and Burne-Jones's *Laus Veneris* (Pl. 139) were hanging in close proximity at the Grosvenor Gallery, Frederick Wedmore devoted a lecture to comparing the two artists. Associating Burne-Jones with sickly bodies and diseased states of mind which expressed too accurately the debilitating effects of 'the stress of modern life', Wedmore claimed that Moore exemplified 'the ideal of reposc and of faultlessness ..., a beauty of quietude, vigour, and peace'. The type and treatment was Moore's own invention, Wedmore claimed, and 'in days of the triumph of sickly ecstacy a thing to be thankful for'.[54] In common with other critics, Wedmore associated 'health' with the formal qualities of the curve, and 'sickliness' with angularity. The debate continued throughout the century and was even addressed in the *British Medical Journal*, in which a physiologist urged artists not to glamorize physical types suggestive of 'maudlin weakness, nervousness, and hysteria', but instead 'teach us something of the more perfect types of the human figure', thereby producing a positive influence on observers.[55]

Critical testimonies to Moore's meticulous workmanship and wholesome imagery provided the artist with considerable cross-over appeal, enabling him to attract patrons of relatively mainstream tastes as well as those who took pride in embracing the avant-garde. Two of the three pictures that Moore contributed to the first Grosvenor exhibition were purchased by Liberal politicians from Birmingham with a reputation for social reform. *The End of the Story* was acquired by the newly elected mayor, William Kenrick, who also owned Moore's *Apples* of 1875.[56] *Sapphires* was acquired by Kenrick's brother-in-law, the Liberal Member of Parliament Joseph Chamberlain, former mayor of Birmingham and father of the future Prime Minister.[57] Chamberlain also acquired Moore's contribution to the 1878 Grosvenor exhibition, *Birds*.[58] As treasurer and president, respectively, of the Birmingham Society of Arts and School of Art Management Committee, Kenrick and Chamberlain were keen to

improve the examples of fine art in their native town, and they probably made their Grosvenor purchases with that goal in mind. Indeed, Chamberlain loaned both of his Moore pictures to the new Birmingham Art Gallery on its opening in 1885.[59] The building was principally funded by the Birmingham engineers Richard and George Tangye, notable collectors of Wedgwood, who in 1883 had purchased Moore's *Dreamers* for the new gallery (Pl. 149).[60]

Moore apparently came to the attention of the Birmingham contingent in 1876 while Chamberlain and Kenrick were heading the search for a new headmaster of the Birmingham School of Art. In expertise if not temperament, Moore perfectly matched the job requirements, which included instruction in drawing and painting and lecturing on 'the History of Art, Development of Style, Analysis of Ornament, Perspective, [and] Practical Geometry'. According to Baldry, Moore was offered the position in 1876, but declined on the grounds that 'this would have involved his leaving London, and devoting to teaching much time that he could not spare without a complete rearrangment of his plans and ambitions'.[61] With his painting career in the ascendant, Moore had scant reason for abandoning it.

Moore's popularity among Birmingham collectors occurred at an ideal time, coinciding with the end of a long period of sponsorship by Liverpool patrons. In fact, prior to selling *Birds* to Joseph Chamberlain, Moore had attempted to interest Frederic Leyland, who had evidently expressed a desire to add a fourth life-size painting by Moore to his collection. In a letter of 29 January 1878, Moore explained that he had not offered Leyland *Sapphires* as he 'did not consider [it] suitable in colour', but there was another full-length— *Birds*—'which I have all but finished, [and] I venture to mention to you, in case I might have the pleasure of a visit from you in order to see it'.[62] By that date, however, Leyland had evidently reconsidered his offer. He had little free wall space remaining in his London house and was still reeling from the shock of Whistler's unsanctioned transformation of his dining room at Princes's Gate into the extraordinary Peacock Room. Nevertheless, he remained cautiously interested in Moore's painting. In his reply from Liverpool, he wrote: 'I am not buying pictures at present, but I will be very glad to see the one you have finished if it is still with you when I am up in town, which however will probably not be for some weeks yet.'[63]

Leyland lost an exquisite painting in *Birds*, which epitomizes Moore's mature preparatory techniques and executive skill, as well as the sophisticated approach to pattern engendered by his new interest in textile design. The geometric print of the wall hanging provides a finely textured backdrop to the picture's complex linear patterning, dominated by the diagonal pleats of filmy white drapery worn over the canary-yellow shift.[64] Irregular swags of patterned cloth at the top of the picture provide graceful counterbalances to the rigid linearity of the marble floor and woven mat below. Full-scale nude cartoons for this and a smaller version (painted for the Glaswegian collector Alexander Ballantyne Stewart)[65] bear out the truth of Colvin's assertion that Moore conceived of the human figure 'simply as the

principal element in a pattern'.[66] The artist established the figure's proportions and placement through a complex network of intersecting circles traced by a compass (Pl. 140).[67] The use of geometry to determine the ideal structure of the human body was not new, and most obviously recalls the perfectly proportioned man that Leonardo da Vinci derived from a superimposed circle and square—an idea that he, in turn, borrowed from the ancient Roman architect Vitruvius. However, Moore was unusual in employing a geometric system to determine not merely the internal proportions of his figures, but also their relationship to the overall picture-pattern, which was itself devised from this system of proportion. The anatomical 'errors' occasionally noted by quibbling critics actually reflect Moore's adaptation of the human body to the same abstract ideal to which he accommodated flowers and foliage in his fabric patterns. On top of the system of intersecting curves, Moore juxtaposed a diaper pattern of curving diagonal and vertical lines (Pl. 141). These construction lines also influenced the proportions and placement of the figure, the major drapery folds, and other elements of the composition. Moore's geometric diagrams are responsible for the satisfying orderliness of his paintings, enabling the artist to transform a cacophonous medley of patterns into a perfectly balanced and harmonious picture.

Having left Red Lion Square in 1875, Moore passed two years in nomadic studio-hopping—a disruption that seems to have impeded his already slow progress, so that he was able to exhibit only one picture, *Beads*, in 1876.[68] In early November 1877 Moore settled into a newly erected house (no longer extant) in Holland Park (Pl. 142). He may have been directed to the property by Nesfield, whose former partner, Richard Norman Shaw, was building artists' studio houses throughout the neighbourhood.[69] Like so many of these houses, Moore's was built in the Queen Anne style that Nesfield and Shaw had helped to popularize. The façade was divided into seven courses and topped by two asymmetrical gables, with a front door painted pale green. The plan, approved on 20 November 1876, stipulated 'No Cement to be used, but to be built in Red Brick and Stone, or Brick Dressings'.[70] Geographically, the move brought Moore full circle, within yards of Lower Phillimore Place where he had lived with his mother and brothers on first arriving in London in 1855. Socially, it placed him within the charmed circle of London's most prestigious artistic neighbourhood, 'the red-bricked, royal suburb of Kensington'.[71] When Frederic Leighton moved to the area in 1866, herds of animals still grazed in unspoiled pastures and artisans occupied the humble houses. Leighton often joked that he lived in a mews.[72] In reality, it was a combination palace and Aladdin's cave—complete with exotic Arab Hall—designed to the artist's specifications by his friend George Aitchison. Within a decade, an entire village of impressive studio houses had sprung up around the charismatic Leighton, who became the official head of English art in 1878 upon his election to the presidency of the Royal Academy.[73]

Moore's new house owed its existence to Holland Park's ambitious redevelopment scheme, and yet remained fundamentally peripheral to it. Most of the area's artistic showplaces dotted Melbury Road, a new thoroughfare that replaced an older street called Holland Lane—

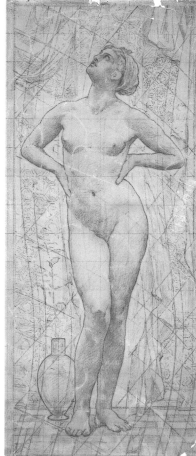

140
Computer reconstruction of a nude cartoon for *Birds*, with enhanced construction lines (original drawing, *c*.1878, charcoal on grey paper, Victoria and Albert Museum, London)

141
NUDE FIGURE STUDY FOR 'BIRDS OF THE AIR'
c.1878
Charcoal on grey paper
88.2 x 38.9 cm
(34¾ x 15⅜ in)
Victoria and Albert Museum, London

replaced all of it, that is, except a short strip at the southernmost tip connecting the Holland Arms public house in Kensington High Street with stables in Holland Road (Pl. 143). It was to this service alley that Moore relocated. Tucked into the recessed angle of the lane, Moore's house was virtually invisible from the connecting streets. In a letter written shortly after he moved in, he warned his patron Leyland, 'My new place is rather difficult to find there being as yet no name on the corner of the street ... [It] is next to the Holland Arms which cabmen and coachmen are likely to know.'[74] Moore's street sign may never have materialized, for Holland Lane and its solitary resident failed to appear in any of the postal directories published during the dozen years he lived there. Quite reasonably, the record-keepers may have mistaken Moore's street (popularly known as 'the Back Road')[75] for an unoccupied alleyway.

The only other occupants of Holland Lane were the cows and bulls of Tunks's and Tisdall's dairy farm. The dairy was built in 1878, in the fashionable Queen Anne style, with a red-brick exterior and a richly ornamented interior reminiscent of the model dairies that Moore had decorated years earlier at Shipley, Croxteth and Combe Abbey.[76] For all its charm, the dairy deflated any pretence of sophistication that Moore might have gained from his Holland Park address. The cow stalls and covered yard stood directly opposite his house, and cattle paraded daily past his door on their way to grazing land.[77] The arrangement presented obvious deterrents to would-be clients come to call. Leighton may have joked that he lived in a mews, but Moore almost literally lived in a farmyard, nestled between the horses of the pub's stable on one side of the house, and the dairy cows across the lane. It is a wonder that he accomplished any work at all amid the sounds and smells emanating from his neighbours. That he produced images of ideal beauty and calm in these circumstances attests to the intensity of his concentration and imagination.

Edward Godwin asserted in a lecture of 1879 that Moore had 'designed his own building—I presume at a much greater cost than if an architect had been called in'.[78] The evidence suggests that Godwin was mistaken, and that Moore—unlike his well-to-do artistic neighbours—could not afford the cost of erecting his own purpose-built residence. His slow and painstaking method of work limited his productivity, but Baldry hinted that he was also a poor businessman and that 'certain peculiarities of temperament ... were occasionally the cause of difficulties in his dealings with the practical details of existence and prevented him from reaping the full benefits of his activity'.[79]

Rather than build his dream house, Moore merely modified a structure already under way, which he rented from the proprietor of the Holland Arms.[80] The plan of November 1876 indicates that the building was originally intended as a non-residential professional space for two artists, but Moore transformed it into a combined studio and residence for one.[81] In the back corner of the house, he carved out modest living spaces consisting of a small sitting room, a bedroom (originally intended as a second sitting room) and a kitchen. A small, wedge-shaped bedroom above the kitchen was presumably occupied

The Studio & Residence of Albert Moore RA. 1 Holland Lane

142
Ernest Stamp
THE STUDIO AND
RESIDENCE OF ALBERT
MOORE, RA [SIC].
1 HOLLAND LANE
1938
Black chalk
16.4 x 22.8 cm
(16½ x 9 in)
Museum of London

143
Map of the intersection of
Kensington High Street
and Melbury Road,
showing Albert Moore's
studio on the west side of
Holland Lane

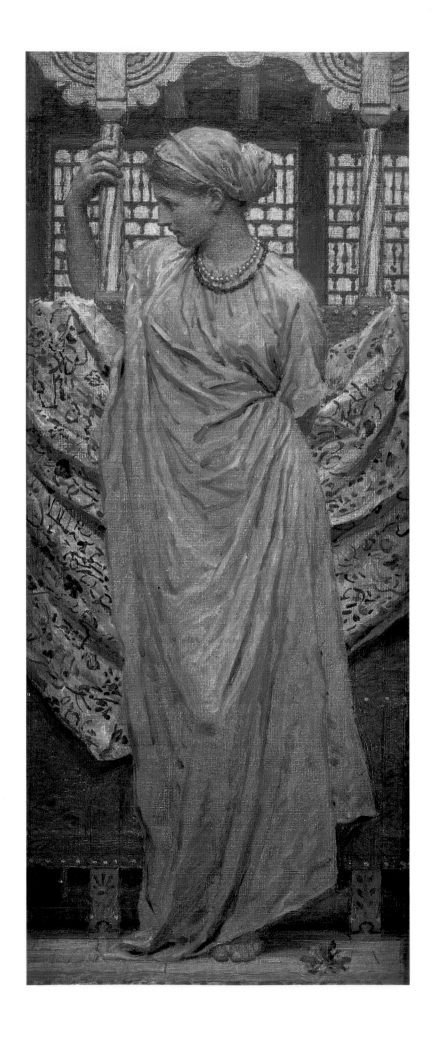

144
FORGET-ME-NOTS
1881
Oil on canvas
37.7 x 14.9 cm
(14⅞ x 5⅞ in)
Private collection

by Moore's live-in housekeeper. Dominating the house were two generously proportioned studios at the front, measuring 32 by 30 feet and 28 by 27 feet respectively. A door in the smaller studio opened on to a long covered passageway providing access to the street entrance, where models and deliverymen entered. Other artists' houses in the area were far larger and more elaborate, but they, too, made the studio pre-eminent in the overall plan, with minimal square footage devoted to bedrooms.[82]

If the plan of the house was not eccentric, Moore's spartan décor was. One frequent visitor described his studio as a 'huge, desolate workroom', with nothing to sit on in the sitting room and 'nothing in the way of papering, painting or white-washing ... ever done'.[83] Moore's minimalist décor resulted in large part from sheer indifference, but it was also strikingly modern. Whistler cultivated the same spare aesthetic as a progressive form of interior decoration at his White House, built by Godwin in 1878. The studio there was described by the American artist Edwin Austin Abbey as 'queer inside ... an immense room with white walls, and one side all windows, like a bare country church'. Of Leighton's more ornately appointed studio, Abbey remarked, 'He has such beautiful things around him. I wonder if they don't clog his brain? ... I am beginning to think that a bald barn is the best place to see visions in, not a luxurious museum filled with precious scraps that command one's attention and insist upon being respected.'[84]

Indeed, in his own 'bald barn', Moore envisioned scenes that surpassed Leighton's luxurious museum. From the early 1880s, his paintings represent increasingly elaborate items of imagined furniture and architecture, all evidently designed and executed (if only in paint) by the artist. *Forget-me-nots* of 1881 provides the first hint of things to come (Pl. 144). Within the narrow constraints of this tiny painting, Moore envisioned a lavishly appointed interior featuring a painted and upholstered screen with carved pillar supports, along with latticed windows and an elaborate ceiling of Moorish design. The only item in the painting that probably existed in reality is the pansy-patterned fabric draped behind the figure, which has already been noted in several other pictures. Suggestive of a seraglio, the setting of *Forget-me-nots* provides the first example of deliberate Orientalism in Moore's art since *Dancing Girl Resting* of 1864 (Pl. 33), and was possibly inspired by his new-found enthusiasm for Turkish and Persian fabrics.[85]

Abbey's description of the wall of windows in Whistler's studio points up one respect in which Moore's accommodations were surprisingly ill-equipped. Most studios contained oversized north-facing windows which admitted consistent light throughout the day. All of Moore's windows, by contrast, faced east—both the two tall windows in the students' room, and the single oversized window in his own studio—providing intense early morning light which faded through the day. The artist supplemented these windows with skylights in the ceiling,[86] but, according to Godwin, he did more than that. A thumbnail sketch in one of Godwin's notebooks shows that Moore modified the walls of his own studio in order to create an octagon, possibly in emulation of

the famous octagonal studio of Sir Joshua Reynolds.[87] Godwin claimed that Moore modified the walls (and, similarly, the ceiling) 'upon the principle of endeavouring to get rid of every right angle, and to reflect as much light as possible'. The architect examined and sketched Moore's studio in the summer of 1877 while he was designing the studio for Whistler's White House. 'When you go in you think you've got inside one of those many-sided figures used for mathematical demonstrations of angles and prisms,' Godwin noted; 'It has, indeed, numerous sides, is very dodgy and well worthy of consideration by every artist.'[88]

Godwin's allusion to geometry and optics is intriguing. As noted earlier, Moore had demonstrated a precocious aptitude for mathematics and he may have gained some knowledge of light refraction through his brother Frederick, an optician. In view of the artist's analytical use of geometry in designing his pictures, it would not be at all surprising for him to have adopted an equally analytical, geometric approach to redesigning a building. His aim was evidently to ensure that light admitted to the studio from the overhead and side windows bounced continuously off the walls and ceiling, generating diffuse but uniform illumination with minimal shadow. Moore faithfully transcribed this peculiar lighting effect in his paintings, where it became a keynote of his art and a puzzle to many critics. At the same time that the Impressionists were associating modern art with natural lighting effects observed out of doors, Moore, it was noted, pursued an idiosyncratic and patently artificial effect, which he rendered with exacting realism. One admirer observed of his unconventional lighting, 'No matter if it gives a peculiar opaque greyness to the English complexion which he so constantly chooses in his models, or effaces the pale tints of fair hair—he finds in it a beauty all its own.'[89] Whistler pursued the same shadowless effect in his paintings for a time, putting viewers in mind of Japanese and Chinese art. At his house in Lindsay Row, he had reportedly covered the windows with Indian muslin curtains in order to produce 'a very diffused light without any definite shadow'.[90] It is no wonder that his architect, Godwin, took particular interest in Moore's ingenious means of achieving the same effect.

It was in reaction against the smoke-filled gloom of late Victorian London that Moore created an art of pure light and perfect clarity. He shared the antipathy of many of his colleagues towards the encroaching ugliness of modern urban life. But while Edward Poynter protested against architectural 'carbuncles' in fiery lectures and essays, Moore addressed the subject in poetic missives to the newspapers, and whereas William Blake Richmond formed committees to attack air pollution, Moore preferred to create his own crystalline atmosphere within the walls of his studio.[91] Abbey likened Leighton's studio to a museum. He might have termed Moore's a greenhouse, for the artist filled it with 'objects naturally beautiful'. According to Baldry, 'He never failed to place prominently in his studio bowls of bright coloured flowers, most delicately combined and arranged.' Enveloped by blossoming plants in an insular fantasy garden of his own creation, Moore blocked out 'the sordid surroundings of London life' and was 'consoled for the colourless out-of-doors which he viewed with a sense

almost of repulsion'.[92] According to Baldry, this artfully arranged natural environment was essential to Moore's 'sensitive temperament':

> He happened one morning to find these bowls unfilled, and, though he made an effort to work, the absence of what had become to him indispensable companions so affected him that he threw down his brushes, and, hurrying to the nearest florist, returned with his arms filled with flowers. It was not until he had made his room gay with them that he resumed his paintings.[93]

The artist's delight in these floral displays is evident in rapidly executed still-life studies such as *A Vase of Dahlias*, which he presented to his loyal supporter, Leighton (Pl. 145).[94] In oil sketches such as this, Moore allowed himself a spontaneity and freedom that he refined away from more purposeful work.

In addition to enjoying their general ambience, Moore derived specific pictorial ideas from the natural objects displayed in his studio. Baldry claimed that Moore based his colour arrangements on 'flowers, feathers, shells, and suchlike things, which nature had decorated with inspiring harmonies'.[95] He first analysed these harmonies through fairly literal transcription in still-life studies. For example, his 'almost inarticulate delight' on seeing 'a couple of open oysters lying on a bit of blue paper', or 'some lemons laid out on blue paper on a costermonger's barrow' inspired Moore to arrange a plate of oysters and lemon peel in his studio and to explore the silvery tonalities in *Study of Colour*, an unlocated pastel shown at the New English Art Club in 1890.[96] In the same year, he exhibited the human incarnation of this medley of pearly whites and lemon yellows in his ambitious figure painting *A Summer Night* (Pl. 179).

For broader pictorial effects, Moore journeyed to nearby Holland Park. On one such outing, he was struck by the scintillating tracery pattern created by white cherry blossoms against a dark wall.[97] The effect reportedly inspired the background of his painting *Blossoms* of 1881 (Pl. 146), a work that exemplifies his sensitivity to the abstract decorative patterns of nature.[98] The floral screen functions in precisely the same fashion as the botanically designed fabrics that appear in other paintings, such as *Topaz*, exhibited at the Grosvenor Gallery in 1879, in which the flat, decorative backdrop reinforces the reading of the picture as a two-dimensional design (Pl. 147). As in Moore's stained glass, the filigree pattern of the background provides a lively counterpoint to the slow, rhythmic swags of the figures' drapery folds.[99]

According to Baldry, Moore 'never enjoyed the consciousness that his aesthetic aims were generally appreciated, or, indeed, understood outside the limited circle of his particular admirers'.[100] By translating his abstract impressions of nature into representational, figurative terms, Moore had opened an inviting point of access to many viewers who remained blind to the formal logic behind his 'pretty' pictures. Moore's contemporary reputation was consequently much higher than that of his ally Whistler, who adopted a less mediated and therefore more challenging approach to embodying his subjective visual

145
A VASE OF DAHLIAS
*c.*1880s
Oil on canvas
25.1 x 16.5 cm
(9⅞ x 6½ in)
Private collection

146
BLOSSOMS
1881
Oil on canvas
147.1 x 46.3 cm
(58 x 18¼ in)
Tate Gallery, London

impressions. Merely suggesting what Moore analysed and refined, Whistler was denounced for what many perceived as slapdash composition and lack of finish. At the inaugural Grosvenor Gallery exhibition of 1877, Whistler's *Nocturne in Black and Gold: The Falling Rocket* proved the last straw for John Ruskin, who was outraged to learn the price Whistler asked for the painting. In a white fury, he penned an inflammatory notice of the picture. 'I have seen, and heard, much of Cockney impudence before now', he thundered, 'but never expected to hear a coxcomb ask two hundred guineas for flinging a pot of paint in the public's face.'[101] These intemperate words provided Whistler with an excuse for putting the British art establishment on trial, and he immediately began libel proceedings against Ruskin.

Whistler's case depended on the testimony of established artists who could vouch for his professional stature. Albert Moore's name was included in a long list of potential witnesses, but he cannot have been Whistler's first choice, for he lacked the official credentials which lent authority to the others. Nevertheless, Moore was a loyal friend of long standing who possessed an intimate knowledge of Whistler's art. Although biographers of both Whistler and Moore have minimized their friendship, suggesting that it petered out with the controversy over *Sea-gulls* in 1870, they actually remained intimate friends until Moore's death in 1893 and were particularly close in the late 1870s. Moore attended some of Whistler's celebrated dinner parties, including one on 16 November 1875 as memorable for style ('Lovely blue and white china ... Lovely Japanese lacquer') as for substance ('General conversation and ideas on art unfettered by principles').[102] In 1876 Moore and Whistler were frequently lured from their studios by the American artist Homer Martin, who combined Whistler's spontaneous sparks of caustic humour with Moore's eccentric disregard for convention.[103] The motley trio frequently dined with other friends at an unpretentious French restaurant, whiling away the evening in convivial conversation.[104] They also visited one another's studios with some frequency; on one occasion Whistler announced that he wanted to show Moore ('Albert old chap') 'some work I am pleased with', adding, '*that* we both know is a rare pleasure to each of us!'[105] Most importantly, Moore was a frequent partner in the boat trips along the Thames during which Whistler gathered impressions for his Nocturnes. They often set out at twilight and rowed all night, observing the atmospheric effects of gaslight and moonlight on the darkened scenery. On other occasions, they entered the water before dawn in order to have breakfast with Charles Augustus Howell at Putney.[106] It was probably one of these journeys that inspired Moore's landscapes *Chelsea—Sunrise* (which reminded one commentator of an early Cecil Lawson) and *Nightpiece* (both unlocated).[107] Whistler's *Nocturne in Black and Gold: The Falling Rocket* was also inspired by a late-night excursion along the Thames.

In these circumstances, it was hardly surprising that Whistler should enlist Moore as an ally in defending his art, even though he must have realized that giving testimony in court would be a singularly distasteful experience for his taciturn, reclusive friend. Moore proved his loyalty by acceding without hesitation, as other colleagues deserted Whistler

one by one. Days before the trial, Whistler's attorney wrote in disgust, 'it now finally appeared that Mr. Albert Moore was the only witness who could be relied on to attend and give evidence.'[108] Whistler had already issued a rallying cry to Moore which sounded the familiar note of complicity in a joint crusade:

Moore my dear brother professor I want you now as on an occasion of the kind you might want me and know that I should rush to stand by your side. On Monday next my battle with Ruskin comes off—and I shall call on you to state boldly your opinion of Whistler generally as a painter—colorist, and worker ... Now Moore mon ami I know you won't hesitate—and I write to prepare you for Monday. Meantime come and breakfast with me on Sunday at 11.30—and take fresh confidence in your pal as a painter while you see again the works I have gathered together in my studio. Mind you this is a chance for our side that may never occur again.[109]

Whistler conceived of the battle as an attack not only on Ruskin, but on the conservative aesthetics embodied by the Royal Academy. He anticipated that the trial would include an 'Academic demonstration' on Ruskin's behalf, and warned Moore that among numerous defence witnesses, 'prominent is *Stacey Marks*, "R.A." ready it is said to assert that he can paint a Whistler Nocturne in five minutes in Court!!!'

Whistler founded his case on two of Moore's own guiding principles: that the arrangement of line, form and colour constituted the exclusive concern of a painter; and that only practising artists were qualified to judge works of art.[110] The first proposition received the most attention at the trial, allowing Whistler to present an eloquent definition of the kind of art that he and Moore were pursuing. In the paintings he called Nocturnes, Whistler testified:

I wished to indicate an artistic interest alone, divesting the picture of any outside anecdotal interest which might have been otherwise attached to it. A nocturne is an arrangement of line, form, and color first. The picture is throughout a problem that I attempt to solve. I make use of any means, any incident or object in nature, that will bring about a symmetrical result.[111]

This view directly contradicted Ruskin's philosophy of the moral obligations of art. In a lecture delivered at Oxford in 1870, he had declared that 'The great arts ... have had, and can have, but three principal directions of purpose: —first, that of enforcing the religion of men; secondly, that of perfecting their ethical state; thirdly, that of doing them material service.'[112]

Calling Albert Moore to the stand was in some respects risky. Never one to mince words, he had on several occasions demonstrated an expertise in the gentle art of making enemies that was worthy of Whistler himself. He was particularly outspoken on the subject of the Royal Academy, having early in his career gained notoriety with the

147
TOPAZ
1879
Oil on canvas
91.3 x 43.1 cm
(36 x 17 in)
Private collection

aphorism that 'there was not a single Academician who could design a button.'[113] On a later occasion, hearing that one of the most mediocre of the Academicians was in a private room at Burlington House making revisions to a painting prior to exhibition, Moore reportedly offered the indiscreet advice, 'Don't miss the chance; lock him up there and don't let him out until he promises to take the picture home.'[114] Moore was also outspoken in the defence of his artistic beliefs, and he threw himself into the legal proceedings with evident gusto. In a rapidly scrawled note to Whistler's counsel, he laid out several lines of questioning that were ultimately adopted in the trial:

> Pictures are not valued with respect to the time expended on them. It is said that Tintoret's large picture the Miracle of St Mark was executed in fifteen days—ask the artists on the other side if they have not heard of this & their opinion on the point generally; also Messrs. [Burne-] Jones & Severn [two of Ruskin's defense witnesses] whether they think I have a right to express opinions as to the merits of a painter. Ask me whether Whistler colours, composes & paints well ... Mr. R[uskin] has himself pointed out the superiority of a late picture by Turner to his early and more carefully detailed sea pieces, in that the former suggested wetness in the water ... a benighted critic of the day described this picture as soapsuds & whitewash.[115]

In addition to furnishing evidence of Moore's involvement in the strategic planning of Whistler's defence, his pre-trial statement contains an eloquent testimony to his appreciation of Whistler's art:

> It is not too much to say that some of his qualifications amount to absolute genius—an unerring colourist & composer, he frequently gives me quite a thrill of pleasure by means of the manipulation of his paint ... As for the nocturne, for my part I can fancy the cool air from the surface of the water blowing in my face. In fact this kind of impression constitutes one great charm in his work.[116]

In closing, Moore proclaimed loyally, 'I hope that Mr. W[histler] will long continue to distribute his pots of paint.'

On the day, Moore proved a model witness (Pl. 148). He took only two jabs at Ruskin's counsel, eliciting laughter from the courtroom but in each case couching a serious point in the joke. When the barrister attempted to equate Whistler's price of 200 guineas with the amount of time actually expended on the painting, Moore drew an adroit comparison with the attorneys' own fee system. As the snickers subsided, he added, 'The money is paid for the skill of the artist, not always for the amount of labour expended.'[117] Impatient with the term 'eccentricity' applied to Whistler's works, Moore countered, 'I should call it "originality".' Drawing on the ideas outlined in his pre-trial statement, he upheld Whistler's *Nocturne in Black and Gold* as 'most consummate art', and praised another Nocturne for its remarkable 'sensation of atmosphere'. The extraordinary thing about Whistler's

paintings, he asserted, was that 'he has painted the air, which very few artists have attempted.' In sum, Moore stated generously, 'I wish I could paint as well,' and 'If I were rich I would buy Mr. Whistler's pictures myself.'

The jury found in favour of Whistler, but expressed contempt for his claim by awarding damages of only one farthing rather than the thousand pounds he was seeking. The Pyrrhic victory denied Whistler any sense of closure and not surprisingly he carried on fighting long after the trial had ended. Within a month, he had published *Whistler v. Ruskin: Art and Art Critics*, a diatribe against the invidious profession which he dedicated to his steadfast partner in the trenches, Albert Moore. In 1890, more than a decade after the trial, Whistler published excerpts of the court testimony (with his own speeches judiciously tailored for greater eloquence and wit) as the opening volley in *The Gentle Art of Making Enemies*. The artist Sidney Starr recalled that with the volume 'fresh in the field and Albert Moore in his audience, he [Whistler] read one Sunday the trial scene with dramatic significance.'[118]

Meanwhile, in the immediate aftermath of the trial, Moore continued his loyal support of Whistler's cause. On 28 November 1878 Moore lodged a complaint with several newspapers about an early work by Titian that Ruskin's counsel had introduced as evidence of the handling characteristic of 'the greatest painter'.[119] In truth, Moore charged, this unusually polished specimen failed to represent 'the style and qualities which have obtained for him his great reputation; one obvious point of difference ... being the far greater amount of finish— I do not say completeness—exhibited in it.' By distinguishing between the elaboration of the paint surface—the finish—and the full expression of the concept—completeness—Moore dealt in subtleties that had escaped the jury. That was in fact the real point of his letter which (as Moore confessed to Whistler) he had 'concocted mainly for the last sentence.' In that final line, having already maligned Ruskin's attorney for introducing evidence 'calculated to produce an erroneous impression' on the jury, Moore added contemptuously, 'if, indeed, anyone present at the inquiry can hold that those gentlemen were in any way fitted to understand the issues raised therein'.[120]

No sooner had Moore emerged from the legal battle with Ruskin than he entered another contentious debate. It, too, underscored the rift between the 'advanced' artists aligned with the Grosvenor Gallery and the old guard based at the Royal Academy. A report recommending revisions in the copyright law, published by a specially appointed commission late in 1878, had generated widespread alarm within the artistic community. Fears were unallayed by the Royal Academy's decision to appoint a private committee to draw up a memorial to the government.[121] Seeking more direct representation, artists applied to Sir Coutts Lindsay who had long intended to host discussions of artistic questions at the Grosvenor among a hand-selected committee of artists.[122] The meeting he convened on 1 February 1879 was very much by popular demand, however, attended by 200 men and women.[123]

Artists charged that the copyright commission had disregarded their interests by suggesting that copyright on a work of art should transfer to its purchaser, rather than remaining with the artist as inalienable intellectual property. In addition to preventing artists from profiting by the sale of engravings and photographs of works they had sold, such legislation would prohibit their selling successive versions and preparatory studies.[124] The American artist Edwin Austin Abbey, who attended the Grosvenor meeting following a large dinner at the Arts Club, reported that 'Frith [sic; Fripp], Albert Moore, Herkomer, Sir Coutts Lindsay, and a lot more spoke.'[125] When William Blake Richmond (Moore's friend from Royal Academy School days)[126] moved that the assembled artists formally express their dissatisfaction with the proposed legislation, it was Moore who seconded the proposal, and who was subsequently deputized (along with Richmond, Alfred Downing Fripp and Hubert von Herkomer) to present a list of resolutions to the government.[127] Moore's comments at the meeting are undocumented, but the gist of his argument may well be imagined. Legislation of the kind proposed held dire consequences for an artist who grounded his creative process in continual refinement and reinterpretation of a circumscribed cycle of ideas.

A series of paintings on which Moore had embarked by 1879 helps account for his outspoken engagement in the copyright debate. He was then contemplating one of the most important works of his career, *Dreamers*, which he would ultimately exhibit at the Royal Academy in 1882 (Pl. 149). In it, Moore revived a motif first essayed over a decade earlier in *The Shulamite* (Pl. 77): an intimate group of three languid female figures, set against a backdrop of drapery swags and grillwork. The rigorous design strategy that he had evolved over the previous ten years enabled Moore to reinterpret this group as a far more tightly orchestrated chromatic and linear arrangement. The colour scheme of *Dreamers*, though closely allied with that of *The Shulamite*, more palpably evokes the iridescence of mother-of-pearl. The shimmering silver and gold highlights of the white and cream drapery, flecked with pink and green accents, bear out Baldry's claim that 'from flowers, feathers, and shells came the first hints for the delicate gradations which dominated his colour schemes.'[128] Musical analogies implicit in *The Shulamite* are more powerfully invoked in *Dreamers* through Moore's artful use of repetition and variation. Each set of reiterated elements within the composition—the alternating panels of wallpaper and grille, the knotted bunting and the virtually identical women—marks out its own syncopated rhythm, layered one over the other. As in Moore's other paintings, the human figures are treated as elements of the décor, their resemblance to one another as intentional as the repetitions of the wallpaper pattern. The rhythmically repeated elements also carry the suggestion of melody, played out variously by the tight filigree and geometric configurations on the wall, the stately rise and fall of the bunting, and the flowing drapery across the women's bodies. The deep swags in the lower register of the painting employ the principle of repetition once again, providing diffuse reflections of the bunting above, like clouds reflected in a pool of water.

Moore devoted at least three years to perfecting every detail of

148
Edward William Godwin
EXCHEQUER CHAMBER.
ALBERT MOORE
INSTRUCTED IN COURT,
25 NOVEMBER 1878
1878
Pencil drawing in sketchbook
14.6 x 8.2 cm
(5¾ x 3¼ in)
Victoria and Albert
Museum, London

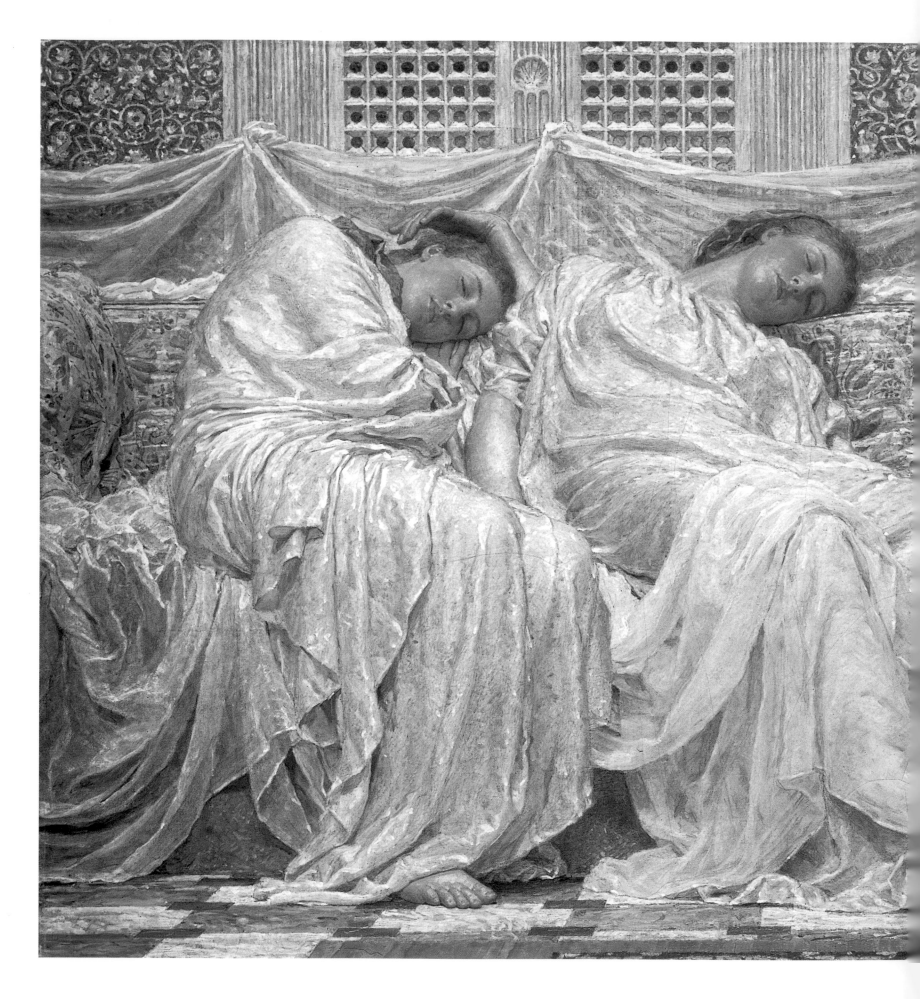

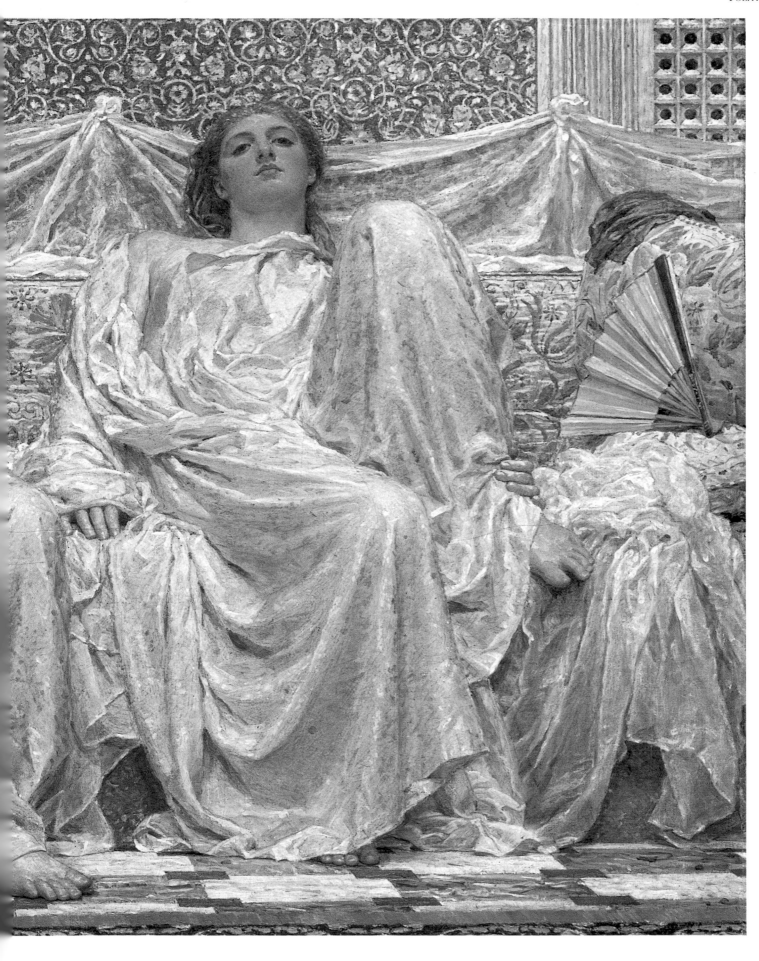

149
DREAMERS
1879-82
Oil on canvas
68.5 x 119.2 cm
(27 x 47 in)
Birmingham Museum and
Art Gallery

Dreamers, focusing particularly on the complex interplay of the drapery systems. He sustained his exhibitions and sales during this time by elaborating preliminary figure studies into independent works of art. Through these pictures, it is possible to trace the evolution of his ideas for *Dreamers*. An early stage in Moore's conception of the central figure is documented by *A Workbasket*, a small study in green, pink and white, exhibited at the Royal Academy in 1879 (Pl. 150). It represents the central woman in a gauzy white shift with an opaque drapery laid over it—an arrangement that Moore would reverse in his final painting. In *Jasmine* (Pl. 151), an arrangement in pink, red, white and grey, exhibited at the Grosvenor Gallery the following year, Moore replaced the sharp edges and constricted folds of the overlying opaque drapery with mellifluous curves rising and falling over the woman's proper right knee. Ripples in the gauzy, white shift were similarly systematized.[129] Moore's final refinements in this particular drapery arrangement appear in *Yellow Marguerites*, exhibited at the Royal Academy in 1881 (Pl. 152). The colours and linear patterning of the drapery, as well as the relationship of transparent and opaque fabrics, have all been determined. By now, the artist's interest had shifted to the background, where he assembled an elaborate checkerboard of contrasting patterns, textures and colours, anchored by a strategically placed black butterfly at far right.

Yellow Marguerites gains additional interest from the construction lines visible beneath the filmy white paint of the figure's lower drapery. These run parallel to the woman's proper right leg, intersecting the orthogonal grid articulated by the dado, sofa and rug. Overlying this geometric structure is a contrasting system of sinuous curves embodied by the draped figure. An analogous arrangement is evident in *An Embroidery*, shown at McLean's Gallery in 1881, in which the sweeping diagonal curves bleed through the pale paint of the wardrobe, whose panelling articulates the underlying orthogonal grid (Pl. 154). In both paintings, lack of spatial depth reinforces a two-dimensional reading, undermining the distinction between subject and setting, foreground and background. An impromptu oil sketch provides yet another insight into Moore's conception of the human figure as an integral element in a unified decorative scheme (Pl. 153). While experimenting with what appears to be a pattern for fabric, the artist's attention wandered to a figurative design, which he executed directly over it. Divorced from its original context, the decorative pattern now serves as the ground layer of the composition and the source of its organic unity. In some areas, Moore went so far as to reinforce the pattern's keynotes on top of the overpainted figure. As a contemporary critic observed of Moore, 'He does not allow to the human figure and face that predominance in tint and in brilliancy of tone to which we are more or less accustomed in Art.'[130] Giving equal weight to each element of his picture-pattern, Moore ensured that every inch of canvas was delightful to the eye.[131]

As noted earlier, Moore's unwillingness to distract himself from painting had impelled him to decline a position as headmaster of the Birmingham School of Art in 1876 (see p. 145). By taking over a double-studio house in 1877, however, he demonstrated his commitment to an alternative plan for disseminating his artistic

theories while simultaneously advancing his painting practice. On 26 January 1878 it was reported: 'Mr. Albert Moore has long entertained the intention of collecting a little knot of art-students, to be trained in his peculiar branch of decorative painting, and we hope sincerely that he will, sooner or later, carry it out.'[132] In 1866, it will be recalled, Moore had sought a student-assistant to aid in his mural work (see p. 63). In the late 1870s he undertook a far more ambitious plan, assembling a small group of male and female students, some of whom also served as his assistants.[133] Unfortunately, the identity of only two of these students is certain. The first is Walford Graham Robertson (1867-1948), son of a wealthy retired shipbuilder, who as a boy had frequented the studios of Thomas Armstrong, Walter Crane and Edward Poynter. At the age of 11, he became fascinated with Moore's paintings, which he saw for the first time at the inaugural Grosvenor Gallery exhibition of 1877.[134] Two years later, Robertson's mother brought his drawings to Moore and asked that he be taken as a pupil. 'Well, I could draw a great deal better than that at his age,' was the artist's laconic response, but he agreed to accept the boy on approval. Robertson remained a year before returning to school in 1880, and then rejoined Moore from 1885 until 1887.[135] During Robertson's absence, Alfred Lys Baldry (1858-1939), a recent Oxford graduate, joined the atelier, having previously studied art at South Kensington. He remained from about 1880 to 1884, and became a friend as well as assistant to Moore.[136] Baldry began to exhibit his own figure paintings and landscapes in the early 1880s, and, like Robertson, became involved in theatre.[137] But his ultimate path lay in art journalism, a career he initiated as the biographer and champion of his former teacher, Albert Moore.[138]

Despite gaps and contradictions in their respective accounts, Baldry and Robertson provide invaluable information about Moore's life and work during his reclusive years at Holland Lane. Penned immediately after his master's death and spurred by bitterness at his unjust neglect, Baldry's numerous biographical writings eulogize Moore as an omniscient and all-powerful genius. 'I am avoiding the more private details of his life,' he assured Whistler, 'and am only considering him as a great artist.'[139] Robertson, by contrast, composed a vivid account of Moore's quirky personal habits and demeanour. He portrays the artist as a lovable eccentric entirely lacking in pretension, who habitually startled Robertson's mother by asking her advice about painting quandaries, and who relished the company of his dachshund Fritz, a George Eliot look-alike who subsisted on sardines and oranges. Moore's 'favourite attitude of repose', Robertson recalled, 'was squatting on his heels like a Japanese ... When settling himself for a talk, [he] would suddenly subside thus upon the floor, to the amazement of casual beholders.' The sight was undoubtedly rendered more peculiar by Moore's habitual indoor costume: 'a large broad-brimmed straw hat without a crown' and 'a very long and very large ulster [overcoat], far too big for him and once, in remote ages, the property of an elder and taller brother.'[140] Small wonder that Sidney Colvin should feel obliged to warn a colleague heading for Moore's studio to expect 'a person resembling in looks and manner a dissipated beau of the working classes.'[141] Even Baldry acknowledged that Moore's eccentric mode of self-presentation harmed him

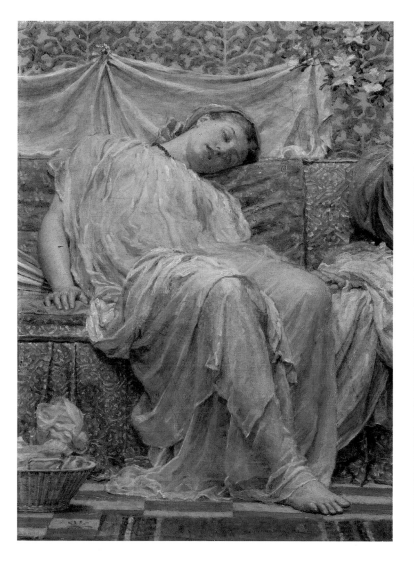

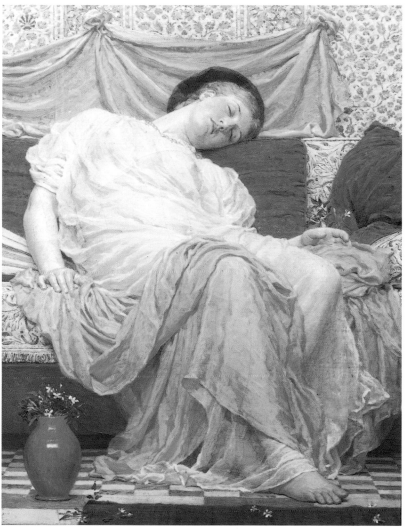

150
A WORKBASKET
1879
Oil on canvas
35.5 x 27.3 cm
(14 x 10¾ in)
Art Gallery of South
Australia, Adelaide

151
JASMINE
1880
Oil on canvas
66.6 x 50.1 cm
(26¼ x 19¾ in)
Watts Gallery, Compton,
Surrey

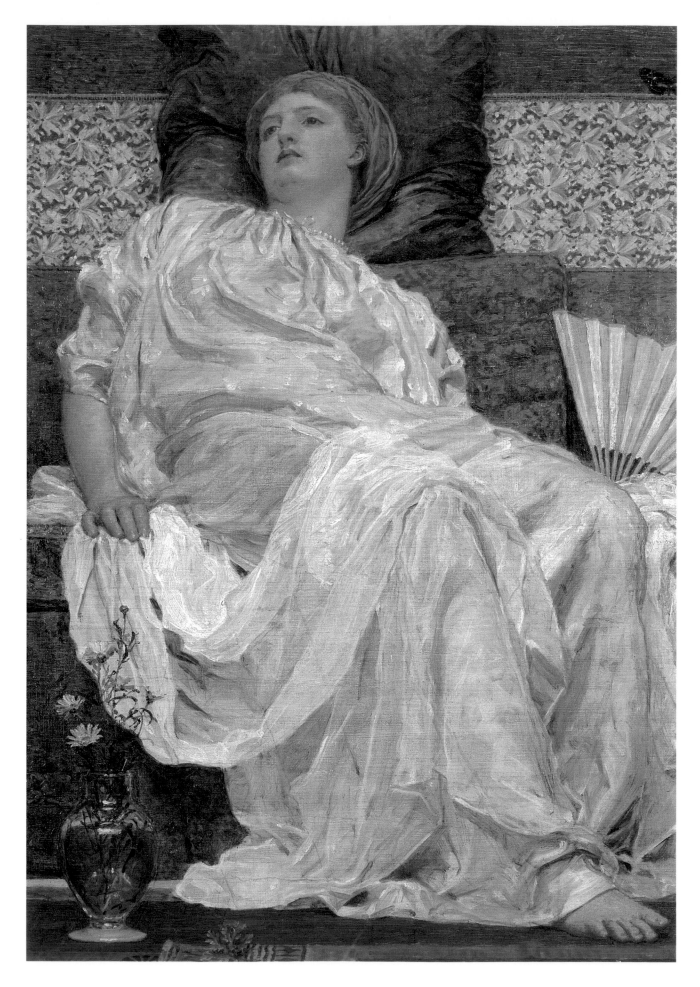

152
YELLOW MARGUERITES
1881
Oil on canvas
64.1 x 50.1 cm
(25⅞ x 19¾ in)
Private collection

153
NUDE WITH SCARF ON A
DECORATIVE PATTERN
*c.*1880s
Oil on canvas
31.4 x 14.6 cm
(12³⁄₈ x 5³⁄₄ in)
Private collection

154
AN EMBROIDERY
1881
Oil on canvas
33.6 x 13 cm
(13¼ x 5¹⁄₈ in)
Private collection

professionally. 'He dressed unconventionally and did not look quite like anyone that had ever been seen; he was [therefore] never suspected of having any serious artistic beliefs.'[142]

Despite the fastidiousness of Moore's technique, he showed an astonishing disregard for domestic order. Robertson painted a dismal picture of his master's leaky, dusty, cobwebby house—new in 1878, but sinking into dilapidation within the first few years of his neglectful tenancy. An army of cats had infiltrated the building, and 'they swarmed in the studios and passages, were born abruptly in coal-scuttles, expired unpleasantly behind canvases' and occasionally fell through skylights. Moore himself, according to Robertson, 'regarded them mournfully but placidly as inevitable'.[143] Wholly absorbed in his art, he preferred to endure the cats, leaks and grime rather than lose time and concentration in eliminating them. This attitude caused Moore to rely dangerously on those with a firmer grasp of prosaic realities. He seems to have been particularly vulnerable to the machinations of housekeepers. Robertson's description of domestic chaos indicates that the artist derived little benefit from his live-in housekeeper.[144] Nevertheless, Moore considered himself dependent upon her, and during her brief absence in January 1886 he forestalled a visit from his pupil until the absent servant had returned.[145] She eventually absconded with a number of the artist's possessions, leaving him nothing but a stack of pawn tickets. According to Robertson, Moore's customary counsellors during economic and social crises such as this were the worldly cab drivers who congregated at the taxi rank across the road. They seem to have adopted a protective and kindly attitude towards the eccentric painter.[146]

As a teacher, Moore grounded his students in the elaborate technical methods that he had developed and continued to revise, encouraging them to make their own modifications to the system. Rather than breeding a band of imitators, Baldry asserted, 'His aim was to induce pupils to think for themselves, to adapt to their own needs, and to suit to their own idiosyncracies, ways of working which he had found out by endless enquiry and experiment.'[147] Moore's renowned expertise in decorative design and mural painting occasionally elicited inquiries from ambitious students unaffiliated with his own atelier. Invited to decorate the refreshment room of the Royal Academy in July 1889, seventeen-year-old William Reynolds-Stephens pressed his mentor Lawrence Alma-Tadema for an introduction to Moore. His influence is palpable in the design that resulted from this consultation.[148] Evidently a mild master, Moore was roused to anger only when disappointed by careless or perfunctory work. However, he periodically grew weary of his responsibilities, Robertson recalled, and would proclaim to his students, 'I have decided to give up teaching. You needn't any of you come again after to-day.' Established members of the atelier reassured panicking newcomers that this was a 'constantly recurring phase' with an established protocol. 'They would all stay away on the morrow—out of respect, as it were—but on the next day they would resume their places early in the studio as if nothing had happened, and when Moore arrived—either forgetful or relenting—he would proceed in a like spirit.'[149] According to Robertson, experienced students assisted Moore with the preparatory stages of his paintings by making flower and drapery studies. At a pinch, they also served as models; Robertson often modelled his hands for Moore to paint, as he did for Edward Poynter and Walter Crane.[150] All of this work took place in the students' own large studio which Moore periodically visited; the smaller studio was the master's private sanctum and they never saw him at work. His new paintings remained unseen until completed.[151]

The relative seclusion and self-sufficiency of Moore's Holland Lane establishment encouraged the full development of those reclusive tendencies that had characterized him from an early age.[152] He had always been an exceptionally diligent artist, but during the 1880s he became a single-minded 'workaholic', seldom taking a day off, even when illness virtually incapacitated him.[153] Robertson remarked that Moore's life 'was in many ways a very lonely one. He lived apart, absorbed in his work, knowing and caring little about the outside world, whose ways sometimes puzzled him very much.' The allusion to Moore's 'loneliness', together with the dependence on housekeepers noted earlier, strongly suggest that by the 1880s at least, he was no longer living conjugally with a woman. Like so much of Moore's life, however, his romantic affiliations remain entirely mysterious, screened by the uncanny cloak of silence that his contemporaries maintained about him. And yet Moore was by no means a hermit. He continued to attend social occasions and to attract praise for his kindliness and humour. During the early 1880s, he frequented the home of the architect Frederic Jameson, Whistler's former studio-mate in Great Russell Street, where he reportedly heard 'lots of Wagner music'. While trying to 'walk off a fit of the blues' one lonely night, Edwin Austin Abbey encountered Moore and the two shared a long perambulatory conversation. Abbey later wrote to his fiancée, 'I liked talking to him. He is one of the few artists ... who feels what you mean and also makes you feel what he means.'[154] But while surrounded by fellow artists with whom he was acquainted, Robertson noted, 'few people knew him well, for he seldom took the trouble to make friends, yet he was the most gentle and affectionate of men.'[155]

Moore's increased reclusiveness owed something, no doubt, to the ill health that began to plague him in the 1880s. In February 1883 he had an attack of blood poisoning, which was complicated by pleurisy and congestion of the lungs. These ailments struck around the same time that one of his models contracted a fatal case of pneumonia while posing for *Kingcups* (Pl. 155), a small oil exhibited at McLean's Gallery in 1883. Actually, the word 'posing' drastically understates the ordeal, for according to Baldry, Moore studied her motions while 'for hours in succession [she] clambered on to and jumped off a table.' Moore himself catalogued further torments, explaining to Whistler that he 'was painting a group of flying figures, and in order to get the right movement in the draperies he had used fans and bellows'. When Whistler dismissed the model's illness and subsequent death with a crude sexual pun ('Ha! and this is how you make consumption!'), the distraught Moore reportedly 'flew into a temper, and the quarrel could never be patched up'.[156] In fact, the rift was only temporary and Moore went on to complete the painting he had begun.

Kingcups harks back to the motion studies that the artist had made more than a decade earlier for *Battledore and Shuttlecock* and *Follow My Leader* (Pls. 105-7, 117). A chalk drawing documenting his initial ideas for the painting demonstrates that it, too, originated as a group of classically draped female figures engaging in childish play (Pl. 156). The drawing shows a procession of nine women moving through a landscape. The last two leap from a short brick wall which the others have already passed, while a third, having fallen to the ground, attracts the attention of a playful dog. The conception exhibits precisely the sort of narrativity and puerile, sentimental charm that Moore loathed in contemporary art. In order to tailor this conception to his own stringent requirements, he lifted a passage out of context (the group of leaping figures) and developed it as a pattern suggestive of movement.[157] Fifteen years earlier, it will be recalled, he had similarly reduced a genre scene of ancient pastoral life into an austere design of women at a fountain (Pls. 58, 59).

Kingcups marks the artist's further development of the effect of dappled light seen through tree branches that he had first incorporated into the

floral backdrop of *Blossoms*. Moore handled his materials with unusual vigour in this small work, overlaying his characteristically cross-hatched surface with rapid, jabbing strokes made with a loaded brush, and using a sharp implement to scratch out the blades of grass in the lower right corner. This lively brushwork creates an overall shimmering appearance that reinforces the evocation of movement in the figural composition, thus counterbalancing the static repose that Moore pursued in other paintings of the period.[158] Evidently seeking variety, he also made several works on paper during the mid-1880s in which he set himself the challenge of capturing the graceful action of figures in motion.[159]

Following Moore's grave illness in 1883, his health, according to Baldry, 'was never afterwards quite the same; ... it is certain that the strain of continued labour was telling more and more upon his physical condition.'[160] While recuperating, he stayed at Solsgirth, near Dollar, Perthshire, at the country estate of William Connal, a wealthy Glaswegian pig-iron broker and warehouseman who had become one of the artist's most important patrons as well as his intimate personal friend.[161] In 1877 Connal had purchased two studies for *Topaz*, and he subsequently acquired *Elijah's Sacrifice* (1863), *Yellow Marguerites* (1881),

155
KINGCUPS
1883
Oil on canvas
39.3 x 20.9 cm
(15½ x 8¼ in)
York City Art Gallery

156
COMPOSITIONAL STUDY
FOR KINGCUPS
*c.*1866?
Black and white chalk
Private collection

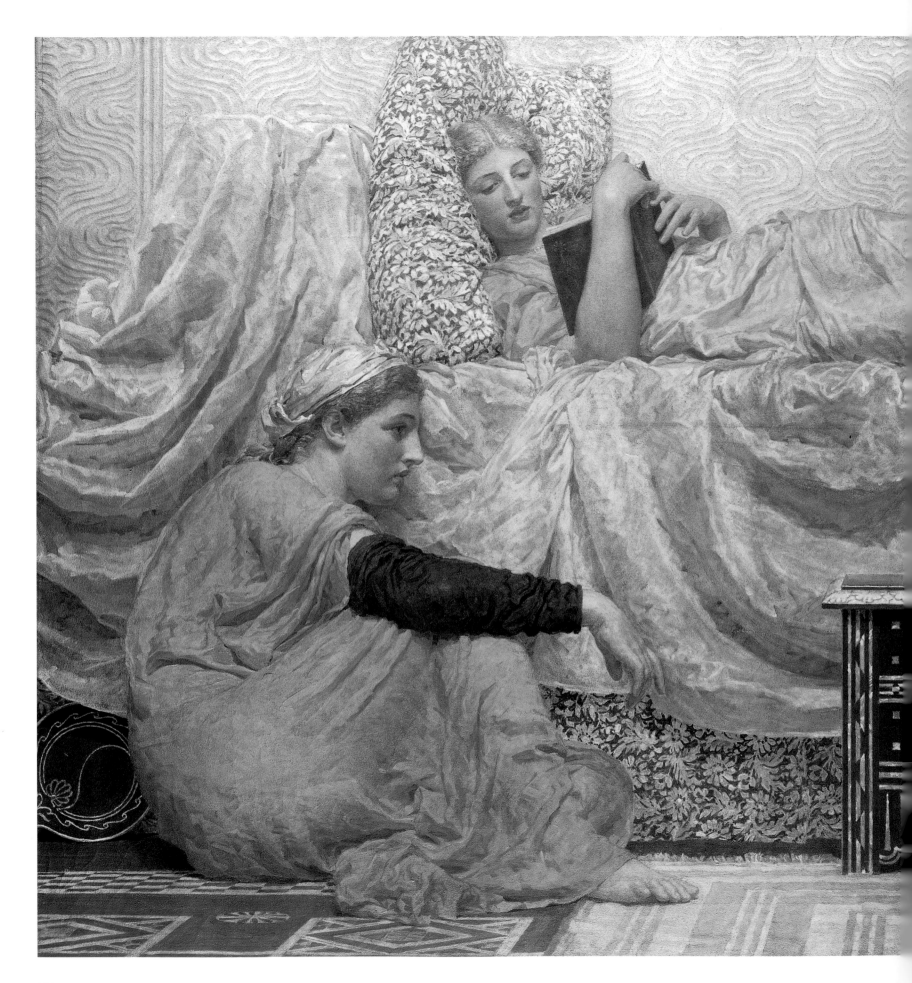

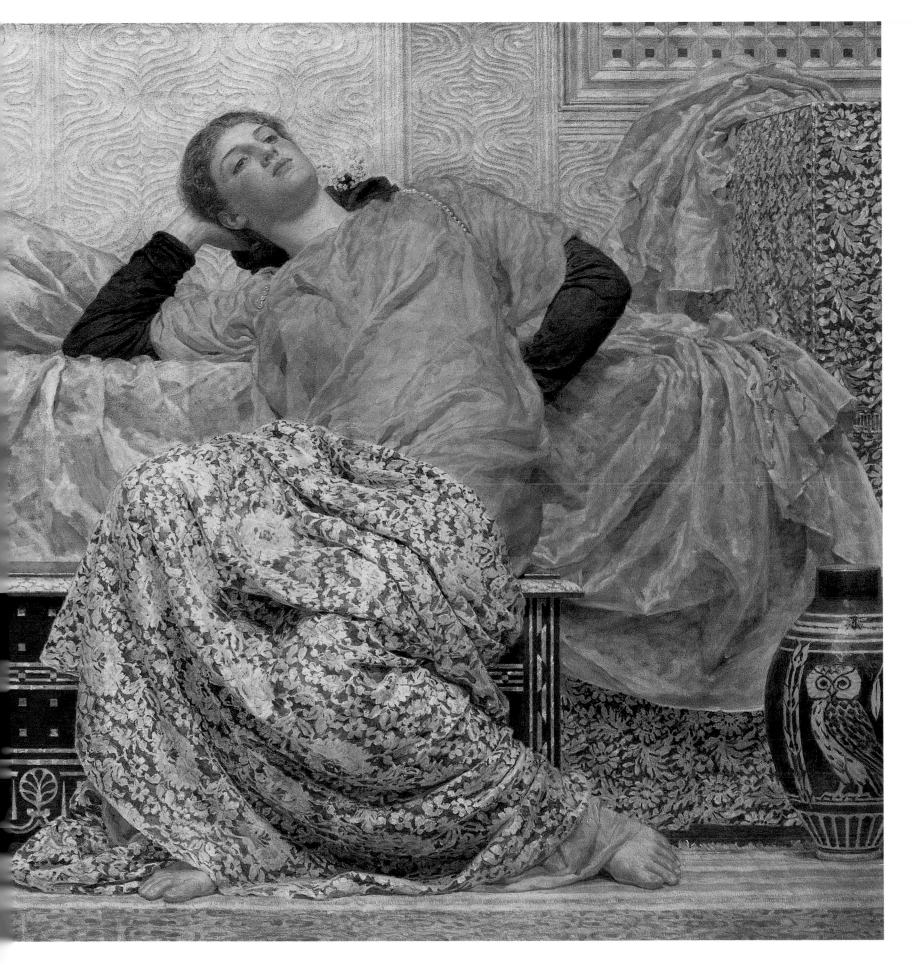

Rose Leaves (1881), a study for *Blossoms* (c. 1881) and at least ten other paintings.[162] Connal also proved an exceptionally generous patron to Edward Burne-Jones, further underscoring the imperviousness of collectors to the ethical and stylistic oppositions generated by critics.[163] When his illness struck, Moore was completing a painting for Connal, *Reading Aloud*, one of only three life-size works that he produced during the 1880s (Pl. 157). He had been labouring over the painting at least since 1881. On a visit to the artist's studio that year, Connal reportedly spotted an attractive 'colour note' and commissioned Moore to carry it out as a painting. The work that evidently caught Connal's eye was an unusual oil sketch executed on a small sheet of glass (Pl. 158).[164] The transparent support enabled Moore to make rapid trials of alternative colour schemes by painting directly on the glass while it overlaid a finished chalk drawing of the composition. This technique saved him the effort of re-drawing the composition prior to each new experiment. He habitually superimposed two sheets of tracing paper for the same purpose, one bearing a sketch of the composition, the other a trial colour arrangement.[165] Prior to painting *Reading Aloud*, Moore made a full-scale, trial version on tracing paper which he pinned directly to the canvas. Peeling away small sections as he painted, he kept the unified colour arrangement constantly before his eyes.[166]

Previous page
157
READING ALOUD
1884
Oil on canvas
107.2 x 205.5 cm
(42¼ x 81 in)
Glasgow Art Gallery
and Museum

158
STUDY FOR 'READING
ALOUD'
*c.*1881
Oil on glass
32.7 x 16.2 cm
(12⅞ x 6⅜ in)
Hunterian Art Gallery,
University of Glasgow

The figural poses and accessory details in Moore's oil-on-glass colour study differ in several respects from the final composition, indicating that it was made fairly early in the painting's evolution. The fact that Moore carried out colour trials at this early stage demonstrates his desire to develop the linear and chromatic arrangements in tandem. Despite its prematurity, however, the glass study already demonstrates the nuances of drapery patterning that would ultimately characterize the painting. In both the oil sketch and the final canvas, drapery enlivens the static composition with a range of contrasting actions: the zigzagging folds across the torso of the reclining reader; the swirling ripples about the lower limbs of the crouching woman at left; the broad, diagonal sweep over the legs of the opposite figure; and the ponderous swags falling from the sofa which bridge the gap between them. It was this 'abstract perfection of fold and combination of line' that distinguished Moore's treatment of drapery from the mere realism of contemporary classical revivalists.[167]

Baldry considered *Reading Aloud* a culminating work for Moore: 'the outcome of all [his] experiment', 'the product of [his] perfected knowledge', 'the most successful in expressing his convictions and in illustrating his methods'.[168] In theme, the painting constitutes a further development of the languid female audiences that Moore had first undertaken in *The Shulamite* and *A Musician* (Pls. 77, 86) of the mid-1860s. However, the title and subject-matter are uncharacteristically descriptive of an actual narrative event, far more so than the picture's

159
AN OPEN BOOK
1884
Watercolour
29.5 x 23.5 cm
(11⅝ x 9¼ in)
Victoria and Albert
Museum, London

most recent thematic precursors, *A Reader* and *The End of the Story*. The specificity is sustained in one of the accessories that Moore included in the picture: the owl-ornamented black and white vase that he modelled on an example in the British Museum.[169] The quotation exemplifies the sort of archaeological detail that the artist scrupulously avoided, and suggests that he had a reason for substituting this particular vase for the seated cat represented in his original oil-on-glass study. The owl's ancient associations with Athena, goddess of wisdom, may be relevant to the puzzle, as may the picture's purchaser William Connal. Moore inserted a symbolic reference to Connal in the form of a honey bee—his patron's personal emblem—shown alighting on the owl vase.[170] This unprecedented allusion leaves Connal's mark on the painting as decisively as Moore's anthemions leave his own (rendered in the mother-of-pearl inlay of the ebony chest and in the incised design of the ceramic dish). It seems likely that this unusual tribute reflects the artist's gratitude towards his patron, who had generously spirited Moore to Scotland when his health failed during the painting's execution.

In design, *Reading Aloud* elaborates principles that Moore had been developing for some time. Visible construction lines confirm that he based the composition on two systems of parallel diagonal lines which intersect to form a diaper pattern similar to those noted previously in *Birds*, *Sapphires* and other works.[171] Geometry remains subliminal in both of those pictures, but it is brought to the fore in *Reading Aloud* by unusually bold colour contrasts. Set against shimmering, candyfloss pinks and creams, the passages of charcoal grey leap out with considerable force. In several instances, these passages actually articulate the picture's underlying linear armature, most noticeably in the figure at right, whose arms coincide with diagonal construction lines. The book held by the reclining woman is angled along a parallel diagonal, and the outstretched arm of the crouching woman forms part of an implied horizontal which encompasses the charcoal-coloured chest and vase. Moore deliberately enhanced these angular features after the picture was already well advanced. They play no part in his initial oil sketch, and evidently required the last-minute sartorial innovation of arm-warmers. The importance of these details to the overall decorative scheme is revealed by *An Open Book*, Moore's watercolour rendition of the righthand figure, in the margins of which he carefully studied such details as the positioning of the arm-warmers and a Japanese fan (Pl. 159).

To eyes accustomed to the subsequent experiments of Cubism, Moore's accommodation of human anatomy to ideal geometry no longer appears revolutionary, but to contemporary viewers, the effect was startling indeed. Failing to understand the artist's intentions, critics dismissed the unusual effect as poor draughtsmanship. One complained that 'in spite of the extreme gracefulness of his work as a whole, Mr. Moore has always shown a curious weakness in managing the articulations of his lolling ladies: their heads and necks are often ill set on, their knees and elbows too aggressive, their limbs at awkward angles with the bodies to which they belong.' Another critic came a little closer to the truth in characterizing the figures as 'animated dummies in the decorative motive'.[172]

The figures form part of a complex array of abstract and naturalistic patterns that fill every inch of canvas. Most prominent among them is a fabric effect found in several of Moore's paintings of this period, in which white lace is layered over cloth of a darker colour. Like the floral screen in *Blossoms*, this effect derived from Moore's study of 'the patterning of flickering glints of daylight between overhead masses of leaves and interlacing branches'.[173] A drapery and flower study for *Reading Aloud* attests to the seamless fashion in which Moore translated such natural phenomena into stylized form (Pl. 160). Having begun to paint the chrysanthemum- and anemone-patterned lace, Moore drifted off into a still-life study of actual anemone blossoms and chrysanthemum leaves, which dot the margins and impinge on the figure itself.[174] This materialized daydream may have inspired Moore to paint *Red Berries* (Pl. 161), exhibited at the Grosvenor Gallery in 1884 and purchased by a colleague of Connal's, the Glasgow warehouseman T.G. Arthur. In this densely patterned and curiously elongated canvas, Moore juxtaposed vases of chrysanthemums against stylized textile renderings of the flower, and allowed the shape of the vase to reverberate in the curved hip of the reclining woman and the Japanese wave pattern on the wall.

At first glance, it may seem odd that Moore sent *Red Berries* to the Grosvenor in 1884 while reserving his major work, *Reading Aloud*, for the Royal Academy.[175] In fact, a shift in the artist's loyalties had first emerged in 1882, when he showed *Dreamers* at the Academy and a less ambitious painting, *Acacias* (Carnegie Museum of Art, Pittsburgh), at the Grosvenor. Illness prevented his exhibiting at either institution in 1883, but in each subsequent year Moore showed a clear preference for the Academy. The change in venue may owe something to the strong support he had received in the Academy's most recent elections of associate members. On 20 January 1881 he gained the highest number of votes (12) among the four candidates in a run-off ballot, but was ultimately defeated by Frank Dicksee by a margin of 25 to 18.[176] Eight days later, six Academicians doggedly backed Moore in the preliminary phases of three new elections, but he succeeded in picking up only two or three additional votes—insufficient to advance to the final ballots.[177] He again seemed poised for success on 18 January 1882, overleaping the preliminary hurdles in each of two elections only to be defeated in the final ballots, first by Henry Woods (by a vote of 23 to 31), and then by G.F. Bodley (18 to 36). In 1883 and again in January 1884, Moore's half-dozen or so loyal supporters consistently advanced him to the interim ballot, where he was unable to collect more than a dozen votes.[178] By May 1884, however, election to the Academy must have seemed the logical next step in a succession of advances. In March he was elected an Associate of the Royal Society of Painters in Water-Colours without ever having exhibited there.[179] In the same year, the first of his works entered public institutions: *Dreamers* was given to the Birmingham City Art Gallery by the gallery's chief benefactors, Sir Richard and George Tangye,[180] and in February the South Kensington Museum purchased *An Open Book*.[181]

At the same time, Moore may have been growing disenchanted with the Grosvenor Gallery. In 1882 Sir Coutts Lindsay, a notorious philanderer, separated from his long-suffering and widely admired

wife. In the absence of Lady Lindsay (the source of much of the gallery's financial backing and social refinement), Sir Coutts aggressively expanded the Grosvenor's commercial activities in a way that struck many as inimical to the institution's original ideals.[182] Moore's disaffection was no doubt strengthened in the spring of 1884 when Lindsay demanded that Whistler withdraw one of his paintings from the spring exhibition, stating, 'The work is so incomplete and slightly made out that I cannot accept it at the Grosvenor.'[183] In light of the gallery's vaunted policy of inviting artists to exhibit whatever they chose, the letter was outrageous, and explains Whistler's decision never again to exhibit there.

But having already made himself *persona non grata* at the Royal Academy, Whistler could not emulate Moore in using that institution as an alternative exhibition venue. Instead, he launched a covert campaign to take over the Society of British Artists, a distinctly second-tier institution at which Moore himself had not deigned to exhibit since sending two watercolours at the age of 19. By 1884 the society was desperate enough for publicity to accept a Trojan horse: eschewing standard procedure, they hastily elected Whistler a member on 21 November 1884. Once inside, Whistler immediately began recruiting friends and followers to bolster his bid for the presidency. Albert Moore was among those invited to join the coup, which Whistler evidently pitched as an opportunity to gain revenge on their mutual enemy, the Royal Academy:

'Only' I mean that the Academy has insulted you—and that if they were to elect you tomorrow, their periodical insolence for these last years, still remains a fact—and I am happy in knowing that if you had joined a body of which I am a member, you would have punished the Academy in the face of the world—for we all know that Albert Moore is a continual reproach to Burlington House—and that establishment could scarcely afford his taking up his abode in any other![184]

160
DRAPERY AND FLOWER
STUDY FOR 'READING
ALOUD'
c.1881–4
Oil on canvas
39.3 x 55.8 cm
(15½ x 22 in)
Private collection

Moore received Whistler's initial invitation while he was suffering another 'bad attack' of his old complaint, during which he could 'hardly think of anything else'. When he finally responded on 30 January 1885, it was with philosophical resignation. Addressing Whistler as 'dear J', he thanked him for the letter ('which is, of course, charming'), but confessed that he could not share his friend's point of view, for 'I don't see why you should be running other people's shows instead of your own.' Whistler had been 'rather sanguine you know about the Grosvenor when it was starting', Moore reminded his friend, but his recent falling-out with Sir Coutts Lindsay demonstrated how ill-founded his high hopes had been.

In closing, Moore drew attention to the contrasts in their personalities, which led them to adopt radically different forms of artistic rebellion:

I don't wish to predict a mistake on your part—besides you

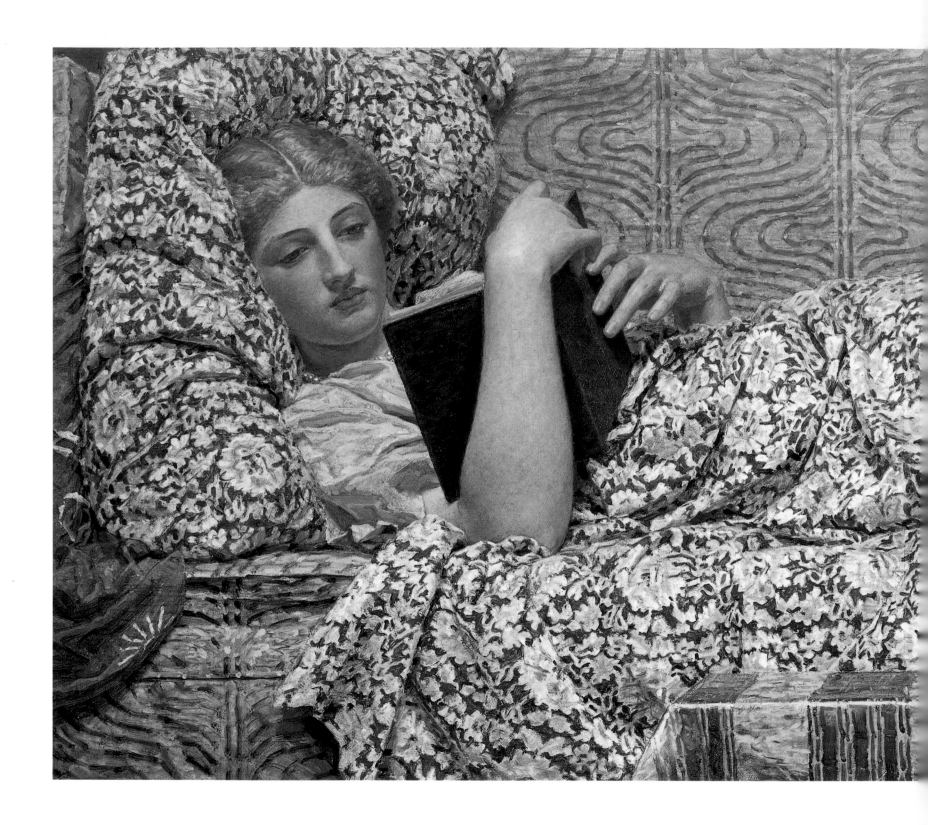

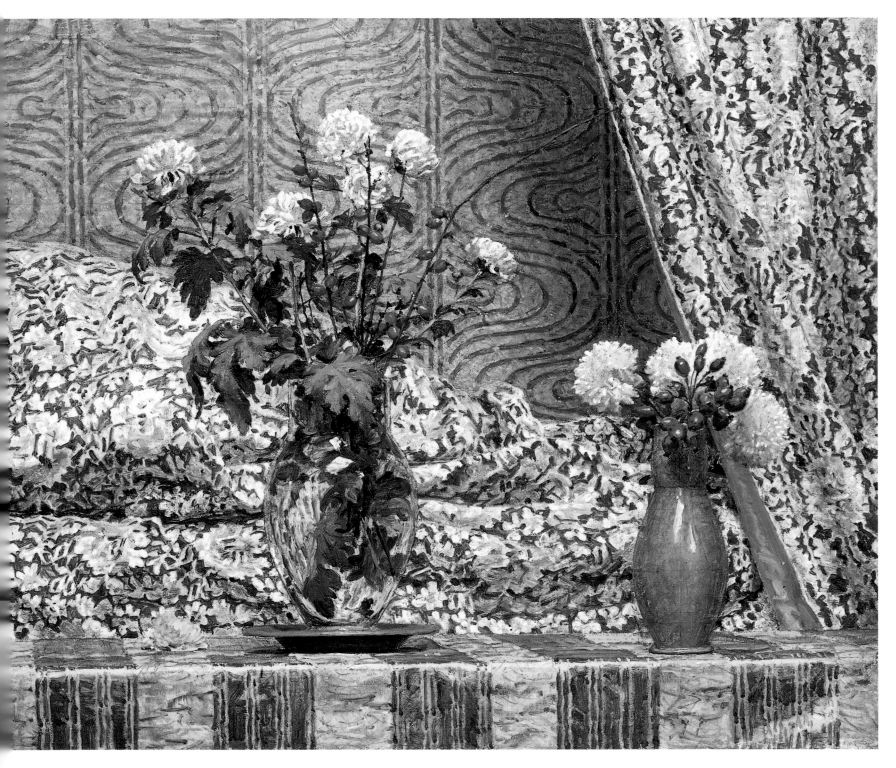

161
RED BERRIES
1884
Oil on canvas
47.6 x 116.7 cm
(18³/₄ x 46 in)
Private collection

have a knack of turning a defeat into a victory. Now I have
no such talent, and while I shall always have a pleasure in
taking up the cudgels on your behalf, it has not been my
line to do it for myself, in fact on my own account I know
I should make a mess of it, whereas you do it perfectly.

Moore's health had seriously declined in the seven years since he
'took up the cudgels' on Whistler's behalf in the Ruskin trial, and his
decision not to join the campaign at the Society of British Artists
reflects a strategy as calculated as Whistler's own:

> I have already mentioned to you that I am very uncertain
> about getting my work done, and have promised that the only
> picture I am bound to finish shall go to the academy. So that
> if I did enter into a free fight I should be a disappointment
> to my new friends [i.e., the Society of British Artists], and an
> object of derision to my enemies new and old.[185]

At a remove of 100 years, it has proved impossible to identify Moore's
'enemies' within the Academy—or, for that matter, his friends there
(apart from Leighton). His comment to Whistler confirms his own
consciousness that these enemies existed, however, and his sense that
his career was being played out under their hostile scrutiny. In the
circumstances, Moore wisely adhered to his decision to concentrate
quietly on perfecting his paintings, rather than gratifying his
opponents with a prominent display of inferior work. As it happened,
his trepidation about the Society of British Artists proved well-
founded. Elected president in 1886, Whistler resigned in anger
within two years. What else could he have expected, Moore asked
philosophically: 'If I had a flying machine, do you think I'd hitch it
to an old omnibus?'[186]

In the same letter in which he urged Moore to rebuke the Royal
Academy by joining the Society of British Artists, Whistler invited
his friend to participate in a related event—a public lecture intended
to confound their enemies and preach a new aesthetic gospel.
The performance—entitled the 'Ten O'Clock', on account of its
fashionably late hour—was meticulously orchestrated right down
to the seating arrangement, which was engineered as a show of
solidarity. 'I am so glad that you have a good seat for hearing,'
Whistler wrote to Moore, 'although a few rows further back, would
almost have been better for the ensemble—However you really have
a capital place—and will have to look as if "our side" were as usual
triumphant!'[187] Whistler masterminded the style of the performance,
but Moore seems to have inspired its content. Indeed, the artistic
ideals propounded in the Ten O'Clock Lecture are so highly
suggestive of Moore's own practice and persona (and in several
respects so contrary to Whistler's), that one suspects the audacious
American of speaking on behalf of his less demonstrative friend.

In his lecture Whistler characterized art as reticent, unobtrusive, and
engaged in an insular pursuit of perfection. He defined the true artist
in terms of his profound seclusion: 'stand[ing] in no relation to the
moment at which he occurs—a monument of isolation—hinting at

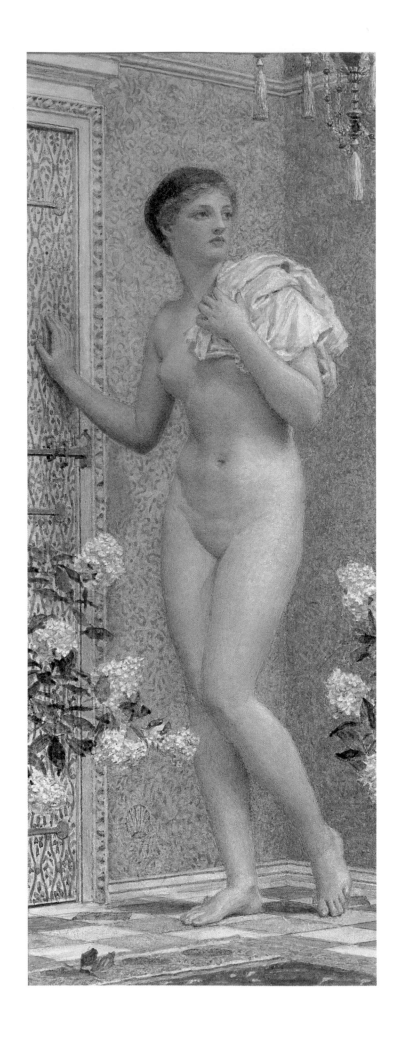

sadness—having no part in the progress of his fellow men.' In the past, he claimed, great artists had no public role: 'Their productions alone were their occupation, and, filled with the poetry of their science, they required not to alter their surroundings ... Their world was completely severed from that of their fellow-creatures.' Moore might easily have inspired this description, but it is impossible to square with Whistler's showmanship.

Equally evocative of Moore is Whistler's description of the artist's patient derivation of lessons from nature: from the 'brilliant tones and delicate tints' of flowers and 'the citron wing of the pale butterfly, with its dainty spots of orange' come 'suggestions of future harmonies'; in 'the long curve of the narrow leaf, corrected by the straight tall stem', lie principles of linear elegance. Moreover, the anachronistic combinations invoked in the lecture paraphrase the essential ingredients of Moore's art. Thus, we are told that in ancient Greece, art 'yielded up the secret of repeated line ... mark[ing], in marble, the measured rhyme of lovely limb and draperies in unison', and that 'seeking and finding the beautiful in all conditions and in all times', ideal beauty is 'hewn in the marbles of the Parthenon—and broidered, with the birds, upon the fan of Hokusai'.[188] Whistler had struggled in vain to emulate his friend's principles and practices in the 1860s. The text of the Ten O'Clock Lecture suggests that Moore continued to constitute an unattainable ideal for him well into the 1880s.

Moore shared Whistler's eagerness to set the record straight about his art, and he knew that he could not rely on professional critics to do it for him. According to Baldry, they had so completely misunderstood him that 'he deprecated even the well-meant treatise on his work because he knew that some mistake, some misapprehension of his aims, was bound to creep into it.' Moore had long toyed with the idea of documenting his singular views in a formal account of his artistic methods and principles, for 'he fancied that it might be possible to convert a few people by a clear statement of his definite beliefs.'[189] He evidently made a start, but ultimately abandoned the scheme for fear of stealing time and attention from painting.[190] He may also have feared the likelihood of 'mak[ing] a mess of it' and exciting the derision of his 'enemies'. But as Moore himself recognized, Whistler had a talent for defending his views, for executing perfectly the public performances that Moore undertook with reluctance. He doubtless would have welcomed an opportunity to express himself, vicariously, through his more extroverted colleague.

As he had anticipated, the exhibition season of 1885 proved remarkably bleak for Moore, with the critics in universal agreement that the quality of his work had fallen off. In characteristically philistine vein, a writer for *Truth* dismissed Moore's pictures at the Royal Society of Painters in Water-Colours as two 'tiresome girls, called, for reasons unknown, "Lanterns" and "Oranges"'. The same writer was equally disparaging of a pair of pastels at the Grosvenor, 'clumsy girls, clad in various-coloured sheets and necklaces, and labelled with fantastic names':

162
A YELLOW ROOM
1885
Watercolour
38.1 x 15.2 cm
(15 x 6 in)
Private collection

163
CARTOON FOR 'WHITE
HYDRANGEA' WITH THE
BACKGROUND OF 'A
YELLOW ROOM'
*c.*1885
Charcoal on grey paper
88.2 x 38.9 cm
(34¾ x 15⅜ in)
Victoria and Albert
Museum, London

Sometimes the girl, as in 'Roses', puts her hands behind her back, as though vainly trying to tighten her stays; sometimes she holds her right hand and sometimes her left in the air; but she is always the same, except in the colour of her sheet and the surrounding flowers.

'I dare say that Mr. Moore is an astute person', the critic concluded, 'for this sort of imbecility is generally rewarded with an associateship.'[191] In the view of others, it was actually the failure of the Academy to grant Moore an Associateship that accounted for the poor quality of his pictures that year. Admitting that Moore's works in the Academy exhibition showed 'less patience and beauty than usual', the critic for the *Spectator* suggested that both he and his brother Henry had 'lost heart at the persistent neglect with which the Academy has treated them', adding 'It would be worth while getting angry about, if it were any use being angry with the official actions of the Academy.'[192] Proud and independent-minded, Moore must have smarted under this sympathetic suggestion that he cared in the least whether the Academy voted him in or not.

Moore's paintings were not only attacked verbally in 1885, but also physically by an unknown assailant who smuggled a pin or knife into the Academy on 18 May. Moore's most important picture that year, a nude about three-quarters lifesize entitled *White Hydrangea* (Pl. 124),[193] was among several that sustained severe cuts and scratches.[194] *A Yellow Room* (Pl. 162), a small variation in watercolour exhibited in the same year at the Royal Society of Painters in Water-Colour, escaped unscathed. Because many of the targeted works were painted by members of the Academy's Council and Hanging Committee, it was initially assumed that a rejected painter had sought revenge against the art establishment by vandalizing their pictures. Moore obviously would have made a singularly inappropriate victim in such a campaign.[195]

However, the plot thickened with the eruption of a second controversy a few days later. A letter bearing the signature 'A British Matron' appeared in *The Times*, protesting against the indecent display of two dozen or so nudes at the Royal Academy and Grosvenor. The anonymous screed triggered a furious spate of letters arguing for and against the morality of nudity in art. On 23 May *The Times* printed a letter from 'Another British Matron' which singled out Moore's *White Hydrangea* as particularly offensive, remarking, 'I wonder that the friends and relatives of the young lady (No. 360) [Herkomer's *Miss Katherine Grant*] can countenance the juxtaposition of her beautiful portrait in all its innocence with No. 356 [Moore's *Hydrangea*], and I deplore the enforced contact with the latter picture which the fair friends and admirers of the former, young, fresh, and innocent as many of them must be, have necessarily to undergo.'[196] Ironically, another critic wrote that same day that the harmful influence worked in the opposite direction—aesthetically, if not ethically—and that Moore's delicately tinted painting was 'absolutely ruined' by its proximity to Herkomer's brilliantly coloured portrait.[197]

According to rumour, Moore's picture had been scratched by the very

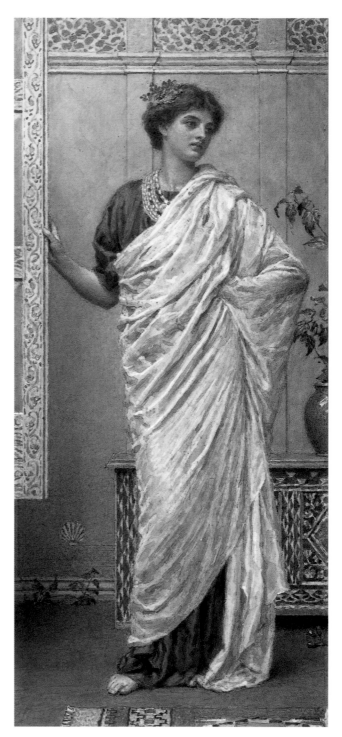

164
THE DOOR OF
A WARDROBE
1885
Watercolour
38.1 x 16.5 cm
(15 x 6½ in)
Private collection

'British Matron' whose letter to *The Times* had unleashed the debate over nudity. Beneath the misleading pseudonym, it was whispered, lurked John Callcott Horsley, RA, an outspoken enemy of artistic representations of nudity, and a crusader against the 'degrading practice' of life study from nude models. The Academician's moralistic views had earned him the nickname 'Clothes Horsley', and following the attack on Moore's painting, Whistler added the epigram 'Horsley soit qui mal y pense' to a nude he exhibited at the Society of British Artists.[198] Horsley was by no means unique in his inability to view representations of female nudity with aesthetic detachment. Many visitors to the exhibitions were unsettled by their sense of a palpable connection between the pictures on the walls and the real women who had posed for them. Writing of Moore's *White Hydrangea*, one critic asserted, 'This figure is so exactly the type of a modern society young lady, and so exceedingly realistic in her tripping walk, that there is a kind of ludicrous impropriety about it; it is as if we were sitting in a rather aesthetic drawing-room, and the young lady of the house suddenly tripped in, with a little conventional simper on her face, and an unfortunate but entirely innocent forgetfulness of the fact that she had nothing on but her cap.'[199]

The criticism was not unjust, for Moore deliberately avoided presenting the figure as a conventional nude—that is, with evident consciousness of her nakedness and its capacity to excite desire. On the contrary, she makes no effort to either entice or repel the viewer's gaze, appearing entirely unaware of her exposure. Moore very likely emulated the straightforward presentation of the naked body that Victorian commentators lauded in Greek sculpture predating the era of Praxiteles. This mode of presentation reflects his strategy of undermining the erotic character of the painting, a strategy that had earlier dictated the artificial treatment of *A Venus* (Pl. 98). Sixteen years later, while continuing to conceive of the female body as an object of formal beauty rather than sexual desire, Moore tried to integrate greater realism into his depiction. He reportedly took great pains to ensure that the stance and gesture in *White Hydrangea* and *A Yellow Room* appeared 'natural'. According to Baldry, that goal inflicted yet another tedious ordeal on his model as the artist repeatedy 'tested and adjusted by action so as to get exactly the right turn of the body and the correct placing of the hand upon the door.'[200] And yet, in

accordance with Moore's custom, this acutely analytical naturalism was translated into an abstract geometric design. A cartoon related to both *A Yellow Room* and *White Hydrangea* clearly reveals the familiar grid of curved horizontal and vertical lines, overlaid by a diaper pattern of long, intersecting diagonal curves (Pl. 163).[201] The contours of the figure were accommodated to this geometric framework, which also determined the disposition of the hydrangeas, the patterned wallpaper, Moore's anthemion, and every other element in the composition. In adapting the gestural motif to draped figures in works such as *The Door of a Wardrobe* (exhibited at the Royal Society of Painters in Water-Colours during the winter of 1885-6), Moore devised entirely different geometric frameworks (Pl. 164).[202]

It seems significant that among the numerous artists' letters published during the 1885 controversy over nudity, none emanated from the red-brick house at One Holland Lane. Moore's failure to weigh in with the others—despite his well-earned reputation for outspokenness and the crucial role of the human body in his analysis of beauty—attests to the artist's lack of interest in influencing the course of popular aesthetic debate, except through his art. The bruising series of public quarrels that had dissipated Moore's energies over the past decade appear to have reinforced his instinctive insularity and resistence to external criticism. While outside his door art enthusiasts by the carriage-full blocked the streets and flooded into the opulent studios of his glamorous neighbours, Moore admitted only a select few patrons and an occasional journalist.[203] Baldry claimed that Moore deliberately avoided exposure to the voguish ideas and methods pursued by his contemporaries and curtailed opportunities for collegial conversation. In his view, Moore's criticism of himself 'was so severe and so impartial' that he regarded as 'impertinent ... any attempt to set him right on details of practice to which he had necessarily given far more attention than the men who criticised him'.[204] It seems likely, however, that Baldry exaggerated Moore's isolation during this period. His decision to paint his first nudes in sixteen years for exhibition in 1885—a year dominated by the unclothed figure—is too extraordinary a coincidence not to furnish evidence of his engagement in progressive contemporary art trends. The remaining years of Moore's career did, however, witness increasing insularity as his quest for beauty intensified and his hold on life dwindled inexorably.

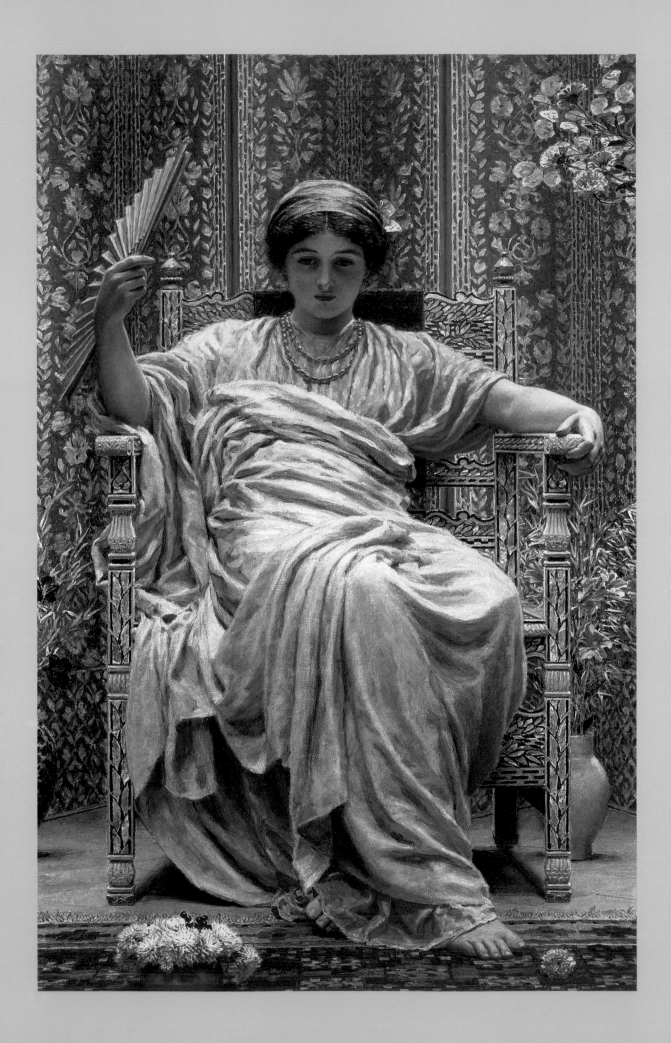

165
A REVERY
1892
Oil on canvas
116.7 x 74.8 cm
(46 x 29½ in)
Private collection

166
HEAD OF A WOMAN
*c.*1885
*Black and white chalks on buff
paper*
23.5 x 17.8 cm
(9¼ x 7 in)
Private collection

CHAPTER FIVE INTIMATIONS OF MORTALITY

1885-1893

THE MULTI-PRONGED ATTACK ON MOORE'S HEALTH IN FEBRUARY 1883 SET THE TONE FOR THE FINAL DECADE OF HIS LIFE, DURING WHICH HE SUFFERED CHRONIC PAIN AND ILLNESS, CAPPED BY TWO OPERATIONS FOR THE REMOVAL OF CANCEROUS TUMOURS.[1] PHYSICAL AND MENTAL SUFFERING HAD A SIGNIFICANT EFFECT ON MOORE'S ART. THE AIR OF DETACHMENT THAT HE HAD CULTIVATED FOR THE PAST TWENTY YEARS WAS AT LAST MITIGATED BY A RE-CONNECTION WITH HUMANITY. EMOTIONAL SENSITIVITY AND PSYCHOLOGICAL INSIGHT, SUPPRESSED SINCE THE EARLY 1860S, REASSERTED THEMSELVES IN A VARIETY OF STYLISTIC AND THEMATIC FORMS. ALTHOUGH MOORE NEVER REPEATED THE CONCENTRATED EMOTIONALISM OF YOUTHFUL PICTURES SUCH AS *THE MOTHER OF SISERA* (PL. 26), HIS LATE PAINTINGS EVINCE A TENDERNESS AND SENSUALITY THAT SUGGEST HIS RENEWED INTEREST IN EXPRESSING THE POIGNANCE AND PASSION OF HUMAN LIFE. THE CHANGE WAS NOT LOST ON MOORE'S CONTEMPORARIES. 'MR. ALBERT MOORE'S FIGURES BECOME MORE AND MORE REAL AS HE GROWS A SADDER, AND, IN MY OPINION, A WISER PAINTER,' GEORGE BERNARD SHAW OBSERVED IN 1888.[2]

The earliest manifestation of this new sensibility in Moore's art arose in connection with William Connal, the artist's intimate friend and faithful patron. As noted in the previous chapter, it was while at work on Connal's *Reading Aloud* (Pl. 157) that Moore had suffered his first significant physical breakdown in 1883, and it was to Connal's house in Perthshire that the artist retreated for a month while recuperating his strength. While there, he painted what was then a rarity in his art, a portrait (Pl. 167).[3] Remarkably fresh and straightforward, this representation of Connal provides a striking contrast to the more elaborately orchestrated and idealized compositions that had absorbed Moore over the past two decades. The dramatic use of chiaroscuro is also without precedent in his work. Exposing the right side of Connal's face to a harsh glare while cloaking the left in deep shadow, the artist used light and shade not to define his subject's features, but to assert their mysteriousness. This enigmatic quality is reinforced by the tenebrous gloom of the background from which Connal only partly emerges, and by the oblique direction of his gaze. At the same time, the attentively cocked head and pleasant expression suggest a lively and congenial companion. Robust paint handling reinforces this impression of warm spontaneity.[4]

The single, vivid keynote in Moore's subtle palette of browns and flesh

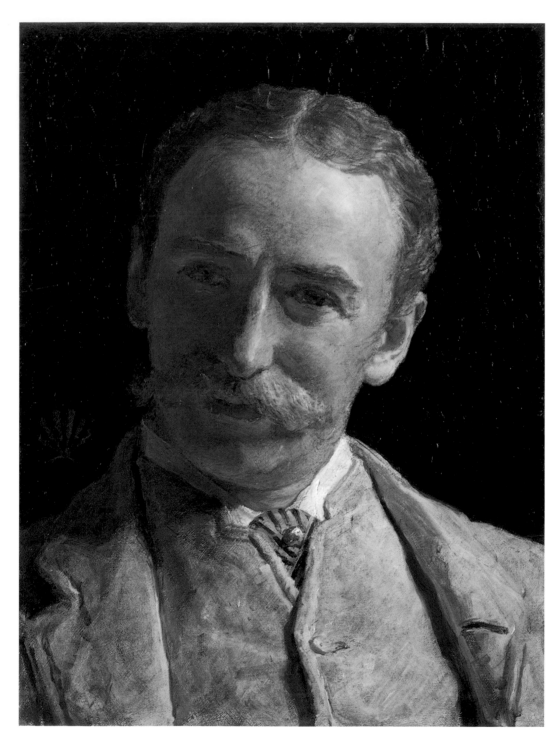

167
WILLIAM CONNAL, ESQ JR,
OF SOLSGIRTH
1883
Oil on canvas
33 x 25.4 cm
(13 x 10 in)
York City Art Gallery

tones is provided by the cravat at Connal's throat. Its dramatic appearance betrays its significance: striped in yellow and black, it mimics the appearance of the honey-bee that Connal employed as his personal emblem and that Moore inserted into *Reading Aloud* as a parallel to his own anthemion signature. In the portrait, the fanning lines of the cravat clearly echo those of the anthemion to the left. The anthemion and cravat are also key elements in the painting's underlying structure: along with the buttonhole of Connal's lapel, they chart points in an implied diagonal (descending from left to right) which intersects the opposing diagonal of the sitter's inclined head and shadowed shoulder. Despite its unmediated appearance, the portrait is evidently anchored by the same geometric rigour that underpins Moore's other work.

Moore probably undertook this portrait as a mark of the friendship and gratitude he felt for Connal. It is more difficult to determine the exact nature of other portrait studies that he executed around this time. Almost exclusively female and rarely identified by name, the subjects were presumably models. Numerous drawings in chalk, seemingly executed for pleasure in the manner of Moore's impromptu studies of beautiful flowers, may actually represent that early stage in his preparatory process at which he precisely documented his model's appearance, without idealization (Pl. 166). Psychological nuance adds an affecting touch of humanity to these straightforward records of physical beauty.

Of a similar character are the uncommissioned oil portraits that Moore occasionally offered for sale.[5] One of the earliest examples of this kind (Pl. 168) recalls the contemplative pose of the central figure in *Reading Aloud*, and possibly originated as a preliminary study for that painting. Comparison of the facial features in the two pictures demonstrates the model's resemblance to Moore's classical ideal, as well as his subtle accommodation of her individuality to the generic type he favoured. Lost in thought, her head and eyelids lowered, she gazes vaguely at her enfolded hands while her parted lips seem to murmur the words passing through her mind. As in the portrait of Connal, Moore emphasized the enigmatic character of his sitter, intimating an impenetrable, interior complexity beneath the external features he describes. Sensitive observation of such details as the transparent blond eyelashes and the erratically twisting yellow ribbon enhance the delicacy of this evocation of mental absorption. Moore couched his new naturalistic and psychological conception of the human figure within a characteristically abstract setting: a flat backdrop composed of contrasting patterns. The picture's realism is no less compelling for this emphasis on two-dimensional design, nor is its aesthetic rigour diminished by the infusion of human interest.

This portrait is possibly identifiable as *The Blonde*, one of a pair that Moore exhibited at McLean's Gallery in 1885.[6] The uncharacteristic title was most likely a concoction of the gallery's commercially minded proprietors, whom Moore had publicly chastised four years earlier for assigning faddish titles to his paintings (see p. 87). Perhaps as little faith should be placed in the title of the second painting Moore showed at McLean's that year, *Portia* (Pl. 169). The woman's cap and

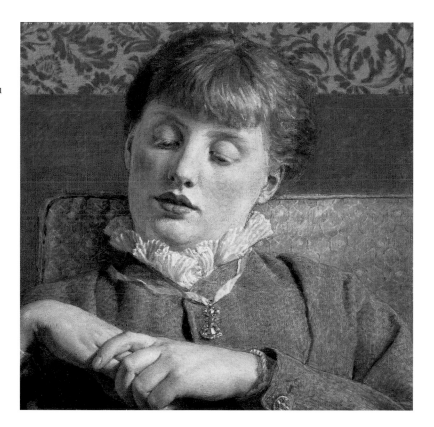

168
PORTRAIT OF A WOMAN
*c.*1885
Oil on canvas
25.4 x 25.4 cm
(10 x 10 in)
Private collection

high collar are vaguely reminiscent of the costume worn by Ellen Terry in the role, and there is even a hint of her prominent square jaw.[7] The likeness ends there, however, and the idealized cast of the features mark it as an imaginative work (possibly the artist's reminiscence of a performance of *The Merchant of Venice*), rather than a portrait.[8]

The picture actually originated with Moore's portrait studies of a very different model, a younger girl with long, dark waves of hair (Pl. 170).[9] The distinctions between Moore's imaginative picture and his study from the life demonstrate his sensitivity to the outward manifestations of personality and mood. The downcast gaze which suggests modest diffidence in the head of the young girl conveys an icy superciliousness in his idealized head. Moore achieved these very different effects through subtle manipulation of facial feature and bearing, using contrasting personalities to reinvent a single pose in the same way that he had employed alternative colour schemes to generate multiple incarnations of a single pictorial design.

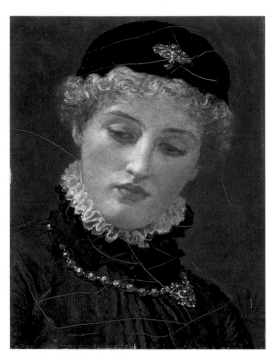

While reviving the studies of human physiognomy and psychology that had absorbed him during the late 1850s and early 1860s, Moore also returned—quite literally—to his youthful experiments with landscape and seasonal cycles. At the Royal Society of Painters in Water-Colour in 1886 he exhibited a drawing entitled *Moonlight— sketched near Ullswater in 1858, finished 1886*,[10] and two years later he showed *A Study Painted in 1857* (both unlocated). An element of nostalgia is implicit in Moore's rekindled interest in observations made decades earlier as a teenager touring the Lake District. Nostalgia for the preoccupations of his youth also underlies *Midsummer*, one of the most important paintings of Moore's career when completed in 1887 (Pl. 171). William Blake Richmond may have provided the germ of the painting with his suggestion three years earlier that Moore return to his abandoned drawing *Somnus* of 1866-8 (Pl. 51).[11] In *Midsummer*, Moore merged the motif of an enthroned figure and attendant from the upper tier of *Somnus* with the idea of passive sleepers from the drawing's lower tier. In theme, *Midsummer* recalls the classically draped personifications of Months and Seasons that Moore had designed for Nesfield's architectural projects, as well as his fresco *The Four Seasons* of 1864 (Pls. 31, 38, 44).

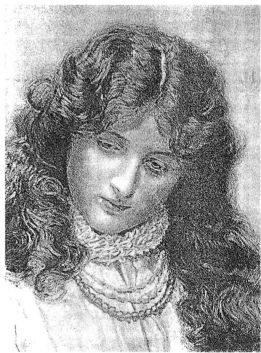

169
PORTIA
1885
Oil on canvas
29.2 x 23.2 cm
(11½ x 9⅛ in)
Private collection

170
YOUNG GIRL'S HEAD
1885
Oil on canvas
34.2 x 26 cm
(13½ x 10¼ in)
Whereabouts unknown
(from Baldry, *Albert Moore*, opp. p. 88)

171
MIDSUMMER
1887
Oil on canvas
158.6 x 152.2 cm
(62½ x 60 in)
Russell-Cotes Art Gallery, Bournemouth

But whereas Moore's earlier works were based on the intellectual association of natural cycles with agricultural activities and symbolic attributes, *Midsummer* triggers a direct, visceral experience of the sultry languor of an afternoon in July. The brilliant orange of the women's outer drapery creates an impression of scorching heat and dazzling light that is accentuated by the contrasting green tint of the fans and the cool silvers and greys of the setting. The chromatic exuberance of the drapery is matched by the stylistic richness of the surroundings, which feature a Moorish chest inlaid with mother-of-pearl, a marble bench modelled on Italian sarcophagi, and a Northern European throne of silver, ornamented with peacocks' heads and acanthus leaves. Imposing order on this profusion, the quasi-architectonic, post-and-lintel structure of the painting establishes a sense of stasis appropriate to the restful theme. Critics rehearsed the familiar

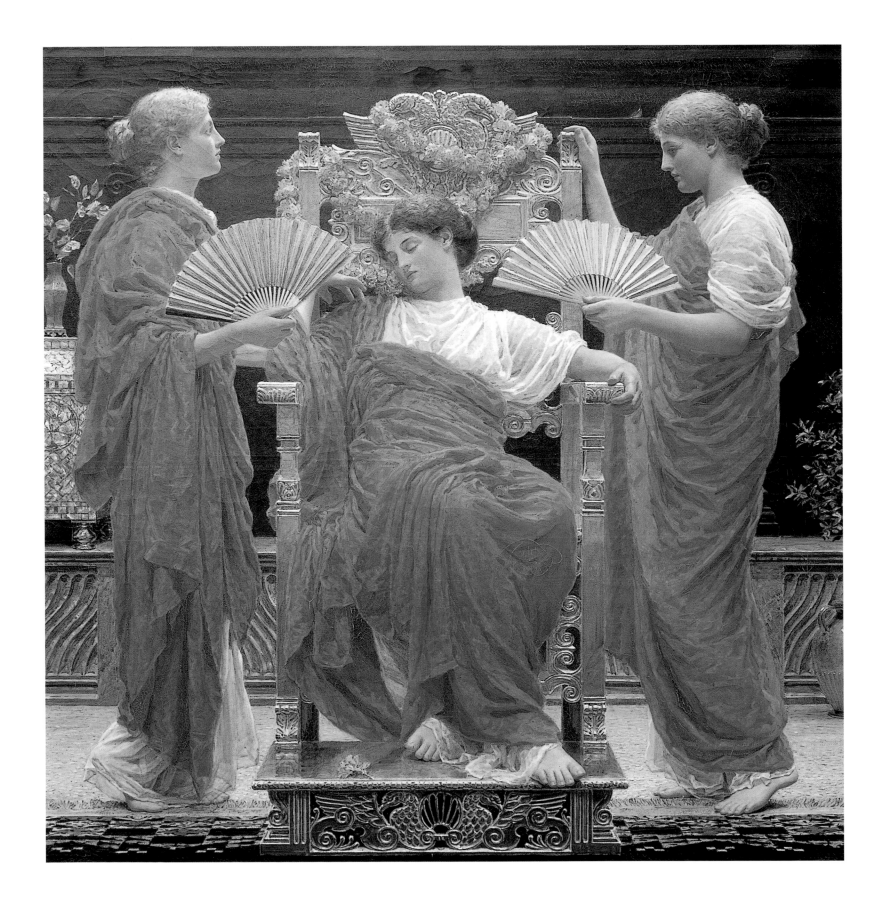

complaint that Moore had relied on a single model for the three figures in *Midsummer*, but his preparatory drawings indicate that he worked from a variety of women whose physical features he distilled, for reasons of symmetry and rhythmic repetition, into an ideal type (Pls. 172, 173).[12] Indeed, Graham Robertson recalled that he himself had sat for Moore's studies of the hands.

Robertson was not allowed a glimpse of *Midsummer* until it was completed, and his first sight in Moore's dusty, grey studio came as a revelation: 'It was like a flood of sunshine, a bed of marigolds.' He characterized the bold orange canvas as 'a joy'.[13] Yet ironically, marigolds have a time-honoured association with grief, and it is very likely that Greek funerary lekythoi and grave stelai informed the central motif of a classically draped, seated figure flanked by attendants in profile (Pl. 174). The composition may also draw on a famed Greek votive relief relating to the Eleusinian mysteries and depicting the goddesses Demeter and Persephone—heralds of autumn and spring—framing a central figure (Pl. 175).[14] The single fallen leaf that Moore represents on the high wall to the right of the throne[15] also presages the transition of the seasons, from summer splendour to autumn harvest. In view of Moore's deteriorating health, it is tempting to interpret this mysterious tribute to the transience of the seasons as a meditation on human mortality. Having studied Greek artefacts in a life-long quest for the 'secrets' of formal beauty, perhaps he had absorbed something of the philosophy that lay behind the objects: specifically, the ancient recognition of death's place in the eternal cycle of nature—an experience of fruition as well as decadence, and of culminating peace as well as parting sorrow. In any case, both the splendid vitality of the colours and the pleasant restfulness of the theme constitute remarkable affirmations of positive sensation in the midst of much suffering.

According to Graham Robertson, Moore painted *Midsummer* expressly for William Connal, to whom 'he loved to dedicate his best work'.[16] It was shown at the Royal Academy in 1887 where it attracted positive notice as a 'daring and ambitious piece of decoration'.[17] Indeed, according to Robert Walker, the Chantrey Fund had been prepared to acquire the picture for the nation, had Connal not purchased it in advance.[18] The uncharacteristically bold orange of Moore's colour scheme elicited a few negative reviews from the critics, but it seems to have made an impression on Frederic Leighton, who later employed the same scorching hue in his own remarkable homage to female repose, *Flaming June* (Pl. 129).[19] Moore himself was sufficiently pleased to attend the private view at the Academy on 29 April, dining afterwards at the Liberal Club with the poet William Allingham.[20]

In January 1888, several months after *Midsummer*'s sensational appearance at the Academy, a concerted effort was launched to elect Moore to an Associateship. He made it to the final ballot in each of three elections, only to be defeated when virtually everyone but his original backers consolidated their votes with his opponent. The peculiarity of this circumstance, which demonstrated as determined a will to keep Moore out as to bring him in, did not pass unremarked.[21] Indeed, Moore's non-election merely confirmed the accusations of a

172
STUDY OF A SLEEPING
WOMAN'S HEAD
*c.*1887
Black chalk
21.6 x 30.4 cm
(8½ x 12 in)
Private collection

173
STUDY OF A WOMAN'S
HEAD FOR 'MIDSUMMER'
*c.*1887
Black chalk
23.5 x 19 cm
(9¼ x 7½ in)
Private collection

group of 'outsiders' led by the artists William Holman Hunt, Walter Crane and George Clausen, who alleged that internal politics dictated all of the Academy's decisions from the election of members to the acceptance and hanging of pictures. In a fiery letter to *The Times* in August 1886, Hunt had outlined the elaborate game of human chess by which a powerful majority within the Academy strategically frustrated the efforts of any artist whom they considered a threat, systematically favouring the docile and mediocre over the independent and talented.[22] The Academy's blind balloting process precludes identification of those who relentlessly excluded Moore from their club, but it is no wonder that his candidacy foundered in this poisonously politicized climate. His art constituted a perpetual affront to the Academy's less progressive artists, whose inadequacies he was only too happy to deride with a fatally quotable riposte. Although they undoubtedly harboured a personal animus against Moore, these members could claim the moral high ground as preservers of the Academy's sanctity against a renegade whom few knew well, but whose reputation was tainted by the 'common knowledge' of moral transgressions (see pp. 123-4).

Rather than campaign for the Academy's acceptance, Moore entrenched his outsider status through conspicuous association with Whistler, who continued to coax his friend into public demonstrations of solidarity. In late October 1888 Moore (along with Whistler's compatriot George Boughton and his protégé Mortimer Menpes) presided over a juried show featuring female pupils of Albert Ludovici, one of Whistler's best-known followers. Displayed at Whistler's dealers, Dowdeswell, the entries advertised the master's impact on a rising generation of artists.[23] The next year Moore joined a committee formed to honour Whistler with 'a complimentary Dinner ... in recognition of his influence upon Art, at Home and Abroad, and to congratulate him on the honour recently conferred upon him by the Royal Academy of Munich, Bavaria'.[24] Whistler relished such foreign honours for their irony as much as their prestige, for they called attention to his comparative neglect by the British art establishment. In this regard, he identified closely with Moore. On receiving the prestigious distinction of Officer of the French Legion of Honour, for example, Whistler contemplated using the award to dramatize the Academy's 'animosity and opposition' to himself and to Moore, whom he was furious to learn had been defeated in yet another election the previous month. 'This last struggle at the Burlington Bazaar place', he complained to his wife, 'shows how meretricious are the distinctions still withheld from Albert Moore, and distributed among the foolish mediocrities by the Bourgeois who live in it'.[25]

Despite Whistler's low opinion of art critics, a handful shared his anger at Moore's ill treatment. Perennially demanding 'a single reason, good, bad, or indifferent' for Moore's exclusion, Harry Quilter lambasted the Academy for hanging 'his masterpieces ... in a corner of a back room, lest they should interfere with Mr. Cooper's Cows, or the bronze-boot girls with which Mr. Sant, R.A., still gladdens the heart of the British matron'. Behind the scenes Quilter lobbied Academicians on Moore's behalf. His overtures 'struck a responsive chord' with

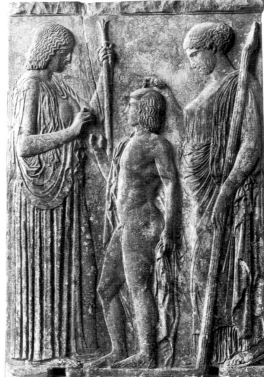

174
WOMAN WITH HER MAID
*c.*380 BC
Marble relief from the Piraeus
Height 121 cm *(47¾ in)*
National Archaeological Museum, Athens

175
DEMETER AND PERSEPHONE WITH TRIPTOLEMOS
*c.*450 BC
Marble votive relief from Eleusis
Height 219.1 cm *(86⅜ in)*
National Archaeological Museum, Athens

Philip Richard Morris, who replied, 'I have both voted and worked for votes for him [Moore] since I have a vote to give. I agree with you it is a scandal on the RA that he is not elected.'[26] Moore himself apparently felt the slight less keenly, confident that 'each rejection accentuated the justice of his claim'. Indeed, according to Baldry, it was 'with more of contempt than resentment' that he 'viewed the tactics with which the efforts of his supporters at Burlington House were defeated by his opponents'.[27]

As it happened, the close-run elections of January 1888 marked the last occasions on which Moore was a serious contender for an Academy Associateship. In four elections held between 1889 and 1892, the support of half a dozen or so members in the first vote and a few more in the interim ballot failed to advance Moore to the final run-off. In the last two elections of 1892 and one in May of the following year, four months before his death, only one member backed Moore, presumably Frederic Leighton.[28] Following his assumption of the Academy presidency in 1878, Leighton had conscientiously abstained from expressing any opinions on contemporary artists, and his confidential letters to G.F. Watts attest to equally scrupulous abstention from influencing the course of the Academy elections. Nevertheless, it was 'an open secret' that he reserved his vote in each Associate's election for Moore.[29] Indeed, it was most likely Leighton who had cast the very first vote for Moore in 1869. The solitary endorsement of his earliest and most steadfast supporter thus frames the futile 25-year campaign to gain Moore official footing within the Academy.

Around 1890 Moore returned to his studies for the iconic, enthroned woman in *Midsummer*. Altering the pose slightly, he reinvented her as an emblem of contemplation in *A Revery* (Pl. 165). Exhibited at the New Gallery in 1892, this lavishly appointed painting exceeds virtually all of Moore's previous works in its dense amalgamation of patterns and materials. Moore exercised tight control over these complex elements so that their profusion fails to interfere with the overall sense of static repose. A surviving sketch for the pattern covering the folding screen in the background hints at the careful planning that went into each of these accessories.[30] The woven rug and elaborate chair (fashioned of carved ivory, mother-of-pearl inlay and polished brass accents) probably also represent the artist's own meticulously imagined inventions.

Bowled over by the luxurious setting of *A Revery*, one or two critics expressed disappointment with the woman at the centre of it. One critic complained that 'the draped figure, charming as it is in line, is no more interesting than any other part of the composition.'[31] In earlier instances, Moore had consciously intended precisely this effect.

Subordinated to the overall decorative pattern, his figures were not meant to be 'interesting' except as vehicles of line and colour. His intentions are less clear in this case, however, for by the time he exhibited *A Revery*, Moore had composed accompanying verses which project an emotional and philosophical significance on to the figure that could scarcely be discerned otherwise:

A look of sadness on a restful face,
 She hath no cares—
A Thing hereditary in the race,
 Comes unawares,
And will recur till death its smile shall place
 Where now it fares.

This was the first occasion on which Moore had used a poetic text to gloss one of his paintings since the biblical and Tennysonian quotations he employed in the early 1860s. He had never before used his own words in this way. Moore's verses touch on some of the ideas already hinted at in *Midsummer*, namely his cyclical conception of human existence and his notion of death as a happy release from the ills of mortality. Like his paintings, Moore's poem is simultaneously simple and complex. From a fleeting facial expression, he extracted a profound idea, which he expressed in misleadingly plain language, honed to a bare minimum and ordered according to the same principle of layered, rhythmic repetition that underpins his paintings.

Moore had dabbled in poetry since the mid-1880s, but he pursued it more earnestly as his physical powers dwindled and he began to face the fact of his own mortality.[32] 'I have been writing a few more things which I should like you to see,' he wrote to Whistler in November 1892, and around the same time he transcribed copies of his verse for a female friend, identified by Baldry as Miss Cresswell, perhaps the watercolourist Henrietta Cresswell.[33] The issues that preoccupied him as he faced the end of his life differed from those he had entertained with the prospect of many years before him. A purely visual art, concerned with beauty alone, no longer sufficed to express all that he was thinking and, more importantly, feeling. Having devoted his career to inculcating a non-literary response to visual art, he now harnessed the power of words and narrative to give full expression to his altered point of view.

Since 1884, Moore had been labouring over an ambitious composition which, like *Midsummer*, employed languid feminine beauty, static geometry and material opulence to invoke seasonal attributes.[34] In *A Summer Night* (Pl. 179), floral garlands rise and fall in rhythmic swags above a group of female figures resting on benches covered in saffron-

coloured damask. Exotic vessels of Japanese and Greek design stand at either side of the composition, with a chest inlaid with ebony and mother-of-pearl nearer the centre. The floor is covered with a fur rug and a richly patterned carpet. This heady scene culminates the fascination with repose that had absorbed Moore over the past two decades. It draws on such earlier works as his 1869 design for the 'St Patrick' mosaic (from which Moore directly lifted the recumbent central figure), *Reading Aloud* (which informs the structure of the composition) and *Somnus* of 1866 (Pls. 51, 70, 157).

The picture also constitutes Moore's most ambitious and seductive celebration of the female body. No longer indifferent elements in a decorative pattern, the figures here are rendered expressly as objects of desire. The fine cross-hatching of the paint surface lends exquisite delicacy to the flesh, which gains an appearance of unprecedented realism. Expertly calibrated modulations of light and shade emphasize the curves, crevices and folds of the women's bodies, which are observed with novel naturalism.[35] Moreover, Moore placed the figures in poses resembling successive frames in a mildly erotic peepshow:

reclining in sleep, rising from bed, stretching the limbs, adjusting the coiffure. Notwithstanding all this, the women exhibit an uncanny sense of detachment which keeps the viewer at arm's length. Their blank stares, disjointed placement and chill, pearl-like pallor conveys a dispassionate, almost inhuman quality, unwarmed by the sultry atmosphere. The delight is solely in looking, Moore seems to suggest; we are not encouraged to touch.

The overall composition of a *A Summer Night* seems to derive from the Portland Vase, one of the most celebrated objects in the British Museum (Pl. 176). The balanced composition and restful theme of the vase would have held obvious appeal for Moore, as would the elegant outline created by silhouetting pale figures in low relief against a dark background. Moore mimicked the use of two half-draped, bookend-like figures to frame a reclining woman with sharply angled arms. He disguised the relationship between his painting and its famous Roman prototype by splitting the components of the complex central pose between two figures and by rotating one of them so that she is shown from the back. The original frontal orientation of this figure is

176
PORTLAND VASE
*c.*25 BC
Cameo glass
Height 24.8 cm *(9¾ in)*
British Museum, London

177
THE TOILETTE
1886
Oil on canvas
41.9 x 24.1 cm
(16½ x 9½ in)
Tate Gallery, London

178
COMPOSITIONAL STUDY
FOR 'A SUMMER NIGHT'
*c.*1884-6
Watercolour heightened with white on photographic base
18.1 x 33.9 cm
(7⅛ x 13⅜ in)
Private collection

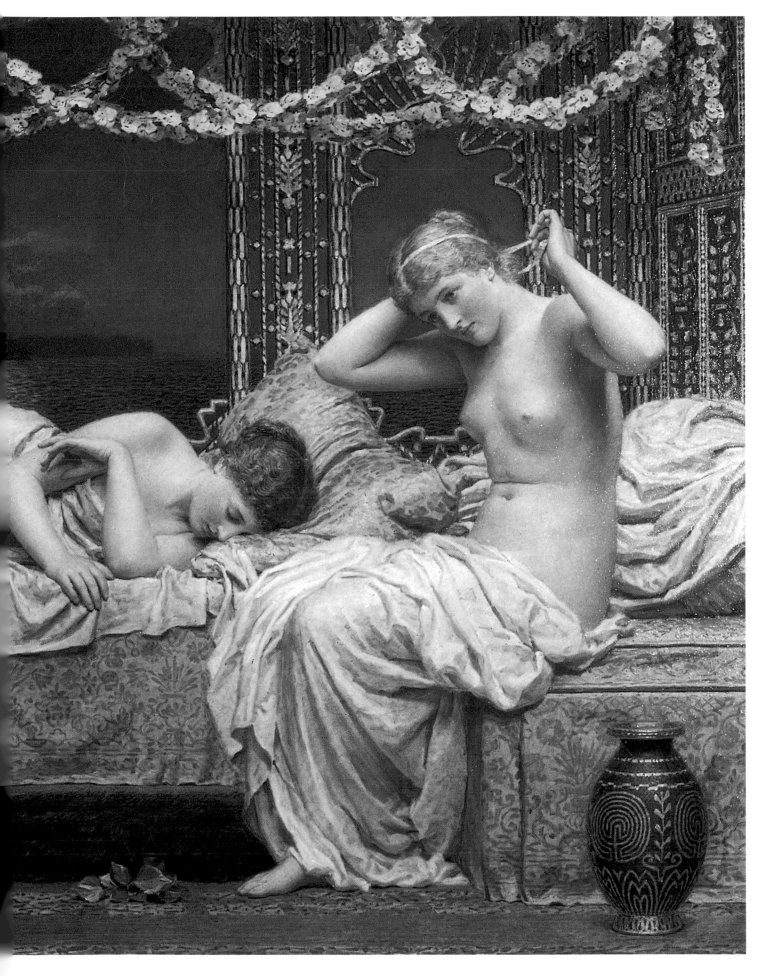

179
SUMMER NIGHT
1884-90
Oil on canvas
129.4 x 224.5 cm
(51 x 88½ in)
Walker Art Gallery,
Liverpool

documented by a number of pictures that Moore elaborated from his preliminary studies in 1886. One of these, *The Toilette*, became the property of his then pupil Graham Robertson (Pl. 177).[36] It anticipates the apple-green, cream and yellow scheme of *A Revery*, as well as the vibrant orange of *Midsummer*.

Pictures such as *The Toilette*, along with the preparatory studies on which they were based, chart progressive stages in the slow germination of *A Summer Night*. Photography evidently aided Moore in resolving his difficulties. Working with a photographic print of his original compositional study, he experimented freely with modifications in watercolour and gouache (Pl. 178). The resulting composite sketch indicates that the artist initially contemplated a mirror image of the ultimate arrangement, and rather different poses for some of the figures. He changed his mind at a late stage in the composition process (having already gone so far as to draw up a full-scale nude cartoon of the far left-hand figure in the preliminary sketch) before radically altering his conception.[37] These changes, together with the artist's deteriorating health, account for the exceptionally slow development of the painting, which was already well advanced in 1884, when Moore exhibited a watercolour version of the previously mentioned left-hand figure.[38] He was still hard at work on *A Summer Night* in 1889, a year in which he exhibited nothing but a small watercolour and a pastel. Harry Quilter, who was privileged with a view of the incomplete painting in Moore's studio, later reported, 'I saw this well on towards completion some time before the sending-in day; but the artist then told me he saw no hopes of "getting it through".'[39] Moore was evidently struggling to satisfy his own perfectionistic standards. Following a chance conversation with the artist in March 1889, Edwin Austin Abbey noted, 'He remains the pure artist always—always trying for the best and sticking to his principles—his artistic principles.'[40]

In *A Summer Night*, Moore at last dissolved the shallowly placed background wall long conventional in his paintings and replaced it with interlacing floral garlands and the silvery filigree of an openwork trellis. His hermetic, artificially constructed world now opens up to an atmospheric prospect of nature, but one which closely parallels the human scene in the foreground. The floral garlands are mirrored by pale clouds festooning the dark sky above a placid sea. Light seems to spill from the curved hip of the reclining figure, charting a shimmering path across the water to the echoing silhouette of a distant island.[41] The orange ranunculus blossoms dotting the upper left of the trellis are similarly reflected in tiny lights twinkling along the horizon below. Moore had made preliminary experiments in integrating idealized figures within naturalistic landscape settings in two paintings exhibited in 1888, *A Riverside* and *Waiting to Cross*.[42] But the specific inspiration for the shimmering moonlit seascape in *A Summer Night* is very likely the nostalgically revisited sketch of the Lake District mentioned earlier, *Moonlight—sketched near Ullswater in 1858, finished 1886*.[43]

A Summer Night was exhibited to acclaim at the Royal Academy in 1890, despite the fact that it 'hung in a corner of the fifth room by the door, in an extremely unbecoming light, and we may safely say looked as bad as would be possible under any circumstances'.[44] Claude Phillips, a progressive critic who had championed Moore in recent years, took the opportunity to remark on the institutional bias against him. Proclaiming that 'no artist of purely British origin has the same mastery over the keyboard of tints and tones' as this 'master of decoration', he added caustically, 'That such a painter ... should persistently be excluded from the ranks of the Academicians, while that august body contains so many crude, perfunctory, and unspeakably tiresome practitioners, is a riddle the solution of which had, perhaps, better not be attempted.'[45] The problem was stated more baldly in a review by the controversial novelist George Moore (no relation to Albert), who as an art critic was instrumental in inculcating an awareness of advanced trends on the continent. 'No

difference exists even in Academic circles as to the merits of Mr. Albert Moore's work', he wrote. 'Many Academicians will freely acknowledge that his non-election is a very grave scandal; they will tell you that they have done everything to get him elected, and have given up the task in despair.' Leaguing Albert Moore with his friend Whistler, the critic concluded bitterly, 'the two greatest artists living in England, will never be elected Academicians; and artistic England is asked to acquiesce in this grave scandal.'[46]

A Summer Night appeared to greater advantage in Liverpool during the autumn of 1890 and attracted a number of purchase offers—although none equal to the £1,500 price Moore listed in the catalogue. In declining the Corporation of Liverpool's offer of £800 on 28 August, the artist stated that he could accept no less than £1,200, but on 17

October he agreed to sell the painting and copyright to the wealthy hotelier Merton Russell-Cotes for just £1,000. His disappointment must have been great when that offer was withdrawn on the objections of Annie Russell-Cotes, who convinced her husband that the painting would offend patrons of the Bournemouth hotel in which it was to hang. This reversal diminished Moore's chances of receiving a good price, leaving him little choice but to accept Liverpool's original offer.[47] The placement of one of his paintings in a public collection provided the silver lining to this mortifying conclusion of the hard labour of half a decade.

The haggling over *A Summer Night* came at a difficult time for Moore. During the early months of 1890, while completing the painting, he had been diagnosed with a tumour in his thigh and doctors predicted

The expansion of Moore's pictorial world begun with *A Summer Night* continued with *Lightning and Light*, a painting exhibited at the Royal Academy in 1892 (Pl. 181). Moving the figures further out of doors, Moore intensified their relationship with the natural world, which is no longer merely an atmospheric backdrop, but the absorbing focus of human attention. The dramatic flash of lightning in the cloud-choked sky unifies the figures in a manner that contrasts markedly with the abstracted expressions and disconnected actions of *A Summer Night*. The startled figure at right wheels around to stare at the bolt in the sky, clutching the back of her chair with one hand while the other hovers in mid-air. Unperturbed, the woman at far left turns to direct a smile of mild amusement toward the viewer while draping a comforting arm over her recumbent companion. The gesture is the same one that Moore had employed in *The Marble Seat* (Pl. 73) and

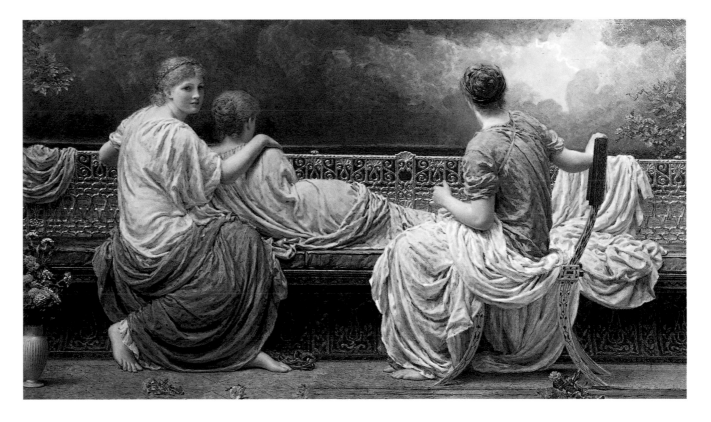

180
STUDY OF DRAPERY
AND GRILLWORK FOR
'LIGHTNING AND LIGHT'
*c.*1892
Black chalk
20.9 x 17.8 cm
(8¼ x 7 in)
Private collection

181
LIGHTNING AND LIGHT
1892
Oil on canvas
79.9 x 138.3 cm
(31½ x 54½ in)
Forbes Magazine
Collection, New York

that amputation of his leg would be required. Doubtful that he could survive the operation in his weakened state, he gained their consent to delay the operation for eight or nine months, during which time he 'set to work with renewed energy'. In addition to negotiating the sale of *A Summer Night*, Moore completed a number of small pictures, organized his personal affairs and drew up his will in December. Just before Christmas 1890, under the pretence of going away on a brief holiday, he bid farewell to his closest associates and held a dinner party for a few friends and family members, 'among whom he was the brightest and most cheerful'. Shortly thereafter, the tumour was removed from his leg, and amputation was deemed unnecessary.[48] There followed a long period of recuperation which proved hard on Moore's finances. In June 1891 he had to ask William Connal for an advance of £100. 'I am hard at work now', he assured him, adding with characteristic dryness, 'not having been over fit in the spring.'[49]

rehearsed often during the 1860s and 1870s, but in the 1890s it acquires new emotional content. A deeper symbolism very likely exists beneath this seemingly trivial incident. The calm acceptance of natural cycles that informs *Midsummer* and *A Revery* may also be implied here.

Notwithstanding its unaccustomed suggestion of pathos and meaning, *Lightning and Light* is no less scientifically designed than Moore's previous works. Emphatic, concentric curves generated by the figures' drapery (and echoed in details such as the chair legs) lead the eye across the canvas in a series of wave-like movements. A preparatory drawing for the swag of drapery hanging over the grille at far left reveals Moore's habitual armature of diagonal, horizontal and vertical lines underpinning this curvilinear system (Pl. 180). Another drawing suggests that the anthemion-ornamented grille was an imaginative

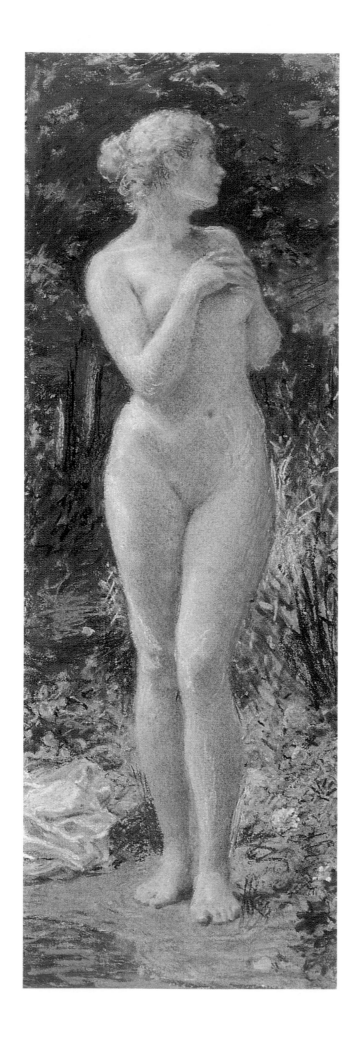

182
A BATHING PLACE
1890
Pastel
38.1 x 15.2 cm
(15 x 6 in)
Private collection

invention of the artist's own devising.[50] The inlaid wooden chair at right, by contrast, imitates a type frequently represented in classical Greek vase paintings and relief sculptures.

Baldry abhorred the emotionally nuanced, quasi-narrative works that Moore produced during the last three years of his life. In his view, only nervous strain could account for the fact that after decades of keeping himself 'aloof from influences that would prove hurtful to his art', Moore suddenly allowed himself to dwell on 'emotions that in his previous strength he had passed by without heeding' and to relapse 'into beliefs less precise, directly illness had weakened his powers of concentration and self-control'.[51] Baldry's negative assessment underestimates the significance of this transition in Moore's art. It is more fruitful to examine the phase as an experiment which was artificially accelerated, as well as prematurely aborted, by his fast-approaching death. The paintings executed during this period provide clues to the kind of work that Moore might have produced had he lived long enough to bring his new ideas to fruition.

Further clues are provided by the artist's growing affinity with pastel. Many of the qualities that Moore had struggled to cultivate in his oil paintings were characteristic of this medium, such as clarity and permanence of colour, ease of handling, and a dry, roughly textured appearance. Perhaps more importantly, pastel provided a less cumbersome and more direct means of self-expression than oil painting. For much of Moore's career, pastel had served primarily as an aid to preparatory study, enabling him to record his ideas for line and colour simultaneously.[52] By the 1890s, however, the pliancy, ease and subtlety of pastel seem to have encouraged him to pursue qualities hitherto neglected in his practice, and to produce works of unprecedented intimacy and immediacy. Indeed, the idiosyncracies of *Lightning and Light* may stem from the fact that it replicates a pastel, carried out in the same size and year (1892).[53] Expanded use of pastel was perhaps encouraged by Whistler, whom Moore had reportedly indoctrinated in the medium decades earlier.[54] In Venice, where he had gone to shore up his shaky finances and wounded pride following the disastrous Ruskin trial and his subsequent bankruptcy, Whistler derived fresh delight from working in pastel. The exhibition of some of these works at the Fine Art Society in 1881 created a popular sensation, and an astonished British public fell in love with the medium.[55] Various pastel societies were formed during the last decade of the century, and enthusiastic crowds turned out for exhibitions initiated at the Grosvenor Gallery in 1888.

While awaiting surgery for the tumour in his leg, Moore completed four drawings for the third of the Grosvenor pastel exhibitions in 1890. *Near Home* and *Down the Road* (unlocated)—'quaint little landscape notes', according to Baldry—were the first outdoor studies that he had exhibited since 1860.[56] He also contributed *A Bathing Place*, a nude female figure standing out of doors, which became the property of his friend Frederic Leighton (Pl. 182).[57] The motif is reminiscent of Moore's pastel version of the painting *Shells* of 1874, in which the figure stands in a wood at the edge of a body of water.[58] A more recent inspiration may have been his chance glimpse of a

183
STUDY OF A NUDE FIGURE FOR 'A BATHING PLACE'
*c.*1890
Black chalk on brown paper
33.6 x 18.4 cm
(13¼ x 7¼ in)
Private collection

184
STUDY OF A GIRL BATHING
Pastel
n.d.
32.3 x 17.1 cm
(12¾ x 6¾ in)
Central Library, Borough
of Hammersmith, London

185
STUDIES OF A WOMAN
DISROBING
*Black chalk on brown paper laid
on card*
*c.*1891
25.4 x 12.7 cm
(10 x 5 in)
Private collection

woman bathing under Hammersmith Bridge, which he recorded in pastel from memory (Pl. 184).[59]

Moore's ability to retain vivid mental impressions helps account for the freshness of *A Bathing Place*, which is remarkable for its sensation of evanescent movement and atmosphere, and for the sensuous and tender, almost vulnerable naturalism of the figure. Apparently a spontaneously documented plein-air scene, the drawing was actually constructed in the artist's studio with his characteristic attention to formal design principles. A preparatory drawing of the composition strips away the background foliage to reveal an underlying armature of angles and curves that were ultimately articulated through bold

contrasts of colour and line (Pl. 183). Notwithstanding his careful preparations, Moore allowed himself exceptional freedom and vigour in the handling of the pastel. Rapid strokes of colour convey the ephemeral effects of light and shadow, lending a scintillating appearance to figure and backdrop alike. Reflections of pale blue and ruddy brown in the highlights and shadows of the flesh tones recall Ruskin's praise for the naturalistic observations of Moore's *A Flower Walk* fifteen years earlier (Pl. 131). But the palpable evocation of real atmosphere and lighting is new, suggesting the influence of Impressionism. Moore had long pursued the challenge of wedding modern realism to the ideal forms he had derived from classical prototypes. In *A Bathing Place*, he revisited the *Venus de' Medici* in the atmospheric manner of Claude Monet.[60]

Lending itself to subtle nuance, pastel moderated Moore's rigorously analytical approach to composition. The female body, which he had long endeavoured to render dispassionately, attained greater sensuality in his last works. A sheet of drawings representing a woman in the act of disrobing (Pl. 185) recalls the quasi-scientific motion studies that preceded earlier pictures such as *Battledore and Shuttlecock* and *Follow my Leader* (Pls. 105-7, 117). But the composition in pastel that Moore developed from this sheet of studies is radically different (Pl. 186). Passionate, mysterious and atmospheric, it privileges subjective impression and sensuous handling over objective analysis. Energetic slashes of the crayon define the figure, lending it a shimmering appearance analogous to that of the background pool. The drapery's contours are defined in a wholly different manner, by dragging a blunt piece of white chalk over the brown paper to produce bold contrasts

186
STUDY FOR 'A BATHER'
c.1891
Black, white and coloured chalks on orange-brown paper
44.4 x 19.7 cm
(17½ x 7¾ in)
Private collection

187
NUDE STUDY OF A FEMALE FIGURE HOLDING DRAPERY, FOR 'A BATHER'
c.1891
Black chalk on brown paper
152.2 x 60.9 cm
(60 x 24 in)
Victoria and Albert Museum, London

188
CARITAS
*c.*1890
Pastel on grey paper
128.1 x 54.5 cm
(50½ x 21½ in)
Private collection

of highlight and shadow. In the background, feathery strokes combine with nervous squiggles to suggest the vegetation surrounding the figure. Moore intended to translate this alluring study into a large-scale oil painting, and went so far as to execute a life-size cartoon (Pl. 187). Unfortunately, ill health appears to have prevented his completion of the picture.[61] The provocative pose, inviting gaze and nuanced light and shadow are without precedent in his art, and would have made an astonishing addition to his oeuvre.

Intimations of love and affection merely hinted at in earlier compositions became overt themes in Moore's later pastels and related works. The bond between mother and child provided the subject of *Caritas*, a nearly life-size pastel derived from Moore's design for a memorial window (Pl. 188).[62] The stance and drapery patterns of the central figure recall a number of the artist's earlier pictures, but the substitution of small children for a vase of flowers or an open book recasts the woman's vacant expression as a gaze of maternal care. Here, poignant emotion as well as pliant materials blur the rigorous contours of Moore's design.

The same was true of an unlocated tempera painting, *Larkspurs*, in which the artist invoked associations of romantic love by reinterpreting the paired female figures in pictures such as *Topaz* (Pl. 147) as an affectionately intertwined man and woman.[63] A preliminary sketch of the composition demonstrates the freedom with which Moore developed his ideas in pastel (Pl. 189). With vigorous dashes of coloured chalk, he built the figures up from the same brown paper ground, so that they appear organically unified with each other and with the surrounding landscape. It was far more difficult to attain this quality of organic relation in painting, owing to Moore's laborious preparatory process. Contemporary mores added to his difficulties. A full-scale nude drawing for *Larkspurs* shows the well-realized male figure embracing the ghostly silhouette of the female, indicating that the artist was obliged to study the two models separately.[64]

While carrying out these works, Moore was living in derelict conditions in Holland Lane. Paying a visit in the early 1890s, Graham Robertson and Whistler found him at his easel, encircled by a ring of jugs with cones of brown paper in their mouths. Intrigued, they respectfully inquired about the purpose of the jugs, only to be told that they were for 'the drips'—the rain water that seeped in steadily through holes in Moore's roof. Robertson speculated that the roof had probably leaked for months or perhaps years, 'but Albert Moore sat dreaming among his jugs and never thought of repairs'.[65] Despite Moore's obliviousness to his surroundings, his family and friends must have seen that the squalid state of the house was ill-suited to a man in poor health. Whistler did his best to rally Moore, writing gaily on one occasion, 'Albert—you are to put on a tail coat this afternoon for I insist upon taking you this evening to the Gallery Club with me!— We are going to dine at the Century Club and so on together.'[66] Moore was hardly averse to public outings of this kind, and he continued to frequent the Arts Club, where he occasionally received and posted letters and presumably took some of his meals.[67] His habitual presence there goes some way to mitigate his reputation as a hermit-like recluse.

189
STUDY FOR 'LARKSPURS'
*c.*1890
Coloured chalks on brown paper
30.4 x 16.5 cm
(12 x 6½ in)
Private collection

In late December 1891, Moore left Holland Lane and moved to 2 Spenser Street, in the bustling if shabby commercial area near Victoria Station.[68] His new studio was evidently as commodious as his last; following his departure, it was shared by four artists.[69] By relocating to a recently erected building in a newly developed street, Moore once again elected to situate himself in an obscure spot that few of his acquaintances were likely to know. Colleagues and former students were swift in seeking him out, however. In February 1892 he sat for a portrait sketch by Walker Hodgson,[70] and later that spring assented to Graham Robertson's request for a visit, encouraging him to bring his mother along. 'The pictures I am showing [at the Royal Academy and New Gallery] you have seen before,' Moore informed Robertson, 'but I think they are improved now they are finished.'[71] The pictures in question, *Lightning and Light* and *A Revery*, were among several that Moore had begun at Holland Lane and completed at Spenser Street. Around the time of Robertson's visit, Baldry wrote to his former master with the news that Montague Marks, editor of the *Art Amateur*, had commissioned him to write an illustrated account of Moore's artistic career. Baldry had scarcely any experience as a journalist, but he was the editor's only hope of getting to Moore, who was by now notorious (in Marks's words) for 'car[ing] absolutely nothing for publicity' and for 'discourag[ing] all attempts to illustrate or describe his work'. In hot pursuit of this rare scoop, Marks journeyed from New York to London and arranged an appointment with the reclusive painter at the house of a mutual acquaintance (presumably Baldry). But Moore remained elusive to the end. 'He knew why I had come expressly from a considerable distance to see him,' Marks later recalled, 'but although perfectly courteous he parried successfully every effort by my friend and myself to make him talk on the subject. After prolonging my visit until a late hour, I had to give up the attempt, and take my leave.'[72]

Moore sidestepped this unwelcome intrusion while coping with a new health crisis, having developed another tumour in his leg. Again, the situation required surgery, which he determined to undergo at the home of an unknown friend in Aberdeen that summer. During the suspenseful interim period, Moore devoted himself to *An Idyll*, a large painting for William Connal which clearly betrays both the influence of his recent work in pastel and the emotional sensitivity engendered by precarious health (Pl. 190). Further developing the romantic theme of *Larkspurs*, this painting (according to Baldry) represents a lover's quarrel—evidently a harmless one, judging from the picture's title. Once again, Moore was reinterpreting an earlier composition: in this case, his first important classical work, *The Marble Seat* of 1864-5. Absence of emotion was the essential point of that painting, in which the two seated women gaze dispassionately at a naked youth pouring wine. In *An Idyll*, by contrast, it is the overcharged state of their emotions that causes the seated man and woman to stare blindly at water pouring from a fountain. The casual embrace of *The Marble Seat* gains greater urgency in *An Idyll*. Half lowering herself to one knee and leaning forward impulsively, the woman simultaneously expresses entreaty, contrition and consolation. Averting his head and enfolding his body tightly, the man signals his resistance. The well-observed gestures enhance the picture's naturalism, as does the delicate

morbidezza of the flesh, an effect created by Moore's technique of brushing successive layers of white lead over the canvas in alternating directions (see pp. 121-2).[73]

As with so many other paintings, Moore developed his ideas for *An Idyll* through the intimate and direct medium of pastel, executing a preliminary pastel study in vibrant colours.[74] Although he ultimately adopted a more subdued colour scheme, Moore faithfully transferred the virtuoso techniques of pastel to his canvas. Scratching with the end of his brush handle, he added texture to the grass in the foreground, a technique he had employed on numerous previous occasions. More unusual are the erratic, squiggling strokes he used to break up the fluid lines of the drapery, resulting in a roughly chiselled appearance reminiscent of weathered marble. The swirling, serpentine locks of the woman's hair are defined with great delicacy, yet other areas—such as the background foliage and the foreground grass—betray perfunctory handling.

In early August 1892, just prior to leaving London for his fateful journey to the Scottish surgeon, Moore visited Kew Gardens, presumably in order to study the summer flowers—poppies, tiger lilies, roses and irises—that appear in *An Idyll*. Surrounded by the floral beauty that had delighted him since childhood, Moore found pleasant distraction from fears relating to his surgery. He expressed his sensations in a few lines of verse, which ascribe to the placid surroundings of Kew the same condition of suspended animation that he had for many years cultivated in his paintings:

> Moving no leaf, the air sleeps in the trees,
> Aspen herself seems from her fears released;
> Under some spell, anxiety hath ceased,
> Dear day of respite for a Damocles!

The allusion to Damocles—the Greek courtier compelled to sit beneath a sword suspended by a single thread—indicates the forbidding sense of doom that hung over Moore at this time. Yet in poetry and painting alike, he chose to commemorate the spell-like state of repose that brought relief from worry, rather than dramatizing the agony of fraught emotions. He consistently used art to expand the pleasures of life rather than to dwell on its ills.

A few days after his visit to Kew, Moore set out from London on his arduous journey to Aberdeen, having once again settled his affairs with the assistance of his brother Henry.[75] The surgery was carried out before the end of the month, and he was initially optimistic about the results. 'The deed was done on Sunday morning, and apparently in a very satisfactory manner', he wrote to a friend toward the end of August. 'At any rate, I am progressing very fast, and am giving evident cause of jubilation to the doctor, so that I hope to be back to my pictures rather sooner than I expected and in better fettle.' Still in Scotland on 1 September, Moore informed his friend, 'I am up again and allowed to go downstairs to-day for the first time. I shall be able to get back to town on Saturday week, the doctor says, if I like, and probably shall, as I want to get the pictures done ... All this has been

190
IDYLL
1892-3
Oil on canvas
86.3 x 79.9 cm
(34 x 31½ in)
Manchester City Art
Gallery

remarkably rapid, and you will be glad to hear that the pathologists here pronounce the tumour non-malignant, which is, of course, a matter of great importance to me.'[76]

Despite his cheerful tone, Moore's finances as well as his health provided ample cause for concern. In November he took the hazardous step of selling the one painting by Whistler that he owned, *Nocturne: Trafalgar Square, Chelsea—Snow* (Pl. 191).[77] Only dire financial necessity can have prompted this potentially calamitous action, and indeed, while attempting to smooth Whistler's ruffled feathers, Moore assured him that the money had arrived 'in the nick of time for something that was pressing'. It is unknown exactly when Moore purchased the painting, which is believed to date from the mid-1870s. Graham Robertson recalled seeing it in Moore's studio with its face turned to the wall in the manner that Whistler affected in his own studio.[78] When Moore lent the picture to Whistler for a couple of exhibitions in 1892, it attracted the attention of the Glasgow art dealer Alexander Reid, who wrote to Moore on 6 November 1892 offering £80 for it. Believing the painting worth at least £100, Moore resolutely declined to take less than £90 and prepared to seek another purchaser. Reid, however, informed Whistler on 25 November that the deal was all but concluded, and asked that the picture be sent immediately to Glasgow.[79]

Although in delicate health, Moore could not bear to stand by while his property was highjacked. Stubborn to the end, he launched into retaliation, consulting a lawyer and firing off a volley of correspondence, including a threatening letter to Reid.[80] This strategy induced the dealer to send Moore 'another letter which is as humbugging as the previous ones', but this time accompanied by a cheque for £90. 'Victory for Yorkshire,' Moore wrote to Whistler in triumph; 'did not eat enough porridge, this one,' he added in reference to his Scottish opponent. More solemnly, he concluded, 'I am only sorry that present circumstances obliged me to entertain the idea of letting your beautiful picture go for anything like this sum.'[81] The afterthought failed to assuage Whistler's wounded pride. Questioning the credit done Yorkshire by the deflated price Moore had negotiated, he issued the sort of barbed complaint that terminated so many of his friendships. Moore refused to be baited into an argument, however. He replied on 9 December:

> It was ... agreeable to kick that Scot, but I lost sight of the fact that he was making off with my purse. Therefore, as you remark, the less said about Yorkshire the better. However, please realise that my hands were tied, so that the kick was all I was able to do. So now, my dear James, I hope I have modified to a certain extent the scolding that you have doubtless been meditating.[82]

Moore's reply demonstrates the engaging combination of good humour, self-effacement and candour that enabled him to maintain his long friendship with the notoriously difficult Whistler.

At this time, moreover, Moore had scant leisure for petty quarrels.

191
James McNeill Whistler
NOCTURNE: TRAFALGAR
SQUARE – SNOW
*c.*1875-7
Oil on canvas
47.3 x 62.5 cm
(18⅝ x 24⅝ in)
Freer Gallery of Art,
Washington DC

He was then commencing his labours on *The Loves of the Winds and the Seasons* (Pl. 193), an enormous painting—the largest of his career—which developed the connubial embrace of *Larkspurs* into a far more ambitious composition. In this canvas, Moore gave full vent to the psychological and amorous preoccupations that had emerged in his recent work. While making studies for the picture in January 1893, he composed a poetic 'Portrait of a Mouth', which indicates the psychological complexities that his study of the human face now impressed upon him:

> Gentle of mien, perhaps a little small,
> With changing curves—a charm is in them all—
> And softly wrought in deepest coral hue,
> It would, like scarce-closed casket, leave in view
> Its pearls, but for a gesture prim and wise
> Of little mother, which it quaintly tries.
> But markest thou a quiv'ring movement there?
> Behind those lips, 'tis Eros doth prepare
> His bow, and as thou gazest while they part,
> He gleams upon thee and hath pierced thy heart.

Moore shifts seamlessly from a fairly objective assessment of the physical properties of the mouth—its lines, curves, and colour—to the personality that animates it, and from there to its emotional impact on an observer. The poem suggests the exquisite sensitivity of the artist's perceptions and his poignant, amorous longings as he worked in increasing pain, alone but for his beautiful, young models, in his cavernous new studio.

By March 1893, Moore was contemplating a third operation. He reportedly hoped to keep his illness at bay by repeating these painful procedures indefinitely. Once surgery became impossible, he often remarked with a shrug, 'well, there was an end of it.'[83] As it happened, Moore's doctors knew within weeks that the cancer had spread to his organs, making recovery impossible. With remarkable pragmatism, he resolved to complete *The Loves of the Winds and the Seasons* in the brief time remaining to him. For the next six months, he toiled day and night, in acute pain, fearful of losing an hour. According to one report, 'he had to be strung up in a hammock chair, in which he worked, while his legs, swollen to twice their natural size, were tapped for dropsy.'[84] Robertson had the impression that the effort 'was killing him', but that 'as his life passed into the fair limbs of the Winds and the Seasons he was happy.'[85] Numerous preparatory studies found in the artist's studio after his death indicate that he went about the painting with his habitual thoroughness, despite his diminished physical capacity and the sense of urgency he must have felt. Drapery studies were carried out and translated to full-scale cartoons which match his late pastels in their technical versatility. Meticulous nude studies were similarly translated to life-size cartoons, and these were pounced for transfer to the final canvas (Pl. 192).[86] By now, Moore had dispensed with the elaborate system of intersecting circles employed in *Birds* (Pl. 140) and other paintings of the late 1870s. Instead, the cardinal points of intersection were marked by a series of equidistant horizontal lines. On top of this system he constructed the familiar

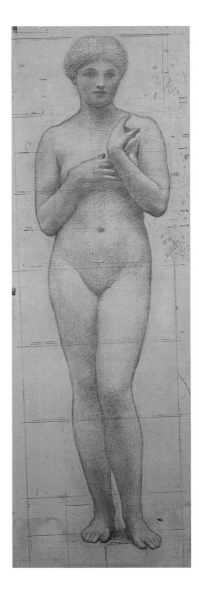

192
NUDE STUDY FOR THE
FIGURE OF AUTUMN IN
'THE LOVES OF THE WINDS
AND THE SEASONS'
*c.*1893
Black chalk on grey paper
150 x 49.6 cm
(59⅛ x 19½ in)
Victoria and Albert
Museum, London

diaper pattern of subtly bowed diagonals, which he carried across the entire composition.[87]

Measurements, mathematical calculations and other annotations in the margins of Moore's figure cartoons reveal the minute adjustments by which he accommodated his models' bodies to an underlying linear armature. Even the arrangement of flowers in the foreground was determined by this system, as indicated by his numbered 'map' of an isolated section (Pl. 194).[88] However, Moore's careful portrait studies for the heads of the figures were transferred to the final canvas with minimal idealization. His drawing of spurned Summer (Pl. 196), delineated directly from the model, faithfully records the ruffled collar and contemporary hairstyle that the artist saw before him. In subsequent studies, he experimented with modifications appropriate to his subject, such as Summer's classical coiffure (Pl. 195). With little time to spare, Moore took the precaution of executing a colour cartoon on tracing paper which he pinned to the canvas and peeled away in sections as he painted.[89] On analysis, the uneven execution of the painting seems to betray his diminishing physical capacity as well as his sense of a race against time. Passages in the immediate foreground are rendered with meticulous precision and include such charmingly observed minutiae as the bird at lower left and the butterfly alighting on the tree trunk at lower right, just above Moore's anthemion signature. Beyond the foreground, however, the landscape elements are painted cursorily and almost crudely, though with a variety of vigorous brushwork reminiscent of his recent pastels.

Shutting himself up in his studio, Moore refused to see anyone, according to Robertson, 'save a former pupil, a kind and charming woman, who now came to him, ostensibly for some final lessons, but I think really that she might bring him some help and sympathy'.[90] A few others were evidently admitted as well. Merton Russell-Cotes, who had caused Moore such disappointment three years earlier by reneging on his bid for *A Summer Night*, paid a final visit in September, two weeks before the artist's death, when 'the fact that his days were numbered seemed to be ever present in his mind'. Echoing a remark made by others, Russell-Cotes claimed that even in this terminal phase of his illness, Moore was 'always cheerful' and 'always ready to crack a joke or tell some funny little story whilst he was smoking his pipe ... A casual observer would never have dreamt for one moment from his cheerful demeanour that he was such a patient and suffering martyr.'[91] Russell-Cotes recalled that in greeting, Moore 'shook hands with me as usual in the heartiest manner, and afterwards placed his hands on my shoulders saying, "I am delighted to see you, my old friend, as I feel that my days on this earth are drawing to a close ... In fact, it is now becoming a fight beween the 'fell enemy' and myself as to whether I shall be able to finish this picture for Mr. McCulloch or not."' The comment helps confirm that *The Loves of the Winds and the Seasons* was completed as a commission for the Australian mine-owner George McCulloch—a rare exception to McCulloch's subsequent rule of waiting until the summer exhibitions in order to purchase the most popular picture of the year.[92]

During this last visit, Moore presented Russell-Cotes with an oil sketch

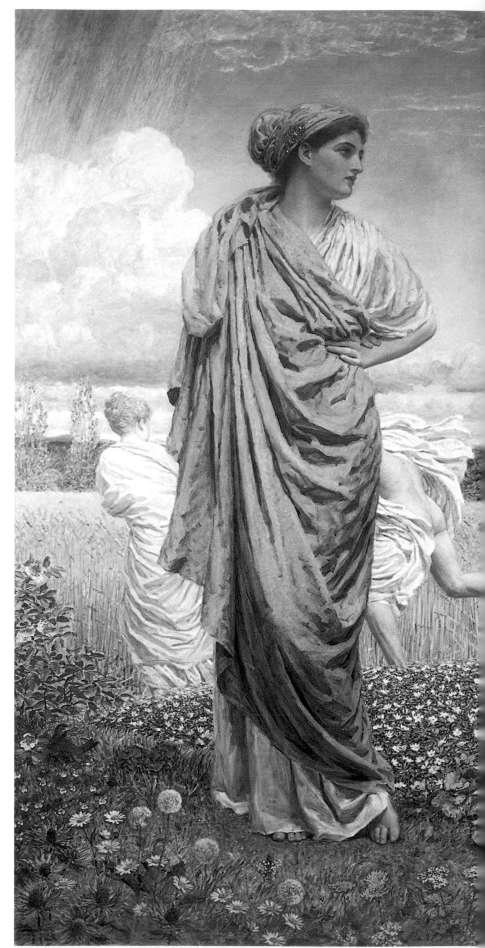

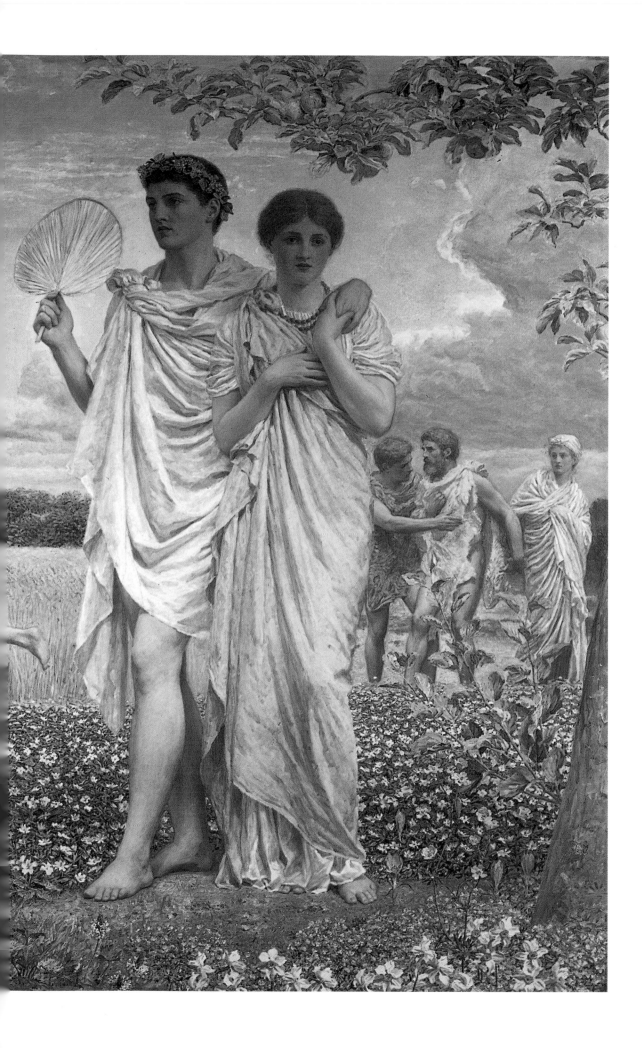

193
THE LOVES OF THE WINDS
AND THE SEASONS
1893
Oil on canvas
184.6 x 216.3 cm
(72¾ x 85¼ in)
Blackburn Museum and
Art Gallery

for the first figure in *Follow My Leader*, executed twenty years earlier during his protracted preparations for Lord Armstrong's picture.[93] The circumstance suggests that the artist was reviewing his studies of classically draped figures running through a flowery grove while working out similar imagery in *The Loves of the Winds and the Seasons*. But he was also casting his mind back further still, to the natural allegories with which he had commenced his career. In this, his final painting, Moore equated the eternal cycle of the seasons with age-old human conflicts and concords resulting from erotic passion. Flirtation, lust, rivalry, prudery, jealousy, rejection, fickleness, consummation— all these phases of human attraction and repulsion flow through the canvas, shifting from one to another as the natural world makes it own transitions from wintry sky through sunshine to rain; from frosty ground through spring and summer flowers to autumnal apples and wheat.

The artist glossed the picture's narrative in the verses he wrote to accompany it:

> Lo! fickle Zephyr chaseth wayward Spring,
> > It is a merry race;
> > Flowers laugh to birds that sing,
> Yet frequent tears shall cloud her comely face.
>
> The South Wind shall with blushing Autumn mate,
> > Contented with her lot;
> > Summer sigheth—such her fate
> She and her burning kisses are forgot.
>
> Two lovers rough for shudd'ring Winter strive,
> > Beneath a shroud of snow;
> > Heaven haply shall contrive
> Their violence she may not further know.[94]

Poem and painting alike recall the mythology of the Greeks, which conceived natural phenomena as narratives of human romance. In a sense, this is what Moore had been doing all along, translating the qualities of nature (flowers, foliage, shells and so on) into human imagery. By the end of his life, however, it was not the eternal laws of beauty that Moore was seeking from nature, but the laws of life itself. His last painting asserts that love, in all its phases—bewitching, tormenting, occasionally profoundly satisfying—is essential to human existence, no less than the eternal repetition of the seasons is essential to the natural world. This is a curiously humane affirmation from an artist whose work had studiously suppressed the basic longing of one human being for another. Moreover, it is a conviction seemingly belied by his final act of immersing himself in his art to the exclusion of family and friends. It is the ultimate enigma in a complex and intensely private life.[95]

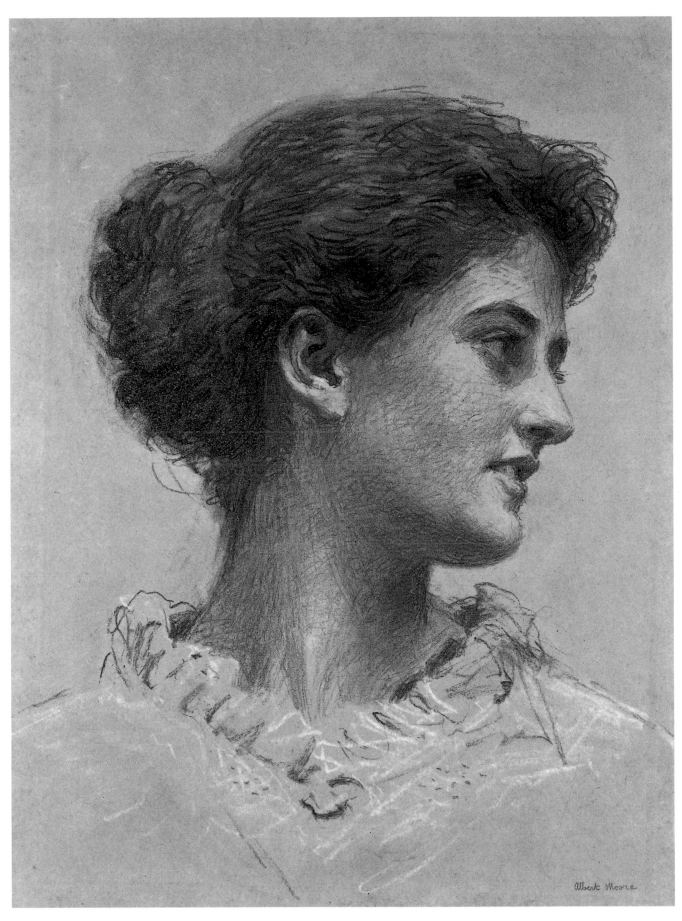

196
STUDY OF A WOMAN'S
HEAD ('SUMMER') FOR
'THE LOVES OF THE WINDS
AND THE SEASONS'
*c.*1893
Chalk on yellow paper
43.1 x 34.9 cm
(17 x 13¾ in)
Private collection

Epilogue

At 3:00 am on 25 September 1893, nine days after completing his last picture, Moore died at the age of 52 at his Spenser Street studio. The cause of death was recorded as a sarcoma of the thigh, which had plagued him for two and a half years, and a recurrent sarcoma of the abdomen from which he had suffered since January.[1] He had made his favourite brother Henry sole heir to his estate, which was valued at just over £1,184, a modest sum far short of the princely fortunes accumulated by many of his colleagues.[2]

Moore was buried at Highgate cemetery on Wednesday afternoon, 27 September, in the family grave already occupied by his mother and brother John Collingham Moore. His funeral was attended by a motley group of family members,[3] colleagues and minor patrons, including the painters Arthur Dampier May and Solomon Joseph Solomon (who had been a neighbour in Holland Park); the photographer H.P. Robinson of Tunbridge Wells (a friend of Henry Moore); and Mrs Harris Holland, wife of the well-known gunmaker (who owned Moore's painting *A Decorator* as well as studies for three of his last works).[4] Also present were the two witnesses to Moore's will of December 1890: the landscape artist Frederic Tucker and the solicitor J. Granville Layard, presumably a relation of the Nineveh explorer and former Minister of Works, with whom Moore had wrangled over the decoration of the Houses of Parliament in 1869.[5] The presence of these men and women at Moore's grave hints at personal friendships and professional alliances that remain undocumented. Others who might have been present, such as Leighton and Whistler, were abroad at the time.[6]

Moore achieved in death the broad, mainstream endorsement that had eluded him in life. The art critics who wrote his obituaries rued his death as 'a loss to national art', even though many of them had been instrumental in enforcing his marginal status.[7] With virtual unanimity, they chastised the Royal Academy for excluding Moore from its ranks, characterizing this gross injustice as the central fact of the artist's career.[8] It is difficult to say how much these lamentations had to do with genuine admiration for Moore and how much with delight in embarrassing the Academy. In any case, Moore's friends cast the blame for his neglect more widely. Receiving the news of Moore's death in Paris, where he had fled in 1892 in search of the appreciation denied him in England, Whistler immediately pronounced Moore 'the greatest artist that, in the century, England might have cared for, and called her own—how sad for him to live there—how mad to die in that land of important ignorance and Beadledom!' Amplifying the charge of 'important ignorance' that Whistler levelled against the nation, Baldry wrote, 'What better term could be applied to the self-sufficiency which is at the root of our national incapacity to appreciate even the rudiments of aestheticism? The ignorance which in this country hampers every artistic effort, and clogs every attempt at aesthetic advance ... the stupid, stolid vacuity, which is proud of its very emptiness, and glories in its impartial inability to understand anything.'[9]

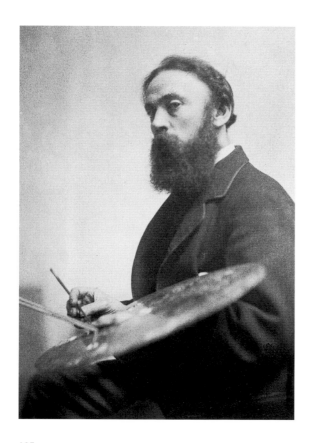

197
Photograph of Albert
Moore by Frederick
Hollyer
*c.*1892
Royal Photographic
Society, London

The Albert Moore of the obituaries—a misunderstood genius, martyred by the Academy, faithfully pursuing beauty all the way to his deathbed—enjoyed a brief run as a topical human interest story.[10] Frederick Hollyer's photograph of Moore (billed as 'the last likeness of the deceased artist') attracted inordinate attention when exhibited at the Dudley Gallery in early October 1893 (Pl. 197).[11] On the 21st of that month the proprietors of the newly opened Grafton Gallery (successor of the defunct Grosvenor as the headquarters of advanced art) announced that their next exhibition would feature a collection of Moore's works.[12] Baldry and Graham Robertson collaborated on organizing that display of 100 paintings and drawings, which they intended as 'a tribute of respect to the memory of that great Artist, whose loss we deplore, and with a view of giving some idea how great this loss is to English Art'.[13] The exhibition opened on 22 January 1894, and its positive reception encouraged Baldry to undertake an illustrated biography of Moore.[14] By early March, he was soliciting information on the artist, and he had completed the book by the end of the year.[15]

Writing rapidly and angrily, Baldry was too deeply immersed in old quarrels to articulate fully the original theories and eclectic principles that shaped his former master's work. He dutifully catalogued Moore's pictures and working methods, but reserved his passion for diatribes against the contemporary taste for sentimental narratives involving 'funerals and big dogs'—a taste that had devalued Moore's pioneering pursuit of radical beauty and led to his reputation as 'a revolutionary, openly flouting public opinion and unreasonably advancing his beliefs against those of the majority'.[16] A more sophisticated analysis of Moore's art might have been made by another writer who had begun to investigate him several months before Baldry. The novelist and critic George Moore (who had previously complained of the Royal Academy's hostility toward the artist he considered England's greatest) had asked to examine Albert's private papers a few weeks after his death—presumably intending to expand his former words of praise into a fuller analysis. Warned off by well-meaning friends, Henry Moore refused, and it remains a tantalizing question how differently Albert Moore's posthumous reputation might have fared had it been one of Britain's most progressive and cosmopolitan art critics,

rather than Baldry, who became the first chronicler of his ideas.[17]

A century later, it is evident that Albert Moore was an artist out of his time. Spurning the social and artistic conventions of his own era, he pursued an autonomous quest for abstract beauty, becoming in the process a one-man avant-garde. His uncompromising dedication to formal purity attracted the admiration of his most sophisticated colleagues but baffled the vast majority of his contemporaries, who searched his pictures in vain for story and sentiment. While anticipating the non-literary, purely visual concerns of twentieth-century abstraction, Moore also looked beyond formalism to the intrinsic limitations of a rigorously analytical aesthetic. In his last works, he began to experiment with the reconcilation of formal rigour with emotional and symbolic content.

Within years of Moore's death, the aesthetic tide had turned, and a re-educated art public rejected the artist not because he lacked sentimentality and a propensity for cosy story-telling, but because he, like any other Victorian painter, was presumed to exemplify those very qualities. He had been all too successful in concealing the analysis behind his art, and in clothing in conventional imagery the radical geometric and chromatic puzzles that underpinned his fictive worlds. To the negligent eye, his abstractly reasoned arrangements of line and colour were indistinguishable from the bevies of classically draped female figures produced in great number in nineteenth-century England.

But while there are many superficial similarities between Moore's paintings and those of his contemporaries, profound differences lie beneath the surface—differences developed through penetrating analysis of the eternal laws of nature and the enduring forms of art. As much as the lovely women and luxurious surroundings depicted in his paintings, it is the primitive, subliminal power of this underlying structure—balanced, rhythmic, and harmonious—that accounts for the fundamental satisfaction still derived from his work. Fascinating by their sheer beauty alone, Moore's paintings have required no apologist to ensure their continuing appeal. They exist in a serene and silent world in which words are unnecessary.

NOTES

ABBREVIATIONS

[N.B. In most quoted manuscripts, abbreviations have been expanded and obvious errors corrected]

ADC/UBC = Helen (Rossetti) Angeli-Imogene Dennis Collection, University of British Columbia
AJM = Albert Moore
FRL = Frederic R. Leyland
JAMW = James Abbott McNeill Whistler
JCM = John Collingham Moore
JL = James Leathart
K&C = Kensington and Chelsea Public Library, Local Studies Department
LP/UBC = Leathart Family Papers, University of British Columbia
PRO = Public Record Office, London
PRO/Works = Works 11/64, Part 1 (records of Office of Works and Buildings, Public Record Office, Kew)
PWC/LC = Pennell Whistler Collection, Library of Congress, Washington, D. C.
RA = Royal Academy of Arts
RIBA = Royal Institute of British Architects
RSPWC = Royal Society of Painters in Water-Colour
V&A = Victoria and Albert Museum, London
WBR = William Blake Richmond
WC/GUL = Whistler Collection, Glasgow University Library
WEN/RIBA = William Eden Nesfield Collection, RIBA
WMR = William Michael Rossetti

Full details of works regularly cited in an abbreviated form can be found in the Bibliography.

INTRODUCTION

1 Baldry, 'Albert Moore', *Studio*, 3 (April 1894): 3.
2 Maclean, *Henry Moore, R.A.*, 99-100.
3 This was the progressive critic George Moore, a great admirer of Albert Moore (no relation), whom he had considered one of 'the two greatest artists living in England'; see above, p. 188.
4 Baldry, *Albert Moore: His Life and Works* (London: George Bell & Sons, 1894).
5 Baldry, *Albert Moore*, 99. Articles by Baldry include: 'Albert Moore', *Pall Mall Budget* (February 1894); 'Albert Moore', *Studio*, 3 (April 1894): 3-6, 46-51; 'Albert Moore: An Appreciation', *Art Journal* (February 1903), 33-6; 'Albert Moore (1841-1893)', *The Old Water-Colour Society's Club*, 8 (1930-1): 41-7.
6 Even Baldry was moved to lament, just six months after Moore's death, that the artist 'lived such an isolated life that it is difficult to find out matters which are really necessary for a book' (Baldry to JAMW, 3 March 1894, Whistler B9, WC/GUL).
7 Richard Green is author of the exhibition catalogue *Albert Moore and his Contemporaries* (Newcastle-upon-Tyne: Laing Art Gallery, 23 September-22 October 1972) and the essay 'Albert Moore: Recent Discoveries' in the catalogue *The Moore Family Pictures* (York City Art Gallery, 2-31 August 1980 and London: Julian Hartnoll's Gallery, 22 September-10 October 1980). He also organized an in-house exhibition of twelve of Moore's paintings and drawings at the York City Art Gallery, 4 September-3 October 1993.

CHAPTER ONE

1 Harold Frederic, 'A Painter of Beautiful Dreams', *Scribner's Magazine*, 10 (December 1891): 718; York 1912, 17; Robert Walker, 'Private Picture Collections in Glasgow and the West of Scotland. III. The Collection of Mr. William Connal, Jun.', *Magazine of Art*, 17 (1894): 361; Baldry, *Albert Moore*, 11.
2 Walker records a specific incident involving 'a lady visitor' who admired the child's drawing of a Christmas rose ('Private Picture Collections', 361; cf. Baldry, *Albert Moore*, 11).
3 Regarding Pl. 4, see Baldry, *Albert Moore*, 12; Walford Graham Robertson, *Time Was* (London: Hamish Hamilton, 1931), 57; *Albert Moore Memorial Exhibition* (Grafton 1894), no. 218; see also Ernest Radford, 'Albert Moore', *The Idler*, 13 (August 1898), 6.
4 These included the animal painter Henry Calvert, the history painter and Royal Academician William Hilton, and the future Pre-Raphaelite and RA President John Everett Millais (Maclean, *Henry Moore*, 17; Baldry, *Albert Moore*, 9-10).
5 *Yorkshire Gazette* (30 March 1839): 1, (12 June 1841): 4, (23 December 1871): 6, (13 October 1883): 3; John Ward Knowles, *York Artists (MS. Scrapbooks)*, 1: 273, York Central Library; Harry Turnbull, *Artists of Yorkshire: A Short Dictionary* (Bedale, North Yorkshire: Thornton Gallery, Snape, 1976), 32.
6 Knowles, *York Artists*, 1: 276.
7 The remaining children of the 'first family' were Thomas Jackson (1814-30), an invalid who died young, and Eliza (1823-89), who married the Rev. T. Betty; information from private family papers; Knowles, *York Artists*, 1: 272-80; Maclean, *Henry Moore*, 16-17, 41.
8 J.C. Moore won third prize for 'Unimproved shading' on 1 July 1843, a prize for shading on 22 December 1843, and a prize for the best chalk drawing from a cast on 31 May 1844. Knowles is likely mistaken in claiming that Robert Collingham Moore enrolled in 1842; he was then six years old (Knowles, *York Artists*, 1: 272, 277).
9 John W. Knowles, *York School of Design (MS. Scrapbook)*, 20: 75, 88, York Central Library.
10 Knowles, *York Artists*, 1: 275.
11 Knowles, *York Artists*, 1: 272. Apparently a friend of Henry Moore, Knowles painted his portrait and owned several of his oil sketches (*Loan Collection of Works by the 'Moore' Family of York* [York 1912], nos. 224, 379B). For a more charitable account of 'the Moore pomposity', see Maclean, *Henry Moore*, 22.
12 Baldry, *Albert Moore*, 10-12.
13 Draft Regulations for the Appointment of Local Committee, 19 September 1842, in Knowles, *York School of Design*, 20: 35; letter from C.H. Wilson to G. Dodsworth and J.B. Atkinson, 28 January 1846, *Miscellaneous papers and letters*, Acc. 203 A.S., no. 95, York City Archives.
14 Many suspected the York branch of being 'a drawing and painting school for aspiring artists and well-born young ladies'; see Stuart Macdonald, *The History and Philosophy of Art Education* (London: University of London Press Ltd., 1970), 75, 78, 81-2, 87, 103; Quentin Bell, *The Schools of Design* (London: Routledge and Kegan Paul, 1983), 126-7.
15 Alexander Gilchrist, *Life of William Etty*, 2 vols. (London: David Bogue, 1855), 2: 87-8, 121-2, 239-40, 255-9; Miss Moore, 'William Etty', *Yorkshire Philosophical Society Annual Report for 1901* (1902), 9:

90-7; Bell, *Schools of Design*, 125; P.M. Tillott, ed., *A History of Yorkshire: The City of York* (London: Oxford University Press, 1961), 455.
16 Gilchrist, *Life of William Etty*, 1: 102, 114. A portrait of William Moore Sr., probably dating from the 1830s, has descended through the family as a work by Etty (York 1980, no. 1).
17 On 22 December 1848, Etty addressed the School on the importance of studying the human figure and congratulated his audience on its new life class (Knowles, *York School of Design*, 20: 80; see also Gilchrist, *Life of William Etty*, 2: 257; Miscellaneous papers and letters: Acc. 203 A.S., no. 105, York City Archives).
18 Moore, 'William Etty', 90, 94-5.
19 On 13 November 1851 Cotchett noted that 'the studies from nature, taken up by several students … require a continual supply of specimens which are not easily obtained'. On 13 September 1852 he mentioned the 'supply of flowers and leafage' that the school regularly received from 'the Museum and Mr. Barber's Garden' (*Minute Book of Monthly Reports to the Committee of the York School of Design [October 1842-May 1856]*, Acc. 203. 3A, York City Archives).
20 'York School of Design', unidentified newspaper clipping in *York School of Art Minute Book, 1842-55*, 9th General Meeting (16 March 1852), York City Archives.
21 Knowles, *York School of Design*, 20: 37 and 96. Casts of the Parthenon sculptures were purchased in December 1849, supplementing the Venus de Milo, the Venus de Medici, the Discobolus and other canonical works.
22 Death certificate of William Moore, registered 10 October 1851, Office of National Statistics.
23 Walker, 'Private Picture Collections', 361.
24 Henry Moore's prizes for lithography (1851) and silver painting (1853) are cited in Knowles, *York Artists*, 1: 278. For Henry and Albert's relationship, see Maclean, *Henry Moore*, 21, 99-100; Montague Marks, 'My Notebook', *Art Amateur*, 29 [November 1893], 132.
25 Maclean, *Henry Moore*, 22; Knowles, *York Artists*, 1: 280. Knowles further records that Albert 'shewed as a student the assiduity that characterised all his work'. The curriculum of the Schools of Design consisted of study in outline and shading from copy and cast; painting in oil and water colour; anatomy; perspective; life drawing; and designing for manufactures.
26 'York School of Design' in *York School of Art Minute Book, 1842-55*, York City Archives. The medal was in the possession of Henry Moore in 1894 (Walker, 'Private Picture Collections', 361).
27 J.C. Moore had been admitted a probationer on 18 July 1850 with a reference from G. Hyde (*Council Minutes*, C. X 1844-1852, ff. 293, 311, 376, RA).
28 *Minute Book of Monthly Reports*, report of 16 August 1852, York City Archives. See also *Council Minutes*, C. X 1844-1852, f. 410, and C. XI 1853-60, ff. 26, 43, RA. The well-known art master James Mathews Leigh provided Henry's reference to the RA Schools.
29 *Kensington Proprietary Grammar School Share Book, Christmas 1855 to [blank]*, MSS. 24656, 151, K&C.
30 David Moore built several houses near Victoria Road, Kensington, including his own, York Villa, No. 2 Clarendon Road (Cottesmore Gardens), completed in 1857; see Hermione Hobhouse, ed., *Survey of London (Southern Kensington)* (London: The Athlone Press for Greater London Council, 1986), 42: 14; *Post Office London Directory* (London: Frederic Kelly, 1857), 310; *Builder*, 37 (1 November 1879): 1215.

31 William Blake Richmond quoted in Anna Maria Wilhelmina Stirling, *The Richmond Papers* (London: William Heinemann, 1926), 159. When David Moore's son recovered his health in January 1857, it was arranged for Albert to assume the place recently resigned by the son of George Nelson Emmett Sr (*Kensington Proprietary Grammar School Share Book, Christmas 1855 to [blank]*, 58 [Share No. 29] and 151 [Share No. 76], MS. 24656, K&C).

32 Having ranked in the bottom half of his class during his first term in Classics, Divinity and English (slightly higher in French), Moore ranked third of thirteen in his fifth (and final) term; see *Kensington Grammar School* (reports for the terms from January 1856 through summer 1857) and *Kensington Proprietary Grammar School, in Union with King's College, London … December 1856* (London: c.1856), K&C.

33 Frederic, 'A Painter of Beautiful Dreams', 718; Whitworth Wallis and Arthur Bensley Chamberlain, *Illustrated Catalogue (with Descriptive Notes) of the Permanent Collection of Paintings in Oil and Water-Colours, and the Collection of Statuary, and the Pictures at Aston Hall* (Birmingham: George Jones and Son, 1892), 124; *Pall Mall Gazette*, 57 (27 September 1893): 5; 'Art News', *Liverpool Mercury* (28 September 1893); 'Obituary', *Yorkshire Herald* (27 September 1893); cf. Austin Chester, 'The Art of Albert Moore', *Windsor*, 22 (September 1905): 376.

34 Baldry, *Albert Moore*, 12-13.

35 Albert may also have joined Henry's 'semi-nomadic' excursions 'with little more to embarrass him than the clothes he wore and the painting materials he carried'. In the 1850s Henry travelled in Scotland, Wales, Cumberland, Devonshire, Hampshire, France and Switzerland (Maclean, *Henry Moore*, 18-19, 25, 28-32).

36 Baldry, *Albert Moore* 26; Maclean, *Henry Moore*, 23, 35.

37 In 1845, for example, Henry Moore entered a competition, judged by William Etty's brother, 'for the best drawing or painting in body colours [gouache] of the wild flowers, weeds, and grasses of an English hedge-bottom, done accurately from the objects in arrangement as well as details' (Moore, 'William Etty', 95; Maclean, *Henry Moore*, 22-3).

38 This famous passage on 'The Duty and After Privileges of All Students' appeared in the first volume of *Modern Painters* (1843); see Edward Tyas Cook and Alexander Wedderburn, eds., *The Works of John Ruskin*, 39 vols. (London: George Allen, 1903-12), 3: 624.

39 Prior to the opening of the 1856 exhibition, Henry Moore recorded, 'I had a long chat with Millais. He began by asking me if I knew who painted my own picture "On the Dart"—and admired it very much' (Maclean, *Henry Moore*, 44). For the family relationship, see note 1:4.

40 Of *A Swiss Meadow in June* (repro: Christie's 9 February 1990 [207A]), Ruskin confessed, 'I cannot judge of this study, it gives me too much pleasure; but it seems to me *very* perfect in general harmony of light, and in the sweet motion of the clouds along the horizon' (Cook and Wedderburn, *Works of John Ruskin*, 14: 104). In April 1858 Ruskin wrote to Henry Moore to criticize the gorse in one of his landscapes (Maclean, *Henry Moore*, 42-3).

41 Henry Moore to W.M. Rossetti, Clovelly, North Devon, 18 July 1857, folder 22-13, ADC/UBC; cf. Virginia Surtees, ed., *The Diary of George Price Boyce* (Norwich: Real World, 1980), 17.

42 Henry Holiday, *Reminiscences of My Life* (London:

William Heinemann, 1914), 45-6; see also Henry Stacy Marks, *Pen and Pencil Sketches*, 2 vols. (London: Chatto & Windus, 1894), 1: 225-6; Maclean, *Henry Moore*, 36-7. Henry Moore's early identification with the Pre-Raphaelites is attested by his inclusion in Percy H. Bate's *The English Pre-Raphaelite Painters, Their Associates and Successors* (London: George Bell and Sons, 1899), 87-90.

43 Baldry, *Albert Moore*, 13.

44 Baldry, *Albert Moore*, 71.

45 York 1980, 19.

46 Cook and Wedderburn, *Works of John Ruskin*, 6: 117-18 and passim.

47 The drawings were exhibited at the Liverpool Academy later in the year, priced at £5 and £3 respectively (information from files of Walker Art Gallery, Liverpool).

48 For a fuller discussion, see Robyn Asleson, 'Nature and Abstraction in the Aesthetic Development of Albert Moore' in Elizabeth Prettejohn, ed., *After the Pre-Raphaelites: Art and Aestheticism in Victorian England* (Manchester: Manchester University Press, 1999), 118-20.

49 'At the beginning of my studies as an artist I was visited by what has proved a lifelong hindrance—a great defect in my sight; but the strong love of art in me, and my simple trust in a loving and guiding Providence, have enabled me to realise something of what I longed for' (William Moore quoted in 'The Late Mr. Wm. Moore, York. Death of a Veteran Artist,' unidentified newspaper clipping of 15 April 1909 in Knowles, *York Artists*, 2: 276).

50 They had lived at 78 Newman Street, next to the popular art school operated by James Mathews Leigh. In 1858 Sarah Moore returned to York to live with a married son, leaving Albert and Henry on their own at 8 Berners Street (Maclean, *Henry Moore*, 38). Following Henry's marriage to Mary Bollans on 19 July 1860, the newlyweds, together with Albert, John and their mother, resided at 23 Berners Street (*1861 Census*, RG9\66, f. 63b; *Post Office London Directory, 1862* [London: Kelly & Co., 1862], 153 and [1863], 2077).

51 Joseph Lamb, *Lions in Their Dens: Lord Leighton and Late Victorian Studio Life*, Ph.D. thesis, University of California, Santa Barbara, 1987), 41, 70; Walter Goodman, 'Artists' Studios: As They Were And As They Are—II', *Magazine of Art*, 24 (1901), 398-9.

52 Stirling, *Richmond Papers*, 135-8.

53 Stirling, *Richmond Papers*, 159.

54 Claude Phillips, *Frederick Walker and his Works* (London: Seeley and Co., 1897), 9; John George Marks, *Life and Letters of Frederick Walker, A.R.A.* (London: Macmillan and Co., Ltd., 1896), 1-7; Joseph Williams Comyns Carr, *Essays on Art* (London: Smith, Elder & Co., 1879), 211-12.

55 These included *An Introduction to the Construction of those Shapes or Figures … called Plane Geometrical Figures* (1853), *Practical Geometry* (1855), *Practical Perspective* (1856), and *Linear Perspective* (1856), all published by Chapman & Hall, London.

56 Macdonald, *History and Philosophy of Art Education*, 230-1.

57 Royal Academy of Arts, *Laws Relating to the Schools, the Library, and the Students* (London: W. Clowes and Sons, 1854), 7-9.

58 For the inadequacies of the RA's teaching, see Stirling, *Richmond Papers*, 162, and W.S. Spanton, *An Art Student and his Teachers in the Sixties with Other Rigmaroles* (London: Robert Scott, 1927), 23-43.

59 Marks, *Life and Letters of Frederick Walker*, 6.

60 J.C. Richmond, 'Obituary. John Collingham Moore', *Art Journal*, 32 (1880): 348; Maclean, *Henry Moore*, 99-100.

61 He concluded, 'I repeat that I am very much obliged to you for the valuable advice contained in your letter; and be assured it will not be altogether thrown away upon your affectionate brother' (letter to Henry Moore, 8 Berners Street, Oxford Street, n.d. [c. January-May 1858], priv. coll.).

62 AJM to JCM, 8 Berners Street, n.d. [c. January-March 1858], priv. coll.

63 'When I was at York it occurred to me that a pair of trousers and a pair of boots would not come at all amiss, but I own I never entertained the idea of getting them there. I recollect that I acquainted you with the state of my wardrobe when at Dockwray [sic], but you never in any way suggested that I should get anything at York, nor sent me any money for that purpose—I did not think them absolutely necessary, and I have always, since I have been in the country endeavoured to be as ecomonical as possible. Besides, was there time to get them made in three days? I plead guilty to no indolence in this instance. During the time I was at Walsham I was never ashamed of my appearance and I don't believe that I did discredit to you in the Martinaux [?]' (AJM to Henry Moore, 8 Berners Street, n.d. [c. January-May 1858], priv. coll.).

64 Royal Academy, *Laws Relating to the Schools, the Library, and the Students*, 11. One of Moore's RA schoolmates recalled that sheer overcrowding doomed students to years of tedious copy work in the Antique School 'because the little room used for the Life-School was crammed and the Academy would take no step to provide sufficient space' (Holiday, *Reminiscences*, 46).

65 Walker, 'Private Picture Collections', 362.

66 Baldry, *Albert Moore*, 13.

67 *Council Minutes*, C. XI 1853-60, f. 392, RA; 'The Royal Academy', *Art Journal*, 22 (1860): 29; H.W.C. Davis and J.R.H. Weaver, eds., *Dictionary of National Biography, 1912-1921* (Oxford: Oxford University Press, 1921), 461.

68 AJM to JCM, 8 Berners Street, n.d. [c. January-March 1858], priv. coll.

69 Francis Stephen Cary's school in Charlotte Street was considered more expensive and restrictive than others. John Ruskin's Thursday evening drawing classes at the Working Men's College in Great Ormond Street focused on landscape; see Robert Hewison, *Ruskin and Oxford: The Art of Education* (Oxford: Clarendon Press, 1996), 7-9, 34-7.

70 'James Mathews Leigh', *Art Journal*, 22 (1860): 200.

71 Marks, *Pen and Pencil Sketches*, 1: 22-3; Marks, *Frederick Walker*, 4-5; Rose Eva, 'Heatherley's: The First 100 Years' in *The Heatherley School of Fine Art 150th Anniversary Exhibition* (London: The Heatherley School of Art, 1996), 3-6; Paula Gillett, *The Victorian Painter's World* (Gloucester: Alan Sutton, 1990), 144. See also Spanton, *An Art Student and his Teachers*, 15-22.

72 Marks, *Pen and Pencil Sketches*, 1: 22-6; Walter Crane, *An Artist's Reminiscences* (London: Methuen & Co., 1907), 81.

73 One former student recalled the room leading to the studio as a 'chamber of anatomy', decked with drawings 'of bones and muscles and skinned men writhing in agonies … notably one that was twice the size of life, with a dreadful blue eye with red veins that seemed to follow you all round the place' (Eva, *The Heatherley School*, 4).

74 Baldry denied the often repeated claim that Moore was a member of the Langham Sketching Club, which inspired the club formed by Solomon, Holiday and Stone. (Baldry, *Albert Moore*, 14; cf. Holiday, *Reminiscences*, 40; M.H. Spielmann, 'Death of Mr. Albert Moore', *Daily Graphic* [24 September 1893]; 'Our Illustrated Note-Book', *Magazine of Art*, 17 [1894]: 34; 'The Langham Sketching Club', *Art Journal*, 57 [1895]: 2).

75 Baldry, *Albert Moore*, 14.

76 Admissions to Print Room, 1 November 1859, *[Outgoing] Letter Book*, 212, Central Archives, British Museum.

77 The photographer Frederick Hollyer once owned this drawing (Grafton 1894, no. 234).

78 Henry Ellis to Joseph W. Walker, 15 January 1855, *Letter Book of Principal Librarian*, CE27/102, f. 47, Central Archives, British Museum. My research at the Central Archives and the Greek and Roman Department yielded no records pertaining to Moore during the 1851-72 period.

79 Referred to in a letter of 1858 to JCM; see above, p. 25.

80 AJM to JCM, 8 Berners Street, 20 April 1860, priv. coll.

81 Baldry, *Albert Moore*, 70.

82 Linda Merrill, *A Pot of Paint: Aesthetics on Trial in Whistler v. Ruskin* (Washington and London: Smithsonian Institution, 1992), 265, 353-4, 365, 396.

83 Maclean, *Henry Moore*, 20, 142. For *Boy in Boat*, an 'early etching by Albert Moore' owned by Wilfred Hargrave, see York 1912, no. 306.

84 Baldry, *Albert Moore*, 59; for the statement that 'up to his sixteenth or seventeenth year he [Moore] had rarely, if ever painted in oil', see Stirling, *Richmond Papers*, 160. Moore exh. *A Study Painted in 1857* at the RSPWC in 1888.

85 'I have been to Pinner with Harry since you left, but have not yet got the baby painted. I shall do so next week very likely. I have begun with Mrs. Eastlake and like her very much' (AJM to JCM, 20 April [1860], priv. coll.). The two thinly painted heads are possibly identifiable as the study of a Nubian woman (unlocated; exh. RA 1859) and *The Mother of Sisera* (exh. RA 1861; Pl. 26).

86 Stirling, *Richmond Papers*, 163, 135-58; see also WBR to Thomas Knyvett Richmond, 1860, Richmond Papers, RI/1/6, RA; Simon Reynolds, *William Blake Richmond: An Artist's Life, 1842-1921* (Wilby, Norwich: Michael Russell, 1995), 24 and *The Vision of Simeon Solomon* (Stroud, Gloucestershire: Catulpa Press, 1984), 8-9.; Holiday, *Reminiscences*, 42-56, passim; Gayle Marie Seymour, *The Life and Work of Simeon Solomon (1840-1905)* (University of California, Santa Barbara, Ph.D. thesis, 1986), 30-2, 38-42.

87 Stirling, *Richmond Papers*, 161.

88 Moore was staying in 'very comfortable diggings' at Moorgate House, evidently the guest of his brother John's friend, Mrs Hyde, whom he described as 'the most good-natured of my acquaintance', adding 'If you please, your portrait of her does not do her justice' (AJM to JCM, n.d. [c. spring 1860], MA 4500 M, Pierpont Morgan Library). In a subsequent letter, he wrote, 'I have written a longish letter to Mrs. Hyde since receipt of yours. I am surprised that I haven't written long ago as I consider her the nicest lady of my acquaintance' (AJM to JCM, 8 Berners Street, 20 April 1860, priv. coll.). She was possibly a relation of the G. Hyde who provided J.C. Moore's recommendation to the RA Schools in 1850, and

perhaps the namesake of his daughter, Margaret Hyde Moore.

89 The drawings were offered for sale at £12 12s. and £10 10s. respectively (Jane Johnson, *Works Exhibited at the Royal Society of British Artists, 1824-93* [Woodbridge, Suffolk: Antique Collectors Club, 1975], 329).

90 'Society of British Artists', *Athenaeum*, no. 1692 (31 March 1860): 448. Moore later informed his brother John that his watercolours had 'been noticed somewhat favorably' in the *Athenaeum* (AJM to JCM, 8 Berners Street, 20 April 1860, priv. coll.). They evidently disappeared early on; neither is catalogued by Baldry.

91 'I have begun again with the Tennyson designs, Harry and Smallfield having advised me to do ... I think in my case I shall not join him [Henry Moore, who had proposed a walking tour of Cornwall] as there will not be too much time for the Tennyson drawings' (AJM to JCM, 8 Berners Street, April 1860, priv. coll.).

92 Baldry, *Albert Moore*, 28.

93 See, for example, Stirling, *Richmond Papers*, 136-7; Holiday, *Reminiscences*, 42, 47-8.

94 Albert saw the painting prior to the exhibition opening while overseeing delivery of six portraits by his brother John who was absent in Rome (AJM to JCM, 20 April 1860, priv. coll.).

95 Tate Gallery, *The Pre-Raphaelites* (London: The Tate Gallery/ Penguin Books, 1984), 184-6.

96 AJM to JCM, 8 Berners Street, n.d. [c. January-March 1858], priv. coll. 'Mr. E. Richardson' was probably the landscape painter and watercolourist, Edward M. Richardson (1810-74). See also Maclean, *Henry Moore*, 42-4.

97 Stirling, *Richmond Papers*, 160.

98 Richmond, 'John Collingham Moore', 348; Maclean, *Henry Moore*, 20-1, 124.

99 Seymour, *Life and Work of Simeon Solomon*, 68-9; see also Holiday, *Reminiscences*, 11, 18-19, 38, 57, 61-3, 77.

100 For memories of the Artists' Rifles, see: John Guille Millais, *The Life and Letters of Sir John Everett Millais*, 2 vols. (New York: Frederick A. Stokes Company, 1899), 1: 259; Stirling, *Richmond Papers*, 164-7; Holiday, *Reminiscences*, 47-8, 64-5; John Callcott Horsley, *Recollections of a Royal Academician* (London: John Murray, 1903), 266-7; Emilie Isabel Barrington, *The Life, Letters and Work of Frederic Leighton*, 2 vols. (London: George Allen, 1906), 2: 55, 111, 243-4.

101 Robertson, *Time Was*, 57, 129.

102 Regarding the large debt that Moore had accumulated in the books of Company No. 1, Prinsep wrote, 'I have paid this for tis a pity to see good names in this situation, and scratched your name off the books to prevent further bother. This is of course between ourselves and I am in no hurry for payment' (Prinsep to AJM, 28 August 1871, priv. coll.).

103 For Leighton's assessment of Moore's 'impracticable' character, see above, p. 74. Leighton strove to overcome Moore's reclusive tendencies and engage him in a wider professional field. See, for example, his letter of introduction to Moore on behalf of the commissioner of the Berlin international exhibition, January 1886, 86.WW.1; MSL 7461-1979/236, V&A.

104 Frederic Leighton to Walter Crane, 5 October 1893, Leighton MSS 12494, K&C.

105 For early drawings corrected by Harding, see WEN [17], RIBA. It is not known exactly when and how Nesfield and Moore met. Baldry claimed that it was

'about the time of his [Moore's] leaving school and commencing the business of his life' (*Albert Moore*, 14). J.C. Moore had painted a portrait of Nesfield's father, the watercolourist turned landscape artist William Andrews Nesfield (Leslie Stephen and Sidney Lee, eds., *Dictionary of National Biography*, 23 vols. [Oxford: Oxford University Press, 1921], 14: 226). He may have met the younger Nesfield in Rome while they were both there in 1858. For Nesfield's early career, see Dennis Jones, *The Work of William Eden Nesfield at Cloverley Hall, nr. Whitchurch, Shropshire*, M.A. dissertation, University of Keele, 1991, and Andrew Saint, *Richard Norman Shaw* (New Haven and London: Yale University Press, 1976).

106 John McKean Brydon, 'William Eden Nesfield, 1835-1888', *Architectural Review*, 1 (April 1897): 238.

107 Cecil Y. Lang, ed., *The Swinburne Letters*, 6 vols. (New Haven: Yale University Press, 1969), 1: 44. For the date of this letter, see Seymour, *Life and Work of Simeon Solomon*, 90. Like Moore, Nesfield reportedly had 'an imperfect sympathy with conventional society' (John Hebb, 'William Eden Nesfield', *Journal of the Royal Institute of British Architects*, 10 [23 May 1903]: 398).

108 WEN [12], RIBA.

109 Nesfield drew the armoire in Pl. 21 during his 1859 trip to Bayeux with Moore (WEN [15], ff. 10-11, RIBA).

110 Baldry believed that Moore began his return journey from Paris to London at the beginning of July, but Robert Walker stated (apparently on Henry Moore's authority) that he journeyed further south to visit Rome with J.C. Moore. Walker failed to mention Moore's 1859 French tour with Nesfield, and likely confused it with Moore's 1862-3 journey to Rome (Walker, 'Private Picture Collections', 362; cf. Baldry, *Albert Moore*, 14).

111 'Action for Libel against Mr. Ruskin', *Globe* (26 November 1878): 3.

112 Solomon's mother, like Moore's, was an amateur artist. His brother, the painter Abraham Solomon, was 17 years his senior and often misidentified as his father (Seymour, *Life and Work of Simeon Solomon*, 15, 74).

113 Seymour, *Life and Work of Simeon Solomon*, 18-19.

114 Stirling, *Richmond Papers*, 161. Solomon's unconventional treatment of Old Testament lore inspired Richmond to undertake his own Biblical subjects in the following year (Reynolds, *William Blake Richmond*, 25-6); see also Crane, *An Artist's Reminiscences*, 86; William Michael Rossetti, *Selected Letters of William Michael Rossetti*, ed. Roger W. Peattie (University Park and London: The Pennsylvania State University, 1990), 634.

115 A later, simplified version, said to date from 1865, is in the York City Art Gallery (repro. Baldry, *Albert Moore*, opp. 80; for dating, see Grafton 1894, no. 229; York 1912, no. 378. The drawing was possibly intended for engraving; Simeon Solomon's pen-and-ink drawing *Ruth, Naomi, and the Child Obed* of 1860 (City of Birmingham Museum and Art Gallery) was engraved by Dalziel in 1865.

116 WBR to Thomas K. Richmond, 16 October 1862, Richmond Papers, RI/1/11/2, RA.

117 Ian Jenkins, *Archaeologists and Aesthetes in the Sculpture Galleries of the British Museum 1800-1939* (London: British Museum Press, 1992), 167.

118 *Illustrated London News* (26 June 1847, 16 December 1848, 31 March 1849, 21 December 1850) quoted in Edward Bacon, ed., *The Great Archaeologists: The*

Modern World's Discovery of Ancient Civilisations (London: Secker and Warburg, 1976), 19-22. See also Seymour, *Life and Work of Simeon Solomon*, 33-68 passim.

119 A.H. Layard, *Nineveh and its Remains*, 2 vols. (New York: George P. Putnam, 1849) 2: 237, 248-51; see also his *Discoveries in the Ruins of Nineveh and Babylon* (London: J. Murray, 1853).

120 See, for example, a scene of Ashurnasirpal II hunting lions, British Museum, no. 124579.

121 Baldry, *Albert Moore*, 83.

122 The model for Elijah also reportedly sat for Simeon Solomon's *Isaiah Reproving the Women of Jerusalem* in May 1861 (Seymour, *Life and Work of Simeon Solomon*, 68).

123 'The mother of Sisera looked out at a window, and cried through the lattice, Why is his chariot so long in coming? why tarry the wheels of his chariots?' (Judges 5: 28).

124 'Royal Academy', *Athenaeum*, no. 1699 (19 May 1860): 688. For a discussion of this model, see Seymour, *Life and Work of Simeon Solomon*, 57.

125 Moore's picture was judged 'much less pretentious in style, and very much more forcible in character' than paintings of similar subjects in the exhibition, 'the expression of the woman's head being very good indeed' ('Exhibition of the Royal Academy', *Art Journal*, 23 [June 1861]: 171).

126 The painting apparently failed to sell and passed into the collection of Henry Moore's brother-in-law, Edward Bollans (Grafton 1894, no. 180).

127 Seymour, *Life and Work of Simeon Solomon*, 23-5, 50-2, 59-61; William Michael Rossetti, 'Art-Exhibitions in London', *Fine Arts Quarterly Review*, 2 (May 1864): 306-7; *Frederic Leighton, 1830-1896* (London: Royal Academy of Arts, 1996), no. 56.

128 Baldry, *Albert Moore*, 21.

129 Baldry, *Albert Moore*, 27-8.

130 For the feminization of late-Victorian culture, see Kathy Alexis Psomiades, *Beauty's Body: Femininity and Representation in British Aestheticism* (Stanford: Stanford University Press, 1997).

131 In a letter to his parents, he wrote: 'Moore and I took a lovely walk to Monte Mario. I was perfectly enraptured by the beauty of every thing, all the landscape here is so suggestive, the olaves [sic], oranges, oliander, roses, almond trees, palms, date trees, I now see where the lovely simple landscapes of the early painters came from. I hope to get many studies of trees of different kinds ... It is now four o'clock. Every moment I expect Moore to take a walk in the country' (WBR to George and Julia Richmond, 22 February 1866; see also 12 February and March 1866, Richmond Papers, RI/1/25-7, RA).

132 The profound impact on Moore of his Roman sojourn is indicated by his subsequently dating his London career from 1863—the year of his return from Rome—despite his prior professional experience there. See 'Action for Libel against Mr. Ruskin', *Daily News* (26 November 1878), 2.

133 Baldry, *Albert Moore*, 28.

134 Baldry, *Albert Moore*, 28.

135 Christopher Newall, *The Etruscans: Painters of the Italian Landscape, 1850-1900* (Stoke on Trent: Stoke on Trent City Museum and Art Gallery, 1989), 97; WBR to George and Julia Richmond, 22 February 1866, Richmond Papers, RI/1/26, RA; Stirling, *Richmond Papers*, 206-7; Reynolds, *William Blake Richmond*, 40-4, 71.

136 In a letter of 30 January, Mason thanked John Moore for the opportunity to 'work with and know your pre-Raphaelite Brother who if he is anything like yourself must be a very interesting curiosity' (George Mason to JCM, 30 January 1859, priv. coll.); see also Richmond, 'Obituary. John Collingham Moore', 348.

137 The mirroring device occurs elsewhere in the Sistine ceiling, for example in *The Creation of the Sun and Moon* and the *Ignudi*.

138 WBR to George and Julia Richmond, 22 February 1866, Richmond Papers, RI/1/26, RA.

139 Moore's admiration for fresco was shared by his friends. At Pompeii in 1867 Holiday made 'careful water-colour copies of three of the lovely figures of nymphs, and drawings of several more' (Holiday, *Reminiscences*, 133). Richmond declared in a letter from Rome, 'I must paint in Fresco for I feel the beauty of it so much that until I have tried my hand at it, I shall not be content'. He studied with Francesco Podesti, the leading practitioner in Rome, executing a fresco of Bacchus that was too heavy to be moved and a smaller specimen that he sent to England (WBR to George and Julia Richmond, Richmond Papers, RI/1/27-31, RA; see also Reynolds, *William Blake Richmond*, 39, 52).

140 Baldry, *Albert Moore*, 16. Sarah Collingham Moore died, aged 64, at 23 Berners Street from various ailments including emphysema of the lungs, from which she had suffered for 21 years. Henry and Mary Bollans Moore had cared for her while Albert and John were in Rome (private family papers; death certificate issued 30 January 1863, Office of National Statistics; see also Maclean, *Henry Moore*, 45, 49-50).

141 Moore possibly left the family home prior to his Roman sojourn. In 1862 an Albert Moore (occupation unspecified) resided at 2 Fitzroy cottages, Kentish town; *Simpson's Street Directory of St. Pancras, with Businesses Attached, and Court Guide. 1862* (London: Tomkies and Son, 1862); *The St. Pancras Directory for 1862* (London: James Giddings, 1862).

142 F.G. Stephens, 'Fine-Art Gossip', *Athenaeum*, no. 1895 (20 February 1864): 270.

143 In mid-January 1863 Simeon Solomon was among the contributors to an independent exhibition of 170 works at William Cox's gallery, 14 Berners Street (W.M. Rossetti, 'Summary of Art News', *Fine Arts Quarterly Review*, 1 [May 1863]: 195). That spring William Holman Hunt and several artists rejected at the RA—including Henry Moore and Henry Holiday—organized a 'Salon des Refusés' at the Cosmopolitan Club in Charles Street ('Art-Exhibitions in London', *Fine Arts Quarterly Review*, 1 (October 1863): 338; Holiday, *Reminiscences*, 95-6).

144 F.G. Stephens, 'Fine-Art Gossip', *Athenaeum*, no. 1909 (28 May 1864): 746; W.M. Rossetti, 'Fine Arts Record', *Fine Arts Quarterly Review*, 3 (October 1864): 148. A second annual exhibition for works in oil was later introduced at the Dudley.

145 'La peinture de ceux-ci est une peinture d'épiderme: les os, les muscles, ne se sentent point sous le vêtement'. Philippe Burty, 'L'Exposition de la Royal Academy', *Gazette des Beaux-Arts*, 18 (1 June 1865): 558; similarly F.G. Stephens, 'Royal Academy', *Athenaeum*, no. 1959 (13 May 1865): 658.

146 Others praised by Burty included Leighton, George Frederic Watts, Paul Falconer Poole and Frederick Sandys (Burty, 'Exposition de la Royal Academy', 559-60).

147 'The Royal Academy Exhibition (Second Notice)', *Saturday Review*, 19 (27 May 1865): 635; F.G. Stephens, 'Royal Academy', *Athenaeum*, no. 1959 (13 May 1865): 658; W.M. Rossetti, 'The Royal Academy Exhibition', *Fraser's Magazine*, 71 (June 1865): 747.

148 'The Royal Academy', *Art Journal*, 27 (1 June 1865): 163.

149 F.T. Palgrave, 'English Pictures in 1865', *Fortnightly Review*, 1 (August 1865): 668-9. Elsewhere, the critic wrote, 'We are very glad ... to find that we have again, in Mr. Moore, a painter keenly sensible to that beauty of line from which the pursuit of other qualities has in some degree diverted his contemporaries. Let him only not be satisfied with the easy praise which has ruined so many beginners, but put his gift on the sure foundation of truthful study, and he may do good service in the cause of our art' ('The Royal Academy Exhibition [Second Notice]', *Saturday Review*, 19 [27 May 1865]: 635). For a subsequent discussion relating the picture to Blake and praising its naturalism, see W.M. Rossetti, 'A Pre-Raphaelite Collection', *Art Journal*, 58 (1896): 133.

150 James Leathart, who had already commissioned several Old Testament watercolours from Simeon Solomon, had hoped to purchase *Elijah's Sacrifice* at the RA in 1865 but was 'a little too late'. The artist Arthur Hughes assisted him in buying it privately from Trist three years later at its original price, although Trist believed its value had doubled. 'I assure you I am far from being tired of it', he told Leathart, but the picture 'ought for its own sake, and Moore's, to be placed in a great collection, where it can be properly seen' (Trist to JL, 9 March 1868, LP/UBC). Trist also purchased Moore's painting *Pomegranates* (Pl. 78)

151 Baldry, *Albert Moore*, 30. *Dancing Girl* was in the collection of Mrs G.S. Warren in 1912 (York 1912, no. 141).

152 F.G. Stephens, 'Fine-Art Gossip', *Athenaeum*, no. 1895 (20 February 1864): 271.

153 Other examples include: oil and pen-and-ink versions of *David Playing to King Saul*, executed in 1859 (City of Birmingham Museum and Art Gallery); a pen-and-ink drawing of 1860 *A Jewish Musician in the Temple* (Huntington Library, Art Collections, and Botanical Gardens); an oil *The Child Jeremiah* of 1861 (priv. coll., Cheshire); an oil painting *Hosannah* of 1861, engraved for *Dalziel's Bible Gallery* in 1865 (Tate Gallery).

154 William Burges, 'The Late Exhibition', *Ecclesiologist*, 23 (December 1862): 339.

155 'Maiden Spring rests one arm on the shoulder of Summer, while, with her disengaged hand she holds the Lethean emblem, a poppy, to her lips, intimating forgetfulness of the past; her hair is golden, her eyes are clear and unconscious of beauty, her figure full—yet slender, her robes bright green and white. Summer, the new bride, with glittering eyes, is a fervid beauty, exuberant of life, dark-haired, ripe-hued, high-bosomed, like Homer's women, tall and strong: in one hand she holds a golden orb, on the hither side of which the sun shines full; her other hand rests on a glass vase of clear water. Matron Autumn, her face shaded, on the Winter side, by her mantle, watches an apple ripening in her outstretched hand ... She holds the hand of widowed Winter, who, her face upon her hand and her elbow on her knee, leans forward from the

bench, and, with regretful face, looks back upon the countenances of her companions; round her own a wimple is gathered' (F.G. Stephens, 'Fine Arts', *Athenaeum*, no. 1895 (20 February 1864): 270-1).

156 Moore's picture was the last item in the 1864 exhibition catalogue. It was evidently a late addition, as some catalogues went to press with only the number 1062 under the heading 'FRESCO', without title or artist's name (Yale Center for British Art).

157 Rossetti echoed some of Stephens's observations, noting that 'with some imperfections natural to a young artist, it is remarkably complete as an example of the particular class of art to which it belongs' ('The Royal Academy Exhibition', *Fraser's Magazine*, 70 [July 1864]: 62, 69, and 'Art-Exhibitions in London', *Fine Arts Quarterly Review*, 3 [October 1863]: 30).

158 Sidney Colvin, 'English Painters of the Present Day. II.—Albert Moore', *Portfolio*, 1 (1870): 4.

CHAPTER TWO

1 Edward William Godwin, 'The Architectural Exhibition', *Building News*, 14 (17 May 1867): 336.

2 These problems plagued recent murals by George Frederic Watts and Frederic Leighton, see Thomas Gambier Parry, 'The Walls and Windows of the Future', *Ecclesiologist*, 28 (October 1867): 297-301.

3 For the persistence of these concerns throughout the latter half of the century, see Thomas Gambier Parry, 'Whitewash and Yellow Dab.—No. V.', *Ecclesiologist*, 21 (April 1860): 78-82, and 'On Architectural Painting', *Builder*, 23 (30 September 1865): 686-8; Edward Armitage, 'Mural Painting', *Architect*, 19 (8 June 1878): 339-40; Lewis F. Day, 'The Place of Pictures in the Decoration of a Room', *Magazine of Art*, 4 (1881): 319-23; Margaret Armour, 'Mural Decoration in Scotland', *Studio*, 10 (March 1897): 100-3. See also Helen Elizabeth Smith, *Decorative Painting in the Domestic Interior in England and Wales, c. 1850-1890* (New York and London: Garland Publishing, 1984).

4 Detailed drawings and verbal notations in Nesfield's French sketchbooks attest to his acute sensitivity to the forms and colours employed in the decoration of medieval churches (WEN, [12, 15-16, 18], RIBA).

5 Burges referred to Nesfield's illustrations of these artefacts in *Art Applied to Industry* (London: Parker and Co., 1865), 71. For Burges's debt to medieval French furniture, see Charles Handley-Read, 'Notes on William Burges's Painted Furniture', *Burlington Magazine*, 105 (November 1963): 496-509.

6 Among them were Moore's comrades from the RA Schools, Simeon Solomon and Henry Holiday, and his brother Henry's friend, Frederick Smallfield—at 31 among the eldest of Burges's crew of painters. Other collaborators included Edward Coley Burne-Jones, Edward John Poynter, Dante Gabriel Rossetti, Nat Hubert John Westlake and William Frederick Yeames. For a full list, see Handley-Read, 'Notes on William Burges's Painted Furniture', 503-4; J. Mordaunt Crook, *The Strange Genius of William Burges: 'Art-Architect'* (Cardiff: National Museum of Wales, 1982), B.6.

7 Marks, *Pen and Pencil Sketches*, 1: 219-20; see also Holiday, *Reminiscences*, 74. Burges's drawings for the bookcase are discussed in Handley-Read, 'Notes on William Burges's Painted Furniture', 501, and Crook, *The Strange Genius of William Burges*, B.1. For Burges's personal and professional involvement with artists, see Smith, *Decorative Painting*, 53-61.

8 Burges believed that unless an architect 'can give small drawings sufficient to show what groups or figures he wants … he only knows one half of his profession' (*Art Applied to Industry*, 112).

9 Burges urged Gothic Revivalists to 'do what they did in the Middle Ages, and not neglect antiquity, but press it into our service' ('Pagan Art', *Builder*, 20 [24 May 1862]: 368; see also *Ecclesiologist*, 18 [August 1857]: 205-14; 'What was Done by the Greeks and What is Done by the Present Classic (?) [sic] School', *Builder*, 20 [14 June 1862]: 246-7).

10 This aspect of Burges's art is discussed in E.W. Godwin, 'The Home of an English Architect', *Art Journal*, 48 (1886): 170.

11 Saint, *Richard Norman Shaw*, 18.

12 James Forsyth, 'William Eden Nesfield', *Architectural Association Notes*, 16 (August 1901): 111. For examples of Nesfield's copiously illustrated correspondence, see *The Deuce of an Uproar: William Eden Nesfield's Letters to the Rector of Radwinter in Essex* (Saffron Walden, Essex: Friends of Radwinter Church, 1988).

13 For a thumbnail sketch inscribed 'glazing of a cottage window/ A. Moore del.' on the back of an enveloped addressed to Moore at Stonethwaite, near Borrowdale, see WEN [13], f. 27, RIBA.

14 Nesfield also designed several lodges and cottages at Shipley (Hebb, 'William Eden Nesfield', 398; Jones, *The Work of William Eden Nesfield*, 23-5).

15 Stephen Glover, *The History of Ilkeston*, 3rd edn. (Ilkeston: Moorley's Bible and Book Shop, 1970), 33-6.

16 The border is now in the York City Art Gallery. The dairy had been stripped of its stained glass and tiles by the 1950s, when it was reported that the glass would be returned following restoration and that the central font had been saved (Nikolaus Pevsner, *Derbyshire*, The Buildings of England series, rev. edn. [Harmondsworth: Penguin, 1953], 317). Derelict and vandalized by the 1970s (Saint, *Richard Norman Shaw*, 18), the dairy underwent meticulous restoration in the 1980s (documented by architectural drawings at Shipley Country Park and a photograph in Jones, *The Work of William Eden Nesfield*). It has been much altered by the present owner. I am grateful to Kathryn Wilson, John Thompson, and Beverley Rhodes of Shipley Country Park for enabling me to see the dairy and for discussing its decoration with me.

17 In addition to designing alterations to the Hall (1863-6) which were never carried out, Nesfield built the estate laundry (1864-5); see Jones, *The Work of William Eden Nesfield*, 18-23. I am grateful to Lisa Murray of Croxteth Hall & Country Park for showing me the dairy and discussing its decoration and operation with me.

18 Brydon, 'William Eden Nesfield, 1835-1888', 242. The walls of the dairy have also been described as covered with mosaic panels (Hebb, 'William Eden Nesfield', 397).

19 The only ceiling decorations to survive at Croxteth are four iron lotus blossoms in the central section, and stylized floral roundels and heraldic cross-moline devices on the beams (derived from the Molyneux coat of arms). These reflect Nesfield's developing interest in heraldic and Japanese ornament and probably have nothing to do with Moore.

20 L'Aigle-Cole, 'Walks on the Croxteth Estate', *Liverpool Daily Post* (17 November 1903), 7.

21 Baldry identified these drawings as designs for tiles (*Albert Moore*, 1). Extant examples, handpainted on Minton, Hollins & Co. earthenware (15.2 x 15.2 cm),

are repro. in Ronald G. Pisano, *The Tile Club and the Aesthetic Movement* (New York: Harry N. Abrams, in association with the Museums of Stony Brook, 1999), 74-5. For an ambiguous suggestion that Moore may have designed tiles for William Morris's firm, see John William Mackail, *The Life of William Morris*, 2 vols. (London: Longmans, Green & Co., 1922), 1:158.

22 N.H.J. Westlake and W. Purdue, *The Illustrations of Old Testament History in Queen Mary's Psalter* (London: Joseph Masters and Co., Oxford: John Henry and James Parker, 1865); see also 'Westlake's Illustrated Old Testament History', *Ecclesiologist*, 20 (February 1859): 43 and (December 1859): 415-16.

23 A replica of the dairy was reportedly erected in Potsdam at the palace of the Crown Princess of Prussia, afterwards the Empress Frederick, who had admired the dairy during a visit to Croxteth (Hebb, 'William Eden Nesfield', 397). The origins of the nineteenth-century model farm are discussed in John Martin Robinson, *Georgian Model Farms: A Study of Decorative and Model Farm Buildings in the Age of Improvement* (Oxford: Clarendon Press, 1983).

24 'International Exhibition. Carved Gothic Stonework', *Building News*, 8 (27 June 1862): 444; Robert Hunt, *Handbook to the Industrial Department of the International Exhibition, 1862*, 2 vols. (London: Edward Stanford, 1862), 1: 336; J.B. Waring, *Masterpieces of Industrial Art and Sculpture at the International Exhibition, 1862*, 3 vols. (London: Day and Son, 1863), 1: Pl. 2.

25 Colvin, 'English Painters of the Present Day', 4.

26 I have been unable to determine whether Slater, a well-known Gothic Revivalist, was related to the Edward Slater of Guilford Street whose daughter married Moore's elder brother William in 1853.

27 'International Exhibition. Carved Gothic Stonework', *Building News*, 8 (27 June 1862): 444.

28 Burges, 'The International Exhibition,' *Gentleman's Magazine*, 212 (June 1862): 668-9; 'The Late Exhibition', 337; see also 'Pagan Art', 368.

29 The first monthly instalment had been issued during the summer of 1860 (*Builder*, 18 [28 July 1860]: 486).

30 The design shows four male figures—an Egyptian (labelled 1500 BC), a Greek (500 BC), a Roman (30 BC), and a medieval man (1199 AD)—approaching an enthroned female figure symbolic of Architecture. For the original drawings, see WEN [15], f. 2 and [14], f. 174, RIBA.

31 William Niven, *Illustrations of Old Warwickshire Houses* (London: Chiswick Press, 1878), 19; Robin Moore, *A History of Coombe Abbey* (Coventry; Jones-Sands Publishing, 1983), 76-80.

32 Baldry, *Albert Moore*, 28-9.

33 For the various problems associated with fresco painting in Britain, see: Thomas Gambier Parry, 'Wall-Painting Versus English Climate', *Ecclesiologist*, 23 (June 1862): 134-42; Edward Wilberforce, 'Modern Fresco Painting', *Edinburgh Review*, 123 (January 1866): 1-34; 'Can Fresco-Painting be Acclimatized in England?', *Building News*, 15 (3 April 1868): 221-2; Alfred Lys Baldry, *Modern Mural Decoration* (London: George Newnes Ltd., 1902), 16-37. For recent summaries of the nineteenth-century literature, see: Smith, *Decorative Painting in the Domestic Interior*; Peter Burman, 'Thomas Gambier Parry. An Introduction' and Tracy Manning, 'The "Spirit Fresco" Technique and its Historical Context' in Dennis Farr, ed., *Thomas Gambier Parry (1816-1888)* (London: Courtauld Institute Galleries, 1993).

34 Moore, *A History of Coombe Abbey*, 91.

35 A similar processsional subject ornamented the dining room chimney piece at Cloverley Hall, another Nesfield project to which Moore contributed decorative designs (repro. Brydon, 'William Eden Nesfield', 284).

36 'Gothic Art in the International Exhibition', *Building News*, 8 (9 May 1862): 319-20.

37 Baldry, *Albert Moore*, 29.

38 The shrouded figure of 'January' and the wind-tossed 'March' anticipate his paintings *Sea-gulls* and *Shells* (Pls. 71, 115), while 'September' and 'October', plucking fruit and arranging flowers, call to mind *Azaleas* and *A Garden* (Pls. 90, 103).

39 For further details of Nesfield's commission, see Jones, *The Work of William Eden Nesfield*, 32-62.

40 C.L. Eastlake, *A History of the Gothic Revival* [orig. pub. 1872] (Watkins Glen, New York: American Life Foundation, 1979), 342; see also Forsyth, 'William Eden Nesfield', 110. The carvings were removed from the building prior to its demolition and are still extant at Cloverley. Although each figure is labelled with the name of a month of the year, the panels were interpreted by both Eastlake and Forsyth as 'The Seasons'. Forsyth also executed carved panels illustrating Aesop's fables for the chimneypiece in the Great Hall (Brydon, 'William Eden Nesfield', 242).

41 The mother, infant, and child at far left in the frieze above the fireplace anticipate Moore's later watercolour *Caritas* (Pl. 188), which Baldry identified as a design for stained glass (*Albert Moore*, xii).

42 Eastlake, *History of the Gothic Revival*, 341.

43 The same order book contains the notation 'Mr. Poynter can recommend a young artist to draw subjects, April 11, 1863'; see *Window glass order book* (May 1860-January 1870), James Powell & Sons Stained Glassmaking Records, AAD 1/2-1977, V&A.

44 *Window glass cash book* (Jan. 1862-June 1864), AAD 1/53-1977, 163, V&A; see also: Martin Harrison, *Victorian Stained Glass* (London: Barrie & Jenkins, 1980), Pl. 15; Julian Orbach, *Victorian Architecture in Britain* (London: A & C Black, 1987), 330. For Scott-Chad, see Derek Hudson, ed., *Munby, Man of Two Worlds: The Life and Diaries of Arthur J. Munby, 1828-1910* (London: John Murray, 1972), 74, 300.

45 Moore would have received about 15s. per square foot for his cartoons. Powell's prices and procedures are described in William Burges, 'As to Stained Glass', *Builder*, 19 (31 August 1861): 598. The price of ruby glass, used extensively in the background of Moore's window, had fallen dramatically by the 1860s (Clement Heaton, 'Stained Glass: Ancient and Modern', *Building News*, 12 [17 February 1865]: 125). It has been suggested that the window contains a superior grade of 'Antique' glass rather than the coarse machine-made product that often marred Powell's windows (Harrison, *Victorian Stained Glass*, 13-14, 45) but the firm's account book makes no note of this.

46 Knowles, *York School of Design*, 20: 85. York contains as much as three-quarters of all medieval glass surviving in England (Fred Harrison, *The Painted Glass of York* [London: Society for Promoting Christian Knowledge, 1927], 2; see also 'York Artist Glaziers', *Annual Report of the Council of the Yorkshire Philosophical Society for 1914* [1915], 186-9).

47 Harrison, *Victorian Stained Glass*, 15-26.

48 Unfortunately, Pevsner misattributed the window to 'the almost unknown Rev. *Arthur Moore*' (*North-East Norfolk and Norwich* [Harmondsworth: Penguin Books, 1962], 332, 681).

49 G.R.G., 'Some Remarks on Glass Painting', *Ecclesiologist*, 19 (December 1858): 357; 'Stained Glass Windows', *Builder*, 18 (17 March 1860): 175; Heaton, 'Stained Glass: Ancient and Modern', 125-6.

50 As a rule, artists employed by Powell's supplied coloured cartoons which the firm endeavoured to replicate faithfully (William Burges, 'As to Stained Glass', 598 and 'The Late Exhibition', 338; Henry Holiday, *Stained Glass as an Art* (London: Macmillan and Co., 1896), 19-20.

51 For the failure of much Victorian stained glass in this respect, see Herbert Edward Read, *English Stained Glass* (London and New York: G.P. Putnam's Sons, 1926), 222-4.

52 The window, installed in 1864 as a memorial to Mary Hartley of Fulford Grange, York, was removed in 1958 prior to demolition of the east end of the building. In 1992 it was restored by the York Glazier's Trust and inserted into the north ambulatory wall of the church (information from archives of Bradford Cathedral).

53 Mackail, *The Life of William Morris*, 2: 44-5; May Morris, *William Morris: Artist, Writer and Socialist*, 2 vols. (New York: Russell & Russell, 1966), 1: 26-7. William Richard Lethaby believed that Morris underestimated his own skills in figure drawing and noted that his cartoon for a figure of Artemis was 'strangely akin to the single figures of Albert Moore' (*Philip Webb and His Work* [London: Raven Oak Press, 1979], 34).

54 Although Baldry described Moore's late pastel *Caritas* (Pl. 188) as a design for a memorial window, there is no evidence that it was ever executed. For a contemporary window of similar design at Bingley Church, Yorkshire, executed by Henry Holiday, see his *Stained Glass as an-Art*, 57.

55 Holiday, *Reminiscences*, 76-7, 94-7; Harrison, *Victorian Stained Glass*, 45, 52; Paul Thompson, *The Work of William Morris* (Oxford and New York: Oxford University Press, 1991), 147-8. Burne-Jones testified in 1878 that he had 'known Mr. Albert Moore for many years' (Merrill, *A Pot of Paint*, 176).

56 The Scottish glass designer Stephen Adam recommended Moore's drawing style as a model in *Stained Glass, its History and Modern Development* (Glasgow: Maclehose, 1877), 27. Harry Ellis Wooldridge, a protégé of Holiday and Burne-Jones, 'is perhaps best seen as stylistic inheritor of Albert Moore'. He designed Thursford's north and south chancel windows for Powell's in 1873, and two of his cartoons for another project were misattributed to Moore in the Powell's sale at Sotheby's (Belgravia) 23 March 1976 (Harrison, *Victorian Stained Glass*, 52-6; fig. 57).

57 'Burning of the Dutch Church, Austin Friars', *Building News*, 9 (28 November 1862): 419. The church was ultimately destroyed during an air raid in October 1940.

58 *Ecclesiologist*, 24 (1863): 119; *Building News*, 9 (3 April 1863): 263.

59 *Ecclesiologist*, 24 (1863): 212-13, 235-7; F.S.A., 'Austin Friars' Church', *The Times* (13 July 1863), 10; George Gilbert Scott, 'The Threatened Demolition of the Church of Austin Friars', *The Times* (23 July 1863), 7.

60 In a letter of 20 November 1871 to W.S. Kershaw, John Hebb explained Moore's intention that the Passover be balanced on each side by panels representing the Destroying Angel on the night of the smiting of the firstborn in Egypt (Z1/64, RIBA).

61 Institute of British Architects, 'The Restoration of the Dutch Church, Austin Friars', *Building News*, 13 (2 February 1866): 64. See also 'The Architectural Exhibition', *Builder*, 23 (13 May 1865): 332; 'The Church of the Augustine Friars, Old Broad Street, London', *Builder*, 23 (20 May 1865): 354; John Hebb, 'Albert Moore and the "D.N.B."', *Notes and Queries*, 8, 10th ser. (20 July 1907), 46-7; Johannes Lindeboom, *Austin Friars: History of the Dutch Reformed Church in London, 1550-1950* (The Hague: Martinus Nijhoff, 1950), 11-80. Baldry claimed that financial as well as doctrinal concerns prompted the sudden abandonment of the scheme (Baldry, *Albert Moore*, 15), but it is difficult to imagine that Moore's fresco would have had much impact on the £13,097 cost of restoration.

62 The full title of the picture (generally known as *Somnus*) is recorded in Stirling, *Richmond Papers*, 184. In 1868 Richmond painted a fresco of the same subject on the ceiling of an inn in Assisi (Reynolds, *William Blake Richmond*, 67).

63 Baldry, *Albert Moore*, 35, 102. See also black and white chalk studies for the seated figure at far left (Baldry, *Albert Moore*, opp. 88) and the reclining figure at far right (23.5 x 41.2 cm, 1906-7-19-6, British Museum).

64 For Clarke's Gothic Revival buildings in the vicinity of Rochdale, see 'Laying of the Foundation Stone of St. Alban's Church, Rochdale', *Rochdale Sentinel* (15 July 1854); 'Rochdale', *Builder*, 14 (23 February 1856): 105; 'New Parsonages', *Ecclesiologist*, 24 (1863): 129; 'Church Restorations', *Ecclesiologist*, 25 (June 1864): 183; H. Harrison, *Historical Sketch for the Jubilee of the Parish and Church of St. Alban, Rochdale, 1856-1906 AD* (1906), Rochdale Local Studies Library.

65 'Stained Glass,' *Builder*, 21 (14 March 1863): 193; 'Fresco Decorations of S. Alban's Rochdale', *Ecclesiologist*, 25 (June 1864): 154-5; Nikolaus Pevsner, *South Lancashire* (Harmondsworth: Penguin Books, 1969), 35, 380; Harrison, *Historical Sketch for the Jubilee*, 9, 10, 17, 18; and *Parish and Church of St. Alban, Rochdale, Centenary, 1856-1956* (Rochdale: privately printed, 1955), 29, 31, 35, Rochdale Local Studies Library. Nield's extensive collection of paintings and sculpture was sold at Christie's, 3 May 1879.

66 For a detailed description of the proposed decoration, see 'St. Alban's Church, Rochdale', *Builder*, 21 (29 August 1863): 620.

67 For the cost of the chancel paintings, see: 'Mural Painting', *Architect*, 19 (8 June 1878): 344. The Birmingham glassmaker John Hardman & Co. produced the east window, the stone carving was by Joseph Bonehill of Manchester, and some of the wood carving was by H. Ringham of Ipswich ('Rochdale', *Builder*, 14 [23 February 1856]: 105).

68 *Building News*, 9 (3 April 1863): 263.

69 'Ecclesiological Society', *Ecclesiologist*, 25 (June 1864): 173; see also 'Fresco Decorations of S. Alban's, Rochdale,' 154. Two months later Moore's work at Rochdale was singled out as evidence that 'polychromatic decoration is in a more hopeful state' ('Twenty-fifth Anniversary Meeting', *Ecclesiologist*, 25 [August 1864]: 214).

70 The other nine painters mentioned by Rossetti were Leighton, Millais, Prinsep, Solomon, Edward Armitage, John Phillip, Frederic Sandys and John Roddam Spencer-Stanhope (W.M. Rossetti, 'The Royal Academy Exhibition', *Frasers*, 70 [July 1864]:

62-3).

71 The churchwardens' account book records the completion of Moore's painting at Rochdale in 1865 (Harrison, *Historical Sketch for the Jubilee*, 7). It thus appears that the work began and finished a year earlier than previously thought (cf. Baldry, *Albert Moore*, 31). In addition to the works already described, Moore carried out *Christ with a Vine* and *John the Baptist* on the north side of the chancel and the *Emblems of the Four Evangelists* on the upper east wall. For a discussion of the iconography, see 'Fresco Decorations of S. Alban's, Rochdale', 154-5.

72 Armitage, 'Mural Painting', 339.

73 Godwin, 'The Architectural Exhibition', 336.

74 Moore's full-scale charcoal and red chalk cartoons are D.3-1906 to D.8-1906, V&A. See also a black and white chalk drapery study, repro. Baldry, *Albert Moore*, opp. 92.

75 Godwin, 'The Architectural Exhibition', 336.

76 Thomas Armstrong loaned these drawings to the South Kensington Museum in October 1898 for use by the Royal College of Art, and sold them to the museum for £60 on 22 February 1901 (Armstrong's nominal file, V&A; Grafton 1894, nos. 224, 231).

77 Baldry, *Albert Moore*, 31

78 For the resulting condition problems, see Malcolm A. Hay, 'The Westminster Frescoes: The Restoration of the Victorian Murals', *Apollo*, 135 (May 1992): 307-11.

79 'Mural Painting', *Architect*, 19 (8 June 1878): 344.

80 The churchwardens' account book of that year records that Moore's frescoes in the chancel and on each side of the east window had almost disappeared. Restoration was deemed unfeasible and they were painted out. *The Last Supper* also deteriorated over the years, and in 1955 it was repainted by Eric Griffiths, a server of the church (Harrison, *Historical Sketch for the Jubilee*, 9; *Parish and Church of St. Alban, Rochdale, Centenary*, 31; Hebb, 'Albert Moore and the "D.N.B."', 47).

81 Between 1857 and 1869 J.C. Moore painted the families of Thomas Percival Heywood, Henry Robinson Heywood and Arthur Henry Heywood, along with other Heywood relations (Algernon Graves, *The Royal Academy of Arts: A Complete Dictionary of Contributors*, 8 vols. (New York: Burt Franklin, 1972), 5: 286; Hilda Margaret Heywood, *Reminiscences, Letters, and Journals of Thomas Percival Heywood, Baronet* [Manchester: Thomas Fargie, 1899], 122; information from Moore family papers). For Oliver Heywood, see *Manchester Newspaper Cuttings (1880-1892)*, 2: 180-4, Local Studies Unit, Manchester Central Library.

82 Claremont entered the possession of the Heywood family in 1821; Thomas Heywood, *A Memoir of Sir Benjamin Heywood, Baronet. With Two Chapters of Domestic Life and Letters, 1840-1865* (Manchester: Thomas Fargie: n.d. [c.1875]), 34-6, 260, 262 and passim; 'Stately Homes of Salford, No. 5: "Claremont"', *Salford City Reporter*, 7 (October 1949), Salford Local History Library.

83 Richmond Papers, RI/1/30, RA. The letter provides the firmest evidence of the project's hitherto unknown commencement date. The proportions and immense dimensions cited by Richmond suggest a ceiling, and Claremont is the only ceiling Moore is known to have carried out at this time. However, a drawing possibly related to the project and dated 1865 suggests an even earlier inception (see n. 86). According to Baldry, Moore completed the project in

1867 (*Albert Moore*, 35, 102).

84 The connection between these drawings and the Claremont frescoes was first suggested by Richard Green (Newcastle 1972, no. 17). *Music*, Moore's cartoon for a frieze of dancing and piping female figures, may also relate to this project (D.247-1905, V&A). The situation is complicated by Thomas Armstrong's recollection in 1907 that Moore 'painted an octagonal vestibule at Claremont … for the late Sir Thomas Heywood, Bart., with small figure subjects in the middle of the panels (battledore and shuttlecock), and ornament on the rest' (Hebb, 'Albert Moore and the "D.N.B."', 317). See also note 3:172.

85 Between 1836 and 1868, a dozen sixth-century black-figure Athenian *hydriae* of this type entered the collection of the British Museum; H.B. Walters, *Corpus Vasorum Antiquorum. Great Britain. British Museum* (London: British Museum, 1931), fasc. 8, 8-10, nos. B329-38; B. Dunkley, 'Greek Fountain-Buildings before 300 BC', *Annual of the British School at Athens*, 26 (1939): 142-204. Leighton later based his celebrated painting *Captive Andromache* (1888) on the same artefacts (Robyn Asleson, 'On Translating Homer: Prehistory and the Limits of Classicism' in Tim Barringer and Elizabeth Prettejohn, eds., *Frederic Leighton: Antiquity, Renaissance, Modernity* [New Haven and London: Yale University Press, 1999], 76-8).

86 Pl. 60 is possibly identifiable as *Girl Carrying Pitcher. Draped Study, 1865*, a drawing formerly in the possession of Henry Holiday (Grafton 1894, no. 228).

87 Moore added, 'If the step should seem to you advisable as regards Mr. Murray I shall be much obliged if you will kindly ask him to call on me someday this week as I could give him a trial trip immediately.' Moore presumably meant a trip to Claremont (AJM to Charles Augustus Howell, Fitzroy Square, 14 November 1866, MA 3553, Pierpont Morgan Library).

88 Spanton, *An Art Student and his Teachers*, 63-83; Penelope Fitzgerald, *Edward Burne-Jones: A Biography* (London: Michael Joseph, 1975), 100. Though an inveterate collector, Murray showed little interest in Moore's works. Presumably from William Morris he obtained Moore's preparatory drawing for the window at Bradford (Pl. 35), and at William Connal's sale in 1908 he purchased *Elijah's Sacrifice* (Pl. 28) for 100 guineas but sold it immediately to the Bury Art Gallery.

89 Godwin, 'Painted Decoration. No. VIII', *Building News*, 13 (16 November 1866): 757.

90 'I can conceive few things in art more outrageous, more saddening—I may say more revolting', Godwin added, than to see bad architecture 'made the framework of wall painting such as Mr. Moore might do' ('Painted Decorations.—No. X', *Building News*, 14 (19 July 1867): 490-1).

91 'Art Cliques. No. IV', *Building News*, 12 (13 October 1865): 707. Indeed, the close working relationship that Nesfield enjoyed with Moore probably inspired Murray Marks's proposal for a new decoration firm modelled on Morris & Co., to be established in partnership with Nesfield and Richard Norman Shaw (WMR MS. diary, 22 October 1867, f. 966a, ADC/UBC).

92 Raymond Mander and Joe Mitchenson, *The Lost Theaters of London* (London: Rupert Hart-Davis, 1968), 358-9; Erroll Sherson, *London's Lost Theaters of*

the Nineteenth Century (London: John Lane, 1925), 201.

93 Godwin, 'Painted Decorations.—No. XI', *Building News*, 14 (18 October 1867): 716.

94 For Moore's fee, see Phipps's comments in 'Mural Painting', *Architect*, 19 (8 June 1878): 344, and excerpt from letter of Thomas Armstrong (19717/1901), Objects File, no. 249-1902, V&A. Moore's engagement in the project is mentioned in Sidney Colvin, 'English Painters and Painting in 1867', *Fortnightly Review*, 8 (1 October 1867): 473.

95 Lionel Lawson claimed that the painting (249-1902, V&A) was violently ripped from its backing boards during the theatre's conversion into the Clerical Co-Operative Stores in April 1878. By 1894, according to Baldry, 'The colour has almost entirely peeled from the canvas and it is only at one end of the panel that any distinct traces of the design are left'. In 1901 Henry Labouchere gave the wrecked canvas to Baldry, who donated it to the South Kensington Museum. E.J. Lambert restored it in October 1902, but the museum's director, Thomas Armstrong, restricted him 'to the filling in of fresh color where the original paint had come away', noting that 'in some places there was very little of the original color left'. New conservation work was carried out in 1981. See extract from report of T. Armstrong, 28 October 1902, Objects file, no. 249-1902, V&A; Baldry, *Albert Moore*, 36; 'The Queen's Theatre—Past and Present', *Illustrated Sporting and Dramatic News* (20 September 1879): 8; Walker, 'Private Picture Collections', 363.

96 J.M. Swan to A.L. Baldry, Objects File, No. 249-1902, V&A.

97 In addition to Pl. 68, extant nude cartoons (in black chalk, pricked for transfer) include D.230-1905 to D.233-1905, V&A.

98 Citation of Thomas Armstrong (19177/1901), Objects File, No. 249-1902, V&A.

99 The medium may have been suggested by the scene painter William Telbin (1813-73), whom Phipps commissioned to create a drop curtain to harmonize with Moore's painting. It showed a large medallion filled with a Greek temple set in a classical landscape (Geoffrey Ashton, *Catalogue of Painting at the Theatre Museum* [London: Victoria and Albert Museum, 1992], 62; Ellen Terry, *The Story of My Life*, 2nd edn. [London: Hutchinson & Co.], 1912], 69). Telbin was an authority on tempera, which he purchased, pre-ground, at Brodie's in Long Acre (George Somes Layard, *The Life and Letters of Charles Keene* [London: Sampson Low, Marston and Company, 1893], 95-6).

100 Excerpt from letter of Thomas Armstrong (19717/1901), Objects File, no. 249-1902, V&A.

101 Unaided by the inscriptions, a critic for the *Morning Advertiser* reported on 25 October 1867 that Moore had painted 'a fine scene from the "Antigone"'. See similar error in Ashton, *Catalogue of Paintings at the Theatre Museum*, 62-3.

102 In Moore's day, a plaster cast of the Louvre sculpture (Pl. 65) was inserted in sequence within the original Parthenon frieze at the British Museum. A new mould was made for the museum in 1872 (C.T. Newton to the Trustees of the British Museum, 10 July 1872 Original Letters and Papers, v. 21, f. 348; see also Minutes of Committee Meeting, 13 July 1872, C.12496-7, British Museum Central Archives; Ian Jenkins, *Archaeologists and Aesthetes in the Sculpture Galleries of the British Museum 1800-1939* [London: British Museum Press, 1992], 81-2, 99).

103 Alexander Stuart Murray, 'Archaeology', *Encyclopaedia*

Britannica, 9th edn. (Philadelphia: J.M. Stoddart & Co., 1875), 2: 313-14.

104 Godwin, 'Painted Decorations.—No. XI', 716, and Anon., 'The New Queen's Theatre, Long Acre', *Building News*, 14 (18 October 1867): 716, 719-20.

105 Godwin, 'Painted Decorations. —No.XI', 716-17.

106 The writer added ironically, 'The only alternative would be to suppose that some one had altered Mr. Moore's suggestions or drawing, a course so impertinent that it is impossible to suppose anyone could be guilty of it' (A.Z., 'Mr. Moore's Decorations', *Building News*, 15 [29 May 1868]: 368). A previously published review had taken a contrary view of the colour scheme, stating that 'The architects who favour strong colours and violent contrasts, whose eyes can rest well pleased on vermilion furniture and yellow walls, will very naturally oppose Mr. Moore's scheme and call it weak and washy' ('The Architectural Exhibition', *Building News*, 15 [1 May 1868]: 287).

107 Albert Moore, 'Mr. Moore's Decorations', *Building News*, 15 (5 June 1868): 385.

108 Hart also expressed his indignation in a private letter to Phipps (*Building News*, 15 [5 June 1868]: 385). Prior to bringing Phipps and Moore together, Godwin had published an account of a similar incident in which an architect had treated a painter 'with somewhat less consideration than he would treat the bricklayer' and passed off his original sketches as his own productions (Godwin, 'Painted Decorations.—No. X', 490; see also 'Mr. Moore's Decorations', *Building News*, 15 (26 June 1868): 438.

109 *Building News*, 15 (19 June 1868): 423.

110 *Building News*, 15 (26 June 1868): 438-49.

111 *Building News*, 15 (3 July 1868): 457.

112 'The Architectural Exhibition, Conduit-Street', *Building News*, 15 (26 June 1868): 427.

113 Henry Cole Diaries, V&A.

114 Baldry, *Albert Moore*, 15.

115 Among the seven professionals were Poynter, Marks and Yeames who had collaborated with Moore on Burges's bookcase earlier in the decade (see above, p. 210, n. 6). The others were Edward Armitage, John Callcott Horsley, Frederick Richard Pickersgill and the sculptor Henry Hugh Armstead; see *Survey of London: The Museum Area of South Kensington and Westminster*, 42 vols. (London: The Athlone Press, 1975), 38: 189-90; Ronald W. Clark, *The Royal Albert Hall* (London: Hamish Hamilton, 1958), 45-6.

116 Edward M. Barry to A.H. Layard, 4 January 1869, and Barry to George Russell, 21 October 1869, PRO/Works; E.J. Poynter to Layard, 23 September 1869, Layard Papers, Add. MS. 38,996, f. 403, British Library; Thomas Wilson, *Historical Notes on the Mosaics at the Palaces of Westminster* (London: privately printed, 1926); M.H. Port, ed., *The Houses of Parliament* (New Haven and London: Yale University Press, 1976), 180; *Hansard's Parliamentary Debates*, 3rd series (London: Cornelius Buck, 1869), 179: 682-3, 1433-4.

117 James Fergusson to AJM [17 Fitzroy Square], 6 January 1869, PRO/Works. The £100 remuneration was evidently low. Questioned in the Commons, Layard confessed that 'he was almost ashamed to tell the House what he was paying these gentlemen for making their cartoons; but there was no doubt that the honour of taking part in the decoration of the Houses of Parliament was itself of some value' (*Hansard's Parliamentary Debates*, 1434). Poynter later recalled, 'At the time I did the St George I was a beginner and I did it for a sum for which I should not undertake them now' (Letter of 20 April 1896 to F.G. Stephens, MS. Don.e.85, f. 194, Bodleian Library, Oxford).

118 AJM to Fergusson, 17 Fitzroy Street, 13 January 1869. Poynter and Prinsep had received letters the same day as Moore (6 January), but Leighton was not contacted until 12 January (PRO/Works).

119 Poynter to Fergusson, 7 May 1869. Leighton submitted what he considered 'a very rough sketch' on 3 June (PRO/Works).

120 To ensure that the mosaics harmonized with each other and with their setting, Fergusson reiterated the requirement of a gold background and added that the cartoons were 'to be coloured to at least such an extent as to leave the mosaicist in no uncertainty as to what is intended' (draft letters to Poynter and AJM, 17 June 1869, PRO/Works).

121 Barry to Fergusson, 22 June 1869, and AJM to Layard, 17 Fitzroy Street, 23 June 1869, PRO/Works.

122 Fergusson to AJM [17 Fitzroy St.], 30 June 1869, and AJM to Layard, 17 Fitzroy St., 1 July 1869; see also Poynter to Layard, 1 July 1869, PRO/Works. *St Patrick*, the companion to Pl. 70, is also at the PRO (Kew). A more finished pair, inscribed with the names of the principal figures, was deposited with the V&A by the Department of Works in 1893 (Newcastle 1972, nos. 26-7).

123 Office of Works and Buildings, Whitehall, to AJM [17 Fitzroy Street], 10 August 1869, PRO/Works. Edward Oldfield to Layard, 17 August 1869, Layard Papers, Add. MS. 38,996, f. 372, British Library.

124 Moore had indeed been 'publicly named' as a participant in the mosaic scheme and his work was eagerly anticipated. J.B. Atkinson noted, 'It must be confessed that few of our artists are better trained in schools of strict monumental decoration than Mr. Moore' ('The London Art Season', *Blackwood's Magazine*, 106 [August 1869]: 225). The reasons for his exclusion ultimately leaked out. In a review of the 1870 RA exhibition, one critic stated, 'It may be remembered that Mr. Poynter and Mr. Moore … were at first associated in a joint commission for the Salviati mosaics. In the opinion of Mr. Layard, however, Mr. Moore's manner proved too classic for a Gothic interior, and therefore the whole work was entrusted to Mr. Poynter' ('The Royal Academy', *Art Journal*, 32 [1 June 1870]: 171).

125 Moore also observed that 'the designs do, in fact, correspond more than could have been expected, in case of two artists being employed' (AJM to Layard, 14 August 1869, PRO/Works).

126 Oldfield to Layard, 17 August 1869, Layard Papers, Add. MS. 38,996, f. 372, British Library.

127 Oldfield to Layard, 17 August, Add. MS. 38,996, f. 372, British Library. Layard to Oldfield, 22 August 1869; see also Office of Works and Buildings to AJM, 27 August 1869, PRO/Works.

128 *The Times* (28 June 1871), 9, quoted in Port, *The Houses of Parliament*, 81; Leighton referred to Ayrton as 'that impudent prig', adding 'I have a hope he may prove a kind of reductio ad absurdum of the whole system and lead to a better state of things— He will sicken everybody' (Leighton to Layard, n.d. [c. October 1869], see also Barry to Layard, 25 October 1869, Layard Papers, Add. MS. 38,997, ff. 39-40, 167, British Library; William Napier Bruce, ed., *Sir A. Henry Layard*, 2 vols. [London: J. Murray, 1903], 2: 257-63; Gordon Waterfield, *Layard of Nineveh* [New York and Washington: Frederick A. Praeger, 1963], 308-13).

129 J. Willis to Lords Commissioners of her Majesty's Treasury, 18 November 1869; Office of Works and Buildings, Whitehall, to AJM [3 Red Lion Square], 29 December 1869, and replies of 30 November, 1 December and 9 December 1869; AJM to Ayrton, 3 Red Lion Square, 3 December 1860 and replies of 7 December and 29 December 1869, PRO/Works. By this date Poynter had agreed to execute alternative designs for Saints Andrew and Patrick, but he doubted Ayrton would honour the commission (MS. Don.e.85, ff. 193-4, Bodleian Library). Baldry attempted to generate interest in executing Moore's cartoons (*Albert Moore*, 39, and *Modern Mural Decoration*, 56-7). He may also have written a scathing (and rather misleading) summary of the Government's negligence, illustrated by Moore's cartoons ('Studio-Talk', *Studio*, 19 [May 1900]: 262). Not until the 1920s were the Andrew and Patrick panels added, based on designs by Robert Anning Bell.

130 Leighton to Layard, Saturday n.d. [c. October 1869], Layard Papers, Add. MS. 38,997, f. 167, British Library.

CHAPTER THREE

1 Colvin, 'English Painters of the Present Day', 4.

2 'Royal Academy', *Athenaeum*, no. 1959 (13 May 1865): 658. In the view of another critic, Moore 'by his eccentricities, excited curiosity, and raised expectations not wholly unfavourable' ('The Royal Academy. Introduction', *Art Journal*, 28 [1 June 1866]: 164).

3 The painting is unlocated. For two related studies, see Newcastle 1972, no. 11, and letter of Cecil French, 2 August 1952, York City Art Gallery.

4 'Royal Academy Exhibition. Fourth Notice', *The Times* (24 May 1865), 6; 'Royal Academy', *Athenaeum*, no. 1959 (13 May 1865): 658; 'The Royal Academy Exhibition (Second Notice)', *Saturday Review*, 19 (27 May 1865): 635. In addition to the pair of seated goddesses, Moore adapted the flanking figures on either side, as well as the reclining *Ilissos* of the west pediment.

5 Jerome J. Pollitt, *The Art of Ancient Greece: Sources and Documents* (Cambridge: Cambridge University Press, 1990), 230-1.

6 Rossetti pronounced it 'the most conspicuously successful picture, whether classical or otherwise, in the whole exhibition'. He prefaced these remarks by noting the rising interest in classicism among young painters: 'The treatment of a mythologic, a Greek, or a Roman subject, has ceased to be regarded as a specialty proper to the votaries of academic "high art", and is taken up by some of our younger painters in a spirit, to a great extent, unconventional and hopeful—a spirit which, recognising the ideal requirements of the subjects, does not lose sight of the nature, and still less of the pictorial qualities, which are indispensable for interesting or living pictures' ('The Royal Academy Exhibition', *Fraser's Magazine*, 71 [June 1865]: 743-4).

7 Daphne du Maurier, ed., *The Young George du Maurier: A Selection of his Letters, 1860-67* (London: Peter Davies, 1951), 235-6.

8 Herbert M. Schuller and Robert L. Peters, eds., *Letters of John Addington Symonds*, 3 vols. (Detroit: Wayne State University Press, 1968), 2: 26. Solomon

fled England under a cloud of suspicion in 1866 and again in 1870. His arrest in 1873 for indecent exposure and attempted sodomy in a public urinal resulted in social exile (WMR MS. diary, 15 February 1867, folder 15-1, ff. 897, 954, ADC/UBC; Seymour, *Life and Work of Simeon Solomon*, 164-205).

9 Simeon Solomon's drawings of nude youths may also have influenced Moore (for example, Pls. 13, 16, 36, 37, 39, 40 in Simon Reynolds, *The Vision of Simeon Solomon* [Stroud, Gloucestershire: Catulpa Press, 1984]), but these overtly erotic images merely reconfirm the two artists' very different interpretation of similar materials.

10 For recent discussions of the rise of 'effeminate' male nudity in Victorian art, see Alison Smith, *The Victorian Nude: Sexuality, Morality, and Art* (Manchester and New York: Manchester University Press, 1996), 135-42, 173-85; Richard Dellamora, *Masculine Desire: The Sexual Politics of Victorian Aestheticism* (Chapel Hill and London: University of North Carolina Press, 1990), passim; cf. Athena Leoussi, *Nationalism and Classicism: The Classical Body as National Symbol in Nineteenth-century England and France* (New York: St. Martin's Press, 1998), 144-54.

11 Lang, *Swinburne Letters*, 2: 33-5.

12 See above, p. 89.

13 The RA catalogue quoted only a few of the bride's words: 'I charge you, O daughters of Jerusalem, if ye find my beloved, that ye tell him, that I am sick of love … My beloved is white and ruddy, the chiefest among ten thousand' (Song of Solomon 5: 8).

14 For a summary, see Edward Morris, *Victorian and Edwardian Paintings in the Walker Art Gallery and at Sudley House* (London: HMSO, 1996), 308, note 1.

15 *Love Amongst the Schoolboys* (1865), for example, translates Moore's audience of chaste women into a bevy of languishing boys; see also *A Prelude by Bach* (1866), *A Prelude by Bach* (1868), *A Youth Relating Tales to Ladies* (1870) (repro. Reynolds, *The Vision of Simeon Solomon*, Pls. 3, 38, 41, 56); *The Little Improvisatrice*, 1867 (Christies, 4 June 1982 [59]).

16 The watercolour (measuring 14 x 33 cm) is in the Walker Art Gallery, Liverpool.

17 One warned that Moore worked 'in so novel a style that the artist must expect some time to pass before it is popularly mastered' ('Royal Academy', *Athenaeum*, no. 2104 [2 June 1866]: 742). Another commented less charitably that 'the artist's latest manifesto … has no beauty or charm to recommend its singularity' ('The Royal Academy. Introduction', *Art Journal*, 28 [1 June 1866]: 164). See also 'Fine Arts. Exhibition of the Royal Academy', *Illustrated London News* (19 May 1866), 498.

18 'Exhibition of the Royal Academy (Second Article),' *The Times* (22 May 1866), 12; Colvin, 'English Painters and Painting in 1867', 474. See also: 'Exhibition of the Royal Academy', *Illustrated London News* (26 May 1866): 518; 'Pictures of the Year. V', *Saturday Review*, 21 (30 June 1866): 782-3; F.G. Stephens, 'The Private Collections of England. No. LXXXV—Collections near Liverpool', *Athenaeum*, no. 3073 (18 September 1886): 377; see also 'The Royal Academy. Introduction', *Art Journal*, 28 (1 June 1866): 164.

19 J. Beavington Atkinson, 'Exhibitions of the Year', *Fine Arts Quarterly Review*, n.s. 1 (October 1866): 347; see also 'The Royal Academy [Third Notice]', *Spectator*, 21 (26 May 1866): 579; 'Exhibition of the Royal Academy', *Illustrated London News* (19 May

1866), 498. For the same response to a later picture by Moore, see 'The Royal Academy. III', *Saturday Review*, 35 (17 May 1873): 651.

20 For example, six black and white chalk drawings on brown paper (D.1661-1904 to D.1664-1904, V&A; Sotheby's [Belgravia], 24 June 1980 [16]; and Sotheby's, 2 November 1994 [196]).

21 For a discussion of this group, see Dianne Sachko Macleod, *Art and the Victorian Middle Class: Money and the Making of Cultural Identity* (Cambridge: Cambridge University Press, 1997), 267-325.

22 Cosmo Monkhouse, 'A Pre-Raphaelite Collection', *Magazine of Art*, 6 (1883): 62-70; Macleod, *Art and the Victorian Middle Class*, 481. Trist may have purchased the two paintings at the same time. *Pomegranates* was described as 'Painted in 1865' when he lent it to Grafton 1894 (169).

23 The *Yorkshire Gazette* reported on 27 May 1865 that Moore had 'just disposed of one of his paintings for the sum of £300 … This is, we believe, an unprecedented price for so young an artist to obtain for a picture'. The timing is right for Rathbone's purchase of *The Marble Seat*, but the price is too high and possibly includes *The Shulamite*, which Rathbone exhibited at Wrexham in 1876. In September 1886 the two paintings hung in the dark green dining room of Rathbone's house, The Cottage, Greenbank, Liverpool (Stephens, 'Private Collections of England … Liverpool', 377; letter of Mrs. E. Cotton to Timothy Stevens, 6 April 1971, Walker Art Gallery, Liverpool). Visiting in 1891, Whistler noted 'a very sweet and really most beautiful early Albert Moore in the Rathbone dining room—"The Song of Solomon"—simply charming!' (JAMW to Beatrix Whistler, 3 August 1891, W558 WC/GUL).

24 Philip Henry Rathbone, 'The Encouragement of Monumental Forms of Art', *Transactions of the National Association for the Advancement of Art* (1889), 349. He asserted on another occasion, 'A decorative picture hung among other pictures often does not get fair judgment, because it is judged from a wrong standpoint, whereas if it were used for the purpose it is intended, namely, as part of the wall where it is hung, everyone would recognise the bright restfulness which is its chief purpose and aim' (Rathbone, *Impressionism in Art: A Lecture at the Walker Art Gallery* [1890], 9, photocopy on file at Walker Art Gallery, Liverpool).

25 Philip Henry Rathbone, 'The Mission of the Undraped Figure in Art', *Transactions of the National Association for the Promotion of Social Science* (1879), 717. Yet the outspoken collector guarded vigilantly against immorality. Following a lecture on Rossetti, he outraged the audience with a vote of thanks that censured the artist for lacking 'acquaintance with anything but the purely fleshly side of human life' ('Art for Art', *Builder*, 37 [8 February 1879]: 158). See also Morris, *Victorian and Edwardian Paintings*, 6-15, 22-3.

26 Poussin's iconic painting *Et in Arcadia Ego* (c.1640) has been suggested as the model for the figural grouping, providing evidence of Moore's eclecticism (John Sandberg, 'Whistler Studies', *Art Bulletin*, 1 [March 1968]: 60).

27 Moore had also employed Japanese tables and benches in his gouache drawing *The Elements*, his mural design for *The Last Supper* at Austin Friars, and his painting *A Greek Play* for the Queen's Theatre (Pls. 46, 50, 64). In the margin of one of his cartoons for the latter (Pl. 68), he sketched cranes flying across a

full moon, a cliché of Japanese *kacho-ga* (flower-and-bird painting).

28 By contrast, according to John Leighton, most of Moore's contemporaries relied on chiaroscuro as 'a cloak … that covers a multitude of sins'. He went on to associate the neoclassical style of John Flaxman with the clarity of Japanese art ('On Japanese Art. —Illustrated by Native Examples', *Building News*, 9 [29 May 1863]: 413). For the lack of chiaroscuro and naturalistic lighting that differentiated Moore from contemporaries such as Leighton, see W.M. Rossetti, 'The Royal Academy Exhibition', *Fraser's Magazine*, 71 (June 1865): 744.

29 The resemblance to Roman wall painting was noted in J.B. Atkinson, 'Exhibitions of the Year', *Fine Arts Quarterly Review*, n.s. 1 (October 1866): 347.

30 The monogram first appears in *Elijah Running to Jezreel* of 1861 (Pl. 22).

31 Christopher Dresser, 'The Prevailing Ornament of China and Japan', *Building News*, 9 (22 May 1863): 388; Leighton, 'On Japanese Art', 413; 'Japanese Ornamentation', *Builder*, 21 (2 May 1863): 308-9; Laura Dyer, 'The Acanthus, the Lotus, and the Honeysuckle', *Art Journal*, 51 (1889): 188.

32 The preparatory watercolour sketch for *The Shulamite* (a painting begun around 1864 and exhibited in 1866) contains both the anthemion and Moore's old monogram (see n. 16). Moore used the new anthemion signature in his crayon and gouache drawing *The Elements* (Pl. 46).

33 The critic Tom Taylor remarked on 'the queer little labels with bloody hands upon them which Mr. A. Moore and Mr. Whistler and *their* followers love to stick into the corners of their pictures like a postage stamp' ('The Royal Academy Exhibition [First Article]', *Times* [30 April 1870], 12). In its initial form, Whistler's signature merely inverted Moore's anthemion (see *Variations in Flesh Colour and Green: The Balcony*, 1870, Freer Gallery of Art, Washington, D.C.). For pictures bearing Solomon's anthemion-embellished monogram, see Reynolds, *The Vision of Simeon Solomon*, Pls. 17, 19, 20, 21, 20, 71.

34 For the influence of Japanese diagonal compositions on western art, see Siegfrid Wichmann, *Japonisme: The Japanese Influence on Western Art in the 19th and 20th Centuries* (New York: Park Lane, 1985), 218-23.

35 '[In Japanese art] it is common to omit foreground and background. Figures exist only in and by themselves, quite independent of local accessories. No attention is given to perspective, symmetry, light and shadow according to our rules' (James Jackson Jarves, 'Japanese Art', *Art Journal*, 31 [1 June 1869]: 182).

36 Baldry, *Albert Moore*, 77.

37 A black and white chalk drapery study of the right-hand figure is repro. Baldry, *Albert Moore*, opp. 8.

38 'The great man appeared disappointed; he had hoped to have shown his friends a picture with a title such as "Socrates Swallowing the Hemlock", "Boadicæa Addressing her Troops", "The Finding of the Body of Harold", or something of that sort. Moore was not disposed to humour him on this point; they parted, and the picture was never painted' (John Hebb, 'Eden v. Whistler', *Pall Mall Gazette*, 60 [22 March 1895]: 11; cf. Baldry, *Albert Moore*, 91-2).

39 Picking up the story, another journal reminded its readers that Moore 'is a student of line and colour, and not a professed archaeologist' ('Notes on Art and Archaeology', *Academy*, 19 [14 May 1881]: 363). The

irrelevance of the titles was also mentioned in 'Art Notes', *Magazine of Art*, 4 (1881): xxvi. The works in question were presumably two small oils, *A Study in Yellow (Blossoms)*, 1881, (38.1 x 13 cm , repro. Sotheby's, 15 June 1982 [73]) and *An Embroidery* (Pl. 154).

40 Stanley Weintraub, *Whistler: A Biography* (New York: Weybright and Talley, 1974), 136.

41 For the confusion between the titles of Moore's pictures and still life paintings, see Walter Armstrong, 'Study. By Albert Moore, A.R.W.S.' *Portfolio*, 19 (1888): 145.

42 Robertson, *Time Was*, 82. Similarly, Whistler would remark of a snow scene containing a single figure, 'I care nothing for the past, present, or future of the black figure, placed there because the black was wanted at that spot' (*The Gentle Art of Making Enemies* [New York: G.P. Putnam's Sons, 1924], 126). For a critique of the 'dangerous' and 'warping' influence of this 'inhuman detachment' and 'coldly abstract sensual vision', see A.J. Finberg, 'Mr. Whistler and Artistic Solipsism', *Athenaeum*, no. 3954 (8 August 1903): 198.

43 The 1865 RA catalogue records Moore's address as 14 Russell Place; the following year he is listed at 16 Russell Place. When the name and numbering of Russell Place changed in 1867, his address became 17 Fitzroy Square.

44 Two decades before Moore's arrival, the squalor of Newman Street compelled William Makepeace Thackeray to demand, 'Has earth in any dismal corner of her great round face, a spot more desperately gloomy? … I wonder how men live in it, and are decently cheerful', quoted in Lamb, *Lions in their Dens*, 176.

45 'The mornings were given almost unremittingly to work in the studio, more frequently from a model than not, though painstaking studies and experiments in methods were made for the pictures in progress. The work received criticism from brother artists, who with new friends in other professions came to the studio in the afternoons … Dinner was the signal for a congenial gathering, as it fell into a custom for quite a large band of friends to meet at the same restaurant' (L.M. Lamont, ed., *Thomas Armstrong, C.B., A Memoir, 1832-1911* [London: Martin Secker, 1912], 24).

46 On moving across the street from Moore in 1868, Solomon noted pragmatically, 'The neighbourhood is perhaps not the most aristocratic in London, but the house is spacious and clean' (Solomon to FRL, n.d. [c. 1868], PWC/LC). Solomon had lived at various addresses within a few blocks of Moore from 1862 to 1867 before finally joining him in Fitzroy Street.

47 Of the 1864-76 period, Armstrong later recalled, 'Moore was living close at hand and I saw him nearly every day' (quoted in Hebb, 'Albert Moore and the "D.N.B."', 317). Armstrong owned Moore's cartoon for *A Venus* (Pl. 97) and nude and draped studies of a female figure for the chancel of St Alban's, Rochdale (Pls. 55-6), which he lent to the South Kensington Museum in 1898 for use by the Royal College of Art (Report on Objects, Received from: T. Armstrong, Esqr., 15 October 1898 [nominal file, V&A]).

48 Quoted in Lamont, *Thomas Armstrong*, ii; see also 24.

49 Forsyth, 'William Eden Nesfield', 119; Lamont, *Thomas Armstrong*, 15, 34, 152-3, 194, 213; see also Henry Blackburn, *Randolph Caldecott: A Personal Memoir of his Early Art Career* (London: Sampson Low, Marston, Searle, & Rivington, 1886), 30.

50 Solomon to FRL, 13 March [n.d.], PWC/LC.

51 Robertson, *Time Was*, 57, 59, 129. Robertson penned an evocative portrait of the artist's beatific aspect, 'his splendid Christ-like head with its broad brows and great visionary brown eyes … beautiful, tender eyes which could light up with a brilliant smile that never reached the lips'. He added that Moore was 'emphatically [of] the dog nature, loyal and affectionate'.

52 Walker, 'Private Picture Collections', 364. See also Edwin A. Ward, *Recollections of a Savage* (London: Herbert Jenkins, 1923), 252; Edward Verrall Lucas, *Edwin Austin Abbey, Royal Academician: The Record of his Life and Work*, 2 vols. (London: Methuen and Company, 1921), 1: 191-2.

53 Baldry, 'Whistler and Albert Moore', *Pall Mall Budget*, no. 1323 (1 February 1894): 14.

54 In 1878 Moore testified that he had known Whistler for 14 years ('Action for Libel Against Mr. Ruskin', *Daily News* [26 November 1878], 2).

55 Bernard Denvir, *A Most Agreeable Society: A Hundred and Twenty-five Years of the Arts Club* (London: The Arts Club [London] Limited, 1989), 9-10.

56 These included Leighton, Poynter, Prinsep, Walker, Godwin and Burges. Many other close colleagues of Moore became members in subsequent years. See G.A.F. Rogers, *The Arts Club and its Members* (London: Truslove and Hanson, Ltd, 1920), passim. As the club's early nomination records no longer exist, it is unknown who put Moore's name forward. I am grateful for the assistance of Michael Preston, former Keeper of Pictures and Works of Art at the Arts Club.

57 JAMW to Henri Fantin-Latour, 3 February 1864, microfilm 797-802, PWC/LC. The volatile nature of Whistler's friendships is suggested by the fact that he had known Rossetti for only about 18 months when he recommended his inclusion in Fantin's *Hommage à Delacroix*. Whistler never completed his own group portrait with Fantin and Moore, and two preliminary sketches (Art Institute of Chicago and the Municipal Gallery of Modern Art, Dublin) contain no hint of any male companions. The artist apparently decided against creating a permanent record of his evanescent friendships.

58 Robertson, *Time Was*, 60.

59 Robertson, *Time Was*, 60. For another version of this story, see Holiday, *Reminiscences*, 76.

60 DGR to Ford Madox Brown, n.d. [c. 1864] in W.M. Rossetti, ed., *Rossetti Papers, 1862 to 1870* (New York: AMS Press, 1970), 65.

61 DGR to JL, 22 April 1868, LP/UBC; Joseph Comyns Carr, *Some Eminent Victorians: Personal Recollections in the World of Art and Letters* (London: Duckworth & Co., 1908), 67. On another occasion, Rossetti wrote that Moore's paintings combined 'great merit with a good deal of silly conceit and woeful shortcoming' (Allen Staley, 'The Condition of Music', *Art News Annual*, 33 [1967]: 85).

62 Defending his friend against Rossetti's charge, Whistler reportedly said that Moore 'thinks slowly, but he's not in the least dull' (Robertson, *Time Was*, 60).

63 Merton Russell-Cotes, *Home and Abroad: An Autobiography of an Octogenarian*, 2 vols. (Bournemouth, privately printed, 1921), 717.

64 '"Umph?" as Albert Moore says' (JAMW to Beatrice Whistler, 3 August 1891). '"What I mean", as Albert says' (JAMW to E.W. Godwin, n.d. [after May 1880]), W558 and G118, WC/GUL.

65 Robertson added that he 'had been brought up by Albert Moore in the knowledge and love of Whistler', and that on their meeting in 1890, Whistler's 'easy acceptance of me was due to friendship for Albert Moore, with whom he had discussed me' (Robertson, *Time Was*, 188).

66 'Winter Exhibitions—M. Gambart's Gallery, 120, Pall-Mall', *The Times* (20 November 1866), 10; see also F.G. Stephens, 'The Private Collections of England. No. IV—Tynemouth—Gateshead', *Athenaeum*, no. 2396 (27 September 1873): 407. Moore's *Study—Reclining Girl* of 1865, once in the possession of Henry Holiday (Grafton 1894, no. 226), may have been a preparatory drawing for *Lilies*, although *Somnus* (Pl. 51) and *A Sleeping Girl* (p. 221, n. 4) also date from this period.

67 On 5 February 1864, the artist George Price Boyce noted 'the most interesting collection of old blue china porcelain' at Whistler's house (Surtees, *The Diary of George Price Boyce*, 39). Whistler's mother reported that year, 'He considers the painting upon them the finest specimens of Art and his companions (Artists) who resort here for an evening relaxation occasionally get enthusiastic as they handle and examine the curious objects' (Ronald Anderson and Anne Koval, *James McNeill Whistler: Beyond the Myth* [London: John Murray, 1994], 143). See also Moncure Daniel Conway, *Travels in South Kensington, with Notes on Decorative Art and Architecture in England* (London: Trübner & Co., 1882), 183-4.

68 For a discussion of Moore's anticipation of this aspect of Whistler's art, see Smith, *Decorative Painting*, 194-8; Nancy Burch Wilkinson, *Edward William Godwin and Japonisme in England* (Ph.D. thesis, University of California, Los Angeles, 1987), 168.

69 For the exhibition and its impact, see Wilkinson, *Godwin and Japonisme*, 1-56 passim.

70 W.M. Rossetti, 'The Fine Art of the International Exhibition', *Fraser's Magazine*, 66 (August 1862): 188. For the seeming impossibility of interpreting the symbolism of Japanese art, see Dresser, 'The Prevailing Ornament of China and Japan', 388.

71 Brydon, 'William Eden Nesfield', 238. For his sketches of Japanese artifacts (c. February 1863), see WEN [13], ff. 33-6, 67, RIBA.

72 Moore was also familiar with Charles Augustus Howell's collection, amassed in the early 1860s in rivalry with D.G. Rossetti. In a testimonial of 7 August 1872, Moore described Howell's collections as affording 'clear proof of his great taste and judgement in the appreciation and selection of such matters' (Miscellaneous Correspondence File, 1871-2, 8314.3.1.1, Tate Archives). For the paucity of publicly accessible examples of Japanese art, see Leighton, 'On Japanese Art', 432; W.M. Rossetti, *Fine Arts Quarterly Review*, 1 (October 1863): 433.

73 Solomon to Swinburne, 1863, in Lang, *Swinburne Letters*, 2: 32-3. For the redating of this letter, see Seymour, *Life and Work of Simeon Solomon*, 90.

74 See above, p. 51. For the Japanese prototypes for Nesfield's 'pies', see Forsyth, 'William Eden Nesfield', 119; Wilkinson, *Godwin and Japonisme*, 86-92.

75 Eastlake, *History of the Gothic Revival*, 340-1.

76 Solomon to Leathart, LP/UBC. Solomon's letter indicates that *A Musician* dates from 1865, two years earlier than previously thought. Although undated, the letter refers to Solomon's move to 106 Gower Street, his progress on the 'Chinese picture' for

William Watson Pattinson, and his lack of travel plans—all indicative of 1865. Moore apparently had no intention of exhibiting *A Musician*, but found himself unable to complete a more ambitious picture, *Azaleas* (Pl. 90), in time for the 1867 RA exhibition. A few days prior to the sending-in deadline, he asked to borrow *A Musician* from Leathart, as he had nothing else to show (AJM to JL, 3 April 1867, LP/UBC). He also postponed his next session with Milly Jones, the model for *Azaleas*, explaining that the picture could not be finished. Sittings were resumed by the first week of May (AJM to Milly Jones, n.d. and 4 May 1867, 17 Fitzroy Street, photocopies WC/GUL). See p. 217, n. 109.

77 Moore contributed two additional illustrations to the volume; see *Milton's Ode on the Morning of Christ's Nativity. Illustrated by Eminent Artists* (London and Edinburgh: Nisbet, 1868), 13, 28, 35. See also Walter Crane, *Of the Decorative Illustration of Books Old and New* (London: G. Bell and Sons, Ltd., 1916), 154-5; Ruari McLean, *Victorian Book Design and Colour Printing*, rev. edn. (London: Faber and Faber, 1972), 135, 168.

78 On 24 February 1869 W.M. Rossetti recommended Moore (along with Leighton and Noel Paton) to produce illustrations for a volume of Milton's poetry then contemplated by the Moxon publishing firm (Rossetti, *Rossetti Papers*, 384; John Bertrand Payne to WMR, 20 February 1869, folder 23-7, ADC/UBC). Moore also illustrated 'The Maiden of Morven' for *Songs of the North: Gathered Together from the Highlands and Lowlands of Scotland*, ed. Anne Campbell Macleod and Harold Boulton (London: Field and Tuer: 1885).

79 F.G. Stephens, 'Mr. Humphrey Roberts's Collection. Modern English Oil Pictures', *Magazine of Art*, 19 (1896): 47. Stephens had earlier observed that Moore's paintings 'are in many respects what one can imagine antique pictures to have been' ('The Royal Academy (Second Notice)', *Athenaeum*, no. 2532 (6 May 1876): 640. For a contemporary discussion of formal equivalents for musical structure, see James Sully, 'The Perception of Musical Form', *Fortnightly Review*, 20 (September 1873): 371-81.

80 Peter Kivy, *The Fine Art of Repetition: Essays in the Philosophy of Music* (Cambridge: Cambridge University Press, 1993), 344. For the historical background, see John Onions, 'On How to Listen to High Renaissance Art', *Art History*, 7 (December 1984): 411-36.

81 Barrington, *Life, Letters and Work of Leighton*, 2: 63.

82 For example, Ruskin wrote of colour as 'visible music' and continually struck analogies between music and painting in *The Elements of Drawing* and *The New Path* (Cook and Wedderburn, *Works of John Ruskin*, 14: xxvi; 16: 286). See also Ron Johnson, 'Whistler's Musical Modes: Symbolist Symphonies' and 'Whistler's Musical Modes: Numinous Nocturnes', *Arts Magazine*, 55 (April 1981): 164-76.

83 Walter Pater, 'The School of Giorgione' (1877) in *The Renaissance* (New York: The Modern Library, 1960), 111. Allen Staley has noted that 'before Pater's theories appeared in print, Moore was providing their visual equivalent' ('The Condition of Music', 86). Simeon Solomon, a great friend of both Moore and Pater, provided a likely conduit between them. In 1868, while living cheek-by-jowl with Moore in Fitzroy Street, he was paying frequent visits to Pater at Oxford. See Solomon's letters to Oscar Browning, 1/1531, King's College,

Cambridge.

84 See, for example, *The Natural Principles and Analogy of The Harmony of Form* (Edinburgh: William Blackwood and Sons, 1842); *A Nomenclature of Colours, Hues, Tints, and Shades, Applicable to the Arts and Natural Sciences; to Manufactures, and other purposes of general utility* (Edinburgh: William Blackwood & Sons, 1845); *The Harmonic Law of Nature applied to Architectural Design* (Edinburgh and London: William Blackwood and Sons, 1855).

85 The plural form of the title (*The Musicians*) that appears in the 1867 RA catalogue is presumed an error. See also p. 215, n. 76.

86 'Exhibition of the Royal Academy', *Illustrated London News* (25 May 1867), 519; similarly, F.G. Stephens noted that Whistler intended his painting as 'ineffable Art itself, not as mere illustrations of "subjects"' ('Royal Academy', *Athenaeum*, no. 2064 [18 May 1867]: 667). See also Dennis Farr, 'James McNeill Whistler—His Links with Poetry, Music and Symbolism', *Royal Society for the Encouragement of the Arts, Manufactures, and Commerce Journal*, 122 (April 1974): 267-84.

87 J.B. Atkinson, 'The Royal Academy and Other Exhibitions', *Blackwood's Magazine*, 102 (July 1867): 90 and 'The Royal Academy. Introduction', *Art Journal*, 29 (1 June 1867): 143.

88 Colvin, 'English Painters and Painting in 1867', 473-4. Colvin rehearsed these ideas in *Notes on the Exhibitions of the Royal Academy and Old Water-colour Society* (London: Macmillan and Co., 1869), 47-8. His admiration for the musical aspect of Moore's art is attested by his possession of a study for *A Quartet* which he gave to the British Museum in 1888 (Pl. 92).

89 Colvin, *Notes on the Exhibitions*, 48.

90 Colvin, 'English Painters of the Present Day', 6.

91 F.G. Stephens, the critic quoted here, added that Moore's 'feeling for beauty is far higher in its tone than that of ninety-nine painters in a hundred here' ('Royal Academy', *Athenaeum*, no. 2064 [18 May 1867]: 667). Similarly, having complained that the exhibition suffered from a lack of 'style, or any abstract or nobly decorative quality of art', Tom Taylor singled out Moore along with seven other painters (including Leighton, Watts, Armstrong, Prinsep, Poynter and Alphonse Legros) as exceptions to the rule ('Exhibition of the Royal Academy', *The Times* [Saturday 4 May 1867], 12). See also 'The Royal Academy. Introduction', *Art Journal* 29 (1 June 1867): 143; J.B. Atkinson, 'The Royal Academy and Other Exhibitions', *Blackwood's Magazine*, 102 (July 1867): 90; 'Exhibition of the Royal Academy', *Illustrated London News* (25 May 1867), 519.

92 This exhibition was instrumental in associating Moore and Whistler in the public eye, largely because both artists exhibited studies in white, 'a colour with which, just now, artists are playing pranks'. Both men aroused suspicion as 'artists who absolutely despise beaten paths' ('The Royal Academy. Introduction', *Art Journal*, 29 [1 June 1867]: 143; see also 'Royal Academy', *Athenaeum*, no. 2064 [18 May 1867]: 667; 'Exhibition of the Royal Academy', *Illustrated London News* [25 May 1867], 519; cf. 'Exhibition of the Royal Academy', *Illustrated London News* [30 May 1868], 543; Richard St. John Tyrwhitt, 'Pictures of the Year', *Contemporary Review*, 11 [July 1869]: 358).

93 Baldry, *Albert Moore*, 32, 70, 81.

94 Thomas Robert Way, *Memories of James McNeill*

Whistler the Artist (London and New York: John Lane, 1912), 27.

95 For example, 'The Royal Academy. IV', *Saturday Review*, 27 (5 June 1869): 744; J.B. Atkinson, 'The London Art Season', *Blackwood's Magazine*, 106 (August 1869): 224; Frederic, 'A Painter of Beautiful Dreams', 722. See also Baldry, *Albert Moore*, 70.

96 Whistler shared the flat with the architect Frederick Jameson. For the dates of his residence, see Linda Merrill, *The Peacock Room: A Cultural Biography* (Washington, DC: Freer Gallery of Art and New Haven: Yale University Press, 1998), 98-9, 360, n. 71.

97 During this period in Whistler's career, Jacques-Emile Blanche wrote, 'He had browsed much at the British Museum, together with Albert Moore, and had been struck by the similarity between a certain type of Greek and English beauty' (*Portraits of a Lifetime: The Late Victorian Era, The Edwardian Pageant, 1870-1914* [London: J.M. Dent & Sons, 1937], 76).

98 For a description of the technique of memory drawing, see Horace Lecoq de Boisbaudran, *The Training of the Memory in Art and the Education of the Artist*, trans. L.D. Luard with an introduction by Selwyn Image (London: Macmillan and Co., 1911). Whistler had learned it in Paris during the 1850s (Elizabeth Robins Pennell and Joseph Pennell, *The Life of James McNeill Whistler*, new and rev. edn. [Philadelphia: J.B. Lippincott Co., 1911], 1: 66). Moore adopted it for his drawing *Elijah Running to Jezreel* (Pl. 22).

99 JAMW to Henri Fantin-Latour, n.d. [?September 1867], PWC/LC.

100 Baldry, *Albert Moore*, 81. One of Moore's students later recalled, 'Each detail of his picture was always learned by a succession of studies until his power to express it approached in completeness his own mental image' ('Albert Moore [By a Pupil]', *Pall Mall Gazette* [30 September 1893], 2).

101 Way, *Memories of Whistler*, 27-8. Whistler also began to imitate Moore's use of brown drawing paper, curved cross-hatching, and transfer by pouncing (Joyce Hill Stoner, *Textured Surfaces: Techniques, Facture, and Friendship in the Work of James McNeill Whistler*, Ph.D. thesis, University of Delaware, 95-6, and passim for several other borrowings from Moore).

102 JAMW to Henri Fantin-Latour, PWC/LC.

103 Way, *Memories of James McNeill Whistler*, 3, 27-8. Frederick Wedmore detected Moore's influence on Whistler's paintings, pastels, etchings and lithographs (*Whistler and Others* [London: Sir Isaac Pitman & Sons, 1906], 12-13). Whistler entrenched his indebtedness by seeking Moore's advice; in one instance, it resulted in his scraping down *The Three Girls* to the bare canvas and he was never able to put it right again (Way, *Memories of Whistler*, 28; Elizabeth Robins Pennell and Joseph Pennell, *The Whistler Journal* (Philadelphia: J.B. Lippincott Company, 1921), 233; Lamont, *Thomas Armstrong*, 197-8). During the 1865-70 period Whistler commenced and abandoned 13 Moore-inspired painting projects. For further discussion, see Stoner, *Textured Surfaces*, 87-111; Robin A. Spencer, *James McNeill Whistler and his Circle: A Study of His Work from the Mid-1860s to the Mid-1870s*, M.A. report, Courtauld Institute, University of London, 1968, 2-47.

104 Robertson, *Time Was*, 62.

105 By the 1890s, according to Graham Robertson, his technique involved 'no mechanical process, no laying of an elaborate foundation, as with Albert Moore'. Mentally, however, Whistler, like Moore, prepared

every detail of a project before the first stroke of his brush (Robertson, *Time Was*, 191).

106 Kerrison Preston, ed., *Letters from Graham Robertson* (London: Hamish Hamilton, 1953), 343. Similarly, Robertson, *Time Was*, 195, 275; Carr, *Some Eminent Victorians*, 138; Val Prinsep, 'James A. McNeill Whistler: 1834-1903', *Magazine of Art*, n.s. 1 (1903): 578; Sir Rennell Rodd quoted in Pennell and Pennell, *Life of Whistler*, 225; Starr, 'Personal Recollections of Whistler', 530; A.L. Baldry, 'James McNeill Whistler. His Art and Influence', *Studio*, 29 (September 1903): 241.

107 Baldry, *Albert Moore*, 32, 71, 80-1. Baldry is doubtless justified in claiming that Moore 'arrived at his own technical conclusions and constructed his guiding rule of practice' through independent observation of nature, but parallelism and optical balance are in fact traditional devices of landscape composition that Moore undoubtedly learned first from his brothers, the landscape painters Edwin and William (Asleson, 'Nature and Abstraction', 117-20).

108 Baldry, *Albert Moore*, 81.

109 The facial features in Moore's nude cartoon for *Azaleas* are those of Milly Jones, a professional model to whom he had written in the spring of 1867 (see above, p. 215, n. 76), and who kneels at right in Whistler's *Symphony in White No. III* (Pl. 83). Her identification in Whistler's painting is based on a book of cuttings compiled by Charles Augustus Howell (WC/GUL); see Spencer, *James McNeill Whistler and his Circle*, n.51.

110 Stoner considers this technique unique to Moore (*Textured Surfaces*, 1: 96).

111 Baldry, *Albert Moore*, 86. Of a much later work, *Dreamers* (Pl. 149), Harry Quilter would write, 'The picture is, in fact, a scientific study of beauty; scientific in its thoroughness and skill, but ... the appearance of having been done with ease and pleasure prevents the spectator from suspecting the labour, thought, and toil which have been necessary to produce it' ('Notes on the Royal Academy Exhibition', *Contemporary Review*, 41 [June 1882]: 953).

112 'Albert Moore. (By a Pupil)', 2; Baldry, *Albert Moore*, 77; *Masters of Art: Albert Moore* (Boston: Bates and Guild, 1908), 27.

113 Moore employed the carp bowl again in the watercolour *Oranges* and the pastel *Crocuses*, both exhibited in 1885; see p. 226, n. 159.

114 An extensive collection of moths and butterflies was available to Moore through his brother Henry, a keen entomologist (Maclean, *Henry Moore*, 122-3, 126). Moore first used a butterfly as a colour accent in *Apricots* (1866). Several of Whistler's paintings emulate his use of these compositional accents, most strikingly *Harmony in Grey and Green: Miss Cicely Alexander* of 1872-3 (Tate Gallery, London). In 1869 he adopted a stylized butterfly signature device in imitation of Moore's anthemion (see p. 214, n. 33).

115 Baldry, *Albert Moore*, 73.

116 'Exhibition of the Royal Academy (Second Notice)', *Daily Telegraph* (8 May 1868), 7.

117 JAMW to Henry Fantin Latour (30 September 1868), PWC/LC. The comment also reflects the influence of M.E. Chevreul, whose theories of colour were inspired by the threads in Gobelin tapestries; see above, p. 114.

118 'The Royal Academy', *Building News*, 15 (1 May 1868): 288. For the same response to a later picture by Moore, see 'The Royal Academy [Second Notice]' *Spectator*, 46 (17 May 1873): 637-8.

119 'The forms employed are simple and well known, but are so judiciously employed that they have all the charm of novelty ... the result is a frame in perfect harmony, both in form as well as in feeling, with the painting it holds' ('Picture Frames at the Royal Academy', *Building News*, 15 [5 June 1868]: 384).

120 'Exhibition of the Royal Academy (Second Notice)', *Daily Telegraph* (8 May 1868), 7. The painters Daniel Maclise, Thomas Sidney Cooper and Philip Hermogenes Calderon comprised the hanging committee that year ('Fine-Art Gossip', *Athenaeum*, no. 2108 [21 March 1868]: 428).

121 'The Royal Academy. Introduction', *Art Journal*, 30 (1 June 1868): 106; similarly, Richard St John Tyrwhitt, 'Pictures of the Season', *Contemporary Review*, 8 (July 1868): 346; 'Exhibition of the Royal Academy', *Illustrated London News* (30 May 1868), 543. Graham Robertson later wrote, 'It was one of Moore's earliest pictures after he had completely formed his style, and seemed to puzzle people considerably when it appeared (badly skied) at the Academy. The lovely fairness of the colour, screwed up to a very high key, was then quite new and strange and appreciated by hardly anyone but Whistler.' Of the picture's subsequent history, he wrote, 'I remember Hugh Lane telling me that he had bought it for next to nothing and exulting hugely in being its possessor' (Preston, *Letters from Graham Robertson*, 396).

122 Solomon's reference to Moore in a letter of 1863 to Swinburne suggests that the artist was already known to the poet by that date (see above, pp. 80-1). W.M. Rossetti also met Moore around this time, but he later recalled, 'Of Albert Moore neither my Brother nor myself saw much at any time.' His enthusiasm for Moore's work was not shared by D.G. Rossetti, who 'thought ... very badly of Moore's *Azaleas*' when he saw it at the RA (Rossetti, *Rossetti Papers*, 64, 322).

123 W.M. Rossetti and Algernon Swinburne, *Notes on the Royal Academy Exhibition, 1868* (London: John Camen Hotten, 1868), 23-4. Similarly, Baldry noted: 'It was immaterial whether the objects represented in his pictures were relics of the past or modern manufactures ... If a tulip, for instance, would give him the accent he wanted in one of his colour combinations, he attached no importance to the fact that it came from Haarlem and not from Athens. It was beautiful, it touched the right note in his scheme, and in his view of his duty to art those were the only points which he had to consider' (Baldry, 'Albert Moore: An Appreciation', 36).

124 He added, 'Of all the few great or the many good painters now at work among us, no one has so keen and clear a sense of this absolute beauty as Mr. Albert Moore.' Swinburne extended the musical metaphor in his discussion of Whistler's doomed 'Six Projects', which he had seen in progress in the artist's studio. Acknowledging that 'no task is harder than this of translation from colour into speech', he remarked, 'Music or verse might strike some string accordant in sound to such painting.' The rest of his review describes the 'main strings', 'varying chords', 'interludes', 'tender tones', and 'keynote' of Whistler's 'symphony' (Rossetti and Swinburne, *Notes on the Royal Academy Exhibition*, 31-2).

125 Baldry, *Albert Moore*, 37.

126 Baldry, *Albert Moore*, 83; Maclean, *Henry Moore*, 21.

127 'Royal Academy', *Athenaeum*, no. 2169 (22 May 1869): 707.

128 The writer added, 'It is impossible not to feel that

the musical instruments were introduced solely for their decorative effect, for their own beautiful lines and colour' (Luna May Ellis, *Music in Art* [Boston: L.C. Page, 1904], 191).

129 'Albert Moore's Pictures', *Saturday Review*, 77 (27 January 1894): 89. Another critic proclaimed the painting 'the highest realisation of the painter's powers' ('Art in February', *Magazine of Art*, 17 [1894]: xvii). Nine years earlier, it was deemed 'still his best and most poetical production, seem[ing] to belong to another world. Its beauty is of a luxurious dream' ('Art at the Manchester Exhibition', *Athenaeum*, no. 3116 [16 July 1887]: 91). The painting was exhibited on six occasions between 1886 and 1908, always under the modified title affected by its owner, the Liverpool merchant William Coltart: *The Quartette* (Algernon Graves, *A Century of Loan Exhibitions, 1813-1912*, 4 vols. [New York: Burt Franklin, 1913-15], 2: 802-3; 4: 2074).

130 Cosmo Monkhouse, 'Albert Moore', *Magazine of Art*, 8 (1885): 195. Monkhouse pilloried the philistine observer who would observe of a painting such as Moore's *Yellow Marguerites* (Pl. 152), 'Nice, but not really Greek, you know. She is an English girl, evidently. I question whether they had yellow marguerites in Athens; and as for that Spanish lace, it is a rank anachronism.' Explaining that each of these elements constituted a deliberate choice, rather than an error, Monkhouse added, 'He seeks after beauty in the first place, and the beauty which he sees around him ... The world he paints is our world after all, only selected and arranged with taste.' As Baldry expressed it, Moore's art represented 'neither present, past, nor future; it was of every date and for all time' ('Albert Moore', 46).

131 Robertson, *Time Was*, 88. For the sort of nitpicking criticism Moore sought to evade, see George Birdwood, 'Anachronisms', *Athenaeum*, no. 2595 (21 July 1877): 86-7.

132 'The State of English Painting', *Quarterly Review*, 134 (April 1873): 305. For more thoughtful consideration of the issues raised by Moore's 'homage of modern to ancient art', see F.W. Cornish, 'Greek Beauty and Modern Art', *Fortnightly Review*, 20 (September 1873): 326-36.

133 Richard St John Tyrwhitt, 'Pictures of the Year', *Contemporary Review*, 11 (July 1869): 360. Sidney Colvin, 'Royal Academy (Third Article)', *Pall Mall Gazette*, 9 (31 May 1869): 11. In a subsequent version of his criticism, Colvin asserted, '[The picture] is not designed (as the catalogue sufficiently explains) as an illustration of a Greek subject. If it were, the fiddles and double-basses would be an obvious anachronism. It is simply designed as an ideal group of people in the most beautiful clothes, playing the instruments that make the most beautiful music' (*Notes on the Exhibitions*, 48).

134 'Exhibition of the Royal Academy. Sixth Article', *The Times* (11 June 1869), 12.

135 'The Royal Academy. IV', *Saturday Review*, 27 (5 June 1869): 744.

136 Moreover, *A Quartet* had been an uncommissioned work which the artist was reportedly willing to sell cheaply (Oscar Browning, *Memories of Sixty Years at Eton, Cambridge and Elsewhere*, 2nd edn. [London and New York: John Lane, 1910], 107).

137 The juxtaposition of a standing nude figure against a backdrop of loosely flowing drapery may have been suggested by the south metopes from the Parthenon; see nos. 3, 6, 14, 16, 26, 27 (numbering as in John

Boardman, *The Parthenon and its Sculptures* [London: Thames & Hudson, 1985]).

138 It sold under this title at Christie's, 12 June 1880 [127] (owner Prange), and the purchaser William Coltart exhibited it under the same name (or, simply, *Venus*) on five occasions between 1887 and 1910 (Algernon Graves, *Art Sales*, 3 vols. [New York: Burt Franklin, 1970], 2:234; Graves, *A Century of Loan Exhibitions*, 2: 802-3; 4: 2074; A.G. Temple, 'Collection of William Coltart, Esq., of Woodleigh, Birkenhead', *Art Journal* 58 [1896], 101, G. Campbell Ross, *Municipal Gallery of Modern Art, Johannesburg* [Johannesburg: Argus Company, 1910], 4-5). For Coltart's retitling of *A Quartet*, see p. 217, n. 129; for Coltart, see Macleod, *Art and the Victorian Middle Class*, 290-1, 401-2.

139 Similarly, Walter Crane recalled Leyland's 'saying something kind about my "Venus"' but, he added ruefully, 'he did not offer to purchase it' (Crane, *An Artist's Reminiscences*, 200).

140 This study may be the *Nude Figure* (1868) that once belonged to the photographer Frederick Hollyer (Grafton 1894, no. 148). Another likely oil study for Leyland's picture, *A Bath Room* (1868, 49.2 x 21.6 cm), belonged to Henry Moore's brother-in-law, Edward Bollans (Grafton 1894, no. 147); see also Baldry, *Albert Moore*, 102.

141 AJM to FRL, 17 Fitzroy St, 22 December 1868, PWC/LC.

142 AJM to FRL, 17 Fitzroy St, 12 December 1868, PWC/LC.

143 It was for sensitive analysis rather than direct imitation that Sidney Colvin declared Moore 'nearer in spirit to the Greeks than any other artist among us', adding, 'I do not know of any piece of his upon which one could lay one's finger and say that it had been directly suggested by Greek work' ('English Painters of the Present Day', 6).

144 AJM to FRL, 17 Fitzroy St, 22 December 1868, PWC/LC.

145 Leyland also paid a £100 advance (AJM to FRL, 22 January 1869, 17 Fitzroy St, PWC/LC).

146 See AJM to FRL, 8 April 1869, and Moore's receipt for balance of £136 5s., 4 May 1869, PWC/LC.

147 'I saw Albert Moore's picture a few days ago and really I cannot tell you how beautiful I thought it was' (Solomon to FRL, n.d. [before April 1868], PWC/LC). 'I am most happy to tell you that you have, as I prophesied you would, in Moore's Venus, the most beautiful work in the Academy—no that would be saying nothing—I mean one of the most miraculously perfect things that he's produced—I cannot be too enthusiastic about it—To me me [sic] it is faultless! I never have enjoyed anything so thoroughly—and know that you have one of the finest things in England' (JAMW to FRL, n.d., PWC/LC). Whistler evinced the sincerity of his compliment by commencing a large-scale nude cartoon which imitated the pose, accessories, technique and veiled signature of Moore's picture (*Venus*, 1869, black and white chalk on brown paper, 119.4 x 61.4 cm, Freer Gallery of Art, Washington, D.C.).

148 Colvin, 'Royal Academy (Third Article)', 11. In a subsequent version of his criticism, Colvin wrote, 'The scheme of the artist has been to make a sort of symphony of pale flesh-colour; he has placed here a tint of pure white, there a tint of pure rose; he has coloured this drapery a little yellower than the flesh, then balanced it with drapery a little greyer, and so

on, producing a complete and satisfying harmony in a certain key' (*Notes on the Exhibitions*, 49).

149 Colvin acknowledged that paintings like *A Venus* stood 'little chance of meeting with popular recognition' as they required 'some knowledge and love of Greek statuary before they can be appreciated' ('Royal Academy [Third Article]', 11; cf. Colvin, (*Notes on the Exhibitions*, 48). Similarly, F.G. Stephens noted that the picture's subtle merits were 'hardly to be appreciated except by artists, and those artists of a particular kind of taste and training' ('Royal Academy', *Athenaeum*, no. 2169 [22 May 1869]: 707).

150 Colvin, 'Royal Academy. (Third Article)', 11 and *Notes on the Exhibitions*, 49; 'Exhibition of the Royal Academy. Sixth Article', *The Times* (11 June 1869), 12; 'The Royal Academy. IV' *Saturday Review*, 27 (5 June 1869): 744.

151 J.B. Atkinson, 'The London Art Season', *Blackwood's Magazine*, 106 (August 1869): 224; 'The Royal Academy. IV', *Saturday Review*, 27 (5 June 1869): 744; F.G. Stephens characterized the execution as antipathetical to the subject, but considered errors of proportion the picture's real defect ('Royal Academy', *Athenaeum*, no. 2170 [29 May 1869]: 738).

152 'Undraped figures matter nothing, when their nudity is unconnected with evil thoughts in the mind of the painter. And when he is free from such association he generally shows it, either by the severity of his lines … or by tenderness of colour, and careful abstinence from the "peachy and downy" style … This Mr. A. Moore has done with his "Venus"' (Richard St John Tyrwhitt, 'Pictures of the Year', *Contemporary Review*, 11 [July 1869]: 360). In his review of the previous year's exhibition, Tyrwhitt noted 'The hopeful thing about this exhibition is the increased vigour it shows in study of the human form, without a single offensive or pruriently-suggestive picture' ('Pictures of the Season', *Contemporary Review*, 8 [July 1868]: 348).

153 Smith, *The Victorian Nude*, 101-61.

154 For the 1869 exhibition and the rise of classicism in English painting, see Robyn Asleson, *Classic into Modern: The Inspiration of Antiquity in English Painting, 1864-1918*, Yale University Ph.D. thesis, 1993.

155 J.B. Atkinson, 'The London Art Season', *Blackwood's Magazine*, 106 (August 1869): 222-3; 'The Royal Academy. IV', *Saturday Review* 27 (5 June 1869): 744. Two years later a critic noted, 'It was but the other day that certain singular products obtained a place in the Academy on sufferance, and now Gallery VII. is mainly given up to the party; pictures which were used at first as foils become the ruling fashion, and a style which once provoked a smile is at length the symbol of faith, the badge of a party. The clique is numerous and compact; that it is sustained by more than common talent is at once obvious in the contributions (by the way, mostly sold) of Mr. Albert Moore, Mr. Barclay, Mr. Armstrong, Mr. Maclaren, and others' ('The Royal Academy. IV', *Saturday Review*, 31 [27 May 1871]: 666). In the same year, another critic listed the leaders of this 'new, select, and also small school' as Moore, Mclaren, Barclay and W.B. Morris ('The Royal Academy. Second Notice', *Art Journal*, 33 [1 June 1871]: 176).

156 Edgcumbe Staley, *Lord Leighton of Stretton, P.R.A.* (London: The Walter Scott Publishing Co., 1906), 179. Shared themes in the art of Leighton and Moore suggest a degree of interaction between them. In addition to anticipating Moore's *A Venus*

with his own *Venus Disrobing for the Bath*, Leighton had exhibited a 'A Lady with Azaleas' (possibly *A Noble Lady of Venice*) in 1866, around the time that Moore commenced *Azaleas*. He painted *Lady with Pomegranates* in 1867, a year after Moore exhibited *Pomegranates*; see 'Fine Art Gossip', *Athenaeum*, no. 2057 (30 March 1867): 426.

157 The assemblage of 'master-works' was likened by one critics to the Tribuna of the Uffizi. The sparser installation minimized visual fatigue and allowed the qualities of each picture to stand out individually. Moore's painting hung in close proximity to Poynter's drawings for the mosaic scheme at the Houses of Parliament—an ironic juxtaposition, it was noted, as Moore had lost the commission with designs deemed 'too classical' for a medieval building ('The Royal Academy', *Art Journal*, 32 [1 June 1870]: 171).

158 'Royal Academy', *Art Journal*, 32 (1 June 1870): 171; see also 'The Royal Academy Exhibition', *The Times* (30 April 1870), 12.

159 For Moore's use of pastel at an earlier stage of the composition process, see Baldry, *Albert Moore*, 81.

160 Baldry, *Albert Moore*, 73.

161 Baldry, *Albert Moore*, 75. As a preliminary step, Moore made small black and white chalk drawings of the draped figure; a study for *A Garden* (36.8 x 20.6 cm) is repro. Christie's 14 March 1997 (40).

162 AJM to JL, 3 Red Lion Square, 10 November 1869, LP/UBC.

163 AJM to JL, 3 Red Lion Square, 10 November 1869; see also Moore's letters of 17 November 1869 and 4 March 1870 acknowledging two further instalments of £50 each for 'pictures in progress' (LP/UBC).

164 Robertson, *Time Was*, 59.

165 Lamont, *Thomas Armstrong*, unpag.

166 Baldry, *Albert Moore*, 83. Additional preparatory sketches are D.234-1905 and D.235-1905, V&A.

167 Pennell and Pennell, *Life of Whistler*, 129.

168 Boisbaudran, *Training of the Memory in Art*, 37.

169 Baldry, *Albert Moore*, 83.

170 Baldry noted, 'His was not the narrow and too accurate observation of the instantaneous photograph that misses the idea of action by reproducing one part only out of a continuous succession; he, on the contrary, combined a whole series of varying and not really simultaneous movements into a kind of pattern' (*Albert Moore*, 84).

171 Oddly, Baldry failed to discuss the painting in his biography of Moore, but his appendix lists *Battledore and Shuttlecock* (oil, 36.8 x 15.2 cm) under the year 1872 (*Albert Moore*, 103). The date was evidently a guess; months earlier, when the art dealer Thomas McLean lent the painting to Moore's posthumous exhibition, the date 1880 was cited (Grafton 1894, no. 189; also exh. was *Study for Battledore and Shuttlecock*, lent by E.J. Van Wissenlingh [no. 190]). The painting later entered the collection of Charles Edward Lees of Werneth Park, Oldham, who sold it (together with *A Workbasket* [Pl. 150]) at Christie's, 24 April 1936 (152). The dimensions listed by Baldry are close but not identical to the preparatory drawing illustrated here (Pl. 104), which Moore annotated with the dimensions '3.10 x 2' feet (116.8 x 60.8 cm), suggesting his intention of carrying it out on a larger scale. An extant cartoon of appropriate size (123.2 x 66 cm) lacks pinholes, indicating that it was never transferred to canvas (D.234-1905, V&A). However, Thomas Armstrong recollected in 1907 that Moore had employed the battledore and shuttlecock theme for fresco panels in the octagonal

172 hall at Claremont, c.1866-7; see p. 212, n. 84.

172 Compounding the uncanniness of the scene is the fact that the game of battledore and shuttlecock had fallen from fashion among adults, and was valued principally 'as a means of keeping children out of mischief in bare rooms on wet days'. Revived by the Duke of Beaufort around 1870, the game became known as badminton ('Old English Games IV. Shuttlecock', *Pall Mall Budget*, 1326 [22 February 1894]: 8; Mary Ann Wingfield, *Sport and the Artist* [Woodbridge, Suffolk: Antique Collectors' Club, 1988], 47-55).

173 See, for example, Frederic Leighton's *Greek Girls Picking up Pebbles by the Sea*, c.1871 (priv. coll.) and *Greek Girls Playing at Ball*, 1888-9 (Dick Institute, Kilmarnock), and Edward Poynter's *Nausicaa and her Maidens Playing at Ball* and *Atalanta's Race*, 1879 (both destroyed, repro. Alison Inglis, 'Sir Edward Poynter and the Earl of Wharncliffe's Billiard Room', *Apollo*, 126 [October 1987]: 252-3; full compositional oil sketches repro. Christies, 9 June 1995 [341]).

174 Rossetti acknowledged, 'There can be no doubt that he possesses certain gifts of drawing and of design (in its artistic relation) in an admirable degree' (DGR to JL, 22 April 1868, LP/UBC).

175 They were simply 'the Shuttlecock pictures' (with the second known as 'Shuttlecock No. 2') until the 1871 RA catalogue necessitated differentiation by title. Indeed, confusion long persisted as to which painting was which (Minneapolis 1978, no. 74).

176 AJM to JL, 10 November 1869, 3 Red Lion Square, LP/UBC.

177 AJM to JL, 15 February 1870, 3 Red Lion Square, LP/UBC. The companion to Pl. 110 is also in the Sheffield Art Galleries. The initial oil sketch with a lighter colour scheme is very likely *Battledore* (37 x 15.2 cm, priv. coll., Cleveland, Ohio, repro. Hilary Morgan, *Burne-Jones, The Pre-Raphaelites, and their Century*, 2 vols. [London: Peter Nahum, 1989], 2: Pl. 88). Moore worked it up as a finished picture, but its composition remains far simpler than the full-scale painting. Early ideas for *Battledore* are documented in a pastel sketch (23 x 12 cm, repro. Sotheby's (Belgravia), 20 November 1973 [43]). See also a black chalk nude study (35.5 x 16 cm, repro. Christie's [New York], 27 May 1983 [318]) and nude cartoon (D.238-1905, V&A).

178 Moore's concern with the appearance of his works in situ is indicated by his request that 'the light [on *Battledore* and *Shuttlecock*] should be as high as possible and rather from the left' (AJM to JL, 14 September 1870, Royal Oak Hotel, Hastings, LP/UBC). Leathart ultimately placed Moore's pictures on either side of a window at his house, Bracken Dene (see Pl. 113).

179 For the texts on colour endorsed by the Central School, see Richard Redgrave, *An Elementary Manual of Colour, with a Catechism: To Be Used with the Diagram Illustrating the Harmonious Relations of Colour* [orig. pub. 1853], rev. edn. (London: Chapman and Hall, 1884).

180 Monkhouse, 'Albert Moore', 196.

181 W.B. Scott, 'The Royal Academy Exhibition', *Academy*, 2 (15 May 1871): 261.

182 Stephens likened Albert to his brother, the portraitist John Collingham Moore, for their marked interest in colour studies ('The Royal Academy', *Athenaeum*, no. 2270 [29 April 1871]: 533; no. 2273 [20 May 1871]: 627; no. 2275 [3 June 1871]: 693). Henry Moore was also noted for his interest in chromatics (Maclean, *Henry Moore*, passim).

183 'The Royal Academy. IV', *Saturday Review*, 31 (27 May 1871): 666. Another remarked on Moore's emulation of the 'tender and tertiary harmonies made known in this country by large importations of Japanese screens' ('The Royal Academy', *Art Journal*, 33 [1 June 1871]: 176). Moore was also criticized for emulating the colours of Pompeiian mural paintings because they were 'little above the rank of paper-hangings' ('The Royal Academy. III', *Saturday Review*, 35 [17 May 1873]: 651). The prejudice persisted over a decade later when F.G. Stephens demanded, 'Why does not the artist … abandon a style of design which suffices for little else than a fan or a paper-hanging?' ('The Royal Academy [Third Notice]', *Athenaeum*, no. 3109 [28 May 1887]: 708).

184 Rather than Japan, Colvin urged Moore to emulate the rich colour of Venetian painting ('English Painters of the Present Day', 6), a suggestion that elicited a tirade from Baldry 25 years later (*Albert Moore*, 92-7).

185 'The Royal Academy', *Art Journal*, 33 (1 June 1871): 177.

186 AJM to JL, 23 November 1870, 3 Red Lion Square, LP/UBC. His letter of 4 March 1870 to Leathart indicates that the third painting was unrelated to the subject of the previous two: 'I think the Shuttlecock pictures will be finished first, the other proceeding immediately afterwards' (cf. n. 175; for a contrasting opinion, see Newcastle 1972, no. 34). The price charged for Leathart's third picture indicates that its format differed from the previous two, which cost £100 each; in a letter of 23 November 1870, Moore asked Leathart to advance him 'the half of the price (£75) of the [third] picture I am painting for you'. See also his letters of 9 July 1870 and 14 September 1870, LP/UBC.

187 AJM to JL, 24 August 1871, 3 Red Lion Square, LP/UBC.

188 In a letter of complaint to the framers, Foord and Dickenson, Leathart had stated his intention of taking up the matter with Moore during a visit to London in early June. Pressing business intervened and the matter languished until 27 July 1871 when he sent a second letter to the framers (AJM to JL, 7 August 1871, 3 Red Lion Square, and JL to AJM [draft], 9 August 1871, LP/UBC).

189 Convinced of his vindication, Moore had delayed writing 'in case of your making enquiries respecting the point raised, the matter would probably be settled without being referred to me'. He invited Leathart to inspect the account books of the framers to see that he had 'hitherto made no exception in my practice in this respect' (AJM to JL, 7 August 1871, 3 Red Lion Square, LP/UBC).

190 AJM to JL, 6 September 1871, 3 Red Lion Square, LP/UBC.

191 JL to AJM (draft), 9 August 1871, LP/UBC. On framing practices in the late nineteenth century, see Jacob Simon, *The Art of the Picture Frame: Artists, Patrons and the Framing of Portraits in Britain* (London: National Portrait Gallery, 1996).

192 AJM to JL, draft letter of 9 August 1871, LP/UBC.

193 AJM to JL, 24 August and 6 September 1871, 3 Red Lion Square, LP/UBC. Moore had also consulted Val Prinsep, whose absence from home prevented his replying until 28 August when he wrote, 'My experience is that purchasers are only too glad for artists to choose their frames and make no objection to paying for them—but I think in a commission they ought to be consulted in the matter and if not

consulted are not bound to take the frame designed by the artist but if the purchaser takes the frame he ought to pay for it certainly … I always make the frame maker send his bill to the purchaser but I ask what kind of frame the said purchaser would like' (priv. coll.).

194 AJM to JL, 6 September 1871, 3 Red Lion Square, LP/UBC. 20 years later, a similar quarrel over a bill erupted when Whistler failed to consult with his patron prior to authorizing Goupil & Co. to clean one of Leathart's paintings, at the owner's expense (L39 WC/GUL).

195 Moore told Leyland that his other client had 'written to put off my painting anything for him at present' (AJM to FRL, 29 August 1870, 3 Red Lion Square, PWC/LC). The dates seem to rule out Leathart, as his third commission was still pending when Moore wrote him two months later (see n. 186).

196 'I hope this arrangement will meet with your approval, and am glad that it is possible, as I recollect that my impression was that you were pleased with the sketch you have already seen, and as I think that the new figure I have hit upon, will make a very suitable companion' (AJM to FRL, 29 August 1870, 3 Red Lion Square, PWC/LC).

197 Moore's receipt of 1 September 1870, PWC/LC.

198 AJM to JL, Royal Oak Hotel, Hastings, 14 September 1870, LP/UBC.

199 Whistler drafted the letter on Leyland's stationery (JMW to AJM, n.d. [September 1870], M436, WC/GUL); the original letter is unlocated.

200 'My dear Moore—I have something to say to you which in itself difficult enough to say, is doubly so to write. Indeed for the last few days I have several times sat down to the matter and losing courage given it up—however it must be done at once or set aside forever as your precious time may not be lost. This is an awful opening rather and the affair is scarcely worthy of such solemnity. The way of it is this—First tho' I would like you to feel thoroughly that my esteem for you and admiration for your work are such that nothing could alter my regard and in return I would beg that if I am making an egregious mistake you will be indulgent—and forgive—believe that I do so with great timidity wishing for nothing more than to be put right—and would rather anything than that a strangeness should come about in our friendship through any stupid thundering letter I might write' (JMW to AJM, n.d. [September 1870], M436, WC/GUL).

201 Whistler's focus on this sketch is odd, as his painting *Venus* bears far closer resemblance to *Sea-gulls* (Freer Gallery of Art). As the date of the former (c.1868) is hypothetical, the picture may actually postdate *Sea-gulls*, constituting another instance of Whistler's borrowing from Moore. Whistler returned to the idea of Moore's *Sea-gulls* in a much later pastel *Annabel Lee*, c.1879 (Freer Gallery of Art).

202 'The one I mean is one in blue green and flesh color of four girls careering along the sea shore, one with parasol the whole very unfinished and incomplete' (JAMW to AJM, n.d. [September 1870], M436, WC/GUL).

203 Nesfield to JAMW, 19 September 1870, 30 Argyll Street, N20, WC/GUL. The chief interest of *Sea-gulls* is actually Moore's vivacious treatment of drapery which has no precursor in Whistler's work, but rather in Simeon Solomon's *Love in Autumn*, painted in Florence in 1866 (priv. coll.). Significantly, Solomon repeated this device in *Love Dreaming by the*

Sea, a watercolour executed in 1871, the year *Sea-gulls* appeared at the RA (University College of Wales, Aberystwyth).

204 Baldry, *Albert Moore*, 71.

205 Baldry, *Albert Moore*, 83-4. Moore evidently carried out these studies during the winter of 1871, when he confessed to Leyland, 'I have found the blowing draperies more laborious than I expected' (AJM to FRL, 9 January 1871, 3 Red Lion Square, PWC/LC).

206 Maclean, *Henry Moore*, 131, 154-8.

207 Moore indicated these diagonals in the full-size nude cartoon, one of his most attractive preparatory drawings (D.228-1905, V&A).

208 AJM to FRL, 9 January 1871, 3 Red Lion Square, PWC/LC. A small (23.2 x 10.8 cm) oil-on-copper copy was offered at Christie's, 4 November 1988 (216).

209 AJM to FRL, 14 January 1871, 3 Red Lion Square, PWC/LC. Leyland disliked the fact that the repetition would be the same size as his original, but he later consented to Moore's painting a half-size copy of the companion picture *Shells* (repro. Christie's [New York], 18 February 1993 [135]). To further differentiate the copy from the original, Moore employed a radically different colour scheme, altered the design, and dated the canvas 1875 (Minneapolis 1878, no. 75).

210 AJM to FRL, 9 March, 13 March (with receipt), and 4 May 1871 (with receipt), 3 Red Lion Square, PWC/LC.

211 AJM to FRL, 17 June 1871, 3 Red Lion Square, PWC/LC.

212 Following the exhibition of *A Venus* in 1869, Moore had informed Leyland, 'It has since occurred to me that I may be able to do something to alleviate the roughness of the canvas, and I am keeping the picture with that view' (AJM to FRL, 31 August 1869, 17 Fitzroy Street, PWC/LC). The following year he made a similar comment about one of Leathart's pictures, either *Shuttlecock* or *Battledore*, asserting, 'When the paint in the picture is quite hard, I shall be able to improve certain parts which have dried dead, by rubbing with a silk handkerchief' (AJM to JL, 9 July 1870, 3 Red Lion Square, LP/UBC).

213 Leyland apparently attempted to jumpstart the languishing commission in March 1872 by offering to advance Moore the remaining £66 5s. due for the painting. The artist gratefully accepted this proposal (AJM to FRL, 8 March and 11 March 1872 (with receipt), 3 Red Lion Square, PWC/LC). A rough pastel sketch on brown paper (34.2 x 14.6 cm) may indicate Moore's early intention of placing the figure in a wooded setting at the water's edge (Fogg Art Museum, Harvard University).

214 Moore's successive primings served an additional purpose, according to Baldry, by providing the picture with 'a sufficient backing of white to secure it from all risk of darkening or of losing its brilliancy of colour; and to provide also a ground which would be pleasant to work upon' (Baldry, *Albert Moore*, 75-6).

215 Walker, 'Private Picture Collections', 364; York 1912 (4). A journalist later recounted 'a story told by one of his [Moore's] own pupils, who, having been set the task to paint some drapery of subtle tones, accomplished it in a way he considered to be excessively creditable. "Dear me!" said Albert Moore; "and do you really see it like that? Why, you have missed some twenty different shades of colour. Put the canvas aside for a month, and when your

eyes have learnt to see what is before them, you had better take it up again"' (Chester, 'The Art of Albert Moore', 379).

216 'The Royal Academy. II', *Saturday Review*, 37 (9 May 1874): 593; 'Royal Academy Exhibition (Fourth Notice)', *Academy*, 5 (30 May 1874): 615. Trying to interest Leyland in a chalk drawing of his own, D.G. Rossetti noted that it was 'as fully coloured as an Italian fresco,—quite as fully, for instance, as the pictures by Moore which you have' (DGR to FRL, 18 March 1873, PWC/LC).

217 'The Royal Academy [Third Articles]', *Pall Mall Gazette*, 19 (18 May 1874): 11. A previous review asserted, 'Mr. Moore stands almost alone among our painters … In his painting, beside the record of abstract loveliness, we find the signs of its possible relation with the form and movement of actual life' (*Pall Mall Gazette* [2 May 1874], 11). Another critic characterized Moore as 'the most profound and earnest student of form in Art [that] England now possesses', working alone to revive 'a forgotten ideal' ('The Royal Academy. Second Notice', *Art Journal*, 36 [1874]: 197).

218 However, the writer faulted Moore for treating colour systematically, as an abstract pattern ('The Royal Academy. Second Notice', *Art Journal*, 36 [1874]: 197). For other criticism of the colour scheme, see Colvin, 'The Royal Academy [Third Article]', *Pall Mall Gazette*, 19 (18 May 1874): 11; John Forbes-Robertson, 'The Royal Academy', *Examiner* (30 May 1874), 575; 'Painting at the Royal Academy', *Architect*, 11 (9 May 1874), 264.

219 Echoing several other critics, Davies deprecated Moore's focus on formal concerns to the exclusion of sentiment, incident and emotion: 'Ravished with the exquisite beauty of the marbles of the Parthenon, he has sacrificed everything to the reproduction of their fine majestic movement and grand line' ('The State of English Painting', *Quarterly Review*, 134 [April 1873]: 305-6). Another critic deduced that the aim of Moore's art was 'to elevate the commonest incident in every-day life by means of a treatment unreal, far-fetched, and affected' ('The Royal Academy. IV', *Saturday Review*, 31 [27 May 1871]: 666). See also W.B. Scott, 'The Royal Academy Exhibition', *Academy*, 2 (15 May 1871): 261; cf. 'The Royal Academy [Second Notice]' *Spectator*, 46 (17 May 1873): 637-8; F.T. Palgrave, 'Royal Academy Exhibition (Fourth Notice)', *Academy*, 5 (30 May 1874): 615; 'The Royal Academy [Third Notice]', *Spectator*, 47 (30 May 1874): 691.

220 For the history and characteristics of the statuettes, see: *Academy*, 5 (27 June 1874): 730; Thomas Sulman, 'The Terra-cottas of Tanagra', *Good Words*, 39 (1898): 405-10; Marcus B. Huish, 'Tanagra Terra-cottas', *Studio*, 14 (July 1898): 97-104; 'A Lady of Tanagra', *Anglo-Saxon Review*, 63 (1900): 63-74 and *Greek Terracotta Statuettes* (London: John Murray, 1900); C.A. Hutton, *Greek Terra-cotta Statuettes* (London: Seeley & Co., 1900); Reynold Higgins, *Tanagra and the Figurines* (Princeton: Princeton University Press, 1986).

221 Katharine A. Lochnan, *The Etchings of James McNeill Whistler* (New Haven and London: Yale University Press, 1984), 152-5; Spencer, *James McNeill Whistler and His Circle*, 25; cf. Merrill, *The Peacock Room*, 360-1, nn. 84-5; Stoner, *Textured Surfaces*, 104-5.

222 Indeed, a contemporary description of one of the figurines evokes a painting by Moore: '[It] is almost entirely to be regarded as a decorative study in

drapery. There is drapery everywhere, save in the naked arm that emerges from the garment looped on the shoulder. It is very beautiful' ('Art Notes', *Sketch*, 1 [8 February 1893], 83; cf. Richard Muther, *The History of Modern Painting*, trans. Arthur Cecil Hillier [orig. pub. 1893], 3 vols. [London: Henry and Co., 1896], 3: 128-9).

223 AJM to FRL, 9 March, 13 March (with receipt), 4 April (with receipt), 17 June, and 23 June (with receipt) 1871, 3 Red Lion Square, PWC/LC. Leyland invariably paid Moore by return of post.

224 Moore shared the premises with the West Central London Institute of the Young Women's Christian Association, Miss Harriet Baldwin, principal. He was around the corner from Morris & Co., which in 1866 had moved from Red Lion Square to Queen's Square.

225 *1871 Census*, RG 10/369, f. 21.

226 No marriage or death certificate for Elizabeth Moore could be located through the Office of National Statistics, nor is she buried in the Moore family plots at Highgate Cemetery (Camden Local Studies and Archives Centre, Holborn Library). Moore's hometown obituary specified that he died unmarried ('Obituary', *Yorkshire Herald* [27 September 1893]).

227 One of Moore's obituarists asserted, 'As to Moore's not being elected to the Academy, it is a mistake to attribute that fact to the characteristics of his art' ('Mr. Albert Moore', *Athenaeum*, no. 3440 [30 September 1893]: 459; cf. M.H. Spielmann, 'Death of Mr. Albert Moore', *Daily Graphic* [27 September 1893]; Marks, 'My Notebook', 132). Another denied that Moore's exclusion was 'due to any of the unworthy motives which some rather heedless critics have recently imputed to those who guide the fortunes of the Academy' ('Artists and Critics', *Westminster Gazette* [26 September 1893], 1). Henry Moore's biographer stated that 'whatever may have been the real motive for that refusal, it constituted a slight which he never forgot nor forgave', adding 'for his youngest brother [Albert] he cherished a love that neither time nor evil report could weaken' (Maclean, *Henry Moore*, 99-100).

228 He added, 'It was not that his work did not render him eligible—like Charles Keene's; it was not that he was unappreciated—like Alfred Stevens; it was not because he was unpopular by reason of affectation, pose, and caustic witticism—like Mr. Whistler; it was not because he preferred to stay on the outside—like John Linnell and Mr. Holman Hunt' ('Albert Moore and the Royal Academy', *Magazine of Art*, 17 [October 1893]: ii).

229 'Albert Moore and the Royal Academy', ii. While soliciting information for the biographical chapter of his book on Moore, which he wished to make as complete as possible, Baldry stated, 'I am avoiding the more private details of his life, and am only considering him as a great artist. I do not see that the public has any right to know anything else' (Baldry to JMW, 11 July 1894, B10 #2894, WC/GUL).

230 AJM to JCM, n.d. [c. 1860], MA 4500 M, Pierpont Morgan Library; Lamont, *Armstrong*, 27-30; Maclean, *Henry Moore*, 110-11.

231 Baldry, *Albert Moore*, 23.

232 'He was, as a teacher of advanced principles, and as one of the leaders of a growing opposition in the art world, likely to prove a dangerous companion. So they kept him outside the pale of official recognition, and did what they could to minimise his influence', chiefly by 'exclud[ing] him from all those positions of

authority and from all those offices where his influence could be brought into competition with their own' (Baldry, 'Albert Moore', 3-4). Another observer wrote that 'Personal jealousies, his inability to accommodate himself to the views of the official custodians of British art, his open criticisim of his contemporaries, or some other trivial cause, sufficed each election to exclude him' ('Albert Moore', *Art Journal*, 55 [1893]: 335).

233 For fuller discussion and a contemporary photograph of Moore's painting in situ at Cragside, see Mark Girouard, *The Victorian Country House*, rev. edn. (New Haven and London: Yale University Press, 1979), 312-13; see also 'Cragside—The Country Residence of Sir William Armstrong', *Building News*, 22 (10 May 1872): 376; Newcastle 1990, no. 81; E. Rimbault Dibdin, 'Lord Armstrong's Collection of Modern Pictures—II', *Magazine of Art*, 14 (1891): 194-5.

234 Baldry, *Albert Moore*, 84. For black and white chalk studies of various figures, nude and draped, see: Sotheby's (Belgravia) 7 May 1974 [7] and D.239-1905 to D.246-1905, V&A. For an oil sketch, see p. 230, n. 93. See also Quilter, *Preferences in Art, Life, and Literature* [London: Swan Sonnenschein & Co., 1892], 312.

235 Linear diagrams in *Study of a Boy for 'Follow My Leader'* and verbal notes in *Study for the Sixth Figure in 'Follow My Leader'* (e.g., 'shorten thigh', 'move knee to right horizontally') document alterations required to accommodate anatomy to Moore's geometric system (D.239-1905 and D.243-1905, V&A). The idiosyncratic combination of idealism and realism in the painting troubled several critics. See 'The Royal Academy [Second Notice]' *Spectator*, 46 (17 May 1873): 637-8; 'Exhibition of the Royal Academy', *Illustrated London News* (17 May 1873), 471; 'The Royal Academy. III', *Saturday Review*, 35 (17 May 1873): 651; 'Exhibition of the Royal Academy', *Art Journal*, 35 (1873): 168.

236 The connection between this design and *Follow My Leader* was first suggested by Richard Green (Newcastle 1972, no. 40).

237 See also *Study of a Girl for the Drawing 'Design for a Picture'*, c.1870-3 (black and white chalks on brown paper, 35.5 x 20.9 cm, Christie's, 7 June 1996 [560]) and cartoon for a frieze *Music* (charcoal on brown paper, D.247-1905, V&A).

238 AJM to Charles Augustus Howell, 7 August 1872, Banqueting Hall, Jesmond Dene, Newcastle-on-Tyne, Miscellaneous Correspondence File, 1871-2, 8314.3.1.1, Tate Archives.

239 Eastlake, *History of the Gothic Revival*, 290-1.

240 The designs are black and white charcoal on brown paper, D.255-1905 to D.267-1905, V&A. For Lehmann, the son of an artist whose extensive literary and artistic contacts included Dickens, George Eliot, Landseer and Millais, see R.C. Lehmann, ed., *Memoirs of Half a Century: A Record of Friendship* (London: Smith, Elder and Co., 1908).

241 Edward Poynter had previously (1869) designed a frieze of peacocks for the grill-room at the South Kensington Museum (Lionel Lambourne, *The Aesthetic Movement* [London: Phaidon Press, 1996], 58. For a brilliant discussion of the origins and denouement of Whistler's work for Leyland, see Merrill, *The Peacock Room*.

242 Hebb, 'Albert Moore and the "D.N.B."', 47, 317; Conway, *Travels in South Kensington*, 161-4; Conway also illustrates the table installed with Moore's plaques. Baldry reproduced a preparatory study for

one of the figures (*Albert Moore*, opp. 70) and a very different overall arrangement, with a second roundel ornamented with a bearded man, seated and semi-draped, extending a cup toward a naked ephebe bearing a jar (opp. 38).

243 For a description of the picture in situ at Gosforth House, the Smiths' Newcastle residence, see F.G. Stephens, 'The Private Collections of England. No. III—Gosforth House—Tynemouth', *Athenaeum*, no. 2395 (20 September 1873): 374.

244 Aitchison to AJM, 28 July 1875, priv. coll.

245 Smith, *Decorative Painting*, 6; Newcastle 1990, 27-8.

246 George Aitchison, 52 Princes' Gate, Boudoir, design for elevation of wall, watercolour and gold, [1-2], RIBA.

CHAPTER FOUR

1 Indeed, Moore was reportedly 'too careless of outside opinion, and too impatient of the various shifts to which artists who bid for public notice are reduced, to have much inclination to advertise himself' ('Albert Moore. [By a Pupil]', 20; similarly, Wedmore, 'Albert Moore', 436; Quilter, 'The Art of England. II', *Universal Review*, 4 [May 1889], 58).

2 Baldry, *Albert Moore*.

3 'The Grafton Gallery Collection', *Art Journal*, 56 (1894): 89; similarly, 'Rose Leaves', *Art Journal*, 51 (1889): 155. Similarly, while praising the 'delicate harmoniousness of colour and excellent accessories' in J.C. Moore's portraiture, a critic warned, 'Mr. Moore seems in danger of thinking more of the dress and *entourage* of his subject than the subject itself; bronze boots, red apples, and old blue porcelain, are all very good in their way, but unless it is intended to be entirely decorative art, they should be kept in subordination to the face' ('The Dudley Gallery', *Spectator*, 49 [12 February 1876]: 209).

4 *A Sleeping Girl* (oil on canvas, 30.8 x 22.5 cm., Tate Gallery). The animal skin, boldly patterned pillow, and unsystematized drapery suggest a date of c.1866. Two black and white chalk drawings of this period document Moore's experimentation with potential poses: one (31 x 20 cm) is in the National Gallery of Ireland, the other (25.5 x 15.3 cm) is repro. Sotheby's (Belgravia), 29 June 1976 (286). A later drapery study is repro. Baldry, *Albert Moore*, 76.

5 Oil studies include: *Colour Sketch for 'Apples'* (23.5 x 38.1 cm, York City Art Gallery) in which two squat ginger jars replace the slender vases ultimately adopted; *Two Women on a Sofa* (29.3 x 51.7 cm, Fine Art Society, 4-29 June 1979) which substitutes a seated cat at far right; *Two Women on a Sofa* (30 x 49 cm, Yale Center for British Art); and *Study for Beads* (29.3 x 47.3 cm, priv. coll.); see Newcastle 1972, no. 47.

6 Staley, 'The Condition of Music', 86; similarly, Graham Reynolds, *Victorian Painters*, rev. edn. (New York: Harper & Row, 1987), 121.

7 The treatment of women as abstractions is examined in Marina Warner, *Monuments and Maidens: The Allegory of Female Form* (London: Weidenfeld and Nicolson, 1985).

8 For an important new contribution to this argument, see Psomiades, *Beauty's Body*. The contemplative male figure in *'The Thoughts of Youth are Long, Long Thoughts'*, exh. RA 1862 (unlocated), may represent Moore's early attempt to adapt masculine imagery to the Aesthetic theme of repose.

9 Henry Heathcote Statham, 'Reflections at the Royal

Academy', *Fortnightly Review*, 26 (July 1876): 62. Six years earlier Tom Taylor had complained that Moore's exclusive concern with 'expressing the beautiful by lines and colours' resulted in works that seemed 'turned out by receipt and rule' and that failed 'to touch any but the select few who are in time for it beforehand' ('The Royal Academy Exhibition', *The Times* [30 April 1870], 12). For related criticism of *Beads*, see F.G. Stephens, 'The Royal Academy (Second Notice)', *Athenaeum*, no. 2532 (6 May 1876): 640. See also: 'The Royal Academy [Third Notice]', *Spectator*, 47 (30 May 1874): 691; 'The Royal Academy [First Notice]', *Spectator*, 49 (6 May 1876): 391; 'The Royal Academy Exhibition. Concluding Notice', *Art Journal*, 38 (1876): 261; 'The Royal Academy. III', *Saturday Review*, 41 (20 May 1876): 649; 'The Royal Academy (First Notice)', *Academy*, 9 (6 May 1876): 442.

10 'The Royal Academy (First Notice)', *The Times* (1 May 1882), 4; review from the *Observer*, quoted in Baldry, *Albert Moore*, 95. Overlooking the human touches in *Beads*, one critic asserted that the 'two sleeping figures in their contour and diaphanous drapery might pass for literal transcripts from antique marbles' ('The Royal Academy. III', *Saturday Review*, 41 [20 May 1876]: 649).

11 Indeed, according to a contemporary journalist, 'Albert Moore denied in his work the promptings of his own nature, which was both ardent and emotional, and would have led him, had he followed it, to have become, like Rubens, the delineator of materialistic beauty, instead of the portrayer of that which is cold and classic' (Chester, 'The Art of Albert Moore', 371).

12 Russell-Cotes, *Home and Abroad*, 719-20. Edgcumbe Staley claimed, rather cryptically, that in Leighton's painting *The Bracelet*, 'we see the model from whom Moore gained so much' (*Lord Leighton*, 154). Moore's model Milly Jones evidently aspired to the stage; D.G. Rossetti procured her a theatrical engagement around the time she was posing for Moore (WMR MS. diary, 26 February 1867, folder 15-1, f. 899, ADC/UBC; see also p. 215, n. 76 and p. 217, n. 109).

13 Graham Robertson remarked that such 'colour studies of draped figures, done straight off while the model stood and never retouched, were his most perfect works. The touch was so light, the paint so fresh and exquisite in texture, the drawing and colour so true and sensitive, that they were miracles of artistry' (*Time Was*, 61-2; see also Baldry, *Albert Moore*, 73).

14 On sleeping figures in late Victorian art, see Kenneth Bendiner, *An Introduction to Victorian Painting* (New Haven and London: Yale University Press, 1985), 121-43; Staley, 'The Condition of Music', 80-7.

15 'Academy Notes, 1875' in Cook and Wedderburn, *Works of John Ruskin*, 14: 272-3. Another critic later noted, 'Nothing in his [Moore's] pictures was put in without intent: each flower, cushion, piece of drapery, every apparently trivial detail had its exact place and well-defined purpose to serve in the design of the mosaic as a whole' (Chester, 'The Art of Albert Moore', 370).

16 Baldry, 'Albert Moore (1841-1893)', 45; similarly, Baldry, 'The Treatment of Drapery in Painting', *Art Journal*, 71 (1909): 235-8.

17 L. Higgin, *Handbook of Embroidery*, ed. Lady Marian Alford (London: Sampson, Low, Marston, Searle, and Rivington: 1880), vi.

18 Maclean, *Henry Moore*, 123.

19 This group was preceded by the Ladies' Ecclesiastical Embroidery Society and various provincial groups which collaborated with architects in the decoration of churches. See Crane, *An Artist's Reminiscences*, 158, 164, 300-8, 444, and 'Needlework as a Mode of Artistic Expression', *Magazine of Art*, 21 (1898): 144, 197; George Frederic Watts, 'Needlework', *Nineteenth Century*, 9 (March 1881): 429; Mary Seton Watts, *George Frederic Watts*, 2 vols. (New York: Hodder & Stoughton, 1912), 2: 6-8; Robertson, *Time Was*, 35-6; Conway, *Travels in South Kensington*, 168-72.

20 The artist George Dunlop Leslie noted, 'There is hardly any useful handicraft the mysteries of which she has not mastered—carving, modelling, house-painting, carpentry, smith's work, repoussé work, gilding, wood-inlaying, embroidery, gardens and all manner of herb and flower knowledge and culture' (*Our River* [London: Bradbury, Agnew & Co., 1881], 37). See also Michael Tooley and Primrose Arnander, eds., *Gertrude Jekyll: Essays on the Life of a Working Amateur* (Witton-le-Wear: Michaelmas Books, 1995).

21 Armstrong reportedly took 'great trouble over the materials, designs, and colours' of fabrics in his own paintings, 'often making experiments in dyeing with his own hands' (Lamont, *Thomas Armstrong*, 38-40). Moore, too, 'if he could not find the exact shade he wanted for his draperies … dyed the silk himself' (York 1912 [4]). Several of Armstrong's acquisitions entered the South Kensington Museum; in 1882 he deposited an embroidered quilt on loan, and in 1901 he sold the museum a curtain with tambour embroidery, a silk embroidered table cover and an embroidered quilt from Iran (Agenda on objects, etc., received, 18 February 1882, from Thomas Armstrong; List of objects on loan from Mr. T. Armstrong, C.B., 25 November 1901; Minute paper, Walter Crane's report on Thomas Armstrong's collection, 19 November 1900, nominal file, V&A).

22 Francis Jekyll, *Gertrude Jekyll, A Memoir* (London: Jonathan Cape, 1934), 86-7, 101; Conway, *Travels in South Kensington*, 166, 196.

23 As an art student at South Kensington from 1861 to 1863, Jekyll studied with the botanist turned designer Christopher Dresser. In 1863 she travelled through Greece and Turkey with the classical archaeologist Charles T. Newton, whose instruction included a lecture on the ancient principle of entasis, or optical adjustment, at the Parthenon (Jekyll, *Gertrude Jekyll*, 38-75; Joan Edwards, 'Gertrude Jekyll: Prelude and Fugue', in Tooley and Arnander, eds., *Gertrude Jekyll*, 45-51).

24 William Morris also employed plant names, such as 'Honeysuckle' and 'Tulip and Willow' for his fabric designs, as did the designers of the Royal School of Art-Needlework. See Higgin, *Handbook of Embroidery*, 103; Linda Parry, *The Victoria and Albert Museum's Textile Collection: British Textiles from 1850 to 1900* (London: Victoria and Albert Museum, 1993); Gillian Naylor, ed., *William Morris by Himself: Designs and Writings* (Boston: Little, Brown and Co., 1988).

25 Jekyll's photograph is reproduced in Judith B. Tankard and Michael R. Van Valkenburg, *Gertrude Jekyll: A Vision of Garden and Wood* (New York: Harry N. Abrams/Sagapress, 1989), Pl. 47.

26 Attesting to Moore's successful evocation of natural colour harmonies, one critic described the sofa's upholstery as 'wrought in delicate pinks and fresh cool yellows and pansy hues, now dark and deep, and now faint and pale, all of which are so fused and harmonized as to produce an impression of iridescent pearliness, as of the inner surface of a strange and beautiful shell' ('Our Illustrations', *Art Journal*, 43 [June 1881]: 164).

27 These include *The End of Story*, *Forget-me-Nots* and *Kingcups* (pls. 132-3, 144, 155) as well as two other oil paintings: *Standing Female Figure Holding a Glass Pitcher* (c. 1878, 27.3 x 10.1 cm, Sotheby's [New York], 5 May 1999 [130]) and *A Garland* (1887-8, 49.3 x 25 cm, Manchester City Art Gallery).

28 The coverlet (V&A 478-1883) measures 266.4 x 197.9 cm. I am grateful to Linda Parry of the V&A, for her generosity in locating this item and sharing ideas about the fabrics in Moore's paintings. See also memorandum of 19 April 1883 in Albert Moore's nominal file, V&A.

29 Liberty owned Moore's *Study for 'Kingcups'*, c.1883 (39 x 19.5 cm, repro. Sotheby's, 10 July 1995 [203]), *Study for 'A Bather'*, c.1891 (Pl. 186), *Reflections* (see p. 228, n. 38) and *Lovers*, a study for *Larkspurs*, c.1890 (Pl. 189). See also n. 32.

30 'Sir Arthur Liberty', *Daily Telegraph* (12 May 1917), 6. 'Famous artists got the idea that I took a real interest in what we sold and my knowledge and appreciation of art were extended by prolonged visits to their studios, where I was always made welcome' ('The House of Liberty and its Founder', *Daily Chronicle* [1913], news clipping, Liberty & Co. Papers, City of Westminster Archives Centre, 788/10). See also Alfred Lys Baldry, 'The Growth of an Influence', *Art Journal*, 62 (1900): 48; *Liberty's, 1875-1975*, exhibition catalogue, V&A, July-October 1975, 4-5; Alison Adburgham, *Liberty's: A Biography of a Shop* (London: George Allen & Unwin, 1975), 13-22.

31 E.W. Godwin, 'Afternoon Strolls. I, A Japanese Warehouse', *Architect*, 16 (23 December 1876), 363.

32 'The House of Liberty and its Founder'. The drawing is repro. Baldry, 'The Growth of an Influence', 45, and *Albert Moore*, opp. 2 (as 'Design for a Pictorial Advertisement'). It mimics a section of slab V from the Parthenon's east frieze in which priestesses make preparations for a ritual (repro. Ian Jenkins, *The Parthenon Frieze* [London: The Trustees of the British Museum, 1994], 79).

33 Frederic, 'A Painter of Beautiful Dreams', 722.

34 F.R. Conder, 'Exhibition of Indian Textile Fabrics at the Indian Museum, Downing Street', *Art Journal*, 32 (1870): 106.

35 Frederic, 'A Painter of Beautiful Dreams', 722.

36 The patterns recall aspects of historical European as well as late nineteenth-century English style. However, there are no exact matches with extant examples. I am grateful for the generous assistance of Mary Schoeser and Anna Buruma (Liberty Archive, London); Madelyn Shaw and Mattibelle Gittinger (Textile Museum, Washington, DC), and Linda Parry (V&A).

37 Baldry, *Albert Moore*, 15. Descendants of Henry Moore possess Albert's drawing for the decorative wall pattern in *A Revery* (Pl. 165), together with wallpaper samples considered to be his work. See also Pl. 119, and a panel of decoration (gouache over pencil on brown paper, 33.2 x 59 cm), D.9-1906, V&A.

38 'The Grosvenor Gallery', *Art Journal*, 39 (1877): 244.

39 Virginia Surtees, *Coutts Lindsay, 1824-1913* (Wilby, Norwich: Michael Russell, 1993), 94-6, 99-100; Susan P. Casteras and Colleen Denney, eds., *The Grosvenor Gallery: A Palace of Art in Victorian England* (New Haven and London: Yale University Press, 1996), 4.

40 Sidney Colvin, 'The Grosvenor Gallery', *Fortnightly Review*, 21 (June 1877): 831.

41 Baldry considered *Poppies* (1877-8, oil, 40 x 13.9 cm) technically superior to *Sapphires*, with 'greater charm of colour'; for a detailed description see *Albert Moore*, 47. Variations on *Marigolds* include *A Yellow Rose*, 1878 (see p. 223, n. 65), and *A Study in Yellow (The Green Butterfly)* (oil on panel, 39.1 x 13.3 cm, Delaware Art Museum, Wilmington).

42 Christopher Newall, *The Grosvenor Gallery Exhibitions: Change and Continuity in the Victorian Art World* (Cambridge: Cambridge University Press, 1995), 13; Casteras and Denney, *The Grosvenor Gallery*, 21-4.

43 Such comments began in 1865. The unusual colour scheme of *Elijah's Sacrifice*, it was said, 'puts the picture to a disadvantage among the glaring conventional tints of its neighbours' and 'should not be exposed to the exhibition ordeal, as being conceived and executed in a spirit in direct antagonism with everything about them' ('The Royal Academy Exhibition [Second Notice]', *Saturday Review*, 19 [27 May 1865]: 635; 'Royal Academy Exhibition. Fourth Notice', *The Times* [24 May 1865], 6).

44 Pl. 135 is a repetition of the original RA picture (now Manchester City Art Galleries). *Birds* was exhibited as *Canaries* in 1885 and has subsequently retained that title (see p. 223, n. 58). *Garnets* (1878, oil on canvas, 39.3 x 13.5 cm) is repro. Sotheby's, 23 October 1990 [74]; it is an inferior version of *Carnations*, 1877 (see p. 223, n. 65). Another small work, *A Study*, a.k.a. *The Gilded Fan* (oil on canvas laid down on board, 38.1 x 14.6 cm), also exh. Grosvenor 1878, is repro. Sotheby's, 23 May 1990 [72].

45 Charles W. Dempsey, 'Advanced Art', *Magazine of Art*, 5 (1882): 358. See also Crane, *An Artist's Reminiscences*, 175-6.

46 Oscar Wilde, 'L'Envoi' in John Wyse Jackson, ed., *Aristotle at Afternoon Tea: The Rare Oscar Wilde* (London: Fourth Estate, 1991), 196-7.

47 Baldry lists the following titles: *Drapery Cartoon for 'Sea Gulls'*, *Study of Palm Foliage*, *Study of a Poppy in Seed*, *Studies of Flowers*, *Two Studies of Hands*, *Two Studies of Heads*, *Study of Drapery for a Figure in Action* and *Three Studies of Drapery* (Baldry, *Albert Moore*, 104). See also 'Art Chronicle', *Portfolio*, 11 (1880): 37-8; Wilfrid Meynell, 'The Winter Exhibition at the Grosvenor Gallery', *Magazine of Art*, 3 (1880): 165.

48 Agnes D. Atkinson, 'The Grosvenor Gallery', *Portfolio*, 8 (1877): 98. For the architecture and decoration of the gallery, see Newall, *The Grosvenor Gallery Exhibitions*, 10-15; Casteras and Denney, *The Grosvenor Gallery*, 9-35.

49 For the economic argument, see Gene H. Bell-Villada, *Art for Art's Sake and Literary Life: How Politics and Markets Helped Shape the Ideology and Culture of Aestheticism of 1790-1990* (Lincoln and London: University of Nebraska Press, 1996).

50 Lawrence Alma Tadema reportedly sold his tiny painting *A Mirror* in the same Grosvenor exhibition for 1,500 guineas. He asked high prices for two other diminutive works: 700 guineas for *The Bath* (a.k.a. *An Antique Custom*) and 600 for *Sunflowers*. Watts asked 4,000 guineas for *Love and Death*; Crane, 300 guineas for *The Renaissance of Venus*; W.B. Richmond, 750 guineas for *Electra at the Tomb of Agamemnon* ('Studio Gossip', *Architect*, 18 [14 July 1877]: 23).

51 Frederic, 'A Painter of Beautiful Dreams', 722; Baldry, 'Whistler and Albert Moore', 14. The collector William Connal was reportedly offered 'a very large sum' for his group of 15 Moore works ('An Artist's Vindication', *Daily Telegraph* [16 March 1908], 5). For further testimony to Moore's command of a 'ready market' which ensured that 'no picture which he painted during the last thirty years of his life remains unsold' see Baldry, 'Albert Moore (1841-1893)', 42, and 'Albert Moore: An Appreciation', 33; 'Albert Moore', *Art Journal*, 55 (1893): 334; 'Obituary', *Yorkshire Herald* (27 September 1893); 'Albert Moore (By a Pupil)', 2; Wedmore, 'Albert Moore', 436.

52 The author also criticized Simeon Solomon for lending 'actual genius to worthless subjects, and thereby produc[ing] veritable monsters' (Thomas Maitland [a.k.a. Robert Buchanan], 'The Fleshly School of Poetry: Mr. D.G. Rossetti', *Contemporary Review*, 18 [October 1871]: 337, 339; see also W.M. Rossetti, *Dante Gabriel Rossetti: His Family-Letters*, 2 vols. [New York: AMS Press, 1970], 1: 249-50, 2: 293-303).

53 See, for example, 'Pictures of the Year. II.', *Saturday Review*, 23 (23 February 1867): 236; W.H. Mallock, 'A Familiar Colloquy on Recent Art', *Nineteenth Century*, 4 (August 1878), 290-9; R. St John Tyrwhitt, 'The Limits of Modern Art-Criticism', *Nineteenth Century*, 4 (September 1878): 512-16; Sidney Colvin, 'Art and Criticism', *Fortnightly Review*, 32 (August 1879): 211, 220-3; cf. Harry Quilter, 'The Art of Watts', *Contemporary Review*, 41 (February 1882): 274-5, 281.

54 Wedmore, 'Some Tendencies in Recent Painting', 334, 344; see also 'Some Living English Painters', *Art Amateur*, 4 (April 1881): 94; 'Henry and Albert Moore', *Art Journal*, 43 (1881): 164; Armstrong, 'Study', 145; cf. Wilfrid Meynell, 'Our Living Artists. George Frederick [sic] Watts, R.A.', *Magazine of Art*, 1 (1878): 243. For Moore's influence on Burne-Jones, see 'Exhibitions', *Magazine of Art*, 16 (February 1893): xvii; M. Susan Duval, *A Reconstruction of F.R. Leyland's Collection: An Aspect of Northern British Patronage*, Ph.D. thesis, The Courtauld Institute, 1982, 27-8.

55 'Physiology of Expression in Art', *Magazine of Art*, 12 (November 1889): v. For the promotion of this so-called 'Aryan' type as a cultural and physical ideal, see George L. Hersey, *The Evolution of Allure: Sexual Selection from the Medici Venus to the Incredible Hulk* (Cambridge: MIT Press, 1996).

56 R.A. Church, *Kenricks in Hardware: A Family Business: 1791-1966* (Newton Abbot: David & Charles, 1969); Asa Briggs, *History of Birmingham*, 2 vols. (London, New York, Toronto: Oxford University Press, 1952); City of Birmingham Art Gallery, *Catalogue of the Permanent Collection of Paintings in Oil, Tempera, Watercolour, etc.* (Birmingham: Hudson & Sons, n.d.). See also Birmingham Society of Arts and School of Design, *Report of Committee and Statement of Accounts … 19th February, 1878* (Birmingham: The 'Journal' Printing Offices, 1878); Richard Ormond, 'Victorian Paintings and Patronage in Birmingham', *Apollo*, 87 (April 1968): 240-51.

57 For Chamberlain's art collection, see Innes Adair, 'Highbury, Birmingham: The Home of the Right Hon. Joseph Chamberlain, M.P.', *Weekly Scotsman* (8 July 1899); Charles H. Curtis, 'Highbury Gardens, Birmingham', *Gardeners' Magazine* (18 April 1903): 253; 'Where Mr. Chamberlain Lives', *Cassell's Family Magazine*: 375-80; Darby Stafford, 'The Colonial Secretary's Country Home', 229-39 (news clippings, Special Collections, JC 4/12, Birmingham University Library)

58 For unknown reasons, Chamberlain gave *Birds* the title *Canaries* in 1885 when he loaned it (along with *Sapphires*) to the Birmingham Museum and Art Gallery (Whitworth Wallis and Alfred St Johnstone, *Official Catalogue of the Contents of the Birmingham Museum & Art Gallery with notes upon the Industrial Exhibits* [Birmingham: George Jones and Son, 1885], 8-9).

59 Chamberlain had also donated £1,000 towards a core collection of industrial art for Birmingham in 1875. In addition to Moore's pictures, he presented the new gallery with a pair of Egyptian scenes by W.J. Muller (Wallis and St Johnstone, *Official Catalogue … Birmingham Museum & Art Gallery*, 8-10). The following year he lent Leighton's *Greek Girls Picking up Pebbles by the Sea* (Borough of Birmingham. Museum and Art Gallery *Catalogue of the Collection of Paintings in Oil and Water Colours* [Birmingham: Osborne and Son, 1887], 29).

60 'The Old Wedgwood Ware at the Art Gallery', *Birmingham Daily Mail* (8 December 1885), news cuttings collected by G.H. Osborne, 1866-1905, Birmingham Central Library; City of Birmingham, *Report of Museum and School of Art Committee for Presentation at the Special Meeting of the Council, on the 28th of March, 1893* (Birmingham: privately printed, 1893), 26; Whitworth Wallis, 'The Museum and Art Gallery' in J.H. Muirhead, ed., *Birmingham Institions: Lectures Given at the University* (Birmingham: Cornish Brothers Ltd., 1911), 479-80; 'The Art Gallery', *Birmingham Faces and Places. An Illustrated Local Magazine*, 3 (November 1890): 101-2; Sir Richard Tangye, *'One and All': An Autobiography of Sir Richard Tangye of the Cornwall Works, Birmingham* (London: S.W. Partridge & Co., 1889), 145-9. For the relationships of Chamberlain, Kenrick and the Tangyes, see Briggs, *History of Birmingham*, 2: 2, 185.

61 Baldry, *Albert Moore*, 16. See also Birmingham Society of Arts and School of Design, *Report of Committee and Statement of Accounts … 6th February, 1877* (Birmingham: The 'Journal' Printing Offices, 1877), 4-5, 12. No evidence of Moore's invitation to serve as headmaster survives in the archives of the Birmingham School of Art and Design; I am grateful for the assistance of John Swift.

62 AJM to FRL, 1 Holland Lane, Melbury Road, Kensington, 29 January 1878, PWC/LC.

63 FRL's draft response appended to AJM's letter to him, 29 January 1878, PWC/LC. Five weeks later, D.G. Rossetti predicted that Leyland 'won't buy again at all' (Merrill, *The Peacock Room*, 379, n. 8).

64 For a preliminary drapery study (oil on canvas, 152.2 x 63.5 cm), see *Apollo*, 93 (April 1971): 123.

65 Heir to a large Glaswegian drapery firm, Stewart commissioned this copy, known as *Birds of the Air* (86.6 x 35.8 cm), as a companion to *A Reader* (the original of Pl. 135), which he had purchased from Moore around the time of its appearance in the 1877 RA exhibition (both paintings now City of Manchester Art Galleries). He also owned the paintings *Carnations* (1877, 38.1 x 13.5 cm, repro. Sotheby's, 22 November 1983 [50]) and *A Yellow Rose* (1878, 38.6 x 14 cm, unlocated), both exh. Glasgow Institute 1879 under the Whistlerian titles *Harmony in Orange and Pale Yellow* and *Variation in Blue and Gold*. Stewart's patronage was cut short by his death at age 44 on 27 May 1880; his paintings were sold at Christie's, 9 May 1881 (information from files of the Mitchell Library, Glasgow).

66 Sidney Colvin, 'The Grosvenor Gallery', *Fortnightly Review*, 21 (June 1877): 831.

67 I am grateful to Patricia Asleson for creating the computer reconstruction of this drawing, which was necessitated by the faintness of the original (D.227-1905, V&A). The same system is evident in the nude cartoons for *Sapphires* (D.224-1905) and *Shuttlecock* (D.238-1905), V&A.

68 In 1875, while still living in Great Ormond Street, Moore shared a studio in Campden Hill Road, Kensington, with the artist William S. Coleman. Two years later, he was sharing 171 Stanhope Street, Hampstead, with the sculptor Hamilton Macallum; the address appears on the back of Moore's *A Reader* (Manchester City Art Galleries), exh. RA May 1877. See *Royal Blue Book: Fashionable Directory, and Parliamentary Guide* (London: B.W. Gardiner & Son, 1875), 4, 37, 354, 906; *The Post Office London Directory for 1877*, 78th edn. (London: Kelly & Co., 1877), 171, 1177, 1518, 2242.

69 'Some Glimpses of Artistic London', *Harper's New Monthly Magazine*, 67 (November 1883): 834; 'New Houses at Holland Park, Kensington', *Building News*, 31 (29 September 1876), 306-7; Lamb, *Lions in Their Dens*, 207-57; Giles Walkley, *Artists' Houses in London, 1764-1914* (Aldershot: Scolar Press, 1994), 60-4.

70 Robert C. Driver (surveyor to Lord Ilchester), Plan of Proposed New Studios at Kensington, Holland Estate Kensington (f. 6073, K&C). The lessee was the solicitor Henry Roberts of nearby 26 St Mary Abbotts Terrace. Permission was originally granted to build four small private houses on the land behind the pub, but in an indenture of 30 December 1876, Roberts agreed instead to build two artists' studios at his own expense (f. 6072, K&C). On 11 January 1877, Roberts licensed William Goodson of 1 St Mary Abbotts Terrace, proprietor of the Holland Arms pub, to erect the studios (f. 6074, K&C).

71 C. Lewis Hind, 'Painters' Studios', *Art Journal*, 52 (1890): 135.

72 The property had indeed originally been laid out as mews servicing houses along St Mary Abbots Terrace (*Survey of London (Northern Kensington)* 42 vols. [London: Athlone Press, 1973], 37: 106-7, 111, 124).

73 L.V. Fildes, *Luke Fildes, R.A.: A Victorian Painter* (London: Michael Joseph, 1968), 35-7, 43-6; Lamb, *Lions in Their Dens*; Walkley, *Artists' Houses in London*, 28-31.

74 AJM to FRL, 1 Holland Lane, Melbury Road, Kensington, 29 January 1878, PWC/LC. The Holland Arms pub, erected in 1824 on the site of a much older inn, the White Horse, had been rebuilt in 1866.

75 Holland Park Estate Lease to Erect Studios at the Rear of the Holland Arms, 30 December 1860, f. 6072, K&C.

76 The dairy featured stained glass, wood panelling, relief sculpture, and hand-painted tiles depicting farm animals and other motifs including roundels reminiscent of Nesfield's 'pies' ('The New Holland Park Dairy, Kensington', *Building News*, 36 [12 April 1878]: 366). See also *Survey of London*, 37: 127; Vestry of Kensington, Surveyor's Department, Metropolitan Board of Works Applications (1875-76), Case No. 125 [House between the Melbury Road and Holland Lane and Fronting the Kensington Road; Mr. Driver, 1875] and (1876-7), Case No. 151 [House in Kensington High Road; Mr. W. Boutcher, 1876], K&C.

77 A neighbour recalled the clanking of cow bells as a daily feature of the locale (Fildes, *Luke Fildes*, 46).

78 Edward William Godwin, 'Studios and Mouldings', *Building News*, 36 (7 March 1879): 261.

79 Baldry, 'Albert Moore: An Appreciation', 33. Similarly, another contemporary noted, 'The social dignities and commercial emoluments attaching to artistry he utterly ignored. All forms of patronage were intolerable to him' (R. Jope Slade, *Echo* [28 September 1893], quoted in Baldry, *Albert Moore*, 24.

80 The lessee was charged an annual rent of £80; Moore's rent would have been somewhat more than that; see schedule of 9 November 1877, f. 6095 and ff. 6075, 6081, 6089, 6095, K&C. In 1874 Lord Ilchester wrote that his agent Driver was drawing up a few modest villa plans at £200 a year, 'the smallest we should think of but hoping to get offers for larger tenancies' (*Survey of London*, 37: 126).

81 The original plan designates two self-contained studios, each with a sitting room (Robert C. Driver, *Plan of Proposed New Studios at Kensington [Holland Lane]*, c.1877, f. 6073, K&C, neg. no. L/6755). The legal documents consistently refer to the building as 'two artists studios' (ff. 6075, 6081, 6089, K&C).

82 Leighton, Prinsep and Watts deliberately minimized the number of bedrooms in their houses in order to discourage guests (Lamb, *Lions in Their Dens*, 19, 127-8, 212-14; Walkley, *Artists' Houses in London*, 48-50, 65-6).

83 Robertson, *Time Was*, 58-9.

84 Lucas, *Edwin Austin Abbey*, 1: 80-1, 192-3. See also 'A Chat with Mr. J. Whistler in Chelsea', *Pall Mall Budget* (5 June 1885), 16; Robertson, *Time Was*, 192. For an insightful discussion of Whistler's aesthetic, see Deanna Marohn Bendix, *Diabolical Designs: Paintings, Interiors, and Exhibitions of James McNeill Whistler* (Washington and London: Smithsonian Institution Press, 1995).

85 For an attempt to discern veiled Orientalism in much of Moore's work, see Kenneth Bendiner, 'Albert Moore and John Frederick Lewis', *Arts*, 54 (February 1980): 76-9.

86 According to Godwin, Moore 'screened his light by hoods over the windows and skylights, and by movable shutters' ('Studios and Mouldings', 262). For an anecdote concerning the skylights, see Robertson, *Time Was*, 59.

87 Drawing of c.May/August 1877 in Godwin sketchbook, E.244-1963, f. 3, V&A. Moore had not yet moved into the studio when Godwin sketched it; the drawing evidently documents alterations that the artist required prior to taking up residence in November. For Reynolds's studio, see Richard Wendorf, *Joshua Reynolds: The Painter in Society* (Cambridge: Harvard University Press, 1996), 112-13; Walkley, *Artists' Houses in London*, 4, 49.

88 Godwin, 'Studios and Mouldings', 261.

89 'Midsummer', *Art Journal*, 50 (1888): 317. Of *A Summer Night* (Pl. 179) another critic wrote, 'The figures are illuminated in an inexplicable manner, and from the front, but so that, although the illumination is bright, it casts no shadow to speak of' ('The Royal Academy [Third and Concluding Notice]', *Athenaeum*, no. 3265 [24 May 1890]: 677-8.

90 Way, *Memories of Whistler*, 28; see also Godwin, 'Studios and Mouldings', 262.

91 For the environmental concerns of Poynter and Richmond, see Asleson, *Classic into Modern*, 57-71. For Moore's 'protest poetry', see 'Death of Mr. Albert Moore', *Westminster Gazette* (26 September 1893), 4.

92 Baldry, *Albert Moore*, 72.

93 Baldry, *Albert Moore*, 72-3.

94 The painting is reminiscent of Henry Moore's still lifes, such as *Chrysanthemums* (repro. Maclean, *Henry Moore*, opp. 112).

95 Baldry, 'Albert Moore (1841-1893)', 45; see also Baldry, 'Albert Moore', 46.

96 Baldry, *Albert Moore*, 65, 72. Robertson, *Time Was*, 82. Other still lifes executed as chromatic experiments include *Study of Colour—Carnation and Roses* and *Study of Colour—Flesh-Coloured Sultans*, both exh. Institute of Painters in Oil Colours 1884.

97 In March 1886 George Bernard Shaw noted a similar effect in an unlikely urban setting: 'That our foggy atmosphere often produces poetic landscapes in the midst of bricks and mortar will hardly be denied by anyone who has watched the network of bare twigs lacing the mist in Lincoln's-Inn-Fields' (quoted in Stanley Weintraub, ed., *Bernard Shaw on the London Art Scene, 1885-1950* [University Park and London: Pennsylvania State University Press, 1989], 9).

98 Moore's initial sketch emphasized the composition's horizontal lines (repro. Baldry, *Albert Moore*, 72), but he executed his drapery study over a diamond pattern of diagonals (D.254-1905, V&A). In *A Study in Yellow (Blossoms)*, Moore experimented with the same design in yellow and orange (see p. 214, n. 39). This or another small version hung in 1901 in the drawing room at Navarino, Sutton Coldfield (repro. Nicholas Cooper, *The Opulent Eye* [London: Architectural Press, Ltd., 1977], Pl. 120).

99 By autumn 1879 (when exh. Liverpool) *Topaz* had sold, presumably to Humphrey Roberts. Moore translated studies for the picture into smaller variations, including *Forget-me-Nots* (Pl. 144) and two works entitled *Companions*: an oil exh. Dowdeswell 1883 (41.8 x 21.6 cm, priv. coll.; repro. Christie's, 6 November 1995 [124]), and a watercolour, exh. Royal Institute of Painters in Water-Colours 1885 (43.2 x 22.3 cm, Fogg Art Museum, Harvard University).

100 Baldry, 'Albert Moore: An Appreciation', 33. John Hebb sketched a scenario that may have typified Moore's commissions: 'A certain Maecenas, being desirous of decorating his house, consulted a friend of Albert Moore as to how he should obtain a picture by that artist. By the friend's advice Moore was invited by Maecenas to breakfast, when the matter was discussed, Moore being given *carte blanche* as to price and the choice of subject left to him' ('Eden v. Whistler', 11; cf. Baldry, *Albert Moore*, 91-2).

101 Merrill, *A Pot of Paint*, 57-71. Ruskin condemned many of the other 'eccentrities' on dislay, along with the Grosvenor's décor and hanging practices (*Fors Clavigera*, 79 (July 1877) in Cook and Wedderburn, *Works of John Ruskin*, 29: 158-60.

102 Pennell and Pennell, *Life of Whistler*, 134.

103 'Careless and positively untidy in dress, eccentric in gait, his face cruelly marred by a chronic eczema', Martin frittered away much time drinking in taverns. His friend the American artist George Boughton complained 'that he couldn't afford to have Homer about the studio, so deterrent was his effect upon conventionally minded British patrons', and his wife recalled his studio as 'the most untidy room I had ever entered' (Elizabeth Gilbert Davis Martin, *Homer Martin: A Reminiscence* [New York: William Macbeth, 1904], 21-3; Frank Jewett Mather, Jr., *Homer Martin: Poet in Landscape* [New York: privately printed, 1912], 7-10, 17).

104 Their presence apparently lent a Bohemian chic

to the establishment and eventually (according to Whistler), 'the sort of Englishman who is entirely outside all these things, but likes to think he is in it, began to come too, and that ruined it' (Pennell and Pennell, *Whistler Journal*, 233).

105 JAMW to AJM, 29 August n.d. [1878], priv. coll.

106 Pennell and Pennell, *Whistler Journal*, 123; Pennell and Pennell, *Life of Whistler*, 76.

107 'Albert Moore's Pictures', *Saturday Review*, 77 (27 January 1894): 89. *Chelsea—Sunrise* once belonged to Henry Moore (Grafton 1894, no. 182) and *Nightpiece* was owned by Charles Holme, Christopher Dresser's partner, who visited Japan with Arthur Lasenby Liberty and Alfred East in 1889-90 (York 1912, no. 147).

108 Merrill, *A Pot of Paint*, 79-89; cf. Way, *Memories of Whistler*, 32. Two other witnesses spoke on Whistler's behalf: the minor artist and playwright William Gorman Wills and the art critic William Michael Rossetti, who had begged to be excused from testifying and later wrote Ruskin explaining that his participation had been compulsory (WMR MS. diary, 22 November and 1 December 1878, folder 15-3, ff. 54-5, ADC/UBC). Moore was deemed Whistler's best witness ('Art Chronicle', *Portfolio*, 10 [1879]: 22).

109 JAMW to AJM, n.d. (22 November 1878), M437, WC/GUC.

110 Like Whistler, Moore was a great enemy of professional art critics: 'He denied their right to discuss at all the work of a painter, and freely questioned their qualifications for such a task, arguing always that to explain, or even discover, the real merits of a work of art a critic would need technical knowledge almost as complete as that required by the actual executant' (Baldry, *Albert Moore*, 89).

111 Merrill, *A Pot of Paint*, 144. Whistler had already aired these ideas in an interview of May 1878: 'The picture should have its own merit, and not depend upon dramatic, or legendary, or local interest … should stand alone, and appeal to the artistic sense of eye or ear, without confounding this with emotions entirely foreign to it, as devotion, pity, love, patriotism, and the like' ('Celebrities at Home, No. XCII: Mr. James Whistler at Cheyne-walk', *World* [22 May 1878], 4-5; cf. James McNeill Whistler, 'The Red Rag' in *The Gentle Art of Making Enemies*, 127-8).

112 Cook and Wedderburn, *Works of John Ruskin*, 20: 46.

113 'Recent Illustrated Volumes', *Magazine of Art*, 18 (1895), 18: 193.

114 Baldry, *Albert Moore*, 24. Notwithstanding his own propensity for imprudent statements, Moore wrote on the eve of the trial, 'Mr. Ruskin's remarks astound me as much by their injustice, as by the coarseness of the language, which is indeed beyond anything I have met with in a written criticism.' On further consideration, Moore (or Whistler's counsel) crossed out the last 13 words of the sentence (AJM, suggestions for his proof, n.d. [24 November 1878], PWC/LC; I am grateful to Fred Bauman of the Library of Congress for obtaining this document for me).

115 AJM, suggestions for his proof, n.d. [24 November 1878], PWC/LC; cf. Merrill, *A Pot of Paint*, 147-78.

116 Moore crossed out his additional observation, 'One feels that a pebble would penetrate the water of his river and that a kite could fly in his skies.' He inserted: 'Foreign critics consider that our great

defect as painters is an over-wrought or niggled manner of painting, and it is no doubt easier to make an object intelligible to the uninitiated by means of detail, than by the expression of broad truth which latter is essentially the aim of Whistler.' At the trial, Moore repeated this cosmopolitan rebuttal to the charge that Whistler merely flung paint-pots at the canvas (Merrill, *A Pot of Paint*, 158).

117 Henry Moore was in the habit of making this argument about his own art (Maclean, *Henry Moore*, 115-16).

118 Starr, 'Personal Recollections of Whistler', 535.

119 Moore's letter appears as 'The Case of Whistler v. Ruskin', *Echo* (29 November 1878), 6; 'Whistler v. Ruskin', *Daily News* (30 November 1878), 2; 'The Ruskin Libel Case', *Standard* (30 November 1878), 5.

120 Moore monitored press coverage closely following the trial. On 30 November 1878 he wrote to Whistler, 'My sister in law—who once came round to see you, would like to see my evidence as reported in the Globe—Monday evening—can you send it? I find it impossible to get it now.' He enclosed a clipping from the *Athenaeum* ('Fine-Art Gossip', no. 2666 [30 November 1878]: 695) advertising that Whistler's brother-in-law (and nemesis) Seymour Hayden intended to illustrate a lecture on etching by completing a plate before the audience—an ironic demonstration, in view of Ruskin's criticism of Whistler's speed of execution. '[It] is rather a happy suggestion', Moore observed, 'for I think those who sympathise with you can now do no less' (AJM to JAMW, 30 November 1878, MA 3553, Pierpont Morgan Library; cf. Merrill, *A Pot of Paint*, 153 and 147-75 passim).

121 'The Memorial of the Royal Academy', *The Times* (11 February 1879), 6. See also *Minutes of the Evidence Taken before the Royal Commission on Copyright, Together with an Appendix* (London: Her Majesty's Stationery Office, 1878). The artists Thomas Faed, Francis Grant, and Thomas Woolner were among the witnesses providing testimony.

122 'On the House-Top', *Architect*, 19 (26 January 1878): 49.

123 Lindsay issued an open invitation in the *The Times* after receiving 'numerous letters from artists'; see 'Artistic Copyright', *The Times* (28 January 1879), 7, and (3 February 1879), 10.

124 On this subject, see 'Artistic Copyright', *The Times* (11 February 1879), 6 [letter from Henry O'Neil]; (20 February 1879), 8 [from Edwin Long]; (25 May 1882), 4 [from 'R.A.']; F.R.C., 'Artists' Copyright', *Art Journal*, 41 (May 1879): 82-3; William Holman Hunt, 'Artistic Copyright', *Nineteenth Century*, 5 (March 1879): 418-24; Frederic Leighton and Henry T. Wells, 'Government and the Artists', *Nineteenth Century*, 6 (December 1879): 968-84.

125 In his diary account, Abbey added, 'I sat by [Fred] Barnard and nearly killed myself trying not to laugh at his running comments on the speeches. He had the fellows all about in a broad grin' (Lucas, *Edwin Austin Abbey*, 1: 74; see also Crane, *An Artist's Reminiscences*, 176).

126 The meeting provided a first step towards reconciliation with Richmond, from whom Moore had grown estranged owing to his allegiance to 'the Whistler clique'. The following year, on the occasion of John Collingham Moore's death, Richmond wrote to Henry Moore, 'I cannot tell you how much I sympathize with you and Albert, "who I wish would forget my boyish faults and again be friend [sic] with

me"' (WBR to Henry Moore, 1 August 1880, priv. coll.). By 1884 Richmond had secured the rare privilege of visiting Moore's studio to view a work in progress, *Reading Aloud* (Pl. 157); WBR to AJM, 2 April 1884, priv. coll.

127 'Art Copyright', *Builder*, 37 (8 February 1879): 159.

128 Baldry, 'Albert Moore', 46.

129 *Jasmine* (exh. Grosvenor 1880) was classed 'among the most voluptuous and delicious of his combinations of colour, true feasts of the eye. He has never used diaphanous draperies with such exquisite effect, or so successfully combined tender tones of rose and peach blossom in subtle and half transparent harmonies, with such consummately calculated tones of grey' ('The Grosvenor Gallery', *The Times* [11 May 1880], 8).

130 The writer added, 'To him the figure is central indeed as regards arrangement, but is often subordinate to its own draperies as regard interest and importance of colour' ('Rose Leaves', *Art Journal*, 51 [1889]: 155).

131 The evolution of other figures in *Dreamers* is similarly documented by oil paintings exhibited during this period. The woman at far right appeared in *Rose Leaves*, exh. Grosvenor 1880 (68.5 x 48.2 cm, unlocated; repro. Baldry, *Albert Moore*, 52), described as 'a lovely female figure, nude but for a transparent gauze drapery that enfolds without hiding the rose-leaf tinted flesh beneath; the rosy fingers and toes are visible, and the accessories are of a slightly deeper rose and white' (*Portfolio*, 9 [1880]: 104; similarly, 'The Grosvenor Gallery', *Building News*, 38 [7 May 1880]: 534-5). The same figure was reinterpreted in *A Siesta*, exh. Dowdeswell 1880 (68 x 47.6 cm, Sotheby's, 17 June 1970 [129]), an arrangement in red and white, and in *Musk* (68.5 x 50 cm, repro. Sotheby's, 17 June 1986 [45]), a scheme of orange, yellow, green, and white. The left-hand figure appears in *Acacias*, exh. Grosvenor 1882 (58.4 x 31.1 cm, Carnegie Museum of Art, Pittsburgh).

132 The writer, probably Godwin, added, 'Mr. ALBERT MOORE is distinctly a leader; he carries a severe principle of decoration much further than any other painter we know—to the avoidance of all expression of emotion; that the art of painting deals only with what words cannot reproduce—the beauty of matter—is a canon of his school' ('On the House-Top', *Architect*, 19 [26 January 1878]: 49).

133 Baldry, *Albert Moore*, 86; Robertson, *Time Was*, 275.

134 Robertson, *Time Was*, 36-51; Preston, *Letters from Graham Robertson*, 343.

135 Robertson, *Time Was*, 56, 129. Robertson enrolled at Eton in the winter of 1880 (*The Eton Register, Part IV, 1871-1880* [Eton: Spottiswoode & Co., 1907], 165).

136 Baldry to JAMW, 3 March 1894, B9 #2893, PWC/LC. Baldry had been on a scholarship at South Kensington in 1877. He was described as 'a pupil and personal friend' of Moore (*Pall Mall Gazette*, no. 1331 [29 March 1894]: 12). The much younger Robertson never attained the same degree of intimacy; up to the last year of his life, Moore continued to address him as 'Mr. Robertson'; see Moore's letter of 1892, WR 411, Huntington Library.

137 Baldry served as stage manager for theatrical productions at the Vaudeville, including the first production of *Faddimir* (1889) by Adrian Ross and F.O. Carr, the first English production of Ibsen's *Rosmersholm* (1891), and John Todhunter's *Sicilian Idyll*

(1891); see *Who's Who, 1929-1940* (London: Adam and Charles Black, 1941), 56. Baldry never exhibited at the RA; his exhibition venues are listed in *Allgemeines Künstlerlexikon* (Munich: Saur, 1992-), 431. A false report of his death 'by his own hand, during a temporary depression', resulted in a premature obituary which described him as 'an earnest pursuer of "naturalistic" art, whose feeling for colour was delicate, and whose appreciation of landscape was superior to his power of figure drawing' ('Obituary', *Magazine of Art*, 14 [October 1890]: iv). The erroneous paragraph (instigated by the suicide of the portrait painter Harry Lister Baldry) was excised from later editions.

138 In addition to writing numerous books on art, Baldry served for 20 years as London art critic for the *Globe* and the *Birmingham Daily Post* and published frequently in the *Studio*, the *Art Journal* and the *Magazine of Art* (Bernard Dolman, *Who's Who in Art*, 3rd edn. [London: The Art Trade Press, 1934], 21).

139 Baldry to JAMW, 11 July 1894, B10 #2894, WC/GUL.

140 Robertson, *Time Was*, 57-60. By comparison, the impeccable Leighton's at-home dress consisted of 'a black velvet lounging sack and pearl-grey pantaloons; his feet in shining pumps, his countenance superb; he was almost too beautiful' (Julian Hawthorne, *Shapes That Pass: Memories of Old Days* [Boston: Houghton Mifflin, 1928], 175).

141 E.V. Lucas, *The Colvins and their Friends* (London: Methuen & Co., 1928), 14; see also Walker, 'Private Picture Collections', 364.

142 Baldry, 'Whistler and Albert Moore', 14.

143 Robertson, *Time Was*, 58; cf. Walker, 'Private Picture Collections', 367. See also p. 229, n. 65.

144 In 1881 this was Elizabeth Collier, a 68-year-old spinster from Reading (*1881 Census*, RG 11/27, f. 136, PRO). She may have had some connection with the household of John Collingham Moore, whose wife was from Reading and whose cook in 1871 was Elizabeth Collins, a 42-year-old Reading woman (*1871 Census*, RG 10/30, f. 49).

145 'I think I would rather you did not come till Wednesday, as I am afraid my housekeeper will not be able to be here in very good time tomorrow' (AJM to Walford Graham Robertson, 26 January 1886, WR 410, Huntington Library).

146 Robertson, *Time Was*, 60-1.

147 Baldry, *Albert Moore*, 86.

148 In his letter of 6 July 1889, Alma-Tadema had written, 'My dear Albert Moore, My friend Reynolds Stephens wishes me to give him an introduction to you. I do so with great pleasure and I trust that you may find it convenient to give him all the information he wants' (priv. coll.). Completed in 1890, the refreshment room mural was based on *Summer*, the design for which Reynolds-Stephens had received an RA Schools prize in May 1887. He repeated the design as an oil painting in 1891 (Whitford & Hughes [London], 1984); see M.H. Spielmann, 'Our Rising Artists: Mr. W. Reynolds-Stephens', *Magazine of Art*, 20 [May 1897]: 71-4; A.L. Baldry, 'The Work of W. Reynolds-Stephens', *Studio*, 17 [July 1899]: 75-8).

149 M.H. Spielmann, 'Our Rising Artists: Mr. W. Graham Robertson', *Magazine of Art*, 23 (1900): 74-5.

150 Robertson, *Time Was*, 129, 235.

151 A reporter who visited in 1880 while making notes on pictures destined for the summer exhibitions was forbidden a glimpse of Moore's RA work which 'was

not sufficiently advanced when we called to permit its being seen' ('The Round of the Studios. No. II', *Art Journal*, 42 [1880]: 158). An anonymous pupil confirmed, 'no one but his model came into his studio when he was at work; no visitor, indeed, was till late years allowed at any time inside his studio door' ('Albert Moore [By a Pupil]', 20; but cf. p. 225, n. 126 and p. 227, n. 203). Henry Moore also discouraged studio visitors (Maclean, *Henry Moore*, 114-15, 125-6).

152 'He cared absolutely nothing for publicity. Indeed, he discouraged all attempts to illustrate or describe his work. A shy man of most retiring disposition, it was almost impossible to draw him out from the reserve with which he enveloped himself as with a cloak' (Marks, 'My Notebook', 132; similarly Ward, *Recollections of a Savage*, 252; 'The Grafton Gallery', *Art Journal*, 56 [1894]: 89; Elizabeth Robins Pennell, *Whistler the Friend* [Philadelphia and London: J.B. Lippincott Company, 1930], 170-1.

153 'He was always at work, both with brain and fingers, in his studio from early morning till evening in London summer and winter, with often only a few days' holiday in the year' ('Albert Moore [By a Pupil]', 2). Similarly, 'he could … by no means be induced to relax his exertions, and by change and rest to give himself a reasonable chance of improvement. His work was, with him, always the first consideration, and to that consideration everything else had to give way' (Baldry, *Albert Moore*, 17).

154 An incident of 16 March 1889 recorded in Lucas, *Edwin Austin Abbey*, 1: 191-2.

155 Robertson, *Time Was*, 57, 60.

156 The unfortunate comment was made during a dinner at the Café Royal, a setting which seemed to bring out the worst in Whistler. Jacques-Emile Blanche wrote, 'What a direful impression an evening in his company at the Café Royal, or in society, made on us. Everywhere he was noisy, vain, and full of self-advertisement' (*Portraits of a Lifetime*, 77)

157 Nevertheless, contemporary critics insisted on projecting conventional narratives onto the picture. See F.G. Stephens, 'A Modern Private Collection', *Art Journal*, 50 (November 1888): 324.

158 Moore also executed a lively pastel version of *Kingcups*, once owned by Arthur Lasenby Liberty (see p. 222, n. 29).

159 Moore's motion studies of a dancer yielded a pair of large pastels (exh. Grosvenor 1885): in *Crocuses* she steps back and forth in a kind of Spanish dance (101 x 46 cm, repro. Christie's, 14 July 1998 [153]); in *Roses* she pirouettes with her arms clasped behind her back (98 x 38 cm, repro. Sotheby's [New York], 23 May 1996 [164]). Moore reinterpreted these compositions in different colour schemes in two small watercolours (exh. RSPWC 1885): *Oranges* (36.1 x 18.7 cm, Cecil Higgins Art Gallery, Bedford) and *Lanterns* (36.7 x 19 cm, unlocated); see Baldry, *Albert Moore*, 84. An impromptu drawing of the dancer is repro. opp. 90. See also Armstrong, 'Study', *Portfolio*, 19 (1888): 145.

160 Baldry, *Albert Moore*, 17.

161 Connal had houses in Glasgow and London, but preferred to reside at Solsgirth with his wife and large family of five sons and four daughters. Taking little interest in public affairs, his 'one indulgence was the collecting of art' (Walker, 'Private Picture Collections', 335-41, 361-7; see also 'Albert Moore', *Art Journal*, 57 [1895]: 48).

162 Connal sold the majority of his collection at Christie's, 14 March 1908. On his death, his personal movable estate was valued at £209,564 (Anthony Slaven and Sydney Checkland, eds., *Dictionary of Scottish Business Biography, 1860-1960* [Aberdeen: Aberdeen University Press, 1990], 357-8; see also Macleod, *Art and the Victorian Middle Class*, 403-4).

163 Walker, 'Private Picture Collections', 335; see also Connal's letter of 21 September 1887 to Edward Burne-Jones, Glasgow Art Gallery and Museum.

164 The study also entered Connal's collection (Walker, 'Private Picture Collections', 364; Baldry, *Albert Moore*, 56). A manuscript label in the Hunterian Art Gallery, University of Glasgow, reads: 'Original Study for painting/ Reading Aloud / by Albert Moore.—/ Picture now in Glasgow/ Corporation Collection.—/ Painted to order of/ William Connal/ and took nearly five/ years to complete.—/ JT [?] Connal/ 1881-1884/5'.

165 Studies of this kind for *A Bather* and *An Idyll* are cited in p. 227, n. 61 and p. 229, n. 74; see also Armstrong, 'Study', 145.

166 Baldry described this as a standard procedure in Moore's technique (*Albert Moore*, 76). Pinholes in *Reading Aloud* indicate that the cartoons were pinned to the canvas while the ground layer was moist (notes by Helen Irving, October 1982, on file at Glasgow Art Gallery & Museum). This is consistent with Moore's practice of painting on a wet surface.

167 'The Royal Academy [First Notice]', *Spectator*, 58 (2 May 1885): 579.

168 Baldry, *Albert Moore*, 55.

169 Edward Hawkins, *A Catalogue of the Greek and Etruscan Vases in the British Museum*, 2 vols. (London: William Nicol, 1851), 1: 333, no. 936; see also Walker, 'Private Picture Collections', 364.

170 The bee appears on Connal's personal stationery and was also associated with his firm, Connal & Co., Ltd. It was evidently a pun on his motto 'Non Sibi'. See C.A. Oakley, *Connal & Co. Ltd., of Glasgow, 1722-1946* (Glasgow: 1946).

171 A similar linear armature is clearly visible in *An Open Book* (Pl. 159). Related works include the unlocated oil *Sweet and Twenty*, exh. Grosvenor 1884, with a black and white lace background, and the watercolours *A Memory* (28.5 x 22 cm, Williamson Art Gallery and Museum, Birkenhead) and *An Alcove* (35.5 x 15 cm, exh. RSPWC and Liverpool 1884, which combined elements of *Reading Aloud* and *Red Berries* (Pl. 161) in pinkish yellow and red.

172 'Art Chronicle', *Portfolio*, 15 (1884): 123, and an unidentified news clipping in the Hunterian Art Gallery. Another critic observed, 'It is no exaggeration to say that his pictures are mathematical problems constructed on a pattern, a very network of symmetric lines; and, were it possible to eliminate the figures from the canvases there would yet remain, not only traceable but distinct and easy to be followed, the scientific system on which they are constructed, and within which elaborate framework he set himself the task of expounding his philosophy of the beautiful' (Chester, 'The Art of Albert Moore', 370).

173 Baldry, *Albert Moore*, 82. *Reading Aloud* contains two different lace patterns which resurface in other paintings. The chrysanthemum and anemone pattern reappears in *An Open Book* (Pl. 159), *Red Berries* (Pl. 161), *Silver* and *Myrtle* (for the latter two, see p. 228, n. 36). The daisy pattern appears in two

versions of *Companions* (see p. 224, n. 99). A third pattern appears in *Yellow Marguerites* (Pl. 152) and *Acacias* (see p. 225, n. 131).

174 A related drapery study for the seated left-hand figure (with a dense network of visible construction lines) is repro. Christie's (South Kensington), 19 July 1984 (240).

175 Indeed, the shock of seeing a major work by Moore at the Academy, hung in a favourable position, was remarked upon in 'Art Chronicle', *Portfolio*, 15 (1884): 123.

176 In a second election held that day, Moore failed to make the final ballot. Prior to this, he had received one vote in the election held 24 January 1870, three votes on 26 January 1876, one on 22 January 1879, and two on 14 June 1879 (*Election Book*, ff. 32, 112, 118, 133, RA). The RA's electoral procedure called for a first vote to determine the four or five front-runners, who were then reduced to two by an interim ballot. The final ballot pitted these two against one another.

177 In the second election held that day, Moore and William Burges received an equal number of votes and a second interim ballot had to be held, in which Moore received 20 votes and Burges 27. In the final vote, Burges was narrowly defeated by Andrew Carrick Gow, but he was victorious in the third election. Burges's untimely death required another election on 2 June 1881, in which Moore, surprisingly, received just one vote (*Election Book*, ff. 136, 146, RA).

178 As in 1881, a second interim ballot was required in an election held 16 January 1883, in which Moore was defeated by Robert Walker Macbeth, 32 to 23 (*Election Book*, ff. 158, 163, 169, RA).

179 An unsuccessful candidate, Edith Martineau, wrote to Henry Moore on 28 March 1884: 'Had I had the least idea that so distinguished an artist as Mr. Albert Moore was in the field, I do not think I could have ventured to send a picture of a "classical" subject, in which he so excels' (priv. coll.); see also 'Art Chronicle', *Portfolio*, 15 (1884): 103.

180 Moore's painting was considered one of the stars of the collection. A year after its acquisition, a local journalist remarked, 'as for the rich productions of Albert Moore's brush, we believe they will grow more and more valuable each day' ('The Museum and Art Gallery', *Birmingham Times* (3 December 1885), newscuttings collected by G.H. Osborne, 1866-1905, Birmingham Central Library). Two years later, it was reported that *Dreamers*, 'from its poetry, its delicacy of draughtsmanship and daintiness of colour, is one of the most admired of the quite modern pictures in the gallery' (Alfred St Johnstone, 'The Birmingham Corporation Museum and Art Gallery', *Magazine of Art*, 10 [1887]: 366).

181 The drawing was purchased for £100 (as the second watercolour Moore had ever produced) through the agency of Thomas Armstrong; see Albert Moore nominal file, Invoice 6695, 27 February 1884, V&A.

182 Casteras and Denney, *The Grosvenor Gallery*, 35-6.

183 Anderson and Koval, *James McNeill Whistler*, 272.

184 JAMW to AJM, n.d. [c. 20 January 1885], priv. coll.

185 AJM to JAMW, 30 January 1885, M438, WC/GUL. In response, Whistler wrote, 'I am disappointed—disappointed!—disappointed! and I am grieved my dear Albert—but I am not going to nag—nag—nag!—So that's all right' (JAMW to AJM, n.d. [c. 20 January 1885], priv. coll.).

186 Starr, 'Personal Recollections of Whistler', 534.

Whistler resigned from the Society after a conservative faction orchestrated Wyke Bayliss's successful bid for the presidency. For a first-hand account of this episode, see Albert Ludovici, *An Artist's Life in London and Paris, 1870-1925* (London: T. Fisher Unwin, 1926), 70-88.

187 JAMW to AJM, n.d. [c. February 1885], priv. coll. Moore had written to Whistler, 'I will certainly be at your 10 o'clock, and shall write tomorrow for the ticket' (AJM to JAMW, 30 Janary 1885, M438, WC/GUL).

188 James McNeill Whistler, 'Mr. Whistler's Ten O'Clock', *The Gentle Art of Making Enemies*, 135-59.

189 Baldry, *Albert Moore*, 97. See also Frederic, 'A Painter of Beautiful Dreams', 718.

190 'Either his second thoughts dissuaded him, or he realized how hopeless would be his unsupported effort against the mass of perverted popular opinion, for he never carried out his intentions' (Baldry, *Albert Moore*, 97).

191 'The Society of Painters in Water-Colours', *Truth*, 17 (21 May 1885): 810; 'The Grosvenor', *Truth*, 17 (30 April 1885): 689. For further description of these paintings, see p. 226, n. 159. Similarly, Moore's painting *Silver and Gold* (unlocated) was deemed 'in no way worthy his past', but in his RA contribution, *White Hydrangea*, he was thought to have 'done his best to secure their [the Academicians'] approbation and their vote' ('Current Art. —I', *Magazine of Art*, 8 [1885]: 350-1). *Companions* (see p. 224, n. 99), which appeared at another venue, was described as 'an unusually beautiful specimen' ('The Royal Institute of Painters in Water-colours', *Pall Mall Budget* [1 May 1885], 15).

192 'The Royal Academy [Second Notice]', *Spectator*, 58 (23 May 1885): 675-6. The critic rehearsed this theory when accounting for the weakness of Moore's pastels at the Grosvenor: 'We miss in them nearly all the beauty which his graceful arrangements and thorough draughtsmanship of drapery have made familiar to us. Disheartened, perhaps, by his continued exclusion from the Academy, ... Mr. Moore is not this year seen to advantage' ('The Grosvenor Gallery [Third and Last Notice]', *Spectator*, 58 [20 June 1885]: 815). Ironically, Henry Moore was elected an Associate within the fortnight.

193 For consistency, I have adopted the title listed in the 1885 RA catalogue, although Baldry and other authors invariably employ the plural form, *White Hydrangeas*.

194 It reportedly took Moore 'a week's hard work to repair the mischief' done to his picture (Walker, 'Private Picture Collections', 367). Moreover, the surface of the painting 'has a peculiar quality owing to the canvas having been coated with Chinese white. It was Albert More's custom to use oil-pigment for the purpose, but the length of time requisite to its drying induced him in this instance to experiment with a foundation of water-colour' (unidentified newspaper review of Woodbury 1904, Collins Baker archive, Huntington Art Reference Library).

195 Alma Tadema's *A Reading from Homer* and works by Leighton and Thomas Faed were among the most severely damaged; see M.A., 'Mutilation of Pictures at the Academy', *Pall Mall Budget* (22 May 1885): 24; 'Current Art. —IV', *Magazine of Art*, 8 (1885): 470. For further discussion, see Smith, *The Victorian Nude*, 225-37.

196 'A Woman's Plea', *The Times* (20 May 1885), 10; 'Nude Studies' (23 May 1885), 10; see also (20 May 1885), 10; (21 May 1885), 6; (22 May 1885), 5; (25 May 1885), 10; (28 May 1885), 4.

197 'The Royal Academy. Third Notice', *Illustrated London News* (23 May 1885), 533.

198 Weintraub, *Whistler: A Biography*, 309-10.

199 'The Royal Academy Exhibition', *Builder*, 48 (9 May 1885): 647; see also 'The Royal Academy. III', *Graphic*, 31 (23 May 1885): 526; 'The Society of Painters in Water-colours', *Truth*, 17 (21 May 1885): 810. Acknowledging the 'comic' effect of Moore's combination of idealism and realism, Claude Phillips pronounced *White Hydrangea* a failure as a nude, but 'highly successful' as 'a harmony compounded of white and pale grey, relieved with touches of yellow, black, and rose colour, and by contrast enhancing the delicately tinted carnations of the central figure' ('The Royal Academy. I', *Academy*, 27 [9 May 1885]: 335; cf. 'Royal Society of Painters in Water-Colours', *Academy*, 27 [30 May 1885], 391).

200 Baldry, *Albert Moore*, 84. For a rough sketch of the composition, see Ernest Radford, 'Albert Moore', *The Idler*, 13 (August 1898): 7.

201 The cartoon is on the large scale of *White Hydrangea*, but the composition more closely resembles *A Yellow Room*.

202 Further examples include the oil paintings *The Painted Wardrobe*, once owned by Graham Robertson (1886, 39.4 x 16.5 cm, York City Art Gallery); *A Garland*, exh. Royal Manchester Institute 1886 (49.3 x 25.1 cm, Manchester City Art Gallery); *A Decorator*, exh. Grosvenor 1887 (50.1 x 22.1 cm, repro. Christie's, 25 October 1991 [46]).

203 The American novelist Harold Frederic alluded to 'casual talks' with the artist ('A Painter of Beautiful Dreams', 718) and William Ernest Henley, editor of the *Magazine of Art*, gained an entrée to Moore's studio through Sidney Colvin (Lucas, *The Colvins and their Friends*, 14; cf. 122). In 1885 Moore made a black and white chalk drawing for the magazine (repro. *Magazine of Art*, 8 [1885], opp. 195; see also Sotheby's, 21 June 1989 [117]) and in 1888 he provided the *Portfolio* with a drawing on tracing paper (Armstrong, 'Study', 145). Harry Quilter visited Moore in 1889 while he was at work on *A Summer Night* and persuaded him to part with a sketch for the *Universal Review*. The following March, Moore invited Quilter to see the finished picture, promising to have it photographed (AJM to Quilter, 28 May 1889 and 19 March 1890, 1 Holland Lane, MS. Moore 1-2, Yale Center for British Art; Quilter, 'The Art of England. II', 58; *Preferences in Art, Life, and Literature*, 381). In 1887 Moore sat for a pencil sketch by Sydney Prior Hall, an illustrator for the *Graphic* (National Portrait Gallery, no. 2375). He was also photographed by Frederick Hollyer on at least one occasion (Pl. 197).

204 'There was with him none of that artistic carelessness which permits to professional friends the free entry of the working room and the free and outspoken criticism of the work in progress' (Baldry, *Albert Moore*, 7; see also 'Albert Moore [By a Pupil]', 2). Baldry claimed that Moore had scant notion of his reputation as a painter for he never bothered to read his published criticism. The few items that were brought to his attention he could not help ridiculing for their misconstruction of his intentions.

CHAPTER FIVE

1 Baldry, 'Albert Moore: An Appreciation', 36.

2 Quoted in Weintraub, *Bernard Shaw on the London Art Scene*, 221.

3 Walker, 'Private Picture Collections', 367. Baldry based his later date of 1887 on the year of the portrait's Grosvenor exhibition.

4 F.G. Stephens noted that the portrait, 'in warm grey, and painted *en bloc*, like a mosaic, is animated and bright' ('The Grosvenor Exhibition', *Athenaeum*, no. 3106 [7 May 1887], 614). Cosmo Monkhouse, by contrast, considered the colouring 'unhappy' ('The Grosvenor Gallery', *Academy*, 31 [14 May 1887]: 348).

5 Moore also executed at least one commissioned portrait, *Mrs J. Duncuft*, a small (25.4 x 25.4 cm) three-quarter-length painting of a blonde sitter in a black evening dress against a golden-brown background, exh. Society of Portrait Painters 1892 (Baldry, *Albert Moore*, 66; unlocated). The description recalls Moore's watercolour *A Face in the Audience* (38 x 25 cm), exh. RSPWC 1889, purchased by William Connal (York City Art Gallery).

6 The connection was first suggested by Richard Green (Newcastle 1972, no. 62).

7 For the Portia costume, see Ellen Terry, *The Story of My Life*, 2nd edn. (London: Hutchinson & Co., 1912), 184, and Nina Auerbach, *Ellen Terry: Player in Her Time* (London and Melbourne: J.M. Dent & Sons, 1987), 228.

8 Nevertheless, Moore was clearly influenced by the features of a model who appears in numerous studies and finished works, such as *A Face in the Audience* (see n. 5) and *Study of a Female Head* (chalk, 19 x 15.2 cm, Cecil Higgins Art Gallery, Bedford). The square shape of Ellen Terry's face and the strong horizontals of her thick eyebrows and broad, deeply undercut mouth differ entirely from the soft, rounded features favoured by Moore.

9 The same model appears in Moore's unlocated oil paintings *Edelweiss*, exh. Grosvenor 1886 (dimensions unknown), and *Pale Margaret*, exh. RA 1886, purchased by William Connal and later exh. Glasgow Institute 1888 (33 x 25.4 cm; repro. Walker, 'Private Picture Collections', 362). See 'The Grosvenor Exhibition (Second and Concluding Notice)', *Athenaeum*, no. 3055 (15 May 1886): 651; 'The Royal Academy (Fourth Notice)', *Athenaeum*, no. 3059 (12 June 1886): 785; Baldry, *Albert Moore*, 60, 105.

10 This is perhaps identifiable with *A Bit of Moonlight* (34 x 20.9 cm), in William Connal's sale, Christie's, 14 March 1908 (60).

11 Referring to *Reading Aloud*, Richmond wrote, 'Your picture to my mind makes a mark in this generation, and recalls what those Greek pictures must have been in form, light, and colour. How I wish you would do the "Somnus" bit, with all the added power of mature years' (WBR to AJM, 2 April 1884, priv. coll.).

12 See also two studies of the left-hand figure: one in black chalk (23.5 x 44.4 cm; repro. Maas Gallery, 4 June - 12 July 1996 [55]); the other in oil (repro. Chester, 'The Art of Albert Moore', 378). For the charge that the painting 'has its interest somewhat marred by the fact, which the artist almost forces upon our notice, that he has studied his three figures from one model', see 'Midsummer', *Art Journal*, 50 (1888): 317.

13 Preston, *Letters from Graham Robertson*, 343; see also 353. Moore may have shown the painting to a journalist or two, for it was among those described in a pre-exhibition notice of 'the main features of the picture show', for which the public had already 'been pretty well prepared, by their own studio visits or through the gossip of the weekly press' ('Art Chronicle', *Portfolio*, 18 [1887]: 104).

14 Both of the illustrated examples were well known through plaster cast and engraved reproductions. For a summary of contemporary bibliography and reproduction, see Walter Copland Perry, *Greek and Roman Sculpture* (London: Longmans, Green, and Co., 1882), 301-5.

15 I am grateful to Howard Stoner for bringing this detail to my attention.

16 Preston, *Letters from Graham Robertson*, 343.

17 Claude Phillips, 'The Royal Academy. II' *Academy*, 31 (21 May 1887): 369; see also 'The Royal Academy (Third Notice)', *Athenaeum*, no. 3109 (28 May 1887): 708; J.M. Gray, 'The Glasgow International Exhibition', *Academy*, 33 (19 May 1888): 348; 'The Royal Academy (Second Notice),' *The Times* (21 May 1887), 8; 'The Royal Academy (First Notice)', *Spectator*, 60 (30 April 1887): 591; G.B. Shaw, 'At the Academy', *World* (4 May 1887).

18 Walker, 'Private Picture Collections', 367.

19 For assertions of Moore's influence on Leighton, see Minneapolis 1978, no. 83; Bendiner, *An Introduction to Victorian Painting*, 180; *The Victorians: British Painting 1837-1901* (Washington, DC: National Gallery of Art, 1997), nos. 58, 66. The connection is by no means certain and should be viewed with caution. Leighton did not mention Moore's picture in the lengthy, frank RA review that he penned to G.F. Watts; he was far more impressed by John Singer Sargent's 'brilliantly talented' *Carnation, Lily, Lily, Rose* (letter of 9 April 1887, Leighton MSS. 12722, K&C). Moreover, *Midsummer* had been in a private collection in Scotland for eight years by the time Leighton exhibited *Flaming June*.

20 Geoffrey Grigson, ed., *William Allingham's Diary* (Carbondale: Southern Illinois University Press, 1967), 352. Allingham and Moore may have toasted their wife and brother (respectively) who were then sharing the limelight at the Fine Art Society. The exhibition 'In the Country' featured 30 of Helen Allingham's watercolours, and 'Afloat and Ashore' contained 90 drawings by Henry Moore ('Minor Exhibitions', *Athenaeum*, no. 3109 [28 May 1887]: 710; 'Art Chronicle', *Portfolio*, 18 [1887]: 126; 'Art in June', *Magazine of Art*, 10 [June 1887]: xxxiii).

21 Moore's victorious opponents in the three election were his old friend William Blake Richmond (34 votes to Moore's 24); Edward Onslow Ford (38 to 20); and Reginald Theodore Blomfield (37 to 21); see *Election Book*, ff. 177, 180, 186, RA). For a note on Moore's close run, see 'The New Associates of the Royal Academy', *Magazine of Art*, 11 (February 1888): xvii.

22 William Holman Hunt, 'The Royal Academy', *The Times* (18 August 1886), 8; Crane, *An Artist's Reminiscences*, 286-98. Similarly, Harry Quilter, 'An Academy Catechism', *Contemporary Review*, 50 (October 1886): 554-68; George Moore, 'The Royal Academy', *Fortnightly Review*, 57 (June 1892): 828-39, and 'Our Academicians and Their Associates', *New Review*, 8 (June 1893): 665-74.

23 G.B. Shaw, 'In the Picture-Galleries: Pastels at the Grosvenor, etc.' in Weintraub, *Bernard Shaw on the London Art Scene*, 243; see also 134, 203; Ludovici, *An Artist's Life*, 59-60, 112.

24 The dinner was held at the Criterion restaurant, Piccadilly, on 1 May 1889. See AJM to W. Christian Symons, 1 Holland Lane, 29 April 1887 (M439); Symons to JAMW, 3 January 1889 (S280); and printed announcement of the dinner (S282), WC/GUL.

25 JAMW to Beatrix Whistler, postmarked 1 February 1892 (W604, WC/GUL).

26 Quilter, *Preferences in Art, Life, and Literature*, 380-5. P.R. Morris to Quilter, 8 May 1893, MS. Morris 5, Yale Center for British Art. Quilter's aggressive campaign on Moore's behalf dates from the early 1880s (e.g., 'Notes on the Royal Academy Exhibition', *Contemporary Review*, 41 [June 1882]: 952-3, and 'An Academy Catechism', *Contemporary Review*, 50 [October 1886]: 562). He had earlier been rather lukewarm in his support; see 'French and English Pictures' (in which he compared Moore to Puvis de Chavannes', *Cornhill Magazine*, 40 [July 1879]: 102-3, and 'The Apologia of Art', *Cornhill Magazine*, 40 (November 1879): 546; *Sententiae Artis: First Principles of Art for Painters and Picture Lovers* (London: privately printed, 1886), 123, 135; 'The Art of England. II', 58.

27 Baldry, *Albert Moore*, 23.

28 *Election Book*, ff. 197, 200, 206, 213, 219, RA.

29 See, for example, 'Art and Artists', *Sunday Times* (1 October 1893), 8; Ward, *Recollections of a Savage*, 252. Leighton dreaded the elections as 'the most impossible work of all'. He was overjoyed when his protégé Alfred Gilbert was elected by a wide margin in 1887, but the 1888 election of John Bagnold Burgess he considered 'simply deplorable and would have been avoided had 5 members been present who did not turn up to hold the balance' (Leighton MSS. 12724, 12731, 12738, K&C).

30 See p. 222, n. 37.

31 'British Painting at the World's Fair', *Art Amateur*, 30 (January 1894): 6. For a positive opinion, see M. Phipps Jackson, 'Current Art: The New Gallery', *Magazine of Art*, 15 (1892): 290.

32 'In addition to his gifts as a painter, Mr. Moore was possessed of no mean poetic ability' ('Death of Mr. Moore', *Daily Chronicle* [24 September 1893]; see also 'Death of Mr. Albert Moore', *Westminster Gazette* [26 September 1893], 4; Baldry, *Albert Moore*, 22.

33 AJM to JAMW, 3 [sic] Spenser Street, Victoria Street, 5 December 1892, M441, WC/GUL; Baldry, *Albert Moore*, v; see also viii, 19. Although it is tempting to attach a romantic significance to this exchange, Baldry would not have been so indiscreet as to name the woman in such a case.

34 Moore's preliminary studies for this painting generated a number of smaller pictures exhibited between 1884 and 1886, but it was not until 1888 that he began work on the final canvas, purchased from the artists' colourmen Roberson and Co. on 20 July (Morris, *Victorian & Edwardian Paintings*, 531).

35 For the view that 'the vermiculated flesh (due to coarse stippling) is a mistake in taste as well as in fidelity to nature', see 'The Royal Academy (Third and Concluding Notice)', *Athenaeum*, no. 3265 (24 May 1890): 678; similarly, 'Exhibitions', *Magazine of Art*, 17 (February 1894): xvii.

36 See also *Silver*, exh. RA 1886 (oil on canvas, 119 x 63 cm, priv. coll., repro. Christie's, 25 March 1988 [125]), and *Myrtle*, exh. RSPWC 1886 (watercolour and gouache on squared white paper, 29.8 x 16.5 cm, Fogg Art Museum, Harvard University).

37 The black chalk drawing is D.249-1905, V&A.

38 *Hairpins*, exh. Boston 1884, is unlocated; see Baldry, *Albert Moore*, 105. The same figure appears in *Reflections* (coloured chalks on brown paper, 43 x 17.5 cm, repro. Sotheby's [Belgravia], 6 October 1980 [64]. An allusion to Moore's poor health at this time is made in 'The Grafton Gallery', *Art Journal*, 56 (1894): 89.

39 Quilter also reproduced Moore's study of a head for *A Summer Night*, which the artist provided for the purpose, see p. 227, n. 203.

40 Lucas, *Edwin Austin Abbey*, 1: 192.

41 For contemporary criticism of Moore's non-naturalistic lighting effects in *A Summer Night*, see 'The Royal Academy (Second Notice)', *Saturday Review*, 69 (10 May 1890): 568-9; 'The Royal Academy (Third Notice)', *The Times* (13 June 1890), 13; 'The Royal Academy (Third and Concluding Notice)', *Athenaeum*, no. 3265 (24 May 1890): 677- 8.

42 Engravings repro. Frederic, 'A Painter of Beautiful Dreams', 717, 719. For *A Riverside* (unlocated), a life-size oil exh. RA 1888, see Moore's cartoons for each of the figures (D.221-1905 to D.223-1905, V&A) and for the overall composition, Baldry, *Albert Moore*, opp. 80. The latter work clearly illustrates Moore's subordination of the figures to a geometric armature. Related works include *A Footpath* of 1888 (oil on canvas, 44.2 x 16.2 cm, Manchester City Art Gallery), *The Umpire* (oil on canvas, 45.2 x 18.1 cm, Fitwilliam Museum, Cambridge) and an unlocated drapery study (black and white chalk on oiled tracing paper laid down on blue paper, repro. Armstrong, 'Study', 145). A curious pastel on grey paper, titled variously *Lactaeus in the Fig Tree*, *The Judgement of Paris* and *The Apple Picker* (24 x 10 cm, repro. Sotheby's, 21 June 1989 [114]), may relate to *Waiting to Cross*, exh. Grosvenor 1888 (oil on canvas, 68.5 x 44.4 cm, priv. coll.).

43 It is also worth mentioning the unlocated painting *Autumn*, which Robert Walker identified as a work by Moore in William Connal's collection. Moore's style is difficult to discern in this representation of a classically draped female figure, running through a grove before a river and jagged mountain peaks (Walker, 'Private Picture Collections', 367).

44 Quilter, *Preferences in Art, Life, and Literature*, 381. For other endorsements of the importance of *A Summer Night*, see 'The Royal Academy (Second Notice)', *Saturday Review*, 69 (10 May 1890): 568-69; Claude Phillips, 'The Summer Exhibitions', *Art Journal*, 52 (1890): 164; Claude Phillips, 'The Royal Academy. I', *Academy*, 37 (10 May 1890): 326; M.H. Spielmann, 'The Royal Academy. II', *Magazine of Art*, 13 (1890): 258.

45 Claude Phillips, 'The Royal Academy. I', *Academy*, 37 (10 May 1890): 326.

46 Moore, 'The Royal Academy', 829-30, 839; reprinted as 'Our Academicians' in Moore, *Modern Painting* (London: Walter Scott, 1893), 100, 127.

47 'Art Notes', *Liverpool Mercury* (28 September 1893); files of Walker Art Gallery, Liverpool. Moore's early patron, Philip Henry Rathbone, Chairman of Liverpool's Arts and Exhibitions Sub-commitee, very likely urged the purchase; see 'The Alderman in Art' in Moore, *Modern Painting*, 162; Morris, *Victorian and Edwardian Paintings*, 315, n. 12.

48 Baldry, *Albert Moore*, 17-18.

49 AJM to William Connal, 1 Holland Lane, 17 June 1891, Hunterian Art Gallery, University of Glasgow. The advance was presumably made on Connal's picture *An Idyll*, which Moore completed in 1893.

50 Repro. Baldry, *Albert Moore*, vi.

51 Baldry, *Albert Moore*, 22.

52 When Moore's *A Dressing Room* appeared in the Fine Art Society's 1889 exhibition of artists' working sketches, his use of pastel for preparatory studies was deemed exceptional ('Exhibitions', *Saturday Review*, 68 [16 November 1889]: 556).

53 The pastel (79.9 x 138.3 cm) is in the Forbes Magazine Collection, New York; see also Baldry, *Albert Moore*, 65, 106.

54 Way, *Memories of Whistler*, 27; Wedmore, *Whistler and Others*, 12-3.

55 *Whistler Pastels and Related Works in the Hunterian Art Gallery*, exh. cat. (Glasgow: Hunterian Art Gallery, 1984); Margaret F. MacDonald, *James McNeill Whistler: Drawings, Pastels and Water-colours: A Catalogue Raisonné* (New Haven: Yale University Press, 1995). See also Shaw, 'In the Picture-Galleries: Pastels at the Grosvenor, etc.', *World* (24 October 1888) in Weintraub, *Bernard Shaw on the London Art Scene*, 242; 'The Revival of Pastel-Painting', *Magazine of Art*, 12 (November 1889): v; 'Art Chronicle', *Portfolio*, 21 (1890): v.

56 Baldry, *Albert Moore*, 65.

57 Moore's fourth pastel at the Grosvenor in 1890 was *A Girl's Head* (36.1 x 24.1 cm, unlocated). In the same year, he exhibited the pastel *A Young Girl* at the New Gallery and *Study of Colour* at the New English Art Club (Baldry, *Albert Moore*, 106; Johnson, *Works Exhibited at the Royal Society of British Artists*, 2: 588). In 1889 he had exhibited the pastel *A Dressing-Room* at the Fine Arts Society exhibition of artists' preparatory studies (see n. 52).

58 See p. 220, n. 213.

59 On the verso of the drawing, Baldry wrote, 'Moore showed me this when it was just finished and told me that he did it from memory of something he had seen—a girl bathing or swimming under Hammersmith Bridge. The effect of the figure in the water appealed to him as worthy of recording.'

60 Like the Venus, Moore's figure makes 'a gesture of alarm, turning to look for a possible intruder' (Baldry, *Albert Moore*, 65).

61 The absence of pinholes in the cartoon indicates that it was not transferred to canvas. Moore also made a colour trial by superimposing a charcoal drawing of the composition over a second sketch coloured in pastel (both on tracing paper, 28.5 x 15.9 cm, York City Art Gallery).

62 A slightly different version is repro. Baldry, *Albert Moore*, 100.

63 A preliminary version ('a work in its initial stages') in blue and orange was lent by Mrs. Frank Luker (Henry Moore's daughter) to Woodbury 1904 (3) and York 1912 (171) (unidentified newspaper clipping, Collins Baker archive, Huntington Art Reference Library; repro. 'Henry and Albert Moore', *Art Journal*, 66 [1904]: 143). This was perhaps the small version (123.1 x 62.2 cm) that sold at Christie's, 20 April 1925 (80); a larger painting (152.2 x 96.4 cm) in tempera sold at 29 Dover Street, London, sometime after 1940 (202) (repro. Witt Library, Courtauld Institute). One of these versions sold at Dulau, London, in 1940 (281).

64 The charcoal drawing on tracing paper is D.225-1905, V&A. The pastel is also known as *Lovers*; see p. 222, n. 29.

65 The anecdote recalls Turner's notoriously derelict studio, where 'on rainy days the water often streamed down the precious canvases from leaks in warped sashes and ill-fitting skylights' (Walter Goodman, 'Artists' Studios: As They Were And As They Are—II', *Magazine of Art*, 24 [1901]: 400). On another visit, Robertson and Whistler were accompanied by Whistler's new wife, Beatrix, whose deceased husband, E.W. Godwin, had been so intrigued by Moore's house in its pristine condition just ten years earlier (Robertson, *Time Was*, 59-60, 196).

66 JAMW to AJM, 21 Cheyne Walk, n.d. [March 1890-March 1892], priv. coll.

67 For references to Moore's visits to the club, see AJM to JAMW, 3 [sic] Spencer Street, 5 December 1892, M441, WC/GUL.

68 Baldry, *Albert Moore*, 16. A period of refurbishment very likely followed Moore's departure from 1 Holland Lane. It was unoccupied until 1893 when George Lovell Harrison took up residence; he was joined in 1895 by Harry Quilter, an amateur painter as well as Moore's outspoken champion. A pair of artists continued to share the studios until 1961, when Holland Lane was demolished in a major redevelopment scheme by Wates & Co.; see provisional planning permission of 16 July 1958 and final completion certificate of 21 March 1863 (TP/75821, London County Council, Architects Dept.); *Survey of London*, 37: 130; *The Register of Persons Entitled to Vote … Kensington … 1892* (London: Pite and Thynne, 1891), K&C. Walkley's report of demolition in the 1890s is incorrect (*Artists' Houses in London*, 64).

69 According to John Hebb, the artist Frederick Sandys had built the studio for his own use ('Albert Moore and the "D.N.B."', 47). Alfred East, Colin B. Phillip, Mary Barton and Thomas Hope McLachlan occupied it in 1896; all except McLachlan remained for a decade or more (*The Post Office London Directory for 1896* [London: Kelly & Co., 1896], 687; see also subsequent years). For a description of the studio, see Frederick Wedmore, 'The Work of Alfred East, R.I.', *Studio*, 7 (April 1896): 133.

70 The charcoal drawing (York City Gallery) shows Moore wearing the same sort of skull cap favoured by his brother Henry; cf. Jeremy Maas, *The Victorian Art World in Photographs* (London: Barrie & Jenkins, 1984), 45.

71 'Spenser Street is nearly opposite the stores', he added helpfully (AJM to Walford Graham Robertson, 2 Spenser Street, n.d., [c. April 1892], WR411, Huntington Library). Around this time, Robertson began building his own studio house in Melbury Road, around the corner from Holland Lane (*Survey of London*, 37: 149-50).

72 Marks, 'My Notebook', 132. Baldry to AJM, 34 Comeragh Road, West Kensington, 4 April 1892, priv. coll.

73 For mixed reviews of this method, see 'The Royal Academy (Second Notice)', *Athenaeum*, no. 3161 (26 May 1888): 668; M.H. Spielmann, 'The Royal Academy—II', *Magazine of Art*, 13 (1890): 258; 'The Royal Academy (Third and Concluding Notice),' *Athenaeum* no. 3265 (24 May 1890): 677-8; 'The Royal Academy (Second Notice)', *Saturday Review*, 69 (10 May 1890): 568-9; 'Exhibitions', *Magazine of Art*, 17 (February 1894): xvii.

74 In the pastel, *Lovers—Sketch for 'An Idyll'* (30.4 x 27.9 cm, unlocated), Moore adopted a more complicated colour scheme than in the final version: 'the man wears orange drapery, the girl rose colour over transparent white, while the back of the seat is hung with orange' (Baldry, *Albert Moore*, 67, 76). Superimposing a sheet of tracing paper over a detailed black chalk drawing of the composition, Moore tested alternative colour schemes in watercolour (82 x 73 cm, repro. Sotheby's, 10 October 1985 [84]). A pastel sketch of approximately the same size (79 x 71 cm.) reflects an abandoned scheme (repro. Sotheby's, 25 January 1988 [443]).

75 'I have sent an order for both my pictures and I think the one that is to go to Liverpool might be called for on Wednesday morning. New Gallery closes this evening' (AJM to Henry Moore, 2 Spencer Street, 6 August 1892, priv. coll.). Moore had exhibited *Lightning and Light* at the RA and *A Revery* at the New Gallery. The latter went on to Liverpool for the autumn exhibition there, and subsequently to Chicago for the World's Columbian Exhibition of 1893, where it received a medal ('English Rewards at Chicago', *Magazine of Art*, 16 [September 1893]: xlvi).

76 Baldry, *Albert Moore*, 18.

77 The painting represents a lesser-known Trafalgar Square, off the Fulham Road in Chelsea; see Andrew McLaren Young, Margaret MacDonald and Robin Spencer, *The Paintings of James McNeill Whistler*, 2 vols. (New Haven and London: Yale University Press, 1980), 1: 100.

78 Robertson, *Time Was*, 195; see also 'A Chat with Mr. J. Whistler in Chelsea', *Pall Mall Budget* (5 June 1885), 16; Blanche, *Portraits of a Lifetime*, 73-4. That Whistler sold, rather than gave, the picture to Moore is evident from one of his letters, which reads in part: 'I hope also Albert that you kept your head on this occasion and got a good price—you doubtless saw in the World a week ago and in the Pall Mall what these things of mine are now selling for and of course the ones that had been bought by *Albert Moore* ought to have been a rare favorite' (JAMW to AJM, n.d. [postmark 29 November 1892], priv. coll.).

79 JAMW to AJM, n.d. (postmark 29 November 1892), priv. coll.; see also AJM to JAMW, 2 Spenser Street, 28 November 1892, M440, WC/GUL.

80 For Moore's detailed account of the proceedings, see AJM to JAMW, 3 [sic] Spenser Street, 5 December 1892, M441, WC/GUL.

81 AJM to JAMW, 3 [sic] Spenser Street, 5 December 1892, Whistler 441, WC/GUL. The substance of Whistler's unlocated letter has been deduced from Moore's response.

82 AJM to JAMW, 2 Spenser Street, 9 December 1892, M442, WC/GUL.

83 Baldry, *Albert Moore*, 18-19.

84 'Artist Albert Moore Dead', *New York Times* (1 October 1893). I am grateful to Howard Stoner for obtaining this article for me.

85 Robertson, *Time Was*, 275. Moore's doctors, on the contrary, believed that his determination to complete the painting actually prolonged his life ('Death of Mr. Albert Moore', *Westminster Gazette* [26 September 1893], 4; 'Death of Mr. Albert Moore', *Daily Chronicle* [27 September 1893]; Baldry, *Albert Moore*, 19).

86 A small drapery study in chalk for Autumn is in the Russell-Cotes Art Gallery and Museum, Bournemouth; for Moore's full-scale drapery cartoons for Autumn and Summer, see D.216-1905, D.217-1905, D.219-1905, V&A. By laying his paper against a rough surface, Moore was able to transfer to the drapery folds of these cartoons a suggestion

of texture similar to that cultivated in *An Idyll*. For Moore's full-scale nude cartoons for Summer, the South Wind, and Autumn, see D.214-1905, D.215-1905, and D.218-1905, V&A.

87 For the compositional cartoon, see D.213-1905, V&A.

88 Moore allowed himself greater freedom in a large (96.4 x 43 cm) oil-on-canvas sketch of an array of flowers, fruit, and foliage which he superimposed on a study of the drapery worn by Summer (Fine Art Society, 1975).

89 The portion representing Winter in bright orange drapery is in a priv. coll.

90 Robertson, *Time Was*, 275. This was very likely Miss Cresswell, to whom he gave several poems written around this time; see p. 228, n. 33.

91 Russell-Cotes, *Home and Abroad*, 717. Similarly, Walker, 'Private Picture Collections', 364; 'Death of Mr. Albert Moore', *Westminster Gazette* (26 September 1893), 4.

92 McCulloch went on to build Britain's most important private collection of contemporary art. Moore's painting was among his earliest acquisitions. It was certainly in his possession by the time of its first exhibition in January 1894, four months after Moore's death (Grafton 1894, no. 195). Purchased by a dealer for 380 guineas at McCulloch's estate sale on 23 May 1913, it was subsequently sold to the Corporation of Blackburn for £456 (information from files of Blackburn Museum and Art Gallery).

93 In view of the professional embarrassment and financial hardship caused by Annie Russell-Cotes's belated objections to *A Summer Night*, it is ironic that Moore's gift hung in her bedroom for many years, 'a much prized possession' (Russell-Cotes, *Home and Abroad*, 717-18). See also 'The Collection of Merton Russell Cotes, Esq., J.P., The Mayor of Bournemouth', *Art Journal*, 57 (1895): 84. The oil sketch is repro. Sotheby's 27, November 1984 (58).

94 These verses appear in Grafton 1894, no. 195, and in Baldry, *Albert Moore*, 67. For contemporary commentary on the painting, see 'The Grafton Gallery Collection', *Art Journal*, 56 (1894): 89; Baldry, *Albert Moore*, 21; 'Albert Moore's Pictures', *Saturday Review*, 77 (27 January 1894): 89.

95 It is no wonder that Henry Moore's failure to complete his brother's biography was particularly regretted on the grounds that it 'might have thrown much light on the seemingly contradictory elements in Albert Moore's nature'. Baldry's biography was judged of little assistance in this regard, being 'critical rather than biographical' (Maclean, *Henry Moore*, 100-1).

EPILOGUE

1 Death certificate, Office of National Statistics, London. Henry Moore 'caught a severe chill while watching at his brother's bedside, and the doctor absolutely forbade his attendance at the funeral'. He survived his brother by only 21 months. Albert was attended in his last days by another brother, Robert Collingham Moore, of Malpas, Cheshire ('Funeral of Mr. Albert Moore', *Westminster Gazette* [28 September 1893], 4).

2 Will of 20 November 1890, probate 24 November 1893, Inland Revenue, Somerset House, London. Moore was not as prolific as many of his colleagues, but the value of his estate is surprisingly low in view of his austere habits and the high prices his pictures

commanded. For *Reading Aloud* and *Midsummer*, for example, Connal had paid a total of over 1,600 guineas. One of Moore's obituarists claimed hyperbolically, 'An Albert Moore which would command £2000 in London, would make fifty thousand francs in Paris, and ten thousand dollars in New York' ('Art and Artists', *Sunday Times* [1 October 1893], 8). In fact, Christie's could not raise more than 300 guineas for *A Reader*, *Birds* (both at auction in 1881), *Shells* (1892), or *Battledore* (1905). It was not until 1908 that *Midsummer* broke the barrier, fetching 1,000 guineas at William Connal's sale ('An Artist's Vindication', *Daily Telegraph* [16 March 1908], 5).

3 Family members included Albert's brothers Robert and William Moore; his brother Henry's daughter Florence; his brother John's widow Emily Simonds Moore, her son Arthur Collingham Moore and her father George Simonds. The service was conducted by Albert's cousin, the Rev. T.W. May Lund, Chaplain of the School for the Blind at Liverpool ('Funeral of Mr. Albert Moore', 4). See also *Highgate Graves Register, Northern Station*, vols. G and O; *Register of Burials, Highgate*, R/2/29; *Day Book, Highgate Cemetery*, Camden Local Studies and Archives Centre, Holborn Library.

4 The studies were for *Lightning and Light*, *An Idyll*, and *Loves of the Winds and the Seasons*.

5 Others in attendance were Dr Creighton, Mr Vian, Percy Thomas, John Hollins, and Madame des Clarges, to whom Moore had recently given a small pastel related to the oil painting *Stars* (21 x 9 cm, repro. Christie's, 29 February 1980 [84]), inscribed 'Christmas 1891 w/ Albert Moore's best wishes to Mrs. Des Clarges' (21.6 x 8.9 cm, Huntington Library, Art Collections, and Botanical Gardens, San Marino, California).

6 See above, p. 26 for Leighton's response to Moore's death in a letter from Perugia; for Whistler, see below.

7 'Occasional Notes', *Pall Mall Gazette*, 57 (27 September 1893): 2; similarly, 'Our Illustrated Note-Book', *Magazine of Art*, 17 (1894): 34; 'Art and Artists', *Sunday Times* (1 October 1893), 8.

8 'Artists and Critics', *Westminster Gazette* (26 September 1893), 1; 'Death of Mr. Albert Moore', *Westminster Gazette* (26 September 1893), 4; 'Albert Moore', *Art Journal*, 55 (1893): 334-5; M.H. Spielmann, 'Death of Mr. Albert Moore', *Daily Graphic* (27 September 1893); *Yorkshire Daily Post* (27 September 1893); *Daily News* (27 September 1893); 'Obituary. Albert Moore', *The Times* (27 September 1893), 3; 'Obituary. Albert Moore', *Mail* (27 September 1893), 4; 'Occasional Notes', *Pall Mall Gazette*, 57 (27 September 1893): 2 and 5; *Morning Post* (28 September 1893); 'Art Notes', *Liverpool Mercury* (28 September 1893); 'Albert Moore (By a Pupil)', 2; 'Mr. Albert Moore', *Athenaeum*, no. 3440 (30 September 1893): 459; Harry Quilter, 'The Late Albert Moore', *The Times* (30 September 1893), 12; 'Notes on Art and Archaeology', *Academy*, 44 (30 September 1893): 278; 'Art and Artists', *Sunday Times* (1 October 1893), 8; 'Albert Moore and the Academy', *Magazine of Art*, 17 (October 1893): i-ii; Marks, 'My Notebook', 132; N.N., 'The Albert Moore Exhibition', *Nation*, 58 (3 February 1894): 134.

9 Baldry, 'Whistler and Albert Moore', 14.

10 Graham Robertson adopted the language of chivalry in describing Moore as a 'most perfect knight of the Lady Beauty, to whose service all his life had been dedicated and to whom in death he was still faithful' (*Time Was*, 275). Moore's heroic effort to complete

The Loves of the Winds and the Seasons while at death's door was reported in *Daily Chronicle* (27 September 1893); *Westminster Gazette* (24 September 1893), 4; *Yorkshire Daily Post* (27 September 1893); *Daily Telegraph* (27 September 1893); and *New York Times* (1 October 1893).

11 See, for example, 'The Photographic Salon', *Daily Graphic* (7 October 1893), 4; 'Art and Artists', *Saturday Times* (15 October 1893), 8, and (22 October 1893), 6. Hollyer owned several of Moore's earliest drawings, including *Elijah Running to Jezreel*, *Death of Jacob*, *Study for 'A Venus'*, and a copy after Albrecht Dürer (Grafton 1894, nos. 148, 229, 234, 352).

12 'Fine-Art Gossip', *Athenaeum*, no. 3443 (21 October 1893): 560. The Grafton was established by F. G. Prange, former manager of the Grosvenor Gallery and owner of Moore's *A Wardrobe* ('The New "Society of Portraitists"', *Magazine of Art*, 14 [April 1891]: xxv; see also p. 218, n. 138). The inaugural exhibition in March 1893 featured 'a delightful arrangement in green, white, and orange, by Mr. Albert Moore—one of those inimitable little canvases that he alone knows how to paint' (A.L. Baldry, 'The Grafton Galleries', *Art Journal*, 55 [1893]: 145-6). See also 'Notabilia', *Magazine of Art*, 15 (August 1892): xliv; 'Art Notes', *Sketch*, 1 (1 March 1893): 275; 'The Grafton Galleries', *Theatre*, 21 n.s. (1 April 1893): 221; 'The Grafton Gallery', *Pall Mall Budget*, no. 1322 (25 January 1894): 38; N.N., 'The Albert Moore Exhibition', *Nation*, 58 (22 February 1894): 134.

13 Grafton 1894, 23; see also Robertson, *Time Was*, 275.

14 For reviews, see 'Exhibitions', *Magazine of Art*, 17 (February 1894): xvii; 'Art and Artists', *Sunday Times* (21 January 1894), 8; 'Albert Moore's Pictures', *Saturday Review*, 77 (27 January 1894): 89; 'The Grafton Gallery', *Art Journal*, 56 (1894): 89. A few months later, Lawrie's Gallery organized an exhibition of Moore's works featuring 'many of the dead painter's noblest achievements', on loan from the firm's Scottish clients ('Exhibitions', *Magazine of Art*, 17 [July 1894]: xxxviii; Baldry, *Albert Moore*, 102-6). Subsequent exhibitions are listed in the Bibliography.

15 Baldry solicited Whistler's assistance in a letter of 3 March 1894 (B9 #2893; see also Baldry to JAMW, 11 July 1894, B10 #2894, WC/GUL). Whistler in turn recruited other contributors, writing to Graham Robertson on 14 March 1894, 'You ought to see Baldry and help him with all you remember—for the life he is writing of Moore' (WR 659, Huntington Library). A few days later, Baldry addressed a request for assistance to owners of Moore's pictures ('Notes on Art and Archaeology', *Academy*, 45 [17 March 1894]: 235; see also *Pall Mall Budget*, no. 1331 [29 March 1894]: 12).

16 Baldry admitted to having little knowledge of the formative phase of Moore's career prior to 1880 (Baldry to JAMW, 3 March 1894, B9 #2893, WC/GUL). See also Baldry, 'Whistler and Albert Moore', 14; 'Albert Moore (1841-1893)', 42-3; *Albert Moore*, passim.

17 George Moore approached Albert's grieving family within a few weeks of his death. In a letter of 20 November 1893 to his daughter Agnes, Henry Moore wrote, 'I have heard a little about the George Moore who wanted me to send some of Albert's papers & both [F. H.] Gossage & [Ralph W.] Robinson who seem to know a great deal about him say it is a good thing I did not let him have them' (priv. coll.).

Selected Bibliography

Exhibitions

Grafton 1894 = *Albert Moore Memorial Exhibition*, exhibition catalogue, London: Grafton Galleries, 1894

Woodbury 1904 = *Pictures, Drawings, and Studies by Henry Moore, R.A., and Albert Moore*, Woodbury Gallery (New Bond Street), March-April 1904 (consisting entirely of works owned by Moore's relations)

York 1912 = *Loan Collection of Works by the 'Moore' Family of York*, exhibition catalogue, City of York Art Corporation Gallery and Museum, 26 August-5 October 1912

Newcastle 1972 = *Albert Moore and His Contemporaries*, exhibition catalogue, Newcastle-upon-Tyne: Laing Art Gallery, 23 September – 22 October 1972

Newcastle 1990 = *Pre-Raphaelites: Painters and Patrons in the North East*, exhibition catalogue, Newcastle-upon-Tyne: Laing Art Gallery, 14 October 1989-14 January 1990

Minneapolis 1978 = *Victorian High Renaissance*, exhibition catalogue, Minneapolis: The Minneapolis Institute of Arts, 1 September – 15 October 1978, et al.

York 1980 = *The Moore Family Pictures*, exhibition catalogue, York City Art Gallery, 2 – 31 August 1980, and London: Julian Hartnoll's Gallery, 22 September – 10 October 1980

Books and Articles

'Albert Moore', *Art Journal*, 55 (1893): 334-5

'Albert Moore (By a Pupil)', *Pall Mall Gazette*, 62 (30 September 1893): 1-2

'Albert Moore and the Royal Academy', *Magazine of Art*, 17 (October 1893), ii

'An Embroidery', *Art Journal*, 60 (1898): 109

Anderson, Ronald, and Koval, Anne, *James McNeill Whistler: Beyond the Myth* (London: John Murray, 1994)

Armitage, Edward, 'Mural Painting', *Architect*, 19 (8 June 1878), 339-40

Armstrong, Walter, 'Study. By Albert Moore, A.R.W.S.', *Portfolio*, 19 (1888): 145

Asleson, Robyn, *Classic into Modern: The Inspiration of Antiquity in English Painting, 1864-1918*, Yale University Ph.D. thesis, 1993.

_____, 'Nature and Abstraction in the Aesthetic Development of Albert Moore', in Elizabeth Prettejohn, ed., *After the Pre-Raphaelites: Art and Aestheticism in Victorian England* (Manchester: Manchester University Press, 1999)

Baldry, 'Albert Moore', *Studio*, 3 (April 1894): 3-6, 46-51

_____, 'Albert Moore: An Appreciation', *Art Journal*, 65 (February 1903): 33-6

_____, *Albert Moore: His Life and Works* (London: George Bell & Sons, 1894)

_____, 'Albert Moore (1841-1893)', *The Old Water-Colour Society's Club*, 8 (1930-1): 41-7

_____, *Modern Mural Decoration* (London: G. Newnes, 1902)

_____, 'Whistler and Albert Moore', *Pall Mall Budget*, 1323 (1 February 1894): 14

Barrington, Emilie Isabel, *The Life, Letters and Work of Frederic Leighton*, 2 vols. (London: George Allen, 1906)

Bendiner, Kenneth, *An Introduction to Victorian Painting* (New Haven and London: Yale University Press, 1985)

Blanche, Jacques-Emile, *Portraits of a Lifetime: The Late Victorian Era, The Edwardian Pageant, 1870-1914* (London: J. M. Dent & Sons, 1937)

Burges, William, 'The Late Exhibition', *Ecclesiologist*, 23 (December 1862): 337-9

_____, 'Pagan Art', *Builder*, 20 (24 May 1862): 368

Brydon, John McKean, 'William Eden Nesfield, 1835-1888', *Architectural Review*, 1 (April 1897): 235-45 (May 1897): 283-95

Carr, Joseph Comyns, *Some Eminent Victorians: Personal Recollections in the World of Art and Letters* (London: Duckworth & Co., 1908)

Casteras, Susan P., and Denney, Colleen, eds., *The Grosvenor Gallery: A Palace of Art in Victorian England* (New Haven and London: Yale University Press, 1996)

Chester, Austin, 'The Art of Albert Moore', *Windsor*, 22 (September 1905): 369-82

Colvin, Sidney, 'English Painters and Painting in 1867', *Fortnightly Review*, 8 (1 October 1867): 473-4

_____, 'English Painters of the Present Day. II —Albert Moore', *Portfolio*, 1 (1870): 4-6

_____, *Notes on the Exhibitions of the Royal Academy and Old Water-colour Society* (London: Macmillan & Co., 1869)

_____, 'Royal Academy (Third Article)', *Pall Mall Gazette*, 9 (31 May 1869): 11

Conway, Mancure Daniel, *Travels in South Kensington, with Notes on Decorative Art and Architecture in England* (London: Trübner & Co., 1882)

Crane, Walter, *An Artist's Reminiscences* (London: Methuen & Co., 1907)

Eastlake, Charles Lock, *A History of the Gothic Revival* [orig. pub. 1872] (Watkins Glen, New York: American Life Foundation, 1979)

Forsyth, James, 'William Eden Nesfield', *Architectural Association Notes*, 16 (August 1901): 109-11

Frederic, Harold, 'A Painter of Beautiful Dreams', *Scribner's Magazine*, 10 (December 1891): 712-22

Godwin, Edward William, 'The Architectural Exhibition', *Building News*, 14 (17 May 1867), 336

_____, 'Studios and Mouldings', *Building News*, 36 (7 March 1879): 261-2

Harrison, Martin, *Victorian Stained Glass* (London: Barrie & Jenkins, 1980)

Hebb, John, 'Albert Moore and the "D.N.B."', *Notes and Queries*, 8, 10th series (20 July 1907): 46-7; (19 October 1907): 317

_____, 'Eden v. Whistler', *Pall Mall Gazette*, 60 (22 March 1895): 11

_____, 'William Eden Nesfield', *Journal of the Royal Institute of British Architects*, 10 (23 May 1903): 396-400

'Henry and Albert Moore', *Art Journal*, 43 (1881): 161-4

Holiday, Henry, *Reminiscences of My Life* (London: William Heinemann, 1914)

Jones, Dennis, *The Work of William Eden Nesfield at Cloverley Hall, nr. Whitchurch, Shropshire*, masters dissertation, University of Keele, 1991

Knowles, John Ward, *York Artists (MS. Scrapbooks)*, 2 vols., York Central Library

_____, *York School of Design (MS. Scrapbook)*, vol. 20, York Central Library

Lamb, Joseph Frank, *Lions in Their Dens: Lord Leighton and Late Victorian Studio Life*, Ph.D. thesis, University of California, Santa Barbara, 1987

Lang, Cecil Y., ed., *The Swinburne Letters*, 6 vols. (New Haven: Yale University Press, 1969)

Lamont, L.M., ed., *Thomas Armstrong, C.B., A Memoir, 1832-1911* (London: Martin Secker, 1912)

Lecoq de Boisbaudran, Horace, *The Training of the Memory in Art and the Education of the Artist*, trans L. D. Luard with an Introduction by Selwyn Image (London: Macmillan & Co., 1911)

Lucas, Edward Verrall, *Edwin Austin Abbey, Royal Academician: The Record of his Life and Work*, 2 vols. (London: Methuen and Co., 1921)

_____, *The Colvins and their Friends* (London: Methuen & Co., 1928)

Ludovici, Albert, *An Artist's Life in London and Paris, 1870–1925* (London: T. Fisher Unwin, 1926)

Maclean, Francis John, *Henry Moore, R.A.* (London: The Walter Scott Publishing Co., 1905)

Macleod, Dianne Sachko, *Art and the Victorian Middle Class: Money and the Making of Cultural Identity* (Cambridge: Cambridge University Press, 1997)

Masters of Art: Albert Moore (Boston: Bates and Guild, 1908)

Marks, Montague, 'My Notebook', *Art Amateur*, 29 (November 1893), 132

Merrill, Linda, *A Pot of Paint: Aesthetics on Trial in Whistler v. Ruskin* (Washington and London: Smithsonian Institution, 1992)

_____, *The Peacock Room: A Cultural Biography* (Washington, DC: Freer Gallery of Art and New Haven: Yale University Press, 1998)

Monkhouse, Cosmo, 'Albert Moore', *Magazine of Art*, 8 (1885): 191-6

Moore, George, 'The Royal Academy', *Fortnightly Review*, 57 (June 1892): 828-39

Morris, Edward, *Victorian & Edwardian Paintings in the Walker Art Gallery & at Sudley House* (London: HMSO, 1996)

Richard Muther, *The History of Modern Painting* [orig. pub. 1893], 3 vols., trans. Arthur Cecil Hillier (London: Henry and Co., 1896), 3: 127-31

Pennell, Elizabeth Robins and Pennell, Joseph, *The Life of James McNeill Whistler*, new and rev. edn. (Philadelphia: J. B. Lippincott Company, 1911)

_____, *The Whistler Journal* (Philadelphia: J. B. Lippincott Company, 1921)

Preston, Kerrison, ed., *Letters from Graham Robertson* (London: Hamish Hamilton, 1953)

Psomiades, Kathy Alexis, *Beauty's Body: Femininity and Representation in British Aestheticism* (Stanford: Stanford University Press, 1997)

Quilter, Harry, 'The Art of England. II', *Universal Review*, 4 (May 1889): 58

_____, *Preferences in Art, Life, and Literature* (London: Swan Sonnenschein & Co., 1892)

Ernest Radford, 'Albert Moore', *The Idler*, 13 (August 1898): 2-9

Reynolds, Simon, *The Vision of Simeon Solomon* (Stroud, Gloucestershire: Catulpa Press, 1984)

_____, *William Blake Richmond: An Artist's Life, 1842-1921* (Wilby, Norwich: Michael Russell, 1995)

Richmond, J.C., 'Obituary. John Collingham Moore', *Art Journal*, 42 (1880): 348

Robertson, Walford Graham, *Time Was* (London: Hamish Hamilton, 1931)

Rossetti, William Michael, ed., *Rossetti Papers, 1862 to 1870* (London: Sands & Co., 1903)

___ and Swinburne, Algernon, *Notes on the Royal Academy Exhibition, 1868* (London: John Camen Hotten, 1868)

Ruskin, John, *The Works of John Ruskin*, eds. Edward Tyas Cook and Alexander Wedderburn, 39 vols. (London: George Allen, 1903-12)

Russell-Cotes, Merton, *Home and Abroad: An Autobiography of an Octogenarian*, 2 vols. (Bournemouth, privately printed, 1921)

Saint, Andrew, *Richard Norman Shaw* (New Haven and London: Yale University Press, 1976)

Seymour, Gayle Marie, *The Life and Work of Simeon Solomon (1840-1905)*, Ph.D. thesis, University of California, Santa Barbara, 1986

Smith, Alison, *The Victorian Nude: Sexuality, Morality and Art* (Manchester and New York: Manchester University Press, 1996)

Smith, Helen Elizabeth, *Decorative Painting in the Domestic Interior in England and Wales, c. 1850-1890* (New York and London: Garland Publishing, 1984)

Spanton, W. S., *An Art Student and his Teachers in the Sixties with Other Rigmaroles* (London: Robert Scott, 1927)

Spencer, Robin A., *James McNeill Whistler and his Circle: A Study of his work from the mid-1860s to the mid-1870s*, M.A. report, Courtauld Institute, University of London, 1968

Staley, Allen, 'The Condition of Music', *Art News Annual*, 33 (1967): 81-7

Staley, Edgcumbe, *Lord Leighton of Stretton, P. R. A.* (London: The Walter Scott Publishing Co., 1906)

Starr, Sidney, 'Personal Recollections of Whistler', *Atlantic Monthly*, 101 (April 1908): 528-37

Stirling, Anna Maria Wilhelmina, *The Richmond Papers* (London: William Heinemann, 1926)

Stoner, Joyce Hill, *Textured Surfaces: Techniques, Facture, and Friendship in the Work of James McNeill Whistler*, Ph.D. thesis, University of Delaware, 1995

Surtees, Virginia, ed., *The Diary of George Price Boyce* (Norwich: Real World, 1980)

Swinburne, Algernon Charles, *Swinburne Letters*, ed. C. Lang, 6 vols. (New Haven: Yale University Press, 1969)

Terry, Ellen, *The Story of My Life*, 2nd edn. (London: Hutchinson & Co., 1912)

Walker, Robert, 'Private Picture Collections in Glasgow and the West of Scotland. III. Mr. William Connal's Collection of the Works by Albert Moore', *Magazine of Art*, 17 (1894): 361-7

Walkley, Giles, *Artists' Houses in London, 1764–1914* (Aldershot: Scolar Press, 1994)

Ward, Edwin A., *Recollections of a Savage* (London, Herbert Jenkins, 1923)

Way, Thomas Robert, *Memories of James McNeill Whistler the Artist* (London and New York: John Lane, 1912)

Wedmore, Frederic, 'Albert Moore', *Illustrated London News* (7 October 1893), 436

_____, 'Some Tendencies in Recent Painting', *Temple Bar*, 53 (July 1878): 334-48

_____, *Whistler and Others* (London: Sir Isaac Pitman & Sons, 1906)

Weintraub, Stanley, *Bernard Shaw on the London Art Scene, 1885–1950* (University Park and London: Pennsylvania State University Press, 1989)

_____, *Whistler: A Biography* (New York: Weybright and Talley, 1974)

Whistler, James McNeill, *The Gentle Art of Making Enemies* (New York: G. P. Putnam's Sons, 1924)

Wilkinson, Nancy Burch, *Edward William Godwin and Japonisme in England* (Ph. D. thesis, University of California, Los Angeles, 1987)

INDEX OF WORKS

[additional preparatory studies are referenced in the endnotes; relevant page and note numbers are listed under main title]
Plate references are in **bold**

Photographic
Acknowledgements

Photo by Alastair Adams, Abbey Photography, Liverpool: 37; Fratelli Alinari, Florence: 174, 175; Art Resource/Pierpont Morgan Library, New York: 14; Ashmolean Museum, Oxford: 11, 12, 34, 36, 107, 122; John Barry Photography, Cleckheaton: 49; Birmingham Museum and Art Gallery, 24, 137, 138, 149; Bradford Art Galleries and Museums: 75; Bridgeman Art Library, London: 18, 28, 62, 78, 83, 86, 94, 104, 115, 128, 130, 151, 154, 160, 164, 166, 168, 171, 179, 181, 188, 193, Bridgeman/Julian Hartnoll 22, Bridgeman/Christie's 125, Bridgeman/Fine Art Soc 144; British Architectural Library, RIBA, London: photo A C Cooper 50, 121; British Museum, London: 23, 57, 66, 74, 79, 85, 87, 92, 108, 176; Christie's Images, London: 145, 150, 152, 169, 196; Edimedia, Paris/Leicester Galleries: 153; photo by John Evans Photography, Northampton: 53, 194; Faringdon Collections Trust, Buscot Park: 91; Fine Art Society, London: photo A C Cooper 178; Freer Gallery of Art, Smithsonian Institution, Washington DC: 114, 191; Glasgow Museums, Art Gallery and Museum, Kelvingrove: 157; Hammersmith and Fulham Archives and Local History Centre, London: 80, 184; The Heatherley School of Fine Art, London: 15; Hugh Lane Municipal Gallery of Modern Art, Dublin: 90; Hunterian Art Gallery, University of Glasgow: 100, 158; Illustrated London News Picture Library, London: 63, 134; G. King & Son Ltd. Norwich: 48; Library of Congress, Washington: 95; Collection Lord Lloyd-Webber, London: 161; The Maas Gallery Ltd., London: 173; Manchester City Art Gallery: 190; Metropolitan Museum of Art, New York: Harris Brisbane Dick Fund, 1979, 61; Museo de Arte de Ponce: 129; Museum of London: 142; National Galleries of Scotland, Edinburgh: 126; Board of Trustees of the National Museums and Galleries on Merseyside, Walker Art Gallery: 77, 115; National Portrait Gallery, London: 20; Peter Nahum at the Leicester Galleries, London: 7, 60, 93; New York Public Library: 40; Phillips International Auctioneers and Valuers, Edinburgh: 136; Pre-Raphaelite Inc. by courtesy of Julian Hartnoll: 33; photo by Prudence Cuming Associates, London: 112, 119, 127; Public Record Office Image Library, Kew: 70; Rochdale Borough Council Local Studies Library: 54; Royal Photographic Society Picture Library, Bath: 197; Sheffield City Art Gallery: 110; Soprintendenza Archeologica, Naples: 81, 99; Sotheby's, New York: 131, 147, 182; Sotheby's Picture Library, London: 9, 46, 52, 72, 103, 109, 123, 132, 133, 135, 162, 165. 166, 180, 181, 185, 186, 189, 195; Allen Staley, New York: 111; Sterling and Francine Clark Art Institute, Williamstown, MA: 84; Tate Gallery, London: 29, 30, 76, 88, 146, 177; Tullie House City Museum and Art Gallery, Carlisle: 26; Tyne and Wear Museums, Laing Art Gallery: 139, photo courtesy of Dr Gilbert Leathart 113; Victoria and Albert Museum, London: 8 (1798-1888), 13 (P.3-1911), 27 (D.1662-1904), 38 (179-1894), 44 (180-1894), 47 (1422-1907), 51 (885-1901), 55 (1636-1900), 56 (1636B-1900), 59 (D.248-1905), 64 (D.1011-1906), 67 (D.229-1905), 68 (D.229-1905), 89 (D.252-1905), 96 (1636-1900), 101 (D.251-1905), 102 (D.251-1905), 105 (D.237-1905), 118 (886-1901), 120 (D.225-1905), 141 (D.226-1905), 148 (E.248-1963), 159 (42-1884), 163 (D.253-1905), 187 (D.220-1905), 192 (D.218-1905); Williamson Art Gallery and Museum, Birkenhead, Wirral: 71; Witt Library, Courtauld Institute, London: 58, 106, 124; York City Art Gallery: 1, 98, 155, 167, photo Glen Segal 3, 6, 25, 45, 117; York Library: 5.

FOR MY PARENTS
PATRICIA AND ROBERT ASLESON
WITH LOVE AND GRATITUDE

Phaidon Press Limited
Regent's Wharf
All Saints Street
London N1 9PA

First published 2000
© 2000 Phaidon Press Limited

ISBN 0 7148 3846 2

A CIP catalogue record for this book is available from the
British Library

Printed in Singapore

Front illustrations: p. 1: *Study for the Head of Elijah* (Pl. 24);
p. 2: *The Fountain* (Pl. 62); *Azaleas* (Pl. 90); *A Venus* (Pl. 98);
Battledore (Pl. 112); p. 3: *Sea-gulls* (Pl. 71); *Birds* (Pl. 138);
An Embroidery (Pl. 154); *The Door of a Wardrobe* (Pl. 164);
p. 4: *The End of the Storm* (Pl. 132); *Sapphires* (Pl. 137); *A
Reader* (Pl. 135); *Caritas* (Pl. 188); p. 6: *Midsummer* (Pl. 171)

Author's acknowledgements

Liz Prettejohn has offered many astute suggestions which
improved the quality of this book. Other valuable
insights were gained through discussions with Tim Davis,
Catherine Futter, Christopher Gridley, Julian Hartnoll,
Dennis and Madge Jones, Margaret Macdonald, Linda
Merrill, Patricia de Montfort, Peter Nahum, Linda Parry,
Elizabeth Ruhlmann, Mary Shoesser, Allen Staley,
Howard Stoner, Nigel Thorpe and Giles Walkley. I am
thankful for additional assistance provided by Richard
Burns (Bury Art Gallery and Museum), Kirsty Byers
(Tullie House Museum and Art Gallery), Martin
Hopkinson (Hunterian Art Gallery), Alex Kidson (Walker
Art Gallery), Lisa Murray (Croxteth Hall and Country
Park), Charles Newton and Moira Thunder (Victoria and
Albert Museum), Beverley Rhodes, John Thomson and
Katherine Wilson (Shipley Country Park), Maggie Simms
(Blackburn Museum and Art Gallery), Colin Simpson
(Williamson Art Gallery), Peyton Skipwith (Fine Art
Society), Hugh Stevenson (Glasgow Art Gallery and
Museum) and Stephen Wildman (Ruskin Library).
Bernard Dod of Phaidon has proved a singularly patient
and supportive editor who always had the best interest of
the book in mind. Zoë Stollery, Sam Wythe and Giulia
Hetherington also worked diligently to pull the text and
illustrations together. Most of all, I am deeply grateful to
Robert, Patricia and Gail Asleson, Kristin, John and
Megan McDonnell, and the inimitable David Des Roches
for unstinting kindness and support.